COMING OUT JEWISH

A brilliantly anxious reading of the state of Jewish identity. Jon Stratton
has marked the cultural sites where an occluded, unspoken self-image and
a history of given representations might meet. *Coming out Jewish* is a work
of recovery and innovation.

Andrew Renton, University College London

What does it mean to be 'Jewish' in the modern world? In *Coming Out Jewish*, Jon
Stratton explores the nature of 'Jewishness' as a racial and ethnic identity, and
addresses issues of migration, assimilation, diaspora and multiculturalism through the
experience of being Jewish. He argues that 'Jewishness' is being understood in an
increasingly secular and non-essentialist way.

In autobiographical material woven through a number of chapters, Stratton
introduces his own experience of being brought up in a highly assimilatory
household. He goes on to explore attitudes to Jewishness as expressed in cultural
policy and in popular culture, considering the ambivalent place of Jews in Europe,
the United States, and Australia. Stratton discusses the place of Jewish thought within
Cultural Studies, referring to theories of diaspora and identity developed by authors
such as Ien Ang and Stuart Hall, and also to writers from Jewish Studies such as
Daniel Boyarin and Sander Gilman. Using a Cultural Studies perspective, Stratton
is able to show both what is distinctive in the case of the Ashkenazi and Yiddish-
background Jews, and also what is common to them and other minoritised groups
in modern nation states.

Interweaving autobiographical narrative with historical analysis, ranging from the
Jewish origins of cultural pluralism in the United States to the Jewishness of *Seinfeld*,
Coming Out Jewish is a path-breaking book that firmly places the Jewish experience
on the Cultural Studies agenda.

Jon Stratton is Professor of Cultural Studies at Curtin University of Technology,
Perth, Australia.

COMING OUT JEWISH

Constructing ambivalent identities

Jon Stratton

London and New York

First published 2000
by Routledge
11 New Fetter Lane, London EC4P 4EE

Simultaneously published in the USA and Canada
by Routledge
29 West 35th Street, New York, NY 10001

Routledge is an imprint of the Taylor & Francis Group

© 2000 Jon Stratton

Typeset in Bembo by
Keystroke, Jacaranda Lodge, Wolverhampton
Printed and bound in Great Britain by
TJ International, Padstow, Cornwall

British Library Cataloguing in Publication Data
A catalogue record for this book is available from the British Library

Library of Congress Cataloging in Publication Data
Stratton, Jon.
Coming out Jewish : on the impossibility of Jewish assimilation / Jon Stratton.
p. cm.
Includes bibliographical references and index.
1. Jews–Identity. 2. Jews–Cultural assimilation. 3. Jews–Social conditions–20th
century. 4. Antisemitism. 5. Multiculturalism–Religious aspects–Judaism. I. Title.
DS143.S765 2000 99-054124
305.8924–dc21

ISBN 0–415–22208–7 (Pbk)
ISBN 0–415–22207–9 (Hbk)

CONTENTS

v

CONTENTS

ACKNOWLEDGEMENTS

This book began life about four years ago as a number of independent essays. While writing them, I took time off to write a book about race and multi-culturalism in Australia, *Race Daze: Australia in Identity Crisis*, a book that was my contribution to contesting the rise of racism in this country. This development is by no means unique to Australia. Indeed, it is part of the transformation in the national experience of the nation-state that is, perhaps, most profound in 'Western' states but which is a general function of the reorganisation of global capitalism. Thus, both books have a similar moment of genesis, the question of identity in the national context during this time when the traditional national forms are being contested by new emphases that diminish the traditional nation-state. Among these are middle-class migrations; transnational communication systems including satellite television; the Inter-net; regional trading blocks; a new acceptance among elites of cosmopolitanism; multiculturalism in its many forms rather than homogenisation.

The articles in this book were written for various purposes. Five have been presented at conferences in earlier forms, and another one as a seminar paper. A number have not been either presented or published before.

I would like to thank the audience at the 'Jewries at the Frontier' conference, held at the Isaac and Jessie Kaplan Centre for Jewish Studies, University of Cape Town, 1996, for their comments on a version of 'Jews, race and the White Australia policy.' I would especially like to thank the organisers, Sander Gilman and Milton Shain, for their encouragement. 'Speaking as a Jew' was presented at the 'Crossroads in Cultural Studies' conference, Tampere, Finland, 1996. As I recount elsewhere in this book, I was shocked at the large audience for this paper, given that this was not a conference specialising in Jewish matters, and I would like to thank all who were there for their lively and positive contribution. I particularly want to single out and thank Larry Grossberg for his engagement with the paper and with my project generally.

I was invited to give 'Jews and multiculturalism in Australia' at the '(Im)Purity: Critical Hybridity and Transculturation' conference in Sydney in 1996. This piece provides the most obvious connection between this book and *Race Daze*. I would like to thank the Research Centre in Intercommunal

Studies at the University of Western Sydney for the stimulus to write this piece and the opportunity to present it.

'Historicising the idea of diaspora' was presented as a public lecture at the University of Iowa while I was there as a Rockefeller Fellow for three months in 1998. During that time I wrote drafts of the pieces that appear in this book as 'Migrating to utopia' and 'Making social space for Jews in America.' I would like to thank the Rockefeller Foundation for making this research period possible and, in particular, Virginia Dominguez and Jane Desmond, who created and run The International Forum for US Studies. They, and their helpers, produced a wonderful work environment and complemented this by being great friends and colleagues.

'Historicising the idea of diaspora' was also presented as a public lecture at the Illinois Program for Research in the Humanities, University of Illinois, Urbana-Champaign. The Program is presided over by Michael Berube and I would like to thank him for his invitation, and for his enjoyable company. Michael invited me back to present a plenary at his conference entitled 'Culture, Place, and the Cultures of Displacement' in 1999. For this I gave 'Ghetto thinking and everyday life.' I would like to thank the audience, and especially the postgraduates, for their stimulating, and sometimes anxious, interaction with this paper. The sight of a man, who I later discovered to be a middle-aged anthropologist, rapidly bearing down on me from the back of the hall, finger waving, as soon as I had finished speaking, while the chairperson remained seated looking at me, will remain with me for some time! Michael, and his assistant Christine Catanzarite, were both charming and obliging hosts.

A section of 'Making social space for Jews in America' was presented as a seminar paper during my time as a Resident Scholar at the Center for Cultural Studies, University of California, Santa Cruz in 1998. I would like to thank the audience for their thoughtful consideration of the paper. In particular, I wish to mention Mark Slobin for his input. I must thank Chris Connery and Gail Herschatter for facilitating my presence at the Center, and for their hospitality during the time that I was there. In addition, I want to thank Jim Clifford for his interest in, and intellectual input to, my work while I was at the Center.

Versions of 'Seinfeld is a Jewish sitcom, isn't it?' were presented at the Australian Cultural Studies Association conference in Adelaide in 1998, and also at the Capstone conference at the International Forum for US Studies, University of Iowa, in 1999. I would like to thank both audiences, especially that at the Capstone conference. I must say that I was quite overwhelmed at the enthusiasm that many members of that audience showed this piece.

It is also important that I do not forget to thank my own institution, Curtin University of Technology, for whom I have worked during the period of the writing of the pieces that comprise this book. Curtin gave me the sabbatical leave that enabled me to take up the Rockefeller fellowship at the University of Iowa, and the research position at the University of California, Santa Cruz.

I was also able to take Long Service Leave from Curtin which gave me the time to write both 'Ghetto thinking' and the chapter about *Seinfeld*.

I have to thank Helen Mumme for her work keying in the various drafts of what have become these chapters. More, with the new possibilities provided by the Internet, at times I e-mailed Helen revised versions from various parts of the world which she professionally reworked into properly formatted papers.

I wish also to record my gratitude to Rebecca Barden at Routledge for encouraging me to submit this collection for publication and for her wise editorial advice during this process.

I must thank Amanda Third who checked and completed the references for most of the chapters for me, and compiled the bibliography.

Finally, I would like to thank my friends, both Jewish and non-Jewish, who have supported me through this project. It is invidious to single out any specific people but I must mention three, Mitzi Goldman, Heidi Grunebaum-Ralph, and Sarah Schladow. Over the last few years all three have provided sounding boards for my work and have, at various times, read and commented on early drafts of pieces. I must also record the great debt that I owe Ien Ang for her companionship and intellectual insight during the progress of this project.

It just remains for me to remind readers that any mistakes remaining in the book, and all opinions, are my responsibility.

I am grateful for permission to republish the following pieces: 'The Impossible Ethnic: Jews and Multiculturalism in Australia' from *Diaspora: A Journal of Transnational Cultural Studies*, vol. 5(3), 1996, pp. 339–73; '(Dis)Placing the Jews: Historicizing the Idea of Diaspora' from *Diaspora: A Journal of Transnational Cultural Studies*, vol. 6(3), 1997, pp. 301–29; 'Speaking as a Jew: On the Absence of a Jewish Speaking Position in British Cultural Studies' from *The European Journal of Cultural Studies*, vol. 1(3), 1998, pp. 307–25; 'The Colour of Jews: Jews, Race and the White Australia Policy' has been previously published in Sander Gilman and Milton Shain (eds.), *Jewries at the Frontier*, Urbana, University of Illinois Press, 1999. An abbreviated version of this piece also appeared in the *Journal of Australian Studies*, no. 50/51, 1996, pp. 51–65.

INTRODUCTION

These days everyone was insisting on their identity, coming out
as a man, woman, gay, black, Jew – brandishing whichever
features they could claim, as if without a tag they wouldn't be
human.

Hanif Kureishi, *The Black Album*

I am of the generation born and brought up in the West in the years after
the Second World War. We are the baby-boomers, coming to maturity in the
second half of the 1960s. Consumption has defined our generation. Many of
us, especially in settler-states (and I am thinking here of the ones that I know
best, the Anglophone ones) such as the United States of America, Canada, and
Australia, are the children, grandchildren, or great-grandchildren of migrants.
Given that the nation-state itself, in its full governmental and institutional
form, only dates back to around the first half of the nineteenth century, there
is no earlier history to help us to understand the specificity of our experiences
as the descendants of immigrants from other cultural, and sometimes racialised,
backgrounds to this new social form – indeed, the discourse of society is itself
roughly coterminous with the evolution of the state. Our ancestors were
expected, and forced, often in ambivalent ways, to assimilate into the homo-
genising nation-state to which they had travelled.

It was always assumed that migrants could, and willingly would, cast off their
old culture and accept a new one. We now know that it could never be so simple,
that even when migrants were enthusiastically accepted, and determinedly
took on new cultural practices, traces of their parents' and grandparents' lives,
and even those of ancestors further back, have haunted the ensuing generations
as they live out their own lives in the nation-state. For the descendants of
those who were more ambivalently received, and who may, themselves, still be
reminded of their 'racial' or 'ethnic' background, the traces may be deeper,
stronger, more obvious.

Since the early 1970s, multiculturalism in its many forms has become a
buzzword. It is usually associated with the nation-state's attempts to

1

accommodate and manage the large influx of migrants, both European and non-European (a dubious but commonplace distinction which roughly equates with that between 'ethnic' and 'racial,' where 'European' connotes 'white' and ethnicity the plurality of groups within that racial category), since the turn of the century. In the United States, multiculturalism is a social and political movement that has grown out of the failure of cultural pluralism to be inclusive, particularly of African-Americans.[1] In Canada and Australia, multi-culturalism expresses the official espousal of cultural pluralism in the wake of the failure of assimilation.[2] Earlier than any of these, Singapore instituted its policy of multiracialism as a means of managing its racially and culturally diverse population after independence in 1965.[3] Paralleling the spread of the multiculturalist discourse has been a renewed interest in the problem of identity within the nation-state.[4] Reflecting this, identity has now become so prominent as an area of investigation in cultural studies that it has joined the triumvirate of race, class and gender as a defining concern of the (non-)discipline.[5] Indeed, identity is often thought of as subsuming these three key subjectifying categories.

This book is concerned with issues of migration, diaspora and, most of all, assimilation. It is, specifically, concerned with the Jews in Europe and in other English-speaking Western nation-states. Of these Jews I focus particularly on the Ashkenazi Jews of Western Europe, and their intersection with the project of modernity, especially with the historically novel idea of assimilation into the nation-state. My concern is also the Yiddish-speaking Jews of Eastern Europe, the *Ostjuden*, who created a dynamic cultural entity over many centuries and then were basically forced into migration during the last decades of the nineteenth century. It is these Jews who formed the Bund, that is the Jewish socialist workers' party, whose ideas for migration to *Eretz Israel* were a precursor of Theodor Herzl's, and who subsequently formed the backbone of Zionism. It was these Jews and their descendants who, overwhelming in numbers the Sephardi and Western European Ashkenazi migrants to the United States, have more or less produced, and become identified with, American-Jewish everyday life. It was also these Jews who provided much of the political and general organisational, and military, skills in the decades leading up to the establishment of Israel, and whose descendants today still, for good or bad, dominate the sites of power in Israel. And it was the Yiddish Jews who formed the bulk of the six million Jews murdered in the Holocaust, about 5,400,000 coming from Poland and the USSR.[6]

In certain ways, as I will discuss, the Jews in Europe were quite unique. The nearest comparison would be with the Rom, the Gypsies. However, I want to emphasise that, in other ways, the Jews share commonalities with other peoples. For example, what happened to the Jews of Europe as, I think, John Murray Cuddihy was the first to point out, can be thought of as a form of colonisa-tion.[7] As a distinct and excluded group, European Jews were forced to accede to the demands of modernity, especially as expressed through the nation-state.

The emancipation of the Jews was a trade-off for their modernisation. Similarly, the migrant *Ostjuden* had to learn the social practices of civility as well as the cultural practices of the nation-states to which they migrated, in order to become acceptable. For the colonised and modernised Jews of Europe, and the settler-states, the presence of the *Ostjuden* produced a fear that their own relative acceptance would be challenged.

It is important that I specify here. 'The Jew' is a gentile, Western Other, as much a construct as, and indeed often a part of, the construct of the 'Oriental' or 'Asiatic.'[8] Yet, 'the Jew' is also ambivalently considered to be white, Western, and European. Constructing 'the Jew' as a unified entity has led to an attempt to think of Jews as having a common culture. The desire to homogenise cultural diversity into a national culture has been a characteristic of the nation-state. There is no single Jewish culture, though for those, of whom I am not one, who think of Israel as a Jewish state, there is an Israeli culture which is Jewish. I think of Israeli culture as partly Jewish, and certainly heavily influenced by Yiddish culture, but we must also remember that Israeli culture is produced by Jews from a wide variety of cultural backgrounds, as well as Palestinian Arabs and Bedouin. The question of the ways in which Israeli national culture might be thought of as Jewish is fascinating and fraught. Underlying it is the problem of whether there could, by definition, be a *national* Jewish culture. Can Jews be considered as a nation in the modern sense of the term?

In both the West and Israel, a combination of Ashkenazi and Yiddish religio-cultural traits are now talked about with ease as 'Jewish culture' and Jews with these backgrounds have become 'the Jews.' I am not thinking of 'the jews' of Jean-François Lyotard's commentary.[9] That is a rather different, and more ontologically powerful, construct. However, the two formulations do overlap in everyday European understanding. Here, I am thinking merely of the construction of an ambivalently Othered, apparently unitary grouping 'the Jews' – one that the Jews of Europe more or less colluded in the construction of – which has a discursive existence much like 'Asians', though 'Asians' is a more fully Othered category. At the very beginning of *Thinking in Jewish*, his collection of meditations on identity politics from a Jewish perspective, Jonathan Boyarin writes about his title that

> the phrase alludes to the use of the term 'Jewish' to designate the language otherwise known as Yiddish. This usage is peculiar to a certain intermediary generation, child immigrants and the children of immigrants from Jewish Eastern Europe. It is a partial translation, a failed translation, evidence of a barely possible attempt to display attachment and competence in an ancestral idiom on the one hand, while demonstrating an educated, responsible awareness of the new idiom on the other: to claim identity without being claimed by it.[10]

In this nuanced and sympathetic account of the reasons for the use of the general term 'Jewish' for the specific term 'Yiddish' – it is literally a translation – Boyarin fails to acknowledge the impact of this usage. He notes only the important point that the translation takes place into a modern culture in which the ideology of identity has become central to subjectivity. Thus, the meaning of the appellation changes in the translation. Boyarin does not talk about the transformation of the usage into a way of naturalising the dominance of Ashkenazi and Yiddish Jews in the social order of the West. This hegemonic formation has marginalised other Jewish groups, most importantly Sephardi and Mizrahi Jews.[11] In this book I do not speak for, or about these other Jewish groups except where the context makes this clear.[12] We must remember too that it is also possible to talk, for example, of German-Jewish, or Argentine-Jewish, culture; of German Jews and Argentine Jews, that is, of Jewish cultures influenced by the national cultures within which Jews live; and it must be remembered that these cultures are inflected by the variety of Jewish cultures, Ashkenazi, Sephardi, and so forth, that evolved in dynamic interaction with their surrounding populations before modernity.

Of course, as I have indicated, many Jews, both Sephardi and Ashkenazi, were not migrants into the new European nation-states: they already lived there as the nation-state, and its national population, formed around them, precipitating debates about their presence, their exclusion, or ways that they might be included, indeed assimilated, into the nation. There is, now, a large, historical literature on the Jewish experience at that time, and I do not intend to go over this ground again.[13]

It is strange, but also understandable when given this social and cultural context, that Jewish identity should be so often ignored, or at best tokenistically included, in the proliferation of courses and texts that attend to what is now described as the problem of identity. In the United States, where identity talk tends to have a racial inflection, most discussion of identity, and identity politics, is concerned with African-Americans and, increasingly, 'Hispanics' and 'Asians.' Jews are rarely mentioned, not least because having 'become white,' as Karen Brodkin puts it,[14] after the Second World War, Jews do not easily fit this current form of American racialised identity politics.

The prominence of multiculturalism in the United States, and the changes in immigration laws made in 1965 (though the 1965 Immigration Act was fully implemented only in 1968) that have led to high numbers of 'non-white' migrants, have also caused an increasing anxiety among American 'whites' that their naturalised position of power is in danger of being eroded. A good example of a recent American text which expresses well both the new white anxiety about this loss of naturalised power and the traditional Yiddish desire for acceptance in white American society is the film *There's Something About Mary* (1998). This film is popular with younger people as a taboo-breaking, scatological, romantic comedy. It includes, for example, a scene where Mary, played by Cameron Diaz, mistakenly puts semen in her hair thinking it is hair gel.

As the title suggests, the film centres on Mary. It opens with a flashback, Mary riding her bicycle to school. She is blond, blue-eyed, and willowy, as she remains through the time-shift of the film. After she and Ted, played by Ben Stiller, meet, Mary asks Ted to go to the prom with her. Mary's invitation is the best thing that has ever happened to him. Ted is a classic Jewish *schlemiel*, a loser whose every effort at improvement works against him. Ben Stiller, in fact, is the son of the Jewish Jerry Stiller who played George Costanza's father on *Seinfeld*.[15]

In *There's Something About Mary*, Ted's family name is Stroehmann. German-sounding it does not particularly identify Ted as Jewish. Nothing does. Like the characters in *Seinfeld*, Ted offers the viewer the possibility of reading him as a Jew – looks, behaviour, name – but no certainty. This is an ambivalence of representation. At the same time, Mary is clearly marked as the all-American girl. She has 'Nordic,' if not Aryan, looks, and we are also told that she comes from the Midwest, from Minnesota, a part of the American heartland to which there was a lot of Scandinavian migration in the second half of the nineteenth century. Her name, Mary, marks her as the archetypal Christian girl, offering connotations of Jesus' mother. In her book on the whitening of Jews in the United States, Brodkin tells us that, when she was an adolescent, she 'thought of storybook and magazine people as "the blond people," a species for whom life naturally came easily, who inherited happiness as a birthright, and [she] wanted [her Yiddish] family to be like that, to be "normal."'[16] A little later Brodkin tells us that her 'sense of Jewish difference was formed through aspiring to blond-people whiteness.'[17] There is an extra-textual irony in the film as Cameron Diaz's father is of Cuban background. Though her mother combines German, English and Native American, Diaz identifies as a Latina.

In the film Mary is not only positioned as 'white,' she is also rich and, in the 1990s section, apparently a successful orthopaedic surgeon. Everybody, it seems, loves Mary: Dom 'Woogie' Wooganowski, whose family name marks his background as central or eastern European ethnic,[18] Norm, the working-class Pizza delivery boy who desires her so much he pretends to be an upper-class architect named Tucker to be close to her, and Pat Healy whose name suggests an Irish heritage, and who gives up his career as a private investigator to try to go out with her. And Ted, of course, the magazine writer who has spent almost a decade trying to write his novel. Ted has been in love with Mary since she asked him to the school prom. These marginal white men, working class and ethnic, don't just love Mary, they sacrifice their lives for their desire for her. She is a fetish. She stands in for the very quality of whiteness itself as a site of social and cultural power.[19] In the United States, where whiteness and class are deeply imbricated, her upper-middle-classness affirms her whiteness. Richard Dyer has argued that 'The invisibility of whiteness as a racial position in white (which is to say dominant) discourse is of a piece with its ubiquity.'[20] In this film whiteness becomes visible as a function of white anxiety. The film seeks to reassure middle-class Anglo-America that the category of 'white' is still

intact, and that true whiteness, with its trappings of power and wealth, is still dominant and desirable. The something there is about Mary is her whiteness.

The moment of greatest racial anxiety in the film is also the one that threatens to undo the film's project of white racial reassurance. It is, inevitably, introduced as a joke. Ted goes to pick Mary up for the prom. When he knocks on her family's front door it is answered by an African-American. Who is this man? It turns out to be Mary's step-father. He is the only non-white, or Jewish, person in the film. It is the absence of other racial groups that offers success for the film's project. The film creates a mythic white America as part of its strategy to generate reassurance for whites. The joke, of course, lies in the very impossibility of the man being Mary's father. However, his position of power over her, and his circumstance of actually living in a white neighbourhood – both the suburban one in which Mary lives and the metaphorical neighbourhood of the film's diegesis – let alone being married to Mary's mother and therefore having sexual access to her, provides the deconstructive lever for the American white racial anxiety of the film. At the same time, given the overdetermining binary structure of American racialisation, the presence of an African-American helps to whiten Ted.

Meanwhile, Ted stumbles from ignominy to ignominy in gentile society. He gets his penis caught in his zipper in Mary's parents' bathroom and is unable to take her to the prom. In this scene Ted's ambiguous Jewishness is played out in an anxious displacement of circumcision onto castration. There is an episode of the cult television cartoon series *South Park* that plays on the same cultural association. 'Ike's Wee Wee,' (episode 204), centres on the Jewish son, Kyle Broslofski, trying to rescue his adopted younger brother, Ike, from his *bris* (circumcision ceremony), at which Kyle mistakenly thinks his brother will have his penis cut off. Ted's zipper debacle also operates within a more general context. Given how American racial anxieties are played out in terms of penis size, it does not surprise that the first person on the scene is Mary's step-father who is simultaneously horrified and filled with laughter. Is his horror and amusement caused by his empathy with Ted's situation, or by the size of his penis (if Ted is Jewish and circumcised and therefore might already be thought to be castrated . . .), or by a combination of both? The motivation is not made clear leaving the reader to his (and her) uncomfortable, and likely unconscious, speculations. In another, later, scene of ignominy, on the drive to Miami to find Mary, Ted is mistakenly identified by the police as the propositioner of a gay man in a public place. Here, Ted's Jewishness, already associated with castration, is further, and conventionally, extended to his feminisation as he is situated, albeit mistakenly, as something less than a 'proper' man. After this, he is mistaken for a murderer.

It is Ted, though, the general failure in white society, who Mary prefers because of his honesty and preparedness for self-sacrifice – here, the traditional virtues associated with the good Talmudist are secularised into qualities of moral rectitude – over Brett, her all-American, football-playing, male

6

equivalent. Brett is played by Brett Favre, that is Brett Favre plays himself, the quarterback for the Green Bay Packers in the NFL. This archetypally white Anglo-American male anchors reality in the film. At the same time, the film tells what has been a common Yiddish American fantasy since the early part of the century: the story of a Jewish man – journalist and novelist here being the secular transformation of Talmudist – who achieves social success, acceptance and riches, by marrying the white *shiksa* (gentile girl). This conservatism – there is no assertion of Jewish identity here only a desire for acceptance – is linked to the film's anxiety about whiteness. As I have remarked, the film seeks to reassure its white audience that whiteness is still hegemonic and, both literally and metaphorically, desirable, and its Jewish-American audience that they, at least the young males, will still be found desirable, no matter how big a *schlemiel* they are, by the most desired white women who, in marrying them, will give them social acceptance, wealth and, in the process, help to make them white.

JEWISH IDENTITY

The discourse of the Jew has inflected the discourse of identity from the start, informing the attempt to find a way of identifying and talking about a group and its members, whose presence in Europe pre-existed the discursive, and ideological, forms such as individualism and liberalism which became a central part of modern assumptions about identity. Along with the putting-into-place of this discourse was the establishment of its antithesis, the idea of the Other, an idea founded in the presumptions about representation which informed modernity. Tzvetan Todorov has set this founding moment of hermeneutic production around the time of Columbus's second trip to the New World. He also notes, as Ella Shohat points out, that 'Jews formed Europe's internal "other" . . . long before the nations in Latin America, Africa, and Asia became its external "other."'[21] In fact, some Jews, here people who can be identified as having Judaic/Jewish heritage, who were important intellectual figures in the formation of the modern mentality such as Baruch Spinoza (1632–77), helped to think through the philosophical aspects of Otherness. At the same time, in their lives, they found their own and their people's alienness, their lived divergence from European Christian cultural forms, being increasingly reconstituted in the modern terms of difference, of (European) identity and Otherness.

Complicating matters was the fact that Jews were not, themselves, a homogeneous category. Within Europe there was the established distinction between Sephardi and Ashkenazi Jews. On the eastern border of Europe there were the other Ashkenazi Jews, the ones who as the Jews within Europe came to terms in various ways with – indeed often participated in producing – secularisation, nationalism, and the other aspects of modern life, most

particularly its left-wing utopian critique, and began to evolve a Yiddish-based national identity of their own. Then, outside of Europe, there have been the non-Sephardi Jews of the Arab world, the Mizrahi, 'Arab-Jews.' All these groups can be broken down into national and other forms of groupings. It needs to be added that, just as the distinction between Ashkenazi and Yiddish is blurred, so that between Sephardi and Mizrahi is confused. 'Arab-Jews' are sometimes identified as Sephardi depending, perhaps, on whether that term is being used solely for the Jews descended from those of Moorish Spain or if North African and Levantine Jews more generally are being included. In 1981 Ilan Halevi noted that 'The term Sephardic, currently used in Israeli usage as a synonym for Oriental, is understood quite wrongly: while it is true that some of the Jews of North Africa and the Levant still until recently spoke Spanish Jewish and for this reason claimed to be *Sefaradim Tehori*, like the Spanish-speaking Jews of Turkey and the Balkans, the majority of them, particularly in the Middle East, were in no way Spanish: the Iraqis, the Yemenites, even more the Iranians, are only "Sephardic" by a misuse of language.'[22] My point is that the Othering of the Jews of Europe has been no simple matter because, in many ways, those Jews always escaped such binary classification even as it was being imposed on them. More, classificatory distinction among Jewish groups is not certain and agreed upon even by Jews.

Meanwhile, the Jews within Europe raised problems for the increasingly utilised discourse of racial classification. The question of the whiteness of the Jews – of all Jews, of some Jews (those that live in the modern way?), of no Jews – continues to haunt and undermine racialised distinctions, even now when liberal thinkers insist on the secondary significance of race, emphasising, instead, culture. Here, of course, we wade into another quagmire. Can Jews be identified culturally? Are there common cultural features across, even, all European Jews, or all Ashkenazi Jews? Perhaps we are on slightly firmer ground, as I will suggest at times in this collection, in suggesting that Yiddish-background Jews share certain cultural elements, ways of thinking or, to use Raymond Williams's celebrated expression, 'structures of feeling.' In Chapter 3 I describe what I call 'ghetto thinking' as a structure of feeling common to Yiddish-background Jews.

What has been absent so far in this discussion is religion, Judaism. In the modern, and postmodern, world, religion does not define a people. Indeed, religion tends to be thought of primarily as providing a moral basis for social order. Should Judaism be thought of in this way – or in premodern terms as thoroughly integrated into the cultural practices of Jewish everyday life? In the modern world, as a result of Enlightenment pressures, Judaism has fractured into many types. We can, at least, distinguish Orthodox, Conservative and Reform, and add to these the Hasidic movement which was a fundamentalist sect established in the mid-eighteenth century. Is there a Jewish culture aside from any moral principles established by Judaism? The same question could be asked of the claimed existence of a European culture and its relationship with

Christianity, except that 'European' is not thought of as the name for a distinctive people – even though, these days, it is often used as a synonym for racially 'white.' For Jews, as a minority group, the question is more demanding. Is it possible, and if so what would it mean, for a person to subscribe to Judaism but not be a Jew? What is a secular Jew? Someone, perhaps, with a Jewish mother, according to the *halacha*, and no Judaic knowledge or faith; but the *halacha* is a body of religious law. If a person converts to become a Jew they do it by way of Judaism. It is not possible to become a Jew secularly, though it is possible to acquire some characteristics of a certain version of Jewishness. My gentile father, for example has always, in my memory, used more Yiddish than my assimilating mother, and my sister tells a story of a woman she used to work with, who was the daughter of Indian migrants who lived in Golders Green, a North London middle-class suburb popular with Yiddish-background Jews. This woman spoke English with a Yiddish accent, was familiar with the major Jewish religio-cultural festivals, and loved blintzes and latkes. But she was not a Jew. Perhaps, though, she was a little Jewish? Or is such knowledge too super-ficial? Would to be a little Jewish require more, perhaps the naturalised practice of some aspects of Jewish lived culture (what Raymond Williams, reworking a long-established anthropological tradition that goes back to Edward Tyler in the late nineteenth century, called a whole way of life), aspects of Yiddish family life for example?

It may also be possible to think of a common European Jewish experience of modernity, an experience that transcends local, and even national, inflections. I have identified this earlier as a version of colonialism. Other ways of thinking about this experience are in terms of the specifically modern anti-Semitism, and of the pressures of enlightened modernity and its Jewish response, the Haskalah, which was so much always already caught up in the production of modernity and its own primordial Otherness.

Paralleling the problem of identity is the question of authenticity. At the heart of the problematic of identity lies the fantasy of perfect representation. In the case of individuals this means that one is, ideally, what one appears to be, and what one is perceived to be. As I have noted, race, class and gender have been considered to be the key subjectifying discourses in the production of modern identity. They have worked in the context of national identification. If, as was the case in Europe, nations were thought to have an existence long precursing the nation-state, then personal identity was given a final fixing by the individual's membership of the nation. Assimilation into the nation thought of like this was, then, dependent on a common feature, race, which was thought to provide a prior connection between the assimilating person and the nation into which they were assimilating. The claim to authenticity, the feeling that one 'really is' an Italian or whatever, and can speak as such, is dependent on a belief, and indeed a feeling, of identification, a certainty of identity. For Jews, where there is no national site for identification, identity comes in many and varied forms. For example, even subscribing to Judaism is

not necessarily enough to be accepted as a Jew because there are divisions within Judaism on the issue of who might be identified as a Jew. For those wishing to identify as secular Jews, identification, and the possibility of feeling authentic, is even more uncertain.

Language has been bound up with the experience of identity in the modern period. While language acquisition in general was thought to be a defining moment in the development of society, spoken languages have played a pivotal ideological role in nation formation. Yet Jews have had no national language in this sense. The Sephardi Jews spoke a mixture of Spanish and Hebrew known as Ladino, Yiddish Jews spoke Yiddish, a mixture of German, Hebrew, Polish and other Balto-Slavic languages. There was also a language known as Judaeo-Arabic. All these languages still have small pockets of native speakers. Today, Jews speak the national languages of the nation-states in which they live. In Israel, Hebrew is the national language; it is spoken by Israeli Arabs as well as Israeli Jews.

I will argue that what characterised the context for Jewish identity in modernity was ambivalence and indeterminacy, but an ambivalence that more often than not appeared to be weighted towards acceptance provided that Jews assimilated, lost themselves and any Other identity in the nation-states in which they lived. For my generation, the Holocaust ended all possibility of thinking that we could be assimilated. It forced the recognition that assimilatory acceptance, and tolerance, like Othering itself, belong to the dominant, national group. It is theirs, and the state's, to offer and to withdraw. This is easy to write, but the experience, the inflection of the Holocaust as part of the production of (a) Jewish identity, has been profoundly more complicated and traumatic. Not least because of the complexity of feelings that have surrounded the event. For Jews, it has been associated with fear, guilt, and shame among many other emotions. In Europe, and the West, the event seems to have been so shocking to the Western cultural psyche that general knowledge of it was repressed until the 1960s.

While one section of this generation of post-war Jews, especially in the United States, have demanded a national public space to be heard and are speaking within the Jewish community on issues such as gender,[23] sexuality[24] and multiculturalism,[25] there is another section who come from highly assimilated backgrounds, often, as in my case, where only one parent has a Jewish ancestry. These are the people who fascinate me, in whom I see myself. These people know little or nothing of Judaism; sometimes they are not even consciously aware that they have Jewish descent until they find out in adulthood.[26] Often, they have followed their parents, and perhaps grandparents, in finding their Jewish heritage an irrelevance, an anachronism in modernity, or something to be passed over, unspoken. It is this group who are now beginning to speak, to search for how 'being Jewish' is a part of their identity. Often this is difficult, anxiety-producing. It is making plain what the previous generation(s) precisely wanted hidden, or thought could be expunged.

Certainly I believe that it is connected in complex ways to the Holocaust, and to the Holocaust as a European, modern event, in the same way that assimilation in the nation-state was a uniquely modern project.[27] As I have noted, the Holocaust marked an end to the Jewish fantasy that Jews could assimilate if they wanted to and the recognition that the possibility of assimilation was determined by those who dominate the nation and the state. The Holocaust and total assimilation are, therefore, two sides of the same coin, one minted by the nation-state.

Holocaust-Jewishness, the idea that what defines being a Jew for many secular Jews is their relation to the Holocaust, is often derided by religious Jews. The first detailed exposition of Holocaust-Jewishness came from Jean Améry, the Austrian son of a Jewish father and a mother of Jewish-Christian descent. During the Second World War Améry had joined the Belgian resistance. Captured and tortured, identified as a Jew, he was sent to Auschwitz. In 1966 he published *Jenseits von Schuld und Sühne*, which was published in English in 1980 as *At the Mind's Limits*.[28] Brought up a Catholic, and with only the slightest sense of being a Jew, 'It was while reading the Nuremberg Laws in a newspaper in a Vienna coffee-house that the young adult Améry knew not only that they applied distinctly to him, that they "had just made me formally and beyond any question a Jew," but that from then on to be a Jew meant to be a "dead man on leave . . . who only by chance was not yet where he properly belonged." '[29]

To be precise, while Holocaust-Jewishness tends to be thought of as being based in the horror of the genocidal inclusiveness of the Holocaust, it is actually a recognition of the state's power to identify, classify and to destroy. When Améry states that 'It was not only the Nazis who turned me into a Jew. The world insisted that I be one . . .'[30] his 'world' is the modern state of Germany and, more generally, the states of Europe.

Personal identification as a Jew through Holocaust-Jewishness is often thought of in the same way that Jean-Paul Sartre's position in *Anti-Semite and Jew* is, as an abnegation of personal responsibility, that one claims to be a Jew because one is 'seen' as such. Indeed, it is often argued that, for Sartre, Jews only exist because some people are identified as Jews. This mistakes what is at issue and, I suspect, it mistakes the point Sartre was trying to make also.

The discourse of race has been central to the formation of the modern nation-state. In this discourse, race has been assumed to be hereditary and, in its social Darwinist inflection, to mark those whose way of life, thought of as a moral and cultural complex somehow determined as an aspect of their racial characteristics, is too distinct, and likely too inferior, to be included in the racially defined nation. To accept that one is a member of a class of people classified by the state in a particular way is to do the same as any other member of the state does, or perhaps did, when they unquestioningly accepted their interpellation as 'white,' or as a member of the 'Anglo-Saxon race' or, indeed, the 'British race.' This, I think, is at least a part of what Sartre was getting at.

All these terms signal a biological determinism, and an essentialism, away from which Western society has been moving, especially since the Second World War.

It is in this context that the discourse of the Jew, as a modern, racial identification, has been complicated, though not supplanted, by the discourse of Jewish, of religio-cultural, characteristics and, as part of this, of morality and affect. Here, we find a definition of Holocaust-Jewishness which is, in part, bound up in a traumatic identification. This identification is complicated by an increasing sense of the Holocaust, not just as an act perpetrated on those that the Nazi state, and others, saw fit to identify as Jews, but as a part of the moral and cultural baggage of Euro-American, Sephardi and Ashkenazi, Jewry, and most probably of world Jewry. Where the Holocaust, genocide, ethnic cleansing, mark out the effects of a historically racialised classifying by the modern state, the demand to assimilate was the way the modern state dealt with those considered similar enough to include.

The process of assimilation, to which we who are descended from those who attempted to assimilate can attest, marks not only the assimilator but also their children and, in at least some circumstances, their children's children. It seems as if, for some of my generation, born in a Europe which could not even begin to talk clearly about what had been done to the Jews, and often of parents whose not necessarily conscious response to the Holocaust was that it was a visitation for not assimilating enough, the ability to acknowledge one's Jewishness in a public fashion has been difficult in the extreme.

UNCERTAIN JEWISHNESS

This book is entitled *Coming Out Jewish*. While the idea of coming out is often associated with gays and lesbians, it need not be. Coming out is a part of the discourse of assimilation, as is passing. Indeed, coming out may be understood as the reverse of passing. Where passing is the practice whereby a person gives the appearance of being something other than they are, being straight when they are gay, or white when they are a Jew, for example, coming out is the practice of publicly acknowledging that which need not be acknowledged in that particular society, precisely because a person can, and has, in fact, passed. I specify here 'in a particular society' because a person's ability to pass may vary from society to society (the most powerful society in this regard is the national society of the nation-state), and from one part of a society to another.[31]

Eve Kosofsky Sedgwick has compared the structure of coming out for gays and Jews. She suggests that, whereas race is usually always already present in visual identification,

Ethnic/cultural/religious oppressions such as anti-Semitism are more analogous [to gay oppression] in that the stigmatized individual has at

least notionally some discretion – although, importantly, it is never to be taken for granted how much – over other people's knowledge of her or his membership in the group: one could 'come out as' a Jew or a Gypsy in a heterogeneous urbanized society more intelligibly than one could typically 'come out as,' say, female, Black, old, a wheelchair user, or fat.[32]

For Kosofsky Sedgwick, what distinguishes coming out for gays from the same process for Jews and Gypsies is the private context from which one emerges publicly. She argues for a certainty of private Jewish and Gypsy familial identity because of 'clear ancestral linearity and answerability, in the roots . . . of a cultural identification through each individual's originary culture of (at the minimum) the family.'[33]

Kosofsky Sedgwick takes Jewish identification to be much more certain, much more ascribed, than I am suggesting in this book. It is not surprising that, when she delivers her extended, and sophisticated, comparison of Jewish and gay coming out, she uses the Esther narrative from the Bible, especially as retold in Racine's play of that name from 1689. Esther became King Ahasuerus's (Xerxes) queen but did not tell him that she was Jewish. When, under the influence of his advisor Haman, Ahasuerus agreed to the murder of all the Jews in his realm, Esther revealed her background to him. Subsequently, Ahasuerus had Haman hung. In Racine's play there is a certainty of Jewish identity increasingly lacking today. Kosofsky Sedgwick writes that 'Although neither the Bible nor Racine indicates in what, if any, religious behaviors or beliefs Esther's Jewish identity may be manifested *there is no suggestion that that identity might be a debatable, a porous, a mutable fact about her.*'[34] Kosofsky Sedgwick goes on to compare the Jewish circumstance with that of gay self-disclosure when the person may be asked, '"How do you know you're really gay? Why be in such a hurry to leap to conclusions? After all, what you're saying is only based on a few feelings, not real actions [*or alternatively*; on a few actions, not necessarily your real feelings]; hadn't you better talk to a therapist and find out?"'[35] If Kosofsky Sedgwick had chosen, let us say, *Seinfeld*, to illustrate her argument rather than Racine's proto-modern play where identity was already being constructed in absolute and exclusivist terms, then she would have found her distinction more problematic. The questions which she imagines being addressed to a person identifying to family or friends as gay may increasingly be addressed to people claiming to be Jewish – and I would not even alter 'therapist' to rabbi – and providing a wide variety of legitimations for this claim. (I am tempted to suggest a reading of the *Seinfeld* episode entitled 'The Note', episode 18, along these gay/Jewish lines. In this episode, George has a massage from a blond masseur called Raymond and begins to worry that he, George, may be gay. Many viewers of *Seinfeld* wonder if George is Jewish.)

We need not define 'coming out' and 'passing' in essentialist terms, terms which were central to the practice of nation-building in the nineteenth century

and central to the classical modern formulation of 'The Jewish Question'. If Jews were to be considered a race then they could not be assimilated, though they might be able to pass. If they were to be identified by religion or culture – if Jews, or at least European Jews, were to be thought to be white – then they could be assimilated. We can move away from this essentialising context, in much the same way that the rhetorical shift from gay to queer also signals, among other things, a move away from essentialist theoretical assumptions. Kosofsky Sedgwick links the idea of coming out with that of the closet describing them as 'now verging on all-purpose phrases for the potent crossing and recrossing of almost any politically charged lines of representation.'[36] The informing context here is the modern distinction between public and private. However, as Kosofsky Sedgwick explains for gays, there is no legal guarantee of safety if one stays 'in the closet.'[37] The image of the closet is a utopian, liberal idea bound up with both essentialism and privacy. It expresses a fantasy of individual rights in the civic order of the modern state. As such, rather than originating with gays, it was a structure invoked in many cases, not least the emancipation of the Jews and their right to 'be Jews' in the privacy of their own homes while being citizens in the public sphere. Today, the shift away from essentialism and the breakdown of the divide between public and private has made the image of the closet very problematic. Indeed, the loss of a clear distinction between public and private means that any parameters that previously, at least ideally, marked the limits of the closet have become, in some degree, blurred. Not only has the sense of an obligatory and obliging confinement been replaced by a liberatory politics of public self-expression, something intimately bound up with the rise of the ideology of multiculturalism, especially in its American form, but also, who might be considered to be 'in the closet' and therefore able to 'come out,' or, indeed, to be 'outed,' is unsettled by the move towards constructivism.

In using the terms 'coming out' and 'passing' I am not presupposing any essential claim to being a Jew, other than the complex, questionable, and traditional one of heredity but I do want to recognise a continuing everyday cultural understanding of identificatory difference – 'Oh, so you're actually a Jew,' 'Oh, so, in fact, you're black.' However, if there is no racio–cultural essence, then does that mean that anybody can identify as a Jew, or at least as Jewish? There is, I suspect, no clear answer to this very postmodern question though we can say that successful naturalisation of a person's claim would be dependent on their acceptance by other identifying Jews and by the more general, gentile, society.

There is a more or less general stereotype of what a Jew looks like in the West. This includes, for example, curly black hair, high cheekbones, and a large nose.[38] Among other influences, this image is partly based on an idea of Jews being 'oriental' and having 'eastern looks,' and what these are thought to be, and partly on a familiarity with Yiddish migrants and their descendants. I happen to fit this image to some extent – though my hair only started to

become curly after I reached forty! Of course, many Jews do not fit this physical image, and some 'white' gentiles do. The salience of the image varies from place to place and is complicatedly linked to the possibility of passing. In my own case, it is my experience that I am less likely to be identified as a Jew by gentiles in Australia than in England. Thinking primarily of sight, identification as a Jew in Australia takes place within a discursive regime that, since the post-Second World War migration of large numbers of marginal whites, called 'ethnics' in Australia, Maltese, Italians, Greeks, Eastern Europeans, has made a visual differentiation between 'Anglo-Celts' – a term which tends to include northern European and Scandinavian heritage as well as British and Irish – and 'ethnic.' When I started to work on Jewishness, and began to talk about my own experience, two of my identifying Australian Jewish friends, independently of each other, took me aside and gave me a lengthy talking-to about what I was doing. Their points of view were very similar: in Australia nobody knew I was Jewish. I look white enough to pass as Anglo, an assumption reinforced by the knowledge that I come from England, so why make life potentially difficult for myself by coming out? Neither of my friends looks Anglo, which really means here, northern European 'white,' although one can pass under most circumstances – though she would not choose to. The other, with a thick shock of long black wavy hair and a 'Semitic nose' tells me that, since childhood, she has been asked, 'Where are you from?' and has often been identified as Lebanese. In other words, she is viewed as ethnic, as not quite properly Australian, but is not usually identified as Jewish. Nevertheless, this feeling that she is not quite accepted has inflected her determination to acknowledge publicly, and to come to terms with the public as well as the private meaning of, her own Jewishness.

Looking like a Jew is a very problematic idea. Any significantly sized aggregation of Jews will easily demonstrate that they come in all colours, shapes and sizes. Thirty years ago, in *Portrait of a Jew*, Albert Memmi pondered the problem of whether there are physical Jewish distinguishing features. In an important and telling passage he argues that

> I do not maintain . . . that any biological description of the Jew is impossible, or that any recognition of it is fallacious. On the contrary, I am inclined to believe that every group is recognizable in some way: people from the South of France, for example, and the Alsatians, even people from the Auvergne. But recognition is a more complex and more general phenomenon of which the biological index is only one factor and not the most striking.[39]

He goes on:

> Biologically we should not speak of the Jew but of Jews. We must add that his multiple scattered figures are, moreover, relative and changing,

15

now like everyone else, now strange, unfamiliar, like masks that are
now transparent, now opaque.[40]

Memmi's point is that the distinguishing of Jews from the general population
has, historically, to do with the fact that 'The Jew was, in short, a perpetually
displaced person.'[41] What made the Jews stand out was their difference from the
general population in which they found themselves far more than any possibly
inherited characteristics. In many parts of the Western world these days, where
large numbers of migrants from diverse origins have settled, such a context no
longer obtains.

I mentioned above that I pass as Anglo, that is 'white.' However, it is more
complicated than this. In England, people rarely commented on my skin
colour, which is an olive or sallow version of 'white.' I go brown very quickly
in the sun. In Australia, where I am often brown, people comment that I
should not spend so much time on the beach or I will get skin cancer. Thus,
the dominant reading of my 'brownness' is that I am a white person who
spends a lot of time acquiring a tan. It is not thought that I might be naturally
brown, or have a propensity to brownness. After all, 'real Australians' – who
have a British heritage, as I have – are white. Also I have high cheekbones.
For people who are not used to this, it would seem that, especially when I am
wearing sunglasses, I appear to be smiling. It can be quite disconcerting to be
walking down a road minding my own business and have a perfect stranger
walking the other way smile at me! Interestingly, this also has not happened
to me in England, though I have not worn sunglasses so much there. It has,
however, happened to me in Australia where there is, as I have indicated, not a
great sensitisation to 'Jewish looks,' and in the American Midwest where there
are relatively few Jews and non-northern European people.

I have another story. In Petra, in Jordan, my friend and I were having an
evening meal in a restaurant. As we dined, the waiter, a local, looked at me
quizzically. 'Where are you from?' he asked. I wondered why he wanted to
know. I wondered if somehow he recognised me as 'Jewish' and if so what his
reaction would be if I confirmed this recognition. I find, 'Where are you
from?' when asked from outside of Australia a difficult question to answer. Not
just because I have lived in Australia for more than fifteen years now but
because, if I am to acknowledge my Jewish identity, 'England' does not seem
an appropriate answer. It does not fully tackle the question. More, in the
context of where I was, Petra, neither 'England' nor 'Australia' would provide
the answer to the visual riddle that I was thinking the waiter had identified.
Nevertheless, to say I was Jewish would have seemed too obviously to second-
guess him – and, technically, would not answer his question. In the end, I said,
'England, but I live in Australia.' To which he replied something like, 'Oh.
I was wondering because you remind me of the men I used to work with on
the docks at Haifa.' At this point my urge to say that I was Jewish seemed
strangely disproportionate, an ungainly confession. Yet, the waiter's response

posed more questions than it answered so far as I was concerned. Haifa, of course, is in Israel these days. Had the waiter been working with Jews or Arabs? Was he identifying me as 'Jewish-looking' or 'Semitic-looking'? His answer suggested that he didn't think that I looked like him. If he had been able to distinguish Jewish and Arab dockworkers by their looks, assuming an Ashkenazi heritage for these Jews, was this a consequence of a certain idio-syncratic mix of 'white' and 'Jewish' features, or, a combination of a particular set of features and a European (modern) presentation of self? What immediately came to my mind, though, was that I had been mistaken for an Israeli. As an assimilated Jew of the Diaspora, this provoked in me ambivalent feelings of pride and rejection.

The title of this book emphasises the cultural rather than the racial, *Jewish* rather than *a Jew*. As I have already remarked, we live in a time which ostensibly privileges the cultural over the racial. The very term 'multiculturalism' signals this. Nevertheless, the essentialism of heredity is never far away. If we ask a question as simple as 'Who has the right to identify with Italian culture, or with African-American culture, or South Asian culture?' we find essentialism rapidly reasserting itself. In *Beyond Ethnicity*, Werner Sollors coined the term 'ethnic transvestite'. He was thinking of writers who take on another cultural identification as their speaking position.[42] However, the term signals a more general problem, that is, the conditions under which ethnicity, which is defined culturally, might be claimed.

In the essentialist understanding of gender transvestism a person remains biologically a man even though he produces such a successful image that he can pass as a woman (or vice versa). Gender transvestism, in this sense, implies an underlying stability of biologically determined identity. Once we start thinking that there is no biological essence, the question of ethnic identification becomes more problematic. The emphasis shifts to the socio-cultural context. For ethnic transvestism the question becomes 'Who has the right to claim a particular ethnicity; that is, what are the legitimating features that would make a person's claim acceptable to either, or both, assuming that the criteria coincide, the dominant culture and the ethnic group?' The answer most usually given in Western countries, when an answer is forced, is that this is the right of those who were born in a particular country, and preferably whose ancestors were born there, and those people who are descended from people born in that country.[43] These, then, are the people who are 'allowed' to (re)discover their ethnicity. Even here, then, there appears to be, if not a racialisation, then a biological justification for claiming ethnicity.[44] In everyday life, ethnicity operates as a form of cultural differentiation within race, which itself is increasingly understood as a culturally constructed form of differentiation. To talk of coming out Jewish is to suggest the complexity of a postmodern Jewish identity that in part combines and disturbs the discursive features of both ethnicity and race.[45] To put it another way, the title suggests an intervention in the classic modern conundrum of whether Jews are a race or a cultural

grouping, an intervention from within the theoretical terms that privilege the ideas of discursive construction and the postmodern recognition that essentialism is, itself, an ideology.

The first time I presented a paper on Jewish issues at a conference was at the 'Crossroads in Cultural Studies' conference in Tampere, Finland, in 1996. A revised version is republished in this collection with the title 'Speaking as a Jew in British cultural studies.' The conference was large, and there were, if I remember, five parallel sessions. Sessions had drawn audiences averaging around thirty. To my surprise, when I came to give my paper there were, at a rough headcount, about a hundred people present. As I began to introduce my paper, rather nervously explaining that it was part of a public, and academic, coming out process, a well-known and highly respected American cultural studies practitioner seated in the audience announced, to some light-hearted laughter – after all, who, knowing anything about (American) Jews visually and culturally, could have ever identified him otherwise! – that he was a Jew too. This intervention, like my paper, was about the breaking of a silence within mainstream cultural studies. As in this book generally, I have not wanted to assert the place of a Jewish cultural studies[46] but hesitantly to speak from, and about, an uncertain identity, that of a Jewishness in some ways overdetermined by the national cultures of the late-twentieth-century West, and also determined by a problematic heredity and cultural, in a general sense, inheritance.

Regarding the audience, I began to feel that, naively almost, I was giving voice to a more general, personal anxiety about somehow being Jewish, and, perhaps an intellectual anxiety about the need to recognise the importance of Jews and Jewishness, as simultaneously a paradigmatic and idiosyncratic site of the problems of identity, of belonging and of cultural commentary, as these are played out in cultural studies. And also, a recognition of the importance of Jews and Jewish perspectives to cultural studies as well as the importance of cultural studies for those identifying – and especially those problematically identifying – as Jews. I am tempted into suggesting a partial history which considers sociology as a modern, Jewish invention to think through the problems of assimilation – two of three commonly identified 'founding fathers' of sociology were assimilated Jews.[47] Cultural studies can be read as a postmodern area of investigation as equally reflexive and uncertain of its disciplinary status as post-assimilation Jews are of their status as Jews, or of their Jewishness. It can be understood as a minority and subaltern, including Jewish, site for thinking through the problems of cultural entanglement. If identity has become a central trope of cultural studies then its corollary is a preoccupation with the unsettling of identity, or indeed with the never unified identity, and with complex and partial identities, described by way of such theoretical terms as 'hybridity' and 'creolisation.'[48] Identity was once thought of as a given, as an essential and unitary quality. Members of the dominant group could be expected to think of it as certain and fixed. However, those of us in oblique relation to the dominant order – migrants, minorities, women, members of the working class and so

forth – know that identity is a process, perhaps the most profound one, into which we are interpellated.[49]

Some of this was brought home to me after my paper, and particularly at the conference dinner, when what seemed like a stream of people came up to me, thanked me for my presentation, and began to tell me of their own awkward identifications: the woman with the assimilated Jewish father and gentile mother who felt it necessary somehow to acknowledge a Jewishness while denied, of course, as a Jew by orthodox Jewish religio-culture was typical but there were others. For example, the man who had three Jewish grandparents but who came from an apparently fully assimilated family. I was particularly struck by the story of the woman who also had a Jewish father and gentile mother, who had married a Jew and who had converted but was so envious that I was 'naturally' a Jew, halachically speaking. Many of these people have been using cultural studies as a prism for thinking through their own ambiguous Jewishness, their ambiguous, and often ambivalent, experience of themselves as Jews. They have, nevertheless, remained silent.[50]

DISPLACEMENT AND BELONGING

The people I have been describing are some of those who feel unsettled, displaced. Not 'properly' Jews they, nevertheless, like me, also do not feel at ease in their national homelands, do not feel themselves fully members of the nation. If asked if they feel Jewish they usually find this question very problematic, often resorting to a Holocaust-based response. Some part of this experience of feeling unsettled is a consequence of the relatively recent history of familial migration, a history that spans but a couple of generations. In my own case, my mother's family left the Pale in the late-nineteenth-century wave of migration and settled in London. Some of their descendants, my cousins, benefiting from upward social mobility, now live in Golders Green, others have moved to Canada and the United States. For a while, until they moved on before the anxieties and violence precursing independence, I had relatives in what was then Rhodesia, and South Africa. I, myself, took a one year academic contract in Brisbane, Australia, in 1981 and am still in Australia, though now in Perth.

Jews are often stereotyped as a migratory people and my family on my mother's side is a small example of this. However, it is foolish, and indeed repeats nineteenth-century prejudice, to think of Jews as, in some way, essentially migratory, that the myth of the Wandering Jew somehow applies to all Jews. The Yiddish Jews of the Pale had been settled there for centuries. Their migration was a consequence of constant and increasing persecution, pogroms, which led to an early and less organised form of the kind of so-called ethnic cleansing that is going on in the Yugoslav province of Kosovo as I write. Where pogroms started as premodern riots to keep Jews in their subordinate

place in the Christian heirarchy, by the early twentieth century they were increasingly becoming the tool of the state to help promote a homogeneous population by driving out the unwanted, different Jews.

The movements of my family, like those of other Jews, and of other groups such as the Chinese in South-East Asia, and now many other countries (the Chinese have been described as the Jews of Asia[51]), are connected with a sense of not-quite-belonging, of rootlessness in the nation-states in which we live. It was this that caused the term 'cosmopolitan' to be applied to Jews in a negative and derogatory way at the height of the nation-state. Timothy Brennan notes that 'Any student of the late nineteenth and early twentieth centuries is aware that "cosmopolitan" was a code word in Eastern Europe for the Jew, where rootlessness was a condemnation and a proof of nonbelonging precisely there.'[52] This feeling of not belonging is, I should add, not the same as not feeling that one owes allegiance to that particular state. Rather, it is about a complex, sometimes uncertain feeling of national identification. I do believe that, for those of us with a history of migration in the last two or three generations, and who are not completely assimilated, further migration is somehow easier. The nineteenth-century idea of Jews as the prototypical cosmopolitans comes, I think, from this lack of internalised localism. It was this localism, of a peasantry that had hardly moved in centuries, which gave territorial root to nineteenth-century nationalism. Even when this peasantry was driven off the land and transformed into the new working class, its members continued to espouse an ideology of localism.

My mother's desire to assimilate can also be read as a fear of not belonging. Her life has been devoted to becoming English. Yet, when I lived in England, I never quite felt that I belonged. It was not a feeling I could ever really put my finger on. When I was at school I was always on the outside of groups. It was not exactly that I was excluded, but rather that I felt happier outside of them because then I didn't have to worry about saying or doing the right thing. This worry has been the feature of my social life. At parties I became the person who was in charge of the music because in that way I could unobtrusively observe the partying. This is a common enough feeling for those of us who have gone on to be intellectuals. Over the last few years I have had many reassuring conversations with other intellectuals who also felt on the outside at school and throughout their early lives. We thought too much and too deeply as compared to the other kids. Things they took for granted we wondered about. They found us strange, we learnt to keep our thoughts to ourselves. Some of us, especially the girls, learnt to hide our inquiring minds and became more accepted. Some intellectuals never acquire social skills. However, my feeling of not belonging, a feeling of distance that was at the same time both anomic and uncanny, was this and more.

It should come as no surprise to discover that, at university, I originally studied sociology and psychology – in order to understand society and people better, was my thinking. I realise now that much of this feeling of not

belonging, and my anxiety about my behaviour, and the need to watch that goes with it, and to monitor my own behaviour, has been in large part inherited from my mother's practice of assimilation, from her own watching and monitoring. For me, this became combined with a very middle-class English concern with 'manners,' the code of politeness which is not just about civility but the system of etiquette which marks out class difference. This is well portrayed in a tradition of the English novel where Jane Austen's work is the *locus classicus*. I find watching English sitcoms that play on the failure of people to observe manners, *Fawlty Towers* and *Keeping Up Appearances* for example, excruciating as well as funny.

Englishness is as constructed a category as any other national identity. The preferred reading position of these programs is an ideal Englishness into which the reader is interpellated – this includes being white, class-conscious, and being preoccupied with, and knowledgeable in, correct etiquette. My suspicion is that the ideal reader of these programs would watch them from a secure and confident position within the national culture, able to laugh at the transgressions of manners without worrying very much about the feelings of embarrassment and shame that accompany such transgressions. Or, perhaps, that the humour of the transgression would easily outweigh the mortification, and the mortification would introduce an exquisiteness into the humour. Much of this humour is class-based. In *Fawlty Towers* there is a tension between Sybil, Basil Fawlty's wife, and Basil which is based on her upwardly mobile, *nouveau riche*, concern with respectability, and Basil's bourgeois knowledge of proper behaviour but complete inability to subscribe to it. In many of these sitcoms the humour derives from the incapacity of the upwardly mobile to preserve the veneer of etiquette on which the acceptance of their new status depends. For me, as I suspect for many others, these programs are not only about class, they are about the very Englishness in which the class-based comedy of manners is known and played out. For me, these programs raise anxieties about becoming socially visible as the perpetrator of such contraventions but also through an identification with the people subjected to them, an identification not just from within English culture on a class basis but as an ambivalently placed outsider to Englishness itself. Nevertheless, I am English enough for *Fawlty Towers* to be one of my all-time favourite television shows!

I realise that I never felt fully at ease in England and that this was very stressful because, on the one hand, England was where I was born and brought up. I understood it to be 'home' while on the other hand I always felt like I didn't quite know how to behave. It may not be coincidental that at school and university I joined drama groups and gained a certain notoriety as a ham actor. Erving Goffman's use of theatre metaphors to think through how social interaction takes place in everyday life comes to mind here.[53] Cuddihy lists Goffman as one of the modern Jewish intellectuals who, with Jewish Emancipation, 'examine this world in dismay, with wonder, anger, and punitive objectivity.'[54] It seems to me, with hindsight, that the reason I so

enjoyed Goffman's work as a student was that he writes out of the problematic of assimilation.[55]

In this sense, I have found living in Australia much less stressful. This not because I feel more at home here but because, as a migrant, I can feel justified in not feeling at home. I can feel assured in my lack of understanding of Australian culture, even as I learn to swim in it, and I can feel justified in telling people when I don't understand something. In short, in Australia I feel I have a right to feel not at home and can therefore relax, only experiencing the migrant's anxiety of displacement.

The problem of home is made more complex for Jews because of the rhetoric surrounding the state of Israel. Israel invokes a religious quality as well as a secular nationalism. The modern, religio-cultural, history of the Jews is the experience of Diaspora, of being displaced from home, as I argue in Chapter 5, 'Historicising the idea of diaspora.' This cultural prism has been worked into the understanding and legitimation of Israel. Israel has produced itself as 'home' to the Diaspora's feeling of not being at home.

For those descended from the turn-of-the-century migrations from the Pale, there is also the more general feeling of migratory displacement. The descendants of migrants from other places feel similarly.[56] Could one, as a migrant, return home? The longer one leaves it, the less possible it becomes. One remembers the place one left as it was when one left it. When one goes back, it is not the same as one remembers it. Memory has transformed it, but also it has transformed over time. It is no longer the place one left. You, yourself, are not the person you were when you left. The whole problem is compounded for the children of migrants. Never having been there, to what are they returning? Impressions gleaned from their parents, from geography lessons at school, from the community where they live. They return also along the vector of desire, disappointment, and sometimes success, and nostalgia inherited through the family. The Yiddish version would be to return to the region of the Pale, though in this case the effect of the Holocaust has been to erase all but traces of a living culture. Some Yiddish-background people return to visit the camps where their relatives died. Some look for the *shtetlach*, the small towns where their ancestors lived. Nowhere seems like home any more, even less than for other migrants and their descendants.

DREAMING OF NOT BEING AT HOME

On my first visit to Israel, I entered from Jordan, somewhat idiosyncratically, at Eilat, the resort town on the Red Sea. I had ambivalent feelings about Israel, disliking the dominant politics towards Palestinians, and Sephardi and Mizrahi Jews, but recognising a certain historical inevitability about Israel's existence in a time of nation-states. Moreover, the Israeli Jewish migration produces a profound unsettling in the modern, Western Jewish experience of the

economy of diaspora, an experience which, coupled with psychological experience of migration, led to the utopian dreams of home in the United States and in Israel that I have discussed in 'Migrating to utopia.'[57]

On my second night in Eilat I woke from a very vivid dream. In it I was travelling to visit my parents who were, in reality, to be another stop on the same journey on which I was engaged. I draw near their house, which is not a house that, outside of the dream, they have ever lived in. This house is a big, bourgeois, friendly house – friendly describes the way I felt about it in the dream – set in a large garden. Somebody tells me that my parents have to move. I ask why and am told it is because the firm which owns the house has changed hands, and the new owners want the house. My parents are moving to another house nearby, not quite so nice. I enter the new house. My parents are both there. Watching my smartly dressed father, who is retired, I think that he looks better than he has done for some years. I think, 'This move is doing him good: he's got something to do.' At this point I woke up, with the feeling that I still lived a little in this parental house, this house that I had never visited before because my parents had only just moved there.

This is a rich dream, with a lot of dreamwork. I do not intend to unpack it all, especially as I have left out some details. It will also help the reader to know that my parents moved house frequently when I was growing up, every three or four years or so. For me, the remarkable thing about this dream is how it collapses the national experience of home into the familial experience of home. In this, home-accented, reading of the dream, the house that is the most *heimlich* is not even 'their' house. They rent it – something that is anathema to my parents; British culture is one that values ownership of houses. It is worth remembering that one of Herzl's ideas was a kind of leasing arrangement with the Ottoman Empire for *Eretz Israel*. Renting has always been much more acceptable in mainland Europe. In my dream, owning the house seems to be related to having a right to be there, to feeling interpellated as a member of the dominant, national group.

My parents have to leave this house. This is a dream of displacement. (It is a dream that plays out the Freudian idea of displacement as a form of dreamwork while it expresses my feeling of displaced and uncertain identity through a narrative of moving houses.) Although the house seems like it could be home, my parents' presence is always, in the end, at the whim of the owner, much as I have described the context of assimilation. In the dream it is not the smaller, less homely home which is doing my father good, but the move, the settling in. The conundrum, given that I am visiting Israel as I am about to visit my parents, is to work out which of these houses might be Israel. The solution, I think, is that either, or both are. The dream is a coming-to-terms with the recognition that I am not at home in Israel as, in the dream, my parents are not finally at home in either house. Neither house is my home, anyway; I am just visiting. My family – my people? – are not at home anywhere. Yet, I still feel like I live there a little. This seems to suggest the importance of family, of one's

'people' in providing a context for enabling a person, me in this case, to feel, at least partly, at home.

I go into the house to which my parents have moved. Do they own this house? I do not know. Perhaps this house is Israel. If it is, it must carry another signification also because my parents would not live in Israel. It is more likely a part of a general expression of displacement. I enter the house as I entered Israel two days before. Perhaps my parents will be happy here. Perhaps it will be home for them. Perhaps this is a narrative of redemption. I doubt it, but even if it is, I, myself, am still only a visitor. In my dream, as in my experience, Israel is another country like England and Australia in which I feel uncanny, at home enough to feel not at home. More generally, I feel both Jewish and not-Jewish, ambivalently and uncannily interpellated.

The purpose of this collection of essays is to think through some aspects of the 'problem of identity' as they have been, and are being, played out in the Jewish experience in the West. It is my contention that, while the Jews are a specific and, to some extent, idiosyncratic case, their very specificity and idiosyncrasy helps to highlight issues that are of relevance to other groups, both inside and outside the West who, through the modern and postmodern eras, have been identified as Other.

I have not tried to highlight the 'specialness' of the Jews, a trope both religious and secular, that has been used by both Christians and Jews for different purposes for two thousand years, and longer in the Jews' own case. These essays seek to utilise current theoretical debates to discuss the circumstance of the Jewish experience. While I refer to writers such as Daniel Boyarin, Jonathan Boyarin and Alain Finkielkraut, who have written specifically on Jewish matters, and to writers such as Zygmunt Bauman and Sander Gilman, who have written both about the Jewish situation and more generally, these essays are also informed by the ideas of people who have never written about Jews, such as Ien Ang, Homi Bhabha,[58] James Clifford, Paul Gilroy and Stuart Hall.

While I hope this book is read by Jews, whoever and whatever we are today, and especially by Jews in a similar position to myself, I also hope that it will be read by others interested in questions pertaining to identity. This is much more than a book about Jews and Jewishness. It is not intended in any exclusive way to be a Jewish book. Rather, it is a book that takes the circumstance of the Jewish experience in the West as a way of meditating on issues that have affected many people, issues such as those of diaspora, assimilation, migration, multiculturalism, and, of course, identity.

These essays have been written at various times over the last four years. Some of them have been published in other places, some have been given as papers. As far as possible I have eliminated the inevitable overlaps among them. Unfortunately, in some places this has not proved possible. Some chapters have required that certain discussions are repeated, though in different form, so that

the logic of the argument is not disturbed. I hope that the reader will not find such repetition too distracting.

Coming Out Jewish is divided into three sections: 'How not to assimilate,' '(Dis)placement in the state,' and 'Not quite white.' Chapters 1–3 comprise the first section, 4–6 the second section, 7–10 the third. The first section deals with the experience of assimilation, and contains some autobiographical materials.

Chapter 1, 'Speaking as a Jew in British cultural studies,' is a consideration of why Jews, and a Jewish voice, have been so remarkably absent from British cultural studies. This chapter examines how the ambivalent placing of Jews in British society has produced a situation where Jews, as a group, have become inhibited from making public statements about their circumstance. I discuss the enfranchisement of the Jews in Britain, and how Jews have been presented, or not, in the work of such formative cultural thinkers as Matthew Arnold, T. S. Eliot, and Raymond Williams.

The second chapter theorises the connections between assimilation and the uncanny, utilising Derrida's idea of 'excess' and Freud's work on the uncanny. Both Freud and Derrida can be described as ambivalently assimilated Jews, and I also argue that their theories are, themselves, expressions of their ambiguous situation.

The third chapter, 'Ghetto thinking and everyday life,' is the most personal of the chapters presented here. I think through the specificity of Yiddish fear as a function of what I call 'ghetto thinking,' describing it as a version of Raymond Williams's idea of a structure of feeling. Drawing on a number of personal stories, I outline how this fear is transmitted from generation to generation, even when it is no longer a realistic response to present circumstances.

The second section theorises aspects of being a subaltern minority in the nation-state.

In 'Jews, representation and the modern state,' Chapter 4, I argue that the development of modern anti-Semitism was coincident with the deployment of the modern nation-state. If the modern state is founded on the discourse of representation, then the ideal of the state is perfect representation. Thus, the history of the state has been the attempt to construct a homogeneous national population, one which will be able to express perfect identity, and which, therefore will then merge with the state itself. I argue that the Jews, or perhaps more correctly 'the Jews,' were targeted for the failure of this utopian, and always impossible exercise.

Chapter 5, 'Historicising the idea of diaspora,' discusses the idea of diaspora both as a Judaic/Jewish concept and as a concept of postcolonial theory. In Jewish thought I distinguish between the premodern idea of *galut* (exile) and Diaspora. I argue for the historicity of the experience of diaspora, explaining this by way of a psychoanalytic argument founded in the modern nation-state.

Chapter 6, 'Migrating to utopia,' elaborates a theory of migration, with particular reference to the Yiddish Jews who migrated to the United States in the latter part of the nineteenth and early twentieth centuries. This builds on

the psychoanalytic theory that I elaborated in the previous chapter in the context of diaspora. This chapter discusses why the Jews have felt 'at home' in different ways in the United States, and in Israel, but not in the European states.

The third section is more empirical, and deals with issues around race and ethnicity, and Jews and Jewishness, in the United States and Australia.

'Jews, race and the White Australia policy,' the seventh chapter, is concerned with how Jews fared in Australia under the now notorious White Australia policy. This was founded on the Immigration Restriction Act (1901) which was passed after Australia gained self-government that same year. Jews were, in the main, considered to be 'white.' However, through the 1930s, in particular, the Ashkenazi and Yiddish Jews who were trying to migrate to Australia were increasingly racialised and Australian Jews became worried that this racial-isation would reflect back on them. I argue that the ambivalent understanding of Jews as white and as non-white provides a site for deconstructing the White Australia policy and thinking through the reasons for its existence.

Continuing my discussion of Australia, Chapter 8, 'Jews and multiculturalism in Australia,' examines the position of Jews in Australian multiculturalism. In Australia, multiculturalism is an official government policy for managing the population. The discourse of ethnicity is central to this project. Ethnicity is deeply aligned with arguments about migration, and is presumed to be equitable with national background. Of course, Jews have no (single) national background. They are an anomalous category. I explore this, using Jews as a way of unpacking many of the assumptions of multiculturalism as this discourse is played out in Australia.

In Chapters 9 and 10, I turn my focus onto the United States. In, 'Making social space for Jews in America,' I examine the Jewish negotiation with Anglo-American concerns with assimilation. Jews were central to both the popularisation of the idea of the 'melting pot' and the elaboration of the idea of cultural pluralism. Both these ideologies may be understood as tactics by a subaltern group. Cultural pluralism, in particular, was a way for Jews, and other migrant groups, to gain acceptance in the American community without culturally assimilating. Multiculturalism in the United States was propounded by African-Americans. It marked a rejection of cultural pluralism for its failure to deal with race as an issue.

The tenth, and final chapter, 'Seinfeld is a Jewish sitcom, isn't it?' discusses the sitcom which has been one of the most popular American television shows of the 1990s. I examine, in particular, its ambivalent Jewishness. I distinguish between Jews and Jewishness, and I argue that, since the Second World War, there has been a Yiddishisation of American culture. I situate Seinfeld as an ethnic sitcom in the era of multiculturalism when it has become possible to represent ethnicity among the middle class under certain quite specific conditions.

NOTES

1 An important and relevant discussion of American multiculturalism is Joan W. Scott, 'Multiculturalism and the Politics of Identity' in John Rajchman, *The Identity in Question*, New York, Routledge, 1995.

2 For a discussion of race and multiculturalism in Australia see my *Race Daze: Australia in Identity Crisis*, Sydney, Pluto Press, 1998, also Ghassan Hage, *White Nation: Fantasies of White Supremacy in a Multicultural Society*, Sydney, Pluto Press, 1998. On Canada, see Richard Day, 'Constructing the Official Canadian: A Geneology of the Mosaic Metaphor in State Policy Discourse', *Topia: Canadian Journal of Cultural Studies*, vol. 1 (2), 1998, pp. 42–66.

3 See Ien Ang and Jon Stratton, 'The Singapore Way of Multiculturalism: Western Concepts/Asian Values', *New Formations*, no. 31, 1997, pp. 51–66.

4 Relevant discussions of identity include Scott Lash and Jonathan Friedman (eds.), *Modernity and Identity*, Oxford, Blackwell, 1992; Stuart Hall and Paul du Gay (eds.), *Questions of Cultural Identity*, London, Sage, 1996; Jonathan Rutherford (ed.), *Identity: Community, Culture, Difference*, London, Lawrence Wishart, 1990; Elazar Barkan and Marie Denise Shelton (eds.), *Borders, Exiles, Diasporas: Cultural Sitings*, Stanford, Stanford University Press, 1998; David Bennett (ed.), *Multicultural States: Rethinking Difference and Identity*, London, New York, Routledge, 1998.

5 On the problem of Jewish identity a good starting point is the collection edited by David Theo Goldberg and Michael Krausz entitled *Jewish Identity*, Philadelphia, Temple University Press, 1993.

6 This figure is taken from Paul Mendes-Flohr and Jehuda Reinharz (eds.), *The Jew in the Modern World: A Documentary History*, New York, Oxford University Press, 1980, p. 696.

7 John Murray Cuddihy, *The Ordeal of Civility: Freud, Marx, Lévi-Strauss and the Jewish Struggle with Modernity*, New York, Basic Books, 1974, p. 46. I use Cuddihy's work at times later in this book, it is therefore worth noting that his book is not uncontested. Daniel Boyarin has written a violent attack on it: '*Épater l'Embourgeoisement*: Freud, Gender and the (De)Colonized Psyche', *Diacritics*, vol. 24(1), 1994, pp. 17–41.

8 I am thinking here of the tradition of work that stems from Edward Said's *Orientalism: Western Representations of the Orient*, London, Routledge and Kegan Paul, 1978.

9 Jean-François Lyotard, *Heidegger and 'the jews'*, trans. Andreas Michel and Mark S. Roberts, Minneapolis, University of Minnesota Press, 1990.

10 Jonathan Boyarin, *Thinking in Jewish*, Chicago, University of Chicago Press, 1996, p. 1.

11 For discussions of Sephardi Jews see Shlomo Deshen and Walter P. Zenner (eds.), *Jews among Muslims: Communities in the Precolonial Middle East*, London, Macmillan, 1996; Harvey E. Goldberg (ed.), *Sephardi and Middle Eastern Jewries: History and Culture in the Modern Era*, Bloomington, Indiana University Press, 1996.

12 An important antidote to the hegemonising force of the Ashkenazi–Yiddish point of view is Ammiel Alcalay's wonderful *After Jews and Arabs: Remaking Levantine Culture*, Minneapolis, University of Minnesota Press, 1993.

13 Some relevant discussions are Barry Rubin, *Assimilation and its Discontents*, New York, Times Books, Random House, 1995; Jonathan Frankel and Steven Zipperstein (eds.), *Assimilation and Community: The Jews in Nineteenth Century Europe*, Cambridge, Cambridge University Press, 1992; Robert Wistrich, *Socialism and the Jews: The Dilemmas of Assimilation in Germany and Austro-Hungary*,

Rutherford, N.J., Fairleigh Dickinson University Press, 1982; Leo Spitzer, *Lives In Between: Assimilation and Marginality in Austria, Brazil, West Africa 1780–1945*, Cambridge, Cambridge University Press, 1989; Pierre Birnbaum and Ira Katznelson (eds.), *Paths of Emancipation: Jews, States and Citizenship*, Princeton, N.J., Princeton University Press, 1995.

14 Karen Brodkin, *How Jews Became White Folks and What That Says About Race in America*, New Brunswick, N.J., Rutgers University Press, 1998.

15 Ben's mother is Anne Meara who is not a Jew. Thus, halachically speaking, Ben is not Jewish.

16 Karen Brodkin, *How Jews Became White*, p. 10. An article worth investigating is Joseph W. Bendersky, 'The Disappearance of Blonds: Immigration, Race and the Reemergence of "Thinking White"', *Telos*, no. 104, 1995, pp. 135–57.

17 Karen Brodkin, *How Jews Became White*, p. 18.

18 Please note that throughout I use eastern/western (lower case) as a cultural construct, not as the objective, natural category denoted by Eastern/Western.

19 Ted, being the insightful Yiddish-American commentator, says to Mary: 'I realised something today. I'm no better than any of these guys. None of them loves you really. They're just fixated on you because of the way you make them feel about themselves'.

20 Richard Dyer, *White*, London, New York, Routledge, 1997, p. 3.

21 Ella Shohat, *Israeli Cinema: East/West and the Politics of Representation*, Austin, University of Texas, 1989, p. 4.

22 Ilan Halevi, *A History of the Jews: Ancient and Modern*, trans. A.M. Berrett, London, Zed Books, 1987, pp. 207–8.

23 See, for example, Laura Levitt, *Jews and Feminism: The Ambivalent Search for Home*, New York, Routledge, 1997; Laura Levitt and Miriam Peskowitz (eds.), *Judaism Since Gender*, New York, Routledge, 1997.

24 See, for example, David Biale, *Eros and the Jews: From Biblical Israel to Contemporary America*, Berkeley, University of California Press, 1997; Daniel Boyarin, *Unheroic Conduct: The Rise of Heterosexuality and the Invention of the Jewish Man*, Berkeley, University of California Press, 1997. This is also the place to mention one of the more innovative collections on Jewish issues in recent years, Howard Eilberg-Schwartz (ed.), *People of the Body: Jews and Judaism from an Embodied Perspective*, Albany, State University of New York Press, 1992.

25 Marla Brettschneider, *The Narrow Bridge: Jewish Views on Multiculturalism*, New Brunswick, N.J., Rutgers University Press, 1996; David Biale, Michael Galchinsky and Susannah Herschel (eds.), *Insider/Outsider: American Jews and Multiculturalism*, Berkeley, University of California Press, 1998.

26 For a nuanced discussion of this experience see Barbara Kessel, *Suddenly Jewish: Accounts of Hidden Jewish Heritage*, forthcoming, 2000.

27 There is no room here to discuss the historical construction of the Holocaust. However, it is important to note that, when the Holocaust is discussed, it is in terms of the destruction of the European, Ashkenazi Jewish community, and the Yiddish community. There is rarely mention of the Sephardi and North African Jews who were murdered. To the extent that the Holocaust has become a marker of the Jewish community as a single, global community, 'world Jewry,' then this way of thinking of the Holocaust tends to reinforce the hegemony of Ashkenazi Jews.

28 This outline is abridged from Nancy Wood, 'The Victim's Resentments' in Bryan Cheyette and Laura Marcus (eds.), *Modernity, Culture and 'the Jew'*, Polity Press, Cambridge, 1998, p. 258.

29 Nancy Wood, 'The Victim's Resentments', p. 262.

30 Quoted in Nancy Wood, 'The Victim's Resentments', p. 263.
31 In the United States much of the anxiety, and therefore much of the concern, over passing has centred on African-Americans (Blacks) passing as 'white'. See, for example, Elaine Ginsberg, *Passing and the Fictions of Identity*, Durham, N.C., Duke University Press, 1996; Valerie Smith, 'Reading the Intersections of Race and Gender in Narratives of Passing', *Diacritics*, vol. 24 (2–3), 1993, pp. 43–57; Harryette Mullin, 'Optic White: Blackness and the Production of Whiteness', *Diacritics*, vol. 24 (2–3), 1993, pp. 71–89.
32 Eve Kosofsky Sedgwick, *Epistemology of the Closet*, New York, Harvester Wheatsheaf, 1990, p. 75.
33 Kosofsky Sedgwick, *Epistemology of the Closet*, p. 75.
34 Kosofsky Sedgwick, *Epistemology of the Closet*, p. 79, emphasis in original.
35 Kosofsky Sedgwick, *Epistemology of the Closet*, p. 79.
36 Kosofsky Sedgwick, *Epistemology of the Closet*, p. 71.
37 On p. 82 of *Epistemology of the Closet*, Kosofsky Sedgwick describes a Purim photograph of herself in a 'Queen Esther' dress aged about five. I am tempted to wonder how much her discussion of the gay experience, and of the closet in particular, is inflected by her experience, and her background, as a Jew, and, indeed, how much she is describing the Ashkenazi-Yiddish experience. Of course, as I discuss elsewhere about Freud, I am not suggesting that in any way this invalidates her work. The idea that one's own specificity should not influence one's writing was a part of the modern, universalist ideology.
38 For a discussion of the image of the Jew see Sander Gilman, *The Jew's Body*, New York, Routledge, 1991, especially the chapter entitled 'The Jewish Nose.'
39 Albert Memmi, *Portrait of a Jew*, trans. Elisabeth Abbott, London, Eyre and Spottiswoode, 1963, p. 112.
40 Albert Memmi, *Portrait of a Jew*, p. 113.
41 Albert Memmi, *Portrait of a Jew*, p. 112.
42 For a general discussion of, in particular, literary-ethnic transvestism see Joe Lockard and Melinda Micco (eds), *Pretending To Be Me: Ethnic Transvestism and Cross-Writing*, forthcoming, University of Illinois Press.
43 In Australia ethnicity is officially defined in terms of national origin, see my *Race Daze*, p. 51.
44 An American version of the debate over whether ethnicity is based in culture or in genealogy – though the debaters slide between a rhetoric of ethnicity and race – is that between Daniel and Jonathan Boyarin, and Walter Benn Michaels. See Daniel Boyarin and Jonathan Boyarin, 'Diaspora: Generation and the Ground of Jewish Identity' and Walter Benn Michaels, 'The No-Drop Rule'. Both reprinted in Kwame Anthony Appiah and Henry Louis Gates jnr. (eds.), *Identities*, Chicago, University of Chicago Press, 1995. Writing from a Jewish position, Boyarin and Boyarin seek to rescue at least the ideological importance of an emphasis on genealogy as a force for asserting a continuity of identity over what they see as Michaels's dismissal which produces a 'radically individualist, voluntaristic, and attenuated notion of something that can only with difficulty be called 'identity' (p. 314). Boyarin and Boyarin write that circumcision can be understood as 'the cultural construction of a genealogical differentiation, as a diacritic that symbolizes the biological status of Jewishness – not in the sense of a biological difference between Jews and others but in the sense of the biological connection that filiation provides' (p. 317). For Boyarin and Boyarin male circumcision is the physical mark of a heritable continuity. Such a position is meaningful from within the Jewish tradition but does not take account of the social context, the dominant cultural context in which circumcision takes place. That is, its differentiating force is

greatest in a society that, say, abhors circumcision but, as has been the case in the post-World War II West, that force is lessened when the society generally utilises circumcision. One such society is the United States where, in the post-Second World War period the number of circumcised males in the general population reached as high as 80%. The figure in the 1990s has declined to around 60% (for these figures see Brian Morris, *In Favour of Circumcision*, Sydney, UNSW Press, 1999.)

45 Arthur Hertzberg and Aron Hirt-Manheimer's *Jews: The Essence and Character of a People*, Harper, USA, 1998, as its subtitle suggests, is a quite conservative approach to the problem of Jewish identity. Nevertheless, it signals very well the problem of how to claim religio-cultural identity and historical continuity for a group of people who have lived apart in varied situations. As they rightly say, to argue for a distinctive Jewish identity is very difficult when, ideologically, the claim to distinctiveness was set aside as a part of the modern attempt at assimilation. However, Hertzberg and Hirt-Manheimer tend to reify the idea of a Jewish character as when they assert that 'The essential Jewish character was already present and formed in the person of Abraham' and that they 'view the Jewish character as an ancient river surging down into a delta – the delta being the modern age' (p. 4).

46 I would classify Jonathan Boyarin's important *Storm from Paradise: The Politics of Jewish Memory*, Minneapolis, University of Minnesota Press, 1992, in the category of Jewish cultural studies.

47 I am thinking here of Karl Marx and Emile Durkheim. Max Weber did not have a Jewish background.

48 The major populariser of the idea of hybridity is Homi Bhabha, see his *The Location of Culture*, London, Routledge, 1994. For a general meditation on the ideological use of hybridity see Robert Young's *Colonial Desire: Hybridity in Theory, Culture and Race*, London, Routledge, 1995. The theorisation of the idea of creolisation has mostly taken place in the context of Caribbean societies. The pioneer in this work was Rex Nettleford. See his *Caribbean Cultural Identity: The Case of Jamaica: An Essay in Cultural Dynamics*, Los Angeles, University of California Press, 1979.

49 Stuart Hall pioneered the theorisation of this way of understanding identity in pieces like 'Minimal Selves' in *Identity: The Real Me*, ICA Documents 6, London, Institute of Contemporary Arts, 1988; 'New Ethnicities' in Kobena Mercer (ed.), *Black Film, British Cinema*, ICA Documents 7, London, Institute of Contemporary Arts, 1988; 'Old and New Identities: Old and New Ethnicities' in Anthony D. King (ed.), *Culture, Globalization and the World System: Contemporary Conditions for the Representation of Identity*, Basingstoke, Macmillan Education, 1991.

50 I am reminded here of the silencing of a Jewish speaking position in American feminism which Laura Levitt discusses in 'Feminist Dreams of Home' in Laura Levitt, *Jews and Feminism*.

51 See Walter Vella, *Chaiyo! King Vajiravudh and the Development of Thai Nationalism*, Honolulu, The University of Hawaii Press, 1979.

52 Timothy Brennan, *At Home in the World: Cosmopolitanism Now*, Cambridge, Mass., Harvard University Press, 1997, p. 21.

53 See, for example, Erving Goffman, *The Presentation of Self in Everyday Life*, London, Allen Lane, 1969; Erving Goffman, *Asylums: Essays on the Social Situation of Mental Patients and Other Inmates*, Garden City, N.Y., Anchor Books, Harmondsworth, Penguin Books, 1968.

54 John Murray Cuddihy, *The Ordeal of Civility*, p. 68.

55 We can find in the similarity of the experience of assimilation to acting one possible

reason for the importance of Jews in the modern entertainment industry. In Hollywood a surprisingly large number of actors were first- or second-generation migrants. A shortlist of Yiddish-background actors can be found in Neal Gabler, *An Empire of Their Own: How the Jews Invented Hollywood*, New York, Doubleday, 1989, pp. 301–2.

56 There has recently been some insightful work published on the relationship between home, displacement and identity; see, for example, Angelika Bammer (ed.), *Displacements: Cultural Identities in Question*, Theories of Contemporary Culture, vol. 15, Bloomington, Indiana University Press, 1994; Smadar Lavie and Ted Swedenburg (eds.), *Displacement, Diaspora, and Geographies of Identity*, Durham, N.C., Duke University Press, 1996.

57 Moshe Shokeid discusses Israeli Jews in New York in *Children of Circumstances: Israeli Emigrants in New York*, Ithaca, Cornell University Press, 1988.

58 This is not quite true. Homi Bhabha has written the Foreword for Bryan Cheyette's and Laura Marcus's collection *Modernity, Culture and 'the Jew'*, Stanford, Stanford University Press, 1998. In this, Bhabha argues for a similarity between Parsees and Jews in their use of humour to comment on their own societies. I would suggest that this commonness is a function of the reflexivity born of subordination.

Part 1

HOW NOT TO ASSIMILATE

1

SPEAKING AS A JEW IN BRITISH CULTURAL STUDIES

Why is it that British cultural studies, in particular that strand of it which has a history in the Birmingham Centre for Contemporary Cultural Studies, has had no Jewish voice? In one theorisation of the historical production of British cultural studies it is understood as the effect of the enunciation of speaking positions by the silenced and the marginalised in Britain.[1] If, indeed, this was a formative concern then it is the case that, in spite of their obviously continuing marginal position in Britain as members of the national culture – witness the National Front's anti-Semitism for example – there has been no expression of a Jewish speaking position. The only place in which the problematic of Jewishness has been raised, and then not in relation to the question of Jews and Jewishness in Britain as such, is Philip Cohen's discussion of anti-Semitism in his co-edited book entitled *Multi-Racist Britain*, published in 1988.[2]

In this chapter I want to use the trope of British cultural studies to address a much broader problem. Why is it that in post-Second World War – it may be more significant to say post-Holocaust – western intellectual discussions about 'race,' minorities, subalternity and so forth, the situation of the Jew in the west, in western nation-states, has been so absent? In particular, why is it that Jews themselves have been so silent about their own situation?[3] As soon as these questions are asked we have to recognise that they immediately press on us a host of further problems, most importantly who, or what, is a 'Jew.'[4] While this is directly relevant to the issue at hand it is also in an important sense secondary to the problematic of a Jewish voice and a Jewish speaking position. Like all subjectivities that of the 'Jew' is discursively constructed. What interests me in this chapter is the lack of interrogation of that construction, and the silence of 'Jews' themselves about their position in the post-Holocaust west.

What I will argue in this chapter is that the absence of a Jewish voice is most importantly a consequence of the fundamentally ambivalent construction of the Jewish situation in modernity. Zygmunt Bauman has argued that modernity is characterised as a struggle for order over chaos.[5] Ambivalence is, then, a scandal because of its profound unsettling of the category of order. Those who epitomise ambivalence are strangers: 'The stranger comes into the life-world and settles here.'[6] For Bauman: '*The national state is designed primarily to deal with*

35

the problem of strangers not enemies' (Bauman's italics).[7] The typifying stranger, for Bauman, is the Jew. He is right, but not for the reason he gives. The nation-state is not designed to deal with the problem of strangers, rather it historically has *produced* that problem because of its emphasis on homogeneity and exclusion. In modern nation-states Jews were simultaneously ordered to assimilate and barred from assimilation, racialised and declared to be 'white.' Today, Jews are simultaneously the minority victims of anti-Semitism and the holders of some of the most important political and economic positions in most of the western nation-states; not, it must be added, the highest position of authority. There has been no Jewish-American president, no Jewish-British prime minister – with the important and problematic exception of the 'converted Jew,' Disraeli – only one French president or premier who could be described as 'Jewish.' Nevertheless, the extent of the structural assimilatory acceptance of 'Jews' makes a recognition of their cultural silencing and marginalisation difficult.

From the late 1950s the evolution of cultural studies work in Britain, focused through the 1970s at the Birmingham Centre, took place in tandem with the elaboration of the more general western intellectual concern with race, class and gender, a triplet which, by 1994, Kobena Mercer could describe as 'the all-too-familiar "race-class-gender" mantra.'[8] At the Birmingham Centre this entailed a historical movement that went from class to gender to race. Given the history of the ambivalent racialisation of Jews in European thought from the middle of the nineteenth century onwards, one might have expected that a Jewish voice might have been raised in connection with race. This was not the case. When race was put on the agenda of the Birmingham Centre for Contemporary Cultural Studies it was in the context of 'Blacks,' to some extent 'Asian' 'Blacks' but, centrally 'West Indian,' Afro-Caribbean, 'Blacks.' So easy has been the equation of those classified as 'black' with the problematics of race that, when Stuart Hall described the problems in getting race onto the agenda of the BCCCS, he unproblematically elided blackness into race: 'Actually getting cultural studies to put on its own agenda, the critical questions of race, the politics of race, the resistance to racism, the critical questions of cultural politics, was itself a profound theoretical struggle of which *Policing the Crisis*, was, curiously, the first and very late example.'[9] Published in 1978, this book analysed the moral panic in Britain surrounding mugging, a crime which was identified in the moral panic as being typically committed by young men of Afro-Caribbean descent. Here, the lack of problematisation of race leads to a collapsing together of racialisation and 'blackness' which elides those colourised differently or, as is in the main the case with Jews, racialised but not colourised at all. The ambivalent situation of 'Jews' in the nation-state unsettles the binary use of 'race' in the construction of national identity.

There are a further couple of questions. Why was it that race became an issue so late in the work of the Birmingham Centre, and why was it that, when it did become an issue, it was in connection with 'Blacks' rather than Jews? To answer

these questions we must consider briefly the discursive production of 'race,' especially in England, and recognise the use to which it was put in constructing and patrolling the idea of an English – or sometimes British – nation. Indeed, in general terms we can see that, through the modern period, the categories of 'race,' 'class' and 'gender' were mobilised as key organising mechanisms for the nation-state. Where 'race' was used to delimit who could be a part of the nation, 'class' identified position within the nation-state and 'gender' organised the distinction between private and public spheres. It could be argued that one reason for the establishment of race/class/gender as areas of investigation lay in their new visibility as sites of contention because of the gradual weakening of the ideological strategies of assimilationist interpellation, and of Othering and exclusion, of the western nation-state since the Second World War, something that reached a major moment of transition during the 1970s. This weakening provided a space for marginalised and subaltern voices to speak.[10]

In order to understand the continued absence of a Jewish voice we must examine how the idea of an English/British national people was naturalised, effacing the role of racial discourse in its constitution. The ideal of the nation-state as it was elaborated in the nineteenth century was that it should have a homogeneous national population. To this end, race was invoked to establish the perimeters of national membership. In Britain, as elsewhere in Europe, colour was used to mark the limits of those who might be assimilable into the nation.[11] Writing about English colonial practice in India, Homi Bhabha has described how Indians took on English ways but how, in the end, their colour precluded them from being accepted as English: '*Almost the same but not white.*'[12] We need to understand racial designation by colour as a discursive trope in the construction of sameness and Otherness, those who can be assimilated into the nation and those who are to be excluded. It was in this way that the Irish, designated as 'black,' were excluded from English/British nation-building in the nineteenth century.[13]

In *Multi-Racist Britain*, only Cohen's own chapter 'The Perversions of Inheritance: Studies in the Making of Multi-Racist Britain', recognises the problematic situation of Jews in discussions of race and examines the similarities and differences between anti-Semitism and racism. Interestingly, the nearest Cohen comes to expressing what might be his own speaking position is in a discussion of the comparative modalities of anti-Semitism and racism:

> For example, an anti-Semite may say to a Jew, 'That's funny, you don't look Jewish,' adding under his or her own breath, 'though with a name like Cohen you can't help being one.' But the same person might say to an Afro-Caribbean, 'you don't act Black' with the *sotto voce* aside 'even though your skin is'.[14]

In this mythical exchange the passing Jew's Jewishness is assured by the dominant cultural Presence through a claim about the Jewishness of the name

– Cohens just can't help being Jewish. What we have here is a narrative of interpellation in which the author is himself interpellated by his own text. In Cohen's exchange it would seem that the Jew has first of all, for some reason, spoken of his or her Jewishness. In the text's relation to its author, though, it is the text which points out to us Cohen's Jewishness. He, himself, is silent on this matter. The impression from this textual structure is that Cohen has significant difficulty beginning to speak publicly as a Jew. Here we may develop one possible reason for the absence of a Jewish voice. In a national culture where race is predominantly discursively defined by colour, European Jews may pass as 'white' eliding their racial construction.[15] Indeed, it has been names which have been one of the most important mechanisms for identifying someone as Jewish.[16] The Jewish ability to pass has been coupled with a pressure through the eighteenth and nineteenth centuries in England for Jews to assimilate. One aspect of this has been an emphasis on not publicly asserting one's Jewishness. As the maxim attributed to the Jewish Enlightenment philosopher Moses Mendelssohn puts it: 'Be a Jew on the inside and a man on the outside.' Alain Finkielkraut notes that 'Until quite recently [this was] the credo of every Jewish community in liberal Europe.'[17] Being silent as a Jew was a part of the assimilationist bargain that was the other side of the national political incorporations of emancipation and enfranchisement.

JEWS AND RACE

Robert Young argues that 'Racial theory was established on two initially independent bases namely physiology and language.'[18] Leon Poliakov has tracked racial differentiation by colour back to Gregorius Hornius, a professor at Leyden who, in a book published in 1666, combined the medieval Christian division of peoples as being descended from Noah's three sons with what would be the Enlightenment, scientific distinction based on physiology, in the first place colour.[19] However, Poliakov suggests that it was the French philosopher and sceptic, François Bernier, in his book of 1684, who attempted the first racial classification. Bernier was not overly concerned with colour, dividing 'mankind both according to skin–colour and other physical traits.'[20] By the eighteenth century colour was increasing in importance and Linnaeus, the great Swedish classifier, distinguished four coloured races of human beings: *Europaeus albus* (white), *Americanus rubesceus* (tanned skin, red), *Asiaticus luridus* (yellow), *Afer niger* (black).[21] Young identifies J. F. Blumenbach, a professor of natural history who was working in Germany in the last quarter of the eighteenth century, as one of the founders of the modern physiological theorisation of racialism. Young tells us that 'Blumenbach is credited with the invention of the term 'Caucasian' to describe the superior (as he believed) white race' and adds, significantly, 'amongst whom, however, he included Semites.'[22]

The French philologist Ernest Renan, who took up the chair of Hebrew at the College de France in 1862, set about distinguishing the Semitic languages. As Edward Said writes, 'if the Orient had been hitherto identified exclusively with India and China, Renan's ambition was to carve out a new Oriental province for himself, in this case the Semitic Orient.'[23] Said sums up Renan's attitude towards Jews and Muslims, his Semitic people, like this: 'Thus the Semitics are rabid monotheists who produced no mythology, no art, no commerce, no civilisation; their consciousness is a narrow and rigid one; all in all they represent "une combinaison inférieure de la nature humaine."'[24] Previous to Renan the Jews were gradually being racialised. The French writer Gobineau, for example, thought of the Jews as Semites and as one branch of a white race of which Aryans were another branch.[25] Meanwhile, in Germany Richard Wagner was opposing the Jews to the Aryan race which, he considered, was best embodied in his time in the Germans. The Jew, he thought, was 'the devil incarnate of human decadence.'[26] Speaking generally, then, we could say that it is during the nineteenth century that the modern, European discourse of race evolves, and within this it is through Renan's work among others in the latter part of the century that a scientific claim was made for the racialisation of the Jews as a part of a more general 'Semitic' grouping.

To exemplify how profound this discursive shift to race was we need only go back to the French Revolution. The community that was to remain disenfranchised the longest was that of the Jews. In January 1790 the leaders of the Jewish communities of France petitioned the National Assembly with a 107-page booklet. Central to their argument to be accepted as citizens was the assumption that Jews were identifiable by their religion, and that there had been a transformation in the attitude to religion:

> In truth they are of a religion condemned by that which is dominant in France. But the time is past when it was accepted that only the dominant religion gave the right to advantages, to prerogatives, the lucrative and honourable positions in society. . . . In general, civil rights are independent of religious principles.[27]

The Jews were finally enfranchised on September 27, 1791, only three days before the closing of the National Assembly. It is important to note, though, that they were enfranchised as individuals not as Jews. This egalitarian setting aside of Jewish religious difference opened the way for the putting into place of a new kind of individually identifiable difference. This is the other reason for citing this particular document, to highlight the correlation between the establishment in Europe of the modern nation-state through the nineteenth century, and the spread of the discourse of race. In particular, the racialisation of the Jews. Unlike religion which was understood as a part of a lived cultural complex which could be changed, thus promoting assimilation, 'race' was constituted as an essential difference which identified each individual as either assimilable or

unassimilable. 'Race' could be used to claim that differences as various as thought patterns, emotional response and culture were actually essential and ineradicable. In the period before the establishment of the nation-state it was common in Europe to speak of the 'Jewish nation.' As the term 'nation' gradually came to be associated with a collectivity of people associated with a particular territory, the idea of the Jewish nation fell into disuse, replaced by the ambiguous racialisation of the Jews as simultaneously 'white' and a race apart.

In England the acceptance of the Jews into political life happened later than in France. Here the problem was not enfranchisement – in England that was primarily a class-based issue – but rather one of access to political power. While the Catholic Emancipation Act was passed in 1829, Jews were first allowed to sit in the House of Commons in 1858. Jewish peers were given access to the House of Lords in 1866. Sir Nathaniel Rothschild was ennobled in 1885, becoming the first Jewish peer – and, once the Promissory Oaths Act of 1871 became law, Jews 'were placed at last on precisely the same footing as regards political rights as their Christian fellow subjects with one or two insignificant exceptions.'[28] Over this period there were the beginnings of the most significant wave of Jewish migration to Britain. Harold Pollins tells us that 'the first year in which more than 100 Jews arrived at [the port city of] Hull was 1851. Thereafter the rate rose.'[29] He also writes that 'About 60,000 Jews lived in the British Isles in 1880; by 1914 the number had grown to perhaps 300,000.'[30] These migrants mostly came from Eastern Europe, in the main Russia and Russian controlled Poland. It was this flow which led the Conservative government of the day to pass the 1905 Aliens Order, marking the beginning of British controls on immigration, subsequently aimed at 'black' migrants.[31]

In relation to the Jews, then, two contradictory processes were at work. On the one hand, Jewish identity was reduced to religious difference, and in the secularising states of Europe this meant that Jews were urged to assimilate. On the other hand, there was a developing, though ambivalent, racialisation of the Jews which saw them produced in different contexts as both 'white' and Other; increasingly, as Semitic as opposed to Aryan. The context for this was the production of a homogeneous national citizenry of individuals in the new European nation-states. In England, which continued to have an established Church, the concern with Jewish religious difference was played out in evangelical preoccupations with conversion through such groups as the London Society for Promoting Christianity amongst the Jews.[32]

THE NATIONAL CULTURAL PROJECT AND THE ELISION OF JEWS IN ENGLAND

In order to understand why 'race' appears so late on the agenda of the Birmingham Centre, and why the Jewish voice does not appear at all, we must

appreciate the extent to which the development of cultural studies in England happened within an intellectual ethos propagated by Matthew Arnold and other cultural critics from around the mid-nineteenth century. As we shall see, Arnold's concerns were to do with the formation of a single, shared – we might say homogeneous – national culture. His work functions as cultural criticism in ways that are, to some extent, the inverse of those of the Birmingham Centre. Where the Birmingham Centre's pioneering work in cultural studies established the voices of the marginalised, Arnold's work was centred on the construction of a unified national culture which was bourgeois in its ideology and exclusive in its aim to construct an English national culture allied to the English state. To this end Arnold advocated a general state education, arguing, in Chris Baldick's words, that 'The middle classes must embrace state education, not just to assimilate the masses, but to cure their own lack of exemplary governing qualities, otherwise "a great opportunity is missed of fusing all the upper and middle classes into one powerful whole."'[33] The major educational vehicle for this purpose was to be literary criticism and, as Baldick tells us, 'Arnold was not alone . . . in promoting a particular social mission for literary studies against the sectarian entrenchment of the middle classes.'[34] While Baldick emphasises the class concerns, these were set within national preoccupations. The major line of development of British cultural studies is usually argued to come through Richard Hoggart, Raymond Williams and Stuart Hall.[35] All three had literary-critical backgrounds. Indeed, Stuart Hall's doctoral thesis was going to be on Henry James.[36] Arnold's work and Hall's work stand at two ends of the same tradition, the one mapping the means for the construction of a national English culture, the other charting its dissolution as a unified, homogeneous entity. To understand the absence of a Jewish presence in the Birmingham Centre's work, then, we have to go back to Matthew Arnold.

Arnold's *Culture and Anarchy* was published in 1869, during the period of Britain's transformation into a representative democracy. The first Reform Bill was finally passed at the third attempt in 1832, during a period of much unrest in the country. This Bill began the dismantling of the aristocratic dominance of Parliament by disenfranchising 56 boroughs each with less than 2000 voters returning 111 members of Parliament, and adding 97 new seats. It also changed the voting qualification, increasing the number of (male) middle-class voters. The second Reform Bill of 1867 lowered the financial qualification for voters and redistributed seats once more to take account of the new voters. It enabled working-class men to vote and added 938,000 voters to an electorate of 1,057,000 in England and Wales.[37] Male Jews were *de facto* enfranchised as a part of this process. Thus the Jews in Britain, as in Europe more generally, were being enfranchised at the same time that they were being racialised.

It is in the context of this working-class male enfranchisement that we need to look first at what the point of *Culture and Anarchy* was. Arnold begins by defining culture. He sums it up as 'a study of perfection, and of harmonious perfection, general perfection, and perfection which consists in becoming

something rather than in having something, in an inward condition of the mind and spirit, not in an outward set of circumstances.'[38] He then goes on to explain that

> ... in our own country [England] culture has a weighty part to perform, because here that mechanical character, which civilisation tends to take everywhere, is shown in the most eminent degree. . . . The idea of Perfection as an *inward* condition of the mind and spirit is at variance with the mechanical and material civilisation in esteem with us, and nowhere, as I have said, in so much esteem as with us.[39]

Young reminds us that, when it was first published, *Culture and Anarchy* had a subtitle which made clearer the purpose of the book. It was 'An Essay in Political and Social Criticism.'[40] While Arnold's theorisation of culture was fundamentally aesthetic and universalist, his application of this idea was strictly national. Young remarks that, for Arnold, 'although culture serves as the basis of the nation, and therefore becomes associated with nationalism, its identification with Englishness is not at all obvious – for the whole argument of *Culture and Anarchy* is that culture in England is lacking.'[41] This assertion is rather extreme because, for example, Arnold compares the 'England of Elizabeth, a time of splendid spiritual effort' with 'the England of the last twenty years.'[42] There is, it seems, something to be retrieved from the past, some English work that is part of 'the best that has been thought and said.'[43] However, Young's general point is correct. Arnold is writing about the elaboration of a national English culture.

Arnold's concern is that the three major classes in English society have moved away from culture.[44] To these classes, the aristocracy, the middle class and the working class, Arnold gives the names 'barbarians,' 'philistines' and the 'populace.' Now, originally the Philistines were a people in contention with the Jews in ancient Israel. They were finally defeated by the Israelite king, David, in the tenth century BCE. Arnold explains his use of the term:

> *Philistine* gives the notion of something particularly stiff-necked and perverse in the resistance to light and its children; and therein it specially suits our middle class, who not only do not pursue sweetness and light, but who even prefer to them that sort of machinery of business, chapels, tea-meetings, and addresses from Mr. Murphy, which makes up the dismal and illiberal life on which I have so often touched.[45]

Here we need to be reminded of Renan's description of the Semites as given by Said – that *inter alia* they have no civilisation and their consciousness is narrow and rigid. Young tells us that 'The great French Semitist and linguist Ernest Renan is generally agreed to have been the writer who most influenced

Arnold in his thinking.'[46] Arnold was giving to the non-Jews the qualities Renan gave to the Semites. By implication, the Jews became the ideal cultured English. In the process the real Jews in England who, with their different culture and religion, would make problematic this ideal of a single unifying culture, disappear.

The need for the Jews in England to disappear is reinforced by the importance Arnold gives to the established Church. In the Preface to *Culture and Anarchy* in particular, but also right through the book, Arnold asserts the importance of an established Church which is in touch with the mainstream of national life. If a national Church provides a unifying focus, its establishment prevents the Church becoming too Hebraic. Here we have Arnold's second metaphoric usage of the Jews. He distinguishes two 'forces' in people's relation to culture, he gives 'these forces names from the two races of men who have supplied the most singular and splendid manifestation of each of them, we may call them respectively the forces of Hebraism and Hellenism.'[47] Here, indeed, we have a trace of the repressed knowledge that Jews, and Jewish culture, have been as central to the formation of 'western' culture as the Greeks and Greek culture. Distinguishing Hebraism and Hellenism, Arnold writes that 'The uppermost idea with Hellenism is to see things as they really are; the uppermost idea with Hebraism is conduct and obedience;'[48] and that 'The governing idea of Hellenism is *spontaneity of consciousness*; that of Hebraism, *strictness of conscience*.'[49] Arnold argues that English society is too Hebraic. Thus, he reifies Jewish culture into a heuristic device, again eliding the 'real' Jews in England in the process.

Throughout this period there was developing what Bryan Cheyette describes as 'The fear that a supposedly homogeneous national culture was being overwhelmed by an unassimilable "other."'[50] For example, Matthew Arnold's father, Thomas Arnold, the celebrated educational innovator, considered Jews to be fundamentally incompatible with the 'Teutonic' element in 'our English race,'[51] and he campaigned against Jewish emancipation in the 1830s and 1840s. In *Culture and Anarchy* – though it should be remembered, not in all of Matthew Arnold's work – culture is privileged over race as the source of identity. In this context, Cheyette argues, a doubling takes place: 'Within an increasingly exclusivist nation-state . . . Jews [were] constructed in equivocal terms as both the embodiment of a transformable cultural Hebraism and, at the same time, as an unchanging racial "other."'[52] In his description of England as being Hebraic, Arnold is also assimilating Hebraism to his description of philistine, middle-class practices. In this complex textual economy the Jews of nineteenth-century England, who disturbed Arnold's father so much, are made to disappear twice over to make way for the younger Arnold's idea of a unifying, and homogenising, national culture at just the moment when the Jews themselves were beginning to increase in numbers in the country, and at the same time that they were being enfranchised and racialised as an 'oriental' Other.[53] 'Race' in the form of the Jews, and the problem of the formation of a

national community, is repressed in *Culture and Anarchy* to make way for the 'real' problem, class. In 1958, almost 100 years later, the same thing happens in Raymond Williams's *Culture and Society 1780–1950*.[54] However, where for Arnold class difference was something to be overcome by the production of a common culture, for Williams class difference was embedded in cultural difference.

Before discussing Williams it is very important to look at T. S. Eliot's discussions of culture. Setting aside its differences, of which there are many, from Arnold's work, Eliot's discussions of culture form a high point in that tradition which claimed that a national culture should be homogeneous. Where Arnold made modern, living Jews disappear in his adumbration of an English national culture that was, nevertheless, 'Hebraic,' Eliot all but ignored the Jews. The 'all but' is significant. In *After Strange Gods*, Eliot's early discussion of culture – he does not describe it as national culture, but that is clear from the context – he writes:

> The population should be homogeneous; where two or more cultures exist in the same place they are either likely to be fiercely self-conscious or both to become adulterate. What is still more important is unity of religious background; and reasons of race and religion combine to make any large number of free-thinking Jews undesirable. There must be a proper balance between urban and rural, industrial and agricultural development. And a spirit of excessive tolerance is to be deprecated.[55]

In *T. S. Eliot and Prejudice*, Christopher Ricks quotes these lines as the centrepiece of his even-handed discussion of the question of Eliot's anti-Semitism. For all his sophisticated analysis, though, Ricks fails to appreciate what is really at stake in Eliot's pronouncement. This is the assumption that a national culture should be homogeneous and Eliot's assertion that a culture should have a religious component.

Eliot expands on this claim in his *Notes Towards the Definition of Culture* published in 1948, fourteen years after *After Strange Gods*. Here, he argues that 'no culture can appear or develop except in relation to a religion.'[56] Arguing against what he sees as Arnold's privileging of culture, High Culture, over religion, Eliot argues that the two are inevitably thoroughly imbricated. Here, we find the source for Eliot's statement about the undesirability of too many free-thinking Jews in *After Strange Gods*. Eliot regarded Jews as different, Other, in fact, both in terms of race and religion. Ideally a culture, including a national culture, should be homogeneous. Different races have different cultures. This is a correlative of the use of race to mark the limits of national culture. Free-thinking Jews, that is, those who have given up Judaism in the process of assimilation, will remain Other because they are racially distinct. In *Notes*, Eliot also writes that 'It seems to me highly desirable that there should be close

culture-contact between devout and practicing Christians and devout and practicing Jews.'[57] Given his point in *After Strange Gods*, Eliot's proviso would seem to be that not too many, even practising, Jews should live within any particular Christian culture. Free-thinking Jews are, then, a greater problem because, not completely assimilating because of their race, and, indeed, being free-thinkers and not Christians, they will weaken both the religion and the culture of the dominant group – we might say, of the nation.

In one well-known place Eliot outlines the components of the English national culture:

> It includes all the characteristic activities and interests of a people: Derby Day, Henley Regatta, Cowes, the twelfth of August, a cup final, the dog races, the pin table, the dart board, Wensleydale cheese, boiled cabbage cut into sections, beetroot in vinegar, nineteenth-century Gothic churches and the music of Elgar. . . . And then we have to face the strange idea that what is part of our culture is also part of our *lived* religion.[58]

Jews, it would seem, like the members of any other non-Christian religion, may experience this culture but will not be a part of it and could not contribute to it. The same goes for free-thinking Jews who are in a worse situation having no religion/culture of their own. The implication would seem to be that a limited number of Jews may be tolerated as members of the British state but cannot be a part of the homogeneous English national culture, especially as that culture is expressed in and through the established national Christian Church, the Church of England.

CULTURAL STUDIES, RACE AND THE DENATURALISATION OF THE NATIONAL CULTURAL PROJECT

Raymond Williams is commonly regarded as one of the founders of cultural studies in Britain, and his second book, *Culture and Society 1780–1950*, as one of the founding texts. In this book Williams's guiding concern is remarkably similar to that of Arnold in *Culture and Anarchy*: the problem of culture and its utility in binding a society together. In his Introduction, Williams asserts that 'The development of the word *culture* is a record of a number of important and continuing reactions to these changes ['the great historical changes . . . in *industry*, *democracy*, and *class*'] in our social, economic, and political life, and may be seen, in itself, as a special kind of map by means of which the nature of the changes can be explored.'[59] By the end of the book Williams has shifted from tracking the cultural history of the word 'culture' to an advocacy of his own renovation of it. It is, in particular, this final, concluding chapter that has

stamped the book as one of the foundations of British cultural studies – and possibly cultural studies more generally.

Here it is that Williams provides the definition of culture that has subsequently proved so fruitful: 'Yet a culture is not only a body of intellectual and imaginative work; it is also and essentially a whole way of life.'[60] It is a definition which owes much to T. S. Eliot's discussion of culture in *Notes Towards the Definition of Culture*. Here, Eliot writes that 'there is an aspect in which we can see a religion as the *whole way of life* of a people, from birth to the grave, from morning to night and even in sleep, and that way of life is also its culture.'[61] Here, again, we can find Eliot's rationale for excluding Jews as a religious group. For Eliot, a national people should have a single religion. In taking over and secularising Eliot's understanding of culture, Williams also took on board, although it is nowhere spelt out, Eliot's assumptions of homogeneity based in cultural and racial exclusivity. What Williams brought to Eliot's discussion that was new, was a class analysis. He goes on:

> The primary distinction [between bourgeois and working-class culture] is to be sought in the whole way of life, and here, again, we must not confine ourselves to such evidence as housing, dress and modes of leisure. Industrial production tends to produce uniformity in such matters, but the vital distinction lies at a different level. . . . The crucial distinction is between alternative ideas of the nature of social relationships.[62]

Like Arnold, Williams sees the key project as the development of a common culture. His advocacy of this is implicit in the final subheading of *Culture and Society's* Conclusion, 'The Development of a Common Culture.'[63] Unlike Arnold, Williams does not see a common culture happening as a consequence of the educational dissemination from above of sweetness and light. Williams writes that 'In our culture as a whole, there is both a constant interaction between these ways of life and an area which can properly be described as common to or underlying both.'[64] He goes on to argue that 'solidarity is potentially the real basis of a society.'[65] What Williams considers important is to increase the feeling of solidarity in a society which he recognises is riven by cultural difference as a consequence of 'increasing specialization.'[66] In effect, the common culture which Williams is promoting is a national culture which will override the class-based cultures.

The first thing that needs to be acknowledged is that Williams, like Arnold, is writing about English – or, in this local colonial setting, should that be British? – culture.[67] This immediately raises the question of who are members of the 'our' of whom Williams often speaks. Of course in one sense the answer is obvious, 'we' are the English, or those colonised and problematically assimilated as British. However, as we begin to unpack it, this 'our' becomes problematic in a different way. Paul Gilroy is one person who has spent some

time discussing this problematisation. He has argued that 'The entry of blacks into [British] national life is itself a powerful factor in the formation of cultural studies.'[68] This is because, first of all, of the speaking out of another silenced group in addition to the working class and women. But, if this is the case, then we must ask what image of national culture were these Blacks and other groups problematising. It was, in the first place, as I have outlined from Arnold's *Culture and Anarchy*, one of homogeneity ensured, ultimately, by the use of race to mark those who might be assimilated and those who should be excluded. Specifically in relation to race, Gilroy notes that in Britain at large a dominant view has developed, 'where black history and culture are seen like black settlers themselves, as an illegitimate intrusion into a vision of authentic British national life that, prior to their arrival, was as stable and as peaceful as it was ethnically homogeneous.'[69] There was a long-standing, if small, 'black' population as well as a Jewish population. However, both these groups disappear in the nineteenth century production of a mythical homogeneous national English/British race and culture. The socially engaged literary criticism advocated by Arnold and taken up by the likes of T. S. Eliot and Leavis helped to construct and naturalise this idea.

In Williams's discussion of Arnold's work in chapter 6 of *Culture and Society 1780–1950*, a remarkable absence occurs. Most of the attention, naturally, is on *Culture and Anarchy* and yet there is no mention of Arnold's distinction between Hebraism and Hellenism. Where Arnold's text spends two chapters out of the book's six, excluding the Conclusion, guiltily we might say, concerned with these two concepts, in Williams's book they do not appear. Instead, what Williams focuses on is Arnold's discussion of the English class structure. This is understandable given, as we have seen, that class cultures are central to Williams's argument. However, the underlying homogeneity of English/British culture within which it is Williams's concern to distinguish class cultures is achieved by the textual omission – or perhaps we should say repression – of the Jews as well as of 'blacks.'

CONCLUSION

One way of thinking about the development of Birmingham Centre cultural studies is in the context of a dismantling of the Arnoldian project for the construction of a unified, homogeneous national culture. Those designated as 'black' were excluded from this project. However, the Jewish situation was more complex. Arnold made the Jews in the English polity disappear while incorporating the so-called Hebraic character as a key component of English life. Eliot thought that a limited number of Jews were acceptable but considered that Jews were unassimilable. We can now understand why 'race' was the last of the mantra to appear in the work of the Birmingham Centre, and why, as Hall remarks, it was such a struggle to place it on the agenda. It was

race, not class, which marked the specificity of the Arnoldian project as a national, rather than purely cultural, project. Class was the specifically English preoccupation through which English/British society filtered its concern with culture. The resistance to placing race on the agenda was, then, a resistance to acknowledging that, first of all, the importance of the discussion of culture lay in its connection with the production of a national imagined community and, second, that behind culture it was race which marked the limits of those able to be included in that community.

Ien Ang and I have written elsewhere in a discussion of black British cultural studies that 'What was challenged through British cultural studies was ['Blacks"] status as Other to a taken-for-granted 'white' British imagined community.'[70] What this does not explain is the continued absence of a Jewish voice. In order to understand this, we must remember two interrelated things. First, the assimilationist bargain held out to the Jews at the time of their emancipation and enfranchisement which led to a pervasive self-silencing. Second, the ambivalent racialisation of the Jews. Not all strangers who enter and stay in the nation-state are regarded ambivalently, as Bauman describes the Jews. In England, as in other European nation-states, 'blackness' has been a marker of an irreducible Otherness. As Gilroy has put it, 'The characteristic outcome [of the new racism] is a situation in which blackness appears as a kind of disqualification from membership of the national community.'[71] This is not an ambivalent situation.

Jews, on the other hand, have been characterised as both white and non-white (indeed, sometimes as black[72]), European and non-European (that is, Oriental or Asiatic), and therefore as both assimilable and unassimilable, includable and to be excluded. Arnold's very sophisticated solution to this ambivalence was to appropriate Jewish culture as a historical artefact while eliding the Jews living in his modern England. As cultural studies in Britain evolved, the groups who found their voices, the working class, women, 'Blacks,' were all excluded from power, silenced and marginally constructed in relation to capitalism, patriarchy and the nation-state. The ambivalent situation of Jews, however, allows them to speak only uncertainly, in the process unsettling the racial and national discourses through which their situation was constituted – as well as unsettling their own ambivalent assimilation. In this circumstance it is understandable that Jews should remain silent and silenced. One alternative, which is legitimated in relation to the American politics of identity, has been to fall back on speaking out from a Jewish heritage.[73] Now, perhaps it is possible for the Jewish voice to speak out from within its 'European' and nation-state-based history, unsettling the mantra on which British cultural studies has evolved and marking a further deconstruction of the Arnoldian project.

NOTES

1 Jon Stratton and Ien Ang, 'On the Impossibility of Global Cultural Studies' in Kuan-Hsing Chen and David Morley (eds.), *Stuart Hall: Critical Dialogues in Cultural Studies*, London, Routledge, 1996, pp. 361–91.

2 Over the last few years there has begun to be a discussion of the situation of the Jews in British work on, broadly speaking, modern culture. There are, for example, Zygmunt Bauman, *Modernity and the Holocaust*, Cambridge, Polity Press, 1989, and Zygmunt Bauman, *Modernity and Ambivalence*, Cambridge, Polity Press, 1991. There is also Gillian Rose, *Judaism and Modernity: Philosophical Essays*, Oxford, Blackwell, 1993.

3 The situation in the United States has been a little different. Most importantly because of the pioneering work of Sander Gilman who has published a number of books which struggle to take the discussion of the European history of the Jews out of the ghetto of Jewish Studies and into a broad cultural matrix. There is also the important work of Daniel Boyarin and Jonathan Boyarin, including 'Diaspora: Generation and the Ground of Jewish Identity', *Critical Inquiry*, 1993, vol. 19(4), pp. 693–725, and Jonathan Boyarin's book, *Storm from Paradise: The Politics of Jewish Memory*, Minneapolis, University of Minnesota Press, 1992. Whilst Boyarin's book does begin to develop a Jewish speaking position it does so within the American discourse of identity politics and speaks out of a Jewish cultural heritage rather than from a position that recognises the imbrication of cultural contexts in national cultures. There is also now a literature on multiculturalism and Jews in the US. An early article was Michael Galchinsky, 'Glimpsing *Golus* in the Golden Land: Jews and Multiculturalism in America', *Judaism*, 1994, vol. 43(4), pp. 360–8. I have identified two books on this topic in the Introduction.

4 One of the most important theorisations of the construction of the Jew as Other can be found in Jean-François Lyotard, *Heidegger and 'the jews'*, trans. Andreas Michel and Mark S. Roberts, Minneapolis, University of Minnesota Press, 1990.

5 Zygmunt Bauman, *Modernity and Ambivalence*, p. 6.

6 Zygmunt Bauman, *Modernity and Ambivalence*, p. 6.

7 Zygmunt Bauman, *Modernity and Ambivalence*, p. 59.

8 Kobena Mercer, *Welcome to the Jungle*, New York, Routledge, 1994, p. 288.

9 Stuart Hall, 'Cultural Studies and Its Theoretical Legacies' in Lawrence Grossberg et al. (eds.), *Cultural Studies*, New York, Routledge, 1992, p. 283. In general, see Jon Stratton and Ien Ang, 'Speaking (as) Black British: Race, Nation and Cultural Studies in Britain' in Penny van Toorn and David English (eds.), *Speaking Positions: Aboriginality, Gender and Ethnicity in Australian Cultural Studies*, Melbourne, Victoria University of Technology Press, 1995, pp. 14–30.

10 In connection with 'race', this weakening is one aspect in a complex of factors that have underwritten the rise to prominence of the discourse of multiculturalism in the variety of forms it has taken in many, if not most, western nation-states since the 1970s.

11 For a version of this argument in the context of Anglo settler-states, see Jon Stratton and Ien Ang, 'Multicultural Imagined Communities: Cultural Difference and National Identity in the USA and Australia' in David Bennett (ed.), *Multicultural States: Rethinking Difference and Identity*, London, Routledge, 1998, pp. 135–62. For this argument in relation to Jews in Australia, see Chapter Seven of this book.

12 Homi Bhaba, 'Of Mimicry and Man' in Homi Bhaba, *The Location of Culture*, London, Routledge, 1994, p. 89, emphasis in original.

13 See, for example, the discussion in Dietz Bering, *The Stigma of Names: Anti-Semitism in German Daily Life, 1812–1933*, Cambridge, Polity Press, 1992.

14 Philip Cohen, 'The Perversions of Inheritance: Studies in the Making of Multi-Racist Britain' in Philip Cohen and Harwant S. Bains (eds.), *Multi-Racist Britain*, London, Macmillan, 1988, p. 15.

15 There is a complex ideological history behind this development. For example, as Sander Gilman has noted, in the early part of the nineteenth century there was a tendency is some quarters to link skin colour with geography, suggesting that a mobile people like the Jews could change their skin colour (Sander Gilman, 'The Jewish Nose' in *The Jew's Body*, New York, Routledge, 1991, p. 177). More importantly, it seems there was a connection between Jewish acculturation – the use of national languages, adaptation to local dress codes and so forth – and the decline in their racialisation, including by colour. Hence, in both the nineteenth and twentieth centuries Yiddish speaking East European Jews, garbed in the distinctive clothing of the Jewish culture of the Pale were racialised in many western countries, often being colourised as 'black.' See, for example, Sander Gilman, 'The Jewish Nose', pp. 172–6.

16 See, for example, the discussion in Dietz Bering, *The Stigma*.

17 Alain Finkielkraut, *The Imaginary Jew*, trans. Kevin O'Neill and David Suchoff, Lincoln, University of Nebraska Press, 1994, p. 59.

18 Robert Young, *Colonial Desire: Hybridity in Theory, Culture and Race*, London, Routledge, 1995, p. 64.

19 Leon Poliakov, *The Aryan Myth: A History of Racist and Nationalist Ideas in Europe*, trans. Edmund Howard, London, Chatto and Windus Heinemann for Sussex University Press, 1974, pp. 142–3.

20 Leon Poliakov, *The Aryan Myth*, p. 143.

21 Leon Poliakov, *The Aryan Myth*, p. 161.

22 Robert Young, *Colonial Desire*, p. 65.

23 Edward Said, *Orientalism: Western Representations of the Orient*, London, Routledge and Kegan Paul, 1978, p. 139.

24 Edward Said, *Orientalism*, p. 142.

25 Leon Poliakov, *The Aryan Myth*, p. 234.

26 Quoted in Leon Poliakov, *The Aryan Myth*, p. 132.

27 Paul H. Beik (ed.), *The French Revolution*, London, Macmillan, 1971, p. 132.

28 Colin Holmes, *Anti-Semitism in British Society, 1876–1939*, London, Edward Arnold, 1979, p. 8.

29 Harold Pollins, *Economic History of the Jews in England*, Rutherford, Fairleigh Dickinson, 1982, p. 131.

30 Harold Pollins, *Economic History*, p. 130.

31 Some detail on the 1905 Aliens Order and its socio-political context can be found in John Solomos, *Race and Racism in Britain*, London, Macmillan, 1989, pp. 43–7.

32 On conversion, see Michael Ragussis, *Figures of Conversion: 'The Jewish Question' and English National Identity*, Durham, N.C., Duke University Press, 1995.

33 Chris Baldick, *The Social Mission of English Criticism 1848–1932*, Oxford, Clarendon Press, 1983, p. 34.

34 Chris Baldick, *The Social Mission*, p. 60.

35 See, on this, Jon Stratton and Ien Ang, 'On the Impossibility'. For an alternative history see Ioan Davies, *Cultural Studies and Beyond: Fragments of Empire*, New York, Routledge, 1995.

36 Hall discusses this in an interview with Kuan-Hsing Chen in 'The Formation of a Diasporic Intellectual: An Interview With Stuart Hall' in Kuan-Hsing Chen and

David Morley (eds.), *Stuart Hall: Critical Dialogues in Cultural Studies*, New York, Routledge, 1996, pp. 484–503.

37 Sir Llewellyn Woodward, *The Age of Reform 1815–1870*, 2nd ed., Oxford, Oxford University Press, 1962.

38 Matthew Arnold, *Complete Prose Works*, vol. 5: *Culture and Anarchy*, Ann Arbor, University of Michigan Press, 1965, pp. 94–5.

39 Matthew Arnold, *Culture and Anarchy*, p. 95.

40 Robert Young, *Colonial Desire*, p. 59.

41 Robert Young, *Colonial Desire*, p. 57.

42 Matthew Arnold, *Culture and Anarchy*, p. 97.

43 Matthew Arnold, *Culture and Anarchy*, p. 99.

44 Asa Briggs has argued that Charles Hall in his book, *The Effects of Civilisation on the People in European States*, published in 1805, was the first person to develop a class theory of society. See Asa Briggs, 'The Language of "Class" in Early Nineteenth-Century England' in Ron Neale (ed.), *History and Class: Essential Readings in Theory and Interpretation*, Oxford, Basil Blackwell, 1983, pp. 2–29.

45 Matthew Arnold, *Culture and Anarchy*, p. 140.

46 Robert Young, *Colonial Desire*, p. 68.

47 Matthew Arnold, *Culture and Anarchy*, p. 163.

48 Matthew Arnold, *Culture and Anarchy*, p. 165.

49 Matthew Arnold, *Culture and Anarchy*, p. 165 (original emphasis). The connection that Arnold makes between Hebraism and conscience was to reappear in a quite different guise after the Holocaust when gentile Europe began to associate the genocide of the Jews with evil.

50 Bryan Cheyette, *Constructions of 'the Jew' in English Literature and Society: Racial Representations 1875–1945*, Cambridge, Cambridge University Press, 1993, p. 6.

51 Bryan Cheyette, *Constructions*, p. 16.

52 Bryan Cheyette, *Constructions*, pp. 5–6.

53 See, for example, the description by Goldwin Smith, who was Regius Professor of Modern History at Oxford between 1858 and 1866, of Benjamin Disraeli as 'this Semite' and his vindictiveness as 'truly Oriental' (Colin Holmes, *Anti-Semitism*, p. 11). Also, the writings of Joseph Bannister who, in 1901, published *England under the Jews* in which Jews were described as having a 'repulsive Asiatic physiognomy' and as having blood, 'like that of other Oriental breeds' (Colin Holmes, *Anti-Semitism*, pp. 39–40).

54 Raymond Williams, *Culture and Society 1780–1950*, Harmondsworth, Penguin Books, 1963.

55 Quoted in Christopher Ricks, *T. S. Eliot and Prejudice*, London, Faber and Faber, 1994, p. 41.

56 T. S. Eliot, *Notes Towards the Definition of Culture*, London, Faber and Faber, 1948, p. 27.

57 T. S. Eliot, *Notes*, p. 70 (note 1).

58 T. S. Eliot, *Notes*, p. 31.

59 Raymond Williams, *Culture*, p. 16.

60 Raymond Williams, *Culture*, p. 311.

61 T. S. Eliot, *Notes*, p. 31.

62 Raymond Williams, *Culture*, p. 311.

63 Raymond Williams, *Culture*, p. 318.

64 Raymond Williams, *Culture*, p. 313.

65 Raymond Williams, *Culture*, p. 318.

66 Raymond Williams, *Culture*, p. 318.

67 Young briefly discusses the problematic terms 'English' and 'British' at the very beginning of Robert Young, *Colonial Desire*.

68 Paul Gilroy, 'Cultural Studies and Ethnic Absolutism' in Lawrence Grossberg et al. (eds.), *Cultural Studies*, New York, Routledge, 1992, p. 190.

69 Paul Gilroy, 'Cultural Studies', p. 188.

70 Jon Stratton and Ien Ang, 'Speaking (as) Black', p. 18.

71 Paul Gilroy, 'Nationalism, History and Ethnic Absolutism' in *Small Acts: Thoughts on the Politics of Black Cultures*, London, Serpent's Tail, 1993, p. 64.

72 See, for example, Sander Gilman, 'The Jewish Nose'.

73 An example of this is Jonathon Boyarin, *Storm from Paradise*.

2

EUROPEAN JEWS, ASSIMILATION AND THE UNCANNY

When the nation-state evolved through the late eighteenth and nineteenth centuries, the concern was with the establishment of a single, homogeneous national culture that was the expression of a single, national people. The discourse of race was the most important method by which the homogeneous population was produced. Some groups of people were identified as of the same race and could, therefore, be assimilated, others were identified as of different races and were to be excluded. The Jews were sometimes thought of as one, and sometimes the other. In the main, their position was ambivalent. This is their story. Rethought in the terms of the discourse of identity which has pervaded western modernity and postmodernity, the Jews have been constructed ambiguously as both the similar, that is to say, as a version of 'us,' and Other, as another group of 'them.' To put it another way, we can distinguish between two kinds of other. There is the other whose differences are thought of by the dominant group as being mundane, everyday and, in the end, eradicable. This other was thought of as assimilable, as transmutable into 'us.' Then there is the Other, comprising those whose differences are considered to be profound and ineradicable, differences which we may think of in terms of radical alterity, a Difference. This claim of radical alterity means that the members of this particular group are thought to be unassimilable.

Homi Bhabha has discussed the process of colonial Othering on the model of fetishism. Indeed, when he asks 'Does the Freudian fable of fetishism (and disavowal) circulate within the discourse of colonial power requiring the articulation of modes of differentiation – sexual and racial – as well as different modes of theoretical discourse – psychoanalytic and historical?'[1] Bhabha seems to be suggesting that the link between the sexual and the racial may be rather more than analogical. He goes on to suggest that there is both a structural and a functional similarity. Structurally, fetishism involves a disavowal of sexual difference. Bhabha points out that the same thing takes place in the Other's experience of their Othering. Lifting off from the title of Frantz Fanon's book *Black Skin, White Masks*, Bhabha argues that 'the disavowal of difference turns the colonial subject into a misfit – a grotesque mimicry or "doubling" that

threatens to split the soul and whole, undifferentiated skin of the ego.'[2] This outline fits the situation described in those terms used in assimilatory situations where the key marker of radical alterity cannot be erased: 'coconut,' to describe someone who is 'black' on the outside and 'white' on the inside; 'banana' to describe someone 'yellow' on the outside and 'white' on the inside. Importantly, because it signals the problem of the racial differentiation of Jews from 'white,' there is no Jewish equivalent. Meanwhile, members of the national culture, the culture to which the person is trying to assimilate, will often reinforce the impossibility of assimilation by concentrating on precisely that feature which the person attempting to assimilate is disavowing. The feature being precisely that which the national culture identifies as the site for the confirmation of Difference. They will often remark that 'she's just like us apart from her skin/her eyes etc.' Where Jews are concerned they will often say, 'You'd hardly know she was a Jew but for her name/her nose.' The 'just like' and the 'hardly know' signal the practical application of Otherness.

Bhabha describes the functional similarity in this way:

> fetishism is always a 'play' or vacillation between the archaic affirmation of wholeness/similarity – in Freud's terms: 'All men have penises;' in ours: 'All men have the same skin/race/culture' – and the anxiety associated with lack and difference – again, for Freud 'Some do not have penises;' for us 'Some do not have same skin/race/culture.[3]

Later, I will argue that Freud's understandings of the psycho-sexual processes as universal are themselves filtered through the specificity of the Ashkenazi, and particularly Yiddish, experience of being ambivalently Othered within Europe. Here, though, I want, opportunistically, to accept and develop Bhabha's analogy, with its suggestion of a deeper, culturally imbricated, libidinal link to explain the form that modern Otherness takes.

In Bhabha's example we can see how the universal values of the Enlightenment, 'all men [sic] are equal/the same,' which, in representational discourse is expressed as 'all men [sic] are identical, apart from superficial – that is, individual – differences' can be opposed by the claim to a non-representational difference, that is, a fundamental Difference, which signals the non-identity of certain people as members of a certain category of people. This radical alterity may be signified by a claimed general representational Difference. The presence or absence of male genitalia, specifically the penis, signified sexual Difference in modernity. In the Freudian formulation of fetishism only males can experience the neurosis because it is based on an anxiety about the loss of the penis. The colonial equivalent to the not-having of a penis is identified by Bhabha as 'skin/race/culture.' Here, then, 'skin/race/culture' mark the limit to 'true' representation, the limit to the possibility of identification within the nation, that is, the limit to who could be assimilated.

There are two points to make here. First, the importance of the not-having of a penis, its lack, as signalling Difference from the dominant or colonising group depends on the concerns of the dominant group itself. Taking the analogy as having a cultural force we can also appreciate how the colonial Other comes to be feminised – or conversely hyper-masculinised in the case of 'negroid' Africans – and how Jewish circumcision comes to be read in Europe as a form of castration, of feminisation. In the essay on Little Hans, Freud himself argued that 'The castration complex is the deepest unconscious root of anti-semitism; for even in the nursery little boys hear that a Jew has something cut off his penis – a piece of his penis, they think – and this gives them a right to despise Jews.'[4] Here, anti-Semitism is being equated with misogyny with the corollary assumption that the dominant group is 'male.' These 'normal' little boys despise (male) Jews because of their own fear of castration, a fear which, Freud is implying, is displaced into a rage against (male) Jews. The modern, structural organisation of power was gendered. Its determining site was the phallic, male-dominated, Western state. Feminisation was associated with a lack of social power. In this Freudian image of modern social life, circumcision/ castration is what feminises Jews.

The second point is that the items on Bhabha's list, 'skin/race/culture,' are by no means as equivalent as he implies. In fact, where race is usually – the Jews are the crucial exception – inscribed on the skin by way of colour and through modernity and postmodernity has designated ineradicable Difference, radical alterity, culture has been associated with ethnicity and identified in terms of mundane difference. The Second World War, some would argue the Holocaust, marks a watershed in the historical shift in the West from a privileging of the discourse of race to that of culture. This does not mean that the discourse of race is no longer significant, far from it, but that race has been discredited in most quarters as the determinant, in itself, of radical alterity. Since the late 1960s, ethnicity is the discourse that has come to replace race. It founds difference in culture rather than in some immanent aspect of the body. However, the discourse of ethnicity has not supplanted that of race. In ethnicity thinking, racial difference tends to be taken as the signifier of some fundamental cultural Difference, most usually a different set of founding moral and ethical assumptions, that might make a group incompatible with the other members of the nation-state. These assumptions tend to be thought of in terms of religion. Ethnic difference takes place within the cultural Difference signified by race. It is possible for each 'race' to contain a variety of ethnic differences. Nevertheless, associating ethnicity with culture and race with biology, some countries have attempted to dispense officially with race as a form of categorisation. In Canada and Australia, both places where multiculturalism is official government policy, ethnicity is the key descriptive term.[5] The United States continues officially to classify people by race.

The construction of Jews as having a racialised Difference has been ambiguous. Sander Gilman tells us that 'For the eighteenth- and nineteenth-century

scientist the "blackness" of the Jew was not only a mark of racial inferiority, but also an indicator of the diseased nature of the Jew.'[6] That the Jew was black was an idea that went back to the seventeenth century. However, very many, if not most, ethnologists thought of the Jews as white, taking the Jews of Western Europe as their model. That they were black does not seem to have become the common understanding of the Jews until the nineteenth century and was a part of their gradual racialisation. By the mid-century, as in the work of the French thinker Arthur de Gobineau, Jews were becoming designated as being a race in their own right and, a little later, Ernest Renan began to identify the Jews as Semites.

The racialisation of the Jews correlates with the increased perception that assimilation was, in fact, ultimately, impossible. To continue with Bhabha's analogy, it is as if Jews both have a penis and don't have a penis. The fetishistic situation described by Freud is stable because women, definitionally, do not have penises. The assimilating (male) Jew, the 'woman' of late-nineteenth- and twentieth-century-European national political experience, may be thought of in this system as having penis envy and (s/)he strove to acquire the penis – that is, to be assimilated and join the dominant group. This group is, in fact, in Freudian terms, the fraternity who govern the state in the name of the Father. Metaphorised as assimilation, the ambition to gain the penis, phallus we might say, appeared to be possible. In Daniel Boyarin's important account of male Jewish feminisation in modernity, *Unheroic Conduct*, he writes: 'I start with what I think is a widespread sensibility that being Jewish in our culture renders a boy effeminate.'[7] For the Jew, then, the sexual/racial system seemed to be unstable. In this system, assimilation was based on acceptance and led to access to power within the European nation-states and, more generally, offered power over those designated as non-white and non-European, where these terms were thought to be congruent terms, and in this way Othered. It needs to be added that, if the male Jew was feminised, the female Jew was ambivalently excluded and subordinated as a Jew, and excluded from the polity as a woman in common with other women. Like other Othered women, though, such as the 'oriental' woman with whom she was discursively linked, the female Jew – the Jewess – tended to be constructed as highly sexed and highly desirable.[8]

It is in this general context that the cultural power of Otto Weininger's *Geschlecht und Charakter* (1903), translated as *Sex and Character*, lay. Weininger was an anti-Semitic assimilating Viennese Jew who committed suicide at the age of twenty-three. *Sex and Character* was a book of great influence in its time, contributing ideas to the work of both Freud and D. H. Lawrence among others. One of Weininger's most important claims was the equation of the Eternal Feminine with the Jew as forces of evil.[9] From the Jewish perspective we can see that the desire was the apparently possible dream of acquiring the penis. What made the dream seem possible was 'white' European society's uncertainty about whether Jews actually already had the penis – that is to say, were 'white' and therefore already members of the dominant group, having

only to lose their cultural distinctiveness to become full members. In other words, the fetishistic structure of Othering was unstable where Jews were concerned. From the days of emancipation in the late eighteenth century onwards, it appeared that Jewish assimilation was possible provided that Jews were perceived as being culturally and religiously different rather than racially Different.

During the nineteenth century the Jewish experience of emancipation and assimilation coincided with the increasing racialisation of the Jews, which climaxed in the claims that underpinned the Holocaust. The irony of the Holocaust is that it positioned Jews as central to the modern experience of the west. The very attempt to establish the Jews as unambivalently Other to the west, and eradicate them from the European west, led, instead, to a postmodern circumstance in which Jews have become a part of the shared experience of a west itself transformed by the Holocaust. And the genocide that marks the Holocaust signals the failure, and the end, of the project of modernity. Jews no longer need to try the (impossible) task of assimilating to become a part of western modernity. The Holocaust made them a part of an inclusive European postmodernity defined, in part, by that event. At the same time, the massive migrations from the old European colonies to Europe, along with the discursive shift to culture from biology, has led, albeit unwillingly in some cases, to a greater acceptance of cultural diversity in the nation-state. The Jews remain ambivalently Other in western identity, but they do so within a reformation of that identity in which the inclusion of the Jewish Other marks the key moment in the unsettling, and decentring, of the modern formation of identity.

MIMICRY AND EXCESS

The Jews were not Othered in the absolute way that Bhabha describes as part of the practice of colonisation. Rather, they have been ambivalently Othered and even now are thought of as both 'white' and 'non-white.' Radical alterity describes, among other things, the Othering of a group often through claims to its essential difference, which constructs it as impossible to (be) assimilate(d) – as fundamentally different, not able to become the same. The crucial point is that who is allowed to assimilate is determined by the national group itself, and by the government. Likewise, tolerance is a function of power. Those with power can decide whom they tolerate and the limits of their tolerance, and can change their opinion. The possibility of assimilation, whether a person or group finds himself or herself able to assimilate, is another matter. We need to pause for a moment to acknowledge the complexity of the idea of assimilation. At the very least we must distinguish between cultural assimilation and normative assimilation. When the nation-states of Europe demanded that Jews assimilate in exchange for emancipation, they had in mind cultural assimilation. This means, the taking on board of what is thought of as the common culture, based

in the normative moral order, of the nation, expressed among other places in the mode of living of everyday life. Normative assimilation refers to the demand that the assimilating person accept the norms and values, the moral and ethical order, of the dominant society. They will then be able to keep aspects of their own culture. This idea, which has become the accepted pattern in the United States, is typified in the ideology of cultural pluralism which was developed in the 1910s and 1920s. Since the moral and ethical order is expressed in religion, we can see that cultural pluralism assumes a fundamental similarity between Judaism and Christianity.

Mimicry can be understood in two different ways. First, it is the process by which the assimilating person naturalises the practices of the accepting culture. In this context, assuming that the accepting culture considers the person to be acceptable, then mimicry can be a stage on the way to assimilation. Second, and this is the colonial circumstance addressed by Bhabha, and which became that of the Jews as they were racialised, is the mimicry which is encouraged by the colonial culture, through such means as education, but then forbidden the transformation into assimilation. This denial has been most usually achieved by racialisation. In order to understand how this, second, structure works we can turn to Bhabha's discussion of mimicry in 'Of Mimicry and Man.'[10]

Bhabha's account describes mimicry as the *'ironic* compromise'[11] of the conflictual economy of colonial discourse produced as the tension – Bhabha references Edward Said here – between 'the synchronic panoptical vision of domination – the demand for identity, stasis – and the counter pressure of the diachrony of history – change, difference.'[12] For Bhabha colonial mimicry 'is the desire for a reformed, recognisable Other, *as a subject of a difference that is almost the same, but not quite.* Which is to say, that the discourse of mimicry is constructed around an ambivalence; in order to be effective mimicry must continually produce its slippage, its excess, its difference.'[13]

How is this difference, which perpetuates the distinction of the Other, experienced? In this argument Bhabha draws on Samuel Weber's version of the castration complex and the (un)canny. Weber acknowledges that, for Freud, anxiety is central to the experience of the uncanny. He goes on to outline Freud's two different theories about the production of anxiety. In the earlier one 'anxiety is the result of repression, which separates the affective cathexis (Triebbesetzung) from the representation (Vorstellungsinhalt) to which it was previously bound, and which alone forms the object of repression.'[14] As Weber notes, following Freud, this theory of anxiety is primarily descriptive because, while it explains the operation of anxiety it leaves obscure both the basic cause of repression and the means by which repression produces anxiety. It is this theorisation of repression which Freud uses in *Das Unheimliche* ('The "Uncanny"') and it seems reasonable to suggest that Freud's piling up of examples has much to do with his inability to provide a general causative account of repression. At least, this seems to be what Weber thinks. He argues that the application of Freud's later theorisation of the anxiety to his ideas

about the uncanny provides the causative structure missing in the discussion as we have it.

In this second theory, dating from 1926, 'this first theory of anxiety was not only altered: it was reversed. Freud came to the conclusion that it was not "repression . . . which produces anxiety," but anxiety which produces repression.'[15] The most important producer of anxiety is now claimed to be the fear of castration, in other words what has become known in English as the castration complex. In this way Weber grounds and focuses Freud's otherwise diffuse discussion of the uncanny. As we shall see, it is possible to reread Freud's apparently universalist insight from a more specific circumstance, and to recognise that the fear of castration may be understood as the fear of discovery that in spite of one's assimilation, one can be identified as a Jew. In short, the usefulness of Freud's idea as a way of understanding the predicament of a colonised people is a consequence of its evolution *from* the predicament of a colonised people. At the same time, it is the cultural importance of the idea of castration that, as we shall also see, founds the modern feminisation of the Jews.

For Bhabha the fetishism which underlies the colonial structure is based in the castration complex. Two points can now be made. The first is that the implication of Bhabha's culturalist reworking of Weber's understanding of the uncanny is that both forms of mimicry are uncanny. As we shall see, one way of thinking through the assimilatory experience of the Jews in Europe is in the terms of the uncanny. Zygmunt Bauman notes that, in English at least, 'assimilation' took on its modern meaning of 'to *be*, or *become* like to' from the first half of the nineteenth century, 'exactly about the time when an invitation (or more precisely, *the command*) to assimilate was first sent around by rising nationalisms.'[16] This was, as we have seen, also the time when there was beginning to be a general understanding of the Jews as a distinct race.

The second point entails asking where this male cultural anxiety over castration originates. Here we can return to Weber who outlines Lacan's privileging of the castration complex:

> To use a language made popular by Lacan: castration inscribes the phallus in a chain of signifiers, signifying sexual difference, but also as the difference (and prohibition) which necessarily separates desire – in the Freudian theory at least – from its 'object.' Castration thus structures the future identity and experience of the subject, by confronting it with its unconscious desire as a violent and yet constitutive difference, preventing the subject from ever being fully present to itself, or fully conscious.[17]

Weber is describing the child's entry into the Symbolic, something achieved only at the cost of an experience of anxiety and a feeling of lack. Within the patriarchal modern state, racial difference, that is, difference from the dominant race in the nation, is similarly charged.

I have already noted that, for Bhabha, the disavowal of essential difference produces a 'grotesque mimicry,' which he also describes as a doubling. Bhabha's point is that certain colonised people will deny the racial difference that has been imposed on them and continue to try to assimilate. Such was also true of the Jews of pre-Holocaust Europe. This use of the term 'doubling' refers back to Weber's discussion of the *Doppelgänger*. Weber outlines the dual signification of the *Doppelgänger* as it is theorised by Freud: 'On the one hand, it originally represented the attempt to protect the self against death by duplication. . . . On the other hand, the double has come to be a portent of death once the second self is no longer protected by primary narcissism . . .'[18] Using a term that was to become so important in Bhabha's work, Weber describes this dual action of doubling in both protecting the individual from, and portending, death, as ambivalent. Crucial to this paradox of repetition is the modern ideology of identity as it operates both in terms of the 'individual' and the nation-state. It is here, in this notion of the double, who, in the cultural situation, is striving to be the same, identical, that we find the determining assumption of assimilation. The mimicry described by Bhabha, which we could call radical mimicry, is a consequence of the denial of the possibility of full assimilation to the members of a particular group. In radical mimicry, the mimicry can become excessive, either deliberately, for political reasons, or desperately, moving towards parody. It is in light of this distinction, which, as we have seen, is founded on a claim to radical alterity, that we can distinguish colonial mimicry from the mimicry that is thought to presage assimilation. In Bhabha's theorisation, mimicry is a consequence of the coloniser's refusal to allow assimilation. Allowing the Other to assimilate, with her or his ineradicable signifier of Otherness, would engender the 'death' of the modern homogeneous nation through the inevitable failure of the assimilative process. Hitler's rhetoric about the Jews acted out this fear. In this reading, the genocidal assault on European Jewry began as an attempt to protect the homogeneous Aryan German nation-state from the destruction pursuant upon the impossibility of the assimilation of the Jewish Other. Given the racialised construction of the Jew as always, ultimately, unable to assimilate, it is understandable that an aspect of the modern stereotype of the Jew is her or his acting ability, and the genius claimed for the Jew as an impersonator and mimic.

It is, in the first place, the coloniser who produces the radical mimetic situation. Bhabha goes on to explain how the colonised may take advantage of this mimetic structure for their own purposes *vis-à-vis* the colonisers. He writes, 'It is from this area between mimicry and mockery, where the reforming, civilising mission is threatened by the displacing gaze of its disciplinary double, that my instances of colonial imitation come.'[19] We might think, here, of the American genre of the Yiddish-background comedian, Lenny Bruce, Woody Allen, Jerry Seinfeld, to name but three, who, aside from their many differences, all provide commentaries on American society. Now, though, I am not concerned with the tactical advantages that the colonised can extract from the excessive structure of mimicry. Rather, I want to think about the structure itself and how it works when the context is the ambivalent one of modern Jewish assimilation.

Drawing his examples from British colonial practice in India, Bhabha explains how the aim of that practice was to produce Indians schooled in English manners who, nevertheless, could only ever be thought of as imitating the English (here Bhabha quotes Macaulay's Minute of 1835). In other words, and bearing in mind the theoretical heritage of Bhabha's ideas, we could say that the British reformed the Indians, civilising them into a similarity that remained always, in the end, only a mimicry. It could never be assimilation because of the racialised Difference that the British constructed. This left the Indians as mimics and, indeed, as uncanny.

If this is a way of thinking about how the external, colonised Others may be distinguished from those other Others who may be assimilated, then it is also a way of thinking about the situation of that modern, ambivalent Other, internal to Europe, the Jews. In addition, it requires us to ask the extent to which the Jews, landless and always already within the modern nation-state, may be understood as a colonised people, a people who, as they became racialised, were to be made civil, and similar, alike; but not assimilated.[20] At the same time, what made the Jews quite different to colonised peoples such as the Indians was the particular structure of ambivalence in which they were placed. Bhabha describes the ambivalence of mimicry as 'almost the same *but not quite.*'[21] The 'not quite' being the product of the always already present essential difference that others the Other. The Jewish situation was crucially distinct in that, while they were considered to be Other in one racial discourse – that of the Aryan/Semite – Jews were also considered to be white, or at most problematically non-white, in the other, earlier, racial discourse of colour. Jewish ambivalence does not come out of a 'not quite' which always clearly prevents assimilation, but out of a binary system of radically different from/same as. Bhabha reworks his phrase 'almost the same but not quite' into one which signals the absoluteness of colour-based difference: '*Almost the same but not white.*'[22] For the Jews whiteness itself is the ambiguous category. Hence assimilation genuinely appeared to be possible and was counterpointed by an event, an attempted eradication, genocide, the quality of which equalled the other eradication of assimilation. For this reason, that is, because of the ambivalence in the Jewish circumstance, the excess produced in the ambivalent mimetic slippage is more profound and more threatening to both parties. Here, then, we have one of the differences between racism and anti-Semitism.

The ambivalence of mimicry can be played out in many different ways. For example, it can be utilised as a form of group passing in the interest of a subaltern group who do not want to assimilate fully, or in the interest of the dominant group who appear to offer the possibility of assimilation. In my own experience as an assimilated Jew, ambivalence has been the underlying motif. Like my sister, I never felt completely 'in' English culture; rather, when we compare our experiences, we find we have both always positioned ourselves as observers. However, coming from a highly assimilated home, it has only been in the last few years that I have begun to think that this apartness and this watching, this sense of constantly having to learn how to behave properly in

the culture in which I was born and brought up, may well have a lot to do with my mother's determined assimilation. Here, it seems to me, lay a cause of my sister's and my dis-ease with English culture. My mother married a gentile, a London man with no religious leanings though coming from a Church of England background. Interestingly, my father is a racist, believing that 'coloured' people, especially 'blacks,' are destroying English culture. He does not, however, view Jews as racially distinct from the 'white' English – though I do suspect that he thought of my mother's background as somewhat exotic. Although my mother's family did not disown her, a practice not uncommon among Jewish families when someone marries out, she, in a sense, disowned them. As I grew up, ten years younger than my sister, I hardly saw my Jewish relatives. By the time I was in my teenage years, all contact had to all intents and purposes ended. This was a far cry from when my sister was a child: then she and my parents had actually lived with my Jewish grandmother for a couple of years, my sister tells me.

In the meantime, my mother reconstructed herself as her idea of an English middle-class woman; one with no past. It is, perhaps, not surprising that her favourite musical was *My Fair Lady*. She and my father moved away from London making it easier for her to lose touch with her family and easier to remake herself without fear of her Jewishness being discovered. However, as seems to be the case with many versions of this kind of story of assimilation, her very determination to assimilate left its mark on both my sister and me in the shape of a distantiation from the dominant culture.

At the same time, from my birth there are the signs of my mother's ambivalent negotiation with her, and my, Jewishness. I was not baptised, and the name that I was given, Jonathan, can serve as both a Jewish and a non-Jewish name. I was circumcised, but not in a Jewish ceremony, rather as one of a large percentage of post-Second World War boys in England when circumcision was considered an asset for male health and cleanliness.[23] Through these ambiguities I was inducted into both English and Jewish culture as a mimic.

So far I have suggested how my mother ambivalently entered me into English culture, in a way which, she felt, would enable me to assimilate while leaving open the option to take up my Jewish heritage if I wanted – something that I half-remember her telling me once when I was young. However, when I was thirteen, indeed on my thirteenth birthday, my Jewish family reached out to me through a mimicry of a secular ritual. When a Jewish boy is thirteen he has his *bar mitzvah*, a religious ceremony in which he is accepted as a man and takes on adult male responsibilities, including the observation of the 613 commandments (*mitzvot*). I was not bar mitzvahed, indeed at the time I'm not even sure I knew the word. As I started to open my birthday presents, something I always did in the presence of my parents, something strange and disturbing seemed to be happening. First of all I had more presents than normal and, although I had not noticed it at the time, the extra ones were all from my Jewish relatives. The first present was a wallet. I was surprised; I did not have

a wallet and felt no need of one. Then the second present was another wallet. I became embarrassed, how to relate to these unusual, undesired and uncannily similar presents? My parents were silent; retrospectively I realise that they too must have been shocked. Clearly my mother had no idea that my relatives were determined to acknowledge my manhood and my being a Jew in spite of my mother's assimilation, and her effacement of hers and my ancestry. Indeed, my mother became more and more awkward as the present-opening proceeded. As I continued opening presents I found pens, lighters and another wallet. I was in despair as to how to react to this phenomenon. Finally, my parents were forced to explain to me about the bar mitzvah that I had not had.

Here we have a different kind of mimicry and a different kind of ambivalence. Using the guise of a western ritual, ironically Christian in origin, my relatives had given me as much of this key Jewish ritual as they were able and forced my parents to acknowledge my Jewishness to me. My relatives had also established to me that they thought of me as a Jew so that, if ever I wanted, I could break through the cultural amnesia my mother had created and accept my inheritance. Bhabha describes mimicry as a practice by which the colonised can resist the colonial power. Here I have wanted to show how it can operate as a mode of accommodation and negotiation with the dominant power and also how it can be utilised as a tactic against that power – or in this case against the assimilatory movement of my mother – subversively to reinstate the culture of the colonised.[24]

CIRCUMCISION AND CASTRATION

At this point it is particularly important for the discussion of Jews in the modern west to take Bhabha's theorisation one step further by way of remembering its psychoanalytic origin. Freud was a partially assimilated, mostly secular Jew, but one who always recognised the hopelessness of the attempt at assimilation. Sander Gilman quotes him from a letter to the pregnant ex-mistress of Carl Jung: 'We are and remain Jews. The others will only exploit us and will never understand us.'[25] It was in this atmosphere of ambivalence around assimilation, and Freud's own experience of it, that he thought through the theoretical tenets of psychoanalysis. Gilman argues that there is in Freud's work a 'hidden master narrative about racial difference,'[26] in particular about Jewish difference in Europe. In fact, as Jay Geller notes, 'where Freud proposed psychoanalysis as an objective science of the human, others perceived a "Jewish national affair." '[27] Gilman explains that

> The idea of the hysteric was a central one for the imaginative world of Sigmund Freud, as it was close to his self-definition. For at the end of the nineteenth century the idea of seeing the hysteric was closely bound to the idea of seeing the Jew – and very specifically the male

Jew. For if the visual representation of the hysteric within the world of the nineteenth century was the image of the female, its subtext was that feminized males, such as Jews, were also hysterics, and they could be 'seen'. The face of the Jew was as much a sign of the pathological as was the face of the hysteric.[28]

What Gilman is describing is a merging of the discourses of racialised Jewishness and of the hysteric, a merging of which Freud could unconsciously take advantage to think through the psychoanalytic construction of the latter by way of the experience – indeed his own, his family's, and that of many of his patients – of the former. Central to this merging is the importance of sight. Gilman expounds on the importance in late-nineteenth-century discussions of the look of the Jew. This needs to be placed within the modern emphasis on colour as a marker of race and, especially in the theoretical context which I have been elaborating, Bhabha's further connection of racial Othering with fetishism.

The white Jew, who nevertheless feels, and is thought to be, different and therefore not really white, operates within the same discursive frame as the hysteric who behaves normally but, once their hysteria is recognised, is known to be sick. Both provide problems for the gaze which must seek other clues than those to be found in appearance alone. Here we might remember that Gilman singles out the nose as the key physiological sign of the Jew and also argues that 'the "nose" is the iconic representation of the Jew's phallus through-out the nineteenth century.'[29] Modern nose reduction rhinoplasty, the 'nose job,' was pioneered by the German-Jewish surgeon, Jacques Joseph, around the turn of the twentieth century. Gilman notes that 'It is clear that Joseph's initial clientele was heavily Jewish and that he regularly reduced "Jewish noses" to "gentile contours." Many of his patients underwent the operation "to conceal their origins."'[30]

Within the libidinised cultural overlapping of the racial and the sexual the nose job can be read as an inverted symbolic castration, the attempt, perhaps, literally for men and analogically for women, to replace the foreskin lost through circumcision. Jay Geller argues that

> For the Jews to be emancipated and enter modernity meant they had to cut off their ties to their dirty, rigid, pedantic, *bezöpfte, beschnittene* (circumcised) past. They had to cut off that cutting which cut them off from male European bourgeois Christendom. The *Judenzopf*, like the Jewish nose, was a displacement from lower to upper whereby a gendered, Jewish identity was rendered visible, vaunting, and vulnerable.[31]

In this system the nose has become the fetishised displacement for the penis. The nose job operated as the symbolic reversal of castration, the operation which Jews dreamed would enable their assimilation to be completed. With

their penis once again entire, their 'castration' reversed, Jewish men would be able to take their place alongside gentile men in the fraternity of the patriarchal nation-state.

Freud's argument is that circumcision is perceived as a displacement of castration. The castration complex, especially the anxiety attending the fear of castration, as the central moment in the Oedipus complex, occupies a privileged place in Freud's work. In his theory of the primal horde, Freud even argued about the sons that their 'lot was a hard one: if they roused their father's jealousy they were killed or castrated or driven out.'[32] But what if castration is, in fact, the universalisation of the, in European Christian terms, Jewish specificity of circumcision? Freud argues, in the context of a discussion of anti-Semitism, that 'among the customs by which the Jews made themselves separate, that of circumcision has made a disagreeable, uncanny impression'[33] because it recalls the 'dreaded castration.' While this may be, there is an uncanniness in Freud's ideas about castration. We have already seen how Weber elaborates Freud's theory of anxiety, noting its focus in castration anxiety and linking it to the anxiety inherent in the experience of the uncanny. We can now take this idea one step further and suggest that the anxiety described as attendant on the fear of castration is a reinscription of Jewish anxieties that articulate with circumcision, and the significance of circumcision as a marker for the Jews.

In *Archive Fever*, Jacques Derrida considers the possibility, which, as we have noted, has always haunted psychoanalysis, that it is, in some way, intrinsically Jewish:

> But as soon as one speaks of a Jewish science, whatever one's under-standing of this word . . . the archive becomes a founding moment for science as such . . . whether it has to do with writings, documents, or ritualized marks on the body proper. . . . At issue here is nothing less than taking seriously the question whether a science can depend on something like circumcision. We are deliberately saying 'something like circumcision' to designate the place of this problem, a place that is itself problematic, between the figure and literalness.[34]

Between the figure and literalness: castration is a figure. The little boy is never actually castrated by his father in Freudian theory. The role of the idea of castration is to produce fear. However, Freud does describe castration actually having taken place in that presocial time, along with other male infantile sexual fantasies such as the killing of the father, and cannibalism. What does not take place in that presocial world is circumcision; that is, Freud describes a universal humanity, not one specified into groups. When Freud asserts that gentiles think of circumcision as castration, he is transferring the displacement that he has, himself, made onto the general non-Jewish population. Or, alternatively, Freud has naturalised the gentile understanding of circumcision as a foundational formulation of psychoanalysis.

Derrida asks, 'Can one be satisfied with Freud's many statements on circumcision, always quickly tied to castration or the threat of castration?'[35] For Derrida, the answer is clearly no. In his autobiographical piece 'Circumfession' Derrida, born to Jewish parents in Algeria, privileges his circumcision as the defining event of his life.[36] Here, circumcision is described as the null, the originary site for the preoccupation with inscription, and indeed excess, that has haunted so much of Derrida's work. It is the corporeal incision that led to the ambivalently Judaic-derived methodology of deconstruction. Judaic tactics inform Derrida's work.[37]

Derrida writes that

> I have been seeking myself in a sentence, yes, I, and since a circum-bygone period at the end of which I would say I and which would, finally have the form, my language, to the next, knowing that it took place but never, according to the strange turn of the event of nothing . . . I call it circumcision, see the blood but also what comes, cauterization, coagulation or not strictly contains the outpouring of circumcision, mine, the only one, rather than circumnavigation or circumference, although the unforgettable circumcision has carried me to the place I had to go to, and circumfession if I want to say and do something of an avowal without truth turning around itself . . .[38]

In 'Circumfession' full stops are only present at the end of sections. If, as he writes, Derrida has been seeking himself in a sentence, seeking, we might say, self-understanding, there are no sentences in the grammatical sense here. There is nowhere that he could succeed in finding himself in this work. What has made this impossible? Derrida's experience of his absolute marking out, removal from the normative gentile population, caused by the cutting off of his foreskin, disturbs his writing, producing an absence of the punctuation that signals the division of logical, narrative thought. 'Circumfession,' as Derrida tells us, is written beside that classic of Christian meditation *The Confessions* of St Augustine. However, they are incommensurate; the Difference marked by a foreskin. Derrida's circumcision provokes – here, from the literal to the figurative – a circumbulatory text.

Derrida did not have his sons circumcised. He tells us a dream that he attributes to his mother. In this dream two old, blind men are fighting. As Derrida passes them, one of the men turns and assaults him. Finally, the man attacks Derrida by, as Derrida puts it, threatening 'my noncircumcised sons.'[39] Blinding in dreams, Freud stated in *The Interpretation of Dreams*, 'stands for castration.'[40] Are these men castrated? Or are they, in fact, Jews? Does the men's blindness stand for their castration that is actually their circumcision? Are they attacking Derrida through his sons because they have not been circumcised? From this point of view, the men can be read as an expression of a Jewish patriarchal superego. And yet, as is the way with dreamwork, there is also

something else going on here. The nature of the intervention, Derrida walking along minding his own business and being physically beaten for no apparent reason, suggests rather an anti–Semitic attack. Perhaps this is what Derrida's mother, and Derrida himself, are afraid of for his sons. Perhaps this is why they have not been marked out; and, from the point of view of the determination of bodily inscription, therefore have the opportunity to assimilate. Derrida offers no reading of this dream other than that it is to do with 'the return of a family.'[41] Why, though, does he choose this moment to tell us that his sons are not circumcised? Perhaps because he thinks that the dream also expresses his mother's anxiety that his sons are not, not properly, Jewish. Yet, the cultural themes of the dream come from dominant culture. More than anything else, the dream allows us to trace the cultural and psychic connections between castration and circumcision.

Later, Derrida writes about his 'sublime'[42] collection of documents and other texts on circumcision which he keeps, hidden away we might say, in his attic. This is a collection which, he says, 'I'll never do anything with.'[43] Why is the collection sublime? In *The Differend* Jean-François Lyotard discusses Kant's claim that it is impossible to represent 'the infinite import of Ideas' and singles out a statement of Kant's which, interestingly, involves the Jews. Kant wrote:

> Perhaps there is no sublimer passage (*Stelle*) in the Jewish law than the command 'Thou shalt not make to thyself any graven image, nor the likeness of anything which is in heaven or in the earth or under the earth,' etc. This command alone can explain the enthusiasm that the Jewish people in their moral period felt for their religion, when they compared themselves with other peoples, or explain the pride which Mohammedanism inspires.[44]

It may be that it is really circumcision that is sublime, or opens the way for the sublime. Why does Kant link Jews and Muslims here? Both groups practise circumcision, and are therefore literally marked out from the uncircumcised Christian, modern West of Kant's time. Both groups also have injunctions against representation, which is the organising principle of modernity. Circumcision, the mark of exclusion, of the denying of those who have it of full social representation in the modern nation–state, is, it would seem for Kant, also associated with the moral charge against representation and is a determining feature of the sublime. Here we may remember the debates, which are also moral debates, over whether the Holocaust is representable, or should be represented. At this point the failure of secular/Christian modernity is signalled in a crisis over the modern sublime played out in the problematic intersections of representation and immorality, or, as some say, evil. Sublimity is also associated with terror and unreason, and pleasure; bodily affect. Is this the way that Derrida thinks about circumcision? Or is it the way he thinks about the

inscription of circumcision? More likely, there should be no distinction here. From the secular Jewish Derrida's point of view, it is circumcision which brings about the differentiation. If circumcision is the originating cut of differentiation (of *différence*), it is the modern Christian non-circumcision that establishes the fixed and essentialised Difference.

Derrida's collection, like his entire corpus, is an outgrowth of his attempt to reflect on his own circumcision: 'and for years I have been going round in circles, trying to take as a witness not to see myself being seen but to re-member myself around a single event.'[45] The striving not to see himself being seen is a repetition of the psychological structure of the experience of assimilation, the attempt to dispense with the self-consciousness that is the basis of the experience of the assimilating person's mimicry. Something has been lost; a foreskin, yes, and it cannot be replaced. Try as he might, Derrida cannot re-member himself. He cannot, we might say, recover his pre-circumcision identity. He must remain fractured,[46] never entirely assimilated. There is, it would seem, an ambivalence to Derrida's acceptance of himself as marked for a Jew. As Elizabeth Bellamy notes, 'Derrida has often been circumspect about his own Jewish identity.'[47]

That punctual event of Derrida's life is here expressed in terms of the uncanny. It is an event that is both familiar to him yet alien. Earlier, Derrida describes his now senile mother appearing from her room, naked before him, and not once but 'several times.' When he asks her why, he *thinks* she says, for, he tells us, she no longer articulates clearly, 'Because I am attractive.' His hesitation, his textually expressed anxiety, is plain. He even explains to us, the readers, that this statement of hers is improbable. I read this as an Oedipal drama, a drama that involves Derrida's own castration anxiety. Where Freud transformed circumcision into the personal figure of castration, which we can read as the Jewish experience of social exclusion, Derrida gives us the somatics of circumcision as an expression of his personal experience overdetermined by the social anxiety of castration. Either way, we have a supplement, to use a Derridean term, which tropes the (Jewish) anxiety expressed in the idea of the uncanny.

THE JEWISH UNCANNY

Nowhere is the merging of Jewish racialisation and the sexual clearer than in Freud's discussion of the uncanny. It is here that Freud comes closest to expressing the repressed subtext of the impossibility of Jewish assimilation into Austro-German, and by implication European, national identities. It is not surprising, then, that Freud lived with the problem of the uncanny over many years. In the editorial foreword to the translation in the *Complete Works*, James Strachey notes that in a letter to Ferenczi of May 12, 1919, Freud says 'he has dug an old paper out of a drawer and is re-writing it.'[48] According to Strachey, the quotation used from *Totem and Taboo* dates an earlier version to at least 1913.

Both Freud's parents came from families that had originated in Polish Galicia. Jacob Freud, Sigmund's father, had been born in Tysmenitz in Galicia in 1815. In 1852 he moved to Freiberg where he married his second wife, Amalia, who gave birth to Sigmund or Sigismund as he was called, in 1856. Three years later the family moved again and, in 1860, settled in the heartland of Western European modernity, Vienna. Amalia's family had emigrated from Brody when she was young. Theodor Reik has noted she spoke Galician Yiddish and knew only the most basic German. In his discussion of Freud's cultural Jewishness, Emanuel Rice has argued that Freud's parents must have spoken Yiddish at home and that, contrary to Freud's own assertion, Yiddish must have been the young Sigmund's first language.[49]

John Murray Cuddihy has argued that 'Civility is not merely regulative of social behavior; it is an order of appearance constitutive of that behavior.'[50] In this context, Cuddihy reworks the experience of Jews in Western modernity as that of a colonised people, as a struggle simultaneously to retain their culture and to adapt to the civil way which underlies modern life. At the least, Cuddihy writes, civility requires 'the bifurcation of private affect from public demeanor.'[51] Where this modernising was difficult for the long-resident Ashkenazi and Sephardi Jews of Western Europe, the problem was more traumatising still for the Eastern European Jews steeped in *Yiddishkeit* (Yiddish culture) who had not grown up with the experience of modernisation but who confronted it as a result of migration. Clearly, Freud's family was one of these.

Cuddihy, a significant proportion of whose book is devoted to a discussion of Freud's work, suggests that the confrontation between Jewish culture, in particular *Yiddishkeit*, and modernisation can be found played out in the ideas of many assimilated Jewish intellectuals. Universalising claims were typical of modern thinkers. Located in assumptions about the generality of individuals, such claims denied specificity to any one group. Jewish intellectuals, like those from other minority or excluded groups, found that couching their ideas in universal terms aided the acceptance both of the ideas and of themselves within the dominant European intellectual culture. In this way the very specific issues that stimulated the thinking of these intellectuals were disguised. Thus, as Cuddihy puts it:

> In Freud's 'science,' the social troubles of a modernizing Jewry receive a self-enhancing cognitive gloss: social malaise becomes a medical symptom, offences become defences, *kvetches* become hysterical complaints, *tsuris* becomes basic anxiety, social shame becomes moral guilt, deviance becomes incapacity, strangeness becomes alienation; to be badly behaved is to be mentally ill.[52]

As we shall see, the experience of that strangeness becomes understood as the uncanny.

In light of this argument, the importance of the idea of displacement in Freud's work takes on a new meaning. James Strachey has noted that

Verschiebung, the word usually translated as displacement, occurs as early as Freud's preface to his translation of Bernheim's *De la suggestion* (1888–89).[53] However, the idea is not fully theorised until *The Interpretation of Dreams* (1900) where, as Freud puts it, '*Dream-displacement* and *dream-condensation* are the two governing factors to whose activity we may in essence ascribe the form assumed by dreams.'[54] Freud uses displacement, in the first instance, to describe the transfer of psychical intensities from that which is the real source of the dream's preoccupation, but which is repressed, to another site which the censor finds more 'acceptable.' To put it in a differently suggestive way, Paul Ricoeur writes that Freud 'compares displacement to a shift away from the central point, or again, to an inversion of emphasis or value, whereby the various ideas of the latent content [of the dream] transfer their "psychical intensities" to the manifest content.'[55]

Cuddihy contends that, while Freud compares everyday politeness, that is modern civility, to the dissimulation of dreams, that is the dreamwork of displacement and condensation, the instigation of the text actually worked the other way round, 'Freud in fact began with his everyday social life, and then found a "dream parallel."'[56] From this point of view, displacement can be understood as a description of the emotional transference determined by the civil split between personal affect and public politeness. More generally, and here I am working over Ricoeur's definition, displacement echoes the cultural loss involved in the migratory experience of Yiddishers. Displacement condenses, to use Freud's other key theoretical term, both movement away from the cultural centre, that is to say, it tropes migration, and the personal experience of that movement in the more or less self-conscious repression, as part of the attempt to assimilate, of Yiddish, or more generally Jewish, culture.

What, then, has this to do with the uncanny? Well, in short, Freud's somewhat circuitous discussion of the uncanny can be read as an analytical meditation on displacement. Mladen Dolar has argued that 'There is *a specific dimension of the uncanny that emerges with modernity*.'[57] Dolar explains that, unlike the premodern world, where the dimension of the uncanny was segregated, 'With the triumph of the Enlightenment, this privileged and excluded place (the exclusion that founded society) was no more.'[58] It becomes, in Dolar's word, 'unplaceable.' It has been, in fact, displaced. Without a home, the uncanny has become, itself, *unheimlich*, uncanny. Dolar goes on to argue that Freud is misleading 'when he says that the uncanny is the return of something long surmounted, discarded, and superseded in the past.'[59] This universalising move suggests an uncanny that pre-exists the modern, as well as a movement away from a Jewish specificity.

Dolar reworks Lacan's notion of the 'object *a*' which, he writes, 'is most intimately linked with and produced by the rise of modernity. What seems to be a leftover is actually a product of modernity, its counterpart.'[60] In fact, in Lacan's first elaboration of the object *a* it was connected with Judaism, and, interestingly, given my previous discussion, with circumcision. Gérard Haddad

describes how, in his 1963 seminar on *l'Angoisse*, Lacan 'discusses circumcision and critiques the accepted interpretation of an equivalency between it and castration. In a reference to Nunberg, Lacan holds that the foreskin represents a female equivalent from which the male subject distances himself and that its removal is equivalent to the fall of the "object 'a.'"'[61]

We shall see how the understanding of a connection between the object *a* and 'the Jews' gets played out below. Lacan's concern here is not with the feminisation of (male) Jews but, it would seem, with the cultural production of the penis as the phallus. The suggestion is that, no longer hidden by its 'female' foreskin, the circumcised penis may be considered to be the more 'male' penis, the more phallic. This is a very secular and non-Jewish background reading, one, indeed, which could most probably only be made in a period of modernity when, as I have already noted, large numbers of male babies were circumcised on medical grounds. Lacan is here offering a psychoanalytic reason, one which might overdetermine the rational, medical claim.

Before turning to discussion of the connections between the modern object *a* and the uncanny, we can acknowledge that both Freud's theorisation, and Dolar's reworking of Lacan, can produce relevant understandings of the uncanny. Freud's description of the uncanny as the experience of the return of the repressed, can be read as a reworking of the idea of displacement in the terms of personal experience. It is, if you like, a description of the experience of the alienating effect of the eruption of suppressed culture into the smooth veneer of civil acculturation. Cuddihy reminds us of a joke which illustrates this point well. A *nouveau riche* Mrs Cowles, née Cohen, is out in her finest attire at a very proper public dinner. The waiter accidentally spills piping hot soup in her lap. Mrs Cowles lets out a shriek, '*Oy Gevalt*, whatever that means.'[62] Humorous, the story also invokes the uncanny in Mrs Cowles expression of a cultural background which she is denying; what Freud would describe in universalist terms as the return of the repressed. The joke is reminiscent of Oskar Panizza's story 'The Operated Jew,' which I discuss below, in its claim that assimilatory acculturation can never be complete; there is always a residue, an excess, which can undo one at the most crucial moment of identification.

Dolar describes the object *a*, as Lacan does, by way of its contribution to an understanding of the mirror phase: 'the object *a* is precisely that part of the loss that one cannot see in the mirror, the part of the subject that has no mirror reflection.'[63] The complexity of the object *a* lies in understanding that it is a positive entity which describes the drive involved in the negative experience of the moment of lack, the incompleteness in representation. It is this productive lack which means, as Slavoj Zizek puts it in *Tarrying with the Negative*, that the object *a* 'stands for the point of self-consciousness.'[64] Self-consciousness is only possible because, in the process of subject formation, identity is lost. This is the existential paradox of the modern subject.

If, following Dolar, we can argue that it is the Cartesian subject, the subject of modernity, who is also the psychoanalytic subject described in Lacan's

mirror stage, then one site of the production of the object *a* in modernity is in the problematic of representation that is central to the nation-state. The object *a* appears at that moment of failed representation of the people in the nation-state as the nation, at the moment of national identification. Here, the object *a* is a consequence of the always impossible fantasy, drive in its Lacanian sense, of producing a seamless national identity in which people and nation merge, and the state is experienced as the natural expression of this unity. In Lacanian terms, the uncanny is the individual's experience of the object *a*.

Elsewhere, I have described how the Jews became located in Europe as the source of the failure of national identification.[65] Now we can also begin to understand how, profoundly, Jews have been produced as the uncanny excess to the Western nation-state-building project. Zizek remarks that 'Lacan is quite justified in claiming that in paranoia *objet a* "becomes visible": in the person of the persecutor, the object qua gaze assumes the palpable, empirical existence of an agency which "sees into me," is able to read my thoughts.'[66] Here we have described a, perhaps the, most important pathology of modern anti-Semitism, the anti-Semitism most clearly expressed in the Nazi perception of the Jews. Jews are produced as an object, 'the Jews,' the doubly uncanny object *a* that is experienced as pervasive in the modern state. Always already displaced, thought of as essentially displaced in the Diaspora, but also, in very many cases, displaced by migration from the Pale, the 'homeless' Jews of Europe, attacked through the latter part of the nineteenth century as 'cosmopolitan,' thought not to owe allegiance to the nation-states in which they lived because they were not part of the organic nation, materialised the European national object *a*.

The difference between the Freudian uncanny and the Lacanian uncanny, as elaborated by Dolar, is that the former describes the conditions for the individual experience of the uncanny while the latter provides for a structural account of how certain 'objects' are produced as being uncanny. In Dolar's Lacanian revision the association of 'the Jews' with displacement is a pretext which legitimates their identification as the social version of the object *a*. This is, actually, a typically French move. Bellamy has remarked that

> Blanchot's, Kristeva's and Zizek's (almost neo-Hegelian) character-
> izations of the Jew as, respectively, the 'exigency of strangeness,' the
> Freudian *Unheimliche*, and a 'symptom' are themselves symptomatic
> of how, within French postmodernism, real Jews have tended to be
> transformed into tropes or signifiers for the decentred, destabilized
> postmodern subject in a theoretical system that persists in defining (or
> 'fetishizing') them from without.[67]

It is Lyotard's rather self-conscious recognition of this fetishisation that gets played out in his book *Heidegger and 'the jews.'*[68] For Freud, as read through Cuddihy, displacement is the guiding metaphor which organises the particular

modern experience, expressed in anxiety and fear, to which Freud gives form in his theorisation of the uncanny.

THE DISCOVERY MYTH AND THE RETURN
OF THE REPRESSED

In what can be read as an example of textual repression, Freud does not state clearly what his argument about the cause of the feeling of uncanniness is until two-thirds of the way through 'The "Uncanny."' It is here that the connection with the experience of Jewish assimilation is clearest. Freud puts forward two considerations. In the first:

> . . . if psychoanalytic theory is correct in maintaining that every affect belonging to an emotional impulse, whatever its kind, is transformed, if it is repressed, into anxiety, then among instances of frightening things there must be one class in which the frightening element can be shown to be something repressed which *recurs*.[69]

Freud goes on to note that it does not matter whether the original event was frightening, it is experienced as fearful on its recurrence. He associates the feeling of uncanniness with fear and he links fear with anxiety. For Freud this anxious fear is a consequence of repression. What he does not say here, but is implied from his general theory, is that the original events are those of child-hood, repressed around the time of the resolution of the Oedipus Complex and the onset of latency, about the age of five or six. It is usually set around this age because this is the moment of the child's entry into the public social world, the world of school, of friends who are old enough to repeat, without under-standing, their parents' comments, and so on.

Now, there is a different trauma that many children go through around this age, not only Jewish children but all those defined as less or more other/Other by the dominant socio-cultural grouping. This trauma is worse for those child-ren whose parents are attempting to assimilate, and particularly for those whose parents have not thought to tell them that they may be regarded as, and there-fore are, Different. This can often be because the parents, thinking themselves to be successfully assimilated, see no point in raising what they consider to be an irrelevant issue. In the case of Jews, the ambivalence over their racial coding, and the apparent possibility of an assimilation heightened by their looking similar to or the same as the dominant group, increases the belief that nothing needs to be said, and therefore the child's shock at the discovery that she or he is not (regarded as) what they thought they were.

What I am suggesting, then, is that the moment of shock that precipitates the end of infantile sexuality and the repression of the latency period is a universalist version of the shock of self-recognition that one is a member of an

excluded and subaltern group. Specifically, Freud's understanding is a revision of the Jewish experience. I would like to take this one step further. For the Jews in Europe, who, as they adopted the culture of the dominant national group where they lived, often became more or less indistinguishable from the members of the dominant culture, there was also the possibility that, at some point, they would discover or be told that they were Jewish by their parents but that they would also be ordered not to tell anyone. Here, we have a moment when all that was acceptable before has become unacceptable publicly and must be repressed. Of course, the repression structure, including the anxiety at the possibility of discovery, can be put in place much later in life, as the person attempts to pass or assimilate in the dominant culture. The Mrs Cowles/Cohen joke mentioned earlier is a good example of the return of the repressed under stressful circumstances.

The discovery narrative is told so often by those excluded that it takes on the quality of a personal foundation myth of the recognition of Difference. Not all the key components of the story are always present. Usually narrated by the child when he or she has become an adult the story goes something like this: 'I was at school/playing with friends when there was a small disagreement. One of my friends called me a dirty Yid/a slope eyes/a coon. The others all ganged up on me and started calling me names. I said, "I'm not" but they wouldn't stop. I ran home and burst into tears. With a feeling of bemusement (or sometimes fear or shame), I ran to my mother/father and cried out, "I'm not a Yid/slope/coon am I?" My mother/father comforted me and with a sad/stern voice replied, "You are a Jew/Chinese/black person and you must remember that, and be proud of it."' Of course there are endless personal variations on this story. You may be subjected to taunts in the street, or an unthinking teacher may ask how your family life differs from other people's. At the heart of the story is always the moment of personal understanding that other people think you are different, usually of less worth and not properly a member of their group; only to be tolerated.

A very good example comes from William Yang, whose grandfather arrived in Australia in the 1930s. Yang writes:

> One day when I was about six years old, one of the kids at school called at me 'Ching Chong Chinaman, Born in a jar, Christened in a teapot, Ha ha ha.' I had no idea what he meant although I knew from his expression that he was being horrible.
>
> I went home to my mother and I said to her, 'Mum, I'm not Chinese am I?' My mother looked at me and she said, 'Yes, you are.'
>
> Her tone was hard and I knew that being Chinese was some terrible curse and I could not ask my mother for help. Or my brother, who was four years older than me, and much more experienced in the world. He said, 'And you'd better get used to it.'[70]

This story contains virtually all the basic ingredients of the discovery narrative. In this version, there is no attempt to hide that the family is Chinese, rather the children have simply not been told. As Yang tells it, the narrative marks his exit from the nurturing world of childhood embodied in his mother, and his entry into the threatening, adult, public world. Where, previously, he could live unselfconsciously, now he must live the rest of his life as a 'Chinese', in Australia, or as a 'Chinese-Australian.'

Aviva Zeigler's Viennese cousin tells an assimilated Jewish version of the story in her documentary *What is a Jew to You?* (Film Australia, 1985). Answering a question from Zeigler she says:

> I grew up in a family where my parents always thought they aren't Jewish, and they really believed in it – if you're not religious then you're not Jewish, that's the only point. So I've never felt at home anywhere because in school I was obviously different to all the others – and I was told to be different – and at home they told me I'm not different. So it was a very strange feeling that I can't belong anywhere.

In this version of the story we find very well expressed the problem for the child of assimilated parents. In this, a Jewish case, the problem is particularly acute because of the ambiguous racial status of Jews. As a consequence of her parents' refusal to accept that they remain Jewish even though they are assimilated, a label placed on them by the dominant Other as Ziegler's cousin is only too well aware in her own case, she has no cultural 'home' to return to and to sustain her. She feels a part of Viennese culture but apart from it, and knows she is Jewish but is so assimilated that this provides no resource for her, especially given her parents' denial.

This brings me back to Freud's discussion of the uncanny. I am arguing that, for assimilating Jews, the discovery myth marks also the moment of repression. From the time that they have the awareness of their Jewishness forced on them they live in their assimilated state with the possibility that an event from their prediscovery childhood may recur. If that childhood was in any sense 'Jewish' then its recurrence will bring with it the anxious fear that their 'secret,' their Jewishness, will be displayed to the world, their assimilation will be shown to be a failure, and they will be (re)discovered.

I am suggesting two quite different experiences of the uncanny. First, that of the assimilating Jew (or migrant). Second, and more extreme, that of the children of assimilated Jews (or migrants), who may not know, or hardly know, that they are Jewish (or migrants). For these people, the experience of the uncanny is related to their inability to feel at ease, to feel at home in the cultural order in which they find themselves. For one example, I can cite my own constant childhood attempts to 'fit in' which all, I felt, failed somehow. One cause of this was a taking-on-board of what I presume was my mother's more or less self-conscious desire to assimilate culturally as completely as

possible which produced her, in ironic mode, by virtue of her mimicry, as the example and defender of English middle-class values to a far greater extent than most women born into English middle-class life.

Second, the experience of the gentile, the dominant national-cultural, order which knows that there is something strange about a person, may think it knows what this is, colour for example, but is displacing the cause which produces the affect of anxiety. This relates to Freud's second consideration of the uncanny which follows on from the first but actually precedes it in the sense of providing the context in which the experience of recurrence takes place. At the beginning of his article Freud had examined the etymology of *das Heimliche*, showing that it had come to have its meaning extended into its opposite, *das Unheimliche*. Now, he argues, given that uncanniness is a consequence of a recurrence, we can understand why this has taken place. He writes:

> this uncanny is nothing new or alien, but something which is familiar and old-established in the mind and which has become alienated from it through the process of repression. This reference to the factor of repression enables us, furthermore, to understand Schelling's defini-tion of the uncanny as something which ought to have remained hidden but has come to light.[71]

On a Jewish racial reading of this we can understand it as describing how the accommodation that is central to assimilation, which involves the repression of a person's Jewishness, leads in time to a sense of alienation from that part of yourself and your background which was once the most familiar. We should remember that, for Freud, memories cannot be forgotten until they have been recovered from repression and worked through; that in fact the psychoanalytic cure – like the assimilatory process – is always interminable and unfinished. It is in the final sentence that Freud's preoccupation with assimilation becomes clearest. Referring back to Schelling, Freud paraphrases Schelling's idea that the uncanny refers to something that 'ought to have remained hidden.' For the assimilating Jew this injunction is, precisely, the case.

After beginning the article with the etymological discussion of *das Heimliche*, Freud develops a lengthy discussion of E.T.A. Hoffmann's story 'The Sandman.' He is quick to deny Jentsch's claim that the source of the effect of uncanniness in the story is 'the uncertainty whether a particular figure in the story is a human being or an automaton.'[72] Here Freud is referring to Olympia, the automaton made by Professor Spalanzani with whom Nathaniel falls in love, believing her to be human. Published in 1816, what we have here is a story that can be read in the genre of passing and assimilation. The narrative centres on Nathaniel's misrecognition of Olympia as human. From the problematic of assimilation, becoming human operates as a metaphor for becoming a member of the dominant, civil, canny, group – becoming, in another nineteenth-century discourse, normal. Freud reads aspects of the story in a number of ways

to demonstrate how it calls up the feeling of the uncanny but he is unable to find a single concern that would provide a way of understanding why the story can be experienced as uncanny. Perhaps not surprisingly, given what I have argued earlier, one of his most powerful arguments concerns the role of the castration complex in the story. Why is Freud so interested in this story, and why does he need so much to disprove Jentsch's argument? For Freud it would seem, though not consciously, the narrative tropes the modern predicament of the Jews. They can be manufactured to appear like the gentile population, but they remain something else. Once more, Freud reworks the Jewish situation into a universal one: the uncanniness of the assimilating Jew in white, European modernity is thought through the problem of how a narrative about the mistaking of the machinic for the human produces the feeling of the uncanny in the reader. Written from the point of view of a member of the dominant group, 'The Sandman' shows us Nathaniel's confusion and grief at discovering that he has fallen in love with something that only appears to be human.

In Franz Kafka's work the problem of this radical ambivalence caused by Jews being perceived as both 'the same as' and 'different from' the dominant, 'white' group becomes clearer. Bauman argues that it is Kafka's experience of the assimilated/unassimilated Jew, 'the knight-errant of modernity and the dragon the knight has been retained to kill, that has been forged in those monstrous, hybrid, bastard, over- and under-defined, incongruous creatures that populate his writings.'[73] Nowhere is this more true than in Kafka's story 'The Metamorphosis,' published in 1915, in which Gregor Samsa wakes up one morning to discover that he has turned into a dung beetle. This hard-working petit-bourgeois commercial traveller, the support of his sister and parents, has been mysteriously transformed into the most revolting of creatures, one that scavenges in the dirt and detritus of human society. Finally Gregor, alone and disregarded, dies to the huge relief of his family who move flats and once more engage with bourgeois society. This is a mysterious story; it can be read as telling of a fate that could, perhaps, befall anybody; a universally modern warning that our individual identities are not as secure as we like to think. But there is another way of reading it. What if all Gregor's family are, in fact, dung beetles who have disguised themselves, taken on middle-class ways? Polish Jews from the ghettos were often thought of by bourgeois Austrians as dirty scavengers. Gilman, who has elaborated a similar reading of the story, notes that 'Jews are traditionally compared with insects and through this association with illness, specifically illness of the skin, carried by (or believed to be carried by) bugs.'[74] And what if, say, Gregor, and most likely his sister, do not know that their family's life is a disguise. They have been brought up to think that they really are human. Like many assimilating Jewish parents, Gregor's parents have decided not to tell their children that they are, in the view of the dominant, national population, dung beetles.

In 'The Metamorphosis' once again, the divide between human and non-human metaphorically demarcates those who have access to power within the

nation-state, those who are a part of the nation, who are unmarked and unnominated as the national white (male) bourgeoisie, from those who are distinguished and excluded by their Difference, the essential radical alterity that is claimed for them. Gregor lives as a member of this fraternity of power until, one day, his dung beetleness bursts through his assimilated veneer, leaving him denied by his family and disliked and excluded by the middle-class society of which he had so successfully become a part. Gilman has read the story in the context of the French treason case against Captain Dreyfus, an assimilated Jew. He asks, 'Is Gregor Samsa sick, or is he merely "transformed" into his real (read: inner) state, as the imagined Dreyfus came to be? Is illness merely the return of the fancied Jewish body to its "natural" state?'[75] In this reading, from the point of view of exclusion and Difference, it is not Gregor as the dung beetle who is uncanny. Rather, it is Gregor's family, and especially Gregor as human, who, in this modern discourse of identity and essentialised radical alterity, are repressing what they are, in order to become that which they can never be, who are uncanny. They are mimics.

What is it that drives Gregor's so sudden transformation? Gilman discusses Oskar Panizza's story 'The Operated Jew,' first published in German in 1893[76] just over twenty years earlier than Kafka's story and at the height of the Yiddish exodus from the Pale. Here, a Jew, Itzig Geital Stern, is carefully reconstructed by means of speech coaches, operations, blood transfusions and so on, into an 'Aryan.' He finds an Aryan girl to marry. However, at the wedding ceremony he drinks too much wine and, in an extraordinary and uncanny scene, the veneer of Aryanness is lost and he reverts in all ways, including physically, to his original, essential self. Here we have an assumption of physical determination that suggests the discourse of race. Earlier in the story, Othilia, his betrothed, senses something uncanny about him: '. . . she had a strong woman's intuition. She did not feel entirely comfortable in the presence of the golden youth who purred as he spoke. She sensed something eerie but could not confirm her suspicion.'[77]

Freud's understanding of the uncanny is spelt out, here, *avant la lettre*, as the problem of Jewish assimilation, and done so in a way that was becoming increasingly recognisable as Jewish racial Difference. Gilman's analysis shows how the story assumes a 'unique construction of the Jewish body and the Jewish mind.'[78] Freud's discussion of the uncanny, Panizza's and Kafka's stories, all date from the period when the Yiddish Jews were migrating to western Europe and to the United States, the same period when the Jews were being racialised.

One of my favourite lines from a Marx brothers film is Groucho saying, 'He thinks I look alike,' a line which expresses the problem of assimilation in its surrealistic suggestion of a fracturing and a doubling of an (almost) identical likeness. Here we are returned to Freud's discussion of the *Doppelgänger* and its connection with Bhabha's understanding of mimicry, and we have another meeting with the Freudian uncanny. Freud writes about Hoffmann's novel *The Devil's Elixir*, that

We must content ourselves with selecting those themes of uncanniness which are most prominent. . . . These themes are all concerned with the phenomenon of the 'double', which appears in every shape and in every degree of development. Thus we have characters who are to be considered identical because they look alike.[79]

Philip Cohen notes that the 'Marx brothers belong to that generation of Jewish immigrants who were caught up and absorbed into the mainstream of American society in a period when the tide of anti-semitism was reaching its height in Europe.'[80] My example describes the existential experience of reinterpellation. With my personal preoccupation with observation, it is one with which I easily identify. Cohen provides another, more social, example from *Duck Soup*. Here Groucho is pursuing Harpo who is playing a foreign agent. In an open doorway Harpo goes into a routine in which he copies Groucho's every move creating the illusion that the doorway is a mirror. Cohen sees in this scene a parable about assimilation. Harpo has to predict Groucho's every move in order to be like him, to persuade Groucho that Harpo is, in fact (the same as) him. Groucho remains uncertain, this assimilatory doubling always contains an excess which is to be found, in the first place, in the need of the one assimilating to observe in order to learn how they should behave. I have remarked before that this practice is something both my sister and I have had passed on to us by our mother. It is in this reflexive moment of a difference self-consciously striving to be the same that the experience for the dominant group of the assimilatory uncanny resides. While Harpo strives to mimic successfully, to become the same, it is Groucho who has the uncanny feeling that this same is, in fact, different.

At this point we need to return to Bhabha's idea of mimetic excess. What is announced by Itzig Stern's dissolution back to his Jewish self, and Gregor Samsa's transformation into the dung beetle/Jew, is the European construction of a Jewish core that can never be eliminated, a construction that was more and more understood in the language of race. From the point of view of the Jews, as the assimilating group, what is being represented is the impossibility of just giving up completely one's previous culture. Hence, we have the assimilated Jew who, when seen by members of the national culture, appears to be assimilated but who expresses an unresolved residue, literally in the case of Mrs Cowles/Cohen. She or he is, after all, in the end, the excluded internal Other, whose radical alterity, embodied as an essential trait, and experienced as uncanny, will, finally, show through, returning the repressed to full public view. We must remember that the joke about Mrs Cowles/Cohen, and the stories about Itzig Stern and Gregor Samsa, can all be read from either a Jewish, subaltern and excluded, or gentile, dominant and excluding, point of view. While gentiles might read these narratives as suggesting the racialised and ineradicable difference of the Jews, especially as the nineteenth century drew on, so Jews might read these same narratives as telling how assimilation is

impossible because the dominant culture's demand that one simply erase one's former culture is, itself, impossible. Later, most crucially in the Holocaust, the Jews, and other groups of people, were to understand more fully that being racially designated marked the dominant culture's absolute denial of the possibility of assimilation. In short, in modernity, race was used to demarcate the limits of the national polity. In Bhabha's terms, racialisation was what produced the possibility of colonial fetishisation and of mimetic excess.

The Jewish 'threat' to the perfection of the European nation-states came not only from the perception that Jews were not a part of any particular country's national people, that they did not 'come from' this particular land. What made the threat excessive, what really produced the Jews as Different, as opposed to how they were constructed as Different, is that, setting aside Judaic claims of exile from the Promised Land, within the nationalising narratives of Europe, Jews came from nowhere, they had no origin in a system of thought founded on origins and universals. In modern thinking everybody has a home, an origin, somewhere. The Jews did not. As Derrida might say, their modern origin lay in their circumcised differentiation. As the nineteenth century progressed, the Jews came to be identified in the new nation-state as racially Different. At the root of Freud's theorisation of the uncanny is not so much the impossibility of assimilation for those considered to be Different, though, of course, by the time that Freud wrote and published 'The "Uncanny,"' this was increasingly the case. Rather, it is the idea of home, the site of the canny. In modern thought home was imbricated with identity. Underlying the rhetoric of the modern nation-state was a politics of place and precursive emplacement. The modern renovation of the idea of diaspora came out of this politics.

NOTES

1 Homi Bhabha, 'The Other Question' in Homi Bhabha, *The Location of Culture*, London, Routledge, 1994, p. 73.
2 Homi Bhabha, 'The Other Question', p. 75.
3 Homi Bhabha, 'The Other Question', p. 74.
4 Sigmund Freud, 'Little Hans: Analysis of a Phobia in a Five-Year-Old Child' in James Strachey (ed.), *The Standard Edition of the Complete Psychological Works of Sigmund Freud*, vol. 10, London, The Hogarth Press, 1958, p. 36 note.
5 On Australia, see Jon Stratton, *Race Daze: Australia in Identity Crisis*, Sydney, Pluto Press, 1998.
6 Sander Gilman, *The Jew's Body*, New York, Routledge, 1991, p. 172.
7 Daniel Boyarin, *Unheroic Conduct: The Rise of Heterosexuality and the Invention of the Jewish Man*, Berkeley, University of California Press, 1997, p. xiii.
8 See, for example, Malek Alloula, *The Colonial Harem*, Minneapolis, University of Minnesota Press, 1986.
9 Jacques Le Rider, *Modernity and the Crisis of Identity: Culture and Society in fin-de-siècle Vienna*, Cambridge, Polity Press, 1993, pp. 165–6.
10 Homi Bhabha, 'Of Mimicry and Man' in *The Location of Culture*.
11 Homi Bhabha, 'Of Mimicry and Man', p. 86.

12 Homi Bhabha, 'Of Mimicry and Man', p. 86.
13 Homi Bhabha, 'Of Mimicry and Man', p. 86.
14 Samuel Weber, 'The Sideshow, or: Remarks on a Canny Moment', *Modern Language Notes*, vol. 88, 1973, p. 1110.
15 Samuel Weber, 'The Sideshow', p. 1110–1.
16 Zygmunt Bauman, *Modernity and Ambivalence*, Cambridge, Polity Press, 1991, p. 103.
17 Samuel Weber, 'The Sideshow', p. 1112.
18 Samuel Weber, 'The Sideshow', p. 1114.
19 Homi Bhabha, 'Of Mimicry and Man', p. 86.
20 To my knowledge, the first book that discusses the Jews of Europe as a colonised people is John Murray Cuddihy, *The Ordeal of Civility: Freud, Marx, Lévi-Strauss, and the Jewish Struggle with Modernity*, New York, Basic Books, 1974.
21 Homi Bhabha, 'Of Mimicry and Man', p. 89.
22 Homi Bhabha, 'Of Mimicry and Man', p. 86.
23 In the 1930s approximately 2/3 of Public School boys were circumcised and 1/10 of working class boys. Public Schools are actually private schools. As a middle-class boy I went to one, but later, in the 1960s. By 1949 the overall figure for male babies being circumcised had dropped to about 1/5. By 1963 it had fallen again to around 1/10. It was my experience in the 1960s that more than 1/5 of boys with whom I was at school were circumcised – suggesting a continuation of the class difference in circumcision – and I did not at all feel that I was unusual. My circumcision was not likely to identify me as being a Jew.
24 One way of thinking about my relatives' behaviour is that it is an example, in a social setting, of what the French Situationists called *détournement*. They defined *détournement* as: 'the reuse of pre-existing artistic elements in a new ensemble'. See Ken Knabb (ed. and trans.), *Situationist International Anthology*, Berkeley, Bureau of Public Secrets, 1981.
25 Quoted in Sander Gilman, *The Jew's Body*, p. 195.
26 Sander Gilman, *The Jew's Body*, p. 209.
27 Jay Geller, '*Judenzopf/Chinesenzopf*: Of Jews and Queues', *Positions*, vol. 2(3), 1994, p. 501. Geller is quoting Freud himself here.
28 Sander Gilman, *The Jew's Body*, pp. 62–3.
29 Sander Gilman, *The Jew's Body*, p. 126.
30 Sander Gilman, *The Jew's Body*, pp. 186–7. Gilman's quotations are from Paul Natvig, *Jacques Joseph: Surgical Sculptor*.
31 Jay Geller, '*Judenzopf/Chinesenzopf*', p. 515.
32 Sigmund Freud, *Moses and Monotheism* in James Strachey (ed.), *The Standard Edition of the Complete Psychological Works of Sigmund Freud*, vol. 23, London, The Hogarth Press, 1958, p. 325.
33 Sigmund Freud, *Moses and Monotheism*, p. 236.
34 Jacques Derrida, *Archive Fever: A Freudian Impression*, trans. Eric Prenowitz, Chicago, University of Chicago Press, 1996, p. 46.
35 Jacques Derrida, *Archive Fever*, p. 46.
36 A useful discussion of Derrida's understanding of circumcision can be found in John D. Caputo, *The Prayers and Tears of Jacques Derrida: Religion without Religion*, Bloomington, Indiana University Press, 1997, Section V, 'Circumcision'.
37 See, for example, Susan Handleman, *The Slayers of Moses: The Emergence of Rabbinic Interpretation in Modern Literary Theory*, Albany, State University of New York Press, 1982.
38 Jacques Derrida, 'Circumfession' in Geoffrey Bennington/Jacques Derrida, *Jacques Derrida*, trans. Geoffrey Bennington, Chicago, University of Chicago Press, 1993,

pp. 13–14. A discussion of this piece can be found in Jill Robbins, 'Circumcising Confession: Derrida, Autobiography, Judaism', *Diacritics*, vol, 25(4), 1995, pp. 20–38.

39 Jacques Derrida, 'Circumfession', p. 62.
40 Sigmund Freud, *The Interpretation of Dreams*, Harmondsworth, Penguin Books, 1976, p. 522, note 1.
41 Jacques Derrida, 'Circumfession', p. 62.
42 Jacques Derrida, 'Circumfession', p. 59.
43 Jacques Derrida, 'Circumfession', p. 59.
44 Quoted in Jean-François Lyotard, *The Differend: Phrases in Dispute*, Manchester, Manchester University Press, 1988, p. 106.
45 Jacques Derrida, 'Circumfession', p. 59.
46 There are echoes here of a Jewish, that is, specific rather than universal, rewriting of Lacan's mirror stage.
47 Elizabeth Bellamy, *Affective Genealogies: Psychoanalysis, Postmodernism and the 'Jewish Question' After Auschwitz*, Lincoln, University of Nebraska Press, 1997, p. 46.
48 James Strachey's Foreword to Sigmund Freud, 'The "Uncanny"' in James Strachey (ed.), *The Standard Edition of the Complete Psychological Works of Sigmund Freud*, vol. 17, London, The Hogarth Press, 1968, p. 218.
49 Emanuel Rice, *Freud and Moses: The Long Journey Home*, Albany, State University of New York Press, 1990, p. 30.
50 John Murray Cuddihy, *The Ordeal of Civility*, p. 14.
51 John Murray Cuddihy, *The Ordeal of Civility*, p. 13.
52 John Murray Cuddihy, *The Ordeal of Civility*, pp. 7–8.
53 James Strachey's editorial note in Sigmund Freud, 'The Neuro-Psychoses of Defence' in James Strachey (ed.), *The Standard Edition of the Complete Psychological Works of Sigmund Freud*, vol. 3, London, The Hogarth Press, 1962, p. 54.
54 Sigmund Freud, *The Interpretation of Dreams*, p. 417.
55 Paul Ricoeur, 'Energetics and Hermeneutics in *The Interpretation of Dreams*' in Harold Bloom (ed.), *Sigmund Freud's The Interpretation of Dreams*, New York, Chelsea House Publishers, 1987, p. 70.
56 John Murray Cuddihy, *The Ordeal of Civility*, p. 18.
57 Mladen Dolar, '"I Shall Be with You on Your Wedding Night": Lacan and the Uncanny', *October*, no. 58, 1991, p. 7.
58 Mladen Dolar, 'I Shall Be with You', p. 7.
59 Mladen Dolar, 'I Shall Be with You', p. 7.
60 Mladen Dolar, 'I Shall Be with You', p. 7.
61 Gérard Haddad, 'Judaism in the Life and Work of Jacques Lacan: A Preliminary Study', *Yale French Studies*, no. 85, 1994, pp. 206–7.
62 Told in John Murray Cuddihy, *The Ordeal of Civility*, p. 20.
63 Mladen Dolar, 'I Shall Be with You', p. 13.
64 Slavoj Zizek, *Tarrying with the Negative: Kant, Hegel and the Critique of Ideology*, Durham, N.C., Duke University Press, 1993, p. 66.
65 Chapter 4, 'Jews, representation and the modern state.'
66 Slavoj Zizek, *Tarrying with the Negative*, p. 66.
67 Elizabeth Bellamy, *Affective Genealogies*, p. 31.
68 Jean-François Lyotard, *Heidegger and 'the jews'*, trans. Andreas Michel and Mark S. Roberts, Minneapolis, University of Minnesota Press, 1990.
69 Sigmund Freud, 'The "Uncanny"', p. 241.
70 William Yang, *Sadness*, St Leonards, Allen and Unwin, 1996, pp. 64–5.
71 Sigmund Freud, 'The "Uncanny"', p. 241.
72 Sigmund Freud, 'The "Uncanny"', p. 227.

73 Zygmunt Bauman, *Modernity and Ambivalence*, p. 183.
74 Sander Gilman, *Franz Kafka, the Jewish Patient*, New York, Routledge, 1991, p. 80.
75 Sander Gilman, *Franz Kafka*, p. 80.
76 The full translation of the story can be found in Jack Zipes (ed. and trans.), *The Operated Jew: Two Tales of Anti-Semitism*, New York, Routledge, 1991.
77 Jack Zipes, *The Operated Jew*, p. 65.
78 Sander Gilman, *The Jew's Body*, p. 203.
79 Sigmund Freud, The 'Uncanny', p. 234.
80 Philip Cohen, 'The Perversions of Inheritance' in Philip Cohen and Harwant S. Bains (eds.), *Multi-Racist Britain*, London, Macmillan, 1988, p. 10.

3

GHETTO THINKING AND EVERYDAY LIFE

Fear is an important component in the lives of those of us who come from Ashkenazi, and in particular Yiddish, backgrounds. Some of the provocations of fear which I will be discussing are common to many migrant and minority groups under circumstances of oppression. I make no special claims for these as Jewish experiences. What I will argue is that over many centuries the Jews of Europe evolved a way of being in the world which was premised on an assumption that the world in which they lived their everyday lives was fundamentally antagonistic to them. Fear was an adaptive defence mechanism which kept the Jews on their guard, ever watchful, ever protective of their own. The Holocaust did not produce this attitude to the world. Rather, for Jews, it was mediated through this prior existing lens.

Fear is an experience of many minority groups, especially those who do not feel 'at home,' for whatever reason, in the particular nation-state in which they live. This piece is about this fear, and about the specific inflection of this fear in the Yiddish-background context. Thus, some of what I have to say can be generalised, other things speak to the specificity of the Yiddish experience. Other groups have had different experiences and their fear has been produced differently, and with different effects.

When I write about fear as an aspect of everyday life, I am thinking of a way of being in the world in which the primary assumption is that the world is a dangerous and threatening place, rather than, say, a place full of generous and potentially friendly people. I am not, for example, thinking about an experience of the world in which fear in the individual is produced by an ideology which celebrates fearful events as a part of life. In his discussion of the politics of everyday fear, Brian Massumi has argued that '*Fear is not fundamentally an emotion. It is the objectivity of the subjective under late capitalism.*'[1] He explains this as 'being as being-virtual, virtuality reduced to the possibility of disaster, disaster commodified, commodification as special continuity in the place of threat.'[2] For Massumi, fear is produced in the everyday by the condition of commodification in a capitalist system driven by consumption, and in which we have, in turn, to be driven to consume to support it. The fear of imminent disaster that is ever present in the way the world is presented to us, in for

example, media spectacle, tropes the possible apocalyptic disaster of capitalism itself which is only staved off by increasingly frantic consumption. Massumi may be right, but this is not the genre of fear with which I am concerned here. I am describing a way of being in the world in which the world is considered to be, in and of itself, dangerous and threatening, and to which, culturally speaking, the only appropriate response is considered to be fear. Fear is experienced as the banal, normative attitude to the world. From this point of view, any achievement is only provisional and the future is approached in a spirit of fearful anxiety, where the negative possibilities attendant upon any event have to be canvassed and their consequences considered. For me, personally, the assumption that the world is a place of threat has been intellectualised by a preference for Thomas Hobbes as a political theorist over, say, Jean-Jacques Rousseau.

Central to the view of the world as a fearful place has been what I will call 'ghetto thinking.' Before the Holocaust, in 1928, Louis Wirth published a book about the ghetto in European Jewish experience. A lot of the book is about the voluntary formation of a Jewish 'ghetto' in Chicago by Eastern European migrants. Wirth argues that, even before their forced entry into ghettos in the late medieval period, European Jews had begun to cluster together in particular areas of cities. He writes that 'The ghetto as we have viewed it is not so much a physical fact as it is a state of mind.'[3] It is Wirth's contention that the ghetto is 'an effect of isolation.'[4] Wirth thinks of the Jew as the prototypical modern migrant: the European Jews were an isolated minority among a Christian majority. From this perspective, the Jewish experience becomes a way of understanding why other minority and migrant groups in the United States formed ghettos; to quote Wirth, 'How has the isolation of the Jews produced results that hold good, not only for the Jew, but for the Negro, the Chinaman, the immigrant, and a number of other isolated groups in our modern world?'[5]

Ghetto thinking is founded in, and reinforces, the isolation that Wirth describes. It is, to use Raymond Williams's evocative term, a structure of feeling.[6] Among other attributes of ghetto thinking are a turning away from the world outside the ghetto community, which need not be, in fact, a spatial community, and the development of a mutual self-help system within what is understood to be a closed, and confined group.

Wirth identifies the entirety of the Pale as a ghetto. Within this ghetto, the way of life of the Yiddish inhabitants of the *shtetlach* was permeated by ghetto thinking. To give just one example. In her book on *shtetl* life, focussing on the history of one *shtetl*, Bransk in Poland near the present border with Belarus, Eva Hoffman tells a story of a nineteenth-century Jewish conscript into the tsar's army. Taken when he was thirteen, the man returned to Bransk, having at some point converted to Christianity, forty years later to visit his mother's grave. Hoffman goes on: 'The story does not have a forgiving, prodigal son ending. After the emotional cemetery visit, the brother left Bransk. He occasionally wrote to people back home, but nobody answered him. This time,

he was definitively banished from communal memory.'[7] Why is not explained. Probably his complete excision from the community was because he was now Christian. However, having lived so long outside of Bransk would not have helped his cause. The *shtetl*, like the ghetto, was inward looking.

Wirth does not mention fear, but fear has been an important component of ghetto thinking. Hoffman has described how 'The *shtetl*, in the absence of living actualities, has become a trope, a metaphor frozen in time. In our minds, it tends to be unchanging, filled always with the same Sabbaths, the dybbuks, the fear of Cossacks, the family warmth.'[8] This trope is a materialisation of aspects of ghetto thinking. It includes both the external threat from an antagonistic world, the Cossacks, and the counterbalancing comfort and support of the family, and by extension the community more generally. Of course, over the centuries, the threat was very real. Ilan Halevi tells how

> the 17th century was punctuated by the great massacres of the Cossack revolt, between 1648 and 1658, itself preceded by the 'little massacres' of 1637. The coming of Russian protection for the Cossacks, in 1654, transformed the anti-Polish, anti-Catholic and anti-Jewish revolt of the peasantry into a permanent feature. Wars and invasions (by the Russians and the Swedes), and liberation movements such as that of Stephen Czarniecki against the Swedish invader were unfailingly accompanied by new massacres.[9]

This constant and increasing violence reflects the decline of Poland as a powerful kingdom, and its increasing inability to protect subaltern groups within its borders. By the 1870s these attacks were being complemented by more directed pogroms, especially in the Russian-controlled Pale. The first major wave of pogroms took place in 1881–84 after the assassination of Tsar Alexander II. The second wave began in 1903. This was the year of the terrible Kishinev pogrom. In this, the government colluded with the rioters who were stirred up by an anti-Semitic campaign in a local newspaper. There were widespread atrocities and over one hundred Jews were killed. The lack of protection from the police and other government forces was typical.

THE FAMILY AND THE GENERATIONAL TRANSMISSION OF FEAR

In *The Politics of Experience*, R. D. Laing, the existentialist psychoanalyst, described what he considered to be a dysfunctional family form. I will quote at length:

> Some families live in perpetual anxiety of what, to them, is an external persecuting world. The members of the family live in a family ghetto,

as it were. This is one basis for so-called maternal over-protection. It is not 'over'-protection from the mother's point of view, nor, indeed, often from the point of view of other members of the family.

The 'protection' that such a family offers its members seems to be based on several preconditions: (i) a fantasy of the external world as extraordinarily dangerous; (ii) the generation of terror inside the nexus at this external danger. The 'work' of the nexus is the generation of this terror. This work is *violence*.[10]

In connection with Hoffman's story of the *shtetl* soldier it is worth noting that Laing writes that 'Any defection from the [family] nexus (betrayal, treason, heresy, etc.) is deservedly, by nexus ethics, punishable: the worst punishment devisable by the "group men" is exile or ex-communication: group death.'[11] It has been a common practice among Ashkenazi, including Yiddish, Jews to treat a person who has converted, or even married a gentile, as if they were dead. Family members would even sit *shivah* (mourn) for them.

It is impossible to tell if Laing were modelling this dysfunctional family on the Jewish family, but that he writes of the 'family ghetto' suggests he might have been. For Jews, as for other subaltern groups in societies which identify such groups as Others, the family, particularly in an extended form, is a site of succour and safety. The production of the family ghetto has the added advantage of reinforcing membership of the group. The problem is that, for European Jews in Christian society, there has very often been 'an external persecuting world.' In the terms of that hippie catch-phrase, it is not that 'all paranoia is justified' but that, if one's paranoia is proved to be legitimate often enough then one, or rather the culture in which one is interpellated, will tend to develop adaptive responses to take account of such a potential threat. At which point it becomes likely that a host of otherwise non-threatening interactions will be interpreted through the frame of threat; fear will become a constant.

Of course, Laing's point is very different. Assuming that the external persecution is chimerical, he is seeking to explain how such a family preserves the loyalty of its members by acting *as if* the threat were real, in the process doing mental violence to the family members. Laing divides the experience into two parts. First, the claim that the world outside is dangerous. Second, the production of terror in the family members as an appropriate reaction to that danger. This division asks us to think if there might be an alternative reaction to external danger, thus recognising the importance of cultural mediation in the privileging of fear. We should note here that there is an important difference between the world as being dangerous and the world as antagonistic which Laing elides. As a cultural formation, fear intersects with other aspects of culture. For example, the generation of fear within the family, or ghetto community, at the possibility of an attack from outside can work positively to reinforce the community itself. It mediates and transforms the experience of familial love.

Laing describes how, within the family, the mother takes on the role of the protector, her 'over-protection' if it is thought that the external world really is not a threatening place, helping, ironically, to reproduce in her children the very fear of the world, of the persecution from which she fears they are at risk and from which she seeks to protect them, while, at the same time, binding them ever more closely to her. In assimilated, and secular, Jewish homes, this intimate structure of ghetto thinking is reproduced in the very banalities of the functioning of everyday life. Not so long ago I visited my cousin who lives in Toronto. On this particular day she took me out to see Niagara Falls. Meanwhile, her son was driving back to Queen's University in Kingston, a matter of a few hours on the road. Later we went for a meal. As we sat and talked, waiting for her husband to join us, my cousin began to get quite anxious. Finally she admitted that she was waiting for her son to ring. She had asked him to do so when he got home. We carried on talking; she checked her mobile phone was on. She rang her house to see if he had left a message on the answering machine. At last, with a slightly shame-faced, 'Yes, all right, I know I'm being a Jewish mother; but I'm worried,' she rang him, leaving a message on his answering machine to the effect of 'Please ring me as soon as you get in, even if it's only to be grumpy that I've asked you to.' (He did.)

There are a number of possible readings of this story. One is to say that a mother's anxiety over her children is natural, that the story I am telling could be told about countless mothers, gentile as well as Jewish. It might be noted that my cousin, in addition to being Jewish, is herself a migrant from England to Canada and that such anxieties are characteristic of migrant families. I do not dispute this either. It might also be said that, yes, this is a Jewish story and that, even in multicultural Canada there is anti-Semitism. My cousin has every right to be concerned. Or, perhaps she has no need to be concerned – she appears to think this in some part – after all Canada is a tolerant, multicultural country, but she is anyway. I do not want to choose between these readings. All are in part correct. My point is that this is just one small, everyday incident. It is through the constant piling up of such minutiae in the course of daily life that anxiety is passed from generation to generation and fear is produced. When I left home to go to university, my parents asked me to ring them every Sunday. I did this until I moved to Australia when I was thirty. Since then, I ring my parents once a month, on a Sunday that my father (who is not Jewish) decides upon. If I miss the day, or even if I am late ringing, I am likely to get an anxious call from my mother. She knows the world is dangerous, if not threatening. The call is to reassure them; it is not an expression of the emotional closeness of the family – after all, who knows what might happen in the month between phone calls.

Traditional sociology has tended to think of the familial socialisation process in terms of the handing on of norms, values and attitudes, that is, the reproduction of some moral order which underpins the normative functioning

of society. Cultural studies has tended to write about the making and remaking of the cultural practices which are more or less shared and which, in the sharing, express a culture, and into which we are interpellated and subjectified. I am thinking of something rather different, of how a way of being in the world, what we could describe as a situating in a society or culture, is reproduced, very often quite unconsciously and involuntarily. Thus, for example, it does not matter if a parent says that they are not bringing their children up to be Jewish either in religion or culture; they may, and probably will, still hand on a 'Jewish,' or at least Ashkenazi-Yiddish, way of being in the world. This way of being, an important aspect of which is the experience of ghetto thinking, most obviously expressed in fearfulness, is reproduced, as I have remarked, through the little things of interpersonal interaction, a slight flinch, a turning away at certain moments, an emotional welcome, a 'you must be home by midnight' with an anxious emphasis on the must, a 'please ring me when you get in.'

This form of generational transmission can have quite unexpected effects. To take a personal example. I am the son of a mother from a Yiddish background who married out and assimilated. She has told me that her family called her the *yiddische shiksa* (Jewish gentile girl). This phrase speaks, perhaps more ironically than she realises, of her desire to assimilate. I have no Jewish religious knowledge and no *Yiddishkeit*. And yet; and yet, to take but one example, I have a tendency, which some gentile friends of mine find irritating, to remark 'so far so good' when something goes right. This is a verbal testimony to a way of being in the world in which I experience the future as always uncertain, and possibly disastrous, and present success as equally precarious. The Jewish joke about the man who fell off the roof of a fourteen-floor building and muttered, 'so far so good,' as he passed each floor on the way down typifies this way of thinking. As does the T-shirt which I found in Eilat (the Israeli seaside resort on the Red Sea) which has a happy and intrepid windsurfer on it. He is looking away as, in front of him, a huge shark looms, about to swallow him up. The caption is 'So far so good.' The message is that one should always be on one's guard; the world is not just dangerous, it is threatening. To take another, disparate, example to show how pervasive this attitude is, Woody Allen has commented on his second-generation Yiddish migrant parents that 'They have never been able to shake the feeling of imminent catastrophe. That's the way they grew up.'[12] This, then, is an aspect of ghetto thinking. It articulates with the fear generated by experiencing the outside world as a threat. I will write about my fear at times in this chapter.

In her autobiographical meditation on language, Alice Kaplan describes her grandmother who arrived in the United States as a migrant from a *shtetl*. Kaplan, herself, feels at home in the security offered by America. Her grandmother sees the world through ghetto thinking. She divides the world into the security of home and the threat outside of it. Kaplan remembers how

It was a quick walk [from her grandmother's house] to pick up sprinkles for sugar cookies or some bridge mix to go to services. 'Don't get in a car with any strangers, don't go with strange boys!' She would give me a lesson as we walked alongside some innocent blonde grocery boy, wheeling the cart to 2410 Fremont Avenue for his twenty-five-cent tip.[13]

Her grandmother's anxiety is that strange boys are not Jewish and therefore cannot be trusted not to abuse Alice. Conversely, were a 'strange boy' and Alice to fall in love, she could 'die,' be lost to the Jewish community. I suspect that Kaplan's use of 'blonde' to signify the grocery boy as a gentile is a post-Holocaust inflection. He is innocent, but he is 'Aryan.' (His blondeness also signifies him as being a 'proper' American). It would seem that while her grandmother's words can be enunciated as autobiographical history, the trace of her anxiety haunts Kaplan's present.

Her grandmother's continual preoccupation with the sexual threat made such an impression on Kaplan that it is repeated on the very next page:

'Who's that boy? Don't go with any boys. You don't know what they are going to do with you.'

'Nanny, stop it!'

I made fun of my grandmother's warnings. They came out of nowhere. Sometimes I thought she was making a joke. Then I would look at her up close and see the trembling around her mouth, the tightening of her jaw. She was terrified.[14]

Here, again, we have the terror of the outside world, this time more explicitly identified in the male sexual threat to girls.

Linda Grant is a third-generation English Jew. Both sets of grandparents had migrated from the Pale. Her mother's parents came from Kiev. Grant's book, *Remind Me Who I Am, Again*, is an account of her mother's descent into the tribulations of Alzheimer's disease and how the family dealt with this. Grant provides this vignette:

And later that day, because she had been looking at old photographs she began to talk about how her mother and father had come from Russia and how her father had said he would have stayed if only he could have got his hands on a gun to defend himself and 'Your father told me that when he was a little boy he overheard *his* father talking – in Yiddish, you understand – and there was a girl and they came one night, and they came back every night and she went mad in the end and when it was born they killed it.'

'What are you talking about? Who came? Who was the girl?'

'What girl?'

'The one you were talking about.'
'What was I saying? I can't remember.'[15]

Grant comments on this story that she found such memory fragments frustrating; that she was unable to tell if this terrible event had ever happened, or if, perhaps, it had come from a book or a film. In one sense, whether or not the event ever happened does not matter. What the story, and the memory, do is reinforce the fear which identifies the outside world as a threat and help to legitimate ghetto thinking.

In this narrative, coming immediately before the story of the abused girl, we have an example of migration as a subaltern tactic of survival. Daniel Boyarin has examined what he describes as 'the arts of Jewish resistance.'[16] In his article he traces certain, what he thinks of as 'feminizing,' forms of resistance in Talmudic discussions. These are tactics of the weak invoked as ways of attempting to survive in the face of overbearing power. Boyarin takes as one example a narrative from the Babylonian Talmud. As a way of resisting Roman tyranny a rabbi is advised to run away. Boyarin writes: 'resistance not as the assumption of power and dominance but as resistance *to* the assumption of dominance: "Run away to Lydia," and this prescription is put into the mouth of one of the most authoritative oracles that rabbinic culture can produce, Elijah the Prophet.'[17] He comments that '[t]he tenacity that is valorised in these texts is the tenacity that enables continued Jewish existence, not the tenacity of defending sovereignty unto death.'[18] This is the option taken by Grant's grandfather, and by millions of Yiddish Jews in the Pale and other areas of Eastern Europe.

Grant remarks how remote the two generations are from each other. She means her own, fully English and assimilated – her boyfriends were gentile – and her mother's generation. This she portrays as unsettled, 'those children of immigrants who had in their heads two worlds, the one they lived in and a partial, incomplete place that their parents handed on to them, the *Heim*, the land they came from, be it Poland or Russia or Lithuania or Hungary.'[19] Here, migration is a metaphor for cultural transformation, specifically, for a modernisation that has taken Grant's family out of the *shtetl* and made them members of the English nation. Yet one wonders how distanced Grant actually is from the way of thinking of her parents' generation when, a page later, she writes about how 'Always in *our* [my italics] minds was the consciousness of what would have happened if they had not emigrated,'[20] and goes on to describe the massacre of the Kiev Jewish population at Babi Yar in 1941.

For Kaplan, and for me, and, indeed, our generation, the local pogroms of the Pale have been supplanted in a globalised world of mass travel, mass communications and world war by the Holocaust, the signifier of a threat to an entire, dispersed people. Babi Yar, like so many of the local annihilations in the Pale, marks a moment of transition to a new formation of fear. The concept of genocide was first introduced by Raphael Lemkin, a Polish jurist, in a book he

published in 1944 about German policies in the Second World War, *Axis Rule in Occupied Europe*. Coining the neologism, Lemkin argued that

> genocide does not necessarily mean the immediate destruction of a nation, except when accompanied by mass killings of all members of a nation. It is intended rather to signify a co-ordinated plan of different actions aiming at the destruction of essential foundations of life of national groups, with the aim of annihilating the groups themselves.[21]

Pogroms and the local massacres that had accompanied ghetto and *shtetl* life for European Jews throughout the Middle Ages were never intended to destroy the entire 'race' of the Jews. Such a way of thinking is modern. It depends on the consideration of groups of people as unitary, exclusive and distinct. It requires the idea of a group of people as a totality, the kind of thinking epitomised in the discourse of race, and naturalised in the practice of the modern nation-state. The fear accompanying the realisation that 'they' want to murder, destroy, annihilate all of your 'people,' and everything that you have ever produced, is qualitatively greater, if not personally then culturally, than the fear engendered by the relatively random acts of aggression and massacre that had previously taken place.

But my specific point is that Grant is not as different from her mother's generation as she would like to think. And to go back to Grant's mother's memory of a story that has stayed with her throughout her married life, a story handed down from generation to generation like the way of thinking expressed through it, heard from her husband who had overheard it from his father – the migrant – here we have another narrative of sexual abuse by, we can only presume, powerful gentile strangers in the *shtetl*; this time not 'outside' but in the very security of the home. It carries, and hands on, the affect of fear. Kaplan recounts one of her grandmother's memories, how, in Trask, in Lithuania, 'her mother had hidden her in a closet so the Cossacks wouldn't rape her.'[22] Safety, here, is to be found in the dark recesses of the home, hidden away, where the invading strangers, it is hoped, won't look.

THE HOME AS SANCTUARY

If you stay within your community, ghetto thinking suggests, you might not be visible to the threatening strangers who people the outside world; you might not attract their attention. Again, this fear, translated into the fear of the migrant who is a member of a minority in their new country, is not specifically Jewish. However, for the generations of ghetto-thinking Jews either in the European Diaspora or in their new countries, descendants of migrants, the former anxiety reinforces the latter fear. In the case of Kaplan's grandmother, for example:

The social security form she had to sign remained untouched for months on her coffee table. She had never voted. In her mind an evil force, bigger than the Red Owl, bigger than the Temple, lurking, perhaps, in the Social Security Administration or the Registrar of Voters, was waiting to send her back [to Trask].[23]

For Kaplan's grandmother, sanctuary lay in the home. As her grandmother became senile, Kaplan visited her with another Jewish girl who, she says, 'understood about Nanny.'[24] Her grandmother would call out to them: '"You can't come in girls, they're coming for me. Not safe, not safe."'[25] Kaplan describes how

> Danger was at bay inside her house. Every surface, from the grey nubbly upholstery of the chair next to the window, to the green silk with gold thread covering the couch, to the grey-green oil painting of my glamorous Aunt Helen, spoke of familiarity and comfort.[26]

The city ghetto, which segregated Jews from the Christian population, could also be experienced as place of safety which could be guarded against at least minor attacks by the rest of the population. The *shtetl* was usually shared with non-Jews. Here, the house of the home became the most literal form of safety.

In that fearful binary, the home became the site of security and the mother the final source of succour and protection when, in a world of threat, there was nowhere to run. In her excellent account of how the image of the Jewish woman in the United States has been transformed from Yiddish mother to the Jewish American Princess by way of the modern American emphasis on commodity consumption as a way of life, Riv-Ellen Prell provides a brief discussion of the Yiddish mother. Prell writes that, in the United States

> Jewish women appeared in literature written by Jewish men and women as greedy, bourgeois, and even uncouth as early as the 1920s. These women were, however, always contrasted to an idealized mother, capable not only of perfect love, but inhuman, slavish labor.[27]

She notes how, in the song 'My Yidishe Momme,' released in both English and Yiddish versions by Sophie Tucker on the same record in 1925, there is a significant difference. In the English version

> I see her at her daily task in the morning's early light.
> Her willing hands toiling far into the night.

In the Yiddish version:

> She would have leaped into fire and water to save her children.
> Not cherishing her is certainly the greatest sin.
> Oh, how lucky and rich is the person who has such a beautiful gift from God.[28]

Both versions describe the mother as the protector. In the Yiddish version we find her literally saving her children, not from Cossacks or other strangers – this might, perhaps, have been too disturbing in a song designed to conjure up sentimental nostalgia – but from natural threats. In the English version, the version for those from Yiddish backgrounds who speak English, and who are presumed to have somewhat acculturated to the American way of life, the mother now protects her children, and provides security for them, by working excessively. In this way she can provide both house and home.

During my twenties I had a lengthy relationship with a Jewish woman. She, too, was third-generation English, though I know all-too-little about her background, not having enquired at the time. On occasion I would visit, and sometimes stay with, her parents. They lived in Hendon, a quite expensive middle-class suburb in North London where a largish number of Jews live. Their house – I realise now that what I mean is their manner of living in their house – always struck me as exceptional. They were welcoming, generous people, perhaps a little unsure how to relate to this Jew lacking in all obvious cultural and religious capital. The house was furnished tastefully and without any cutting of corners. It might be ungracious to describe it as a celebration of economic upward mobility but it was, in the nicest way. I think that this affirmation of comfortable wealth was, itself, a signifier of protective reassurance in a capitalist society where money, rather than family (even in the case of many Jewish families where ties of kin and obligation have faded), was the protection against the threat of poverty.

What made most impact on me, on every visit, was how quiet and calm the house was. With deep-pile carpets, double-glazed windows and securely fitting external doors, once one crossed the lintel from the outside it was like being in another world. I understand now that this is exactly what it was. The house was not only a home, it was a haven, a refuge from the rest of the world. Sometimes, if I had not left the house for a few days, when I did leave I would be overwhelmed by the noise, the dirt, the speed, the day-to-day aggression of London life. My heart would pound and my fear would rise in my throat and, as I drove around the North Circular, I would have to take control of myself and once more settle into life in the outside world.

MIGRATION AND YIDDISH FEAR

Eva Hoffman's *Lost in Translation* is an intellectual autobiography about the acquisition of language and culture. Hoffman grew up in a not-very-observant Jewish household in Cracow. In 1959, when she was fourteen, the family migrated to Vancouver. In the book, Hoffman has titled the section describing her Cracow years 'Paradise.' The following section, which is an account of her teenage life in Vancouver and at Rice University in Texas, is called 'Exile.' Much of Hoffman's concern is with the complex unsettlings that the migrant

feels when having to learn simultaneously a new language and a new culture. The two, she argues, are deeply and essentially imbricated. Exile, then, is certainly exile from Poland, and the Polish language, but it also expresses the migrant feeling of isolation and loss.

However, there is a paradox here. In Canada and the United States Hoffman feels accepted. Poland is a different matter. She writes about the exodus after the ban on immigration was lifted in 1957. Noting the families that were leaving, Hoffman comments that 'Our personal world is changing: it begins to seem less and less possible to be Jewish and of our class – that is, definitely Jewish, non-Communist, without a particular stake or significance in the society – and to remain.'[29] The Jewish support network is weakening. Finally, Hoffman's childhood love Marek leaves, with his family, for Israel. She writes that

> My parents had no doubt about the matter. Poland is home, but it is also hostile territory. They had tried to get out once before, shortly after the war, when some Jews were given exit visas, but didn't succeed. The question is not whether to leave, but for where.[30]

Paradise is a place which, while home, is also hostile, a place that her parents have wanted to leave since the war. The war, here, stands in for the Holocaust.

In the early pages of the book Hoffman tells us about the destruction of her parents' pre-war world. They came from a *shtetl* called Zalosce near Lvov. Much of the time of the Holocaust they spent in hiding; after the bunker in the woods was discovered, they spent a year in the attic of a gentile Polish peasant. Hoffman was born two months after the end of the war, which was also the end of the Holocaust as such but not of Polish pogroms against the remaining Jews.

As the narrative of the book progresses, Hoffman's Jewishness recedes as an issue. Her description of the lack of hostility to Jews in Canada and the United States, and her own lack of integration into a Jewish network, helps legitimate the primary focus which is migration. Yet being Jewish clearly remains important for Hoffman. The immigrant tale she likes most is Mary Antin's *The Promised Land*,[31] the autobiography of a Yiddish girl's migration to the United States around the turn of the century, and, while her first American love is a gentile Texan, the man she marries is Jewish. In spite of this, after the family migration to Vancouver, the overt importance of Hoffman having a Yiddish background is replaced, rather than complemented, by an emphasis on her Polish background.

This is the narratival context in which I want briefly to reconsider what Hoffman thinks of as a pivotal moment of self-recognition in her life. She describes a nightmare she has on her third night in Vancouver, while the family is staying with an ungenerous, Polish Jewish couple called Rosenberg who have, nevertheless, helped them through the procedures for migration. In it:

I'm drowning in the ocean while my mother and father swim farther and farther away from me. I know, in this dream, what it is to be cast adrift in incomprehensible space; I know what it is to lose one's mooring. I wake up in the middle of a prolonged scream. The fear is stronger than anything I have ever known.[32]

Hoffman writes that she 'feel[s] as though I have stepped through a door into a dark place.'[33] Is this dark place inside or outside? It is, in an important sense, both. The metaphor is redolent with echoes of places of sanctuary that become, also, places of terrifying confinement. Houses, closets, attics have formed a thread through my narrative, here. Most immediately, in Hoffman's autobiography, we have the bunker and the attic in which her parents hid before she was born.

Hoffman describes how

The black, bituminous terror of the dream solders itself to the chemical base of my being – and from then on, fragments of fear lodge themselves in my consciousness, thorns and pinpricks of anxiety, loose electricity floating in a psyche that has been forcibly pried from its structures. Eventually, I become accustomed to it; I know that it comes, and that it also goes; but when it hits with full force, in its pure form, I call it the Big Fear.[34]

Hoffman identifies this as the migrant's fear, 'The primal scream of my birth into the New World.'[35] It is a product of leaving one's culture and one's language – Polish culture, not Polish-Yiddish, and the Polish language. In this reading, the dream acknowledges Hoffman's fear of being unable to cope, and more, to live this new culture and language as a natural part of her being.

There is a complementary reading. This is also a dream of adolescence. Hoffman, remember, is fourteen. In this nightmare she is becoming an adult, no longer supported, nurtured, protected by her parents. We might even be able to detect an Oedipal suggestion in the aural play of 'father,' 'farther,' 'farther.' She, in fact, is moving away from him rather than the other way round.

However, what lies behind both these readings, what makes Hoffman's migrant fear more than average, and what is silenced in her reading, is her Yiddish background. I have already begun to suggest that what is repressed in Hoffman's reading of her own nightmare is its Yiddish context. I now want to expand this. Hoffman's parents are both swimming away from her. In this anxious libidinal economy where familial support merges with community support, their leaving (and they are, after all, in reality not leaving her) brings to mind the break-up of the Jewish support community in Cracow, where families had been leaving for various countries, and leaving Hoffman, and her family, more exposed. In this dreamwork her father carries also the emotional entanglement of her first love, Marek, who, as I have already noted, went to

Israel. Hoffman is drowning, then, not only because she has migrated away from the cultural and linguistic sea in which she can swim but also because she has lost the support which helped her to survive in the Polish environment which her parents, at least, felt was hostile.

Of what, then, is she so fearful? Here, we can usefully distinguish between anxiety and fear. In their book *Psychoanalytic Perspectives on Migration and Exile* Leon and Rebecca Grinberg suggest that migrants feel insecure and that this, in part, stems 'from uncertainty and anxiety in the face of the unknown'[36] and in part from a certain regression caused by the migrant's inability to function in the new culture, and possibly language, in which they find themselves. To be anxious suggests an extreme form of worry, often about the future, sometimes about possibly forthcoming pleasure, in this case about fitting in, and about being able to live successfully in this new country. Anxiety can be connected to fear, and certainly is produced by fearful situations, as we shall see, but it is also possible to be anxious without being frightened. (I have to say that for me anxiety connotes almost exclusively fear.) For Sigmund Freud, who, at the end of his life, escaped Hitler's death camps, unlike his sisters, by moving to England, 'anxiety is a psychic reaction that is a response to danger – but anxiety . . . does not always "know" the danger it is a reaction against.'[37] This suggests, among other things, the possibility of the naturalisation of anxiety. Freud spent a lot of time meditating on anxiety but, as a person who wanted to create a universal science, he never connected its importance to his work with his own experience as a Yiddish-background Jew in Europe. What Hoffman experiences is not anxiety, though, it is fear – actually, the way she describes it, it sounds more like terror. Fear, for the migrant, is, at the very least, reinforced by an anticipated lack of welcome, or more likely active antagonism, from the host population. This expectation does not have to be conscious. Hoffman has found herself in a new country with no protective support network; the Rosenbergs, she knows by this time, are unsympathetic. Her inherited understanding of the outside world in Poland is that it is hostile. Stripped of her support, she finds herself fearful in an unknown place which her unconscious presumes to be threatening. For the rest of the book, among her new gentile friends, her Jewishness is simultaneously acknowledged and made invisible since, as we have already seen, Hoffman becomes a Polish, not a Polish-Yiddish migrant.

Marianne Hirsch has asked:

> What repressions are behind the feeling that Cracow is 'both home and the universe' when only a few years before all of her parents' relatives had died there, including her aunt who 'was among those who had to dig their own graves, and . . . her hair turned grey the day before her death'.[38]

Her answer to this question is that, for Hoffman, 'Canada is freedom, but . . . [she] has displaced her parents' suffering with her own happiness, and Canada

is only *exile* for her.'[39] Migration, or more correctly *galut* (exile), has replaced Jewishness as the theme of Hoffman's life as told in the book and, in order to achieve this, the Holocaust itself has been repressed.

THE HOLOCAUST AND GHETTO THINKING

Aaron Hass discusses a landmark 1964 study by William Niederland, a psychiatrist, who listed among other symptoms exhibited by Holocaust survivors, 'chronic anxiety, fear of renewed persecution, depression, recurring nightmares, psycho-somatic disorders, anhedonia (an inability to experience pleasure) . . . a hostile and mistrustful attitude towards the world.'[40] Hass has commented on survivors' attitudes to the world that 'If one believes one is alive simply or mostly because of luck, one may live with an uneasiness, a fearfulness. Just as one was given life by chance, something just as capricious may snatch it away.'[41] This sounds like an excessive version of 'so far so good.' Lea Haravon, herself a child of survivors, has recounted her experience:

> Things my parents always told us. It is good to save money, in case 'godforbidsomethingshouldhappen' and you have to leave the country. When I got older I learnt that not all parents say this to their children. Some kids do not grow up afraid, as I did, that 'godforbid-somethingshouldhappen'.[42]

The 'godforbid' here is an extreme version of the Yiddish sense of the lack of certainty in a future ultimately determined by those who have power over you and irregularly threaten and attack you. It is the product of a particular kind of subaltern experience. My father, who is not Jewish and not a survivor in any conventional definition, but who took on some of the Yiddish worldview, some of the ghetto thinking, as my mother divested herself of her more obvious cultural signifiers, used to say the same thing in connection with almost any major future event – though he never suggested that we might have to leave England. Here, anticipation was always tinged with a fraught anxiety. A less anxious, and more conventional, version of the same idea is the statement 'God willing.' In Sara Bershtel and Allen Graubard's book *Saving Remnants: Feeling Jewish in America*, there is commentary from a man brought up Orthodox in New York: 'it is easy to spot someone who wasn't Orthodox from birth; for example, they'll say much more often, "*im yirtzeh Hashem,*" that's like, "I'll see you tomorrow, *if God is willing.*" Fine, OK, that's always implicit in anything anybody does, but these newly Orthodox tend to say it noticeably more . . .'[43]

Discussing the children of survivors, Hass is interested in what he calls 'intergenerational transmission.' He notes that

Survivors' protective and often intrusive style of parenting may not simply be a reflection of their Holocaust experiences and losses. Their relationship to their children may be modelled on family norms they experienced growing up in Europe. These norms emphasized the primacy of the family and inculcated in the child a sense of obligation and deference to parental needs.[44]

The emphasis on protection in the family from, one presumes, threat refers us back to the ghetto thinking of the *shtetl*.

What interests me here is how, in certain ways, many of the symptoms of survivors' children are also extreme versions of ghetto thinking and how those of us from Yiddish, and more generally Ashkenazi, backgrounds, although not directly related to survivors but of the same generation as survivors' children, have often also experienced a certain reinforcement in the ghetto thinking which we have acquired. Summing up his interviews with survivors' children, Hass writes that 'The experience of being a child of a survivor is reflected by three words uttered by almost every such person with whom I came into contact: fear, mistrust, cynicism;'[45] and he goes on to note, 'The world, for these children of survivors, is clearly a hostile protagonist.'[46]

In common with many of my generation, my own first encounter with the Holocaust came in the early 1960s, before the term had become common currency, and certainly before it had become capitalised. In those days there was still a relative public silence about what had happened. I was about twelve, I had bought my mother a birthday present, an egg timer in the form of a monk holding the timing glass in his hands. My mother unwrapped my gift and looked at it; turning it upside down she saw written there 'Made in Germany.' At this, rather than thanking me, and to my utter bewilderment and astonishment, she flew into a rage. She told me never, ever, to buy her anything made in Germany again. Then she said that all our relatives in Europe had been murdered by the Germans. That was all. However, that remark stayed with me. It seemed so lacking in reason, after all, why should the Germans have done this? My mother had made the remark in such a way that I knew that the murders were not personal; all the other Jews that the Germans had been able to get their hands on had also been murdered. Genocide, I realise now, is always in the service of some higher cause, usually associated with the state. At the same time, what hurt me the most was on a personal level: that my mother never acknowledged my emotional reaching out to her in giving her that gift. Instead of love I had, unwittingly, provoked her anger.

Consciously, I knew next to nothing about Jewish culture or religion, but I knew that I was a Jew and I knew that Hitler and 'the Germans' had tried to kill all Jews. For me, then, what I much later learnt to call the Holocaust was formative in my understanding of my own Jewishness, and my discovery of what had happened, coming in the form of a rejection and an angry attack by

my mother at a time when I had expected some demonstration of affection, ensured that this knowledge remained overdetermined by a traumatic family moment.

Growing up in England, I used to wonder what would have happened if we had been invaded. I remember telling the cleaner that my mother employed to come once a week that there would always be resistance in the hills. This was my 'English fantasy.' At the same time, I also 'knew' but did not say, that if the Germans had successfully invaded, my mother would have been killed and I would not have existed. I also sometimes wondered what would have happened if the Germans had invaded 'now,' when I was alive. I used to think about whether I would have resisted, or whether I would have been sent to a concentration camp. At that time, though, I did not have a full sense of the horrors of the camps, let alone that there was a distinction between concentration camps and death camps.

Hass quotes the daughter of survivors who would have horrific visions of the camps at school. In her view of the world, 'Burglars and murderers – the words came in a pair – were always at large, liable to break up a party or disrupt my class in school or even take three thousand people out of Carnegie Hall.'[47] Here, typically in the structure of ghetto thinking, the attacks come from outside, from people breaking in, rather than from, for example, other kids in her class. The attackers are burglars and murderers; where the female fears from the *shtetlach* that I have quoted were focussed on rape, for post-Holocaust Jews, women as well as men, murderous annihilation is, ultimately, a worse fear. Even for me, to give an example that is banal by comparison, but which, nevertheless, has a similar source – and, as I have noted, it is in the banalities of life that our being in the world is most redolently expressed – when I use the jogging machine in my local gym, I sometimes catch myself imagining that I am being chased by Nazis as an aid to get myself to run faster.

One aspect of the rape fear, I suspect, has to do with the traditional observant Jewish understanding of the awfulness of defilement by a gentile. This surfaces again in the following quotation from another daughter of survivors:

> I learned the world is a scary place. It's best to live in a world that is very small and like you, not to trust anyone who isn't Jewish. I'm a very fearful person. I don't believe when someone says that everything will be okay, that I'm safe. I was in Acre [Israel] once with several girlfriends. There were many Arabs around, and suddenly I was seized with an irrational fear that I would be raped by them.[48]

Here the *topos* of the fear of rape comes as a part of an illustration after an expression of ghetto thinking that includes the image of the outside world as threatening, an understanding that a 'ghetto' where people 'like you' can live together is a good idea, and that gentiles are not to be trusted. In other words, this version of ghetto thinking is complemented by the 'traditional,' Yiddish

female fear, rape by the gentile attackers – the transformation here is from Cossacks, more than Nazis, to Arabs – rather than being complemented by the post-Holocaust fear of murder, and by implication genocidal annihilation of the Jews.

One of the elements of ghetto thinking left out in the above quotation is the importance of the house/home and mother as a source of safety and protection. For this we can go to another quotation, this time from the son of survivors. He says:

> The Holocaust has scared me, wounded me, at best. I'm a fearful person. My mother, because of her overprotectiveness, instituted a sense of mistrust, that the world is a dangerous place. She was always reminding us to be on the alert to real or imagined dangers – making sure no one was following you, making sure you look around when you come home at night. There were constant reminders to check the doors and windows to see if they were locked.[49]

Here, the mother's protection, as is typical of ghetto thinking, correlates with a dangerous and threatening world. The securing of the doors and windows is what guarantees the home of the house as a place of safety, and of Jewish life. The parents of my Jewish lover always kept the windows locked, and the front door closed. In summer, the kitchen door would be left open into the back garden, which had a high fence around it.

THE TACTIC OF INVISIBILITY

In the modern world the binary structure of Ashkenazi life was transformed. In Chapter 1 I quoted the Haskalah saying, attributed to Moses Mendelssohn, that one should be a Jew on the inside and a man on the outside. This was lived out in the nation-states where Jews were emancipated and enfranchised in terms of 'being Jewish' in the privacy of one's own house, in the home, and 'being like every other member of the nation' in the public space outside of the house. Zygmunt Bauman has pointed out that assimilation is a nineteenth-century strategy of the nation to produce a homogeneous national people.[50] If everybody is culturally the same, then they can be differentiated as individuals. Assimilation expresses a desire of the powerful. However, there is another way to think about this injunction to become like everybody else 'on the outside,' or, at least, the way it was taken up by large numbers of Jews. This is as a subaltern tactic to escape the threat posed to you by the dominant population. Again, I want to emphasise that this way of thinking is not unique to Ashkenazi Jews, it has been a characteristic of many migrants, and minority groups, in circumstances where they have not been accepted for what they are, but attacked for their difference. It is, to coin a phrase, the attempt to become *invisible* to the host population.

Invisibility has an utterly different hermeneutic to assimilation, and its traditional corollary, passing. In assimilation, the state, as the actor for the national population, is concerned with migrants and minorities taking on the moral assumptions and/or the national culture. To assimilate, as a subaltern tactic, is the most radical form of becoming invisible. I have briefly discussed passing in the Introduction. In modernity, passing was the practice of appearing to be something one was not, and it presupposed some notion of essential difference: that one is 'really' black while passing for white, 'really' gay while passing as a heterosexual. Invisibility may involve elements of assimilation and of passing but its primary concern for the migrant or minority group is to enable them to live unnoticed, unremarked on, within the general population. Invisibility is often associated with the ideology of tolerance. Tolerance implies limits and, in Europe, has been intimately linked with a form of anti-Semitism which accepts the presence of a limited number of Jews under particular circumstances. If a group makes itself invisible – and the demand that its members assimilate, which in Europe meant acculturate, offers the alternative possibility of invisibility – it is more easily tolerated.

Although I am describing invisibility in modern terms, the classic reference point for it is the Conversos, or Marranos of premodern Spain and Portugal. These were the Jews who had been forced to convert to Christianity after the Reconquista in 1492. There is now much debate about how many of these Jews genuinely became Christian but it is clear that numbers of them were transformed into crypto-Jews, accepting Christianity on the outside but continuing to practise Judaism in secret. Of course, this raises a welter of issues about who was at that time considered by the dominant population, and by the Jews, to be a Jew. Also, this invisibility was more or less thrust upon these Jews rather than being a voluntary camouflage. Signalling the complexity of Jewishness in the modern world, Elaine Marks has taken up the idea of the Marrano as a metaphor 'for Jews who have to some extent been taken in by or assimilated to the other religious cultures in which they live (these may be Christian or Muslim) and who continue in spite of this inevitable acculturation to profess a belonging to Jewishness,'[51] or, she might have added, who have become secularised. What Marks has let go of here is the tactic of invisibility, and the anxiety that it produces among the dominant population about who is still 'really' a Jew/Jewish.

Writing about the post-emancipation Jewish experience, Alain Finkielkraut describes how

> Hatred or disgust for Jewish difference became a natural part of being an Israelite [the French term for an assimilated Jew]. Such difference, it must be understood, in Judaism extends well beyond the limited scope of the private sphere, and includes everything that meets the eye: gestures, sign language . . . the shape of the face, dress, pronunciation, the religious injunctions one must follow each day. . . . The only good Jew was an invisible Jew.[52]

When increasing numbers of strange-garbed, strangely behaved, Yiddish-speaking Jews started appearing from the Pale, they produced great anxiety among the invisible, and also the assimilated, Jews because it was feared that the visibility of the new arrivals would make all Jews visible. In Britain, as Andrea Freud Loewenstein notes, the explosion of anti-Semitism following the attempt to pass a Bill through Parliament in 1735 that would have given some Jews certain rights of citizenship taught the same lesson: 'Jews, who might be tolerated if they contributed economically but otherwise remained invisible, would be subject to persecution if they spoke out, or in any way called attention to themselves.'[53] When the *Ostjuden* started coming to Britain, 'the Board of Deputies joined with the British authorities to keep the newcomers out.'[54]

Individual invisibility may be a crucial element in personal success within the dominant culture. Discussing the Jewish situation in the United States in the post-Second World War period, Norman Kleeblatt has explained how

> Radical assimilation and clear separation of public persona from private self became standard strategy for Jews who sought entry to humanist and commercial professions. . . . The Jewish community thus achieved visible success while its individual members were becoming invisible.[55]

Here we have an example of how Mendelssohn's recommendation could be utilised. The assumption in this case is that, if you become invisible, you will not be prejudicially treated. Invisibility, as here, can be a means of entry into places, from hotels to professions, from which the dominant culture bans members of your group. In other, more negative circumstances, invisibility can simply be a protection against attack.

The practice of invisibility is very often a function of fear. Conversely, to become visible opens you, and often the group of which you are a member, up to attack, or, rarely but hopefully, praise. Virtually any schoolkid knows this. Becoming visible is often a function of nomination. For a group to be named makes it possible to identify people as members of that group. The Nazis understood this politics of visibility when they made those they designated as Jews wear yellow stars. Jews of Yiddish background understand it also when they comment on a Jew who has become newsworthy as a criminal that it is 'a pity (or a shame) for the people' (*shande far di goyim* – shame before the gentiles) or, when a Jew has gained public success, that it is 'a joy for the people.' Fear very often drives the desire for invisibility.

For Jews one of the most used tactics to aid in their becoming invisible has been to change the family name. Linda Grant had heard two family stories about why their name was changed from Ginsberg in the early 1950s. In one: 'Well, you were starting school and when Dad was a boy they called him guinea pig and he didn't want that to happen to you.'[56] Here the problem of being identified as Jewish is suppressed, and the solution to school-kids' vicious

humour seems quite disproportionate. In the other, Grant's father's name, appearing in 1948 in a London newspaper as part of his application for naturalisation as a British citizen provoked an anonymous, abusive, threatening, anti-Semitic letter, signed 'Anti-Jew.'[57]

Another tactic has been simply to become 'not-Jewish.' There is a very lengthy history of this as a subaltern, European Jewish tactic. The examples are legion, and increase with the knowledge of the Holocaust. Ivan Kalmar writes that 'Parents, fearful of anti-Semites, often decided not to tell their children that were of Jewish descent.'[58] The examples that he gives are Ludwig Wittgenstein (who, though, while having a father whose parents were both halachically Jewish [that is, Jewish in terms of Jewish law] but had converted from Judaism, was not, himself, halachically Jewish) and Albert Einstein. Kalmar quotes Einstein remarking on his finding out that he was Jewish: 'I owe this discovery more to the gentiles than to Jews.'[59] Haravon writes that her parents, having come as refugees to the United States, told their children 'not to tell people we were Jewish.'[60] Hirsch tells this story:

> And being Jewish [in Romania] is the fear of repetition, the nightly dreams of The War. It is what makes us leave and what allows us to leave. When we get to Vienna my parents decide it might be easier not to be Jewish any longer, and they truthfully put 'atheist' on our forms [they are non-observant]. But it is a lie I have to defend in front of Sabine, the only other Jewish girl in my class. She eventually guesses, of course, and I confess.[61]

Migration, even as it makes one visible in some ways, enables one to acquire invisibility in others. However, as Hirsch discovered, a knowledgeable observer may see through the dissimulation.

Successful invisibility can also create awkward problems. Madelaine Albright, née Korbel, was born of Jewish parents who fled communist Czechoslovakia in the late 1940s, after the end of World War II. In the United States the Korbels professed Catholicism and never mentioned their 'Jewishness.' Albright, herself, was brought up a Catholic, celebrating Easter and Christmas, and sharing a room at Wellesley with a Catholic. I do not here want to get into the complexities of definition of who might be considered a Jew other than to note that Albright is halachically Jewish. Only after her appointment as American Secretary of State, the highest position in American politics ever held by a woman, did a reporter break the news that her parents were, in fact, Jewish – and that, according to *halachic* law she is, therefore, Jewish. Suddenly, Albright's visibility as a woman, and as occupying a site of immense power in the American government, provided a platform for a new kind of visibility, one that her parents had sought to avoid.[62]

As for me, I have lived my academic life attempting to resolve the paradox of being an over-achiever while not wanting to become, indeed being fearful

of becoming, visible, not, it must be said, in the first place as a Jew. I did not used to think in these terms. Nevertheless, the knowledge lay there, repressed. When I was seven, I went to a convent school. It was the school closest to where we lived and I presume that my parents, being non-religious, sent me there because it was convenient. In class one day the Religious Education teacher, wanting to begin preparation for First Communion, went round each boy asking if he had been baptised. Of course, I was the only one who had to say I did not know. I did not, in fact, know, I did not even have a clear idea what baptism was! I was sent home with the injunction to ask my mother. This, I found a thoroughly traumatising idea. I knew the question would upset her profoundly, though I was unclear why it should. In my memory of what is, for me, a very emotionally charged story, the moment of greatest crisis was actually asking my mother the question. Indeed so anxious was I that my memory does not include how she replied. Suffice to say, though, that at the end of the term I was removed from the school and sent to another that limited its religious involvement to Church of England morning prayers – the statutory requirement – Religious Education classes, and church for the school boarders on Sunday.

I am sure that this story, of all my childhood stories about 'not fitting in,' about failing assimilation, is the most highly charged because in it I come the closest out of any of those events to becoming publicly visible *as a Jew* and also forcing my mother to admit what she was desperately trying to erase. Being visible as a Jew is different from simply acknowledging being a Jew. I remember some years later, in 1967 during the Six Day War, when I was a boarder at public school, my confusion when three of my friends there came up to me and told me that they were on my side. My first realisation was that they associated me with Israel. This was immensely confusing because I did not; I had not even really thought about Israel. My second realisation, and one that immediately produced anxiety was that these people *thought of me, in some way, as a Jew*. Although I knew they knew that I was Jewish, I had not thought of myself as being visible to them as a Jew.

Much later, during the mid-1970s when Jews in Britain were marching with the Anti-Nazi League against the National Front, I remember arguing with my Jewish lover's best friend's Jewish boyfriend that the best thing Jews could do was to ignore the National Front, that without publicity it would wither away. Even at the time, this argument of mine seemed somewhat self-serving; I had this feeling that I did not want to march for some other reason. Only more recently have I begun to understand how my attitude was connected with my fear of publicly declaring myself as a Jew and of becoming publicly visible, even for the length of time of a march. I am sure that this terrible fear of visibility was inherited from my mother, whose determination to 'assimilate' involved her not only marrying out but moving away from, and losing touch with, almost all her family in spite of their attempts to accept my father. This retrospective insight was helped by my observation of my fearful anxiety before

I gave my first 'Jewish paper' at a cultural studies conference.[63] There, it was immediately clear to me that making myself visible as a Jew giving a paper on a Jewish topic was something I found terrifying. This fear, too, of becoming visible, is a part of ghetto thinking.

NO FEAR: THE UNITED STATES AND ISRAEL

For many Jews in the United States, especially those descended from pre-Second World War migrants, and including those whose Yiddish ancestors came in the great migration of the late-nineteenth and early-twentieth centuries, the fear of becoming visible is much slighter, as is the sense of the world – in particular the United States – as a place of threat. For many and complicated reasons, some of which I have discussed elsewhere (see Chapter 6, 'Migrating to utopia'), Jews feel more 'at home' in the United States. As I have explained, in ghetto thinking, to feel at home is also to feel safe, free from the threat that makes one feel fearful in the world outside of the home.

In *Chutzpah*, a big-selling populist American assertion of Jewish identity, Alan Dershowitz, a human rights lawyer, avers that 'The eternal "wandering Jew" has now settled into two *goldeneh medinahs* – golden nations. Perhaps we have finally stopped wandering.'[64] The other *goldene medinah* is Israel. Dershowitz compares the Jewish circumstance in these two countries with that of the Jews in Europe. He argues that

> We [in the United States] are nervous, insecure, and 'even cringing.'
> But we are also different from French, German, Polish, Soviet, and
> Egyptian Jews. The source of *their* nervousness, insecurity, and
> cringing was largely *external*. They really were second-class citizens,
> guests in someone else's country. The source of *our* nervousness is
> largely *internal*. We may think of ourselves as guests in America, but
> the reality is different.[65]

The thrust of Dershowitz's argument is that American Jews should take what is theirs by right, which is their proper place as equals in American society. His claim is that Jews are accepted in the United States, that there is no threat of which to be frightened. Whether or not this is the case, this is what many Jews believe. In an interview in the British style magazine *The Face*, Mike D, one of the rap group The Beastie Boys, remarks, 'Why do most articles in the UK have to mention the words "Jewish" and "upper class"?'[66] This is a small, everyday perception. Mike D's point, correct or not, is that, in being identified as Jewish, and being made visible, the members of the group are being estranged from the dominant, white society of which they feel a part in the United States. It is through such perceptions, or the lack of them, that the feeling of 'home' is reinforced.

Dershowitz writes of Jews mistakenly thinking of themselves as guests in the United States. The use of the term 'guest' is worth commenting on. A guest is a visitor who usually has been invited, and who is made welcome. Guests are respectful, acknowledge their temporary presence, and do not assert themselves. They have certain rights and obligations, and they do not feel threatened. When Georg Simmel described the stranger in his 1908 sociological article, he wrote: 'The stranger will thus not be considered here in the usual sense of the term, as the wanderer who comes today and goes tomorrow, but rather as the man who comes today and stays tomorrow – the potential wanderer, so to speak, who although he has gone no further, has not quite got over the freedom of coming and going.'[67] He had in mind the Jew in Europe. The stranger is uninvited and is not necessarily made to feel welcome.

Discovering that one is more or less unwelcome, tolerated to some degree, is an important moment of recognition for members of minority and subaltern groups. I have already indicated how tolerance works in the modern nation-states of Europe, in the context of visibility. My own founding moment in this regard, the moment when I recognised that, as a member of a particular group, as a Jew, I was not universally accepted in England came when I was about nine. I had travelled up to London by train with my father. At Victoria Station I went to the toilets. As I sat on the seat, I started to read the graffiti on the door in front of me. I found myself confronted with the first anti-Semitic scrawl that I had ever consciously seen. I remember sitting there in the privacy (and safety) of the cubicle realising for the very first time that this general statement about Jews – I cannot remember exactly what it said, something along the lines of 'Jew scum, you should all be killed' – applied to me specifically as an individual. It was a shocking and profoundly alienating event. Before, I had felt like I did not belong, now I felt unwanted.

Dershowitz's point, though, is that the Jew in the United States is not (even) a guest. Jews should not feel nervous and insecure, fearful I would say, because there is no justification for this. He contrasts this with Europe where, as he describes synagogues he has visited there, he creates a sense of permanent and oppressive threat. Here is Dershowitz's description of the synagogues of Western Europe:

> In Italy, France and Spain there are metal detectors in the entry-ways to the synagogues. Once, when I was leaving for a visit to Paris, my mother pleaded with me to stay away from dangerous places. I thought she meant Place Pigalle. But she quickly told me it was the synagogues – which had recently been bombed by terrorists – that she had in mind.[68]

The invocation of his mother's solicitous protection is a nice touch. Europe, for Dershowitz, the site of the Diaspora, is contrasted with the United States and Israel, the twin sites of home. Europe is the outside world, the place of gentile

threat, and Jewish fear, where Jews cannot be at home, again as compared to the United States and Israel, both utopian golden lands. It becomes clear that Dershowitz has not got past his ghetto thinking. Rather, he, and many other American Jews one presumes, has redrawn the form of the binary structure: now it is two countries which are 'home,' and Europe, at least, is the dangerous and threatening world outside.

For Dershowitz, if the United States is home because it is the country that Jews are able to share on equal terms with gentiles, Israel is the home that Jews have carved out for themselves in the face of European genocide and Arab destruction. As he writes: 'For Jews like me ... Israel represents Jewry's positive response to centuries of anti-Semitism in general and to Hitler's attempted genocide in particular.'[69] At the same time:

> The most serious threats to the physical survival of Jews are today directed against Israel, where more than three million Jews make their home. Israel, which has become the secular religion for millions of Jews around the world, presents both the greatest hope and the most profound challenge to the future of the Jewish community.[70]

To describe Israel as a secular religion suggests as remarkable a libidinal engagement as it does to suggest that 'modern Zionism has become for many Jews a new and more affirmative raison d'être for their Judaism.'[71]

Israel is, for Dershowitz, an answer to, among other things, 'Jewish power-lessness – our inability to defend ourselves against Crusades, pogroms, and the Holocaust – and our reliance on the generosity of others who did have power (but all too often refused to use it on our behalf).'[72] Dershowitz was rehashing and celebrating in 1991 a way of thinking about Israel, actually a part of Zionist and Israeli ideology, that had been dismissed by the well-known Israeli novelist and commentator, Amos Oz, in 1962. In a piece entitled 'The State as Reprisal,' Oz wrote:

> who, other than one who hates himself, can take pleasure in the vision of the State of Israel as a perpetual armed camp ready at any moment to 'teach a lesson' to all sorts of non-Jews? Who, other than a self-hater, would feel the need to protest endlessly that we are strong and cruel and suntanned and we work on the land and love sports and we are bold and warlike?[73]

Oz views this image of Israeli Jews as the product of an inversion of the image of Jews as 'studious weaklings, full of pity, pale-faced and intellectual, hating bloodshed.'[74]

Where Dershowitz sees Europe as a place where all but a remnant of oppressed and constantly threatened Jews have disappeared, Israel is the new active ghetto, created by Jews themselves and defended by the new type of (Ashkenazi) Jew with all the attributes so critically outlined by Oz. What I am

suggesting here is that Dershowitz, and others, are making a displacement. If the United States is the safe home as opposed to the threatening outside world of Europe, then Israel, the uncanny other home of the Jews, an *ex nihilo* self-creation by Ashkenazi, and particularly Yiddish, Zionists, who remain the most powerful group there, takes on the fantastic characteristics of inverted ghetto thinking. In this way, while American Jews are able, ideally, to live without fear, Israel lives out the fantasy of the powerful ghetto. Israel, then, is also, but in a different way, the antithesis of the European Diaspora. If fear is banished from American Jewish life, it is central to Israeli life, and what makes Israel strong.

The way to understand this is through a discussion of the image of the sabra, the native-born Israeli Jew. The term has been applied to Jews born in Palestine since before the state of Israel was established, at least since 1945. Sabra is the Hebrew word for the prickly pear cactus. This grows in the desert and is hard and prickly on the outside but soft on the inside. This is supposed to express the qualities of the true Israeli who is courageous and tough but also sensitive and generous. By analogy, it expresses the image of Israel that the Zionist/Israeli ideology would like to naturalise. Echoing Oz, Ella Shohat has commented that 'The prototypical newly emerging Jew in Palestine – physically strong, with blonde hair and blue eyes, healthy looking and cleansed of all "Jewish inferiority complexes," and a cultivator of the land – was conceived as an antithesis to the Zionist virtually anti-Semitic image of the "Diaspora Jew."'[75] The reference to blonde hair and blue eyes connotes the introjection of an Aryan, if not Nazi memory. We should remember Kaplan's description of the grocery boy who walked with her and her grandmother. Here, though, the characteristics of the aggressor, the provoker of fear, have been internalised as aspects of the new fearless Israeli Jew.

In *States of Fantasy*, Jacqueline Rose discusses the insight of the Palestinian writer Rajeh Shehadeh that 'Sometimes I think I am the victim of the victims of the Nazis. . . . He acts, and I dream the dreams that he should have.'[76] Rose writes about this using the psychoanalytic idea gleaned from Nicolas Abraham and Maria Torok of 'transgenerational haunting,' in which 'one generation finds itself performing the unspoken unconscious agendas of the one that went before.'[77] Both Abraham and Torok were Hungarian and Jewish. They began working together in 1950. Elizabeth Bellamy has remarked that their work 'seems uncannily attuned to the complex collective unconsciousness of the generation that survived Auschwitz.'[78] One gets the feeling that the Israeli cultural imaginary thinks the Palestinian refugee camps, the Gaza Strip and the West Bank, and the towns like Hebron now handed back to the Palestinian Governing Authority, through the prism of ghetto thinking as ghettos. This time, though, it is the ghettos that contain the threat which enters the home of Israel (which, of course, is a reverse ghetto; that is, ideally, an area of no fear for Jews where they are not confined but live voluntarily in freedom) and can be contained by closing off traffic. It is, then, within this much older way of thinking that Ashkenazi-descended Israelis act out their fearful internalisation

of Nazi threat as part of their fantasmatic, utopian inversion of the European stereotype of the Jew.

In *The First Million Sabras: A Portrait of the Native-born Israelis*, Herbert Russcol and Margalit Banai provide the most detailed discussion of the sabra as she or he exists in Israeli national discourse. They write that 'The sabra's complex feelings towards Jews abroad are colored by the fact that he can never grasp, although he knows the sad answers, why six million Jews let themselves be murdered by the Nazis.'[79] The 'sad answers' have to do with the Israeli image of the Diaspora Jew as weak and ineffectual. Russcol and Banai provide an Israeli heritage for 'Fortress Israel' in 'Fortress Masada,' the Jewish fortress to which the Romans laid siege in 67 CE;[80] fortress, then, rather than the inversion of the ghetto that I have been suggesting. The structure is the same, only the connotations are different. In 'Masada or Yavneh?' Boyarin has argued that, in fact, the myth of Masada in which, it is claimed, the Jews defended the fortress for three years and, when further defence was impossible, the defenders killed themselves rather than surrender to the Romans, is actually an appropriation of the Roman value system. Boyarin counterposes Josephus's version of what happened at Masada with a story from the Babylonian Talmud in which the defenders of Masada are described as 'hooligans.' Boyarin argues that, in this, other, circumstance, 'Rabbi Yohanan [who had himself smuggled out of the fortress] prefers life and the possibility of serving God through the study of Torah over everything else.'[81] His point is that accepting Josephus's version is an example of how Zionist ideology has incorporated Roman (and 'masculine') and, indeed, I would add, dominant 'Western,' values over Talmudic, subaltern values.

Russcol and Banai also write about fear. In the context of kibbutz life, they explain:

> Other traits and norms of the Children's Houses also spread quickly to sabras in town. One hid one's emotions; one was matter-of-fact, stolid. As an Israeli psychiatrist has observed, 'our children are ashamed to be ashamed, afraid to be afraid.' One was unhesitatingly loyal to one's comrades. This, as a hundred books have noted, was fully displayed by the sabra's unhesitating courage and loyalty to his army unit during the Six Days' War.[82]

Here, sabra fear is conquered by fear itself. However, to be afraid to be afraid does not suggest that a person is not fearful. Rather, the person is repressing their primary fear in order not to appear fearful in society. In this way, fear is converted into courage; though, more likely into aggression. Likewise, it would seem that, rather than getting rid of the fear inherent in ghetto thinking, the Ashkenazi-Israelis have repressed and transformed it.

On my first visit to Israel my friend and I were driven to the Israeli/Jordanian border by a Palestinian taxi-driver. As we neared the border crossing

we saw groups of smartly dressed Israeli army personnel, all heavily armed and edgily alert. As we got to the dropping off point near the Sheikh Hussein Bridge our driver asked, somewhat rhetorically, 'What are they all so afraid of?' While we waited in the midday heat to cross the border we were closely but surreptitiously watched. My friend slipped away to go to the toilet without any of the customs or army people noticing and there was a certain agitation when they saw the place empty where she had been sitting. Finally, with a show of great officiousness and bureaucratic efficiency, we were allowed onto the bus that took us over the bridge, across the River Jordan and to the Jordanian customs post. Here there was a markedly relaxed atmosphere. The customs officials were friendly, helpful, possibly a little lackadaisical. There were just a couple of soldiers, chatting, and one soldier manning a machine-gun post had his feet up and was reading a newspaper. This was not an army about to invade.

What, indeed, are the Israelis afraid of? Everything, of course. The history of Arab and Palestinian violence and war against Israel is too well known to need repeating here. But we also must remember how Jewish-Israeli attitudes are mediated by ghetto thinking. If the Palestinians and other Arabs did not exist, the Israelis would have to invent them. To some extent they have, through their own intransigence and violence. In the process they have legitimated what I call the 'paranoid posture.' This is a way of looking out at the world which assumes that Israel is always under threat, always about to be attacked, and that any individual, if not Jewish (but these days this is a problematic category), and Zionist, might be an aggressor. Therefore, Israel always has to be on the alert, especially at the borders. Israeli politics are, in part, the politics of everyday fear.

NOTES

1 Brian Massumi (ed.), *The Politics of Everyday Fear*, Minneapolis, University of Minnesota Press, 1993, p. 12. (Massumi's italics).
2 Brian Massumi, *The Politics of Everyday Fear*, p. 12.
3 Louis Wirth, *The Ghetto*, Chicago, University of Chicago Press, 1928, p. 287.
4 Louis Wirth, *The Ghetto*, p. 287.
5 Louis Wirth, *The Ghetto*, p. 10.
6 In *Marxism and Literature* (Oxford, Oxford University Press, 1977), Raymond Williams writes of structures of feeling that, 'We are talking about characteristic elements of impulse, restraint, and tone; specifically affective elements of consciousness and relationships: not feeling against thought, but thought as felt and feeling as thought: practical consciousness as a present kind, in a living and interrelating continuity' (p. 132).
7 Eva Hoffman, *Shtetl: The Life and Death of a Small Town and the World of Polish Jews*, Boston, Houghton Mifflin, 1997, p. 116.
8 Eva Hoffman, *Shtetl*, p. 80.
9 Ilan Halevi, *A History of the Jews: Ancient and Modern*, trans. A. M. Berrett, London, Zed Books, 1988, p. 115.

10 R. D. Laing, *The Politics of Experience and the Bird of Paradise*, Harmondsworth, Penguin Books, 1967, p. 74.
11 R. D. Laing, *The Politics of Experience*, p. 74.
12 Quoted in Annette Wernblad, *Brooklyn Is Not Expanding: Woody Allen's Comic Universe*, Rutherford, N. J., Fairleigh Dickinson University Press, 1992, p. 16.
13 Alice Kaplan, *French Lessons: A Memoir*, Chicago, University of Chicago Press, 1993, p. 10.
14 Alice Kaplan, *French Lessons*, p. 11.
15 Linda Grant, *Remind Me Who I Am, Again*, London, Granta Books, 1998, p. 27.
16 Daniel Boyarin, 'Masada or Yavneh? Gender and the Arts of Jewish Resistance' in Jonathan Boyarin and David Boyarin (eds.), *Jews and Other Differences: The New Jewish Cultural Studies*, Minneapolis, University of Minnesota Press, 1997, pp. 306–29.
17 Daniel Boyarin, 'Masada or Yavneh?', p. 315.
18 Daniel Boyarin, 'Masada or Yavneh?', p. 315.
19 Linda Grant, *Remind Me Who I Am, Again*, p. 31.
20 Linda Grant, *Remind Me Who I Am, Again*, p. 32.
21 Quoted here from Helen Fein, *Genocide: A Sociological Perspective*, London, Sage, 1990, p. 9.
22 Alice Kaplan, *French Lessons*, p. 11.
23 Alice Kaplan, *French Lessons*, p. 11.
24 Alice Kaplan, *French Lessons*, p. 12.
25 Alice Kaplan, *French Lessons*, p. 12.
26 Alice Kaplan, *French Lessons*, p. 10.
27 Riv-Ellen Prell, 'Why Jewish Princesses don't Sweat' in Howard Eilberg-Schwartz (ed.), *People of the Body: Jews and Judaism from an Embodied Perspective*, Albany, State University of New York Press, 1992, p. 338.
28 Both versions are given in full in English in Mark Slobin, *Tenement Songs: The Popular Music of the Jewish Immigrants*, Urbana, University of Illinois Press, 1982, pp. 203–4.
29 Eva Hoffman, *Lost in Translation: A Life in a New Language*, New York, Penguin Books, 1990, p. 83.
30 Eva Hoffman, *Lost in Translation*, p. 84.
31 Eva Hoffman, *Lost in Translation*, pp. 162–4.
32 Eva Hoffman, *Lost in Translation*, p. 104.
33 Eva Hoffman, *Lost in Translation*, p. 104.
34 Eva Hoffman, *Lost in Translation*, p. 104.
35 Eva Hoffman, *Lost in Translation*, p. 104.
36 Leon Grinberg and Rebecca Grinberg, *Psychoanalytic Perspectives on Migration and Exile*, New Haven, Yale University Press, 1989, p. 75.
37 Elizabeth Bellamy, *Affective Genealogies: Psychoanalysis, Postmodernism, and the 'Jewish Question' after Auschwitz*, Lincoln, University of Nebraska Press, 1997, p. 45.
38 Marianne Hirsch, 'Pictures of a Displaced Girlhood' in Angelika Bammer (ed.), *Displacements: Cultural Identities in Question*, Bloomington, Indiana University Press, 1994, p. 77.
39 Marianne Hirsch, 'Pictures of a Displaced Girlhood', p. 77.
40 Aaron Hass, *In the Shadow of the Holocaust: The Second Generation*, Cambridge, Cambridge University Press, 1996, p. 8.
41 Aaron Hass, *In the Shadow of the Holocaust*, p. 12.
42 Lea Haravon, 'A Child of Survivors Reflects', *The Daily Iowan*, 1997.
43 Quoted in Sara Bershtel and Allen Graubard, *Saving Remnants: Feeling Jewish in America*, Berkeley, University of California Press, 1993, p. 170.

44 Aaron Hass, *In the Shadow of the Holocaust*, p. 30.
45 Aaron Hass, *In the Shadow of the Holocaust*, pp. 36–7.
46 Aaron Hass, *In the Shadow of the Holocaust*, pp. 37.
47 Quoted in Aaron Hass, *In the Shadow of the Holocaust*, p. 30.
48 Quoted in Aaron Hass, *In the Shadow of the Holocaust*, p. 37.
49 Quoted in Aaron Hass, *In the Shadow of the Holocaust*, pp. 38–9.
50 Zygmunt Bauman, *Modernity and Ambivalence*, Cambridge, Polity Press, 1991.
51 Elaine Marks, *Marrano as Metaphor: The Jewish Presence in French Writing*, New York, Columbia University Press, 1996, p. xviii.
52 Alain Finkielkraut, *The Imaginary Jew*, trans. Kevin O'Neill and David Suchoff, Lincoln, University of Nebraska Press, 1994, pp. 65–6.
53 Andrea Freud Loewenstein, *Loathsome Jews and Engulfing Women: Metaphors of Projection in the Works of Wyndham Lewis, Charles Williams and Graham Greene*, New York, New York University Press, 1993, p. 19.
54 Andrea Freud Loewenstein, *Loathsome Jews and Engulfing Women*, p. 19.
55 Norman Kleeblatt, '"Passing" into Multiculturalism' in Norman Kleeblatt (ed.), *Too Jewish? Challenging Traditional Identities*, New Brunswick, N.J., Rutgers University Press, 1996, p. 5.
56 Linda Grant, *Remind Me Who I Am, Again*, p. 48.
57 Linda Grant, *Remind Me Who I Am, Again*, p. 39.
58 Ivan Kalmar, *The Trotskys, Freuds and Woody Allens: Portrait of a Culture*, Toronto, Viking, 1993, p. 36.
59 Ivan Kalmar, *The Trotskys, Freuds and Woody Allens*, p. 36.
60 Lea Haravon, 'A Child of Survivors Reflects'.
61 Marianne Hirsch, 'Pictures of a Displaced Girlhood', p. 79.
62 For a discussion of Albright's Jewishness see Marjorie Garber, *Symptoms of Culture*, New York, Routledge, 1998, pp. 88–99.
63 This was the conference in Tampere in 1996 that I discuss in the Introduction.
64 Alan Dershowitz, *Chutzpah*, Boston, Little, Brown and Co., 1991, p. 5.
65 Alan Dershowitz, *Chutzpah*, p. 7.
66 Johnny Davis, 'The Boys Who Never Grew Up', *The Face*, vol. 2(18), July 1998, p. 85.
67 Georg Simmel, 'The Stranger' in Donald Levine (ed.), *George Simmel: On Individuality and Social Forms: Selected Writings*, Chicago, University of Chicago Press, 1971, p. 143.
68 Alan Dershowitz, *Chutzpah*, p. 187.
69 Alan Dershowitz, *Chutzpah*, p. 209.
70 Alan Dershowitz, *Chutzpah*, p. 208.
71 Alan Dershowitz, *Chutzpah*, p. 209.
72 Alan Dershowitz, *Chutzpah*, p. 209.
73 Amos Oz, 'The State as Reprisal' in Amos Oz, *Under This Blazing Light: Essays*, Cambridge, New York, Press Syndicate of the University of Cambridge, 1995, p. 68.
74 Amos Oz, 'The State as Reprisal', p. 67.
75 Ella Shohat, 'Columbus, Palestine and Arab-Jews: Toward a Relational Approach to Jewish Identity' in Keith Ansell-Pearson, Benita Parry and Judith Squires (eds.), *Cultural Readings of Imperialism: Edward Said and the Gravity of History*, New York, St Martin's Press, 1997, p. 98.
76 Rajeh Shehadeh, *The Third Way: A Journal of Life in the West Bank* quoted in Jacqueline Rose, *States of Fantasy*, Oxford, Clarendon Press, 1996, p. 31.
77 Jacqueline Rose, *States of Fantasy*, p. 31.
78 Elizabeth Bellamy, *Affective Genealogies*, p. 22.

79 Herbert Russcol and Margalit Banai, *The First Million Sabras: A Portrait of the Native-born Israelis*, New York, Dodd, Mead and Co., 1970, p. 11.
80 Herbert Russcol and Margalit Banai, *The First Million Sabras*, p. 27.
81 Daniel Boyarin, 'Masada or Yavneh', p. 323.
82 Herbert Russcol and Margalit Banai, *The First Million Sabras*, p. 211.

Part 2

(DIS)PLACEMENT
IN THE STATE

4

JEWS, REPRESENTATION AND THE MODERN STATE

In the Jewish religio-cultural complex, Diaspora, and its complementary theme, the Return, are pervasive ideological tropes through which the experience of being Jewish is mediated.[1] As Sander Gilman has pointed out, 'the overarching model for Jewish history has been that of the center and the periphery.'[2] For Immanuel Wallerstein, who first theorised the core-periphery model, it was a way of understanding the economic organisation of the modern world system.[3] This is certainly not to suggest that Jews were modern *avant la lettre* but, rather, that the Jewish understanding of Diaspora intersects in complicated ways with the organisation of the modern 'western' world. Until 1948 there was nowhere for Jews to return to, the Return was a myth set in a utopian future. With the establishment of Israel the mythic core-periphery structure of Diaspora and Return was fundamentally altered, at least in the ideological claims of Zionists and of the Israeli state. The important point here is that the materialisation of Israel took the shape of a modern state.

The core-periphery model is central to modernity because of the way spatial relationships tended to be organised in capitalist modernity. In global terms this meant the 'west' and the rest, within each state it meant the capital and the provinces. When the Jewish core was set in a semi-mythic past and an imaginary future, the Diasporic present operated as a temporalised periphery which was, simultaneously, always already a representation of the core-that-is-to-come. To put it simply, the Diaspora had to be lived as home because the *real* home was impossibly positioned in the future. As the modern states took shape around them the Jews became, literally, displaced; people out of place. Unlike the great diasporas of modernity, most importantly the African, the Jewish diaspora preceded modernity but was, nevertheless, reconstituted by it. Within the modern states the pre-existing Jewish presence, with no Jewish state to give referential meaning to the 'Jews' – the problem, if you like, of whether 'Jews' are a nation or a religious group – placed the Jews in an anomolous situation. Zionism offered one Jewish solution to this anomoly.

The realisation of Israel – albeit with a concretisation of precisely the same problem: whether Israel is a secular state composed mostly of Jews or a religious state composed solely of Jews – altered, as I have remarked, the Jewish

experience of the core-periphery problem. One aspect of that alteration was an unsettling of the Diaspora. As Israel passed the Law of Return and Zionists and Israelis argued for Jewish allegiance, if not *aliyah*, to Israel, so there was an attempt to transform the Diaspora into a diaspora; that is, to strip the Diaspora of its metaphysical form and reconstitute Diasporic Jewry as the diasporic periphery to Israel.

If postmodern Jewry may be defined as those 'Jews' of the post-Holocaust, post-assimilation and post-acceptance of Israel world, then the postcolonial aspect of that experience lies in the ambiguities of being a Diaspora Jew in the time of the Israeli state.[4] Logically, then, the experience of Jewry in the modern period, before the creation of Israel, is, in ambiguous and complicated ways, a colonial experience. The construction of the Jews as Other to the representational order of the modern state was a key feature in the formation of those states. It is this construction that I want to explore here, and I want to do this through a discussion of the ideas of Sigmund Freud, Jean-François Lyotard and Slavoj Zizek as each, in turn and in different ways, has concerned himself with the problem of representation as the defining feature of Jewish Otherness in modernity. Finally, I will argue that representation is the defining political feature of the modern state and that the modern state's desire and inevitable failure to achieve perfect representation, identity, between its leaders and its citizens has been the cause of modern political anti-Semitism.

RACE AND NATION

Through the late eighteenth and nineteenth centuries the Jews of Europe were gradually emancipated. This happened in the context of the establishment of that new, modern phenomenon, the nation-state in which the government took its claim to a right to govern not as something God-given but as a mandate from, a social contract with, the people. Of course, this was not a new idea. It was an important theme in the political theory of the Enlightenment from at least Hobbes to Rousseau. However, with the various ends to absolutist regimes across Europe, most often linked to the changes wrought by Napoleon, the claim, in some form or another, to represent the people of the nation-state became the basic form of legitimisation. It was within this context that the notion of a group of people as a single nation which should be, more or less, coterminous with a particular state, evolved. At the same time the historical claim was always that the 'nation' preceded the bureaucratic structure of the state. In turn, the claim to nationhood was *de facto* a claim to a certain area of land, the land on which the nation had evolved and with which it had been linked since time immemorial. It was within this context that the Jews were emancipated within the various European nation-states.

The emancipation of the Jews tended to take place after that of working-class men but before that of women. In one sense the emancipation of the Jews was

quite different from that of these other two groups. Unlike the Jews, both working-class men and women were thought of as incontrovertibly members of the nation. However, Jews were not so thought of. Central to the modern thinking about the nation was the idea of homogeneity. I have argued in earlier chapters that, ideally, the modern nation was considered to be made up of a single people, manifested in one culture, one language, and limited in mem-bership to one race, identified usually by colour and physiognomy, and that the racialisation of the Jews took place during the nineteenth century.

In popular narratives of the nation-state, the state arises out of the nation. Anthony Giddens has defined the state – though here he calls it the nation-state – in this way:

> The nation-state, which exists in a complex of other nation-states, is a set of institutional forms of governance maintaining an administrative monopoly over a territory with demarcated boundaries (borders), its rule being sanctioned by law and direct control of internal and external violence.[5]

In this logic, the nation is thought of as the undifferentiated entity made up of individuals who represent themselves to themselves as an imagined community having the identity of a particular nation.[6] The state represents the nation, something expressed through the importance of voting to the modern state. In the vote the individual member of the nation joins with the other members of the nation in establishing the state as representative of the nation. It is no wonder, then, that in some nation-states voting is compulsory. In those modern states which are not democratic, the government, occupying the position of power within the state, still argues its legitimacy through a claim to embody the will of, and represent, the people – that is, the nation. It is in relation to the state, then, not the nation, that the historical emancipation of the Jews between working-class men and women is important. In the first place, the problem is not membership of the nation but access to power in the state. In the case of the Jews it so happens that right of access to state power depended on the belief that Jews could be assimilated into the nation. In the other cases the question was not one of national membership but of the broadening of access to state power from the male bourgeoisie to other groups of people within the nation.

Representation and identity have underpinned the practice of the nation-state. Moreover, representation has been central to the politics of the nation-state. In one aspect, it is expressed through the connection between the state's concern over who should be emancipated, and enfranchised, and the national concern with assimilation.[7] If a group is to be emancipated it should also be assimilable. Assimilation was supposed to be total, with only religious differ-ence somewhat allowable but, even here, religious difference was really only possible within the limits of Christianity; non–Christian religions were heathen

119

and not really to be tolerated within the secular but still ultimately Christian nation-states of Europe.[8]

Emancipation was thought of in universalist terms as involving the rights of all human beings. However, assimilation was thought of in particularistic terms, the ability to assimilate as part of a specific national group. The point of assimilation was the preservation of what was considered to be a perfectly homogeneous national group, a group having a single national identity which, in representational terms, meant that it was perfectly representable to itself. The Jews were emancipated as human beings but, in the end, their assimilation foundered on a claim to their racial difference which varied across the nation-states of Europe. As we shall see, if Jews were thought of ambivalently as potential members of the nation, then their situation in relation to membership of the state was equally ambivalent. The question this chapter addresses is, to the extent that, as a fundamental part of their ambivalence, Jews were constructed in the modern, European state as Other, how has this Otherness been constituted? The conventional way in which Jews have been Othered in the nation-state has been through their racialisation. In the first place, this pertains to the nation. However, I will be arguing, as I outlined at the beginning, that what is really at stake is the problem of representation in the formation of the modern state.

As we saw in Chapter 1, the discourse of race was appropriated by the states as the most important way of limiting membership of the nation which formed the membership of the state. The ambivalent racialisation of the Jews correlates with the ambivalence of their inclusion/exclusion as members of the new European nation-states. The claim to a Jewish racial difference – and the development of political anti-Semitism – was greatest in those nation-states, such as Germany, in which the problem of constructing a single nation, and providing legitimacy for a single state government, was most to the fore. To illustrate this we can briefly trace the history of the racialisation of the Jews in German thought through the career of Wilhelm Marr, whose life spans both the upheavals of 1848 and the founding of the modern German Empire, and who is credited with inventing the term 'anti-Semitism.'

Marr was born in 1819. In the years before 1848 he was a radical, as his biographer, Mosche Zimmermann, puts it, 'Marr dreamed of the coming revolution, giving his first priority to the "universal European republic," while according a lesser position to the "indivisible German republic." '[9] At this point Marr supported Jewish emancipation, arguing for a general, social revolution. With the failure of the 1848 revolution, Marr began turning away from concerns with universal liberation and looking more towards the establishment of a unified German republic. For this reason he began to support Prussia. From this period, Marr's interest in the Jews shifts from emancipation to assimilation. In 1862, just before the publication of his book *Der Judenspiegel* ('The Mirror of the Jews'), Marr wrote back to an associate who was seeking his help in campaigning for equal rights for the Jews of Bremen: 'Leave me

alone. The truth on the Jewish question is slowly being revealed to me. . . . I am no longer willing to co-operate on this issue.'[10] Zimmermann comments that 'this letter . . . shows that the strange change which Marr is undergoing *is based on, and is a continuation of, his radicalism*.'[11] Marr's interest now is in a national, German revolution and he sees what he thinks of as Jewish difference as an impediment to this. At this point Marr describes the Jews as a 'state within a state.'[12] This conflates the distinction between 'nation' and 'state' and shows well what Marr, and many others, considered to be the threat posed by the Jews. From this point of view the threat from a group who are not a part of the dominant – ideally, the only – national group, and who are understood to be (part of) another national group who do not have a nation-state of their own elsewhere, is that it may form a state within the dominant state.

It is at this time, in *The Mirror of the Jews*, that Marr began to racialise the Jews. He describes them as Orientals but, at the same time, seems to argue that, if they are prepared to assimilate, their racial difference will be eliminated. Marr argues that assimilation will produce emancipation by default! He avers that, in Zimmermann's words, 'If there are racial characteristics, they can be ascribed to the process of degeneration which is a consequence of the Orthodox Jewish law which demands exclusivity in marriage.'[13] His solution is intermarriage.[14] I will return to this aspect of Marr's ideas when I discuss Freud's thinking about anti-Semitism below.

By the late 1860s Marr had developed his racial outlook more fully. Now his European-based universalism was manifested in his claim to the existence of three European races, Slavs, Romans and Germans, which break down into national units that can vary over time within each racial grouping. These races are contrasted with a generalised Orientalism or Asianism. From this time on Marr began to argue that racial difference was ineradicable, even by the means of intermarriage.

The work for which Marr is most well-known is *Der Sieg des Judenthums über das Germanenthum* (*The Victory of Jewry over Germandom*), published in 1879. Incredibly pessimistic, this book nevertheless achieved significant popularity, going into a seventh printing after only four months. In ten editions the book sold 16,500 copies.[15] Published after the founding of the Prussian-based German Empire, *The Victory of Jewry over Germandom* found fertile soil in increasing anti-Jewish activity. In this book Marr provides what he claims is a cultural and historical history demonstrating '*the world-historical triumph of Jewry*.'[16] Lifting off from the stereotype of the Jew as having 'Semitic cunning and the realistic spirit of business,'[17] Marr describes how

> the stubbornness and endurance of the Semites have led them in the course of the nineteenth century to the position of pre-eminence in the society of the West. In fact, in Germany it is not Jewry that has merged into Germandom but Germandom that has merged in Jewry.[18]

In a newspaper article about this time Marr argued for 'the isolation of Jewry within the state and society' in the hope that 'the Jews would disappear from the Fatherland, never to return.'[19] Marr had travelled a long road. Still the revolutionary radical, he now viewed Jews as members of a race which must be excluded from Germany if Germany was going to fulfil its destiny as a German nation-state. It was now that Marr coined the term 'anti-Semitism' as part of the title for his 'Anti-Semitic League.'

Marr spent his declining years fighting against what he called 'the business of anti-Semitism.' From his point of view this consisted of crude, racist attacks that were linked to a nationalism which had no radical and revolutionary form. This was, in fact, the new anti-Semitism which views the Jews simply as the source of all the problems in the nation-state. Nowhere was this more the case than in Germany where, in addition to the nationalist drive of the late nineteenth century, rapid industrialisation also caused havoc. As Dietz Bering puts it, 'in this epoch, scapegoats had to be sought and found for phenomena of unprecedented dimension, extreme tensions which were produced by this period of upheaval.'[20]

Where the 'business of anti-Semitism' was the modernised form of traditional, everyday anti-Judaism, the anti-Semitism espoused, and given this name, by Marr was quite different. Marr's anti-Semitism was concerned with eradicating Jews from the incipient German nation-state. By the time Marr's ideas had coalesced, he thought of the Jews as a race which had no place within the nation that formed the basis of the German state. It was the Jews, we might say, who Marr thought of as threatening the very presence of the German state − a presence founded on the nation's homogeneity, its existence as a singular identity which could be represented in the political process of the state.

FREUD, LYOTARD, ZIZEK AND THE PROBLEM OF REPRESENTATION

Freud, Lyotard and Zizek all identify Jewish difference in religious terms. At the same time, as in the claims to racial difference, the claims that these thinkers make about Jewish religious difference are couched in universalist rhetoric. I will argue that, once we set aside the universalist ideas, the discussions of all three thinkers can help us to understand how the Jews have been produced as Other in terms of the assumptions which form the ideological basis of the state. The mystery of why Freud, Lyotard and Zizek should be concerned with religious difference rather than racial difference is resolved once we realise that, in their discussions of religious difference, what is really at stake is the representability of the Jews. Now that we can appreciate the centrality of representation to the practice of the modern state, we can understand that these thinkers are, in fact, concerned with how in Europe, the Jews have been constructed as Other to the modern state rather than to the nation.

Freud's focus in *Moses and Monotheism* is twofold: to identify what is particular to Judaism and what is the nub of anti-Semitism. His argument, that Jewish difference and persecution are founded on the Jews' refusal to admit to killing the Father, depends on Freud's narrative about the origin of society in which society comes into existence as a consequence of the son's murder of the primal Father. I will argue that, if this narrative is understood as actually being about the formation of the nation-state then Freud's discussion of Jewish difference can be more usefully read. Implicit in Freud's argument is the importance of representation to the organisation of society, or, rather, the state. Representation is central to both Lyotard's and Zizek's arguments. However, neither makes the connection with the importance of representation to the state, instead, viewing it in terms of a religious difference between Judaism and Christianity. Having retheorised the work of Freud, Lyotard and Zizek on Jewish difference to illuminate how Jews have been thought of as problematising the representational system of the nation-state, I go on to discuss the importance of conspiracy as the Other to the social contract which operates as the foundational myth of the state. Where representation arises out of the order implied by the social contract, conspiracy challenges that order, and by implication unsettles representation. Yet, as we will see, conspiracy also precurses society in Freud's formulation, or, in my rereading of Freud, the state. In the guise of the Other who threatens the (nation)-state, Jews have been construed as the arch-modern conspirators, and *The Protocols of the Elders of Zion* as the text which most clearly portrays their conspiracy.

Moses and Monotheism is an awkward book, full of repetition and with the key argument about the particularity of Judaism coming in the final section. All this was a result of the pressures of writing it in Vienna just before the *Anschluss* and subsequently rewriting it in the comparative freedom of London. Bearing in mind Freud's assimilation, that this is his most sustained discussion of Judaism may well also have played its part in the book's convoluted organisation. Freud's argument is that Jewish monotheism represents a return of the repressed. We might add that the same point about the return of the repressed might be made about Freud's concern with the Jews in this work, and their absence in any integral sense in his other psychoanalytic writings. Freud takes up his claim, made in *Totem and Taboo*, that society is founded on the sons' killing and eating of the primal Father of the horde. This is the event which Freud argues forms the basis for exogamy. Now Freud extends his argument, suggesting that as society evolved so humanity's gods gradually gave way to one single, omnipotent God:

> One of [the gods] was often elevated into being supreme lord over gods and men. After this, the further step was hesitatingly taken of paying respect to only one god, and finally the decision was taken of giving all power to a single god and of tolerating no other gods beside him. Only thus was it that the supremacy of the father of the primal

horde was re-established and that the emotions relating to him could be repeated.[21]

Here, what is special about Judaism is that its monotheism presages Christianity and Islam as an aspect of socio-cultural development.

It is within this context that Freud accounts for the antipathy in the west to the Jews:

> The poor Jewish people, who with their habitual stubbornness continue to disavow the father's murder, atoned heavily in the course of time. They were constantly met with the reproach 'You killed our God!' And this reproach is true, if it is correctly translated. If it is brought into relation with the history of religions, it runs: 'You will not *admit* that you murdered God' (the primal picture of God, the primal father and his later incarnations).[22]

In this somewhat abstruse passage, Freud is referring to the crucifixion of Jesus. For Freud, the murder of Jesus repeats a primal moment when the Jews murdered Moses who led them out of captivity in Egypt. In Freud's argument it was this Moses, actually an Egyptian, who converted them to monotheism. The murder of this Moses was repressed and, two generations later, there was another Hebrew leader called Moses. Eventually, the memory of the two Moseses was fused into a single person. Freud sees a continuity in the reason for antipathy to the Jews from the time of Jesus' murder to the present. Freud identifies Jesus as the Son who stands in for the Father. Taking on board the version of history in which the crucifixion of Jesus was the result of Jewish intervention, Freud argues that the history of Jewish persecution is the consequence of the Jews' refusal to admit that, from a Christian perspective in which Jesus is, indeed, the Son of the Father, they have (once again) murdered the Father. Freud goes on to argue that, in contrast, the Christians admit their role in Jesus' crucifixion and feel themselves to be absolved. He does not develop this part of his argument any further but one can suppose that, no longer tied to their God by guilt – and, indeed, the Jewish vengeful God being transformed into a loving God – Christians obey their God out of love not terror.[23]

Lyotard has a more fundamental reading of – I presume because he does not reference it – this passage of Freud's. Central to Lyotard's argument is the problem of representation or, more precisely, that which cannot be represented, that against which there is a God-given proscription about representation. Lyotard argues that the refusal to admit the murder of the Father applies (also?) to the very first murder on which society was founded, and this refusal was a consequence of the injunction by God against representation:

> [The people] is asked not to represent, not to stage the original difference, as is the case with all religions, including Christianity, by

means of sacrifice, the first representational economy. Freud calls this the refusal to admit the murder of the father, a murder he holds to be foundational for any community.[24]

There are two important points to note here. First, unlike Freud, Lyotard essentialises Jewish difference by setting the Jewish disavowal back in the primal scene of the original, foundational murder, and making this a consequence of a precursive intervention by God. The second point is Lyotard's emphasis on the importance of representation. Unable to have the totemic feast, the Jews are 'constrained to irreconciliation because of this "denial", exiled from the inside and chased away, deprived of settling in a landed domain, in a scene; chased forward, in the interpretation of the voice, of the originary difference.'[25] What I want to highlight here is the connection between the deprivation of land on which to live and the disallowance of representation. To put this insight into its historical context, we could say that the claim of a people to be a 'proper' nation depends on two things which go together: an apparently essential relationship with a particular area of land and the representability of the people to itself as a homogeneous entity.

Lyotard's intent is to describe an originary difference to other Europeans which places the Jews as the Othered category, 'the jews:'

> within the 'spirit' of the Occident that is so preoccupied with foundational thinking, what resists this spirit; within its will, the will to want, what gets in the way of this will; within its accomplishments, projects and progress, what never ceases to reopen the wound of the unaccomplished. 'The jews' are the irremissable in the West's movement of remission and pardon.[26]

Here the Jews are experienced as the Other whose presence blocks the modern utopian dream of the perfectability of representation, the deployment of a seamless Western (I use a capital here because in this fantasy the West would define itself) identity. The Jews, in the form given them by the west as 'the jews,' are the site of an internal, productive and absolute Difference.

Zizek also constructs Jews as the Other in – one presumes, because he does not specify – western thought.[27] However, Zizek is less concerned with representation as such. Rather, he connects Jews with Lacan's 'Che vuoi?' in the political domain. Following Lacan, Zizek describes the 'Che vuoi?' – the 'what is it you really want?' – as the expression of a gap, the gap that persists 'between utterance and enunciation: at the level of utterance you're saying this, but what do you want to tell me with it, through it?'[28] Lacan, and Zizek, argue that this unfulfillable desire is the consequence of our subjective construction by the Other. Zizek suggests that in the political domain this 'Che vuoi?' 'erupts most violently in the purest, so to say distilled form of racism, in anti-Semitism: in the anti-Semitic perspective, the Jew is precisely a person about whom it is

never clear 'what he really wants' – that is, his actions are always suspected of being guided by some hidden motives (the Jewish conspiracy, world domination and the moral corruption of gentiles and so on).'[29] Here we need to note, again, the false universalism. This construction of Jews, this element of 'the jews,' has only arisen in the west, and only since the development of the modern state and the formulation of what became known as 'the Jewish problem,' the complex connection between emancipation and assimilation.

We must, then, ask why Jews have come to occupy this position of the Other whose desire is unknowable. Here, Zizek resorts to a claim about the Jewish religion. He asks, 'is not the Jewish God the purest embodiment of this "*Che vuoi?*," of the desire of the Other in its terrifying abyss, with the formal prohibition to "make an image of God" – to fill out the gap of the Other's desire with a positive fantasy-scenario?'[30] Here we are returned to Lyotard's concern with representation. In both cases it is the proscription on representation which Others Jews. What Zizek is implying is that, unlike for Christians, for Jews – it is, of course true about Muslims also but they are not constructed as the internal Other of the west – there can be no representation to serve as a substitute, and weak, fulfilment of the subject's unquenchable desire.

Like Freud, Zizek compares the Jewish and Christian religions but with a different purpose. He argues that the Jewish religion is a religion of anxiety. For the Jews there is no transcendental, no ontological representation to provide relief 'from the unbearable gap of "*Che vuoi?*,"'[31] whereas Christianity is a religion of love in which the claim about God's love replicates what, in fact, we really desire: 'In this sense love is, as Lacan pointed out, an interpretation of the desire of the Other: the answer of love is "I am what is lacking in you."'[32] The Jewish religion reveals what the Christian religion conceals, the unassuagibility of desire. From this point of view, the Christian religion offers comfort while the Jewish religion offers the truth. Anti-Semitism, then, may be understood as a consequence of most people's inability to live without some mollification of their endless desire. Again, we must question the implicit essentialism and universalism here. While Jewish persecution is as old as Christianity, anti-Semitism is specifically modern. Further, I would argue that feudal pogroms do not simply differ in degree and technology from the Holocaust. Rather, the modern construction of 'the jews' involves a distinctively modern preoccupation with representation as the site of (re)production not of society itself, but of the modern, secular, patriarchal state – the state which is founded on a notion of representing itself to itself, whether this be in the massifications of fascism or the democracy of the liberal state. In both these cases, and others, the state seeks identity in itself as a perfect representation of itself. Freud's narrative of the primal horde and the murder of the father is better read as an origin story for the authoritarian and patriarchal modern state.

Following on from this, we can understand modern Jewish difference better as presenting a fracture, a blockage in the representational order of the modern,

western state. In Freud's story, the father in the horde is everybody's father — there is no primal mother. The father has a monopoly over sexual access to the women of the horde. The sons kill their father in order to gain this access. However, having murdered him, the guilt they experience gives him a power in death even greater than the power he had in life. Here we have the source for Lacan's idea of the proscriptive Law of the Father. The lived manifestation of this is in the Law of the state. At the beginning of *The Trial*, Franz Kafka describes Joseph K.'s thoughts when the warders come for him:

> What authority could they represent? K. lived in a country with a legal constitution, there was universal peace, all the laws were in force; who dared seize him in his own dwelling?[33]

However, one of the warders tells K. that

> Our officials, so far as I know them, and I only know the lowest grades among them, never go hunting for crime in the populace, but, as the Law decrees, are drawn towards the guilty and must then send out us warders. That is the Law.[34]

What K. misunderstands is that the legal constitution only limits the power of the state to the extent that those who make the laws are held to that limit. The actual Law of the state is equivalent to the state's power over the individual. Here we should remember Giddens's observation that the rule of the state is sanctioned by both law and violence. It is the latter which establishes and guarantees the former. This Law patrols the limits of the state itself. From this point of view one reading of *The Trial* is that, written by an assimilated Jew, it describes the fear of being identified as Jewish and, therefore, not completely a member of the state's nation. It is in this situation, on the border of the state, if you like, that the Law of the state becomes most apparent.

In Freud's narrative, the upshot of the sons' inability to practice endogamy is an exogamy which, in the exchange of women, provides the binding moment which creates society. This is spelled out in Claude Lévi-Strauss's reworking of Freud's myth in his classic book *The Elementary Forms of Kinship*.[35] What this story does not tell us is what the limits to exogamy are. I would argue that they are, ideally in the modern state, the nation-come-racial limits of the nation itself. In other words, reworking Freud's myth, we can say that the nation-state is constructed through the exogamous linking of primal hordes — families — which, bound together by the exchange of women, form the basis for the always already existent nation. In the terms of this formulation we can see how the exogamous circulation of women within the nation-state forms the secondary condition for representation.[36] The primary condition, as we have seen, lies in the totemic feast which, symbolically, suggests the internalisation of the guilt which, in turn, establishes exogamy.

Within the nation-state, then, homogeneity is produced through the exogamic circulation of women. However, not only may Jews not marry gentiles from the nation-state in which they live, but they are able to marry Jews who are members of other nation-states. Here we have a twofold threat to representation. First, and most importantly, the endogamy of Jews within the nation-state challenges the representational unity of the nation-state. In his anti-Semitic book, *Wenn ich der Kaiser wär* (*If I Were the Kaiser*), published in 1912, Daniel Fryman argued for an Aliens Law in Germany to be imposed on Jews. He suggested a definition of a Jew for the purposes of such a law as, 'anyone who belonged to the Jewish religious community as of January 18, 1871, as well as descendants of persons who were Jews on this date, even if only one parent were Jewish.'[37] This date was that of the establishment of the German nation-state in the form of the German Empire. Fryman is arguing for the racialisation of the Jews from this time. As the category of race evolved in the nineteenth century, so it was used not only to mark the absolute limit to membership of the nation but also to mark the limit of marriageability.[38] Implicit in Fryman's suggestion are claims about race, the limits of exogamy and the construction of the German nation-state. Also implicit is a concern about Jewish endogamy. It is endogamy which underlies Fryman's connection of a Jewish religious community with a Jewish race. Second, the possibility of exogamy beyond the limits of the Law offers the spectre of allegiances among Jews which challenge the integrity of the nation-state in relation to other nation-states. I will come back to this point below when I discuss the development of Jewish world-conspiracy theory.

We do not need to resort to claims about the forbiddenness of the representation of God in Judaism to help explain the virulence of anti-Semitism. The Jews are thought to block the national possibility for perfect representation. Zizek makes a similar point but then devalues it in favour of a universalist argument about the nature of society. He writes that 'The whole Fascist ideology is structured as a struggle against the element which holds the place of the immanent impossibility of the very Fascist project; the "Jew" is nothing but the fetishistic embodiment of a certain fundamental blockage.'[39] He goes on to write that 'Society is not prevented from achieving its full identity because of Jews: it is prevented by its own antagonistic nature, by its own imminent blockage and it "projects" this internal negativity into the figure of the Jew.'[40] The Jews, this people, neither a religious grouping nor a race, not a national group but Other to all western nationalities, are taken to be the source of the failure of the nation-state to represent itself to itself perfectly. If this is indeed the source of the failure then effacement, whether by assimilation or genocide would seem to offer a solution. We can, then, understand both in terms of a crisis of representation in the modern state. Of course it goes without saying that neither solution would, in fact, solve the problem of perfecting the nation-state's representation to itself. In this sense Zizek has hit the nail on the head, the desire for perfect representation is always unassuagable, the nation-state's identity can never be transcendentalised in itself; it can never be perfect.

THE NATION-STATE, CONSPIRACY
AND THE JEWS

There is another way of thinking through this problem of Jewish difference, one which more clearly picks up on Freud's myth of the fraternal slaying of the father. This is to think of the modern state in terms of the political myth of contract theory which provides its ideological support. The foundation of contract theory is the claim that all interaction in society – or, better, all interaction in the civil society of the state – is based on contract, and that all contracts in the state can be traced back to an original, mythical contract which founded society or, in my terms, the state. In her important discussion of the patriarchal form of modern contract theory, Carole Pateman identifies two main versions of the foundation story. In one, espoused by the classical contract theorists of the seventeenth and eighteenth centuries, Hobbes, Locke and Rousseau:

> the inhabitants of the state of nature exchange the insecurities of natural freedom for equal, civil freedom which is protected by the state. In civil society freedom is universal; all adults enjoy the same civil standing and can exercise their freedom by, as it were, replicating the original contract when, for example, they enter into the employment contract or the marriage contract.[41]

The other version, narrativised by Freud and utilised by Lévi-Strauss, 'is that freedom is won by sons who cast off their natural subjection to their fathers and replace paternal rule by civil government.'[42] Pateman convincingly argues that in both these accounts women are excluded from the originating contract providing an ideological legitimation for the development of the modern state in terms of a patriarchal political system. Here we should remember that, alongside women, it was the Jews who remained excluded the longest from the modern state and that Jews were consistently feminised in nineteenth-century thought.[43]

The basis of contract theory lies in the ideas of individual freedom and the equality of all men (*sic*). These ideas provide the basis for the construction of the membership of any particular state. It is within this context that we can understand the new importance of the discourse of race in the eighteenth and nineteenth centuries. Since race supposedly carries with it certain natural traits, it enables the ideology of all men (*sic*) being equal to be circumscribed where certain individuals, groups, states considered it to be necessary.

The counterpoise to this strategy of exclusion by identifying certain people as fundamentally different was the ideology of assimilation. Here, the idea was to transform a group which had only non-essential, mundane differences into a part of the identical, homogeneous group which, by virtue of their very sameness, could be bound together by a shared contract. At this point we must recognise again the fundamental modernity of anti-Semitism. As Finkielkraut

puts it so well, after emancipation the Jews devoted their energies to assimilating, refuting the charges of separatism, meanwhile:

> a far more serious charge, being prepared at that very moment by the most sophisticated intellectuals, had gone unseen: the conspiracy myth. As ardent fighters for universal freedom of belief, the Israelites had cleared themselves of obstinately clinging to their identity. But even as they answered suspicions as to their *stubbornness*, new adversaries arose to accuse them of attempting to *Jewify* society as a whole.[44]

Conspiracy, and particularly conspiracy to take over the nation-state, and the world, is a central tenet of modern anti-Semitism. This, indeed, is the ideological backdrop to the Holocaust, and what separates its intent from the intent of the premodern pogroms. As Norman Cohn writes, 'Exterminatory anti-Semitism appears where Jews are imagined as a collective embodiment of evil, a conspiratorial body dedicated to the task of ruining then dominating the rest of mankind.'[45] In *Warrant for Genocide*, Cohn not only traces the history of that most notorious of forgeries which claims to prove a Jewish conspiracy to take over the world, *The Protocols of the Elders of Zion*, but sets it in the context of the development of an atmosphere in which the assumption of a Jewish conspiracy was naturalised.

In order to understand how this came to be we need to return to the theorisations of the original contract that formed the basis for the modern state. In both of the versions what we find is that the original contract is preceded by what we can only call a conspiracy. The classical version of contract theory is notorious for one particular intractable problem. How was it that people came together in the state of nature so that they might make the original contract? Such an arrangement suggests a prior series of discussions, a conspiracy, out of which the original contractual meeting was agreed upon. The Freudian version makes the conspiracy more obvious. Here, the sons come together and conspire to kill their father. It is their success which paves the way for the modern state. Conspiracy, then, shadows the modern state. It is what precedes it and the rule of law; that is, the establishment of the power of the name-of-the-father. Conspiracy is what enables the modern state to exist but it is not, itself, a part of the legitimate ordering of that state.[46] As a consequence, it is not surprising that conspiracy is what the modern state fears most because, if conspiracy brought the state, and its rule in the-name-of-the-father, into existence then it can equally destroy it.

Moreover, conspiracy against the state always sets the conspirators against the original contract. This is bad enough if they are members of the state, but if their membership is at best ambiguous, if, as in the case of the Jews, in spite of emancipation they remain Other, then their conspiracy is perceived as an inevitable consequence of their radical Difference. In *Anti-Semite and Jew*

Jean-Paul Sartre explained how, in liberal-democratic nation-states, the democrat thinks in terms of individuals and 'by individual [the democrat] means the incarnation in a single example of the universal traits which make up human nature.'[47] For this reason, Sartre argued, '[The democrat] recognizes neither Jew, nor Arab, nor Negro, nor bourgeois, nor worker, but only man – man always the same in all times and places.'[48] The democrat thinks of individuals, the nation thinks of a unique, homogeneous collectivity. The resolution lies in the idea of a group of individuals who all share, or can come to share, the same culture. Race is the ultimate, essential, marker of the limit to that possibility. Thus racialisation was the way in which the modern world distinguished the possibility of inclusion from exclusion. Jew, Arab and Negro are all racial categories.[49] Those who remain a part of what Sartre calls 'concrete syntheses' formed in history and who either exclude themselves or are excluded from the nation in which they live will, ultimately, be considered as conspirators against the state in which they live.

Cohn finds the first modern conspiracy myth in a 1797 book about the French Revolution by the Abbé Barruel called *Mémoire pour servir à l'histoire du jacobinisme*. This is not surprising given that it was the French Revolution which ushered into existence the French nation-state, the state which became the model for later western nation-states. The main idea for the Abbé's book was lifted from a Scottish mathematician called John Robison who published his own book one year later than Barruel's. Cohn notes that Barruel's five-volume work 'was translated into English, Polish, Italian, Spanish, and Russian, and it made its author a rich man.'[50] That two men could be writing simultaneously on the same theme and that one of their books could become so immensely popular suggests a new, modern cultural myth was being elaborated. This, first, version of the conspiracy myth did not involve the Jews, rather these conspirators were the Templars, the Illuminati and the Freemasons. In this conservative attack on the modern state, these groups were thought to have destroyed the old order in the French Revolution.

The first association of the Jews with grand conspiracy came in the shape of the Simonini letter, a letter from Florence purporting to come from an army officer called J.B. Simonini – but which may well have been fabricated by the French secret police to influence Napoleon against the Jews. This was sent to Barruel and pointed to the supposed power and influence of 'the Judaic sect' throughout Europe.[51] However, most conspiracy theories until the mid-nineteenth century seem to have concentrated on the Freemasons rather than the Jews. Then, in 1868, Hermann Goedsche, using the pseudonym Sir John Retcliffe, published a novel called *Biarritz* which contains a chapter entitled 'In the Jewish Cemetery in Prague.' It describes a nocturnal meeting between representatives of the twelve tribes of Israel plus one more person representing 'the unfortunates and the exiles.' Their discussion centres on the Jewish attempts to undermine or take control of the main aspects of modern society after which, within the next hundred years, the Jews will have taken power in

the world. This chapter was subsequently excised, revised and published in a variety of forms, often claiming to be the report of an actual meeting. From this period on a variety of books and pamphlets in numerous languages inveighed against the Jews and the supposed Jewish world-conspiracy including Osman-Bey's *World Conquest by the Jews* which had reached its seventh edition in 1875. On the French-based Jewish self-help organisation, Osman-Bey wrote that 'The Alliance Israélite Universelle can be destroyed only through the complete extermination of the Jewish race.'[52]

The *Protocols* itself was first published in Russian in a number of editions between 1903 and 1907.[53] English, German and French versions were published in 1920 and the Nazi party acquired the rights to a German edition in 1929 after which it ran to twenty-two editions by 1938. Cohn outlines the basic idea of the *Protocols* like this:

> Over a period of many centuries a plot has been in operation to place all political power in the hands of those who alone are qualified to use it properly – that is to say, in the hands of the Elders of Zion. Much has been achieved but the plot has not yet reached fruition. Before the Elders can establish their rule over the whole world the existing gentile states, already seriously undermined, must be finally abolished; and the Elders have very precise ideas as to how this is to be accomplished.[54]

There is no need here to detail what these are. Suffice it to say that, by a variety of means, the capitalist and nation-state based system of economics and government will be brought down and replaced by a Jewish sovereign who will rule over a world united in the Jewish religion.

Certain points remain a constant from here on: the critical perception of premodern aristocratic rule, the generation of chaos, and the destruction of the nation-states through conspiracy. It is important to note that, whereas Barruel saw his conspiracy as succeeding in overthrowing the *ancien régime*, the *Protocols* and subsequent anti-Semitism view the Jews as a threat to the nation-state. Arguably, then, Barruel's history materialises the contract theory myth of a conspiracy which puts in place the original contract on which the nation-state is founded while the *Protocols* view conspiracy as the transgressive threat to the nation-state itself. It is not simply that a different political grouping will gain power. Rather, first of all, viewing the Jews as a racialised Other means that, if they gain power, a different race will control the nation-state. Second, the Jews ultimately seek the destruction of the nation-state system itself. If conspiracy can bring the state into existence then it can also destroy it. Where the Freemasons, being a secret society, were a good choice for an internal, conspiratorial threat to the state, the Jews were the best choice. The idea of the Jews as conspirators against the state-form itself draws on the ambiguous positioning of the Jews as white/non-white, a national group/a religious and

cultural grouping, and, of course, as that group who, though having been emancipated, ultimately remain Other – exemplified in their endogamy – and cannot be assimilated into the nation-state.

This helps to explain the apparent paradox that those states, France and Germany, which most espoused the humanist and universalist values of the Enlightenment, and which attempted to establish the most completely enlightened political state apparatuses, were also the nation-states in which political anti-Semitism throve most virulently in the late nineteenth and twentieth centuries. Britain, on the other hand, has often been celebrated for its tolerance of Jews – its relatively low level of political anti-Semitism. Here, since Jews were allowed into positions of political power in the mid-nineteenth century, there has been relatively little institutionalised, political anti-Semitism. This is not to discount groups such as Oswald Mosley's Black Shirts, or the National Front, but rather to think through why anti-Semitism has never become a major part of political rhetoric in the countries of Britain.[55] Isaiah Berlin, to take one prominent Jewish and English political philosopher, has argued for a particular inflection in the English understanding of political freedom – the emphasis on tolerance.[56] This may well be. I would argue that the cause lies in the historical failure of the bourgeoisie in England to establish a representational state system based on Enlightenment values. Britain's political system, its mode of government and its political ethos, all operate in a complex complicity with the older, aristocratic system.[57] It is the least modern of all the European states, with the possible exception of Russia. Representation is, then, not as central to the formation of the British state as it has been to, say, that of France or Germany. At the same time the idea of a conspiracy that threatens the existence of the state is not so important in a country which has no myth of the founding of the modern state.

While the British contract theorists were writing in the wake of the English civil war, the hybrid state form that developed after that period owed relatively little, even in its post-nineteenth-century form, to Enlightenment ideas. Taking all this into account we can understand that the relative lack of political anti-Semitism in Britain owes less to any greater sense of tolerance among the British, a greater acceptance of the virtues of universal humanist values, and much more to Britain's neo-feudal, premodern political backwardness. It has, for example, no written constitution. Within this context, in thinking about the British nation-state, neither Jewish assimilation nor Jewish Otherness has been as central an issue in the political sphere as they have been in other European states.

CONCLUSION

Given this argument, we can see that political anti-Semitism will be most likely in precisely those nation-states that are most modern. This does not mean it

will occur. First of all, it would seem that political anti-Semitism correlates with a situation in which there is a struggle to form a modern state, or where the legitimacy of the state is in doubt. Second, other groups may occupy a position analogous to that of the Jews. This is the case in the United States where the problematic position of African-Americans in relation to the American state has, in the main, overwhelmed the ambivalence attributed to Jews. In general, though, it was the Jews, ambivalently Othered in relation to the nation, who were perceived as the threat to the representational system on which the modern state was founded.

NOTES

1 The most relevant discussion of the idea of Diaspora is Daniel Boyarin and Jonathan Boyarin's important article, 'Diaspora: Generation and the Ground of Jewish Identity', *Critical Inquiry*, vol. 19(4), 1993, pp. 693–725.
2 Quoted here from 'The Frontier as a Model for Jewish History' given as a lecture at the 'Jewries at the Frontier' conference, The Isaac and Jessie Kaplan Centre for Jewish Studies, University of Cape Town, South Africa, August, 1996.
3 Immanuel Wallerstein, *The Modern World-System*, New York, Academic Press, 1974.
4 In the same paper of Gilman's from which I have already quoted, he refers to a talk by Amos Elon in which he coined the term 'post-Zionism,' an important aspect of the acceptance of the reality of Israel as an established nation-state.
5 Anthony Giddens quoting himself in *The Nation-State and Violence* in *A Contemporary Critique of Historical Materialism*, vol. 2, Berkeley, University of California Press, 1985, p. 121.
6 The evocative term 'imagined community' comes from Benedict Anderson's important book *Imagined Communities*, London, Verso, rev. ed., 1991.
7 Aside from Anderson's *Imagined Communities* there are a number of good discussions on the nation. Two of the best are Ernest Gellner, *Nations and Nationalism*, Oxford, Blackwell, 1983; Anthony D. Smith, *The Ethnic Origins of Nations*, Oxford, Blackwell, 1986.
8 We should not forget that England still has an established Church.
9 Mosche Zimmermann, *Wilhelm Marr: The Patriarch of Anti-Semitism*, New York, Oxford University Press, 1986, p. 22.
10 Quoted in Mosche Zimmermann, *Wilhelm Marr*, p. 43.
11 Mosche Zimmermann, *Wilhelm Marr*, p. 44. Zimmermann's italics.
12 Mosche Zimmermann, *Wilhelm Marr*, p. 47.
13 Mosche Zimmermann, *Wilhelm Marr*, p. 47.
14 Some of which he himself practised, three of his four wives being Jewish.
15 Mosche Zimmermann, *Wilhelm Marr*, p. 166, note 58.
16 Wilhelm Marr, *The Victory of Jewry over Germandom* in Richard Levy (ed.), *Antisemitism in the Modern World: An Anthology of Texts*, Lexington, Mass., D.C. Heath, 1991, p. 77.
17 Wilhelm Marr, *The Victory*, p. 81.
18 Wilhelm Marr, *The Victory*, p. 80.
19 Quoted in Mosche Zimmermann, *Wilhelm Marr*, p. 88.
20 Dietz Bering, *The Stigma of Names: Antisemitism in German Daily Life, 1812–1933*, Cambridge, Polity Press, 1992, p. 87.

21 Sigmund Freud, *Moses and Monotheism* in James Strachey (ed.), *The Standard Edition of the Complete Psychological Works of Sigmund Freud*, vol. 23, London, The Hogarth Press, 1958, p. 133.

22 Sigmund Freud, *Moses and Monotheism*, p. 90.

23 The most detailed, erudite and incisive discussion of *Moses and Monotheism* is Yosef Hayim Yerushalmi, *Freud's Moses: Judaism Terminable and Interminable*, New Haven, Yale University Press, 1993.

24 Jean-François Lyotard, *Heidegger and 'the jews'*, trans. Andreas Michel and Mark S. Roberts, Minneapolis, University of Minnesota Press, 1990, pp. 21–2.

25 Jean-François Lyotard, *Heidegger and 'the jews'*, p. 22.

26 Jean-François Lyotard, *Heidegger and 'the jews'*, p. 22.

27 Eric Santner, 'Postmodernism's Jewish Question: Slavoj Zizek and the Monotheistic Perverse' in Lynne Cooke and Peter Wollen (eds.), *Visual Display: Culture Beyond Appearances*, Seattle, Bay Press, 1995, provides a rather more detailed discussion of Zizek's use of the Jews in his work, in connection with Zizek's contribution to the foundation of a postmodern ethics. What is most striking to me about Santner's discussion is his acceptance of Zizek's socio-psychoanalytic universalism.

28 Slavoj Zizek, *The Sublime Object of Ideology*, London, Verso, 1989, p. 111.

29 Slavoj Zizek, *The Sublime Object of Ideology*, p. 114.

30 Slavoj Zizek, *The Sublime Object of Ideology*, p. 115.

31 Slavoj Zizek, *The Sublime Object of Ideology*, p. 116.

32 Slavoj Zizek, *The Sublime Object of Ideology*, p. 116.

33 Franz Kafka, *The Trial*, London, Secker and Warburg, 1968, p. 10.

34 Franz Kafka, *The Trial*, p. 13.

35 It is interesting to note that Lévi-Strauss, like Freud, was an assimilated Jew.

36 Alide Cagidementriu in 'A Plea for Fictional Histories and Old-Time "Jewesses"' in Werner Sollors (ed.), *The Invention of Ethnicity*, New York, Oxford University Press, 1989, repeats Simone Vauthier's insight from 'Textualité et stéréotypes: Of African Queens and Afro-American Princes and Princesses: Miscegenation in *Old Hepsy*' that 'there is a symmetry between incest and miscegenation.'

37 Daniel Fryman, *If I Were the Kaiser*, extracted in Richard Levy, *Antisemitism in the Modern World*, p. 131.

38 On race and the limits to marriageability see Robert Young, *Colonial Desire: Hybridity in Theory, Culture and Race*, London, Routledge, 1995.

39 Slavoj Zizek, *The Sublime Object of Ideology*, p. 126.

40 Slavoj Zizek, *The Sublime Object of Ideology*, p. 127.

41 Carole Pateman, *The Sexual Contract*, Cambridge, Polity Press, 1988, p. 2.

42 Carole Pateman, *The Sexual Contract*, p. 2.

43 On this see Jacques Le Rider, *Modernity and the Crisis of Identity: Culture and Society in fin-de-siècle Vienna*, Cambridge, Polity Press, 1993; Sander Gilman, *The Jew's Body*, New York, Routledge, 1991.

44 Alain Finkielkraut, *The Imaginary Jew*, trans. Kevin O'Neill and David Suchoff, Lincoln, University of Nebraska Press, 1994, p. 73.

45 Norman Cohn, *Warrant for Genocide*, Harmondsworth, Penguin Books, 1970, p. 280.

46 In 'Postmodernism's Jewish Question,' Santner argues that 'At the "origin" of every social space one finds a void filled by a foundational act that establishes the conditions of intelligibility and the necessity of that space. Such foundational acts, even when they inaugurate a reign of law, are, in essence, acts of violence' (p. 241).
 Santner goes on to quote Zizek on violence and the reign of law from Zizek's *For They Know Not What They Do: Enjoyment as a Political Factor*, London, Verso,

1991. Once again the experience of the modern state is ignored in the elaboration of a universalist socio-psychoanalytic argument.

47 Jean-Paul Sartre, *Anti-Semite and Jew*, trans. George J. Becker, New York, Schocken Books, 1965, p. 55.

48 Jean-Paul Sartre, *Anti-Semite and Jew*, p. 55.

49 'Bourgeois' and 'worker' are not analogous categories to Jew, Arab and Negro. Their presence in Sartre's list is a function of a Marxist understanding of class construction. Only this would legitimate thinking of bourgeois and worker as members of concrete syntheses.

50 Norman Cohn, *Warrant for Genocide*, p. 31.

51 All this information comes from Norman Cohn, *Warrant for Genocide*, pp. 31–4.

52 Quoted in Norman Cohn, *Warrant for Genocide*, p. 65.

53 Norman Cohn, *Warrant for Genocide*, p. 72.

54 Norman Cohn, *Warrant for Genocide*, p. 68.

55 Here I am making a distinction between political and everyday anti-Semitism. While these two forms do overlap, political anti-Semitism is primarily concerned with the role of Jews in the public sphere and in the political life of the nation-state. In contrast, everyday anti-Semitism describes the lived experience of anti-Semitism in everyday life. It is in this kind of anti-Semitism that visible difference and cultural assimilation are most important. Everyday anti-Semitism has been quite common in England, as George Orwell remarked in his essay 'Anti-Semitism in Britain,' published in 1945, 'Prejudice against Jews has always been pretty widespread in England.' See also Margaret Sampson 'Jewish Anti-Semitism? The Attitudes of the Jewish Community in Britain Toward Refugees from Nazi Germany', *The Jewish Chronicle*, March 1933–September 1938' in John Milfull (ed.) *Why Germany? National Socialist Anti-Semitism and the European Context*, Providence, Berg, 1993.

56 Isaiah Berlin, *Four Essays on Liberty*, Oxford University Press, 1969, in particular 'John Stuart Mill and the Ends of Life' in which Berlin follows Mill's emphasis on the importance of tolerance and the acceptance of diversity in ideas, including religious ideas, in *On Liberty*.

57 On the unique relationship in Europe between the aristocracy and bourgeoisie in England see Perry Anderson, 'Components of the National Culture' in Alexander Cockburn and Robin Blackburn (eds.), *Student Power*, Harmondsworth, Penguin Books, 1969. See also Tom Nairn, *The Break-up of Britain: Crisis and Neo-Nationalism*, London, New Left Books, 1977.

5

HISTORICISING THE IDEA OF DIASPORA

This chapter explores the idea of diaspora from the point of view of the Jewish experience. This is not because I want to take the Jewish diaspora as in some way typical. Indeed, quite the reverse is the case. I want to argue for a historical understanding of diaspora. One that recognises that the changes in the historical context of what we generally call diasporas affect the meaning and experience of being in diaspora. Distinguishing the variety of western Jewish diasporic experience from that of other groups of people who experience themselves as diasporic will help us to theorise the meaning of 'diaspora' as it is more generally applied.

THEORISING DIASPORA

Undoubtedly, diaspora is more and more being used as a descriptive, and rather under-theorised, term for the massive population movements that are one aspect of the development of global capitalism. Before elaborating her own theorisation of the term, Avtar Brah writes that

> In the context of a proliferation of new border crossings, the language of 'borders' and of 'diaspora' acquires a new currency. A variety of new scholarly journals have one or other of these terms in their titles. Yet, surprisingly, there have been relatively few attempts made to theorise these terms.[1]

She is right. Moreover, James Clifford notes, 'the language of diaspora is increasingly invoked by displaced peoples who feel (maintain, revive, invent) a connection with a prior home.'[2] As he indicates, this use of the term 'diaspora' is a recent phenomenon. Khachig Tölölyan, who has provided a detailed discussion of this development, distinguishes between the traditional application of the term to what he describes as the three 'classical' diasporas, the Jewish, Greek and Armenian, and the new usage, which he dates from around the late 1960s, in which the term has been generalised to cover those previously

described as 'exile groups, overseas communities, ethnic and racial minorities, and so forth.'[3]

Tölölyan argues for the importance of a variety of diverse and apparently quite unconnected factors in this discursive shift. He names twelve, from 'Accelerated immigration to the industrialized world,' 'The degree of existing institutional organization in the national homeland, and the extent to which those organizations accompany the immigrants,' to 'Racial difference,' 'The affirmation of a collective subject' and a specific set of changes in 'The American University.'[4] However, none of these important specific factors enables us to understand why there has been a general discursive shift, an impulse to reimagine a wide variety of types and experiences of population movements as being similar enough to apply the same terminology to them.

Perhaps Tölölyan's best insight here comes when he notes that 'In the past three decades, just as the nation-state has begun to encounter limits to its supremacy and perhaps even to lose some of its sovereignty, diasporas have emerged in scholarly and intellectual discourse as "the exemplary communities of the transnational moment" or as "exemplary social, cultural and even political conditions of late modernity."'[5] Here, a recognition of the changing circumstance, and experience, of the modern nation-state is connected with a refiguring of many of the groups who compose the state's citizens, and perhaps its nation. Later in this chapter I will delineate some of the features which we can theorise as specifying 'diaspora' as a modern, and now postmodern, phenomenon. To both these classifications their links to the psychic experience of the nation-state is crucial.

Though the generalised application of the term 'diaspora' took place around the 1960s the intellectual steps that led to this took place earlier, in the second half of the nineteenth century, according to the *OED*. The earliest found usage of it having a 'transferred sense', as the Dictionary puts it, is given as 1876. It is this transferred sense which characterises the use of diaspora in its modern and postmodern forms. The next use is dated to 1881 in the *Encyclopaedia Britannica*, where it is reapplied to describe the exodus of eastern European Jews from the Pale. The Pale was that area of Poland and Russia to which the Tsars confined their Jewish subjects. It was defined by Tsar Nicholas I in 1835 and the massive exodus of Yiddish-speaking Jews from it, which began in the early 1880s was caused by the escalating number of pogroms. It is important to note that this new usage is understood by the *OED* as a transferred sense. Clearly, the thinking is that even for the Jews we can understand two kinds of 'diaspora;' a literal one – limited to the original meaning of the term – which is the historical/mythic/religious understanding of the Babylonian captivity and the Roman exile, and one shaped by the metaphoric transfer of this sense to describe the mundane, large-scale movement of *Ostjuden* to the west.

The very significant flows of people in the nineteenth century, then mostly out of Europe to settler-colonies, were not generally thought of in terms of 'diaspora' at the time. Nor, for that matter, was the massive movement of

Africans across the Atlantic thought of in the rhetoric of diaspora though, of course, it is increasingly reconstituted as such today in, for example, the important work of Paul Gilroy. My point is that this new usage, the transferred sense, originates in the hey-day of the nation-state, but that its use does not become generalised and normalised until the psychic power of the nation-state itself, born of its claims to uniqueness, to absolute power within its territory, of claims to particularised destiny and so forth, have been critically weakened by the globalisation of capitalism, the necessity for trading blocks, for security blocks and so on. What we must elucidate, then, is what it is about the discursive construction of 'diaspora' that makes it such a connotatively powerful term at a time when there has been a weakening of the meaning of the nation-state.

The new use of the term suggests a reformation in the western understanding of the present transmigration of people, one that can be set beside a generalisation of Vijay Mishra's insightful distinction between two Indian diasporas. He argues that there is 'a radical break between the older diasporas of classic capitalism which were usually a consequence of the colonization of territories such as Fiji or Uganda, and the mid- to late twentieth-century diasporas of advanced capital to the metropolitan centres of the Empire, the New World and the former settler colonies.'[6] Mishra distinguishes between 'the old ("exclusive") and the new ("border") Indian diasporas.'[7] It seems that 'diaspora's' transferred sense was specified with reference to this new kind of population migration which, as Mishra points out, took a previously unknown form. Since the 1960s the application has been further generalised.

This generalisation has two steps to it. First, it has been a consequence of the transformation in the form of population movement from the 1960s on. Where the exclusivist diasporas were a function of a colonial capitalism that demanded the movement of workers between colonies and their semi-permanent resettlement, the new border diasporas are, in part, a consequence of a post-Fordist capitalist regime of 'flexible accumulation [which] requires massive transnational flows of capital and labor – depending on, and producing, diasporic populations.'[8] In this order, diasporic flows are often to the old core countries of Europe and to the United States. The impermanence of the work available to these diasporic populations, a part of a strategy of flexible accumulation which prizes above all low costs, lends them what Mishra describes as 'the overriding characteristic of mobility,'[9] producing what he calls 'transcultured subjects.'[10]

Second, it has been to this postmodern diasporic structure that the term 'diaspora' has come to be generally applied. From here, the diasporic experience has become so naturalised that it is generalised in both scholarly and everyday contexts to a wide variety of historically distinct experiences. What we need to be able to do, and this will be a major concern of this chapter, is to establish what the contextual circumstances are that provide the common base for the modern and postmodern experience called 'diaspora' other than the

physical fact of dispersion itself. This will also enable us to distinguish these experiences from the premodern movements of people which are, now, colloquially and anachronistically called 'diasporic.'

Certainly 'diaspora' has a premodern usage. Tölölyan tells us that in the wake of its early organic meaning of the scattering of seeds, Thucydides uses it metaphorically, in his history of *The Peloponnesian War*, to describe what happened to the population of Aegina after its destruction.[11] It appears to have been first used in the Jewish context in a Greek translation of the Torah around 250 BCE.[12] It was this early, religious usage of a dispersion ordained by God that led to the capitalisation of Diaspora when applied to the Jews. This distinction between a divinely ordained premodern Diaspora and a modern diaspora is expressed in the *OED*'s identification of the application of 'Diaspora' to the Jewish mass movement out of the Pale as a 'transferred sense.'

The continued description of the Jewish situation outside of Israel as the 'Jewish Diaspora' therefore carries a heavy political and religious weight. First of all, it associates the Jewish Diaspora with divine intervention. In this way it suggests a certain uniqueness to the Jewish experience. Second, with this religious connotation, the term suggests a premodern origin to the Jewish diasporic presence, something which we shall see is only partly the case. Third, with the establishment of the Israeli nation-state, the valence of the 'Jewish Diaspora' as a description has been radically altered. If, as I will suggest, the modern and postmodern understandings of 'diaspora' are intimately bound up with the experience of the nation-state, then the formation of a nation-state that claims to be the Jewish homeland, and which is situated on at least part of *Eretz Israel*, the Holy Land of Israel, sets in motion a new, if you like postmodern, dynamic around the connotations of 'Jewish Diaspora.' To describe this new tension, ambivalently secular and religious, as 'postmodern' implies another threefold division in the meaning of 'diaspora,' specifically in relation to the Jewish D/diaspora.[13]

The premodern Diasporic experience most usually goes by the Hebrew *galut*, usually translated as 'exile.' The modern reformation of the experience parallels the shift to its description as the Jewish Diaspora. Here, the word's capitalisation, signifying its religious connotation, allows it to span both pre-modern and modern meanings by way of a concentration on the Jewish circumstance of displacement. However, like the Gypsies but unlike the modern peoples of Europe, in the modern world Jews did not have a national homeland occupied by significant numbers of their own people. The crucial Jewish experience of modernity was the lack of a national home. This lack made the nationalising peoples of Europe suspicious of Jews. They were seen as a nation without land. This suggested that they would not assimilate into the national population and be loyal to the country in which they lived, but rather give their allegiance to the Jewish nation spread, as the Jews were, across almost all of the new nation-states of Europe.

The Zionist drive, in the latter part of the nineteenth century to establish a state that would be the national homeland became, of necessity, a drive to politicise the diaspora. Since the founding of Israel in 1948, the argument that Jews in the Israeli nation-state are no longer in Diaspora has been central to this project. Now, while it might be argued, albeit highly contentiously, that they are not in diaspora, to say that they are not in Diaspora, with all the Judaic religious assumptions this term has, is extraordinary because it conflates the Judaic claim as to God's will with a particular, modern discourse, that of the nation-state. One aspect of this argument is the Zionist fundamentalist argument that Israel is a divinely willed nation-state for Jews. If the European Jews of modernity were premodern in the sense of not having a European homeland, the 'modernising' of the Jews transformed their circumstance in quite unexpected ways. While *Eretz Israel* may be the spiritual homeland of religious Jews in the Diaspora, it is much more moot whether the nation-state of Israel is the Diasporic homeland.

The problem is compounded when we ask if a nation-state can be the secular homeland for a diasporic people who never left it. Interestingly, Tölölyan cites the creation of Israel as one of his twelve reasons for the late 1960s onwards popularity of diasporic rhetoric. He argues that, especially after the 1967 Six Day War, which was perceived to establish Israel on a permanent footing, 'the culmination of the diasporan Zionist dream in the 1967 war elicited (usually reluctant) admiration in numerous communities.'[14] Since relatively few modern diasporas are without an originary nation-state, Tölölyan's major reference must be to the Armenians. The idea of creating a nation-state to which the diasporans can return is highly unusual. Liberia is the other example that comes to mind. For Jews, the teleology involved in the construction of a national homeland for diasporic return itself suggests a problematisation of Diaspora and of a modern experience already at odds with modernity. After all, a diasporic homeland is supposed to be the homeland which you, or your ancestors, left in the past. From this point of view, while this could, conceivably be claimed to be the case for *Eretz Israel*, it is certainly not the case for Israel as a nation-state. In this sense, Israel is the diasporic homeland for migrant Israelis, including, of course, Muslim Israeli-Arabs and any other non-Jewish citizens of Israel.

While, as Clifford, Brah and Tölölyan discuss, 'diaspora' was most commonly used to describe the Jewish experience, the situation is by no means as straightforward as this. The Jewish description of the Jews' circumstance in terms of 'Diaspora' is fundamentally modern. Arnold Eisen writes that 'The task for Jewish *religious* thought . . . became the imagination of Judaisms compatible with Emancipation in lands where the Jews resided. Those countries would soon not be called *galut* at all – but rather *diaspora*.'[15] Here we can see that the shift from a description of the Jewish experience using a Hebrew word to one derived from Greek, that is a non-Jewish European word,

one that suggests a certain incorporation of Jews into European life, takes place around the period of Jewish emancipation. In addition, the change in terminology reflects the secularisation of Jewish experience explicit in the Haskalah (the Jewish Enlightenment) and concomitant with the gentile secularisation that was an important feature of the Enlightenment. Moreover, the Europeanisation of the Jewish experience coincides with a fundamental shift in the meaning of that experience, a shift defined in the distinct parameters of meaning allied to *galut* and to Diaspora.

In order to understand what is at stake in this description we must turn to an influential article by William Safran entitled 'Diasporas in Modern Societies: Myths of Homeland and Return.' Here, Safran describes 'the Jewish Diaspora' as an '"ideal type,"'[16] following, probably, Max Weber's use of the term. Without acknowledging the historicity of the Jewish experience, Safran identifies six features of a people's experience which, he implies, characterise the Jewish Diaspora (*sic*). These are as follows: dispersion from an original 'center;' retention of a collective memory or myth of the homeland; belief that they are not fully accepted by the host society; belief that the ancestral homeland is their true home and that they will some day return to it; the belief that they should be committed to the maintenance or restoration of their original homeland; and that they continue to relate, personally or vicariously, to that homeland in one way or another.[17]

The first point to make here is that if this is really meant to work as a description of the Jewish Diaspora, then it can only apply to certain Jewish groups' experience in the twentieth century. This is because the last three features only make sense in Zionist terms, and specifically in relation to the Israeli nation-state. Here we can also note that one crucial aspect of *galut* thinking is that the Jews should not return to *Eretz Israel* until the coming of the Messiah. This is founded in a fundamentally religious view of a return which, by implication, advocates acceptance of exile as a punishment from God.

More generally, within Safran's list there is an emphasis on displacement, on original homeland, on not feeling at home in one's present place and a more or less literal relationship with the place designated as home. What I want to argue is that these are ahistorical or anachronistic attributions of a modern view to a two thousand year old, non-modern social formation. Safran's assumptions encompass those of the modern diaspora and depend in crucial ways on modern constructions of the nation, the national people and the space – the land – which the nation claims belongs to it. Indeed, one of the modern connotations of diaspora relates to its emphasis on the importance of the unity of the diasporic group founded in the sense of a common geographical origin. As we shall see, central to Safran's assumptions is the rhetoric of the 'homeland,' a term which Safran uses uncritically and descriptively.

To begin with, it is important to distinguish the three major formations of western Jewry's understanding of the experience that has come to be

generalised as 'diaspora.' I have already very briefly identified the first two, *galut* and Diaspora. I will return to these in the next section. The third also goes by the name 'diaspora' and therefore is commonly merged with the second. I am suggesting here that the present Jewish understanding of Diaspora differs in crucial ways from the previous understanding. The shift from what we could call the modern to the postmodern Jewish understanding of diaspora has taken place in connection with three crucial events in western Jewish experience: the creation of the state of Israel along with its ideology of being, in some sense, either secular or religious, a Jewish state; the experience of the Nazi genocide and its memorialisation as the unique Holocaust; the recognition by the post-Holocaust generation of apparently assimilated Jews that the modern offer of assimilation has always been, ultimately, dependent on the whim of the host nation-state.

Most important in the reformation of the meaning of 'Diaspora,' as I have argued already, has been the foundation of Israel. Sander Gilman notes that

> One of the great problems Jews and non-Jews since the founding of the state of Israel have had is to understand the very meaning of Jewish life beyond Israel or the Holy Land as a valid life experience to be expressed authentically in a language and/or discourse adequate to the message. For a millenium this had been the distance from an imagined, textually-based center – Torah as the symbolic topography of the missing center. Following the founding of the state of Israel, 'exile' has meant exile from a real, geographically bounded place, while the act of returning, endlessly postponed, is now a possibility.[18]

Gilman, here, begins from a Judaic understanding. He therefore uses the word exile rather than the modern, and secular, word diaspora. The point he makes is overstated. The transmogrification of 'exile,' that is *galut*, into a rhetoric of physical exile is one that Zionist ideology has striven for and one that operates in a complex negotiation with various Jewish religious understandings of the appropriateness of returning to *Eretz Israel* before the coming of the Messiah. Nevertheless, the spirit of Gilman's point is well taken. The establishment of a Jewish territorial state, which is what Israel claims to be regardless of the much more complicated reality, transforms fundamentally the modern Jewish experience of diaspora. In the process, and as an aspect of the Israeli attempt to legitimise Israel as the 'Jewish homeland,' there is a concomitant attempt to devalue the Diaspora. An important historical irony here is that this attempted devaluation has taken place during the same period that in the West more generally the rhetoric of diaspora has been valorised.

While the effect of Gilman's comparison is to signal the shock of the establishment of Israel to the religious experience of Jews, I want to suggest much more the transformation in secular experience. At the end of *The Jewish State* (1896), Theodor Herzl's great cry for the establishment of a Jewish state,

he wrote that, in that state 'We [Jews] shall live at last as free men on our own soil, and die peacefully in our own homes.'[19] The implication here is that, in the new European nation-states, Jews could not feel at home because they were on somebody else's soil. Herzl makes clear one aspect of the modern condition, the establishment of a connection between the nation and its land such that exclusion from the nation goes hand in hand with a sense of alienation from the land.

If we want to track the history of the Jews in modernity, the place to start is not with the debates over emancipation and assimilation in the new states but, rather, with the ghettoisation of the Jews. The creation of the ghetto, a spatial mechanism for the segregation and management of a population designated as distinct, took place as the feudal systems of government based on allegiance and duty, and which placed the Jews under the special protection of the crown or the Pope, were breaking down. Central to the long-term shift towards statist forms of government was the move towards coalescing the governed population in a particular space, that is, on a particular territory.

The first of what Louis Wirth calls 'the compulsory ghetto[s]'[20] is often considered to be the ghetto of Venice where, 'In three days from 29 March 1516, the Senate "Party" escorted about seven hundred Jews, Germans and some Italians, into the existing houses in the Ghetto Nuovo round San Girolamo, a "very capacious space."'[21] The term 'ghetto' itself seems to be derived from the prior name for this place which identifies it as having been the site of a public foundry. In Italian, *getto* had this association. In 1555, Paul IV's papal bull 'Cum nimis absurdum' imposed such compulsory spaces of confinement for Jews in Rome. After this, 'every Italian city except Leghorn sooner or later set up its own ghetto with walls and gates.'[22] In spite of the derivation of the name, Wirth, in recounting the history of the ghetto of Frankfört, in Germany, notes this:

> Every three months, from the fifteenth century on, the Jews had to renew their lease permitting them to live in the city. The city council, on these occasions, had to pass an act known as *Judenordnung*, which the Jews, by means of money, were always successful in having passed. In one of these acts, that of 1460, the Jews were compelled to leave their homes and move to a segregated area, thus establishing the *Judengasse*, or ghetto.[23]

Clearly, the Frankfört ghetto is earlier than the one at Venice. More important, though, is the recognition that the compulsory ghettoisation of the Jews took place across Europe between roughly the mid-fifteenth and mid-sixteenth centuries.

What the gathering together of the Jews of Frankfört signifies is the move to a form of spatial thinking and spatial organisation, as opposed, for example, to a kind of thinking of social relations based on obligation and reciprocity,

which was to become characteristic of the effects of centralised power in the city, the state, and in modernity generally. In *Madness and Civilization* Michel Foucault argues that the seventeenth century was the century of 'The Great Confinement.' He writes that confinement 'constituted one of the answers the seventeenth century gave to the economic crisis that affected the entire Western world.'[24] However, while the methods of spatial segregation were generalised during this period, as the rapid spread of the ghetto a century earlier suggests, the sensibility which thought in terms of such a solution was older. Aptly, Foucault writes that 'A sensibility was born which had drawn a line and laid down a cornerstone, and which chose – only to banish.'[25] Indeed, the Jews were sometimes banished from the cities, and the new states, in which they lived. Most of the time, though, they remained segregated, and surveilled, in the ghettos assigned to them.

The segregation of the Jews marks the prehistory of modern state formation. We must distinguish between the letting of the Jews out of the ghettoes and the processes around emancipation and assimilation. The former took place at the time when the administrative and surveillance institutions of the state made spatial segregation unnecessary. The latter expresses the modern preoccupation with a normatively similar population, a state population of homogeneous 'national origin' which was, through the nineteenth century, increasingly associated with deterministic notions of race. The modern discourse of diaspora evolved out of the association of the ideas of a national population as being homogeneous and its being distributed over a particular territorial space; that is the new, nineteenth century usage of diaspora developed as a way of talking about people who were thought of as being out of place, displaced.

GALUT AND DIASPORA

I want now to explore briefly the meaning of *galut*. This will enable us to understand the radical nature of the transformation that is signalled by the eighteenth- and nineteenth-century shift to the ideology of diaspora. *Galut* derives from the same Hebrew source as *golah*. The latter, Eisen tells us, 'refers to an exiled population and not to the place of its exile.'[26] He goes on, '*Galut* can refer to either the population or the act of exiling them.'[27] As we have seen, it is usually translated as 'exile.' Eisen isolates the

> salient features of the medieval and early modern reinterpretation of galut, proceeding in terms of the three principal components of the rabbis' achievement: their recognition that exile consisted of both the interrelated dimensions [of the] 'political' and 'metaphysical'; their association of homecoming to the Land with fulfilment of Torah; and, finally, their pronounced ambivalence concerning the Land's

centrality – the fact that memory of and aspiration for the Land paradoxically made possible and meaningful a life lived somewhere else.[28]

At the heart of this religious understanding of *galut* was the idea that exile was a punishment from God. As a consequence, Jews should not look towards a return, or actively seek it, but rather accept their exilic circumstance until such time as the Messiah comes.[29]

Near the end of the medieval period Rabbi Isaac Luria Ashkenazi (1534–72) produced a religious reinterpretation of the idea of exile which became very influential in Jewish religious thought. Gershom Scholem puts the reinterpretation this way: 'The *Galut* [Luria's] Kabbalah saw as a terrible and pitiless state permeating and embittering all of Jewish life, but *Galut* was also the condition of the universe as a whole, even of the deity.'[30] In this way the Jewish understanding of their situation as exile was universalised into the condition of all existence and Jewish exile became only a special circumstance of a general condition. The effect of this religious ideology was to increase Jewish acceptance of their exilic situation.

Over the next two centuries, two major thinkers of the Haskalah, Spinoza and Mendelssohn, secularised Jewish thought and reinforced exile as a condition that was to be accepted and given meaning. Reflecting the new political order, Eisen argues that Spinoza considered 'the power of religion . . . would be supplanted by the only two authorities which Spinoza believed the modern world should recognise: human reason (i.e. philosophy) and the state.'[31] With Mendelssohn, too, as Eisen sums up his most influential work, *Jerusalem* (1783), 'The center of Jewish concern, religious as well as political, the locus of Jewish aspirations, shifts to exile.'[32] Key to Mendelssohn's work was the modern Jewish preoccupation with emancipation. It was the secularisation of Jewish thought, pioneered by Spinoza and Mendelssohn in the context of the pervasive secularisation of European thought in the Enlightenment, that paved the way for the shift of understanding of Jewish experience from *galut* to diaspora.

What Eisen's work makes plain is that the Jewish shift to a diaspora consciousness was historical.[33] What he implies is that the production of Zionist ideology, and perhaps in particular Herzl's *The Jewish State*, was built on the secular,

> modern reconception of galut and Eretz Israel inaugurated by Spinoza and Mendelssohn. The land had been *demystified*: considered now not as the font of revelation, but in terms of its suitability for large-scale immigration. The idea of a return to it had been *politicized*: a matter of calculating financial arrangements and the shifts in the balance of power, rather than a ledger of sin and repentance on which the Messiah's coming would be inscribed.[34]

In Herzl's text we can see clearly the establishment in the modern context of a new ideology of 'migration,' one that is secular, that has a claim to a particular geographical space as a site of origin, in which the rhetoric implies that a 'people' should, in the first and perhaps last, instance live in their own 'land.'

In the historical transition from feudal to modern structures of government, the Jewish experience shifted from being understood by Jews and gentiles alike in religious terms to being understood in political terms. In relation to a theorisation of diaspora what this forces us to recognise is that the modern rhetoric of diaspora is fundamentally political, and that its politics are bound up with those of the nation-state. How important land is to the nation is illustrated by remembering that Zionism, as it developed in late-nineteenth-century Europe, was one inflection of a broader Jewish movement which came to be called 'territorialism.' What separated the Zionists from the territorialists was their particular mix of modern political thought, secular Judaism and, with it, a desire to (re)claim the land that was argued to be the Land given by God to the original Jews, the Israelites. In contrast, the territorialists looked more generally for land that might be given to the Jews, in Argentina, in Uganda, in the Kimberley region of Western Australia,[35] where a more or less autonomous Jewish state might have been developed.

At this point it is enlightening to compare the Zionist and territorialist position with that of the Bundists. The Bund, the common name for the General Jewish Workers' Union in Lithuania, Poland and Russia, was founded in Vilna in October 1897. Heavily inflected by Marxist theory, the Bund was very influential throughout the Pale, going into a lengthy decline at the end of the first decade of the twentieth century. At the Bundists' Fourth Congress in 1901 'The delegates rejected categorically any solution to the nationalities problem based on territory.'[36] Rather, the Bund

> viewed Jews as a national group, upheld its right to exist as such, and sought means of ensuring their continued existence through cultural and civil equality. The Jews could maintain their educational, linguistic, and artistic individuality while participating in civil functions such as taxation and communications on the same basis as all other citizens.[37]

Bundist thinkers were particularly thinking of the situation of Yiddish Jews in the Russian territories. The major radical opposition to the Bundists came from the Zionists. As history has shown, the Zionists were more in tune with the modern formulation of the nation-state and the assumptions about national populations. Interestingly, many of the concerns of the Bundists around the national question are reappearing in what is sometimes called the post-national state, with its celebration of cultural diversity, and 'multiculturalism' in its various meanings, and its rhetoric of diaspora.

In thinking about this, it is important to remember that *galut* ideology carried no sense of the establishment of a Jewish state. That, of course, would

have been anachronistic. Indeed, right into the early part of the twentieth century the settlements founded in Palestine by European Jews and funded by the Rothschilds had no desires for the creation of a Jewish state. The distinction between land and Land, an area of land with which a particular group of people claim to have a specific tie, is not modern. As Daniel and Jonathan Boyarin point out, 'it is crucial to recognize that the Jewish conception of the Land of Israel is similar to the discourse of the Land of many (if not all) "indigenous" peoples of the world.'[38] However, as they also point out, in the Jewish case the connection between the people and the Land, *Eretz Israel*, is by no means straightforward.

William Davies writes, in what is the most detailed discussion of the Jewish relationship with the Land taken from biblical sources, that

> Certain historical facts are fundamental. The Land of Israel was not the birthplace of the Jewish people, which did not emerge there (as most peoples have on their own soil). On the contrary it had to enter the Land from without; there is a sense in which Israel was born in exile. Abraham had to leave his own land to go to the Promised Land: the father of Jewry was deterritorialized.[39]

Davies goes on to note that 'It is surprising that, until late in the Middle Ages, Judaism did not produce a developed theology of exile.'[40] What he appears to mean here is a theology which places the Land, and exile from it, as central. As we have seen, *galut* is a theology of exile but it does not privilege the Land in any literal sense, removing any return to it in the future to a transcendent time after the coming of the Messiah. To suggest, as Davies does, that Israel was born in exile implies an always already existent claim to the land as the Land. Moreover, the land that God promised to Abraham was already inhabited. In its religious form, the Jewish claim to the Land is founded on the dispossession of others. Such a claim has become highly problematic in modernity. As the notion of 'exile' was being transformed in the late Middle Ages into an ideology which laid the basis for a literal interpretation of the Land, so the prerequisites for the modern myth of national autochthony were being established.

Boyarin and Boyarin describe how, in the Jewish context, there has developed 'a confusion of "indigenous" (the people who belong here, whose land this rightfully is – a political claim, founded on present and recently past political realities) and "autochthonous" (the people who were never anywhere else but here and have a natural right to the land).'[41] However, this confusion has been by no means uniquely Jewish. Indeed, Eric Hobsbawm, in the Introduction to *The Invention of Tradition* implies that just such a conflation has been at the heart of the production of modern western national identities when he writes that 'modern nations and all their impedimenta generally claim to be the opposite of novel, namely rooted in the remotest antiquity, and the

opposite of constructed, namely human communities so "natural" as to require no definition other than self-assertion.'[42] To put it slightly differently, it is the myth of national autochthony which underlies the ideology that in a mystical but taken-for-granted sense the nation and the Land are one, legitimates political claims about indigeneity and, as a consequence, justifies the production of a state on the Land to order the nation. Of course, such a logic does not interfere with the historical recognition that in many circumstances, most obviously in settler-colonies outside of Europe, the existence of the state has preceded the production of an imagined national community.

The point about autochthony in this context is that the nation-state always claims to have original and unique claim to the Land on which it is formed. It is in this way that the exclusivity of the national population, established through a combination of racial and cultural terms, can be legitimated. It is here that other groups' claims to 'indigeneity' become problematic. This is most obvious in settler-states. Israel is, obviously, a settler-state. It is not unusual for settler-states to attempt to deny the prior presence of the land's inhabitants. In Australia, for example, there was the legally enforced fiction of *terra nullius*.[43] For the early-twentieth-century Zionists, there was the slogan 'A land without people, for a people without land.'[44] The modern preoccupation with original indigeneity can be easily demonstrated in the context of Israel. Here, as Boyarin and Boyarin tell us:

> One modernist story of Israel, the Israeli Declaration of Independence, begins with an imaginary autochthony – 'In the Land of Israel this people came into existence' – and ends with the triumphant return of the people to their natural Land, making them 're-autochthonized' 'like all of the nations'.[45]

Once again, we have the peculiar Zionist combination of the secular and the religious. In this modern narrative of nation-state formation, the state comes into existence to govern the people who, in the mists of time, were formed on this Land and subsequently exiled from it. In this formulation we come upon perhaps the key element in the modern ideological formation of diaspora, the notion of, for some reason, having had to leave, or having left, the place, not just of one's own origin – one's birthplace – but the origin of one's people.[46] For this reason, the ideology of diaspora has become important in both the modern and postmodern periods as a way that displaced groups of people can preserve their identity regardless of the pressures from the host population for them to assimilate. It is here that the ideology of diaspora connects with the modern ideology of the nation-state. It is in this context that the complex modern understanding of the Jewish situation as being, in Judaic terms, a metaphysical Diaspora structured through time and, in secular terms, a geographical diaspora, articulates with the claim of the Israeli state to be the 'home' of all Jews.

DIASPORA AND THE PSYCHIC STRUCTURE
OF 'HOMELAND'

Mishra has theorised diaspora using the neo-Freudian work of Slavoj Zizek and of Renata Salecl. He argues that

> in the construction of [the] 'Nation Thing' the nation itself is a fiction since it is built around a narrative imaginatively constructed by its subjects. The idea of a homeland then becomes (and here the terms 'imaginary' and 'fantasy' do coalesce), as Renata Salecl has pointed out, '[a] fantasy structure, [a] scenario, through which society perceives itself as a homogeneous entity'.[47]

Having established the connection between the fictive construction of the nation and the idea of a homeland, Mishra applies it to the experience of diaspora:

> We can follow up Salecl to make a more precise connection between a general theory of homelands . . . and a theory of the diasporic homeland. Salecl refers, after Lacan, to fantasy as something that is predicated upon the construction of desire around a particularly traumatic event. The fantasy of the homeland is then linked, in the case of the diaspora, to that recollected moment when diasporic subjects feel they were wrenched from their mother(father)land.[48]

Now, this is a fascinating and sophisticated theorisation of diaspora. However, it raises a number of questions.

Perhaps most importantly, when Mishra makes the rhetorical shift from writing about nation to writing about homeland, and writes of 'a general theory of homelands,' he moves from describing a specifically modern phenomenon to something more general. Of course, this parallels one of the classic questions about Freud's (and Lacan's) work. Does it describe a specifically modern formation of psycho-sexual identity, or does it have a universal significance? In Mishra's formulation, what is absent is a notion of the land as the psychically empowered Land where the ideologies of nation and homeland come together. While, as we have seen, in premodern understandings of indigeneity, the people are fused with their Land, in the modern formation this fusing is mediated by the ideology of the nation and a psychic component which is reinforced, as we might say that the bourgeois, privatised nuclear family reinforces the psychic structures described by Freud. Here we can notice a shift from a religious organisation in which an external God gives, or promises, land, thereby transforming it into Land, to a secular, psychic organisation based on the individual. The idea of the 'homeland' – the mother- or fatherland – takes on a new psychic valency in modernity, one which is

transferred in variable ways to the nation and the state as they are articulated together in the nation-state.

In this reformulation we can appreciate how certain psychic aspects of the diaspora experience have a more or less general quality while also acknowledging that there is a modern specificity to diaspora, not least in its preoccupation with a national origin. It is the link to a homeland/national origin that provides the basis for the descriptor that unifies the diasporic subjects. In this sense, then, diaspora is a modern phenomenon because it describes the leaving of a national homeland. Here we find a marked shift from the psychic economy of *galut*. In *galut*, as we have seen, the emphasis was on a future transcendental, Messiah-led time of fulfilment, more metaphorical than literal, in the Land. In modern diaspora thinking, as Mishra's theorisation illustrates, the emphasis is on what has been left behind. Here is Brah making this same point:

> Where is home? On the one hand, 'home' is a mythic place of desire in the diasporic imagination. In this sense it is a place of no return, even if it is possible to visit the geographical territory that is seen as the place of 'origin.' On the other hand, home is also the lived experience of a locality.[49]

Again, we find the metaphorics of home bound up in a diasporic sensibility of loss.

In *On Longing*, Susan Stewart has gone to the *OED* and found that in its meaning of 'yearning desire,' longing 'experiences a split in the eighteenth century.'[50] In 1713 Addison used the term in connection with immortality; however, in 1748 it is used in connection with travelling: 'Our native country, for which many of us by this time began to have real longings.'[51] This experience was shortly to receive a name, 'nostalgia.' Made up of two Greek elements meaning 'return home' and 'pain,' nostalgia began, it seems, as a medical diagnosis. The *OED* provides a quotation from 1780 which refers to 'Many perplexing instances of indisposition . . . called by Dr Cullen *nostalgia* or home sickness.' Here we find, once more, the connection with 'home.' The *OED* defines this first use of nostalgia as 'A form of melancholia caused by prolonged absence from one's home or country; severe homesickness.' Given this definition, derived it seems from the term's first medical usage, it is not surprising that the first usage the *OED* gives for nostalgia is from Joseph Banks's *Journal* (1770) on his voyage with the explorer James Cook: 'The greatest part of them [the ship's company] were now pretty far gone with the longing for home which the Physicians have gone so far as to esteem a disease under the name of Nostalgia.' We should remember, as Benedict Anderson tells us, 'in Western Europe the eighteenth century marks not only the dawn of the age of nationalism but the dusk of religious modes of thought.'[52] It was in this secular world that the shift took place from the psychic economy of *galut* to that of diaspora.

Whereas the emphasis in *galut* was more temporal, that in diaspora, including the ideology of the Jewish Diaspora, is more spatial. Writing about nostalgia in its twentieth-century temporal form, but equally applicable to the experience of diasporic displacement, Stewart comments that 'hostile to history and its invisible origins, and yet longing for an impossibly pure context of lived experience at a place of origin, nostalgia wears a distinctly utopian face, a face turned toward a future-past, a past which has only ideological reality.'[53] Modern diasporas may have what Brah calls a 'homing desire,'[54] but it is for a return to a place of origin as it *was*, not as it is now. Moreover, it is for a return that returns the diasporic subjects to the way they were, to an imagined past time created in memory, before the impact of their diasporic experience.

The ideology of the Jewish Diaspora, with its combination of Judaic and secular Zionist, premodern and modern, components, was quite different. Remarking on an image of David Ben-Gurion's, Eisen comments that it:

> derives more from the European Enlightenment, and particularly Marx, than from Judaism, but then that is typical of both spiritual Zionism and the socialist Zionism linked to it by the common ancestry of [Moses Hess's *Rome and Jerusalem* [1862]]. From Hess onward, appeal to Jewish tradition had been married to a secular messianism couched in terms of both Israel's prophets and Europe's.[55]

Here, the emphasis is on the future construction of a nation-state which will act as a utopian site of plenitude and, in doing so, provide the future origin-site for the pre-existing Jewish Diaspora. It is, if you like, a nostalgia of the future rather than the past. Nowhere is this construction more obvious than in Herzl's own futuristic novel about Jewish migration to Palestine – the name Herzl himself uses – called *Altneuland*, published in 1902. In this, after mass European Jewish migration, a remarkably Bundist organisation called the New Society is founded, Palestine still being under the suzereignty of Ottoman Turkey, which builds the ideal technologically modern society.[56]

That the reality of return could not match up to the coalescence of the imaginary and of fantasy, to use Salecl's terms, was inevitable. Here, for example, is A.D. Gordon (1856–1922) whom Boas Evron aptly describes as an 'early Zionist visionary and pioneer:'

> On making Aliya to Eretz Israel we expect to have a certain sort of impression. But I, coming to the Holy Land, felt far, for whatever reason, from what R. Yehudah Halevy [the renowned medieval Jewish poet] felt on such an occasion. Even later, on visiting the settlements, I did not feel what any good Zionist should feel. . . . True, nature here . . . is wondrously beautiful, but I feel something lacking in this beauty, perhaps there is too much of it. It looks artificial, not natural. . . . In the landscape of Eretz Israel, I feel like an alien.[57]

Stewart argues that 'the nostalgic's utopia is prelapsarian, a genesis where lived and mediated experience are one, where authenticity and transcendence are both present and everywhere.'[58] Gordon's description of Palestine as 'lacking' something sums up well the inability of place to fulfil the nostalgic's impossible desire. In this sense, the modern renovation of the ideology of the Promised Land, the sanctified Land rather than the mundane land, as the site of a future plenitudinous origin is found wanting. Ben-Gurion himself had a similar experience when he arrived in *Eretz Israel* in 1907:

> When the intoxication of our first enthusiasm wore off, we glimpsed an old picture in a new frame – the picture of the 'galut,' the exile. The skies were new, the skies of Eretz Israel, and the land was new – the homeland. But the people, the members of the Yishuv, were people of the 'Galut,' engaged in 'Galut' occupations.[59]

It is the very ordinariness of the place that Ben-Gurion confronts, an ordinariness summed up in the fact that the Jews of *Eretz Israel* perform the same work as the Jews of the *galut*. Implicit is Ben-Gurion's Zionist rethinking of the *galut* from a temporal emphasis to a spatial one, a rethinking which modernises Jewish experience into a form which combines both a religious Diasporic aspect and a secular diasporic aspect.[60]

Ben-Gurion, like many of the other diasporic thinkers and thinkers about diaspora that I have been discussing, uses the rhetoric of 'homeland.' As we have seen, the discourse of home is central to diasporic thinking. In order to understand this we need to return to Mishra's theorization of diaspora. Following Salecl and Lacan, Mishra associates desire with 'a particularly traumatic event' and suggests that 'the fantasy of the homeland is then linked, in the case of diaspora, to that recollected moment when diasporic subjects feel they were wrenched from their mother(father)land.' What is it that gives the psychic charge to this event and makes it so traumatising? The clue comes in the constant association of the nation-state with 'home.' If we turn to Freud, we find in his article on 'The "Uncanny"' this comment:

> It often happens that neurotic men declare that they feel there is something uncanny about the female genital organs. This *unheimlich* place, however, is the entrance to the former *Heim* [home] of all human beings, to the place where each one of us lived once upon a time and in the beginning.[61]

Freud, himself, goes on to make the connection between home and country:

> There is a joking saying that 'Love is home-sickness'; and whenever a man dreams of a place or a country and says to himself, while he is still dreaming: 'this place is familiar to me, I've been here before,' we may interpret the place as being his mother's genitals or her body.[62]

We have already noted the historicity of 'homesickness' and its connection with spatial displacement from a particular, clearly emotionally charged, place. Freud's insight connecting home to women's genitals, the site of birth and the loss of the womb-home, allows us to recognise that the psychic association that gives libidinal power to Mishra's 'traumatic event,' the experience of being 'wrenched from [the] mother(father)land' is birth. Evron describes how A. D. Gordon, whom I have already quoted feeling alienated in *Eretz Israel*, 'consciously forced himself to create for himself a territorial subconscious – to possess Eretz Israel as his mother.'[63] Even more evocatively, Russcol and Banai quote Yigael Yadin, the archeologist of Masada, as writing that 'In Israel, archeology is a seeking for confirmation of roots. We are digging into the motherland, back into the womb.'[64] Here, the association elaborated by Freud needs no further comment. However, we should also acknowledge the experience of the uncanny at the core of a nation-state which claims legitimation by way of a history of connectedness with land but from which the ancestors of the nation have been separated by almost two thousand years. Archeology digs into the (mother)Land to connect with the historical origin, the womb. In doing so, it confronts the uncanniness of the Israeli circumstance.

Such an explanation also allows us to understand the preoccupation with origins which, as we have seen, pervades diasporic thinking. Stewart writes that 'The prevailing motif of nostalgia is the erasure of the gap between nature and culture, and hence a return to the utopia of biology and symbol united within the walled city of the maternal.'[65] Freud's description is of a person – let us generalise the sexes here – who feels familiar in a place or country to which they have never been. The diasporic experience is the reverse, the disturbing feeling of difference, the sense of loss, the impossible, nostalgic, desire to return to a place from which one was traumatically separated, no matter how voluntary the separation. What is significant here is that this desire is to return to the home*land*. It is not to return either to the nation or to the state but to the space that both occupy in a deeply imbricated way. At this point we can disentangle Mishra's identification of a 'mother(father)land.' The land of the nation-state, the modern version of the numinously endowed Land, is experienced in western modernity by way of the qualities of both mother and father, or, to make the psychic equivalence directly, nation and state. In Andrew Parker et al.'s Introduction to their collection, *Nationalisms and Sexualities*, they note, 'how deeply ingrained has been the depiction of the homeland as a female body' and associate it with the 'trope of the nation-as-woman.'[66]

THE NATION AND THE JEWISH FAMILY

In modernity, without a nation-state, the Jewish family took on the role otherwise associated with the nation. As Alain Finkielkraut so pithily puts it:

'In Christian society, the Jewish family and Jewish nation are two indistinguishable structures: leaving one in any way means deserting the other.'[67] Expanding on this, Finkielkraut connects this development with the modern effects of assimilation: 'But without a Jewish nation (a burnt offering on the alter of assimilation), the family was entrusted with the task of perpetuating a sense of Jewishness. The famous "family-centrism" of the Jews was something like a counterweight to assimilation.'[68] There is an alternative way of thinking about this which connects with the psychoanalytic argument about the nation-state that I have put forward. In short, it is not so much the loss of the Jewish 'nation' that has caused the modern extreme version of Jewish family-centredness. Rather, it is an effect of the pervasiveness of patriarchal power as an aspect of the functioning of the modern state. In other words, unlike previous governmental systems, the state is a bounded organization throughout which the rule of law operates. In this modern system, where ideally the family reproduces the normative code of the state – we can think of the functionalist sociological idea of socialisation as a form of assimilation into civility – the family also becomes the major bastion of defence against such assimilation.

At the heart of this nation-family home life is the Jewish mother. Finkielkraut argues that 'There's no dividing line in the Jewish family separating principles from sentiment. Everything is love, and everything, at the same time, is Jewishness.'[69] The reason for this is the dual loading of the modern Jewish family, at once needing to reproduce the social order and the psychic structures common to all nuclear families in western modernity, and also reproducing the nation–cultural specifics (or perhaps just group specifics such as Ashkenazi) of 'Jewish identity,' something problematic in the assimilatory world of modernity, and more problematic again given the lack ever of a Jewish 'nation' in the modern sense.

It is here that the Jewish mother, in particular, traces the national. Finkielkraut argues that what distinguishes the Jewish mother from the modern gentile mother is that the latter 'lets go,' allows her children to enter the 'world,' society. The Jewish mother holds on. Where the gentile mother allows her child to go out into the national society of the homeland, the Jewish mother holds on to her child, keeping her/him safe within the nation of the family. In a perceptive insight, Finkielkraut writes that 'The "Don't leave me," the "Be mine" of maternal desire becomes "Don't forget your origins," and the incalculable nuance tosses prohibition aside, renders possessiveness legitimate.'[70] Here we find the mapping of the family structure onto the nation. The mother's concern with origin echoes Freud's insight that there is a psychic equivalence between 'home,' the womb, and the country where one is born and brought up, where one becomes 'nationalised.' While this insight most applies to Jews, because, *pace* Israel, the family and the mother especially, stands in for the absent nation, it also applies, to some extent, to other modern western diasporic communities who wish to maintain their difference from the

host society. However, these communities tend to look to the national homeland (*sic*) for renewal.

In western modernity the family has also been commonly used as a metaphor for the state. In *The Social Contract* (1762), for example, Jean-Jacques Rousseau writes that 'the family may . . . perhaps be seen as the first model of political societies: the head of state bears the image of the father, the people the image of his children . . .'[71] Here, the mother, and the national, feminine, aspect of the family have been elided in order that there can be a concentration on the patriarchal image of the head of state as the father. This modern thinking echoes the Judaic understanding of God as the presenter of the Law to the people, in the process bringing them into being. As Davies describes it:

> Deuteronomy, then, fused together the promise of The Land made to the early patriarchs and the tradition of the giving of the Law at Sinai. The relationship of the commandments to The Land is regarded in Deuteronomy as twofold. On the one hand, the commandments are regulatory; that is, they are intended to provide guidance for the government of The Land, for the conduct of the *cultus*, and for the arrangements demanded by the settlement. On the other hand, the commandments are conditional; that is, only if they are observed can The Land received because of the promise to the Fathers be possessed.[72]

In Judaic thought, it is the acceptance of God's Law that created the Jewish people, and the Law provided for the right ordering of life in the Promised Land. It is easy to see how, in the reorganisation of religious everyday life outside of the Promised Land, the familial father, and above him the rabbis, would take on the patriarchal role bequeathed, in Judaism, by the male God who handed down the Law which, in its everyday form, is supposed to be embodied in the *halachah*.

In recent theory, Jacques Lacan's description of the Law of the Father reproduces the Judaic patriarchal formulation, but with a sexual and familial basis rather than a premodern divine one. As Elizabeth Grosz sums it up:

> The 'Law of the Father,' as Lacan sees it, 'is the threshold between the "Kingdom of culture" and "that of nature abandoned to the law of copulation." It is not a function of Real, biological blood relations, but of systems of nomenclature or kinship systems. One is forbidden sexual access to those one *has named* as family.'[73]

In this formulation, the barrier of incest, the basis of Lacan's Law of the Father, becomes the foundation of the creation not of the Jewish nation but of human culture. Lacan's formulation reworks Freud's origin myth for society, as told in *Totem and Taboo*, which I will discuss in the next chapter. The

Freudian/Lacanian narrative of societal origin is better understood as the description of the psychic experience of the modern state, fundamentally patriarchal and governed by a Law which we have to obey.[74] Within modernity, then, if the Diasporic Jewish family merges with the Jewish nation, out of its patriarchy would have emerged the incipient Jewish state. In the processes of assimilation it was the loss of that particularised patriarchy which had religio-legally delimited the Jewish 'nation' in the medieval sense of the word, which was necessary for the Jewish family's assimilation into the modern state.[75]

Language is central to the organisation of the nation-state. Anderson makes this point, describing the importance of what he calls 'print-languages' – that is, recognising the importance of the spread of printing in Europe for fixing and standardising languages, he notes how nationalist ideology 'stresses the primordial fatality of *particular* languages and their associations with *particular* territorial units.'[76] If language has been thought of as a foundational aspect of the nation, it has also been recognised as a necessary element in the elaboration of the state. In European thinking it was the language of the nation that became the language of the nation-state. The state used this language to pass laws, judge, administer, in short, to govern. For the state, the national language was the language of power. In the practice of the European-originated nation-state, it has been the everyday experience of language which has seamlessly merged the national imagined community with the order of the state. In most cases, such as France, Great Britain and Spain, the state has sought, historically, to eliminate other languages within its territory, languages that might be the site of proto-nationalist claims.

I will quote Evron arguing that, for the Jews of the Pale, Yiddish was a proto-national language. Yiddish was known as *mamaloshen*, mother's language. Colloquially the national language is often known as the mother-tongue, making the connection between the feminine nation and the mother's role in the family. However, if eastern European Jews had a language spoken in the home, they had no state. What they did have was a religious-based Law, vested in the father, and expressed in another language, the language of power, Hebrew, known in *Yiddishkeit* as *papaloshen*. Where Yiddish was the evolved local 'national' language of eastern European Jews, Hebrew was the 'universal' language of Diasporan Jewish (patriarchal) authority. Around the turn of the century it was Eliezer Ben Yehuda (1858–1922) who proselytised most strongly for Hebrew to be the language of the new Jewish nation. However, he saw it as a revival. Arguing for a return to *Eretz Israel*, he wrote: 'let us increase the numbers of Jews in our desolate land; let the remnants of our people return to the land of their fathers; *let us revive the nation and its tongue will be revived too.*'[77] Here the idea of the revival of the ancient Israelite 'nation' carries with it a subtext of the patriarchal, divine establishment of that 'nation.' In Herzl's *Altneuland*, there is no state and Herzl pays little attention to the process of Jewish national unification in the New Society, which non-Jews like the

Palestinian Arab Rashid Bey can join. Hence, here, Hebrew is one language among many used in the New Society. Yet, as Israel evolved into a state it was Hebrew that became the dominant language, and subsequently the language of the state.[78] Naomi Seidman describes how 'not only was the language chosen by the Hebraist pioneers the one associated with Jewish masculinity, they also preferred an intonational system and an accentual pattern [that of Sephardi Hebrew] they perceived as masculine'[79] as compared to the 'feminised' Hebrew of Yiddish speakers. 'Masculine' Hebrew was reconstituted as the national language of the 'male,' if not patriarchal, modern state of Israel, learnt by Israeli Jews and also by Arabs, though not, of course, with the same semiotic loading for each group.[80]

CONCLUSION

We are now returned to Mishra's notion of the diasporic subject's wrenching from the 'mother(father)land.' In terms of this diasporic psychic economy Jews were not so wrenched. Rather, their entry into modernity has entailed a renovation of their experience in the terms of the nation-state which has produced in the Jewish subject this new psychic economy, one expressed in complex ways in the ideology of a 'Jewish Diaspora.' Jews had to learn to be modern, they also had to learn to be diasporic.

Mishra's assertion that 'Jewish "homelands" . . . were constantly being re-created: in Babylon, in the Rhineland, in Spain, in Poland and even in America with varying degrees of autonomy'[81] is both correct and incorrect. As we have seen, the idea of the 'homeland' belongs to the psychic economy of modernity. In this sense Israel is a thoroughly modern nation-state. As Evron writes:

> Only Israelis' sense of home, their feeling that it is better and more pleasant for them to live in Israel than any other place, not any idealism or Jewishness or Jewish-Zionist sense of mission, can serve as a true and firm basis of the connection between them and their country. . . . In this sense an Israeli nation has indeed begun to emerge in Israel, a nation whose tie to the country is not spiritual or ideological or historical or deriving from historical rights or Jewishness, but a natural one, like any other nation's.[82]

Here we have a description of how the modern diasporic experience of displacement, of not being at home, gives way, especially we might add for those born into the state of Israel, indeed on its land, to a sense of belonging, a belonging which, circularly, validates the existence of the Israeli nation-state. As Evron suggests, this has nothing, in the first place, to do with being Jewish, whatever that means, or accepting Zionist ideology but a great deal to do with

feeling a natural connection, like it or not, with the evolving Israeli national culture in its most intimate and everyday practices.

In eastern Europe, at the same time that other 'nations' were being formed in Europe, there was the beginnings of another Jewish, more specifically Yiddish, national consciousness. Here, in Evron's words:

> Unlike other Jewish diasporas, the Jews of Eastern and Eastern Middle Europe . . . developed distinct traits of a separate nationality: territorial continuity (mainly in the tsarist 'pale of settlement'); a common (Yiddish) language and culture; and the beginnings of a common secular culture, including newspapers and classical writers . . . who used this language.[83]

During the nineteenth century, along with the gentile population of the region, there was a Jewish population explosion increasing numbers from around 3 million to around 11 million. It was these proto-nationalised Jews who, as a consequence of persecution, flooded out of their proto-homeland from the latter part of the nineteenth century onwards into the modern world of western Europe and the United States. In these modern nation-states, the Yiddishers were perceived by the local assimilated Jews to be premodern. For modernised, western European Jews, modernity entailed secularisation, or at least the reconstitution of Judaism from a halachically lived religion to a religion of choice, emancipation and the struggle to assimilate. As Finkielkraut puts it in the context of France, 'It was not just the fact that the presence of the Ostjuden would disturb the non-Jewish populace; but they seemed intent on making coexistence impossible, with their strange dialect and the bizarre complexity of their culinary rites.'[84] In the context of the exclusivist national preoccupations of the European nation-states, these Yiddishers were con- structed into a characteristically diasporic condition, what Mishra describes as an exclusive diaspora; a function of both the group's own proto-national sensibility and the host nation's exclusivity.

Western Jews also learnt to be diasporic in their migrations. Here, for example, is a description from an Austrian Jewish play written in 1848 by Hermann Mosenthal:

> In the fourth act [of *Deborah*] Ruben, a member of an Austrian group of Jewish emigrants, speaks of Jewish attachment to the land of their birth. As he is about to leave for America, he picks up a handful of earth and calls it the earth of the promised land. When Deborah points out that the promised land is Jerusalem, he contradicts her. That idea, he says, is a beautiful fairy tale. Home is the country whose language we speak, where our cradle stood, where our individual lives have their roots. Austria, Ruben claims, is his mother, and it is only his gentile brothers who are driving away, while he looks forward to a future recognition of their common family bonds.[85]

Set back nearly two generations in the past, in 1780 and 1785, the play naturalises from a Jewish situation all the modern diasporic rhetoric I have been discussing: 'home,' birthplace, sense of bondedness to place, the country – homeland – as feminine, and the idea of being a part of a national family. Going to the United States, Ruben would have been part of the distinctly modern Jewish diaspora, a diaspora nostalgic not for the Land promised to Abraham, nor for the Yiddish proto-national homeland, but for the 'homeland,' in this case the national land of Austria where he had, to a degree, been assimilated.

NOTES

1 Avtar Brah, *Cartographies of Diaspora: Contesting Identities*, London, Routledge, 1996, p. 179.
2 James Clifford, 'Diasporas' in James Clifford, *Routes: Travel and Translation in the Late Twentieth Century*, Cambridge, Mass., Harvard University Press, 1997, p. 255.
3 Khachig Tölölyan, 'Rethinking *Diaspora*(s): Stateless Power in the Transnational Moment', *Diaspora*, vol. 5(1), 1996, p. 3.
4 Khachig Tölölyan, 'Rethinking *Diaspora*(s)', pp. 20–7.
5 Khachig Tölölyan, 'Rethinking *Diaspora*(s)', pp. 3–4. The first quotation is from Khachig Tölölyan, 'The Nation-State and its Others: In Lieu of a Preface', *Diaspora* vol. 1(1), 1991, pp. 3–7. The second is from Vijay Mishra, 'The Diasporic Imaginary: Theorizing the Indian Diaspora', *Textual Practice*, vol. 10 (3), 1996, p. 441.
6 Vijay Mishra, 'The Diasporic Imaginary', p. 421.
7 Vijay Mishra, 'The Diasporic Imaginary', p. 422.
8 James Clifford, 'Diasporas', p. 256.
9 Vijay Mishra, 'The Diasporic Imaginary', p. 422.
10 Vijay Mishra, 'The Diasporic Imaginary', p. 441.
11 Khachig Tölölyan, 'Rethinking *Diaspora*(s)', p. 10.
12 Khachig Tölölyan, 'Rethinking *Diaspora*(s)', p. 11.
13 Neusner argues that Zionism was 'the first of the *postmodern* religious movements' because

> '[it] represents the rejection of modernity, of the confidence of modern man in democracy and – because of Zionism's espousal of a "myth of mission" and a renaissance of society – in secularity. For there was nothing wholly secular about Zionism, and there never was' (J. Neusner, 'A New Heaven and a New Earth' in Jacob Neusner, *Stranger at Home: 'The Holocaust', Zionism and American Judaism*, Chicago, University of Chicago Press, 1981, p. 109).

14 Khachig Tölölyan, 'Rethinking *Diaspora*(s)', p. 24.
15 Arnold Eisen, *Galut: Modern Jewish Reflection on Homelessness and Homecoming*, Bloomington, Indiana University Press, 1986, p. 64.
16 William Safran, 'Diasporas in Modern Societies: Myths of Homeland and Return', *Diaspora*, vol. 1(1), 1991, p. 83.
17 William Safran, 'Diasporas in Modern Societies', pp. 83–4.
18 Sander Gilman, 'The Frontier as a Model for Jewish History', unpublished paper presented at the 'Jewries at the Frontier' conference, University of Cape Town, South Africa, August, 1996, pp. 2–3.

19 Theodor Herzl, *The Jewish State*, New York, Dover, 1988, p. 157.
20 Louis Wirth, *The Ghetto*, Chicago, University of Chicago Press, 1928, p. 29.
21 Umberto Fortis, *The Ghetto in the Lagoon: A Guide to the History and Art of the Venetian Ghetto*, Venice, Storti, 1988, p. 18.
22 Umberto Fortis, *The Ghetto in the Lagoon*, p. 19.
23 Louis Wirth, *The Ghetto*, p. 42.
24 Michel Foucault, *Madness and Civilization: A History of Insanity in the Age of Reason*, New York, Vintage, 1973, p. 49.
25 Michel Foucault, *Madness and Civilization*, p. 64.
26 Arnold Eisen, *Galut*, pp. 202–3.
27 Arnold Eisen, *Galut*, p. 203.
28 Arnold Eisen, *Galut*, p. 50.
29 Gershom Scholem, *The Messianic Idea in Judaism and Other Essays on Jewish Spirituality*, New York, Schocken Books, 1971.
30 Gershom Scholem, *The Messianic Idea*, p. 43.
31 Arnold Eisen, *Galut*, p. 62.
32 Arnold Eisen, *Galut*, p. 64.
33 It is also possible to understand *galut* and 'diaspora' more ahistorically as referring to different ways of understanding the Jewish experience at any particular moment. This is the way Sander Gilman describes the terms. He writes: 'The contradictory yet overlapping models of a Jewish "Diaspora," as opposed to a Jewish "Galut," have formed the Jewish self-understanding of what "exile" means. The voluntary dispersion of the Jews ("Galut" or "Golah") is understood as inherently different from the involuntary exile of the Jews ("Diaspora"). These two models exist simultaneously in Jewish history in the image of rooted and empowered Jews on the one hand, and uprooted and powerless Jews on the other' (*Jews in Today's German Culture*, Bloomington, Indiana University Press, 1995, p. 6).
34 Arnold Eisen, *Galut*, p. 88.
35 On the Kimberleys project see Leon Gettler, *An Unpromised Land*, South Fremantle, Fremantle Arts Press, 1993.
36 Henry J. Tobias, *The Jewish Bund in Russia: From Its Origins to 1905*, Stanford, Stanford University Press, 1972, p. 161.
37 Henry J. Tobias, *The Jewish Bund*, p. 166.
38 Daniel Boyarin and Jonathan Boyarin, 'Diaspora: Generation and the Ground of Jewish Identity', *Critical Inquiry*, vol. 19(4), 1993, p. 719.
39 William Davies, *The Territorial Dimension of Judaism*, Minneapolis, Fortress Press, 1991, p. 63.
40 William Davies, *The Territorial Dimension*, p. 63.
41 Daniel Boyarin and Jonathan Boyarin, 'Diaspora', pp. 715–6.
42 Eric Hobsbawm and Trevor Ranger (eds.), *The Invention of Tradition*, Cambridge, Cambridge University Press, 1983, p. 14.
43 See, for example, Henry Reynolds, *The Law of the Land*, Ringwood, Penguin Books, 1987.
44 Edward Said credits this slogan to the English Jewish author and playwright, Israel Zangwill (Edward Said, *The Question of Palestine*, New York, Vintage, 1980, p. 9). At various times in his life Zangwill was a Zionist, a territorialist and the populariser of the idea of United States as a 'melting pot' via his play *The Melting Pot*, first produced in 1908.
45 Daniel Boyarin and Jonathan Boyarin, 'Diaspora', p. 718.
46 In this regard it is instructive to read Jacqueline Rose, 'In the Land of Israel' in *States of Fantasy*, Oxford, Clarendon Press, 1996.
47 Vijay Mishra, 'The Diasporic Imaginary', p. 423.

48 Vijay Mishra, 'The Diasporic Imaginary', p. 423.
49 Avtar Brah, *Cartographies of Diaspora*, p. 192.
50 Susan Stewart, *On Longing*, Durham, N.C., Duke University Press, 1993, p. ix.
51 Quoted in Susan Stewart, *On Longing*, p. x.
52 Benedict Anderson, *Imagined Communities*, London, Verso, rev. ed., 1991, p. 11.
53 Susan Stewart, *On Longing*, p. 23.
54 Avtar Brah, *Cartographies of Diaspora*, p. 193.
55 Arnold Eisen, *Galut*, p. 90.
56 See Theodor Herzl, *Old-New Land*, New York, Bloch, 1941.
57 Boas Evron, *Jewish State or Israeli Nation?*, Bloomington, Indiana University Press, 1997, pp. 103–4.
58 Susan Stewart, *On Longing*, p. 23.
59 Quoted in Boas Evron, *Jewish State*, p.105.
60 The structure of elation followed by depression is a common one to people returning to the 'diasporic homeland.' Paul Gilroy quotes the African-American Martin Delany on his 'return' to Africa from his 1859 *Report to the Niger Valley Exploring Party*: 'The first sight and impressions of the coast of Africa are always inspiring, producing the most pleasant emotions. These pleasing sensations continue for several days, more or less until they merge into feelings of almost intense excitement . . . a hilarity of feeling almost akin to approaching intoxication . . . like the sensation by the beverage of champagne wine. . . . The first symptoms are succeeded by a relaxity of feelings in which there is a disposition to stretch, gape and yawn with fatigue. The second may or may not be succeeded by actual febrile attacks . . . but whether or not such symptoms ensue, there is one most remarkable. . . . A feeling of regret that you left your native country for another . . .' (Paul Gilroy, *Small Acts: Thoughts on the Politics of Black Cultures*, London, Serpent's Tail, 1993, pp. 130–1).
61 Sigmund Freud, 'The "Uncanny"' in J. Strachey (ed.), *The Standard Edition of the Complete Psychological Works of Sigmund Freud*, vol. 17, London, The Hogarth Press and the Institute of Psychoanalysis, 1962, p. 245.
62 Sigmund Freud, 'The "Uncanny"', p. 245.
63 Boas Evron, *Jewish State*, pp. 104–5.
64 Herbert Russcol and Margalit Banai, *The First Million Sabras: A Portrait of the Native-born Israelis*, New York, Dodd, Mead and Co., 1970, p. 25.
65 Susan Stewart, *On Longing*, p. 23.
66 Andrew Parker et al. (eds.), *Nationalisms and Sexualities*, New York, Routledge, 1992, p. 6.
67 Alain Finkielkraut, *The Imaginary Jew*, trans. Kevin O'Neill and David Suchoff, London, University of Nebraska Press, 1994, p. 105.
68 Alain Finkielkraut, *The Imaginary Jew*, pp. 107–8.
69 Alain Finkielkraut, *The Imaginary Jew*, p. 104.
70 Alain Finkielkraut, *The Imaginary Jew*, p. 105.
71 Jean-Jacques Rousseau, *The Social Contract*, Harmondsworth, Penguin Books, 1968, p. 50.
72 William Davies, *The Territorial Dimension*, p. 7.
73 Elizabeth Grosz, *Jacques Lacan: A Feminist Introduction*, London, Routledge, 1990, p. 70.
74 For a longer version of this argument see Jon Stratton, 'Introduction' in *The Desirable Body: Cultural Fetishism and the Erotics of Consumption*, Manchester, Manchester University Press, 1996.
75 In this context it is not surprising that in the United States, where Jews are simultaneously highly politically assimilated but assert a cultural difference handed down

in the family, and as Finkielkraut would note, via the mother, that much American-Jewish literature is preoccupied with the 'weakness' of the father. Perhaps the archetype here is Philip Roth's *Portnoy's Complaint* (Harmondsworth, Penguin Books, 1970). In this novel Alexander (note the irony of his name), Portnoy's father, is permanently constipated and metaphorically impotent. As Alexander remarks, 'The potent man in the family – successful in business, tyrannical at home – was my father's oldest brother Hymie, the only one of my aunts and uncles born on the other side and to talk with an accent' (p. 51). It would appear that it is Uncle Hymie's Yiddish origin that saves him from the emasculating assimilation of Jewish-American life. In this vein, it is not surprising that, having spent the novel proving his potency, especially with gentile women, Alexander finds himself impotent in Israel when confronted with a sabra woman.

76 Benedict Anderson, *Imagined Communities*, p. 43.
77 Quoted in Shlomo Avineri, *The Making of Modern Zionism: The Intellectual Origins of the Jewish State*, London, Weidenfeld and Nicolson, 1981, p. 85.
78 Naomi Seidman has provided an important account of this history and the sexual politics of language surrounding it. See *A Marriage Made in Heaven: The Sexual Politics of Hebrew and Yiddish*, Berkeley, University of California Press, 1997.
79 Naomi Seidman, 'Lawless Attachments, One Night Stands: The Sexual Politics of the Hebrew-Yiddish Language War' in Jonathan Boyarin and Daniel Boyarin (eds.), *Jews and Other Differences: The New Jewish Cultural Studies*, Minneapolis, University of Minnesota Press, 1997, p. 289.
80 See, for example, Jacqueline Rose, *States of Fantasy*, *passim* but especially Chapter 1, 'In the Land of Israel.' Also, and importantly, Smadar Lavie, 'Blowups in the Borderzones: Third World Israeli Authors' Gropings for Home' in Smadar Lavie and Ted Swedenburg (eds.), *Displacement, Diaspora, and Geographies of Identity*, Durham, N.C., Duke University Press, 1996, pp. 55–96.
81 Vijay Mishra, 'The Diasporic Imaginary', p. 425.
82 Boas Evron, *Jewish State*, p. 182.
83 Boas Evron, *Jewish State*, pp. 56–7.
84 Alain Finkielkraut, *The Imaginary Jew*, p. 67.
85 Ruth Kluger, 'The Theme of Anti-Semitism in the Work of Austrian Jews' in Sander Gilman and Steven Katz (eds.), *Anti-Semitism in Times of Crisis*, New York, New York University Press, 1991, p. 175.

6

MIGRATING TO UTOPIA

Migration can be briefly defined as directed movement in the modern world, movement from one 'home' to a place which is expected to become a new 'home.' There has been little work done to theorise migration. The best is probably Ian Chambers's discussion in *Migrancy, Culture, Identity*.[1] In contradistinction to the definition that I have just given, Chambers writes that

> to travel implies movement between fixed positions, a site of departure, a point of arrival, the knowledge of an itinerary. It also intimates an eventual return, a potential homecoming. Migrancy, on the contrary, involves a movement in which neither the points of departure nor those of arrival are immutable or certain. It calls for a dwelling in language, in histories, in identities that are constantly subject to mutation.[2]

Now, this is a good description of what has become understood, though technically it is a misnomer, as postmodern *nomadism*. As Chambers writes a little further on: 'The migrant's sense of being rootless, of living between worlds, between a lost past and a non-integrated present, is perhaps the most fitting metaphor for the (post)modern condition.'[3] While this may be how migrants came to feel, it was not what they expected to feel. Nor, for that matter, was it how the nation-states and their forerunners that received the migrants expected them to feel. In most cases the migrants knew where they wanted to go, even if they had no idea what the place was like and how long it might take to get there. And the receiving country knew what it expected of them: that they assimilate – the precise expectation implied by this term varied – into the national polity.

Chambers writes that 'It is the dispersal attendant on migrancy that disrupts and interrogates the overarching themes of modernity: the nation and its literature, language and sense of identity; the metropolis; the sense of centre; the sense of psychic and cultural homogeneity.'[4] All this is correct, but these were unforseen consequences. The modern assumption was that large numbers of people could be transported from one place to another and then, provided that they were of the same 'race,' because race designated cultural compatibility,

be expected to merge into the general population. In the United States, the largest receiver of migrants through the nineteenth and early twentieth centuries, the ideologies of the melting pot and cultural pluralism evolved as liberal alternatives to assimilation. What Chambers thinks through so well, are the consequences of the *failure* of the ideology of migration, and its companion, the ideology of assimilation. It has been this failure that has produced the experience designated as 'nomadism' which is a characteristic that helps to define postmodernity, and about which Chambers writes. In this chapter I want to think through the ideology and psychic dynamics of migration.

About 50,000 Jews went to the United States from Central Europe in the first seven decades of the nineteenth century and, in the wake of the pogroms initiated in Russia in 1881, between then and 1900 about 500,000 Eastern European Jews migrated to the United States. Moreover, 'Between 1900 and 1914 nearly two million Jews left Eastern Europe, 75 percent of whom settled in the United States.'[5] It was the movement of Jews from the Pale in the nineteenth century that was described, in an early use of the term in its non-religious sense as a diaspora. The years 1882 to 1932 saw roughly 182,000 Jews, mostly from Eastern Europe, migrate to Palestine – or, in Zionist terms, make *aliyah* (migrate/go up) to *Eretz Israel*. In the years 1932 to 1938 a further 197,235 Jews fled Eastern and Central Europe for Palestine and, between 1939 and 1948, when Israel was founded as a nation-state, a further 138,275 Jews moved to Palestine.[6]

THE MIGRATORY PSYCHIC STRUCTURE

In Chapter 5 I described how 'The idea of the "homeland" . . . takes on a new psychic valency in modernity, one which is transferred in variable ways to the nation and the state as they are articulated together in the nation-state.' Following Vijay Mishra's reworking of the neo-Freudian insights of Slavoj Zizek and Renata Salecl in which he argues that 'The fantasy of the homeland is . . . linked, in the case of the diaspora, to that recollected moment when diasporic subjects feel they were wrenched from their mother (father)land,'[7] I suggested that this traumatic wrenching is experienced through the psychic metaphorics of birth. While this goes some way to explaining the psychic structure of the modern experience of diaspora, with its preoccupation with the 'canny' home, and a nostalgic feeling of loss, it does not help us to under-stand the psychic motivation, the organisation of desire, in the experience of migration. Central to the directed desire of migration was the modern fantasy of utopia. Aaron Segal called the period between 1815 and 1914,[8] 'the century of migration,' Krishan Kumar remarked of the nineteenth century, that it 'is generally, and rightly, regarded as the most utopian century of modern times.'[9]

Topically, the modern utopia can be easily traced back to Thomas More's *Utopia* of 1516. More's Utopia was an island that had been deliberately cut off from the mainland. It was entirely self-contained. Louis Marin has described More's book as being traditionally read by way of two distinct visions:

> on the one hand, a free play of imagination in its indefinite expansion measured only by the desire, itself infinite, of happiness in a space where the moving frontiers of its philosophical and political fictions would be traced; on the other hand, the exact closed totality rigorously coded by all the constraints and obligations of the law binding and closing a place with insuperable frontiers that would guarantee its harmonious functioning.[10]

The paradox of More's book and, I would argue, all modern utopias, is that they are grounded in both these visions. They idealise a world, a nation-state let us say, in which an infinite desire for happiness in a freedom from constraint can be lived, while, at the same time, it is guarded by absolute laws which define the limits, liberalising the utopic metaphor, which make such happiness a possibility.

What can this tell us about the desire of migration? I would suggest that, as an ideal-type, this desire is directed to escape the law which constrains and limits, and persecutes or allows persecution, in the nation-state in which one lives – the motherland of one's literal and metaphoric birth – and aimed towards the utopian dream of a land where there is no law allowing the migrant to live out that infinite desire in a world of unlimited *jouissance*. The law which constrains and limits is the same law which, for Sigmund Freud in his myth of the origin of society, acquired its absolute power after the sons of the myth's original primal horde killed their father in order to gain their freedom from his total and selfish rule. In this story the primal father had sexual access to all the women in the horde and forbade access to his sons. As Freud puts it, after the killing of the father

> A sense of guilt made its appearance.... The dead father became stronger than the living one had been.... What had up to then been prevented by his actual existence was thenceforward prohibited by the sons themselves, in accordance with the psychological procedure so familiar to us in psycho-analyses under the name of 'deferred obedience'.[11]

It is this 'law' which Freud cites as the origin of the incest taboo and the foundations of society. I want to argue, as I have elsewhere, that this narrative is better read as a mythical understanding of the experience of the modern nation-state.[12] Crucial is the recognition that the state, experienced as a transcendental figure as in the capitalised 'State' (Hegel's work provides the

philosophical legitimation of this claim), is founded on proscriptive law. In his structuralist revision of Freud's ideas Jacques Lacan gave this insight of Freud's even greater significance. Very briefly, for Lacan, the real father in the family is ultimately overshadowed by the Symbolic Father who may be described as the phallic organising principle of society. The state can then be understood as being experienced as the incarnation of the Symbolic Father, the internalised expression of the will of the dead primal father. The law of the State is experienced as the manifestation of the Law. Here, we can refer to the insight of Benjamin Constant in his celebrated 1819 Lecture entitled 'Liberty Among the Ancients Compared with the Moderns.' He said, 'First ask yourself, Gentlemen, what an Englishman, a Frenchman, and a citizen of the United States of America understand today by the word "liberty."' For each of them it is, 'the right to be subjected only to the laws [of their own State], and to be neither arrested, detained, put to death or maltreated in any way by the arbitrary will of one or more individuals.'[13] In other words, the power of the state is supreme over its own citizens and it proscribes the ability of citizens to act against other citizens.

Constant is describing what the members of a state experience as the reality of living in that state; that freedom, what he describes as liberty, is limited and determined by the Law of that state. A little further on Constant notes that

> even in the freest of states, [the citizen is] sovereign only in appearance. His sovereignty is restricted and almost always suspended. If at fixed and rare intervals, in which he is again surrounded by precautions and obstacles, he exercises this sovereignty, it is always only to renounce it.[14]

Here we have the recognition that the member of the state is only free within the limits granted by the state and that, like Freud's brothers in the primal horde, the members of the state are unable to accept freedom without restraint. In fact, in the modern world, freedom, liberty, is defined by its relation to constraint. Indeed, what we find clearly laid out in Constant at the beginning of the century of migration is the recognition that the citizen will always have to give up absolute freedom. At the same time, for the inhabitants of the state, the fantasy of freedom is, ultimately, as for Freud's brothers from the primal horde, the utopia of a state with no Law.

At this point we can also gesture to the question of the (degree of) specificity of the Freudian, and for that matter, Lacanian theorisations. In connection with the concern to escape the patriarchal law we should remember, for example, the strict hierarchical gender division of Ashkenazi Jewish life. Writing about the Eastern European Jewish language distinction between Yiddish and Hebrew, Naomi Seidman remarks that 'Yiddish femininity nearly always marked both Yiddish and woman as an inferior within a rigid patriarchal order that valorised both Hebrew and masculinity (although this

inferior position sometimes allowed for the exercise of subversive power).'[15] Freud's theoretical preoccupation with the killing of the father and the failed liberation of the sons may well be at least partly accounted for by his Eastern European Jewish background with its strict patriarchal hierarchy and gender role distinction.[16] It would not be surprising if his image of the origin of society had a Jewish sensibility. In this regard, Peter Gay writes that

> In *Totem and Taboo* [Freud] had argued that all mankind must forever labor under the primal crime, the killing and eating of the father, which constituted the founding act of civilization. In the same way, he believed, the Jews have borne through the centuries the burden of killing Moses and of the harsh, obsessive, self-punishing religion they developed after that murder.[17]

The point, here, is not to invalidate Freud's theory or, for that matter, its general application, but to consider the possibility of its particular origin in the Yiddish-background, and more generally Ashkenazi, Jewish experience. This understanding can be taken further once we recognise that Freud's universalist argument about the origin of society can be better read as an insight into the workings of the modern state. His explanation can provide a way of thinking about the Jewish position in the nineteenth-century assimilatory State.

Without expanding the psychoanalytic argument any more we can say that the ideal-typical migrant desire is determined by the utopian dream of finding a new national space in which the patriarchal law of the state either, ideally, does not exist or runs in a diminished and benevolent fashion. Now, Kumar reminds us that

> With Turgot and Condorcet, *eutopia* becomes *euchronia*. The good place becomes the good time. No longer was utopia to be found on a remote island or in a hidden mountain valley. The European voyages of discovery and the enthusiastic mapping of the world were in any case making it less and less easy to find some *terra incognita* to serve as utopia.[18]

All this is correct, as it applies to literary utopias. For Eastern European Jews in the 1870s and 1880s two alternatives seemed possible. One was migration to the United States and an individual utopian fantasy of social, political, religious and cultural emancipation. The other was the utopian fantasy of the creation of what Theodor Herzl was to call *Der Judenstaat*, the Jews' State. As we shall see, the dichotomy was by no means as clear cut as this, not least because of the various ideas for creating a community of Jews within the United States. Nevertheless, along with the modernising secularisation of Jewish thought in Central and Eastern Europe there came the utopian idea of the creation of a

state for Jews, a space in which the Jews might find their freedom and which would have clearly defined frontiers – for which read borders – which would mark the limits of the new rule of law that would be an expression of Jewish freedom. Juliet Flower MacCannell reminds us that 'We know, after Lacan, that every law is the repression of a desire'[19] and the phallic and patriarchal Law of the state represses the freedom of *jouissance*. At least, this is the modern utopian fantasy.

Perhaps the first Jewish thinker to write clearly about the need for a Jewish state, and the thinker who most obviously precurses Herzl as the founder of a political Zionism, was Leo Pinsker. Pinsker, not coincidentally in connection with this argument, like Herzl, trained as a lawyer. He was born in 1821, and raised in Odessa. Having taught for a year, Pinsker went to the University of Moscow where he retrained as a doctor. He returned to Odessa in 1849 to practise. For some years Pinsker was a member of the Society for the Enlightenment of the Jews which had, as one of its major objectives, the intent of spreading emancipation of the Jews in Russia by enlightening the Jewish masses. However, after the Odessa pogrom of 1871, Pinsker began to doubt the possibility for change in Russia.

It was after the wave of pogroms began in 1881 that Pinsker looked to a different solution, one based on migration. Benzion Netanyahu notes, importantly, that, by the time Pinsker's 'Auto-emancipation' was published in September 1882, 'the national movement was already on the march.'[20] Netanyahu quotes the Christian Zionist, Lawrence Oliphant, writing earlier in 1882 that 'The idea of a return to the East has seized upon the imagination of the masses and produced a wave of enthusiasm in favor of emigration to Palestine, the force and extent of which only those who have come in direct contact with it can appreciate.'[21] Allowing for some wishful hyperbole it is still plain that the enlightening effects of the work of *maskilim* (Jewish enlighteners) such as Pinsker and other Jewish thinkers and teachers had produced the possibility for thinking something which had not been possible before, a secular and political and utopian solution to a problem previously thought of only in religious, Judaic terms, the terms of *galut* and messianic redemption.

Pinsker argued that the Jews must take an active role in their own emancipation rather than waiting for those who controlled state power to emancipate them. He wrote that

> . . . we shall not be able successfully to defend [our] dignity until we stand upon our own feet. As soon as an asylum is found for our poor people, for the fugitives whom our historic and predestined fate will always create for us, we shall simultaneously rise in the opinion of the peoples. . . . We must labor actively to complete the great work of *self-liberation*. We must use all means which human intellect and human experience have devised, in order that the sacred work of national regeneration may not be left to chance.[22]

Here, auto-emancipation is directly connected with the establishment of a space without oppressive law in which Jews can make their own emancipation.

This emancipation is described in terms of a 'regeneration,' an image of positive transformation that recurs constantly in relation to both migration to a Jews' state and to the United States. In connection with Eastern European Jewish migration to the United States, Mark Slobin tells us that the Yiddish *gilgul*, 'is a wonderful word, which can mean migration, reincarnation, or . . . transmigration [of souls].'[23] For Yiddish speakers, then, the idea of regeneration was already intimately bound up in the concept of migration. Stripped of its religious associations, regeneration became, in Yiddish thought, as it did for other migrants, the trope of the effect of entering a space without law, or, more pragmatically, without oppression, where the desire for freedom can be fulfilled.

In the United States, the notion of regeneration was a key theme in the ideology of migrant acceptance, reflecting the American self-understanding of the space of the United States as utopian. As far back as St. John de Crèvecoeur in 1793, we find him writing that

> In this great American asylum, the poor of Europe have by some means met together. . . . Everything has tended to regenerate them: new laws, a new mode of living, a new social system: here they have become men: in Europe they were as so many useless plants, wanting vegetative mould and refreshing showers . . .[24]

Such a perception corresponded with the regenerative trope as used by Jewish thinkers such as Pinsker and Herzl.

In turn-of-the-century Jewish migratory experience in the United States the migratory and the American versions of the modern utopian idea were easily collapsed together in the theme of regeneration. Here, for example, is Kaufman Kohler (1843–1926), one of the leading exponents of Reform Judaism in the United States, in an address to the Council of American Hebrew Congregations in 1911:

> Least of all could Judaism retain its medieval garb, its alien form, its seclusiveness, in a country that rolled off the shame and taunt of centuries from the shoulders of the wandering Jew . . . Behold America, the land of the future! . . . The land of promise for all persecuted! [O]ut of the mingling of races and sects, nay, out of the boldest, the most courageous and most independent elements of society, a new, a stronger, a healthier and happier type of men and women will emerge . . .[25]

There are strong echoes here of Israel Zangwill's image of the melting pot. Zangwill's play of that title had been a great success three years earlier, and both

there and in Kohler's rhetoric there is, as Eli Lederhandler comments on Kohler, an upholding of 'the regenerative formula.'[26]

In a different genre, Mary Antin writes about her own regeneration in her autobiography, *The Promised Land* (1912). Hana Wirth-Nesher describes how Antin

> invoked the Emersonian self, unfettered by history: 'I was born, I have lived, and I have been made over . . . I am absolutely other than the person whose story I tell.' Her transformation into the American Adam is a matter of 'my personal salvation.' For Antin, who saw herself as the representative immigrant made over into an American, Jewish identity was something to be discarded and replaced by American citizenship.[27]

Here, as in Kohler's image, the regeneration found in the United States is a part of a reconstruction transforming the Jewish migrant into an American.[28]

Correspondingly, and dating back to the writings of Pinsker and Herzl, the trope of the regeneration of the Jewish people has been a key Zionist theme in relation to the establishment of the Jewish state. Here, to take just one example, is David Ben-Gurion in a speech to youth leaders made at Haifa in 1944:

> We dare not ever stray from this policy of self-reliance, from the will to make ourselves a wave of the future – the wave of the future of the Jewish people and the land of Israel so regenerated that it will attract Jews unto itself and make other peoples take account of it in their political and social calculations.[29]

In spite of the secular nature of Zionism, religious regeneration in the context of Israel has become an important component of the idea of *aliyah*. In the Zionist use of the trope, regeneration produces a transformed Jew. One who is 'active' rather than 'passive.' After the formation of the Israeli state the image of the Israeli Jew who fights to defend the homeland has been used as an ideological counterpoint to the Jews of the Diaspora in Europe who, so the narrative goes, walked in their millions without resistance into Hitler's gas chambers.

UTOPIAN THINKING AND THE JEWISH STATE

For Pinsker the choice was between migration to America or to Palestine. However, and here is the key point on which he anticipates Herzl, Pinsker was not thinking only of migration but of the formation of a self-governing national community. To this end he recommends the formation of a

'directorate' which would 'purchase a piece of land upon which in the course of time several million Jews could settle. This piece of land might form a small territory in North America, or a sovereign Pashalik in Asiatic Turkey recognised by the Porte and the other Powers as neutral.'[30] It is worth pointing out here that the purchasing of land as a means of extending sovereignty was not unusual in the nineteenth century. For example, in 1803 the United States purchased 'Louisiana' – which comprised 512 million acres and stretched as far north as what are now North Dakota and Nebraska – from the French for 15 million dollars. Commodification of land by states was clearly not a bar to its refiguration as a national homeland.

One reason why the conventional site of utopia is an island is to guarantee its extraordinary separation from the mundane world. In the practice of the modern state, the border of the state has the same utopian effect as the digging of the trench across the isthmus on which Utopia was built. It marks the geographical limit of the rule of the State, of its Law, cutting off the State from the rest of the world and guaranteeing the space within the State to freedom, however that is defined, regulated by the State. It is in the context of the recognition of this utopian moment which recognises both the absolute necessity of the law for the establishment of the space of the State and, paradoxically, the fantasy of a State with no law, that we can move from Pinsker to consider briefly the two key works of Herzl, *Der Judenstaat* (1896) and *Altneuland* (1902).

From Herzl's point of view the similarity between his ideas and Pinsker's was indisputable. He wrote *The Jews' State* not knowing of 'Auto-emancipation.' He found out about Pinsker's pamphlet only when his own book was in press and commented to the effect that 'had he known of the existence of this pamphlet, he would not have bothered writing *The Jews' State*.'[31]

For Herzl, at this time, the choice was between Argentina and Palestine. For the previous five years Baron de Hirsch had been buying agricultural land in Argentina and attempting to direct migration there. Herzl's hope was that Argentina might cede an area of land, or that the Sultan of Turkey might give the Jews Palestine in return for setting in order the Turkish finances. The point here has to do with the political closing of the modern world. Above I quoted Kumar to the effect that by the nineteenth century fictional utopias were no longer to be found in space but rather in the future. By the end of the nineteenth century not only had all the world been 'discovered,' it had also been politically occupied, mostly in some form or another by European countries. Thus, unlike previous colonising practices, space for a new state where a nation might be (re)formed could not simply be found, it had to be somehow acquired, extruded from already existing politicised spaces.

In his preamble to *The Jews' State*, Herzl explicitly denies that his plan is utopian, and refers back to More's *Utopia* for a comparison. His denial reflects an understanding of utopia as a fictional idea, a dream impossible to realise. Perhaps the crucial difference between Pinsker's and Herzl's visions, and those

of More and his successors, is that where the latter describe functioning sites that are already metaphorically in existence, because otherwise they could not be narrativised, the former are concerned with getting across the idea that a new space can be created – bought or ceded – and then a site, a State (*sic*), manifested in its entire material and social order, produced in that space. With reference to the construction of utopian desire it is important to note how Herzl's rhetoric is transformed between the beginning and the end of the book. He starts by recognising that 'The important point is the driving force.'[32] At this point, the force is negative, it is a push rather than a pull: 'The plight of the Jews,'[33] – that is the legal, and the violent, oppression suffered by the Jews in Europe, including Eastern Europe. However, by the end of the book, which is, remember, about how the state and its practice will be achieved, Herzl's rhetoric has shifted. Now he writes

> Let me repeat my word from the beginning one last time: Those Jews who wish it will have their state.
> We must live as free men on our own soil and die in our own homeland in peace.
> By our own freedom the world will be freed, by our own richness enriched, by our greatness ennobled.
> Whatever we attempt over there for our own prosperity will have a powerful effect on all humanity.[34]

Here, we have the idea of a migratory journey to be part of a new State, a desire produced by the utopian dream of escape from oppression into a world of freedom. Here, also, we have Marin's 'indefinite expansion of happiness' limited by the most rigorous of borders and the law of the State. Indeed, Herzl, the lawyer by training, foresees the need for 'a unified legal system' and suggests that there is 'the potential for an exemplary legal code.'[35] This is the image of a thoroughly modern totalised and formalised law as an expression of State power. Within this structure, Jews will be free, and their freedom will be of such quality that it will free the world and enhance the life of all humanity. Such is the literally uninhibited, utopian dream.

In 1902 Herzl published a utopian novel about a Jewish state in Palestine. In *Altneuland*, Old-New Land as it is usually translated, we find Herzl attempting to provoke the desire to construct a Jews' state, using the utopian trope of a visit to an already-existing desirable place.

Herzl's narrative takes place within the time of one generation, moving from the 'present' of 1902 to a 'future' of 1923. In fact, there are two, if not three, utopias in the book. The novel opens with Frederich Lowenberg losing the love of his life who marries another for financial reasons rather than for love. In disillusionment with women and with life, Frederich answers an enigmatic advertisement placed in the newspaper by Kingscourt, who was originally Koenigshoff but who had anglicised his name when he went to the United

States to make his fortune. This he succeeds in doing. Herzl thus reproduces the European fantasy of the United States as a place where anybody can make their fortune. While there he had married a younger woman who then deceived him with his cousin. He now owns an island in the Pacific where he wishes to spend the rest of his life away from humanity, and women in particular, in the company of a male companion and two non-European servants. It is to this utopian dream that the two men travel in Kingscourt's yacht. In the nineteenth century the Pacific became the site of desirable, fantastic utopian, 'desert islands' for western modernity: Tahiti for the French, Fiji for the English, Hawaii for the Americans.[36] Kingscourt's island is in this tradition.

There, on the island, Kingscourt and Frederich live in a benevolent fraternity with Kingscourt, the owner-come-ruler-come-patriarch, playing the brother to Frederich, his formal companion. Here, in fact, is the more fantastic utopia in the book, one where the pleasures of fraternal, homosocial relations are unlimited by the presence of women. As a consequence, in the terms of the Freudian myth of the presocial, prestate I would say, primal horde, there is no need to kill the patriarch, not least because there are no women to whom he is forbidding access. In a sense, power is, then, always already shared by the 'brothers' who rule over the racially Other, and therefore not quite brotherly, servants. This arrangement reinforces Frederich, the Jew, as 'white,' like Kingscourt, and as coloniser rather than colonised. The key psychoanalytic slippage here is that between patriarchal father and brother. A fantasy moment only made possible by the absence of women yet only possible because of the repressed existence of the two mothers. Kingscourt's island is, then, both a state and not-a-state, a fantastic utopia of male freedom and 'white' rule, a State without Law.

Narratively, Herzl places this utopia next to the more 'real' utopia, the political object of his writing, the development of the Jews' state in Palestine – which, I must hasten to add, is not a 'state' in the conventional sense at all. Frederich and Kingscourt travel to their South Sea paradise by way of a brief visit to Palestine which appears to them to be a stagnating country in waiting. When they return, after twenty years, they find it a thoroughly made-over place with a large Jewish population and the very model of a modern, European, technologically advanced, secular society. Structurally, then, the representation of the Jews in Palestine comes at a mid-point, actually just beyond the edge of the mundane, realist 'Europe' and in the exotic Orient on the travellers' journey to the more fully utopian space of the South Seas. This suggests, among other things, the realisable quality of the Palestinian Jewish utopia.

A Jewish organisation called 'The New Society for the Colonization of Palestine' entered into what amounts to a leasing agreement with the Turkish Sultan, who retains ultimate sovereignty, while the Jewish migrants have autonomous rights over the areas in which they settle. Even in this, unlike the

example of the United States' purchase of Louisiana which I mentioned earlier, the Jews do not own, and therefore do not have full rights over, the land on which they live. This land, then, is not fully the Jews' land, unsettling, even after Jewish settlement, any conventional modern claim that involves the indissoluble link between the nation-state and the land on which it is established. But, as we discover, there is, in any case, no Jewish state. Indeed, as Dr Marcus says, during the debate over who should be the next president of the New Society:

> We have come here not to choose the head of a state, since we are not a state.
> We are a commonwealth. . . . We are simply a large co-operative association composed of affiliated co-operatives. And this, our congress, is really nothing more than the general assembly of the co-operative association which is called the New Society.[37]

Moreover, this 'commonwealth' does not even have a name other than the New Society. The co-operative system outlined by Herzl bears a resemblance to anarcho-syndicalism. Perhaps the most important aspect of nineteenth-century anarchism was its rejection of the state as a basis for social organisation. Like the more extreme fantasy of Kingscourt's South Sea island, there is no State in this Jewish Palestine, and therefore no law, in the total sense, in Herzl's Palestinian utopia. In this way, Herzl's utopia differs fundamentally from most Zionism. However, where on Kingscourt's island we are offered a glimpse of a primal horde, homosocial utopia, in Palestine – where there are women – we are given an image of a social order organised from the bottom up, without the governing apparatus of the State. The Jewish migrants who arrive there have left the oppressive nation-states of Europe for a land where they can be Jews in freedom, and pretty much without limit.

THE UNITED STATES AS THE QUINTESSENTIAL MIGRATORY UTOPIA

The psychic structure of utopian thought that I delineated earlier was acted out by the millions of nineteenth-century migrants. Indeed, this is one way of defining the specificity of modern migration. It is in this context that I want to look more closely at the late-nineteenth-century Yiddish-Jewish migrations to the United States and to Palestine. One place to start is with the utopian construction of the New World, a construction which fed directly into the cultural imaginary of the United States and, from there, into the image of the United States that Jewish, and other migrants had. We have to ask why there is a history of Jewry in the United States claiming to feel 'at home' there, when the Jews of the modern Diaspora have always felt 'not'-at-home – I deliberately

use this awkward expression to remind us of the *uncanniness* of the Jewish experience in the modern world, in the modern nation-states. John Murray Cuddihy, for example, writes about Freud's paper 'The "Uncanny"' that it 'exactly catches the psychological coefficient of the ambiguous sociological solidarity experienced by Jews in the modernising period of the Emancipation – namely an unfamiliar familiarity, an open secret, an "us-in-the-midst-of-them" uncanniness.'[38] This, however, has not been the Jewish experience in the United States.

It is this claim to feeling at home in the United States which has led American Jewry to claim a special status *vis-à-vis* Israel, a claim which, at times, gets expressed in the argument that, while the Jews in the United States may still be in the Diaspora, they are not any longer in *galut*. Arnold Eisen states this baldly as one of the two related motifs that strengthened the bond between Judaism and the United States. He writes:

> The first [motif] was the consistent denial by all but the Orthodox that the concept of *galut* (exile) had any relevance to the position of American Jewry. On this matter [Julian] Morgenstern, more moderate Reformers, [Robert] Gordis and [Mordechai] Kaplan were all agreed.[39]

There is a traditional, and quite straightforward, answer to this question. Arthur Hertzberg puts it succinctly when he wrote, in 1964, about the Israeli claim that American Jews are in exile, that

> This estimate of the condition of the Jews outside Israel denies the great dream of a new liberal world in which Jews participate as equals. Did not our ancestors come to America in order to experience that which could be found 'only in America,' the blessedness of enjoying a society of 'Americans all'?[40]

Put in another way, the claim is that Jews are accepted in the United States in the way that they have not been in other modern European, nation-states because of the American regard for 'freedom' – including of religion, signified in the lack of an established religion – and democracy. We can note here the utopian connotations of 'freedom' that I have already discussed. And yet this seems to be only part of the answer. I want to start somewhere else.

The United States has a long historical utopian connection. One which stretches back to Columbus's 'discovery,' from a European point of view, of the land which came to be called 'America.' While Columbus was convinced that he had discovered the Edenic East of the Orient, Amerigo Vespucci wrote to Lorenzo de Medici in 1503 that

> The inhabitants of the New World do not have goods of their own, but all things are held in common. They live without a king, without

government, and each is his own master. . . . There is a great
abundance of gold, and by them it is in no respect esteemed or valued.
. . . Surely if the terrestrial paradise be in any part of this earth,
I esteem, that it is not distant from these parts.[41]

When More came to write *Utopia* he placed Raphael Hythloday, the
'discoverer' of Utopia, as a companion of Vespucci. By the time the Puritans
landed in America, the rhetoric had changed. Kumar tells us that 'They
frequently associated their migration with the Exodus, and compared
themselves to the children of Israel being led through the desert by Moses.'[42]
The children of Israel were, of course, the Jews, who were being led out
of slavery and exile back to the Promised Land.[43]

The myth of America/the United States as the Promised Land has become a
persistent and central aspect of the American cultural imaginary.[44] Kumar goes
on, 'The settlers are the new chosen people; their land is divinely appointed, as
was Israel's: so John Cotton claimed in 1620, quoting 2 Samuel 7:10.'[45] Samuel
Levine has noted how, running through American literature, 'is the meta-
physical transference of Holy Land specifics to New World identities.'[46] Moshe
Davis has discussed the way that the Puritan and Pilgrim settlers lived out their
lives through the prism of the Pentateuch:

> The Fathers of the Republic, for example, did not cite Holy
> Scriptures in the past tense, but as a living, contemporary reality. Their
> political condition was described as 'Egyptian slavery': King George
> III was Pharaoh; the Atlantic Ocean nothing other than the Red Sea;
> and Washington and Adams – Moses and Joshua.[47]

Davis also discusses how the place names used for America suggest a spiritual
folklore. Commenting on the use of Zion which he writes, identifies at least
fifteen locations throughout the United States, Davis notes that 'as a place-
name [it] reflected the organic relationship between the United States and the
Land of Israel.'[48]

Almost 250 years after Cotton, in 1860, and now within the context of the
United States as a nation-state, Herman Melville asserted the same idea that
Americans are, somehow, 'Jews,' only this time, it has a secular and Enlighten-
ment sensibility: 'We Americans are the peculiar, chosen people – the Israel
of our time; we bear the ark of the liberties of the world. Seventy years ago we
escaped from the thrall . . .'.[49] Here, the bondage has become political rather
than being religious persecution. For Melville, the United States' political
incorporation as a nation-state marks its formation as the Promised Land. The
inhabitants of this Promised Land are, then, the new modern chosen people,
the new Jews, who now, rather than bearing a religious burden, carry the
responsibility of bringing political freedom to the world. At this point we need
to remember what the Jews of the twentieth century have claimed to find in

the United States: 'the blessedness of enjoying a society of "Americans all,"' as Hertzberg puts it. We can also ask, but I will not attempt an answer here, what the cultural effect might be for gentile Americans who feel that they live in the Promised Land, and are, therefore, by implication, the 'modern Jews,' on American attitudes towards Israel, a country where the 'original Jews' have claimed to have returned to live in the original Promised Land.

Another version of the connection between Jews and Americans can be found in the ideas of Barrett Wendell who lectured at Harvard in the late nineteenth and early twentieth centuries. In addition to the importance of his own writings on American literary and political matters, Wendell is important because he taught both W. E. B. DuBois, the African-American intellectual, and Horace Kallen, the Jewish proseletyser for cultural pluralism. John Higham writes that Wendell 'entertained a curious theory that the early American Puritans were largely Jewish in blood.'[50] Higham goes on to comment that

> Kallen thought he had escaped from a Hebraic past. Here what he was running away from suddenly became central to what he was pursuing. The stimulus of Wendell's course led him to a renewed study of Jewish culture and thus to Zionism. It suggested that one could remain an unreconstructed Jew while belonging to the core of America.[51]

Wendell's claim unified the 'original' Jews and the traditional founders of the American nation in the most literal manner, indeed utilising the discourse of American racialism in which the myth of blood-transmission has been so central. Wendell's thought clearly had a very significant impact on Kallen, and formed one element in that ideological strand which asserted Jewish ethics as the underpinning of American Enlightenment morality.

The associational thinking that conflated the Jews and the Americans can be found in other places. One is the post-independence debate over what language Americans should speak. Marc Shell tells us that

> [In the idea of the renaissance of an ancient language] Hebrew and Greek played roles. Concerning Hebrew – the language of that other 'chosen people', founders of the famously tolerant and much discussed ancient 'Hebrew commonwealth' – one Frenchman, the Marquis de Chastellux, reported that 'Americans have carried [their anti-British aversion] so far, as seriously to propose introducing a new language; and some persons were desirous, for the convenience of the public, that *Hebrew* should be substituted for the English'.[52]

Here, then, a century and a half before Israel made Hebrew the national language, asserting thereby the Jewish, if not Judaic, nature of the Israeli state, there was a move within the United States to acknowledge its 'Jewish' connection by utilising the sacred language of the Jews.

If the citizens of the United States are modernity's Jews, then how have they, officially, responded to the 'real' Jews? In his reply to the letter of welcome from the Jews of Newport, Rhode Island in 1790, George Washington wrote that in the United States 'All possess alike liberty of conscience and immunities of citizenship. It is now no more that toleration is spoken of, as it was by the indulgence of one class of people that enjoyed the exercise of their inherent natural rights.'[53] In this crucial statement Washington makes the point that toleration is a function of differential power. His implicit claim is that, in the United States, unlike the European nation-states, all individuals, no matter to what group they belong, are treated equally. Of course, this ideal was plainly not the case as the circumstances of native Americans and African-Americans easily demonstrated, but Washington's rhetoric was addressed from one chosen people to another. He goes on to write: 'May the children of the stock of Abraham who dwell in this land continue to enjoy the good will of the other inhabitants, while everyone shall sit in safety under his own vine and fig-tree, and there shall be none to make him afraid.'[54] Both chosen peoples are incorporated together in an image taken from the Bible and referring to the land of the original Promised Land.[55]

It is, though, not the eighteenth-century Jews of Newport that primarily concern us here, but rather the Jewish migrants of the late nineteenth and twentieth centuries, and their descendants. It has become common to group these people into three generations with the second generation (1920–50) being thought of as having 'adopted the American language and American ways of life'[56] and the third (1950–80) generation as having 'to make a decision to learn what it did not know, indeed, what it had no natural reason, in its upbringing and family heritage, to know.'[57]

Of the second generation it was Mordechai Kaplan's work which most clearly set out the premise of two equally chosen peoples in a nation-state where Jewish beliefs, and morality, not only equated with but merged with those of the nation-state itself. Thus, ultimately, Kaplan took his thinking to its logical conclusion when he promoted 'an American civil religion in which Jews along with all other groups would join.'[58] This project was crowned with a book entitled *The Faith of America: Prayers, Readings, and Songs for the Celebration of American Holidays*, published in 1951.

The discursive equation of America as a Promised Land equal to the Jewish Promised Land had a further by-product: the preoccupation with Columbus's faith. Ella Shohat makes the point that 'The Columbus narrative prepared the ground for an enthusiastic reception of Zionist discourse within Euro-America. The Israeli/Palestinian conflict as a whole, touches, I would argue, on some sensitive historical nerves within "America" itself.'[59] Shohat is thinking here primarily of the comparison of the United States and Israel as settler-states, both of which have displaced an indigenous population. While this is so, in the anglophone world the same could be said about Canada and Australia and yet in neither country is there the same intensity of Zionist support.

In the third issue for 1912–13, *The American Historical Review* published an article by Henry Vignaud entitled 'Columbus a Spaniard and a Jew.'[60] Contrary to appearance, the purpose of Vignaud's article was to deny the claim put forward by the Spanish historian Don Garcia de la Riega, and, so Vignaud writes, taken up by a number of other historians including the American Hyland C. Kirk, that Columbus was, in fact, Spanish-born and, on his mother's side of the family, Jewish. The apogee of this work is Simon Wiesenthal's *Sails of Hope: The Secret Mission of Christopher Columbus*, first published in German, and then in English in 1973.[61] The core of Wiesenthal's argument is that Columbus may have been of Marrano descent, that is, descended from Jews of the Spanish peninsula forced to convert to Christianity but who secretly maintained Judaic rites. Whether or not Columbus was Jewish, Wiesenthal goes on, his voyage across the Atlantic was funded by rich Aragonese Jews hoping he would find a fabled Jewish kingdom in Asia which could put pressure on the Spanish crown to stop the persecution of the Jews in Spain.

Discursively, if Columbus were found to be Jewish then he would come even closer to being the modern Moses, and the two chosen peoples even closer, symbolically at least, to being one people. Recognising this connection we can understand why the first anti-Semitic article to be published in Henry Ford's newspaper *The Dearborn Independent*, and the one placed first in the notorious book of those articles *The International Jew: The World's Foremost Problem*, published in 1920, was an article entitled 'The Jewish History of the United States.'[62] In this article the story is told of how Columbus was financed by three Marranos and how at least five Jews accompanied Columbus. Of these, the article tells us, 'Luis de Torres was the first man ashore, the first to discover the use of tobacco; he settled in Cuba and may be said to be the father of Jewish control of the tobacco industry as it exists today.'[63] Here, then, while it is not suggested that Columbus was a Jew, we are told that he was funded and surrounded by Jews, and a Jew was the first to land in the New World. From this anti-Semitic viewpoint the fear is that the Jewish chosen people have been polluting the New World of the new chosen people from the beginning.

THE UNITED STATES AS A UTOPIAN SPACE

So far I have wanted to show how the utopian understanding of the United States, and historically of 'America,' coincided with a religious mythology which established Americans as a chosen people via an appropriation of the Old Testament. In this process an equation was drawn with the Jews which made it possible for Jewish migrants to the United States to view themselves as 'at home' in ways that have not been possible in the modern nation-states of Europe. I now want to shift the focus from this context and talk more about the formation of the United States as a site for utopian settlements. Here we can see better the functioning of migrant desire, and begin to delineate some

of the connections with the Eastern European territorialist and Zionist movement which led, finally, to the establishment of Israel.

Robert Nozick, in *Anarchy, State, and Utopia*, has argued that the United States is best understood as a meta-utopia. As Kumar puts it: 'In this conception utopia is not one community, one vision of the good life, but a "framework for utopias," a place which freely allows people to form and re-form themselves into utopian communities of diverse kinds.'[64] Through the second half of the nineteenth century many, mostly religious-based, communitarian, and socialist communities were founded in various parts of the United States. Many of these groups, such as the True Inspirationists of Amana and the Zoarites, had migrated to the United States. On the secular front there were, for example, the migrant French socialist groups, known as the Icarian communities, founded by Étienne Cabet in the mid-nineteenth century.

As early as 1825 the American Jew, Mordechai Manuel Noah (1785–1851) pioneered the idea of Jewish territorialism:

> For many years [Noah] was intrigued by the idea of Jewish territorial restoration and in 1825 he solicited funds to purchase a tract of land on Grand Island in the Niagara River near Buffalo, New York. He named the territory *Ararat* and declared it the future national home of the Jewish people.[65]

Paul Mendes-Flohr and Jehuda Reinharz note that 'The project was a fiasco' but that it did represent one of the first expressions of the United States as a haven for oppressed Jewry. Noah was no fly-by-night. Mendes-Flohr and Reinharz describe him as 'probably the most influential Jew in the United States in the early nineteenth century;'[66] and Harley Erdman writes of him as 'One of the first celebrated American playwrights.'[67] In addition he had served the American government as a diplomat.

Noah's utopian insight of Jewish territorialism came early in the nineteenth-century flowering of American utopian groups and the same year that Robert Owen lectured on his socialist schemes to the United States Congress. This was also the year that Owen founded New Harmony. In an article on the forerunners of Zionism, Jacob Katz has described Noah as 'the prime example of a crank'[68] because, having bought the land and announced its purpose, Noah did no more to establish Jewish immigration there. However, this is to misunderstand the nature of Noah's American utopianism. Noah thought of the United States as the naturally desirable homeland for Jews. In the hyperbolic language of the Proclamation, Noah writes that 'The desired spot in the State of New York, to which I hereby invite my beloved people throughout the world, in common with those of every religious denomination, is called Grand Island, and on which I shall lay the foundation of a City of Refuge, to be called Ararat.'[69] As I have noted, the island is a utopian motif that goes back to More's *Utopia*. In common with some others,[70] Noah also

considered the Native Americans to be the lost tribes of Israel, thus allowing him to presume Jewish occupation of the land prior to European settlement.

Noah foresaw a Jewish nation 'under the auspices and protection of the constitution and laws of the United States of America; continuing and perpetuating all our rights and privileges, our name, our rank, and our power among the nations of the earth as they existed and were recognised under the government of the Judges.'[71] His fantasy of national incorporation within the United States suggests, again, at least a moral equivalence between two chosen peoples. Speaking from the settler-state that literally understood itself as the Promised Land, Noah's fantasy was of immigration rather than migration, of people coming into the space where he already was. He was not so much envisioning a movement from the mundane to the utopian as accepting the utopian as mundane. From this point of view it is problematic to describe him as even a forerunner of Zionism.

Noah, of course, was a member of the American-Jewish community that preceded the Eastern European migration of the 1880s and after. He is, more than anything else, an early and extraordinary example of that American-Jewish thinking that syncretically accepted the United States as a moral version of the Promised Land and came to view it as the Diasporic 'home' (as opposed to being in *galut*). In 1899 Israel Zangwill republished a story about Noah's plan under the title 'Noah's Ark' in his collection *Ghetto Tragedies*. At this time, three years after the publication of Herzl's *Die Judenstaat*, Zangwill was supportive of the Zionist desire to create a Jewish homeland in Palestine. However, he was more concerned that the Jews should have a place of their own somewhere. At the Sixth Zionist Congress in 1903, Zangwill supported Herzl's proposal to examine the British offer of land in East Africa known as the Uganda plan. At the Seventh Zionist Congress, in 1905, Zangwill and a small group seceded to form the Jewish Territorial Organisation, of which Zangwill became the leader.[72]

In 'Noah's Ark' but one person, Peloni, from the ghetto at Frankfört, answers Noah's Proclamation. He travels to the United States, meets Noah, and goes to Grand Island to await developments. No one else comes. Even Noah himself finally sends Peloni a message which begins 'I am beginning to see that our only hope is Palestine.' Peloni can see no future there: 'A ruined country to regenerate a ruined people!'

After a conversation with an Iroquois man who tells him how his own people are being driven out by the white men, Peloni continues his musing:

> Yes, they were both doomed. Israel had been too bent and broken by the long dispersion and the long persecution – the spring was snapped; he could not recover. He had been too long the pliant protégé of kings and popes: he had prayed too many centuries for the simultaneous welfare of too many governments, to be capable of realising that government of his own for which he likewise prayed.[73]

Peloni throws himself over Niagara Falls. Zangwill's reservations about the possibility of any gathering together of the Jewish people are clear here, in this dystopian reconstruction of the upshot of Noah's great idea. It is this which is the key to Zangwill's subsequent espousal of the idea of the United States as a melting pot.

In his Afterword to the published edition of *The Melting Pot*, Zangwill wrote that

> It is true that its leading figure, David Quixano, advocates absorption in America, but even he is speaking solely of the American Jews and asks his uncle why, if he objects to the dissolving process, he did not work for a separate Jewish land . . . he urges that the conditions offered to the Jew in America are without parallel throughout the world.[74]

Here, Zangwill's utopian faith in the fundamental modernity of the United States is clear. In this modern country Jews have the opportunity to be accepted, to divest themselves of their exclusion, their pre-Enlightenment religio-cultural view of the world, and their oppression, and become part of a new, regenerated, thoroughly modern people. Or they could take an alternative route and strive for a country of their own. This, though, he fears, may be too hard for them.

MIGRATION FROM THE PALE

By the 1880s, as Boas Evron argues in *Jewish State or Israeli Nation?*, the Jews of the Pale had evolved into a proto-nation, a nation without land or state government but with Yiddish as a national, cultural and political language. In 1908, a meeting of the Conference of the Yiddish Language, at Czernowitz, voted Yiddish to be a national language of the Jews.[75] The Pale of Settlement, itself, had been defined by Tsar Nicholas I in 1835. With the assassination of Tsar Alexander II in 1881 there followed two years of state-encouraged pogroms. Arthur Hertzberg has described 1881 as 'a great turning point [for European Jews] as important as 1789.'[76] He argues that up to this time the Jews of the Pale were waiting for Russia to be transformed into a constitutional monarchy in the expectation that the Jews would be emancipated as they had been in Western European countries. With the events of 1881 and after, it became clear to them that this would not happen. As Hertzberg goes on: 'In the mass the Jew had no alternative but to seek radical new solutions in large-scale migration, mostly to America, or by joining the various revolutionary movements, as the young, in particular, were doing in ever-growing numbers.'[77] It is at this time that migration, as a utopian structure of feeling, becomes apparent in Eastern European thought.

As Hertzberg remarks, the majority of late-nineteenth-century Eastern European Jewish migration was to the United States. But why? At one level the answer is obvious. The United States was a massive, and growing, geographical entity that was relatively sparsely populated and did not have restrictive immigration laws, so far as Jews were concerned. The same was true, though, of many other settler-states, for example, the anglophone ones of Australia, Canada, and South Africa. As I have already begun to explain, the Eastern European Jewish attitude to the United States, like that of other potential migrants, was heavily influenced by the United States' own cultural understanding of itself as a utopian Promised Land; an idea even more powerful for Jews than for other migrants. What I want to do now is think through some of the elements in Yiddish thought which made the United States such a desirable proposition.

We can start, then, with the Am Olam movement. I begin here because this movement has many similarities to other, slightly earlier, Western European utopian migration movements to the United States, both religious and secular, ones which I have mentioned above. The Am Olam society – the name means 'Eternal People' – was founded in Odessa in 1881. Odessa was home to the most 'enlightened,' most 'western,' of Russian Jewish intellectuals. The name Am Olam derives from an essay of Peretz Smolenskin, published in *Hashahar* (*The Dawn*), a monthly magazine he had cofounded in 1868, entitled, 'Am Olam.' However, perhaps Smolenskin's most important essays were the series called, in English, It Is a Time to Plant, published between 1875 and 1877.

Smolenskin was, in Hertzberg's term, a 'cultural nationalist.'[78] He argued that 'We are a people because in spirit and thought we regard ourselves bound to one another by ties of fraternity. Our unity has been conserved in a different way, through forms different from those of other peoples, but does this make us any the less a people?'[79] By 1881 Smolenskin was arguing that the Jews should emigrate preferably not to South or North America but to *Eretz Israel* (the Promised Land, the Land of Israel) where wealthy Jewish philanthropists should buy up land on which they could settle. Shlomo Avineri comments on Smolenskin's ideas that 'Here for the first time in modern Jewish thinking the prognosis and the hope is clearly expressed that the Jewish collective process of emigration should be not merely a geographical but also a sociological transformation.'[80] Avineri distinguishes between such a sociological transformation, which implies, on his terms, the Zionist creation of a Jewish nation-state, and 'personal salvation,' Avineri's term again, which he equates with migration to America.

Both of these transformations are, in the thinking of western, secular modernity, utopian. Nevertheless, the division is no way near as neat as Avineri's Zionist binary would suggest. The Am Olam movement, based as it was on Smolenskin's notions of a cultural and spiritual nationalism, and emphasising socialistic principles, promoted the setting up of settlements in the United States. In the end, small and short-lived communes were established in Louisiana, South Dakota, Oregon, Utah and Michigan. At the same time:

In discussions of the need for a 'Jewish Homeland' which developed in Jewish public opinion in Russia after the 'Storms in the South' [pogroms], quite a few people proposed the concentrated settlement of significant numbers of Jews somewhere in the United States. Since sixty thousand settlers were entitled to demand recognition as [a] state in the United States, it was their opinion that Jewish immigrants living in agricultural settlements in one region would be able to establish a 'Jewish state' similar to the Mormon state in Utah.[81]

Noah's proto-territorialism has here returned as a legitimate Eastern European Jewish utopian dream of a self-governing state within the United States. This idea had quite a following in Eastern Europe during the 1880s, being advocated by Moses Schrenzel in his *Die Lösung der Judenfrage* (*The Solution to the Jewish Problem*), published in 1881, and by Saul Pinhas Rabinovits in an article in *Ha-Zefrah* that same year.[82] Jacob Kabakoff tells us that, in his autobiography, the Hebrew writer Yehudah Leib Levine, known as Yehalel, recounts his attraction to the scheme not the least because in their own state, Jews 'could enjoy their own enlightened form of government.'[83]

If we ask what was the dominant image taken in this enlightened form of government, the answer is socialism. In his book *Socialism*, subtitled *The Active Utopia*, Zygmunt Bauman has described this ideology as '*the* utopia of the modern epoch.'[84] Again, I do not want to rehearse this history but, rather, to recognise that, defining socialism broadly in terms of economic and social equality – at least for men – coupled with some degree of communitarianism, we find that this is the dominant practice in the nineteenth-century utopian communities of the United States.[85] The emphasis on male equality should remind us of Freud's brothers, and echo, for example, the French revolutionary preoccupation with liberty, fraternity and equality. As Kumar remarks, 'in America religious and secular socialism were organically related.'[86] The Am Olam movement was no exception. Abraham Cahan, a member of the Balta group of Am Olam, wrote that he 'imagined a fantastic picture of a communist life in distant America, a land in which no man knew of "mine" and "thine," where all are brothers and all are happy.'[87] Cahan arrived in New York in 1882 and subsequently became an important figure in the Jewish labor movement, a radical newspaper editor and novelist.

We can pause here with this emphasis on fraternity, in spite of the recognition that the founding document of the Bethlehem Judea Colony, South Dakota (1883), explicitly states that 'Women shall enjoy equal rights with men' (out of the original twelve members only one was, in fact, a woman),[88] and consider it in the light of the Freudian and Lacanian theorisation of migration I adumbrated earlier. If the utopian desire is to escape the Law of the Father then let us place this in its Freudian, modern, fantastic context. In the original, presocial, primal horde the father, who through his murder by his sons will become, by way of guilt, the internalised and totally controlling Father, has absolute power. In this mythological version of the

modern state, it is important, also, to remember the consistent exclusion of women from the ideology of the social contract.[89] Because the father is the only male with sexual access in this patriarchy, all the other males are brothers. If they do not kill the father, thus establishing the basis for society in Freud's universalising terms, or providing a mythic account of the founding of the modern state as I would have it, then what is the sons' alternative? The short answer is to escape to a place where the father cannot impose his hierarchy, and his policy of ownership and possession there to found a community of brothers. The Am Olam communities, then, were, in utopian fantasy, communities of brothers without patriarchal law.

In Judaic, as well as Christian terms, and here we can note the overlap with post-Columbian Edenic visions of the land of America, the utopian space in which this fraternal socialism can be practised could be described as the prelapsarian Garden of Eden. Thus we find that Cahan himself looked forward to America where he could help establish a Garden of Eden on earth and where men would become like angels.[90] Then there was Alexander Harkavy, in his memoirs remembering how, as one of a group of Vilna intellectuals interested in farming in the United States: 'We imagined to ourselves that we would easily be able to become farmers, especially on American soil, which we presumed a Garden of Eden.'[91] So prevalent was this image that even the negative view could be referred to it. In 1886 Ha-Melitz published a plea from Hillel Malachowsky who was living in Pittsburgh. He wrote that 'Those who consider America to be a Garden of Eden only lie,' and urged his 'brethren' to stay home.[92]

As Eastern European Jews began to conceptualise the United States in utopian terms they did so, at least partly, through the folk myth of *die goldene medinah*, as already mentioned, a Yiddish phrase usually translated as 'the golden land.' Surprisingly, although the phrase has often been acknowledged, and even used for a book title of Jewish immigrant memoirs,[93] there appears to be nothing written on the background to the phrase itself. The idea of *die goldene medinah* would seem to have a lengthy history in Yiddish culture. It is likely connected to the ideology of *galut*, of exile from the Promised Land. Herzl had once considered entitling *Der Judenstaat*, *Das gelobte Land*, that is, *The Promised Land*. The idea of a golden land may well be the oppressed and landless Jewish peasant's fantasy of a country of ease, an equivalent of (and possibly related to) the European Christian peasant myth of the Land of Cockaigne. In a personal e-mail to me the daughter of an Eastern European Jewish migrant reminisced: 'Whenever Mama's neurotic sister Mindel complained about the awfulness of life their mother said, "in the 'goldene medinah' you'll have everything you want." They dreamed about the golden land, sustained by its lustre.' By the latter part of the nineteenth century the meaning of the phrase had been reconfigured. At this time it came to be specifically applied to the United States. Now, what had been an expression of exilic longing takes on a utopian, directed, and future-oriented quality.

As the site of migratory desire the United States was reinforced by its connotations of both the Promised Land and *die goldene medinah*, ideas which in any case overlapped. The connotations of both of these ideologies are present in the title of a book that I have mentioned before. Antin's autobiography, *The Promised Land*, written when she was not yet thirty and published in 1912. Antin had migrated with her family to the United States some years earlier. She writes that 'I know the day when "America" as a world entirely unlike Polotzk [the *shtetl* where her family lived] lodged in my brain, to become the centre of all my dreams and speculation.'[94] She was in bed with the measles, her father had sent a letter just before he sailed:

> There was an elation, a hint of triumph, such as had never been in my father's letters before. I cannot tell how I knew it. I felt a stirring, a straining in my father's letter. . . . My father was inspired by a vision. He saw something – he promised us something. It was this 'America.' And 'America' became my dream.[95]

Here we have an account of the production of utopian migratory desire. The immense popularity of the book – I am working from the twenty-fourth impression dated 1922 – suggests the extent to which Antin successfully captured the Eastern European Jewish migratory experience, but also that of migrants from many other countries.

Of course, the utopian fantasy of the United States as a place that fulfilled everybody's dream, whatever that was – always, though, in some form an effect of a fantastic liberation from the Law of the Father – could not be sustained by the reality of the United States. As my informant goes on to note:

> In the United States the phrase [*die goldene medinah*] was used ironically. Immigrants, living in tenements and working in sweatshops, looked at their poverty and said, 'So here we are, in Die Goldene Medinah.' It was a term of contempt, after a bitter awakening.

The reality of life in the United States could not match the utopian fantasy which drove the desire of the migrant. In fact, Slobin tells us, in his discussion of turn-of-the-century Yiddish songs in the United States: 'The phrase *golden land* or *goldene medine* ("land of gold," or "golden land") is rarely used as a positive epithet; rather it is the standard vehicle for feelings of anti-Americanism.'[96] The disillusionment is well expressed in a popular American-Yiddish song from the first decade of the century entitled 'Die Griene Kuziene' (The Greenhorn Cousin). The song begins:

> A greenhorn cousin has come to us
> This greenhorn is as beautiful as gold
> Cheeks like red oranges
> And feet that would dance constantly

She did not walk, she leapt
She did not speak, she sang
Happy and gay is this greenhorn
And that's my girl cousin.

We can note how the gold motif in the second line connotes *die goldene medinah*. However, in the words again of my informant:

> She finds no money lying loose in the street. She works long hours for a milliner, lives in a slum, barely eats. Her face grows pale, her step heavy. She deteriorates, becomes a wreck. At the end, the narrator asks, 'How are you doing, greenhorn?' His cousin replies, 'Columbus' whole country should have such luck.' ('Was macht's du eppes, griene? Az a mazel auf Columbus' medinah.')

Here, the utopia has been realised as a dystopia. The girl arriving in hope has been destroyed. The song should not be read as a realistic depiction but rather as an expression of the loss of the utopian vision. Columbus's land, the golden land, the Promised Land, turns out to be – just another nation-state. It too has Law, and a variety of forms of oppression.

NOTES

1 Another interesting discussion is Paul Carter, *Living In a New Country: History, Travelling and Language*, London, Faber and Faber, 1992.
2 Ian Chambers, *Migrancy, Culture, Identity*, London, Routledge, 1994, p. 5.
3 Ian Chambers, *Migrancy, Culture, Identity*, p. 27.
4 Ian Chambers, *Migrancy, Culture, Identity*, pp. 23–4.
5 'The Demography of Modern Jewish History' in Paul Mendes-Flohr and Jehuda Reinharz (eds.), *The Jew in the Modern World: A Documentary History*, New York, Oxford University Press, 1980, p. 704. The previous figures for Jewish migration are also taken from here.
6 Paul Mendes-Flohr and Jehuda Reinharz, 'The Demography of Modern Jewish History', p. 716.
7 Vijay Mishra, 'The Diasporic Imaginary: Theorizing the Indian Diaspora', *Textual Practice*, vol. 10 (3), 1996, p. 423.
8 Aaron Segal, *An Atlas of International Migration*, London, Hans Zell, 1993.
9 Krishan Kumar, *Utopia and Anti-Utopia in Modern Times*, Oxford, Blackwell, 1987, p. 33.
10 Louis Marin, 'Frontiers of Utopia: Past and Present', *Critical Inquiry*, no. 19, 1993, pp. 403–7.
11 Sigmund Freud, *Totem and Taboo* in James Strachey (ed.), *The Standard Edition of the Complete Psychological Works of Sigmund Freud*, vol. 13, The Hogarth Press and the Institute of Psychoanalysis, 1962, p. 143.
12 For an expansion of this argument see the Introduction to Jon Stratton, *The Desirable Body: Cultural Fetishism and the Erotics of Consumption*, Manchester, Manchester University Press, 1996.

13 Benjamin Constant, *Political Writings*, B. Fontana (ed.), Cambridge, Cambridge University Press, 1988, p. 310.
14 Benjamin Constant, *Political Writings*, p. 312.
15 Naomi Seidman, *A Marriage Made in Heaven: The Sexual Politics of Hebrew and Yiddish*, Berkeley, University of California Press, 1997, p. 9.
16 John Murray Cuddihy, in *The Ordeal of Civility: Freud, Marx, Lévi-Strauss, and the Jewish Struggle with Modernity*, New York, Basic Books, 1974, runs a rather different argument about Freud's preoccupation with the killing of the father which hinges on Freud's disillusionment as a child with his father, something that in its hold on him, must have had the context of Freud's prior belief in his father's omnipotence (Chapter 4 *passim*).
17 Peter Gay, *A Godless Jew: Freud, Atheism and the Making of Psychoanalysis*, New Haven, Yale University Press, 1987, p. 133.
18 Krishan Kumar, *Utopia and Anti-Utopia*, p. 45.
19 Juliet Flower MacCannell, *The Regime of the Brother: After the Patriarchy*, London, Routledge, 1991, p. 27.
20 Benzion Netanyahu, Introduction to Leo Pinsker, *Road to Freedom: Writings and Addresses by Leo Pinsker*, New York, Scopus, 1944, p. 45.
21 Benzion Netanyahu, Introduction, p. 45.
22 Leo Pinsker, 'Auto-emancipation' in *Road to Freedom*, p. 101.
23 Mark Slobin, *Tenement Songs: The Popular Music of the Jewish Immigrants*, Urbana, University of Illinois Press, 1982, p. 1.
24 Quoted in Eli Lederhandler, *Jewish Responses to Modernity: New Voices in America and Eastern Europe*, New York, New York University Press, 1994, p. 105.
25 Quoted in Lederhandler, *Jewish Responses to Modernity*, p. 116.
26 Eli Lederhandler, *Jewish Responses to Modernity*, p. 116.
27 Eli Hana Wirth-Nesher, 'Introduction: Jewish-American Biography', *Prooftexts*, vol. 18(2), 1998, p. 116.
28 Of course, this does not answer the vexed question of the relationship between being a Jew and being an American, something which depends, in part, on how one defines a Jew.
29 David Ben-Gurion, 'The Imperatives of the Jewish Revolution' in Arthur Hertzberg (ed.), *The Zionist Idea: A Historical Analysis and Reader*, Westport, Conn., Greenwood Press, 1959, p. 613.
30 Leo Pinsker, 'Auto-emancipation', p. 102.
31 Henk Overberg, 'Introduction' to Theodor Herzl, *The Jewish State*, New York, Dover, 1988, p. 21.
32 Theodor Herzl, *The Jewish State*, p. 124.
33 Theodor Herzl, *The Jewish State*, p. 124.
34 Theodor Herzl, *The Jewish State*, p. 206.
35 Theodor Herzl, *The Jewish State*, p. 197.
36 See, for example, Neil Rennie, *Far-fetched Facts: The Literature of Travel and the Idea of the South Seas*, Oxford, Clarendon Press, 1995.
37 Theodor Herzl, *Old-New Land*, trans. Lotte Levensohn, Introduction by Jacques Kornberg, New York, M. Wiener, Herzl Press, 1960, p. 284.
38 John Murray Cuddihy, *The Ordeal of Civility*, p. 87.
39 Arnold Eisen, *The Chosen People in America: A Study in Jewish Religious Ideology*, Bloomington, Indiana University Press, 1983, p. 40.
40 Arthur Hertzberg, 'Is the Jew in Exile?' in *Being Jewish in America: The Modern Experience*, New York, Schocken Books, 1979, p. 192.
41 Quoted in Krishan Kumar, *Utopia and Anti-Utopia*, p. 71.
42 Krishan Kumar, *Utopia and Anti-Utopia*, p. 72.

43 I have explored the apocalyptic aspects of the American cultural imaginary elsewhere. See Jon Stratton, 'The Beast of the Apocalypse: The Postcolonial Experience of the United States', *New Formations*, no. 21, 1993, pp. 34–63.
44 I discuss this in 'The Beast of the Apocalypse'.
45 Krishan Kumar, *Utopia and Anti-Utopia*, pp. 72–3.
46 Quoted in Moshe Davis, *With Eyes Toward Zion*, America and the Holy Land IV, Westport, Conn., Praeger, 1995, p. 12.
47 Moshe Davis, *America and the Holy Land*, p. 12.
48 Moshe Davis, *America and the Holy Land*, p. 14.
49 Quoted in Krishan Kumar, *Utopia and Anti-Utopia*, p. 80.
50 John Higham, *Send These to Me: Immigrants in Urban America*, Baltimore, The Johns Hopkins University Press, rev. ed., 1984, p. 207.
51 John Higham, *Send These to Me*, p. 207.
52 Marc Shell, 'Babel in America: The Politics of Language Diversity', *Critical Inquiry*, vol. 20(1), 1993, p. 108.
53 George Washington, 'A Reply to the Hebrew Congregation of Newport' (c. August 17, 1790) in Paul Mendes-Flohr and Judah Reinharz (eds.), *The Jew in the Modern World: A Documentary History*, New York, Oxford University Press, 1980, p. 458.
54 George Washington, 'A Reply', p. 459.
55 This is not to deny, or ignore, the historically varying levels, and forms, of anti-Semitism in the United States. For a good account see Leonard Dinnerstein, *Anti-Semitism in America*, New York, Oxford University Press, 1994. Cornel West has noted that Jews 'were barred from residing in Massachusetts, Connecticut, and New Hampshire, forbidden to build a synagogue in New York in the late seventeenth century, and not entitled to hold public office during much of the eighteenth century.' Introduction to Marla Brettschneider (ed.), *The Narrow Bridge: Jewish Views on Multiculturalism*, New Brunswick, N.J., Rutgers University Press, 1996, p. xi.
56 Jacob Neusner, *Israel in America*, Boston, Beacon Press, 1985, p. 4.
57 Jacob Neusner, *Israel in America*, p. 5.
58 Arnold Eisen, *The Chosen People in America: A Study in Jewish Religious Ideaology*, Bloomington, Indiana University Press, 1983, p. 49.
59 Ella Shohat, 'Columbus, Palestine and Arab-Jews: Towards a Relational Approach to Jewish Identity', in Keith Ansell-Pearson et al. (eds.), *Cultural Readings of Imperialism: Edward Said and the Gravity of History*, New York, St Martin's Press, 1997, p. 99.
60 Henry Vignaud, 'Columbus a Spaniard and a Jew', *The American Historical Review*, vol. 18 (3), 1912–13, pp. 505–13.
61 Simon Wiesenthal, *Sails of Hope: The Secret Mission of Christopher Columbus*, New York, Christopher Columbus Publications, 1979.
62 Henry Ford (ed.), *The International Jew: The World's Foremost Problem*, republished, Los Angeles, Christian Nationalist Crusade, no date, was the most widely circulated piece of pre-Second World War anti-Semitic literature. Ford even had *The Protocols of the Elders of Zion* translated and published extracts in *The Dearborn Independent*.
63 *The International Jew*, p. 14.
64 Krishan Kumar, *Utopia and Anti-Utopia*, p. 81.
65 Paul Mendes-Flohr and Jehuda Reinharz, *The Jew in the Modern World*, p. 61, note 1.
66 Paul Mendes-Flohr and Jehuda Reinharz, *The Jew in the Modern World*, p. 461, note 1.
67 Harley Erdman, *Staging the Jew: The Performance of an American Ethnicity 1860–1920*, New Brunswick, N.J., Rutgers University Press, 1997, p. 70.

68 Jacob Katz, 'The Forerunners of Zionism' in Jehuda Reinharz and Anita Shapira (eds.), *Essential Papers on Zionism*, New York, New York University Press, 1995, p. 39.
69 Mordechai Manuel Noah, 'Proclamation to the Jews (September 15, 1825)' in Paul Mendes-Flohr and Jehuda Reinharz (eds.), *The Jew in the Modern World: A Documentary History*, New York, Oxford University Press, 1980, p. 460.
70 In his *Historia natural y moral de las Indias,* published towards the end of the sixteenth century, José de Acosta argued against the idea that the Indians of South America were descendants of the lost tribes of Israel. As Anthony Pagden put it: 'The apparent similarities between the supposed natural characteristics of the two races – their mendacity, ceremoniousness, deceitfulness and timidity – had led to a widely held belief that the Indians were the ten lost tribes of Israel' (*The Fall of Natural Man: The American Indian and the Origins of Comparative Ethnology*, Cambridge, Cambridge University Press, 1982, p. 156). This belief that native Americans were Jewish was not confined to South America. It was also considered by some to be the origin of the native peoples of North America.
71 Mordechai Manuel Noah, 'Proclamation to the Jews', p. 460.
72 On this period of Zangwill's life see Maurice Wohlgalernter, *Israel Zangwill: A Study*, New York, Columbia University Press, 1964, pp. 38–9.
73 Israel Zangwill, 'Noah's Ark' in *Ghetto Tragedies*, London, W. Heinemann, 1899, p. 121.
74 Israel Zangwill, 'Afterword', *The Melting Pot*, New York, Arno Press, 1914, p. 208.
75 The aims of the Czernowitz conference can be found in a document reprinted in Paul Mendes-Flohr and Jehuda Reinharz (eds.), *The Jew In the Modern World*, pp. 424–5.
76 Arthur Hertzberg, *The Zionist Idea: A Historical Analysis and Reader*, Westport, Conn., Greenwood Press, 1959, p. 40.
77 Arthur Hertzberg, *The Zionist Idea*, p. 41.
78 Arthur Hertzberg, *The Zionist Idea*, p. 144.
79 Excerpted in Arthur Hertzberg, *The Zionist Idea*, p. 147.
80 Shlomo Avineri, *The Making of Modern Zionism: The Intellectual Origins of the Jewish State*, London, Weidenfeld and Nicolson, 1981, p. 64.
81 Shmuel Ettinger and Israel Bartal, 'The First Aliyah: Ideological Roots and Practical Accomplishments', in Jehuda Reinharz and Anita Shapira (eds.), *Essential Papers on Zionism*, New York, New York University Press, 1995, p. 82.
82 Jacob Kabakoff, 'The View from the Old World: East European Jewish Perspectives' in Robert Seltzer and Norman Cohen (eds.), *The Americanization of the Jews*, New York, New York University Press, 1995, p. 46.
83 Jacob Kabakoff, 'The View from the Old World', p. 46.
84 Quoted in Krishan Kumar, *Utopia and Anti-Utopia*, p. 33.
85 We can also note the specifically Jewish preoccupations of some aspects of socialism. John Murray Cuddihy, in *The Ordeal of Civility*, argues that 'Universalist in its rhetoric and appeal, the socialist ideology that comes out of German Jewry, from Marx to Walter Lippmann, is rooted in the "Jewish Question" which, for German Jewry generally, has always turned on the matter of the public misbehavior of the Jews of Eastern Europe (the proverbial "Ostjuden")' (p. 5).
86 Krishan Kumar, *Utopia and Anti-Utopia*, p. 87.
87 Quoted in Jacob Kabakoff, 'The View from the Old World', p. 47.
88 'The Am Olam Movement' in Paul Mendes-Flohr and Jehudah Reinharz (eds.), *The Jew in the Modern World*, p. 477 and p. 478.
89 On the exclusion of women from the social contract see Carole Pateman, *The Sexual Contract*, Cambridge, Polity Press, 1988.

90 Jacob Kabakoff, 'The View from the Old World', p. 47.
91 Quoted in Jacob Kabakoff, 'The View from the Old World', p. 48.
92 Quoted in Jacob Kabakoff, 'The View from the Old World', p. 43.
93 Azriel Eisenberg (ed.), *The Golden Land: A Literary Portrait of American Jewry, 1654 to the Present*, New York, T. Yoseloff, 1964.
94 Mary Antin, *The Promised Land*, Boston, Houghton Mifflin, 1955, p. 142.
95 Mary Antin, *The Promised Land*, p. 142.
96 Mark Slobin, *Tenement Songs*, p. 157.

Part 3

NOT QUITE WHITE

7

JEWS, RACE AND THE WHITE AUSTRALIA POLICY

There has been much very good social and political history written about the Jews in Australia.[1] However none of this work sets this history within broader ideological understandings of Jews in the west, or in the context of the complex interrelationship of ideas about race and the nation-state which have been central to the development of the Australian nation-state. Conversely, in histories of migration to Australia and discussions of population policy, Jews hardly get mentioned at all — not at all in Stephen Castles et al.'s justly well-known *Mistaken Identity: Multiculturalism and the Demise of Nationalism in Australia*[2] and three pages, one of which is a quotation, in Geoffrey Sherington's standard text, *Australia's Immigrants 1788–1988*.[3] In this chapter I want to bring Jewish history in Australia out of its isolation and begin an examination of the cultural construction of Jews in the context of the evolution of the White Australia policy and its corollary, the idea of assimilation as the central plank in the formation of the Australian nation-state.

CONCEPTUALISING AMBIVALENCE

The most useful way to theorise the situation of Jews as a category in Australia is through the concept of ambivalence. That Jews are hardly mentioned in the standard histories of migration to Australia or, for that matter, in the three major books written on the White Australia policy during its operation should not surprise us when we realise the extent to which the ambivalent situation of the Jews in the context of the Australian nation-state could have unsettled and laid bare the discursive assumptions on which that policy was founded.[4] There have been two recent theorisations of ambivalence both of which, in different ways, help to illuminate the subject in hand. Zygmunt Bauman argues that what characterises the modern is that 'it contains the *alternative* of order and chaos.'[5] He suggests that the primary drive of modernity is the establishment of order. Applied in terms of society, 'There are friends and enemies. And there are *strangers*.'[6] Friends are those who are characterised as like — in the sense of more or less the same as — us; enemies are those who threaten our order.

Reworking Georg Simmel's notion of 'the stranger,' Bauman describes the stranger as one who 'comes into the life-world and settles here, and so – unlike the case of mere 'unfamiliars' – it becomes *relevant* whether he is friend or foe.'[7] For Bauman, the stranger is 'ineradicably *ambivalent* . . . blurring a boundary line vital to the construction of a particular social order or a particular life-world.'[8] Taking ambivalence and its eradication as the founding problem of modernity leads to a certain reification in Bauman's important discussion. He writes that '*The nation-state is designed primarily to deal with the problem of strangers, not enemies.*'[9] It is more useful to describe the nation-state as a machine which produces strangers as it produces friends and enemies. From this point of view it is not that the stranger 'threatens the sociation itself – the very *possibility* of sociation'[10] but, rather, that he or she threatens the integrity, the homogeneity, of the nation by calling into question the assumptions through which the nation constructs itself.

There is an uncertainty in Bauman's theorisation. On the one hand, the stranger has come from elsewhere; she or he is, we might say, Other. On the other hand, she or he blurs boundaries; they are, it would seem, in some sense 'the same as' us. In order to understand what is at stake here, and what is so important in Bauman's understanding of ambivalence, we must turn to Homi Bhabha's work. In a now well-known article, Bhabha describes colonial mimicry as

> the desire for a reformed, recognizable Other, *as a subject of a difference that is almost the same, but not quite.* Which is to say that the discourse of mimicry is constructed around an *ambivalence*; in order to be effective, mimicry must continually produce its slippage, its excess, its difference.[11]

Bhabha's starting point is a discussion of British colonialism, particularly in India. He argues that colonial practice – certainly that of the British in India – was to take the Other and educate her/him in the ways of the coloniser while continuing to mark her/him as Other. In this way the Other is reformed as ambivalent, in some ways the same as the coloniser but, in the end, always excluded and constructed as a mimic.

What is at stake in a comparison of Bauman's and Bhabha's theorisations of ambivalence is the status of the stranger and Other who produces the ambivalence. In Bhabha's work the Other always remains Other, ultimately formed as such along the faultline of race: 'Almost the same but not white.'[12] The ambivalence in this case always in the end falls back into the binariness through which the coloniser constructed the colonised as Other in the first place. In Bauman's case, while the stranger he describes would seem to be Other, the description that Bauman provides of ambivalence suggests a much greater degree of ambiguity. From this description the stranger would seem to be thought of as, partly, the 'same' as the members of the nation. We might say

that, rather than being 'almost the same but not white,' these strangers are both white and not-white, the same and yet also Other. It is, then, no wonder that the group whom Bauman has in mind for his modern strangers are the Jews: 'The Jews have been the prototypical strangers in Europe split in nation-states set on annihilation of everything "intermediate," underdetermined, neither friendly nor inimical.'[13] In the case of Australia, a settler-state where the nation itself had to be brought into existence, the ambivalent situation of the Jews was precisely played out through the processes employed to define and form the Australian nation.

It is no wonder that general discussions of Australia's migrant population history and policy have ignored the Jews. The Jews, as a category, transgress the two major discourses on which Australian population policy has been constructed: race and nation. In Australia the discourse of race was used to demarcate the cultural limits of the nation as it was being formed in order to produce that culturally homogeneous nation which was the classical form of the nation during the modern period. As Ien Ang and I have argued elsewhere, 'the White Australia policy was, in the first instance, a *nationalist* policy and reflects the new nation-state's search for a national identity in a European culture and a British-based racial homogeneity (which inevitably implies the exclusion of racial/cultural Others).'[14] Through the period of the late 1960s when Australia began to open its doors to those groups which had been most determinedly excluded in the era of the White Australia policy – 'Asians' – the biologically essentialist rhetoric of race gave way to the cultural relativist rhetoric of ethnicity. At the same time, the practice of identifying migrants according to national background continued. In both these major eras, the times of assimilation and of multiculturalism, Jews have not fitted the categories used. For example, while Jews were increasingly racialised in popular, and sometimes governmental discourse, from the middle of the nineteenth century, the Australian Census has consistently classified Jews by their religion. As a consequence, all estimates of the numbers of Jews in Australia are dependent on those who give Judaism as their religious affiliation.

With the advent of ethnicity rhetoric, and multiculturalism, the problem is compounded. Ethnicity is closely identified with culture and, in turn, is geographical in the sense that particular ethnic cultures are assumed to come from particular regions or nations. Today, under half of Australia's Jewish population has a background in Anglo-Jewry. Many of Australia's early Anglo-Jewish migrants were descendants of the Sephardis who had begun settling in England during the period of the Commonwealth in the seventeenth century. Probably rather over half of the total population has an Ashkenazi and Yiddish heritage coming from Germany or the Russo-Polish Pale in the years between 1930 and 1950.[15] Moreover, unknown numbers of Australian Jews have arrived by way of a generation or two in England or other countries that received Yiddish migration from the late nineteenth century onwards. Since the Second World War, as we shall see, an increased number of non-Ashkenazi Indian,

Iraqi, and Egyptian Jews of Sephardi and Mizrahi background have entered the country.

In order to illustrate the points I want to make about Jews and the White Australia policy I will focus on three particular periods: the mid-to-late nineteenth century, that is the period leading up to Federation in 1901; the late 1930s and 1940s when there was pressure on Australia to take in Jewish refugees from Europe; and the 1940s and 1950s when many non-European Jews sought to migrate to Australia. In the first period we see the understanding of Jews in Australia being reshaped by the general western racialisation of the Jews. In the second, the pressures placed on Australia by the numbers of Jewish refugees helped to create an increasingly overt discriminatory attitude. One thing this highlights is the interaction between discourses of race and nation where there has been a tendency, all the more present in Australia's version of multiculturalism, for race to hide behind the rhetoric of nation. In the third period we find breaking down the notion of the Jews as a single race in the face of a preoccupation over the colour of prospective non-European-background Jewish migrants. Overall, this history shows how the ambivalent construction of the Jews, using Bauman's theorisation of ambivalence, was acted out in the context of the attempt to form a homogeneous Australian nation and a unitary Australian identity.

ASSIMILATION, RACE AND THE NATION-STATE

With the nineteenth-century rise of the modern nation-state, Jews in Europe were gradually emancipated and expected to assimilate. The nation-state was founded on the notion of representation, identifiable in political theory discussions about the relation between the state and its citizens. In this structure, the citizen was thought of as an individual. In Chapter 4 I have discussed this development, as it relates to Jews, using Jean-Paul Sartre's ideas in *Anti-Semite and Jew*. At the same time, as we have seen, the nation was thought of as a homogeneous entity made up of a single people sharing the same language, culture and, in its most essentialist formulation, the same race. Bauman's theorisation of 'friends' as an expression of a modern understanding translates, in the terms of the nation, as a grouping of people with the same culture and, in terms of those who are not quite the same but who could be, a political emphasis on assimilation.

It was, in fact, the very claimed homogeneity of the nation which enabled all of its members to be thought of in terms of the state as what Sartre describes as 'a collection of individuals.' In this context two divergent approaches were taken to the Jews in Europe. On the one hand Jewishness was reduced to adherence to a particular religion, Judaism. In this way the ideal of assimilation involved the taking on board of the culture and language of the dominant

national group. Judaism could be tolerated as a religion which, while not Christian, was nevertheless the antecedent to Christianity. On the other hand, as an endogamous group whose presence in Europe preceded that of the nation-states, Jews were progressively racialised and often subjected to a political anti-Semitism aimed at excluding them from membership of the modern states in which they found themselves to be living.

As we noted in Chapter 1, it was Gregorius Hornius, in 1666, who first associated race with colour, claiming that there were three basic racial groupings in the world, each descended from one of Noah's three sons, Ham, Shem and Japeth. For Hornius 'the Japhethites became whites, the Semites were the yellow races, and the Hamites became Negroes.'[16] Up until the mid-nineteenth century Jews were usually regarded as a part of the white race. As George Mosse puts it:

> The Jews were either ignored by anthropologists during much of the eighteenth century or considered part of the Caucasian race [the category devised by Blumenbach (1752–1840)], and still considered capable of assimilation into European life. . . . Ideas of cosmopolitanism, equality, and toleration operated for the Jew as they could not for the Negroes; after all, the Jew was white.[17]

The French writer, Arthur de Gobineau (1816–82), in *Essai sur L'Inegalité des Races Humaines* (1853–55) was one of the first to identify the Jews as a separate race. Gobineau also popularised the idea of the white race as being Aryan, and having an origin in northern India. Subsequently another Frenchman, Ernest Renan (1816–92), began to identify the Semites with the Arabs and Jews and, increasingly, with the Jews alone. In this way was produced the basis for the dominant system through which the Jews were racialised in continental Europe in the late nineteenth, and twentieth, centuries, that of Aryan versus Semite, a distinction founded, in the first place, on the claimed geographical origins of these two groups. For the purposes of discussion of Jewish racialisation in Australia it is important to note a distinction between racialisation by colour and racialisation by claimed historical geographical origin and physical type. In Australia, as in other English-speaking countries including the United States, racialisation of the Jews has always been marked by an ambiguity about their colour-status. One reason for the lack of usage of the Aryan/Semite racial distinction in Australia may be that, it being a settler-state, the Jewish presence was never allowed to reach a point where such a clearly discriminatory distinction against a European people would have been useful. At the same time, unlike in Europe, distinction in terms of colour – that is, the classification of 'non-European' peoples – was of much greater importance in excluding those not considered appropriate to the Australian national project.

As an essentialist collective category race was a useful way for Enlightenment Europe to limit its universalist claims about the traits that make up human

nature. In this way 'white,' or Caucasian, could be used to distinguish Europeans from Others. As national claims developed in tandem with the establishment of nation-states so race also began to be used as a way of describing the legitimacy of national groupings. In this way, during the last half of the nineteenth century, writers like Matthew Arnold (1822–88) and Rudyard Kipling (1865–1936) began talking about an 'English race.' It is during this period, with the upsurge of national claims, that Jews began to be racialised. In *Imagined Communities* Anderson argued[18] that 'dreams of racism . . . have their origin in ideologies of *class*, rather than those of nation.'[19] Certainly racism, and anti-Semitism, can be used to establish or preserve class difference but its development in Europe was very deeply associated with the elaboration of the discourse of nationalism. This is nowhere more clearly demonstrated than in the construction of the Jews as the internal Other to the developing European nation-states during the nineteenth century. I have already discussed the German version of this in Chapter 4.

In the nineteenth century Australia was not yet a nation-state in its own right. It was a collection of colonies that were ruled individually from London. In Europe the Jew was constructed as the internal, and partial, Other to particular nations which claimed to have an immemorial existence and the right to a particular area of land. In Australia, as in other settler-states, national identity could not, in the first place, grow out of a claim about the national group's relationship with the land. Here, the Jews and the other, mostly British and Irish, migrants were all displaced. Moreover, the Jewish convicts and migrants had mostly come from Britain where the bourgeois Jews, at least, had been very much assimilated. Unlike in Europe where political anti-Semitism could construct Jews as displaced interlopers in a national territorial community where they had no right to be, in Australia the Anglo-Jewish migrants came from a highly assimilated community and had as little national claim to the Australian land as any other migrant. At this point we need to emphasise the extent of that assimilation. As Charles Price notes:

> that which came to be called the Anglo-Jewish way of life ('orthodoxy and efficiency, piety and dignity, modernity of method with strict adherence to tradition' [V. D. Lipman *Social History of the Jews in England, 1850–1950*, London, 1954, p. 40]) was worked out in England during the half century before 1880, largely under the influence of the German-born Chief Rabbi, Dr Nathan Adler.[20]

In England the influx of eastern European Jews in the decades after 1880 produced a crisis in the situation of Anglo-Jewry[21] and led the British government to enact its first legislation to control immigration, the 1905 Aliens Order. In Australia, the refugees of the 1930s and 1940s produced a comparable crisis in Australian Anglo-Jewry. What the mass migration to England did, as the reports of a threatened influx at this same time did in Australia, and as happened

in Australia in the 1930s and 1940s, was to make the Anglo-Jews visible as a group through their association with the European Jews. In this way the Anglo-Jewish attempt to resolve the ambivalence of their situation by assimilating in British society culturally while retaining Judaism as a religion and endogamy was placed in question.

In comparing the situation in the Australian colonies with that which obtained in Britain we find an anomaly that speaks volumes for an understanding of the situation of Jews in the European nation-states. As Israel Getzler puts it:

> If in England from the 1830s onwards Jews, as before them dissenters and Catholics, had to struggle for equal civil and political rights – especially the right to enter Parliament – this was far less the case in the British colonies. . . . By offering religious tolerance and rights of citizenship to all prospective settlers except Catholics, Britain encouraged the immigration of dissenters, European Protestants and Jews into its colonies.[22]

Unlike Britain where Jews were gradually emancipated through Parliamentary Acts in 1854, 1858 and 1866 'In the Australian colonies Jews appear from the beginning to have enjoyed full civil and political rights: they acquired British nationality, voted at elections, held commissions in the local militia, were elected to municipal offices and were appointed justices of the peace.'[23] In other words Jews were fully integrated into the political and administrative structure of the colonies – *because* they were colonies and did not have the status of national entities. At the same time, this being historically before the late-nineteenth-century racialisation of the Jews, in the Enlightenment tradition, Jewish identity was officially understood as a function of religion. Getzler's book documents what was considered by the Jews of the various Australian colonies to be the one impediment to complete equality, that the Jewish religion was not of an equal official status to Christianity.

RACIAL EXCLUSIVITY AND THE FORMATION OF THE AUSTRALIAN NATION-STATE

Where, for the European nation-states, the biggest threat to a homogeneous nation was always internal, and typified in 'the Jews,'[24] in the Australian colonies through the second half of the nineteenth century the threat to a homogeneous nation was external, that is to say, it was an effect of migration, and was embodied in the Chinese. Chinese males began arriving in numbers in the 1850s, when gold was discovered in Victoria, and by 1859 'made up almost 20 per cent of the male population in Victoria, although only 8 per cent of

Victoria's total population and about 3.3 per cent of the total population in the Australian colonies in 1861.'[25] In June, 1855, the first of many restrictive Acts was passed, the Victorian 'An Act to make Provision for Certain Immigrants.'[26] This limited the number of Chinese passengers that could be brought in any vessel to one for every ten tons of registered tonnage and introduced a head tax. With the Chinese simply shifting their port of entry to South Australia, the entry limitation was lifted. In 1857 Victoria introduced a monthly licence fee on the Chinese of £1, later reduced to £1 every two months.[27] In 1857 South Australia introduced an Act almost identical to Victoria's 1855 Act and in 1861 New South Wales passed the Chinese Immigration Restriction Act which, again, was practically the same as the 1855 Victorian Act.[28] Over the next twenty years the various colonies, independently of each other, varied their laws in response to the local situation. Finally, in 1880 in Melbourne and continuing in early 1881 in Sydney, an Intercolonial Conference with delegates from all colonies decided that, in the face of the possible consequences of large scale Chinese migration, the colonies needed to co-ordinate their legislation. In 1888, at another Intercolonial Conference, the delegates proposed a uniform legislation which limited Chinese passengers on vessels to one per 500 tons of ship's cargo.[29] By 1890 the Australian colonies had in place more or less consistent legislation limiting the entry of Chinese. Standardising laws protecting the Australian colonies from Chinese migration was an important spur to federation.

Throughout this period the Chinese were perceived as racially Other and as unable to be mixed in with the white, British stock of the colonies. Their very numbers made them a threat. In 1857 Sydney's *The Empire* newspaper described them as 'a swarm of human locusts.'[30] Richard White argues that

> during most of the nineteenth century, it was generally accepted that Australia had a clear political and cultural 'image' which was considered neither particularly British nor Australian. Australians saw themselves, and were seen by others, as part of a group of new, transplanted, predominantly Anglo-Saxon emigrant societies.[31]

The reason colonial Australians were not concerned with themselves as either British or Australian was that the colonies did not think of themselves in national terms. Instead, they thought of themselves racially, as Anglo-Saxon. In this thinking the Jews were irrelevant as a separate race. However, the idea of Australian identity as 'a tug-of-war between Australianness and Britishness . . . became common towards the end of the nineteenth century.'[32] By this time, the Chinese were seen as a threat to the British civilisation of the colonies. In 1877 the *Sydney Morning Herald* quoted the Premier of Queensland at the time when Queensland's 1876 Act which legislated on 'Asiatic and African aliens' was withheld the Royal Assent pending changes. He said, 'We fear that both

our rights (of self-government) and our civilisation may be compromised, and that our social and political system may be imperilled, if on any plea whatever a Chinese immigration is forced upon us against our wishes and against our interests.'[33] As we shall see, it was in the latter part of the nineteenth century, concurrent with the rise of Australian nationalism, that the first major wave of anti-Semitism spread through the colonies.

Up to around 1890 the focus of the Australian colonies' concern was specifically with the regulation of Chinese migration. After this the concern became much more directly racial in its form, aimed at excluding non-whites. Andrew Markus describes this transition very well. He writes that

> There was considerable development of racial consciousness in the period 1850–90 and this is particularly apparent in legislation directed at the Chinese. With reference to the definition contained in legislation, there is a change from a territorial emphasis to one specifically couched in the terminology of race.[34]

Myra Willard gives the main reason for this, 'In the fifties this primary reason [of national self-preservation] for [the colonies'] policy found expression in the resolve to maintain the British character and institutions in the Australian Colonies; towards the end of the century, however, it was expressed in terms of Australian nationalism.'[35] The consequence was a shift from a dichotomous construction of Anglo-Saxon/British versus Chinese to a general opposition which instantiated whiteness self-consciously and took the British as the type of 'whiteness,' and opposed it to a general category labelled 'coloured.'[36] Willard argues that around the early 1890s there was an increasing con- sciousness in the Australian colonies of other 'Asian' migrants, mostly Indians and Ceylonese.[37] By the mid-1890s this concern was extended to the Japanese, small numbers of whom had been arriving in Australia. What concentrated the minds of the Australian colonies' legislators, however, was the 1894 Anglo-Japanese Commercial Treaty which enabled free travel of nationals of both countries to either country. The Australian colonies were given the opportunity to ratify the treaty.[38] They did not do so.

There was a push to widen the laws regulating Chinese migration. In 1896 another Intercolonial Conference met and decided to extend the 1888 Restriction Bill 'to all coloured races,' including those people who were British subjects.[39] The Bills to this effect sent to London by New South Wales, South Australia and Tasmania for Assent were all reserved. In a speech to the Australian representatives at the Imperial Conference of 1897 the Secretary of State for the Colonies, Joseph Chamberlain, made very clear that Her Majesty's government, while accepting the need of the colonies to keep out undesirable immigrants – such as those who are dirty, ignorant or paupers – would not sanction exclusion 'by reason of . . . colour, or by reason of . . . race.'[40] Instead, Chamberlain recommended an Act along the lines of that of Natal which was

an education test, requiring prospective migrants 'to write out and sign in a European language an application to the Colonial Secretary in a form set out in a Schedule to the Act.'[41] Chamberlain's speech was most certainly strategic. He did not want either Japan, with whom Britain had so recently signed a commercial treaty, or India, the most populous and economically important country in the Commonwealth, to think that Britain condoned racism. On another occasion Chamberlain affirmed his personal view:

> I believe in this race, the greatest governing race the world has ever seen; in this Anglo-Saxon race, so proud, so tenacious, self-confident and determined, the race which neither climate nor change can degenerate, which will infallibly be the predominant force of future history and civilisation.[42]

Willard notes that the phrase 'White Australia' was being 'frequently used as early as 1896 to denote the Australian policy.'[43] As the colonies moved towards federation and an increasing independence from Britain so race became the crucial marker of the nascent Australian identity, the signifier of both inclusion and exclusion. In the first instance 'white' here meant of British nationality – with the presumption that the British were racially homogeneous – but other northern Europeans were acceptable. Within this context, as I shall now demonstrate, Jews were acceptable up to a point, being thought of ambivalently, as I discussed at the outset, as both white and non-white.

During the nineteenth century there was an undertow of everyday anti-Jewish feeling feeding on European stereotypes of Jews. As *Free Lance* put it in 1896, the Jew in Australia was known as 'a financier, a lawyer, a bookmaker, a pawnbroker or dealer in second-hand goods.'[44] The cartoons of Jewish men had them as fat, unshaven, hooknosed and speaking with an Anglo-Yiddish accent. Against this, Australia's Anglo-Jewry was highly assimilated with only a small presence of Jews from eastern Europe.

In the 1890s there was an upsurge in anti-Jewish feeling, indeed in what we can begin to call anti-Semitism. As I argued in Chapter 5, one of the most important characteristics of anti-Semitism, the defining feature of its modernity, lies in its association with nationalism. As a settler-society, the first form the racialisation of the Jews took was a preoccupation with Jewish immigration. The catalyst for the upsurge seems to have been a report in an English newspaper, taken up by Australian newspapers in early 1891, that the Jewish philanthropist, Baron Maurice de Hirsch, was considering sending 500,000 pauperised Russian Jews to Australia to form an agricultural settlement.[45]

As it happens the report was inaccurate but this is beside the point. The consternation caused in both Australian gentile and Australian Anglo-Jewish circles was considerable. Most of the outcry over the report came in respect of fears of the new migrants taking jobs, lowering wages and therefore the

standard of living. However, it is clear that the Jews were beginning to be racialised. A member of the New South Wales Legislative Assembly talked awkwardly of 'the Jewish people or the people of any religious denomination'[46] but the *Bulletin*, which carried on its masthead the slogan 'Australia for the White Man,' was much more forthright. It wrote:

> Even the Chinaman is cheaper in the end than the Hebrew . . . the one with the tail is preferable to the one with the Talmud every time. We owe much to the Jew – in more senses than one – but until he works, until a fair percentage of him produces, he must always be against democracy.[47]

The claim that the Jew does not work at labouring jobs is a part of the modern stereotype of the Jew. It is a transformation of the image of the Jew as a usurer. In capitalist society, Karl Marx argued in the nineteenth century, integration into the society is gained by one's selling of one's labour-power or one's owning of the means of production. Not to work signifies that one is in some sense not a member of the society. We can think here of Marx's view of the *lumpenproletariat*. In Australia working-class anti-Semitism has always been strong and closely linked with labour politics and radical nationalism.[48] Fears of Jewish workers taking Australian jobs, or Jewish entrepreneurs employing only Jews or else employing Australian labour at low wages, were translated into an assertion of a homogeneous British-based, Australian national identity. In this extract from the Bulletin we can see how this operates by way of a racialisation of the Jew that puts him (*sic*) on a racial equivalence with the Chinese – though the Chinese is preferable as a worker. Here, then, both Jews and Chinese are racialised and in this way Othered equally, with the intention that both should be excluded from a white Australia homogeneous both racially and culturally.

That this comparison is not simply idiosyncratic can be demonstrated by a quotation from an 1891 letter to the London *Jewish Chronicle* written by the Australian Anglo-Jew, Walter D. Benjamin, who feared an influx of Russian Jews. Benjamin explained that the penniless Russian Jew 'would be regarded every whit as unfavourably as the Chinese cook, the Hindoo hawker, the Kanaka plantation hand, the Tamil servant, or the Lascar sailor'[49] and even compared 'the hypothetical mass Russian Jewish migration to Australia with America's "Negro problem."'[50] Here we have again the suggestion that gentile Australians – and even Australian Anglo-Jews as Benjamin's letter suggests – would equate *Russian* Jews with Chinese. The addition of 'Hindoo,' 'Tamil' and 'Lascar' brings us to the assumption informing the comparison: that these Russian Jews will be thought of as 'Asiatic.' Given the European orientalising of European Jews in the second half of the nineteenth century and the perception in Australia that Russians in general were 'Asiatic' rather than 'European' this is understandable.[51] It also points to the fear which may well

have stimulated Benjamin's letter, that Australia's Anglo-Jews might themselves become racialised as 'Asiatic.'

Against this, Benjamin's second rhetorical move is to racialise the Russian Jews so as to emphasise, by contrast, the Britishness of Anglo-Jewry. If the unassimilable Russian Jews are, by implication, 'black,' then the assimilable Anglo-Jews must be, like the British, 'white.' The implication of the blackness of some Jews was not idiosyncratic. It is of a piece with an important European tradition, which precursed their orientalisation – their Asianisation in Australian racial terms – as Semites, which coloured the Jews as black. Sander Gilman writes that 'The general consensus of the ethnological literature of the late nineteenth century was that the Jews were "black" or, at least, "swarthy."'[52] Through the nineteenth century 'black,' as a term of racial colouring, was used by Europeans to define Otherness. For example, in Britain the Irish were described as 'black.'[53] In this way the position of the Irish as a colonised Other was expressed, putting them on a par with Africans.[54] What is important to note here is that, in Australia, the highly assimilated Anglo-Jews were thought of as 'white.'

Hilary Rubinstein describes how the Jewish 'Communal shock at the anti-Semitism of the 1890s was consolidated by populist anti-Semitism in the decades to come.'[55] In Australia, the racialisation of the Jews took place in the context of the nationalism which led to the establishment of a federated Australia and the White Australia policy. The persistence of a racial anti-Semitism was linked to the Australian nationalist desire for a homogeneous white nation. From this time on the fear for Australia's assimilated Jewry, caught in the ambivalence of their white/non-white status, was that any increased visibility for the Jews, any signs of racial/cultural difference, would mark them as a threat to the homogeneity of the nation.

In 1901 the colonies of Australia federated. The first Act passed by the new Commonwealth government was the Commonwealth Immigration Restriction Act. Modelled on the Natal Act, as recommended by Joseph Chamberlain, it 'prohibit[ed] the entry into Australia of any person who, when asked to do so, fail[ed] to write out at dictation, and sign in the presence of an officer, a passage of 50 words in length in a European language.'[56] In 1905, after representations from the Japanese, the Act was made to seem even less racist by the dropping of the requirement that it should be a European language. In fact, in this Act, language operates as a substitute for race. In racialist discourse race is able to be exclusionary because it is claimed to be an essential attribute of the person. Languages, on the other hand, are learnt. However, in this instance, the choice of language used in the test was up to the discretion of the Immigration officials with the consequence that the test could, in fact, be used as an exclusionary device. The use of language in this way has other implications. The modern nation-state had, ideally, a single, uniform language for its homogeneous national population. In Australia the use of English is not simply functional, it has important national and 'racial'

significance as the language of white Australia's British heritage. It is, therefore, not surprising to find that 'in its first draft the dictation test was to be administered in the English language.'[57] That this was changed was a consequence of a worry that it would offend European countries though, ironically, the greater the choice of possible language the greater the insurance that someone who was not considered desirable would be kept out. Nevertheless, the choice of European languages signals what was considered to be the limits to 'whiteness' and where 'colouredness' began.[58]

The justification for the White Australia policy was put forward by Alfred Deakin, the first Attorney-General, in the debate on the Commonwealth Restrictions Bill. He argued that 'A united race means not only that its members can intermarry and associate without degradation on either side, but implies one inspired by the same ideals.'[59] In practical terms Jewish endogamy has been one of the key stumbling blocks in the process of Jewish assimilation. It is significant that Deakin should single out intermarriage as the exemplary form of social integration in the modern state. In essentialist terms racial difference ideally operates as a bar to marriage, the children of such unions often thought to be retarded or themselves sterile.[60] From this point of view the acceptance of intermarriage signifies a lack of racial difference. Jews were thus caught on the horns of a dilemma. If they were accepted as marriage partners by gentiles this was a crucial step in the process of national assimilation but, in marrying gentiles, they destroyed the endogamous basis of Jewish particularity − not just a religious grouping but something more.

The high level of assimilation of Anglo-Australian Jewry, and the general lack of regard of Jews as a race, was reflected in the high levels of intermarriage through the nineteenth and the first half of the twentieth centuries. In 1911, 27 per cent of Jewish husbands in Australia had gentile wives and 13 per cent of Jewish wives had gentile husbands. In 1921 these figures had increased to 29 per cent and 16 per cent respectively.[61] However, by the 1991 census there had been a decline to an overall rate of 10–15 per cent.[62]

With the nationalist rhetoric around Federation new pressures were put on the Jews to assimilate into the new nation-state. In this situation, where Jewish identity was already thought of primarily in terms of religion rather than race, it is no wonder that the rate of intermarriage rose. What brought it down again, and reasserted a distinctive Jewish identity, was the influx of German, Polish and Russian refugees before and after the Second World War. Simultaneously, it was these Jews who heightened the racialisation of Australian Jewry precisely through their reassertion of a Jewish cultural identity.

Apart from the gradation of white to coloured, race was complicatedly mixed in with language and with culture. Premised on an Australo-British norm that combined visual discrimination with the valorisation of the English language and Anglo-Australian cultural practices, assimilation was considered to be possible only for those who did not vary too much in any of these three categories, where difference in any one suggested difference could be found in

the other two. Thus, for example, in the 1930s, in spite of being Europeans, Italians, and especially southern Italians, who were considered similar enough to the British/European norm to be let in by the government were not so considered by the general population. They had a different language, some very different cultural practices such as their version of Catholicism and the using of garlic, and they were considered to be dark enough to be called coloured. In 1934 'there were "anti-dago" riots at Kalgoorlie, in which several people were killed.'[63]

By the 1920s:

> the general impression was that 'good Jews' were those who were Australian or British, conformed with the norms of the Anglicised Australian community, spoke English without an accent, engaged in 'respectable' business practices and in no way stood out from the great anonymous mass of other Australians. 'Bad Jews' were the opposite. They were foreign, exhibited different customs and modes of behaviour, rarely spoke English without an accent (and employed a syntax which held them up to derision), and had business principles derived from the eastern European village or market town rather than the local shop in the high street.[64]

Eastern European Jews had two of the three markers of difference. With any other group, such as the Italians, this would have been enough to have them classified as racially different. However, in the colour typology of race, Jews in Australia tended to be thought of as white. This assumption began to be destabilised in the 1930s when there were an increasing number of applications to come to Australia from German and subsequently eastern European Jews.

THE RACIALISATION OF EUROPEAN JEWS IN AUSTRALIA

From the early 1930s, with the Nazi rise to power, the racialisation of the Jews as Semites was becoming the dominant ideology in Germany. In June 1933, a Cabinet memorandum was prepared for the Minister of the Interior concerning an application from an Australian resident for permission to bring to Australia his brother and wife and child who 'are of the Jewish race.'[65] Here, it would seem, race is used following the Nazi usage. As the 1930s progressed, the Australian government became more and more worried about the numbers of Jews applying to come to Australia. In 1936 Assistant Secretary T.H. Garrett of the Ministry of the Interior opined that 'Jews as a class are not desirable immigrants for the reason that they do not assimilate; speaking generally, they preserve their identity as Jews.'[66] Here, it is unclear what is meant by 'their

identity as Jews.' Not, in all likelihood, their religious identity alone, but, if not, then, could it be their cultural identity? And, if so, then what must be meant is *Yiddishkeit*, not a Jewish cultural identity *per se*, but a *particular* Jewish language and culture which had, in Australia as in other English-speaking western countries, begun to be inflected among the gentile populations as 'Jewish culture.' Perhaps the best example of this is the still-current tendency to identify a Yiddish-English accent as a Jewish accent.

By 1938, the official specifying out of Jews was becoming clearly racially based. In altering the rules for Dutch migrants it was established that the new leniency 'would not apply to persons of Jewish race.'[67] During the same year the British passport-control officer in Budapest, V. C. Farrell, wrote to the Secretary of the Australian Department of the Interior that '99% of the applications are from persons of the Jewish race.'[68] The same year a Department of the Interior memorandum went to the Cabinet which recommended a quota be decided upon specifically for Jews. It finished: 'the adoption of the suggestion to limit the number would mean the establishment of a quota for Jews, who are a separate race as distinct from a nationality.'[69] This precisely lays out the problem.

If Jews cannot be understood as a religious group, and from an Australian perspective the cultural and language differences of some Jews, coupled with their endogamy, mean that this is not (wholly) possible, then how can Jews be classified? In the discursive system of modernity there were two other possibilities, race and nationality, which, as we have seen, overlap, with race sometimes operating to essentialise nationality. Now, Jews cannot be a nation in the modern sense of the word because, first of all, they do not have a nation-state, but, more profoundly, they do not occupy, or claim to have historically occupied, any particular piece of land – Zionist claims about Palestine aside – which could provide the site for a unitary origin. And yet, in some sense, the Jews from different nation-states claim some sort of connection. The only solution had to be that the Jews are a race. This is what enables them to be thought of as a specific group in their own right. Yet again, this did not seem quite right because some Jews, Anglo-Australian Jewry, appeared able to assimilate. These Jews must, therefore, be 'white.' Once again we find Jews being constructed as the source of ambivalence, blurring the racial boundary line that was being used to help construct the Australian nation. Jews, in other words, were being thought of as both 'white' and 'non-white.'

While the weekly *Truth* was describing the Jews as a race, asserting in 1938 that 'As a racial unit they are a menace to our nationhood and standards. As an inflow of migrants, they are a menace to employment . . .',[70] the highly assimilated Jewish community was affirming also in 1938 that it 'does not consider that any sudden large influx is in the interests of the immigrants themselves' and that 'The newcomers must be Australianized as soon and as completely as possible.'[71] Here we have the worry about cultural difference and visibility, differences which, in the Australian context of that time where race

patrolled the cultural homogeneity of the nation, could lead to charges of racial difference such as that expressed by *Truth*.[72]

Tensions between the new Jewish arrivals and Australian Jewry reached such a point by 1944 that A. Masel, president of the Victorian Jewish Advisory Board wrote: 'It must be admitted that many Australian Jews have maintained an aloof, patronizing, even hostile attitude towards newer arrivals. . . . I am convinced that many Australian Jews still look upon the new arrivals as aliens, not as fellow Jews.'[73] This shows well the other side of the problem, Australian Jews who were so assimilated that they had taken on board the homogenising values of assimilatory Australian national culture and thought of European, and especially eastern European, Jews as different. Fifty years on, the position of Australian Anglo-Jewry seems to have been remarkably similar to that espoused by Walter D. Benjamin in his letter to the London *Jewish Chronicle* in 1891, suggesting that, as Australian Jews assimilated, thinking of Judaism as only a religion, then they also thought of themselves racially as 'white.'

The problem with describing the Jews as a race was that some were accepted as having assimilated, and many of these had married into the general population. If this was so then they must also be 'white,' in the Australian racial terms that underlay the White Australia policy. It is this ambiguity which informs this comment, also made in 1938, from the Commonwealth Investigation Branch:

> In type, culture and economic standard these [German] Jews form an entirely different nation from the Jews who here have created some anti-Jewish feeling: the Polish and other Eastern Jews in Carlton [Melbourne] for instance. In looks and behaviour they are rather German than Jewish, [and] the same applies to their culture and business ethics.[74]

Germans were one of the nationalities highly favoured for Australian migration because they were thought to assimilate so well – they were, of course, also thought of as white. In this quotation, then, 'nation' is used rather than 'race' in order, first of all, to be able to distinguish between the modern, assimilated German Jews and the premodern, Yiddish-language- and culture-based Polish Jews. Second, it is used to suggest the assimilability of German Jews in Australia, something possible for other white nations, but not for other races. What could happen, in the Australian version of modern thinking about the nation-state, if a group does not assimilate is well brought out in a Cabinet document of the same period which directed that migration preference should be given to 'Austrian and German Jews because . . . on the whole they have become more assimilated in European ways, say, than the Jews of Poland where they have practically formed a State within a State.'[75]

During 1939 the Australian government attempted a more formal method for identifying Jews. On Form 40, 'Application for Admission of Relative or

Friend to Australia,' and Form 47, 'Application for Permit to Enter Australia,' it asked intending migrants to state whether or not they were Jewish and nominees to state if the person is or is not of Jewish race. It seems that the request to differentiate came originally from the Australian Jewish Welfare Society, though they did not specify in what terms differentiation might be made.[76] When the forms were issued the AJWS complained about the use of the word 'race.' The secretary of the AJWS wrote to the Department of the Interior requesting a change and saying that the Society

> had received numerous protests from members of the Australian Jewish Community in Victoria and New South Wales, who have taken great exception to the words 'JEWISH RACE.' They are most emphatic in their protests and wish to point out that they are BRITISH SUBJECTS of JEWISH FAITH, and the word 'RACE' especially, is most obnoxious to them.[77]

The Department immediately agreed and the word 'race' was dropped. Aside from the Nazi, genocidal, connotations of the idea of a Jewish race – which was itself bound with German nationalism as the discussion of Wilhelm Marr in Chapter 4 explains – it should by now be clear why the Australian Jewish community would much rather have Jews defined in religious rather than racial terms. The insistence on Australian Jews being British subjects – all Australians still were at this time – suggests the connection between race and nationality. Religious difference, especially within Christianity, was tolerable in Enlightenment thought.[78]

The Nazis racialised all Jews, starting with the highly assimilated Jews of Germany and Austria, and moving on to the unassimilated and non-modern Yiddish Jews of the Pale. The Australian government's racialisation of the Jews in the second half of the 1930s took place ambivalently and in relation to migration. Here the general Nazi racialisation articulated in complex ways with the Australian inflection of the discourse on race in which race marked those who, it was considered, could (be) assimilate(d). At the same time the recognition in Australia that Jews continued to preserve a degree of separate identity led to a concern to limit the numbers entering Australia. From this perspective we might take the relatively static figure for the proportion of Jews in the Australian population, between 0.4 and 0.5 per cent over almost all of Australia's existence as a nation, as an index of Australian tolerance of non-assimilation of those considered assimilable during the roughly sixty years of the White Australia policy. One impact of Nazi expansionism was to cause the Jewish refugee crisis to involve Jews of many nationalities. Since the Australian government considered the modernised, and often already assimilated in various ways, Jews of western European countries more assimilable than the Yiddish, Polish and Russian, Jews of the Pale, and since it wanted to limit the numbers of Jews entering Australia anyway, the government was gradually

forced towards a rhetoric of race. However, the Jews of concern were European and eastern European. In Australian racial discourse European Jews were thought of as white and eastern European Jews were also, if more ambivalently, white. As a consequence, while the Jews were strategically racialised they seem to have not been colourised, suggesting once again, in the context of Australian racial discourse, that Jews were both 'white' and 'non-white.' Turning to a discussion of the post-Second World War attempts of Sephardim to migrate to Australia we find, for the first time, an attempt to distinguish 'white,' 'European' Jews from 'coloured,' 'Asiatic' Jews. In this process the racialisation of some Jews as 'coloured' and others as 'white' threw into question the basis for describing the Jews as a unitary group.

THE PROBLEM OF NON-EUROPEAN JEWISH MIGRATION

In the decade following the Second World War, the identification of Jews posed a quite different problem for the Australian government. This involved the Sephardim and other non-European-based Jewish groups some of whom wanted to migrate to Australia from countries such as Egypt, Iraq and India. The reasons why there was a new push by Sephardi and Mizrahi Jews in the post-war period are diverse: the unsettling of Jewish groups in the 'East' as a consequence of Japanese invasion, the establishment of Israel and the allied change in attitude towards Jews in the Arab countries, and the independence of India were all important.

Now, it needs to be remembered that in the organisation of the world according to the White Australia policy, 'Asia' began where 'Europe' ended and people got more 'coloured' the further away they were from Britain. Australia was, therefore, a 'white' nation-state among 'Asiatic' peoples. Given that the majority of European Jews are Ashkenazi and the majority of non-European Jews are Sephardi and Mizrahi we can see how the set of preferences translates into a privileging of Ashkenazi Jews over Sephardi. The question posed for the Australian government by these Jews from outside of Europe was, in itself, very simple – can they be considered to be 'white?' Answering it was highly problematic. In this case the boot was on the other foot. For Jews living outside of Europe it was, ironically, much better to claim Jewishness as in some sense a racial quality, or at least to affirm the practice of endogamy, and to allow Australians to continue to think of Jews as in some sense a 'European,' and therefore 'white,' people. Of course, this produces a very unusual history of the Jews as, in some way, originating from Europe but it is not one that ever seems to have worried either the Australian people – except certain anti-Semitic groups – or the Australian government. Perhaps one reason for this has been the close historical entanglement of British and Anglo-Jewish migration.

In the first instance, Jews from the 'Middle East' were considered to be 'Asian' and were not to be allowed into Australia. In 1949 T.H. Heyes, the Secretary of the Department of Immigration, sent a letter marked 'Secret' to the Department of External Affairs stating the government's position:

> The Minister holds the view that persons who are not of pure European descent are not suitable as settlers in Australia and it is his desire that those wishing to make their homes in this country be not granted the facilities to do so, even though they are predominantly of European extraction and appearance. '[P]ersons of Jewish race of Middle Eastern descent are not eligible, under the existing Immigration Policy, for entry to Australia.'[79]

Here Jews are classified as a race while a particular geographical/racial 'descent' – which would make them 'Asiatic' – is the marker to exclude a certain section of this race. The confusion of the Australian government over whether Jews should be classified by religion or race is demonstrated by comparing the above letter to this internal memorandum of the Department of Immigration written about the same time:

> Non-British Europeans, who are born in the Middle East and are not Jewish, may be admitted provided they can comply with current immigration rules. It will be seen that there is a certain amount of discrimination against persons of the Jewish faith as the fact that they were eligible for admission prior to the decision of 1948 and not afterwards reveals that they are not rejected on racial or other grounds but solely because of their faith.[80]

Within the logic of this memo it would seem that Jews born in the 'Middle East' might be considered to be 'Europeans,' and therefore 'white.' That they are to be excluded from Australia must, therefore, be because they are of the Judaic religion. At this point we are returned to questions of religious tolerance. To follow the logic further, perhaps Judaism might be considered an 'Asiatic' religion? Within the traditional European distinction between 'Europe' and 'Asia' where 'Asia' began at the Muslim Ottoman Empire this was the case. However, these possibilities were never developed as the problem of the Sephardim and Mizrahi (known then as Oriental) Jews got played out in the mutual discourses of race and colour.

In 1954 a confidential Department of Immigration document distinguished between 'Jews who are British subjects and of European origin, [who] are permitted to enter Australia subject to the same conditions as any other European British Subjects' and 'Jews of Middle Eastern origin.'[81] As for these Jews:

it has been found that a proportion of them show distinct traces of non-European origin and their admission is generally restricted to the wives and minor children of residents of Australia. Applications for the admission of this class of persons, whether of British or alien nationality, should be referred, accompanied by evidence that they are at least of 75 per cent European origin, as in the case of Eurasians who are not Jews.[82]

We can start here with the term 'Eurasian.' Given that the White Australia policy adhered to the European definition of 'Asia' that 'Asia' began at the Dardenelles, 'Eurasian' was a term defined, in the first instance by its European, white, component. Once again, it seems, Jews are being considered as, in the first place, 'white.' This is of particular interest because, following on from the assumed mythical history of Jews as 'European,' a hierarchy of Jews can be constructed out of the Australian government rulings which goes Anglo-Jews, German and other northern European Jews, Polish and Russian Jews, non-European Jews. Russia was included in 'Europe.' In the censuses, Afghans, classified as a 'non-European race,' mark the latitudinal limit to Europe. Russians were not a desired migrant nationality and one suspects that, had many Russians wished, or been allowed by the USSR government, to come to Australia, the Australian government would have tried to distinguish 'European Russians' from 'Asiatic Russians.'

This Department of Immigration document also makes plain how much 'coloured' ancestry a person can have and still be allowed into Australia. Anything more than 25 per cent makes a person look too coloured – too 'Asian' – and suggests their unassimilability – or maybe that the 'white' Australian population would not let them assimilate. The general policy of 75 per cent 'European blood' for 'Asian' applicants to migrate was put in place in October, 1951.[83] One further assumption here is, again, that Jews are 'white.'

Later in 1954, Heyes wrote a further memorandum in which he announced that the 75 per cent rule need not be strictly adhered to in the case of Sephardim.[84] Before the 75 per cent rule and, it would seem, after it also, judgements on non-European Sephardi migration applications were made according to a visual inspection of the applicant. In one case around 1950 of two brothers and two sisters, the younger brother was able to migrate. After being rejected, the sisters arrived in Australia on tourist visas. The immigration officer wrote that 'Miss E. Aaron shows very little trace of colour and in my opinion is a quarter caste or less. Her sister appears dark but in my opinion is less than half caste.'[85] The sisters were allowed to stay in Australia. Finally, after many attempts, the elder brother gained entry also.[86]

With this discussion of the Australian government's attitude to the 'problem' of the Sephardim under the White Australia policy, we are returned to Australia's preoccupation with excluding the 'Asiatic' as a cornerstone of the construction

of a homogeneous white Australian nation based on British culture and speaking English. Racial difference was thought of in terms of people being more or less coloured as they varied from the white, British norm. This operated as the basis for an inclusion or exclusion as national groups were thought to be more or less assimilable. Behind the discussions of national groups, and their cultures, lay a Social Darwinist view of race and an idea of superior and inferior civilisations. Thus, while the practical core to the White Australia policy was the attempt to construct a unitary national people, with one language and one culture, behind it lurked the idea of white, British, or at least European, superiority. Within this characteristically modern discursive system the Jews were difficult to categorise. In Enlightenment thinking they were neither clearly a religious group nor a race, and certainly not a nation. They are, in fact, in Bauman's terms, strangers, people whose 'ineradicable ambivalence' blurs the boundaries of the modern nation-state and upsets the neat modern binary distinction between friends and enemies or, more relevantly, 'our nation' and 'their nation.' As the new state of Australia struggled, in the modern tradition, to produce a homogeneous national body, so the Jews disrupted the very discursive categories on which this could be formed: 'race' and 'nation.' From the 1911 census there were two classifications for Jews, 'Jews' as classified by religion and 'Asiatic Jew,' a racial categorisation which was used until 1966. Accepted as 'white,' in the main, by virtue of Anglo-Australian Jewry's colonial presence and a high degree of assimilation, there was always the possibility that Jews in Australia would be racialised as 'Asiatics' and excluded from the nation-state.

This article was written with the aid of an Australian Research Council Large Grant given to Professor Ien Ang and myself for a project entitled 'Reimagining "Asians" in Multicultural Australia.'

NOTES

1 Most importantly and specifically related to my topic, Peter Y. Medding, *From Assimilation to Group Survival: A Political and Sociological Study of an Australian Jewish Community*, Melbourne, F. W. Cheshire, 1968; Israel Getzler, *Neither Toleration nor Favour: The Australian Chapter of Jewish Emancipation*, Melbourne, Melbourne University Press, 1970; Michael Blakeney, *Australia and the Jewish Refugees 1933–1948*, Sydney, Croom Helm, 1985; Suzanne Rutland, *Edge of the Diaspora: Two Centuries of Jewish Settlement in Australia*, Sydney, Collins, 1988; Hilary Rubinstein, *The Jews in Australia: A Thematic History*, vol. 1: *1788–1945*, Port Melbourne, William Heinemann, 1991; Paul R. Bartrop, *Australia and the Holocaust, 1933–1945*, Melbourne, Australian Scholarly Publishing, 1994; Paul R. Bartrop, 'Indifference and Inconvenience: Jewish Refugees and Australia, 1933–1945' in Paul R. Bartrop (ed.), *False Heavens: The British Empire and the Holocaust*, Lanham, USA, 1995.
2 Stephen Castles et al., (eds.), *Mistaken Identity: Multiculturalism and the Demise of Nationalism in Australia*, Sydney, Pluto Press, 1988.

3 Geoffrey Sherington, *Australia's Immigrants 1788–1988*, Sydney, George Allen and Unwin, second ed., 1990.
4 Myra Willard, *History of the White Australia Policy to 1920*, Melbourne, Melbourne University Press, 1923. A.C. Palfreeman, *The Administration of the White Australia Policy*, Melbourne, Melbourne University Press, 1967. H.I. London, *Non-White Immigration and the 'White Australia' Policy*, Sydney, Sydney University Press, 1970.
5 Zygmunt Bauman, *Modernity and Ambivalence*, Cambridge, Polity Press, 1991, p. 6.
6 Zygmunt Bauman, *Modernity and Ambivalence*, p. 53.
7 Zygmunt Bauman, *Modernity and Ambivalence*, p. 59.
8 Zygmunt Bauman, *Modernity and Ambivalence*, p. 61.
9 Zygmunt Bauman, *Modernity and Ambivalence*, p. 63.
10 Zygmunt Bauman, *Modernity and Ambivalence*, p. 55.
11 Homi Bhabha, 'Of Mimicry and Man' in Homi Bhabha, *The Location of Culture*, London, Routledge, 1994, p. 86, emphasis in original.
12 Homi Bhabha, 'Of Mimicry and Man', p. 89.
13 Zygmunt Bauman, *Modernity and Ambivalence*, p. 85.
14 Jon Stratton and Ien Ang, 'Multicultural Imagined Communities: Cultural Difference and National Identity in Australia and the USA', *Continuum: The Australian Journal of Media and Culture*, vol. 8 (2), 1994, p. 141.
15 The 1991 Census, which still classified Jews as a religious group, calculated the Jewish population at 74,186 people which represents 0.44 per cent of the total Australian population. William Rubinstein has analysed the 1991 Australian Census data on Jews in *Judaism in Australia*, Canberra, AGPS, 1995.
16 Leon Poliakov, *The Aryan Myth: A History of Racist and Nationalist Ideas in Europe*, trans. Edmund Howard, London, Chatto and Windus Heinemann for Sussex University Press, 1974, p. 143.
17 George Mosse, *Toward the Final Solution: A History of European Racism*, New York, H. Fertig, 1978, p. 14.
18 *Contra* Tom Nairn in *The Break-up of Britain: Crisis and Neo-Nationalism*, London, New Left, 1977.
19 Benedict Anderson, *Imagined Communities*, London, Verso, rev. ed., 1991, p. 149.
20 Charles Price, *Jewish Settlers in Australia*, Canberra, Australian National University, 1964, p. 15.
21 See, for example, Geoffrey Alderman's discussion, 'English Jews or Jews of the English Persuasion? Reflections on the Emancipation of Anglo-Jewry' in Pierre Birnbaum and Ira Katznelson (eds.), *Paths of Emancipation: Jews, States, and Citizenship*, Princeton, N.J., Princeton University Press, 1995.
22 Israel Getzler, *Neither Toleration Nor Favour*, p. 10.
23 Israel Getzler, *Neither Toleration Nor Favour*, p. 11.
24 Jean-François Lyotard discusses the discursive category of 'the jews' in *Heidegger and 'the jews'*, trans. Andreas Michel and Mark S. Roberts, Minneapolis, University of Minnesota Press, 1990. Lyotard's formulation is more universalist than mine, seeing 'the jews' as 'the irremissable in the West's movement of remission and pardon' (p. 22).
25 Geoffrey Sherington, *Australia's Immigrants 1788–1988*, p. 66.
26 Myra Willard, *History of the White Australia Policy*, p. 21.
27 Myra Willard, *History of the White Australia Policy*, p. 27.
28 Myra Willard, *History of the White Australia Policy*, p. 33.
29 Myra Willard, *History of the White Australia Policy*, p. 90.
30 Quoted in Myra Willard, *History of the White Australia Policy*, p. 19.
31 Richard White, *Inventing Australia*, North Sydney, George Allen and Unwin, 1981, p. 47.

32 Richard White, *Inventing Australia*, p. 47.
33 Quoted in Myra Willard, *History of the White Australia Policy*, p. 47.
34 Andrew Markus, 'Australian Governments and the Concept of Race: An Historical Perspective' in Marie de Lepervanche and Gillian Bottomley (eds.), *The Cultural Construction of Race*, Sydney, Sydney Association for Studies in Society and Culture, 1988, p. 50.
35 Myra Willard, *History of the White Australia Policy*, p. 189.
36 For a discussion of the history of the discourse of whiteness in Australia, see my 'Multiculturalism and the Whitening Machine' in Ghassan Hage (ed.), *The Future of Australian Multiculturalism*, Sydney, Research Institute for the Humanities and Social Science, Sydney University, 1999.
37 Myra Willard, *History of the White Australia Policy*, p. 107.
38 Sean Brawley, *The White Peril: Foreign Relations and Asian Immigration to Australasia and North America 1919–1978*, Sydney, University of New South Wales Press, 1995, pp. 48–9.
39 Myra Willard, *History of the White Australia Policy*, p. 109.
40 Quoted here from Myra Willard, *History of the White Australia Policy*, p. 112. Willard quotes this important speech extensively.
41 Myra Willard, *History of the White Australia Policy*, p. 113.
42 Quoted in Richard White, *Inventing Australia*, p. 71.
43 Myra Willard, *History of the White Australia Policy*, p. 99.
44 Quoted in Suzanne Rutland, *Edge of the Diaspora*, p. 95.
45 Hilary Rubinstein, *The Jews in Australia*, vol. 1, p. 116.
46 Quoted in Hilary Rubinstein, *The Jews in Australia*, vol. 1, p. 479.
47 Quoted in Suzanne Rutland, *Edge of the Diaspora*, p. 95.
48 See, for example, Peter Love, 'The Kingdom of Shylock: A Case-Study of Australian Labour Anti-Semitism', *Journal of the Australian Jewish History Association*, vol. 12 (1), 1993, pp. 54–62.
49 Quoted in Hilary Rubinstein, *The Jews in Australia*, vol. 1, p. 117.
50 Hilary Rubinstein, *The Jews in Australia*, vol. 1, p. 117.
51 One discussion of the nineteenth-century European orientalising of the Jews is Paul Mendes-Flohr, '*Fin-de-Siècle* Orientalism, the *Ostjuden* and the Aesthetics of Jewish Self-Affirmation', in Jonathan Frankel (ed.), *Studies in Contemporary Jewry*, vol. 1, 1984, pp. 96–139. Mendes-Flohr also discusses how Polish Jews came to be described as *Halb-Asien* through the work of the popular Viennese Jewish novelist Karl Emil Franzos, 'indelibly marking the East European Jews as non-European, semi-Oriental people' (p. 102).
52 Sander Gilman, 'The Jewish Nose' in *The Jew's Body*, New York, Routledge, 1991, p. 171.
53 See Anne McClintock, *Imperial Leather: Race, Gender and Sexuality in the Colonial Conquest*, New York, Routledge, 1995.
54 See Theodore W. Allen, *The Invention of the White Race*, vol. 1, London, Verso, 1994.
55 Hilary Rubinstein, *The Jews in Australia*, vol. 1, p. 483.
56 Myra Willard, *History of the White Australia Policy*, p. 121.
57 Michael Blakeney, *Australia and the Jewish Refugees 1933–1948*, p. 28.
58 It is interesting to note in this regard the importance in multicultural rhetoric of the designation 'NES – Non-English Speaker' which has rapidly slipped into 'NESB – Non-English Speaking Background,' in this way introducing a notion of cultural difference between 'English Speaking Background' and 'non-English Speaking Background,' in key ways an ethnic reworking of the White Australian Policy's essentialist, racist distinction.

59 Quoted in Myra Willard, *History of the White Australia Policy*, p. 189.
60 See, for example, Robert Young's discussion of nineteenth-century theories about miscegenation in *Colonial Desire: Hybridity in Theory, Culture and Race*, London, Routledge, 1995.
61 Suzanne Rutland, *Edge of the Diaspora*, p. 141.
62 William Rubinstein, *Judaism in Australia*, p. 43.
63 Stephen Castles et al., *Mistaken Identity*, p. 20.
64 Paul R. Bartrop, *Australia and the Holocaust*, p. 16.
65 Paul R. Bartrop, *Australia and the Holocaust*, p. 27.
66 Paul R. Bartrop, *Australia and the Holocaust*, p. 31.
67 Quoted in Paul R. Bartrop, *Australia and the Holocaust*, p. 47.
68 Quoted in Paul R. Bartrop, *Australia and the Holocaust*, p. 48.
69 Quoted in Paul R. Bartrop, *Australia and the Holocaust*, p. 52.
70 Quoted in Suzanne Rutland, *Edge of the Diaspora*, p. 189.
71 Quoted in Peter Y. Medding, *From Assimilation to Group Survival*, p. 160.
72 As late as 1960, in a study of 'social distance' attitudes carried out in Perth, Western Australia, Jews ranked sixth behind, in order, English, Germans, Dutch, Poles and Italians on a combination of scales indicating acceptability. Below Jews came Malayans. These national categories – except for Jews, of course – are interesting for the way they express racial concerns. This study can be found in Ronald Taft, *From Stranger to Citizen: A Survey of Studies of Immigrant Assimilation in Western Australia*, Perth, University of Western Australia Press, 1965, pp. 18–20.
73 Quoted in Peter Y. Medding, *From Assimilation to Group Survival*, p. 161.
74 Quoted in Paul R. Bartrop, *Australia and the Holocaust*, p. 54.
75 Quoted in Hilary Rubinstein, *The Jews in Australia*, vol. 1, p. 167.
76 Hilary Rubinstein, *The Jews in Australia*, vol. 1, p. 167. Just how sensitive the race issue still is can be gauged from Bartrop's description of it as 'another example of departmental anti-Semitism' (*Australia and the Holocaust*, p. 151), not knowing of the AJWS's request.
77 Quoted in Paul R. Bartrop, *Australia and the Holocaust*, p. 152.
78 It is worth remembering in this connection that the modern European nation-state was not, on the whole, secular. It was, in many cases still is, Christian. Thus, the push for Jewish religious equality in the Australian colonies in the second half of the nineteenth century had implications for the establishment of a Christian state, all the more so when England had the Church of England as its established Church. It is in this context that William Wentworth, then a member of the New South Wales Legislative Council, in 1853, argued that any religious group including, in his word, Mohammedans, should be given religious equality while Jews had a particularly good claim because Christianity originated in Judaism. George Nichol, a former editor of the radical *Australian*, agreed with Wentworth about Judaism but would not go so far as to give religious equality to Mohammedans and pagans. (This debate is taken from Israel Getzler, *Neither Toleration Nor Favour*, p. 43.) Here we can see how close to exclusion from the modern nation-state Judaism was, and how defining Jews in terms of religion still opened up questions about their full membership of particular nation-states.
79 Quoted from Naomi Gale, 'A Case of Double Rejection: The Immigration of Sephardim to Australia', *New Community*, vol. 20 (2), 1994, p. 274. Another relevant article is Rodney Gouttman, 'A Jew and Coloured Too! Immigration of "Jews of Middle East Origin" to Australia, 1949–58', *Immigrants and Minorities*, vol. 12 (2), 1993, pp. 75–91.
80 Quoted in Suzanne Rutland, *Edge of the Diaspora*, p. 242.
81 Quoted in Naomi Gale, 'A Case of Double Rejection', p. 274.

82 Quoted in Naomi Gale, 'A Case of Double Rejection', p. 274.
83 Naomi Gale, 'A Case of Double Rejection', p. 280.
84 Naomi Gale, 'A Case of Double Rejection', p. 280.
85 Quoted in Naomi Gale, 'A Case of Double Rejection', p. 276. I have taken my outline from Gale's discussion of the case.
86 On the Jewish side, the Australian Anglo-Jewish/Ashkenazi establishment treated the Sephardi migrants in a very similar way to the way Australian Anglo-Jewry had treated the European and eastern European refugees. As Gale puts it: 'the Ashkenazim at best displayed little interest in their co-religionists. Indeed, many seemed unwilling to recognise the Sephardim as Jews' (Naomi Gale, 'A Case of Double Rejection', p. 283).

8

JEWS AND MULTICULTURALISM IN AUSTRALIA

This chapter discusses the situation of Jews in the context of Australia's governmental policy of multiculturalism. It is often claimed that the assimilationist and integrationist population management policies of the era of the White Australia policy are thoroughly removed from the practices of multiculturalism. I want to suggest, rather, that there is a complex continuity between the two policies, that they rest on uncomfortably similar assumptions about 'race' and about the connections between 'race' and 'culture.' My discussion centres on the circumstance of Jews in Australian multiculturalism. The ideology of ethnicity is central to multiculturalism. In order to become an 'ethnic group,' a community has to fulfil a number of criteria. Most importantly, as identified in government pamphlets concerned with multiculturalism, communities should ideally have a single language and a single national origin. Jews have neither. Are they, then, an ethnic group, or perhaps a religious group? In this way the ambivalent status of Jews replays the Enlightenment debates over whether Jews were a religious or a national grouping. I end the chapter with a discussion of how the Holocaust has come to stand in for a national origin, providing Jews with a common reference point outside of Australia. I could have, and perhaps should have but for want of space, gone on to discuss the preoccupation with Zionism among Australian Jews (though not near the American level) and Australian political leaders – the recent Labor Prime Minister, Bob Hawke, is the most obvious example here. Here, I can only gesture to the complex ways in which Israel serves teleologically as a pseudo-national origin for sections of the Jewish community and the rest of the Australian population alike.

RACE AND ETHNICITY AND JEWS

As I have discussed in Chapter 7, the ambivalence of Jewish racialisation during the period of the White Australia policy provides an important deconstructive lever for understanding the role of the discourse of race in the construction of

220

Australian national identity through the first half of the twentieth century. Yet, in historically oriented accounts of the White Australia policy, which do not problematise their usage of race, Jews are remarkably absent. Importantly, the same absence occurs in the accounts of multiculturalism. For example, Jews are unmentioned in Lois Foster and David Stockley's *Multiculturalism: The Changing Australian Paradigm*[1] and in Andrew Theophanous's *Understanding Multiculturalism and Australian Identity*.[2] The same is true of Sneja Gunew's theoretically sophisticated book on multicultural literary studies, *Framing Marginality*. Here, the absence is more surprising as Gunew refers to both Judah Waten and Fay Zwicky, even quoting Zwicky on her 'identification with the Jewish faith.'[3] Of course, it is easy to castigate texts for what they do not discuss and this is not my point here. Rather, I want to suggest that the lack of discussion of Jews in relation to multiculturalism in Australia has meant a lost opportunity to theorise the meaning of 'ethnicity' in the Australian context. John Docker's 'Rethinking Postcolonialism and Multiculturalism in the *Fin de Siècle*' is the only major piece so far to discuss Jews as an ethnic group in Australian multiculturalism but Docker suggests an equivalence between Greek and Jewish Australian diasporas which 'normalises' the Jewish situation.

Unlike American multiculturalism, which is a radical movement centred on the notion of race and aimed at including those excluded from the national polity by virtue of their claimed racial difference, Australian multiculturalism is an official government policy, accepted by all four mainstream parties, based in the discourse of ethnicity. Australian multiculturalist rhetoric uses 'race' very little, instead preferring to describe all groups, including those who in the United States are thought of in racial terms, as ethnic groups. In Australia the rhetoric of race is predominantly used by those who wish to discriminate against certain groups, for example, in the annual migration quotas, or those, very often the same people, who wish to argue that the culture of certain groups will not mesh with the dominant Australian culture and that, as a consequence, ghettoes will develop and 'Australian national identity' will be threatened. While the discourse of race is rarely used in Australian multi-culturalism, it can be argued, and this chapter will imply, that in Australian multiculturalism those groups most successfully ethnicised in the rhetoric are of European origin, predominantly the Greeks and Italians. As I will explain, other groups, especially those of 'Asian' origin such as the Vietnamese, have a struggle to get themselves accepted by the general population as 'ethnics' rather than as part of a racial grouping, 'Asians.'[4]

In spite of tactical moves by Jews to represent themselves within the official structures of Australian multiculturalism as an ethnic group alongside the other ethnic groups, they are not an ethnic group in the same sense. Understanding this enables us to begin an investigation into the invention of ethnicity as a fundamental aspect of Australian multiculturalism.[5] In order to do this we need to understand how the discourses of race and ethnicity operate in the context of the Australian nation-state. Ien Ang and I have argued elsewhere that, in the

historical elaboration of the modern nation-state, 'race' functioned as a marker to limit who it was considered could become a member of the state's nation.[6] In the case of the White Australia policy, 'whiteness' was used to judge who was considered able to assimilate into the culturally homogeneous Australian nation that the Australian state wished to construct, the unitary people who would express the Australian national identity. Race was used as the marker of absolute Difference. In many 'western' countries, race not only signified whom it was acceptable to marry, or indeed whom the state would allow one to marry, but as Robert Young[7] has pointed out, mating between members of different races was argued by some to result in either no offspring or sterile offspring where races were thought actually to be incompatible species. Indeed, the nineteenth-century use of the term 'hybrid' had it referring to the offspring of mixed-race unions. As Robert Young writes:

> It was the increasing vigour with which the racial doctrine of poly-genesis was asserted that led to the preoccupation with hybridity in the mid-nineteenth century. This was because the claim that human beings were one or several species . . . stood or fell over the question of hybridity, that is intra-racial fertility – a question which could never in fact be satisfactorily settled according to the terms in which the debate was conducted.[8]

Such incompatibility was also thought to exist culturally. Young describes how the mid-nineteenth-century notion of human 'types' fed into a claim that cultural forms could be associated with particular races. Even when certain aspects of this argument lost scientific credibility, Young notes that 'the analysis of culture as symptomatic of the racial group that produced it continued unimpeded.'[9] It was often thought that different races had Different kinds of culture which were sometimes considered to be incompatible. Hence, in Australia's case limiting entry to Australia to 'whites' was thought to pave the way for a culturally homogeneous nation-state.

Within this context, the ambivalent racialisation of Jews in 'western' thought from the latter part of the nineteenth century onwards led to a determination by Australian Jewry, historically consisting of highly assimilated Anglo-Jews, to become as invisible as possible within the Australian cultural polity. 'Whiteness' correlated 'looking white' with a cultural homogeneity within the dominant 'Australian' culture. If one looked physically different one was likely to be culturally different. Conversely, if one was culturally different, if one's culture made one visible within the dominant culture, then one could be identified as looking different. 'Looking different' was the key marker of racial Difference. At issue here was the Australian preoccupation with the construction and preservation of a homogenous, and British-derived culture. In Australian political rhetoric from before Federation this was considered to be the basis for the production of a strong nation. The consequence was that migrants were

expected to assimilate culturally. Since, up to the Second World War, the majority of migrants came from Britain or Ireland it was assumed that they would simply merge with the general population. After the Second World War, Arthur Calwell, the Labor Government's Minister for Immigration, opened up Australia's migration policy to include southern Europeans, previously considered to be 'non-white.' This opening up was a consequence of the wartime recognition that, if Australia was to protect itself, it needed a significantly larger population than the 7,300,000 which it had at the close of hostilities. The other major reason for the increase in migration was to provide the labour for Australia's further industrialisation. It was Calwell who coined the phrase 'Populate or Perish' as a way to encourage Australians to accept the new immigration policy. Because of the significant increase in non-English speaking migrants whose cultures differed considerably from the Australian norm, assimilation became an issue and, increasingly overtly, government policy manifested in, for example, the Good Neighbour Movement, set up in 1949–50 and finally discontinued in 1978, in which Australians were supposed to teach new migrants proper Australian behaviour.[10] As I have discussed in Chapter 7, in the period around Federation and in the 1930s and 1940s, Australian Jewry feared the effects of the migration of Jews from the Pale.[11]

The ending of the White Australia policy and the advent of an official government policy of multiculturalism transformed this problematic situation of Australian Jewry. Although they are often linked, there is no necessary connection between these two events. Indeed, to some extent, that they happened around the same time is coincidental. As I have been suggesting, the White Australia policy was a racially based way of controlling entrance to Australia with the intention of producing a racially, and therefore culturally, homogeneous population. From the 1930s, as Saul Dubow argues, scientific racialism as a way of differentiating between people rapidly fell into disfavour in the 'west.'[12] In 1950 UNESCO published a 'Statement on Race' which '[explained] differences between different human groups in terms of genetic isolation, drift and frequency. It attacked conventional typological definitions of race and emphasised that likenesses among men far outweigh their differences.'[13] In Australia the administrative apparatus of the White Australia policy was gradually dismantled from around the middle of the 1960s and, in 1974, the reformist Labor Prime Minister, Gough Whitlam, claimed in a speech in the Philippines that 'On immigration, we have removed the last remaining pieces of legislation which could be described as discriminatory on racial grounds.'[14] The dismantling of the White Australia policy had much to do with internal and external pressures related to a general turning away from biological racialism. The shift to a policy of multiculturalism was a quite different matter.

In Australia, where assimilationism and multiculturalism have operated as government policies, they have been practised as key aspects in the state's management of its population. After the Second World War when Calwell made the decision to increase Australia's immigration intake, and to include

southern Europeans, it was never his intention to break down the White Australia policy. As Theophanous puts it: 'Although the program was extended to Europeans in general, a distinction was made between them and people of other races, particularly Asian, African and Middle Eastern peoples who continued to be excluded by the White Australia policy.'[15] Theophanous is here writing in the geographical rhetoric of multiculturalism. In the 1940s and 1950s, the time he is describing, these groups would have been identified as oriental or yellow, black, oriental or Semitic. More generally, they would have been lumped together as 'coloured' as compared to the 'whites' who were allowed in. In fact, Calwell's acceptance of, in particular, southern Italians and Greeks into Australia entailed an expanded redefinition of who was officially classed as 'white.'

Al Grassby's August 1973 speech 'A Multi-Cultural Society for the Future,' which is usually taken as the beginning of multiculturalism as Australian government policy, was prompted by the Whitlam government's recognition of the failure of the policy of assimilation. As Grassby, the Minister for Immigration in Whitlam's newly elected Labor government, put it: 'The increasing diversity of Australian society has . . . rendered untenable any prospects there might have been twenty years ago of fully assimilating to the Australian way of life.'[16] One point I am making here is that it would have been quite possible to institute in Australia a population management policy of multiculturalism while retaining the White Australia policy. That this did not happen was a consequence of a coincidence of developments. What can be recognised from this is that multiculturalism first evolved in Australia to deal with the problems caused by the failure of 'white' groups to assimilate into the Anglo-derived 'Australian way of life.' By 'white' here, in the Australian context, I mean those European groups, most particularly Greeks and Italians, who had previously been thought of as 'non-white' but who were tacitly reclassified in the post-Second World War period.

What has tended to conflate the establishment of the two different policies of multiculturalism and non-racially discriminatory migration was the passing into law of the Racial Discrimination Bill in 1975. This said that 'It is unlawful for a person to do any act involving a distinction, exclusion, restriction or preference based on race, colour, descent or national or ethnic origin.' As Theophanous notes, the passing of this Bill enabled Australia to ratify the United Nations Convention on the Elimination of All Forms of Racial Discrimination.[17] Compared to some other countries of the British Commonwealth, Australia passed this Act quite late. The British *Race Relations Act* had been passed in 1965 and New Zealand's *Race Relations Act* had been passed in 1971.[18] In a speech on the *Racial Discrimination Act*, Whitlam announced that 'The new Act writes it firmly into our laws that Australia is in reality a multicultural nation, in which the linguistic and cultural heritage of the Aboriginal people and of peoples from all parts of the world can find an honoured place.'[19] In reality Australia had become, *de facto*, a 'white' multicultural society.

Like the ending of racially discriminatory immigration, the *Racial Discrimination Act* was the product of a reformist, forward-looking government intent on making Australia acceptable in the eyes of the international community. Whitlam's government had no clear guidelines for integrating this Act with the other two policies. Indeed, there was little administrative aspect to the policy of multiculturalism. What was most surprising about Grassby's speech introducing multiculturalism as government policy was how remarkably unthought-through it was. Adopting a policy of multiculturalism dealt with the consequences of the failure of assimilationism to get migrants to accept the normative Australian culture by publicly asserting the worth of migrant culture – though a thought-through account of how the new policy might be put into practice was not produced until the so-called Galbally Report of 1978 which I will discuss below. Given that the Canadian Prime Minister, Pierre Trudeau, had established multiculturalism as Canadian government policy in a Parliamentary speech in 1971, and that Lee Kwan Yew had instituted a policy of multiracialism in Singapore from independence in 1965, Grassby had little to say about how multiculturalism in Australia might be formalised.[20] Moreover, these precursors were not mentioned in Grassby's, or later, political pronouncements on multiculturalism.

Theophanous argues that Grassby introduced the word 'multiculturalism' to Australia and did so in the context of formulating 'a positive response to the cultural, political and social implications of high levels of immigration on the Australian community.'[21] In fact, neither of these things are the case. In an article entitled 'Australian Jewry – Can It Survive?' published in *The Bridge* in January 1973, Walter Lippmann, a leading figure in the Melbourne Jewish community, argued that 'The positive value of a multicultural society needs promotion in the Australian environment.'[22] Lippmann's argument was developed against the background of the 1971 census figures. His concern was that 'for the first time in the history of Australian Jewry, the 1971 Commonwealth Census has disclosed a decline in the number of Jews identifying as such.'[23] He argued that there were three major reasons for the decline: that the migration of Jews in the immediate post-Second World War period had been mainly middle-aged, that there was a relatively low birth-rate among Jews, and the high rate of marrying out which resulted in a loss of involvement in Jewish communal life.

Lippmann suggested that two interconnected developments needed to take place if the Australian Jewish community were to survive. One was the organisation of a Jewish community relevant to the Australian context. The other was that 'Australian society is still suffering from an ambivalence on the vital "unity through diversity" aspect of nation building, imposing upon immigrants pressures to conform, so that they can establish themselves.'[24] It was in this context that Lippmann argued for a change in government policy. While, on the one hand, Lippmann suggests that Jews have a common cause with post-war migrant groups, on the other hand his point is the long-term

preservation of Jewish communal identity aside from migration. Unlike Grassby, and indeed all the government multicultural rhetoric, and also Theophanous, Lippmann is not thinking of communities which are primarily tied to migration and become increasingly interwoven – to use John Lechte and Gil Bottomley's evocative term which they define as 'the constant interaction between cultural practices, an interaction that never leaves any culture in a pure state'[25] – with the dominant culture over ensuing generations. Rather, Lippmann is concerned that 'For a Jewish community to survive in the Australian environment, it is necessary that Jewish separateness be defined for and imbibed by coming generations.'[26] For Lippmann, multiculturalism was not a way of managing the effects of high levels of migration but rather of preserving cultural identity. Importantly, unlike Grassby who continued to talk in terms of 'migrants,' Lippmann followed Trudeau and Canadian multiculturalism in writing about 'the nature of Australian Jewry as that of an ethnic group.'[27]

The concept of 'ethnic group' is central to managerial multiculturalism. In order to understand why this is the case we need to appreciate the distinction that has evolved in 'western' thought between the discourses of race and ethnicity. The modern conceptualisation of ethnicity evolved in the United States. Conzen et al. argue that by the middle of the nineteenth century 'for the first time large enough groups of culturally alien immigrants were concentrated in particular places to permit Americans to perceive them as threatening.'[28] These 'culturally alien immigrants' were non-Anglo-Europeans and the threat they posed was to the dominant Anglo-American cultural order. These groups were ethnicised *avant la lettre*. At the same time, the cultural differences of these groups were distinguished from racial Difference: 'European Americans quickly learned that the worst thing one could be in the Promised Land was "colored," and they distanced themselves as best they could from this pariah population.'[29] In the United States the discourse of ethnicity evolved in terms of cultural distinctions amid an underlying common cultural pattern which was thought of racially as 'white' or, as began to happen, in connection with geographical origin, as 'European.' Fundamental to the American discourse of race was the colour opposition of 'white' and 'black' which was a consequence of the inclusion of 'blacks' in the state but only questionably within the nation. In Australia, where migration had been heavily patrolled from the time of Federation and where 'whiteness' had been, for a long time, limited to the British and northern Europeans with relatively few exceptions, the process of ethnicisation did not take place until after the Second World War.[30]

Werner Sollors tracks the invention of the term 'ethnicity' to W. Lloyd Warner and Paul Lunt's study of Newburyport, Massachusetts, *The Social Life of a Modern Community* (1941), which also began the modern usage of 'ethnic.'[31] Nathan Glazer and Daniel Moynihan's *Beyond the Melting Pot*, published in 1963, began the American public recognition that what from now on would

be increasingly described as 'ethnic differences' would not melt away.[32] It seems that the idea of 'ethnic groups' was picked up in Canada and moved from there to Australia.

We can now understand how the crucial distinction between race and ethnicity functions in terms of the nation-state. Put simply, the construction of a group as racially distinct distinguishes that group as unable to merge in the national polity. In contrast, ethnic difference suggests a group's divergence from the dominant culture – unless all groups are ethnicised – but also their underlying similarity. In this case, as ethnic diversity takes place within a single race, the ultimate homogeneity of the nation is preserved.

Theorising multiculturalism, Ernesto Laclau has asked how one determines the limits of the context in which cultural pluralism is made possible. He argues that 'the only way out of this difficulty is to postulate a beyond which is not more difference but something which poses a threat (i.e. negates) to all the differences within that context – or, better, that the context constitutes itself as such through the act of exclusion of something alien, of a radical otherness.'[33] Taking the context as the modern nation-state, it was the discourses of race which were used to invent the alien, the radical Otherness. As we have seen in Chapter 4, in Europe in the second half of the nineteenth century Jews were racialised as the Other against which evolving nation-states, most importantly Germany, defined their national invention. In the United States, the incorporation of 'blacks' within the nation-state diminished the importance of Jewish difference and to an extent enabled Jews to be ethnicised as another 'white,' European ethnic group.[34]

In the American situation the importance of the historical shift of Jews from a racial group to an ethnic group, primarily in the post-Second World War period, cannot be underestimated.[35] It is particularly important in connection with the American version of multiculturalism. As Gunew points out, 'In the UK and the US (and to a lesser extent Canada and New Zealand) [multiculturalism] has become a coded way of addressing issues to do with race.'[36] In the United States, where government policy for managing the population is concerned with race rather than ethnicity, multiculturalism has evolved as a way of introducing silenced and excluded 'racial' groups into the public domain previously dominated by 'white' 'ethnic' groups. As Henry Giroux remarks, and we must remember that he is specifically writing about the American context, 'issues concerning multiculturalism are fundamentally about race and identity.'[37]

The development of multiculturalism in the United States has taken place within the context of the elaboration of what David Hollinger calls 'the ethno-racial pentagon.' What he is signalling here by the addition of the prefix 'ethno-' is the post-Second World War reconstitution of race from an emphasis on biological difference to an emphasis on cultural difference. Illustrating his point, Hollinger argues that

On application forms and questionnaires, individuals are routinely invited to declare themselves to be one of the following: Euro-American (or sometimes white), Asian American, African American, Hispanic (or sometimes Latino), and Indigenous Peoples (or sometimes Native American).[38]

Multiculturalism arose in the United States in the 1980s within this ethno-racial context. As the context developed, so 'Jewish identity . . . receded in significance when all Americans of predominantly European stock were grouped together.'[39]

The ethnicisation and Europeanisation of American Jews has been one reason for the loss of their traditional common cause with African-Americans.[40] From the Jewish perspective, this ethnicisation has entailed a loss of the acknowledgement of Jewish distinctiveness. As Michael Galchinsky has argued:

> Multiculturalist Jews feel the need to argue for Jews' distinctiveness. Even when they do so, the multicultural new world seems little more inclined to welcome Jews than the liberal old world. This is because when the word 'multicultural' is used, it is often used to mean 'people of color.' Many 'people of color' perceive the majority of American Jews to be 'white,' part of the monolithic unity, the 'white West,' against which the multiculturalist struggle takes place.[41]

In the nineteenth century the demand that Jews assimilate into the developing nation-states was founded on a claim that Jewish difference could be reduced to religion. Galchinsky argues that, in the United States today, 'Jewishness is narrowly defined as a religious affiliation, without its cultural or ethnic affiliations – and therefore its signs ([such as] *kipot* [skull-caps]) are perceived to represent an uncomfortable intrusion of religiosity into public life, threatening to violate the separation of church and state.'[42] In performing this threat of violation, Jews are also problematising the definition of ethnicity in cultural terms. One of the common cultural elements in European ethnicity is Christianity – or lack of it. While it is common in the English-speaking world to talk of Europe as having a Judaeo-Christian heritage, Judaism is thought of as the religion that came before and out of which Christianity developed. Yet, Judaism is only ambivalently thought of as a 'European' religion. Moreover, no other American ethnic group is defined by its religion.[43]

At this point we need to return to Australia. Here, where multiculturalism is government policy, it is centred on ethnic groups rather than racial categories. The *Report on the Review of Post-Arrival Programs and Services to Migrants*, published in 1982, asserted that 'Australia's population consists of many ethnic groups with varied cultural backgrounds.'[44] The *Report* argues that 'Our ethnic groups are distinguishable by various factors. For our purposes we need to

identify the two major relevant varying attributes of ethnicity as culture and race.'[45] Given what I have been arguing about the discourse of race it should be clear that this attempt to subordinate race to ethnicity is highly unusual. What it signals is the importance of inventing the Australian national polity as being divided only in terms of cultural differences, with no absolute Difference fracturing the representation of its national identity.[46] Laclau argues that 'Only in a situation in which all groups were different from each other and in which none of them wanted to be other than what they are, the pure logic of difference would exclusively govern the relations between groups.'[47] Laclau's example here is apartheid. South Africa's apartheid policy was, somewhat anachronistically, built on a scientific theory of racism.[48]

In the United States the preoccupation with racial Difference led to the establishment of an ideology of integration in which the 'races,' primarily 'blacks' and 'whites' – now rhetorically reconstituted as 'African-Americans' and 'Euro-Americans,' – would remain racially distinct – no intermarriage and interbreeding – while intermixing socio-culturally. In Australia 'integration' replaced assimilation as government policy for a few years before the establishment of multiculturalism. However, what it meant was a recognition of migrants' cultural differences as they took time to assimilate into the dominant cultural order.[49] When Lippmann described Dr Forbes, Minister for Immigration in the conservative Coalition McMahon government which preceded Whitlam's, as '[referring] to the need to enable migrants, through their own groups, to become integrated in Australian society,' he seems to have had in mind an ethnic version of the American idea of integration. Certainly this was the case when, in 1985, Hilary Rubinstein argued that

> The future viability of the Jewish community depends upon a clear realisation of the difference between integration and assimilation. The former has been compared to a 'salad bowl,' the latter to a 'melting pot.' In today's multicultural society, the old Australian Jewish ethos of 'integration without assimilation' has more chance of succeeding than it did in prewar, culturally monolithic Australia where Jews felt constrained to conform and avoided being conspicuous.[50]

Here, we can begin to see that the Jewish concern to preserve their distinctiveness in the face of an invention of ethnicity which produces it as founded in an always already present similarity, and which thinks of ethnicity as remaining distinct while constantly blurring at the 'edges' with the dominant culture, leads to a reconstitution of the ambivalent situation of Jews in the 'west.' Their concern to preserve their distinctiveness generates an ambivalent racialisation of Jews in which they fall between the weak difference of ethnicity and the strong Difference of race.

Ethnic multiculturalism is premised on a claim about the underlying compatibility of peoples and cultures, a compatibility that leads to a constant

blurring of the borders of both through intermarriage and cultural inter-weaving. Indeed, intermarriage operates as a trope for the possibility of cultural hybridisation. Such a scenario offers the possibility that, at some time, the ethnic people and their culture could merge into their surroundings. The Jewish concern, as presented here by Lippmann and Rubinstein, is to preserve the Jewish people and the Jewish religio-cultural complex. Ironically, the Jewish emphasis on endogamy and on cultural separateness founds an ideology of integration similar to that so dominant in American thinking on what is considered to be appropriate in what is thought of as a racially diverse population, and therefore gives the impression of Jews as being more like a race than an ethnic group.

ETHNICITY AND MULTICULTURALISM

In order to understand how Jews are ethnicised in Australian multiculturalism we must first establish how the discourse of ethnicity functions in Australia. Laclau argues of relative difference within a system that 'all differential identity will be constitutively split; it will be a crossing point between the logic of difference and the logic of equivalence.'[51] In terms of the nation-state's pre-occupation with distinguishing acceptable difference from excluded Difference we can think about differential identity as being identified and legitimated through the discourse of 'ethnicity.' This is played out within the organisation of Australian multiculturalism through the invention of ethnic groups which have their own distinctive cultures. These cultures, however, all have under-lying similarities. In *Multiculturalism for all Australians*, put out by the Australian Council on Population and Ethnic Affairs in 1982, we find these two logics expressed in this combination of statements:

> The aim should be to achieve a society in which all people have the freedom to express their cultural identity. . . . A core of moral and cultural values, based on the central institutions of society, will continue to place limits on what is acceptable behaviour for all members of society. However, multiculturalism means that the core values will inevitably be modified by a wide range of cultural influences.[52]

The basis of the construction of a differential, ethnic identity is the idea of an ethnic group which has a particular culture. The Galbally Report offers a definition of culture taken from Edward Tyler's *Primitive Culture*, published in 1891. Quoting Tyler, the Galbally Report avers that culture 'is a way of life, that "complex whole which includes knowledge, belief, art, morals, law, customs, and any other capabilities and habits acquired by man as a member of Society."'[53] In this anthropological definition, culture appears as a unified and homogeneous entity. It is also static and objectified, disengaged from the

people who produce it and remake it in their everyday lives. Such a view of culture enables the invention of discrete ethnic groups, each with its particular identity.[54]

In *Diversity Counts: A Handbook on Ethnicity Data*, published in 1994, we are provided with a list of four major variables which can be used to identify a person's ethnicity. These are Aboriginal and Torres Strait Islanders; birthplace; language spoken; English proficiency.[55] These are complemented by a further five variables which can be used when it is appropriate: year of arrival; religion; birthplace of parents; citizenship; Australian South Sea Islander people.[56]

The identification of a person as an Aborigine or Torres Strait Islander is, in part, a consequence of these groups' refusal to be ethnicised. Having been racialised, and excluded from participatory membership of the Australian state, only being counted in the census as a result of a referendum in 1967, they now refuse to be reconstituted as two more ethnic groups among the others that form the Australian nation.[57] The racialisation of Aborigines and Torres Strait Islanders to preserve the recognition of their different status as the indigenous inhabitants is one subtext of the Galbally Report's attempt to subordinate race to ethnicity as contributing to a governmental attempt to make all difference equivalent.

The two other primary forms of identification concern birthplace and language. English proficiency suggests a dual ethnicising categorisation of English-speaking and non-English-speaking. Non-English-speaking refers to the classification of people from non-English-speaking backgrounds, known colloquially as NESBs. This classification seems to have developed in the late 1970s in relation to educational reform to help non-English speakers.[58] By the mid-1980s, correlating with the Hawke Labor government's new multicultural concern with access and equity issues, NESB identification became increasingly prominent with the unforeseen effect of constructing English-speaking Australians as 'real' Australians, feeding back into the dominance of an Anglo-Celtic-based Australian culture, and non-English-speaking Australians as 'ethnics.'

Setting aside 'English proficiency,' we are left with two remaining major variables: birthplace and language spoken. What these produce is an ethnicity founded on a geographically determined national identity. Ethnic cultural identity can now be understood as national cultural identity. Etienne Balibar has developed the term 'fictive ethnicity' to describe this national form of ethnicity. He writes that

> By constituting the people as a fictively ethnic unity against the background of a universalistic representation which attributes to each individual one – and only one – ethnic identity and which thus divides up the whole of humanity between different ethnic groups corresponding potentially to so many nations, national identity does much more than justify the strategies employed by the state to control

populations. It inscribes their demands in advance in a sense of belonging in a double sense of the term – both what it is that makes one belong to oneself and what makes one belong to other human beings.[59]

Balibar argues that central to the production of national fictive ethnicity are language and race; that between them, 'They constitute two ways of rooting historical populations in a fact of "nature" (the diversity of languages and the diversity of races appearing pre-destined).'[60] In the migration myth that underlies Australian multiculturalism there are claimed to be only cultures, not races. However, as we have seen, Australian multiculturalism is built on a history in which cultural difference became apparent within a single race, the acceptable 'white' race.

The effect of the change of rhetoric from race to culture produces the possibility of 'culture' being used like 'race' to define absolute Difference. Joel Kahn, who has written about the use of the concept of culture in Australian multiculturalism, quotes a letter to the national newspaper *The Australian*, which asserts that 'The question, however, concerns not immigrants' race but their culture. In the course of our immigration debate it is vital for us to recognise that some cultures offer ideas, values and beliefs which are appropriate to Australian society, while the ideas prevalent in certain other cultures are inappropriate.'[61] What this letter signals is that the discourse of race has been transformed from having a biological emphasis to a cultural one.

Moreover, just as in the United States, where colour-based definitions of race have been replaced by predominantly geographical, continental ones – 'black' by 'African-American,' 'yellow' by 'Asian' – so a similar rhetorical shift has taken place in Australia. Here 'Asian' and 'African' now describe cultures more than races, and cultures which may be Differentiated from Australia's 'European' cultural core. Paul Gilroy has pointed out how, in British neo-racism, 'The term "culture" has expanded to displace any overt references to "race" in the older, biological sense of the term.'[62] The same process has taken place in both the United States and Australia. In both these countries, while a national appellation describes a group in ethnic terms, a geographical or continental description signals a racialisation.

In the migrant's movement from their nation to Australia, their original national identity is transmuted into ethnic identity.[63] I use the word 'original' here deliberately because what this formation of ethnicity does is provide a stable, if not an essentialist, anchor for the production of differential identity within the Australian nation-state. Nation-states are relatively long-lasting institutions. Moreover, identification by birthplace and language presupposes an identity that takes little or no account of regional or class differences, or, for that matter, previous migration patterns of the person or their parents. This latter point is acknowledged in *Diversity Counts* as one of the limitations of using birthplace 'as an indicator of a person's cultural background.'[64] The

construction of a person's ethnicity in terms of national origin founds the invention within Australia of a mythic ethnic group identifiable in terms of a national culture. In this way, if Australia is, at least partially, made up of particulars, that is, distinct ethnic groups, then those particulars are representable within the Australian national polity by means of the national representations of those ethnic groups.

REPRESENTATION, MULTICULTURALISM AND JEWS

Representational thinking has been central to the formation of modern nation-states. This is most obvious in the processes of governmental legitimation, whether the government be democratic or totalitarian. Key in this development was the idea of national homogeneity, what we have seen Balibar describing in terms of the production of fictive ethnicity. The construction of a singular national presence, expressed in a unitary national identity, was the basis for the production of unitary national subjectivities constituted, as Louis Althusser might have said, through the ideological state apparatuses of the family, education, religion and the media. Groups which are claimed to be Different, identified as racially Other, threaten this representational system.[65]

Briefly put, in representational terms the distinction between race and ethnicity is that whereas those groups designated as ethnic can be represented within the ultimately unified, if not completely homogeneous, nation-state, those designated as racially Different are considered not to be representable as part of the nation-state, as contributors to national identity. Indeed, any attempt to represent them either nationally – that is in cultural terms – or as part of the state – that is in political terms – will threaten the integrity and existence of the nation-state. This is the problem in the United States where, as we have seen, multiculturalism is associated with race.

In Australia, the conservative prime minister, Malcolm Fraser, with clearer political insight than Whitlam or Grassby, recognised that multiculturalism could be used as a way of managing the diverse 'ethnic' groupings which had been emerging in the Australian national polity. In Foster and Stockley's words:

> Fraser's interest essentially was a political one and one devoted to a particular section of the ethnic population, whereas Whitlam's interest was an intellectual one. This particular emphasis by Fraser (and other senior Government members) was to have important consequences as the Fraser Government deliberately adopted policies of *co-opting* particular ethnic group leaders . . . and tying their interests in maintaining power and status with the Government's interest in asserting a pale celebration of *ethnicity* as one means of managing and containing ethnic pressures for a more significant socio-cultural role in Australia.[66]

Central to this argument is the problem of representation. What the Fraser government did was to formalise multiculturalism in terms of the diversity of politico-cultural interests of ethnic groups. In other words ethnic groups, assumed to be racially/culturally similar to the dominant Anglo-Celt-Australian national group, were constituted as interest groups within the liberal-pluralist system of Australian politics. As Chin Liew Ten has argued: 'It would appear that liberalism is a doctrine that is tailor-made for a multicultural society, because it allows different individuals and groups to flourish in the full diversity of their respective cultures.'[67] From a Jewish perspective, Lippmann would agree. He claimed that the future of the Jewish community 'depends upon . . . a recognition of cultural pluralism in Australia.'[68] We should note here how cultural pluralism is assimilated into a form of political pluralism. Where liberal-pluralism historically entailed the political expression of a variety of compatible but diverse ideologies, it is now expanded to include the interest-group politics of a variety of culturally diverse ethnic groups, the cultures of which are considered to be ultimately compatible.

The Fraser government's key to the organisation of ethnic groups within a political representational structure were the Ethnic Community Councils (ECCs). The first two had been established in Victoria and New South Wales in 1975. At this point Jewish political representation began to be thought of in terms of Jewish ethnicisation, that is, in the Australian case, their segmentation out from the Anglo-Celt population. As Sol Encel writes that: '[The Victorian ECC] was supported by the Victorian Jewish Board of Deputies and had some leading Jewish members. In New South Wales, however, the Board of Deputies declined to affiliate. This decision was influenced by the attitude of the rabbinate, who were opposed to the idea that Jews were an ethnic group.'[69] The New South Wales Jewish Board of Deputies finally voted to join the local ECC in 1988.[70]

To understand why the Jews of Sydney and Melbourne had such different attitudes towards membership of the ECCs we need to know the different demographic make-up of the two communities. Bill Rubinstein describes Sydney's Jewish community as having 'relatively more Jews of Anglo-Australian background and many fewer Poles and others from the former Pale of Settlement.'[71] Andrew Riemer elaborates on this:

> The Jewish community in Melbourne is more closely-knit and more committed to its identity than the other comparably-sized Australian Jewish community in Sydney. The reason for that may have something to do with the cultural and even national differences in the origins of the Jewish population of the two cities. Orthodoxy seems to be more prevalent among Melbourne Jewry, as is a particular sense of Jewishness which embraces some elements of a nationalistic or even racial awareness.[72]

In Sydney, it would seem, the higher degree of cultural integration with the dominant Anglo-Australian culture, a function not least of the historical presence of relatively large numbers of Anglo-Jews whose heritage lay in Britain, has led to a great emphasis being placed on religion as the key distinguishing feature of the Jewish community. As Geoffrey Alderman puts it in relation to British Jewry, 'Historically British Jews have viewed themselves as nothing more nor less than British citizens dissenting from the established Church, and therefore as differing from the Anglican and Christian majorities merely by virtue of their religious beliefs.'[73] Alderman goes on to note the resistance of British Jews to accepting an identity as an ethnic group.[74] In Melbourne, the long-term impact of the *Yiddishkeit* of the Eastern European pre-war and post-war migrants seems to have made it easier for the Melbourne Jewish community to identify itself as an ethnic group.

Clearly, the renovation of Jews in Australia as an ethnic group is complex. Let us begin by examining how the Jews intersect with the official invention of ethnicity. This depends, as we have seen, primarily on birthplace and language. Now, the first thing to remember is that, through the nineteenth century, gentile European definitions of the Jew tended towards either religion or race as the defining feature. In Australia, the Censuses have always categorised European Jews by religion, assuming them to be 'white.' It is still the case that the Censuses define Jews in this way. Hence, Bill Rubinstein's analysis of the Jewish situation in Australia as detailed from the 1991 Census had to be entitled *Judaism in Australia*, rather than *Jews in Australia*. If finding the correct number of Jews in Australia were simply a question of working out what percentage of Jews do not answer the question on religion this could be easily corrected, however the major complication comes from the increasing difficulty in defining who is a Jew. I will come back to this.

Setting religion aside, we have seen that birthplace and language combine to produce ethnicity as a national construct. The first, most obvious comment to make is that Jewish is not a national identity like Greek, or, indeed, Israeli. Moreover, this complexity ramifies. European Jews live as diasporic and less or more assimilated members of almost all European nation-states. In the process they have become 'Anglo-Jews' or 'French-Jews' or 'Greek-Jews.' This situation is further complicated by the waves of Jews who entered Western Europe from the Pale around the turn of the century and around the Second World War. Migration to Australia, and for that matter to the United States and other settler-colonies, has never come from a 'Jewish nation' – unless one defines Israel as a Jewish nation and thinks of Israeli migrants. In the United States, Galchinsky describes how

it was more than a little disconcerting for me to go to Ellis Island, Jewish national landmark if there ever was one, walk up to the map which displays 'every ethnicity in America,' and find that it does not

have a category for Jews. If you want to find out where on the map Jews have settled, you have to push the button for 'Poles' and then make an educated guess how much to subtract.[75]

We have seen that geographical origin – birthplace – serves to define national identity. However, in this rhetoric of ethnicity the lack of a national identity erases the utility of one's geographical origin – leaving the Jewish migrant with no 'origin,' nothing that anchors the representation of a Jewish ethnic identity. The problem of language compounds this situation. There is no single Jewish language. Hebrew is the religious language and the national language of Israel. Yiddish was the 'fusion language'[76] of the Jews of the Pale. In Western Europe, Jews speak the language of the national communities of which they are a part. The problem is, of course, compounded when one looks outside of Europe. Sephardim and Mizrahi Jews speak, or have spoken, Ladino and Judaeo-Arabic. Jews in the rest of the world also speak the languages of the communities in which they live. Language, then, is certainly no help in the construction of a Jewish ethnicity or, in the identificatory terms of *Diversity Counts*, in identifying a person as Jew.

The century from around 1850 to 1950 can be usefully described as that of the modern Jewish diaspora. It was during this century that Jews flowed out of the Pale into Western Europe and when both these Jews and Western European Jews migrated to the settler-states of the American continent and to Australia, New Zealand, South Africa and, of course, to Israel. In the latter part of this century, Jews from the Arab world have also migrated in large numbers. One effect of this modern diaspora has been an extraordinary co-mingling of Jewish communities. This is most obvious in Israel but it has also taken place throughout the settler-states. Within these settler-states this co-mingling is producing new Jewish identities. In Australia this is evident in the tensions that have existed, or do exist, between the Anglo-Jews, the European Jews, the Ashkenazim from Eastern Europe and the Sephardim, as these groups, all identified and identifying as Jewish, forge a new Jewish identity in Australia which is, at the same time, a Jewish-Australian identity, that is, it interweaves also with the dominant Anglo-Australian identity.

This new Jewish-Australian identity is fundamentally postmodern in the sense that it is built out of the problematic modernisation of European Jews in pre-Holocaust Europe. In multicultural Australia, the Australian version of post-assimilation Jewishness, to coin a term, is not only a product of the specifically Australian experience of a subjectivity framed by a history of the policy of assimilation. It is also, and more generally, a function of the recognition brought home by the Holocaust that, within the historical gentile-European construction of the 'Jew,' assimilation into modern settler-states dominated by 'western' culture is only possible on the terms of that state. To put it straightforwardly, the racialisation of Jews is not something that, in the end, Jews have control over because racialisation is a form of Othering. Thus,

one of the ironies of Australian multiculturalism for Jews is that, to the extent that ethnicisation is limited in complex ways to 'European' national identities, indeed to the extent that Australian culture remains dominated by an Anglo-Celtic-Australian hegemony, there will continue to be the possibility of the racialisation of Jews in Australia. This is because the racialisation of the Jews has historically been a European phenomenon, starting in the mid-nineteenth century. In the United States the always possible, always partial, racialisation of the Jews underlay the traditional alliance between Jews and African-Americans. In Australia the same possible and partial racialisation has led to a less obvious, and more tentative, historical connection between Jews and Aborigines.[77]

As I have begun to indicate, the other side of the problematic Australian ethnicisation of Jews is the transformation in the Jewish experience itself. Jonathan Webber has dated the ethnicisation of 'western' Jewry back into the nineteenth century. He argues that 'The development of what was broadly seen from the outside as a *religious* community co-existed with the internal trend towards what is now commonly called Jewish ethnicity, and a conscious move *away* from religious belief or practice as the principal underlying feature.'[78] One aspect of the western Enlightenment was the reconstitution of religion as something primarily apart from the culture of day-to-day life. The inter-mingling of religion and culture as a single entity is considered to offer a threat to the rationality of daily life. I have already referred to this in the context of American multiculturalism. In Webber's view, secularisation has been central to the ethnicisation of Jews. Secularisation was another effect of the Enlightenment as a part of the modernisation of European Jewry, but it was also an aspect of the processes of assimilationist incorporation into western nation-states. When applied to the Jews, the disarticulation of religion from culture, and secularisation, opened the way for a new spectrum of Jewish identities in addition to those that were produced as a consequence of divergences in religio-cultural practice and those that were a consequence of the intersections of Jews with their local, host communities.

One effect of these modern transformations was a decrease among modern Jews everywhere in a clear understanding of who is, and who is not a Jew. Traditionally, officially, Jewish separateness could be preserved through the invocation of endogamy and *halachic* law: Jews marry among themselves and, in cases of marrying-out, only the children of a Jewish mother may be considered to be Jewish. In 1983 even this, most fundamental of Jewish definitions of who is a Jew, was problematised when the peak body of American Reform rabbis, the Central Conference of American Rabbis, in the face of the approximately 50 per cent of Jews in the United States marrying out, ruled to include the children of a Jewish male who married out as Jewish. Aside from this, processes of conversion vary hugely from religious community to religious community and those converted by the rituals of Reform Judaism are not accepted by the Orthodox community.[79] It is secularisation, though, that has caused the most complex blurrings of separateness.

Setting aside *halachic* law, the intractable problem for the Jewish community is in what sense a person brought up outside of the Jewish religio-cultural order can be considered to be a Jew. Indeed, what constitutes 'Jewish culture' when Jewish cultural practices, even at the most mundane levels of modes of mothering, vary between Jewish communities. It is on this site that we can recognise simultaneously the modern process of ethnicisation and the impossibility of ever being able to define clearly 'Who is a Jew.' It is here, also, that we can understand the importance of American and Australian preoccupations with national origin as a means of stabilising, homogenising and delimiting 'ethnicity.' We can now also appreciate why it has become so impossible to count the number of Jews in Australia. I have already argued that the Australian definition of an ethnic group entails an always possible hybridisation taking place in relation to a core national ethnic identity. This is both literally and metaphorically played out in images of inter-ethnic and ethnic-dominant culture marriages. Australian Jews, like Jews everywhere, on the other hand, remain concerned about endogamy while less and less sure who actually is a Jew.

JEWS AND MULTICULTURAL CULTURAL REPRESENTATION

I have argued that the lack of a national origin means that there is nothing to anchor the representation of a Jewish ethnic identity. Laclau writes that 'if that impossible object – the system – cannot be represented but needs, however, to show itself within the field of representation, the means of that representation will be constitutively inadequate. Only the particulars are such means.'[80] The 'impossible object,' here, is a national identity made up of differential identities. Here we must make clear the distinction in the Australian practice of multiculturalism between the differentiated ethnic identities and the incompatible racial identities. Laclau is arguing, in relation to the political organisation of a multicultural nation-state, that one particularity will take on a hegemonic role. All particularities, all ethnic identities, will be constituted, and define themselves, in relation to each other and in relation to the hegemonic dominant culture. This is the problematic within which, as I have already argued, representation articulates with the modern nation-state. In Australia, the Anglo-Celtic-Australian identity, formed from the colonial period through to the 1960s, has remained the hegemonic particularity. In the 1940s and 1950s the ideology of this identity was assertively constituted in articulation with the policy of assimilation, in the face of perceived threats from American consumerist culture and the lack of assimilation of non-British European migrants.[81] It was in the context of a nationalising preoccupation with assimilation that anti-Semitism in Australia had shifted by the 1930s from an emphasis on race *per se* to a cultural emphasis. That is, Jews were acceptable

as part of the Australian imagined community provided that they were not visible, that culturally they looked and behaved like the dominant Anglo-Celt-Australian culture.[82] Being a Jew was in this way reduced to a consequence of membership of a particular religion, Judaism. The key struggle in Australian multiculturalism has been over the decentring of the particularity of Anglo-Celt-Australian culture and the European ethnicities it privileges.

There are two forms of representation, political and cultural, that take place within the Australian multicultural nation-state. Ethnic groups represent the interests of their constituencies in the political arena and the Ethnic Community Councils represent the interests of all ethnic groups. Cultural representation is the process of representing the cultural invention of one's own ethnic group in such a way as to make it meaningful throughout the rest of the population. Through such a dual system of representation a group may struggle to redefine itself from the ethno-racial category, let us say 'Asian,' to the status of a differential ethnic group, let us say 'Vietnamese.'[83] This struggle primarily takes place between the community and the members of the dominant culture – itself a complex mix of Anglo-Celt-Australian and European ethnic groups – who must be convinced of a group's similarity over their Difference, that is, that they are capable of being represented within the Australian multicultural order, both in the political aspect of the state and the cultural aspect of the nation.

When Gunew remarks that 'Multiculturalism in Australia is acceptable as a celebration of costumes, customs and cooking',[84] which is, we should note, a remarkably succinct version of Tyler's definition of culture used by the Galbally Report, she is describing the most representable aspects of culture. It is important to recognise that behind the representation, limiting access to its production, is the legitimisation invoked by migrant, national origin. When the author Helen Darville, of English ethnicity, represented herself as the Ukrainian Helen Demidenko this became apparent in the outrage at her impersonation.[85]

Now, Jews are represented politically through the Board of Deputies and through their membership of Ethnic Community Councils. It is much harder to represent Jews culturally. The lack of a national origin, the diversity of local cultural practices that Jews have in Australia, makes this impossible in any straightforward way. In the United States the massive migration of Eastern European Jews in the period between the late nineteenth century and the 1920s when the American government started introducing discriminatory immigration controls, coupled with the general process of ethnicisation, allowed for the invention of an American-Jewish ethnicity based on a heritage of *Yiddishkeit*. A Jewish-American ethnic presence permeates sites of secondary representation such as Hollywood films and television, especially sitcoms.

In Australia, the assimilationist policy plus the dominance of an integrated, and heavily assimilated, Anglo-Jewish population led to a long-term cultural invisibility of Australian Jews.[86] There is one major exception. During the

1920s and 1930s the Jewish vaudeville comic Roy Rene, known as Mo, performed in the image of a 'Jew.'[87] He also made one film, *Strike Me Lucky*, released in 1934. Freda Freiberg comments that

> It seems to me that the Mo persona owes something to Chaplin's tramp persona (the down-and-out clown, the nebbich loser), and something to Groucho Marx's lecherous persona, but he has neither the charm and pathos of the former, nor the outrageously insouciant insolence of the latter. The leering, cringing, hook-nosed Mo, of *Strike Me Lucky*, who ssppittss and splutters when he speaks, is just too close to the Nazi caricature of the Jew for post-Holocaust Jewish comfort.[88]

In fact, not only is the Mo character like the Nazi caricature, he is also like the characterisation of Jews in the anti-Semitic cartoons and articles that had been a hallmark of the *Bulletin* magazine since the 1890s. Without any visible, Jewish ethnic presence to draw on in Australia at this time, Roy Rene invented a character out of the only Jewish imagery with which the Anglo-Celt-Australian audience would be familiar, the anti-Semitic caricature of the Eastern European Jew in the Western European, modern world. He succeeded because he turned this caricature into a figure of fun, balancing his humour on an equivocation which meant his audience was never completely sure whether it was laughing at him or with him. This ambivalence about being visible in, or assimilated into, the dominant cultural community expressed well the Jewish situation in Australia.

In the era of multiculturalism the question is more about whether Jews are accepted as a part of the dominant Anglo-Celtic-Australian culture or whether they can be ethnicised. Unlike other ethnic groups Jews, based in their ambivalent construction as Anglo and 'white,' have successfully integrated structurally into the social order. It has become a platitude among those who want to argue that there has been no serious anti-Semitism in Australia to point out that Sir John Monash (1865–1931) became a general in the Australian army in 1930 and that Sir Isaac Isaacs (1855–1948) became the first native-born Australian Governor-General in 1931.[89] At the present time, the 1991 Census shows that of Jews identifying by religion 29 per cent of males and 19.8 per cent of females have a bachelor degree or higher as compared to 8.4 per cent of males in the total Australian population and 6.7 per cent of females.[90] The same Census also shows that 42 per cent of Jewish families earn more than $50,000 a year as compared to 22.2 per cent of the total Australian population.[91]

Clearly, the religiously identifying Jewish population is well-entrenched in the Australian middle and upper classes. If Jewish ethnicity in Australia cannot be anchored in a single national origin or in a representable cultural complex, then how might it be founded? Webber has argued that 'today's post-modern

Jewish ethnicity is principally concerned with what has come to be regarded as the revival or reconstruction of authentic traditions.'[92] He suggests that within this context the Holocaust poses a problem. He writes that 'the uniqueness of the Holocaust makes it difficult to sustain the view that an interest in it forms a part of authentic Judaism.'[93] The slippage from talking about Jewish ethnicity to Judaism is important. An interest in the Holocaust may well sit awkwardly with the attempts to (re)construct 'authentic' Jewish traditions, but the Holocaust serves exceptionally well as an originating moment for the invention of a Jewish-European identity.

Jean-François Lyotard has argued that '"Auschwitz,"' his synecdoche for the Holocaust, 'can be taken as a paradigmatic name for the tragic "incompletion" of modernity.'[94] He views the Holocaust as 'the crime opening postmodernity.'[95] Certainly, what the transcendentalised construction of the Holocaust as a unique and unrepresentable event has done for 'western' Jewry is to include it as a particularised presence within the moral and cultural post-Enlightenment, postmodern in this sense, order of the European world.[96] Hence, the power of the two names for this event, the (Jewish) Shoah and the (gentile) Holocaust.[97] Jewish identity in the west is now irrevocably linked to the various definitions of being a Jew, both gentile and Jewish, which converged in and around the genocide of the Holocaust. The Holocaust has become the key site, not bounded by the Jewish community's self-regulating definitions for identification as a Jew.

In multicultural Australia the Holocaust provides a substitute for a national origin. In his book on the Demidenko affair,[98] Robert Manne gives a powerful account of his experience of what I call 'Holocaust-Jewishness.' He describes how he has 'long ceased to practise the Jewish religion,' how most of his close friends are non-Jews and how he, himself, has married out:

> What then explained the intensity of my response to Demidenko? At the very heart of my being lay the fact of the Holocaust. Although, to my memory at least, my parents had rarely discussed it in our home, I had become aware quite young – as most Jewish children of my generation had – that a few years earlier the Germans, [one of] the most sophisticated peoples of Europe, had under the cover of war set about a policy of remorseless extermination of the Jewish people.
>
> My life was shaped by the terrible, unchangeable, untreatable wound of the Holocaust.[99]

If, as I have followed Dubow in arguing, it was revulsion at the Holocaust which was a major factor in the discursive shift away from scientific racism, the racial claims which legitimated the Holocaust still echo in the experience of Holocaust-Jewishness.

In multicultural Australia the Holocaust not only provides a source for Jewish identification, it also operates as a substitute for a national origin in the

process of Jewish ethnicisation. Freiberg makes the point that in Australian multiculturalism, in filmic, televisual and theatrical secondary representations, there are still hardly any representations of a Jewish ethnic community. She notes that in the celebrated mini-series *The Dunera Boys* (1985), based on an actual event, 'The Jews are all refugees or Cockneys; there is no local community in sight;'[100] and writes that 'The sentimental and soapy *Palace of Dreams* [another 1985 mini-series] would appear to be the only exception to this general state of fictional affairs.'[101] Jewish-Australian ethnicity is removed from problematic national origins by situating it in relation to the Holocaust as a geographically European event. Hence, in *The Dunera Boys* the narrative is about a shipload of Second World War refugees, most of whom were Jewish, who come to Australia. It is interesting to note within the 1980s discourse of multiculturalism that, when the refugees first arrive in Australia, they are thought to be Italian prisoners-of-war from Africa. In this way the mini-series recognises the need for identifying a national origin, emphasising the Jewish refugees' lack of one and, by implication, the importance of the unnamed Holocaust as their origin-site.

Freiberg identifies one play and one film about Jewish-Australians. Ron Elisha's play *In Duty Bound* (1988) was 'about the generation gap in Holocaust survivors' families.'[102] The film is Henri Safran's *Norman Loves Rose*, released in 1983. This comedy about Jewish family life in Sydney's Vaucluse was a critical and commercial failure. In the film, *bar mitzvah* boy Norman falls in love with the disaffected wife of his elder brother who is having difficulty making his wife pregnant. Norman succeeds where his brother fails, his brother thinking that the baby is his. The brothers' father is a Holocaust survivor from Warsaw. In the film's one serious scene, he explains his background to his secretary. He tells of his memories of his father and his parental family. All these people were lost in an event, the Holocaust, that neither he nor his secretary can bring themselves to speak aloud. There is no explanation as to how he came to be in Australia. The unspoken, unrepresented Holocaust becomes, itself, the origin of his presence here. In fact, the film is preoccupied with origins and ancestry from the mother's concern over her son's inability to impregnate his wife to Norman's success and the family's relief in Rose's pregnancy.[103] The father's Holocaust origin establishes the family's Jewish ethnicity. However, without a national identity it is difficult to represent the family as distinctively Jewish. To the extent that this is achieved, it is by dealing in stereotypes such as the neurotic Jewish mother mostly developed in Jewish-American ethnic portrayals.[104]

The construction of the Holocaust as an ethnic-origin event marks Jews as a European people because the Holocaust was a European event. In this sense, the transcendentalising of the Holocaust, evidenced in the word's capitalisation, also helps to particularise 'Europe' in a postmodern world of variegated modernities.[105] Within Australia the effect of the production of the Holocaust as the Jewish ethnic-origin has been to provide a common referent for those

with backgrounds as varied as Anglo-Jews, continental Jews and Ashkenazi Eastern European Jews. Moreover, the transcendental force of the genocidal claim within a culturally European dominated context hegemonises non-European Jews as part of the ethnic group. If Holocaust-based ethnicity normalises Jews as an ethnic group within Australia by giving them a secular and European origin it also, simultaneously, reasserts their specialness in proportion to the uniqueness attributed to the Holocaust. In Europe, and in countries dominated by European culture, the Jews are reracialised not in cultural terms but in moral terms. Typical of this new understanding is Lyotard's claim that 'At "Auschwitz," a modern sovereign, a whole people was physically destroyed. The attempt was made to destroy it. It is the crime opening postmodernity, a crime of *lèse-souveraineté* [violated sovereignty] – not regicide this time, but populicide (as distinct from ethnocide).'[106] Here the Jews become the moral signifier of the loss of any absolute, transcendental moral imperative. The Holocaust is positioned as the final consequence of Enlightenment secularisation and the triumph of means–ends rationality. Post-Holocaust Jews become a living, moral reminder of the final loss of modern innocence. In a postmodern world characterised by a loss of moral absolutes, the Jews – and perhaps one should think here in terms of the reification of Jews that Lyotard signals when he writes of 'the jews'[107] – have become a moral *exemplum*.

In the Australian multicultural nation-state's representational order Jews become representable as an ethnic group by their relation to an originating event which cannot be represented. Were the Holocaust to become representable, it would lose its ability to act as the authenticating anchor for Jewish ethnicity. It would simply become another genocide. We can now understand that the argument in Australia over Helen Demidenko/Darville's 1994 novel *The Hand That Signed the Paper*, has a further ramification than whether she had the right to represent, and misrepresent, the Holocaust. The book threatens the use of the Shoah/Holocaust as a moral reference point and as a site for the production of Jewish ethnicity by attempting to normalise the Holocaust as a historical event with understandable causes and, indeed, one to which the selfish actions of Jews themselves helped to contribute.

The problematic particularity of Jewish ethnicity has been highlighted more recently in relation to revisionist historian and Holocaust-denier David Irving's plans to reapply for a visa to enter Australia. *The Australian* reported that 'Australia's Jewish and ethnic community leaders last night expressed confidence that Dr Irving would again be denied entry to Australia.'[108] The article goes on to quote Mr Mark Liebler as a member of the Ethnic Coalition of Australia rather than as a leader of the Jewish community. There is here an ambivalence over the ethnic status of Jews which is common in Australian commentary. It is not one that can be resolved, not least because it is a product of Australian multiculturalism's profound embeddedness in the epistemological assumptions of the modern nation-state.

CONCLUSION

In order to understand the ambivalent ethnicisation of Jews in Australian multiculturalism it has been necessary to explicate the relationships between the discourses of race and ethnicity and examine how multiculturalism functions as governmental policy in Australia. In the discourse of race, as I noted near the beginning, hybridity was thought of negatively. By contrast, the discourse of ethnicity celebrates a cultural intermixing which could also be described as 'hybrid' as an aspect of a pluralist ideology that thinks of different cultures coming together and intermixing. As I have argued, the trope for multicultural hybridity is intermarriage.

Where 1950s assimilationist Australia is now frequently characterised as 'boring' and monochromatic with its claimed single homogeneous Anglo-Celtic-Australian culture, multicultural Australia is thought of as dynamic, enriching and colourful. Ethnicised multicultural Australia still operates, like assimilationist Australia, within a discourse of race. In assimilationist Australia, Jews lived with the possibility that they could be racialised as Orientals, Asiatics. Within multicultural Australia Jews cannot be ethnicised in the same way as other ethnic groups. Moreover, the official Jewish refusal of hybridity, as exemplified in intermarriage, places them at odds with the celebration of the blurring of ethnic and cultural boundaries that is a central part of Australian multiculturalism. In Australia the intermarriage rate is estimated to be about 10–15 per cent. In contrast, in the United States the figure is thought to be around 50 per cent.[109] It is in that blurring, exemplified by intermarriage, that ethnic similarity and difference are represented as aspects of ethnic diversity.

The uncertainties in Jewish ethnicisation, and both cultural and political representation, lead back, ultimately, to the ambivalence of Jewish racialisation. It is not an irony that the racially motivated Holocaust should be a key source of postmodern Jewish ethnicisation. When Jews represent themselves as an ethnic group within the plurality of multicultural ethnic groups, they do so within what is still a fundamentally European-based cultural order. Within this order anti-Semitic racialisation remains a possibility that is never too far away. The paradox of the ambivalent ethnicisation of Jews in Australia, and elsewhere, is that it is built on a foundation of ambivalent racialisation. The possibility of Jews being accepted in multicultural Australia as one ethnic group among many depends on the dissolution of the hegemony of the Anglo-Celt-European-Australian cultural complex.

NOTES

1 Lois Foster and David Stockley, *Multiculturalism: The Changing Australian Paradigm*, Cleveland, Multilingual Matters, 1984.
2 Andrew Theophanous, *Understanding Multiculturalism and Australian Identity*, Melbourne, Elikia, 1995.

3 Interestingly, in the light of what I will argue later about the ethnicisation of Jews in the United States, the American academic Daniel Waldren who, his biography notes, 'has written extensively on multicultural literature in the United States,' identifies both Waten's Russian and Jewish backgrounds, and describes him as 'a Jewish-Australian' (pp. 100–3).

4 On race, ethnicity and multiculturalism in Australia, see my *Race Daze: Australia in Identity Crisis*, Sydney, Pluto Press, 1998. Also, Ghassan Hage, *White Nation: Fantasies of White Supremacy in a Multicultural Society*, Sydney, Pluto Press, 1998.

5 The term 'invention of ethnicity' comes from Werner Sollors, *The Invention of Ethnicity*, New York, Oxford University Press, 1989.

6 Jon Stratton and Ien Ang, 'Multicultural Imagined Communities: Cultural Difference and National Identity in the USA and Australia' in David Bennett (ed.), *Multicultural States: Rethinking Difference and Identity*, London, Routledge, 1998, pp. 135–62.

7 Robert Young, *Colonial Desire: Hybridity in Theory, Culture and Race*, London, Routledge, 1995, p. 9.

8 In the context of Peter Davis's 1996 claim – Davis was the mayor of Port Lincoln in South Australia – that the offspring of Aboriginal and 'white' unions are 'mongrels', we can refer to the nineteenth century 'technical' usage of this term. Quoted in Robert Young, *Colonial Desire*, T. H. Huxley (1863) wrote in his *Six Lectures to Working Men On Our Knowledge of the Causes of the Phenomena of Organic Nature*, that 'there is a great difference between "mongrels," which are crosses between distinct races, and "hybrids," which are crosses between distinct species. The mongrels are, so far as we know, fertile with one another. But between species, in many cases, you cannot succeed in obtaining even the first cross, at any rate it is quite certain that the hybrids are often absolutely infertile with one another' (p. 10).

9 Robert Young, *Colonial Desire*, p. 14.

10 On the Good Neighbour Movement, see Ann-Mari Jordens, *Redefining Australia*, Sydney, Hale and Iremonger, 1995, pp. 82–7. Also the much earlier discussion in Jean Martin, *Community and Identity: Refugee Groups in Adelaide*, Canberra, Australian National University Press, 1972, pp. 101–5.

11 See, for example, Hilary Rubinstein, 'Inter-War Immigration and Australian Jewish Communal Responses, 1918–1945' in *The Jews in Australia: A Thematic History*, vol. 1: 1788–1945, Port Melbourne, Heinemann, 1991 (chapter 3). See also, Peter Y. Medding, *From Assimilation to Group Survival: A Political and Sociological Study of an Australian Jewish Community*, Melbourne, F. W. Cheshire, 1968.

12 Saul Dubow, *Illicit Union: Scientific Racism in Modern South Africa*, Cambridge, Cambridge University Press, 1995, pp. 127–8.

13 Saul Dubow, *Illicit Union*, p. 127.

14 Andrew Theophanous, *Understanding Multiculturalism*, p. 6.

15 Andrew Theophanous, *Understanding Multiculturalism*, pp. 3–4.

16 Andrew Theophanous, *Understanding Multiculturalism*, p. 7.

17 Andrew Theophanous, *Understanding Multiculturalism*, p. 12.

18 A brief legal discussion of the relationship between these three Acts, especially as they affected Jews, can be found in Louis Waller, 'Legal Curbs on Discrimination and Race Hatred' in *Anti-Semitism and Human Rights*, Melbourne, Australian Institute of Jewish Affairs, 1985, pp. 141–6.

19 Quoted in Andrew Theophanous, *Understanding Multiculturalism*, p. 13. Labor Prime Minister Paul Keating's celebrated description of Australia as a 'multicultural nation in Asia' has the first half of this sentence as an intertextual referent.

20 Stephen Castles et al., *Mistaken Identity: Multiculturalism and Demise of Nationalism in Australia*, Sydney, Pluto Press, 1988, quote an editorial from *The Australian*, August 4, 1965, in which connections are made between exchanges of visits between Lee Kwan Yew and senior Labor leaders and the removal of 'White Australia' from Labor's immigration policy.

21 Andrew Theophanous, *Understanding Multiculturalism*, p. 7.

22 Walter Lippmann, 'Australian Jewry – Can It Survive?' *The Bridge*, January, 1973, p. 11.

23 Walter Lippmann, 'Australian Jewry', p. 6.

24 Walter Lippmann, 'Australian Jewry', p. 9.

25 John Lechte and Gil Bottomley, 'Difference, Postmodernity and Image in Multicultural Australia' in Gordon L. Clark et al. (eds.), *Multiculturalism, Difference and Postmodernism*, Melbourne, Longman Cheshire, 1993, p. 25.

26 Walter Lippmann, 'Australian Jewry', p. 9.

27 Walter Lippmann, 'Australian Jewry', p. 10.

28 Kathleen Neils Conzen et al., 'The Invention of Ethnicity: A Perspective from the USA', *Journal of American Ethnic History*, vol. 12 (1), 1992, p. 8.

29 Kathleen Neils Conzen et al., 'The Invention of Ethnicity', p. 14.

30 In Australia 'white' was not constituted in relation to 'black,' rather 'whiteness' faded into 'coloured' as one moved further away from Britain and northern Europe. Thus other races, most importantly in Australia's history, the 'yellow' or 'oriental' or 'Asian' race, were constituent elements of the excluded, 'coloured' Other.

31 Werner Sollors, *The Invention of Ethnicity*, p. 23.

32 An important sidelight on the American concept of 'the melting pot' is that the term, and much of the ideology, derives from Israel Zangwill's play *The Melting Pot*. Zangwill was a well-known English Jewish novelist and playwright, who was, at different times, a Zionist, a territorialist, and a supporter of the American population 'experiment.' (See Maurice Wohlgelernter, *Israel Zangwill: A Study*, New York, Columbia University Press, 1964). The play centres on an Eastern European Jew who migrates to the United States, falls in love with, and finally marries a migrant gentile from the same city. (Werner Sollors, *Beyond Ethnicity: Consent and Descent in American Culture*, New York, Oxford University Press, 1986 (ch. 3), provides a detailed discussion of the play.) It seems that the American idea of a merging of cultures in a new land was significantly formulated from a Jewish version of the Jewish assimilation in Britain and Europe, a version that emphasised cultural mixing rather than cultural loss.

33 Ernesto Laclau, 'Subject of Politics, Politics of the Subject', *Filosofski Vestnik – Acta Philosophica*, vol. 15 (2), 1994, p. 13–4.

34 See, for example, Ruth Frankenberg, *White Women, Race Matters: The Social Contruction of Whiteness*, Minneapolis, University of Minnesota Press, 1993, pp. 151–3. See also, Karen Brodkin, *How Jews Became White Folks and What That Says About Race in America*, New Brunswick, N.J., Rutgers University Press, 1998.

35 Susan Kray comments that 'The American Jew is, for historical reasons, one might say, 'almost a white man or woman.' Until after the Holocaust, Americans considered Jews a race – and not a desirable one' ('Orientalisation of an 'Almost White' Woman: The Interlocking Effects of Race, Class, Gender and Ethnicity in American Mass Media', *Critical Studies in Mass Communication*, vol. 10, 1993, p. 354).

36 Sneja Gunew, *Framing Marginality: Multicultural Literary Studies*, Carlton, Melbourne University Press, 1994, p. 46.

37 Henry Giroux, *Living Dangerously: Multiculturalism and the Politics of Difference*, New York, P. Lang, 1993, p. 60.
38 David Hollinger, *Post-Ethnic America: Beyond Multiculturalism*, New York, Basic Books, 1995, p. 23.
39 David Hollinger, *Post-Ethnic America*, p. 25.
40 See for example, Paul Berman (ed.), *Blacks and Jews: Alliances and Arguments*, New York, Delacorte Press, 1994. Michael Lerner and Cornel West, *Jews and Blacks: A Dialogue on Race, Religion and Culture in America*, New York, G. P. Putnam's Sons, 1995.
41 Michael Galchinsky, 'Glimpsing *Golus* in the Golden Land: Jews and Multiculturalism in America', *Judaism*, vol. 43 (4), 1994, p. 363.
42 Michael Galchinsky, 'Glimpsing *Golus*', p. 364.
43 There is much talk in the United States about 'Muslims' but this operates as a pseudo-racial category rather than an ethnic one.
44 Frank Galbally, *The Report on the Review of Post-Arrival Programs and Services to Migrants*, Melbourne, The Australian Institute for Multicultural Affairs, 1982, p. 47.
45 Frank Galbally, *The Report*, p. 48.
46 Such a fracture is the key problematic in the American attempt to develop a national identity.
47 Ernesto Laclau, 'Subject of Politics', p. 11.
48 This is discussed in Saul Dubow, *Illicit Union*.
49 On integration see Stephen Castles et al., *Mistaken Identity*, pp. 52–5.
50 Hilary Rubenstein, *Chosen: The Jews in Australia*, Sydney, Allen and Unwin, 1987, p. 263.
51 Ernesto Laclau, 'Subject of Politics', p. 15.
52 *Multiculturalism for all Australians*, Canberra, AGPS, 1982, p. 17.
53 Frank Galbally, *The Report*, p. 104.
54 A useful critique of the idea of culture in Australian multiculturalism is Joel Kahn's 'The "Culture" in Multiculturalism: A View From Anthropology', *Meanjin*, vol. 50 (1), 1991, pp. 48–52.
55 *Diversity Counts: A Handbook on Ethnicity Data*, Canberra, AGPS, 1994, p. 14.
56 *Diversity Counts*, p. 14.
57 For a discussion of this, see Ellie Vasta, 'Dialectics of Domination: Racism and Multiculturalism' in Ellie Vasta and Stephen Castles (eds.), *The Teeth Are Smiling: The Persistence of Racism in Multicultural Australia*, St Leonards, NSW, Allen and Unwin, 1996.
58 In Galbally's follow-up report *The Report on the Review of Post-Arrival Programs and Services to Migrants*, published in 1982, he refers to a 1980 survey of child migrant education program funding which was focused on children from non-English-speaking backgrounds. Galbally condenses this to NESB (p. 97).
59 Etienne Balibar, 'The Nation Form: History and Ideology', trans. Chris Turner, in Etienne Balibar and Immanueal Wallerstein, *Race, Nation, Class: Ambiguous Identities*, London, Verso, 1991, p. 91.
60 Etienne Balibar, 'The Nation Form', pp. 96–7.
61 Quoted in Joel Kahn, 'The "Culture" in Multiculturalism', p. 52.
62 Paul Gilroy, 'Nationalism, History and Ethnic Absolutism' in *Small Acts: Thoughts on the Politics of Black Cultures*, London, Serpent's Tail, 1993, p. 63.
63 This is not distinctively Australian. As Kathleen Neils Conzen et al. note about the United States around the turn of the twentieth century: 'To Americans, the provincial and village identities, so important to the immigrants, were meaningless; they were lumped together into ethnonational categories, Irish, Italians or Poles (or more likely, Micks, Wops or Polacks)' ('The Invention of Ethnicity', p. 12).

64 *Diversity Counts*, p. 17.
65 Louis Althusser, 'Ideology and Ideological State Apparatuses' in *'Lenin and Philosophy' and Other Essays*, trans. Ben Brewster, London, Monthly Review Press, 1971.
66 Lois Foster and David Stockley, *Multiculturalism*, p. 68.
67 Chin Liew Ten, 'Liberalism and Multiculturalism' in Gordon L. Clark et al. (eds.), *Multiculturalism, Difference and Postmodernism*, Melbourne, Longman Cheshire, 1993, p. 61.
68 Walter Lippmann, 'Australian Jewry', p. 11.
69 Sol Encel, 'Anti-Semitism and Prejudice in Australia', *Without Prejudice*, vol. 1, 1990, p. 44.
70 This alone problematises Bill Rubinstein's 'official' version of Australian Jewish history in which, he claims, 'The Jewish community readily joined all these [multicultural] bodies, and Jewish policy has been fully to endorse the concept of multiculturalism' (William Rubinstein, *The Jews in Australia: A Thematic History*, vol. 2, Port Melbourne, Heinemann, 1991, p. 474).
71 William Rubinstein, *The Jews in Australia*, pp. 231–2.
72 Andrew Riemer, *The Demidenko Debate*, St Leonard, NSW, Allen and Unwin, 1996, p. 233.
73 Geoffrey Alderman, 'British Jewry: Religious Community or Ethnic Minority?' in Jonathan Webber (ed.), *Jewish Identities in the New Europe*, London, Littman Library of Jewish Civilisation, 1994, p. 189.
74 We need to note further, though, how in Britain 'ethnicity' has been used as a means of reconstituting 'race' in cultural terms. This is made clear in Geoffrey Alderman's remark that, 'A Jew can be a Jew in his home and an Englishman in the street; this type of anonymity is simply not open to an Afro-Caribbean in Brixton or a Muslim in Bradford' ('British Jewry', p. 190). Accepting ethnic status in Britain, then, entails a much greater degree of racialisation for Jews than is the case in Australia where, as I have been arguing, ethnicity has been a mode of differentiating within 'white' culture.
75 Michael Galchinsky, 'Glimpsing *Golus*', p. 364.
76 Max Weinrich, 'The Reality of Jewishness Versus the Ghetto Myth: The Sociolinguistic Roots of Yiddish' in *To Honour Roman Jakobson*, The Hague, Mouton, 1967. Also see Sander Gilman, *Jewish Self-Hatred: Anti-Semitism and the Hidden Language of the Jews*, Baltimore, The Johns Hopkins University Press, 1986.
77 The assumptions that enable this connection, of race and genocide, are well brought out in Ron Castan's 1993 B'nai B'rith Oration entitled 'Australian Catharsis – Coping with Native Title'. Ron Castan has devoted a large portion of his prominent career as a lawyer to promoting Aboriginal rights.
78 Jonathan Webber, 'Modern Jewish Identities' in Jonathan Webber (ed.), *Jewish Identities*, p. 77.
79 These problems are detailed accessibly in the Introduction to Dan Cohn-Sherbok, *The Jewish Faith*, London, SPCK, 1993.
80 Ernesto Laclau, 'Subject of Politics', p. 14.
81 For an account of the centrality of Anglo-Celtic-Australian culture in Australia, couched in terms of a critique of the ideology of tolerance, see Ghassan Hage, 'Locating Multiculturalism's Other: A Critique of Practical Tolerance', *New Formations*, vol. 24, 1994, pp. 19–34. See also Emma Klein, *Lost Jews: The Struggle for Identity Today*, London, Macmillan, 1996.
82 The term 'imagined community' comes from Benedict Anderson, *Imagined Communities*, London, Verso, rev. ed., 1991. Histories of the Jewish presence in Australia have been at pains to minimise the practice of anti-Semitism; see, for

example, Suzanne Rutland, *Edge of the Diaspora: Two Centuries of Jewish Settlement in Australia*, Sydney, Collins, 1988. I have argued differently in Chapter 7.

83 In Australia it is still rare to hear the phrase 'Asian–Australian'. In the United States, where the term 'Asian–American' is common, it signifies both the acceptance of the long history of 'Asian' presence in the United States and the institutionalisation of this racial fracture within the American nation-state. In Australia, the debate over 'Asians' is still couched in terms of migrants rather than in terms of a continuing presence within the Australian nation-state. This suppresses knowledge of the long-term presence of 'Asians,' most importantly, Chinese, in Australia from before Federation.

84 Sneja Gunew, *Framing Marginality*, p. 22.

85 Robert Manne, echoing Gunew, writes that 'For the Anglo-Australian cultural mainstream of the middle 1990s ethnicity frequently meant little more than costume, custom, food. Helen Demidenko performed as a stage Ukrainian for this audience by wearing embroidered peasant blouses, dancing Ukrainian dances, drinking vodka and mumbling Ukrainian phrases' (*The Culture of Forgetting: Helen Demidenko and the Holocaust*, Melbourne, Text Publishing, 1996, p. 61).

86 Freda Freiberg comments that 'The image of the Australian has to date excluded the Jew' ('Lost in Oz? Jews in the Australian Cinema', *Continuum: The Australian Journal of Media and Culture*, vol. 8 (2), 1994, p. 196).

87 Roy Rene's natal name was Harry van der Sluys. He was the son of a Dutch Jew and an English woman and was born in 1892. His life was characterised by the assimilatory ambivalence that was expressed in his comedy. He was educated at a Dominican Convent and a Christian Brothers school, he married out and ate pork, yet he had a Jewish as well as a Christian marriage ceremony and had a Jewish funeral service. See Fred Parsons, *A Man Called Mo*, Melbourne, Heinemann, 1973. For a discussion of Roy Rene, see John Docker, *Postmodernism and Popular Culture: A Cultural History*, Cambridge, Cambridge University Press, 1994.

88 Freda Freiberg, 'Lost in Oz?', p. 202.

89 For short biographies of Monash and Isaacs, as well as other well-known Jewish-Australians see Hilary Rubinstein, *The Jews in Australia*, vol. 1, 'Fruits of Freedom: Jewish Achievement and Achievers in Australia, 1788–1945'.

90 William Rubinstein, *Judaism in Australia*, Canberra, AGPS, 1995, p. 37.

91 William Rubinstein, *Judaism in Australia*, p. 43.

92 Jonathan Webber, 'Modern Jewish Identities', p. 80.

93 Jonathan Webber, 'Modern Jewish Identities', p. 81.

94 Jean-François Lyotard, *The Postmodern Explained to Children: Correspondence 1982–1985*, Sydney, Power Publications, 1992, p. 30.

95 Jean-François Lyotard, *The Postmodern*, p. 31.

96 On the problem of representing the Holocaust see Saul Friedlander (ed.), *Probing the Limits of Representation: Nazism and the 'Final Solution'*, Cambridge, Mass., Harvard University Press, 1992.

97 Shoah is a Hebrew word. Yiddish speakers have other words they use to describe the genocide. My point is that, increasingly, 'Shoah' is being identified as the politically correct 'Jewish' description. Like the transcendentalising of the Holocaust, which effectively took place in the 1970s, the driving force behind the use of the term 'Shoah' would seem to be Israel.

98 In 1994 Helen Demidenko won the prestigious *Australian* Vogel Literary Award for a novel-length manuscript by an unpublished author. As part of her prize the manuscript was subsequently published as *The Hand That Signed The Paper*,

Sydney, Allen and Unwin, 1994. The novel went on to win another important Australian literary award, the Miles Franklin, in 1995. Briefly, Demidenko's book placed the cause of Ukrainian collaboration in the Holocaust in the pre-war Jewish bolshevik treatment of the Ukrainians. The book claimed to be his-torically accurate and to be based on Demidenko's own family history. Subsequently, the book's historical accuracy has been seriously questioned. Moreover, it turned out that Demidenko did not have Ukrainian ancestry. Her parents are English migrants and her family name is Darville. It has also been alleged that parts of the book are plagiarised. The whole event caused a major scandal on a number of grounds, first and foremost the book's purported anti-Semitism.

99 Robert Manne, *The Culture of Forgetting*, p. 106.
100 Freda Freiberg, 'Lost in Oz?', p. 198.
101 Freda Freiberg, 'Lost in Oz?', p. 198.
102 Freda Freiberg, 'Lost in Oz?', p. 197.
103 *Diversity Counts* discusses the problem of ancestry as a variable in ascertaining ethnicity. It argues that it is 'a complex and subjective term which poses diffi-culties for the purposes of measuring the performance of a service. . . . On the other hand, ancestry information may identify ethnic groups (such as Kurds and Maoris) which cannot be identified using information on birthplace or language spoken' (p. 15). As I have been discussing this is precisely the problem with defining Jewish ethnicity.
104 There is, in general, a problem about whether actors of a certain ethnicity should be used to represent that ethnicity in secondary representations. This problem signals the correspondence between ethnic groups and their classification within a particular, 'white' or 'European', race. The situation with Jews is even more complex. If Jews are fully 'white' and not an ethnic group – that is marginal white – then Jewish actors can play Anglo-Celt-Australian Australians. If Jews are an ethnic group, then, playing an Anglo-Celt-Australian Australian is prob-lematic. If Jews are a race, then, of course, it is technically impossible. How, then, to read the ethnicity of a character played by a Jewish actor, for example Ben Mendelsohn's character in *Metal Skin* (1995), is problematic to say the least – if one knows that Ben Mendelsohn is Jewish! This is especially pertinent in a film such as *Metal Skin* where ethnic difference is a salient feature. (On ethnicity in Australian film see Tom O'Regan, *Australian National Cinema*, London, Routledge, 1996, pp. 306–10.)
105 In 'Asianing Australia: Notes Towards a Transnationalism in Cultural Studies', *Cultural Studies*, vol. 10 (1), 1996, pp. 16–36, Ien Ang and I argue that, 'we [can] understand postmodernity in the global context as the simultaneous success and failure of modernity in the production of a singular but deeply fractured world system. That is, the effect of the failure of the universalising project of modernity has produced a proliferation of distinctive, indiginised modernities' (p. 23).
106 Jean-François Lyotard, *The Postmodern*, p. 31.
107 Jean-François Lyotard, *Heidegger and 'the jews'*, trans. Andreas Michel and Mark S. Roberts, Minneapolis, University of Minnesota Press, 1990.
108 'Banned Historian Puts PM to the Test', *The Australian*, September 25, 1996, p. 1.
109 William Rubinstein, *Judaism in Australia*, p. 43.

9

MAKING SOCIAL SPACE FOR
JEWS IN AMERICA

Over the last decade or so, since the mid- to late 1980s, the rhetoric of 'diaspora' has become an increasingly common way of describing the movement of people from one national context to another. As I have pointed out in Chapter 5, not only is this term being used to describe recent movements of people, often more or less associated with the globalisation of capitalism, but it is also coming to be applied to earlier movements of people, especially those of the eighteenth and nineteenth centuries. I am thinking here, for example, of how the term has become popular in American Black studies since roughly the mid-1970s. Of course, there is a previous history here that connects ideas of a black diaspora with messianic movements of return like that of Marcus Garvey; however, I am thinking of the non-religious usage most evidenced in academic and political writing. In 1975 Jacob Drechler edited a book entitled *Black Homelands/Black Diaspora: Crosscurrents of the African Relationship*,[1] and in 1977 Graham Irwin's book *Africans Abroad* was subtitled *A Documentary History of the Black Diaspora in Asia, Latin America and the Caribbean during the Age of Slavery*.[2] There are now even two books entitled *The Black Diaspora*, the first published in 1989.[3] To take a differently constructed group, but one also racialised and historically excluded from the American polity, Stanford Lyman's article 'The Chinese Diaspora in America 1850–1943,' first published in 1976,[4] is most likely the first American usage of diaspora rhetoric in connection with the Chinese presence in the United States.

Over the last ten years or so, the usage of the rhetoric of diaspora has been extended from racialised groups to 'white' ethnicised ones. There is, now, an increasing reference in settler-states like Canada and Australia as well as in the United States to the 'Italian diaspora,' 'the Greek diaspora,' the 'German diaspora,' and so forth. The effect of this overall shift is that another term has tended to fall into disuse, 'migration.' Indeed more than being simply discarded, migration has come, by implication, to have a negative connotation while diaspora is valorised. While a complex theoretical apparatus has evolved around diaspora, migration tends to be thought of as a purely descriptive term. Of course it is not: as we have seen in Chapter 6, it is as highly political as diaspora. The assumption of it as being descriptive is a function of the successful

naturalisation of its application to the movements of large numbers of people over the last two hundred years or so.

At the same time, the group which has, historically, been most associated with the term 'diaspora,' the Jews, now claims to feel 'at home' in the United States and its spokespeople sometimes describe their presence in the United States as being in exile but not in diaspora. In Chapter 6 I provided a context for this with reference to the coinciding use of terms such as 'The Promised Land' by both the Puritan settlers and the Jews. Here, I want to use the example of the Jews in the United States as a focus for talking about the different politics of diaspora and migration. In addition, I will discuss how the successful initiation of the ideology of pluralism by predominantly Jewish thinkers provided a space within the American cultural order where Jews could continue to express a religio-cultural difference thus providing a civil context for Jews to feel accepted and, therefore, 'at home.' I also want to explain how, by working within the philosophical assumptions of Enlightenment political philosophy, pluralism unintentionally reinforced the exclusion of African-Americans from American society and polity.

Arriving, mostly in the half-century around 1900, the Jews were described as migrants. As we shall see, the rhetoric of migration has been developed and deployed by those with political and social control within the country and helps to distinguish this settled elite from those, not necessarily recent arrivals – indeed often people born in the country – who are considered to be, for some reason, different. It operates as an aspect of a discursive system of exlusion. So, while it appears, at first, that the rhetoric of migration is applied to everybody, what is clear is that, in fact, only members of certain groups continue to be described as migrants. It is these people, identified, as I have said, as different, who are enjoined to become 'the same as,' that is, to assimilate. However, again, as we shall see, to assimilate actually means 'to become *like*.' Implicit here is the recognition that the dominant group to whom one assimilates can continue to distinguish you as different regardless of how much you become like them. In the United States the injunction to assimilate operated in a context of social and institutional exclusivity which, in fact, has been one reason for the continued ghettoisation of American cities. In short, Anglo-American society demanded of those it classified as migrants that they assimilate culturally while excluding them, as it had always excluded African-Americans, socially and institutionally.

In the Jewish situation the irony was that, in the main, Jews did not want to assimilate completely. In the particular case of the Eastern European Jews, the Jews who spoke Yiddish and lived *Yiddishkeit*, the problem was how to negotiate cultural assimilation. I will argue that it was in this context that the ideology of pluralism was elaborated: as an interested way, by a subaltern group, to counteract the interested politics of Anglo-conformist assimilation and the ideology of the melting pot. This latter was also, in its most popularising version, the play *The Melting Pot* by the English-Jewish dramatist and novelist

Israel Zangwill, a critique of conformist assimilation while it, nevertheless, celebrated an equalitarian assimilation.

The successful naturalisation of pluralist ideology has been such that, in 1990, Seymour Martin Lipset could edit a collection entitled *American Pluralism and the Jewish Community*, in which no history of the elaboration of pluralism as an ideology for organising American social life was provided, nor, indeed, was there any acknowledgement of its connection with the Eastern European Jewish migration of the 1880s to 1920s. Rather, pluralism was naturalised as typically American.[5] One contributor, for example, Shmuel Eisenstadt, simply wrote of 'the nature of American pluralism' and asked how Jews fitted into this.[6] The point about pluralism will be to understand how it works within the same, modern, Enlightenment premises as assimilation, and, in the end, had the unforeseen consequence of enabling certain groups to be reracialised and accepted as 'white' while reinforcing 'race' as the key exclusionary marker in American society. Thus, we will also see that the Jews, like other Eastern and Southern European groups, who were racialised as migrants were, in the post-Second World War period, 'ethnicised,' and accepted as culturally different, while being at the same time whitened.[7]

In contrast, the exclusion of African-Americans, and also other racialised groups such as the Chinese, from the pluralist social order – at its limit case, the cultural preoccupation with 'racially' mixed relationships and the problem, for the dominant social class, of how to describe the progeny of such relationships 'racially' – has led to an appropriation of the rhetoric of diaspora as a subaltern rhetoric. Coupled with it there has developed the ideology of multiculturalism, an ideology which necessarily critiques the Enlightenment premises on which assimilation and pluralism were grounded because of the way the claim to individual equality allowed for another marker, 'race' most usually, to be used to signify the limits of the extension of that equality. For Jews in the United States the rise of a new radical ideology that celebrates diversity has been highly problematic. It has, as we shall see in the case of the Jewish pluralist thinker Nathan Glazer, produced a crisis of recognition as to how pluralism has worked, and how conservative it is as an ideology.

One other, Enlightenment, aspect of pluralism has been to accept the modern public and private distinction, enabling Jews to be culturally different in private while being 'assimilated' in public. Multiculturalism in the United States challenges this distinction. Thus, for instance, to take an example of Marla Brettschneider's, the American Jewish Congress, a pluralist organisation founded by Horace Kallen, the Jewish philosopher who also pioneered the ideology of pluralism, has tended to argue for the removal of Christmas decorations in this ostensibly secular country rather than for the acceptance of Hanukkah decorations.[8] Multiculturalism would argue for the latter. Jews, in other words, having tried to make themselves publicly invisible as their trade-off for acceptance into 'white' society, are now being enjoined by people such as Alan Dershowitz – who, in fact, would not regard himself as a

multiculturalist – in books like *Chutzpah*,[9] to make themselves visible, to re-establish publicly the difference that pluralism enabled them to retain, providing that it was politely, civilly, hidden.

THE RHETORICS OF DIASPORA AND MIGRATION

Why has the rhetoric of diaspora come to supplant that of migration, not just as a way of thinking about a new and different sort of movement of people, but all modern movements of peoples? The reason this supplanting is of such importance is because, as we shall see, the rhetorics of diaspora and migration are closely bound up with understandings of the forms taken by national imagined communities. In an important overview article entitled 'Diasporas' James Clifford has argued that 'In assimilationist national ideologies such as those of the United States, immigrants may experience loss and nostalgia, but only en route to a whole new home in a new place. Such ideologies are designed to integrate immigrants, not people in diaspora.'[10] Certainly the ideology of assimilation was allied to the construction of people as 'immigrants.' This construction was a function of a particular understanding of the role being given to these people, and a particular set of expectations as to how they should behave as well as being a reflection of certain assumptions held by these people. An analogous complex of social and personal assumptions informs the use of diaspora rhetoric.

In a useful brief description in the same article, Clifford provides what has become pretty much the conventional meaning of diaspora. Comparing diasporas to the notion of borderlands, he writes that 'Diasporas usually presuppose longer distances and a separation more like exile: a constitutive taboo on return, of its postponement for a remote future. Diasporas also connect multiple communities of a dispersed population.'[11] The thing to notice here, and indeed it is a crucial difference in the ideologies of migration and diaspora, is that diaspora privileges an origin over the place, the nation-state conventionally, to which the person or people has travelled, whereas migration emphasises the importance of a commitment to that new place. In ideologies of multiculturalism such as that developed in Australia, which employ the rhetoric of 'ethnic groups,' these also tend to be defined in terms of an external, usually national, origin, thus helping to legitimate the usage of diaspora rhetoric. In general, between 'migration' and 'diaspora' there is an implicit power distinction. Migration suggests an individualised subordination to the new nation-state, an individualised acceptance of a subaltern status as a trade-off for social acceptance, while diaspora suggests an assertion of group rights within the new nation-state to which the person has travelled.

If we look more closely at the changing meaning of the word itself, we find that the *OED* provides a usage of migration by Sir Thomas Browne in 1646 in

which the context suggests that the word simply means a movement (by Adam, the biblical first man) from one place to another. In 1766 Blackstone, in his *Commentaries on the Laws of England*, wrote of 'The right of migration, or sending colonies to find out new habitations.' Here the term's active sense is associated with a movement away from an origin and, interestingly, is clearly connected with the modern formation of colonies. Turning to the compound 'immigrant,' John Higham writes that

> In 1809 a traveler noted, 'Immigrant is perhaps the only new word of which the circumstances of the United States has in any degree demanded the addition to the English language.' The word materialized simultaneously with the creation of a national government. In 1789 Jedidah Morse's famous patriotic textbook, *American Geography*, mentioned the 'many immigrants from Scotland, Ireland, Germany, and some from France' who were living in New York. Paine, Crévecour and earlier writers had referred only to 'emigrants'. By 1789 our language was beginning to identify newcomers with the country that they entered rather than the one they left.[12]

The *OED* provides an earlier quotation which complements the one Higham uses from Kendall's *Travels*. Belknap in his *History of New Hampshire*, from 1792, notes, 'There is another derivation from the strict letter of the English dictionaries which is found extremely convenient in our discourses on population ... The verb *immigrate* and the nouns *immigrant* and *immigration* are used without scruple in some parts of this volume.' What is being tracked here is a very particular politicising of the rhetoric of migration. Not only is immigrate, and its cognates, a late-eighteenth-century neologism, then, but, as Higham asserts, the term comes into use in the context of the historical creation of an American national government, that is, the recognition of a national – and geographical – entity to which people can come and in which they can make their lives. We can also note here the divergence from Blackstone's use of migration in connection with the sending out and establishment of colonies. Now the thinking is more of prospective new members of a nation travelling to it.

The event, if we can call it that, which naturalised the idea of migration, and in particular its connotation of immigration, was the massive global, and more or less voluntary, movement of people in the century between 1815 and 1914. Aaron Segal, in *An Atlas of International Migration*, describes this as 'the maximum period of voluntary international migration in recorded history.'[13] He identifies migrations of over 90 million people globally. Of these, his figures have about 60 million people travelling from Europe and elsewhere to the Americas, Oceania, and South and East Africa. Higham suggests that, in the eighteenth century, roughly 450,000 mostly northern Europeans sailed for what would become the United States.[14] In the nineteenth and early

twentieth century, he states, about 50 million people arrived from Europe, broadly defined.[15]

From the 1870s there was an increasing concern to regulate migration to the United States, in particular to control Chinese migration to California. Increasingly draconian laws were passed and, in 1900, the Chinese were forbidden the right to migrate. By the time the Congressional Committee on Immigration reported in 1920, precursing the first general law restricting immigration which was passed in 1921, the focus was over the shift in pro-portions of European migrants towards Southern Europeans, especially Italians, and Eastern Europeans, in particular the large number of Eastern European, Yiddish-speaking, Jews. This concern can be traced back at least as far as 1906 when 'an Italian American had been told by a member of President Theodore Roosevelt's immigration commission that "the movement toward restriction in all its phases is directed against Jewish immigration . . ."'[16] What the Chinese and the Eastern European Jews were considered to have in common was their inability, and indeed their lack of desire, to assimilate, or, in the language of the time, 'Americanise.' For example, as Lyman tells us, 'In 1869 Henry George [in an article in the New York Tribune] opened the discussion [about the assimilability of the Chinese in American society] by insisting that the Chinese were unassimilable.'[17] Discursively, for the Chinese, this 'unassimilability' was expressed in terms of 'race.' Through the nineteenth century in the United States, as in Europe, the Jews also were increasingly racialised and claimed to be unassimilable even as they were being enjoined to assimilate. This claimed unassimilability was especially thought to be the case with the Eastern Euro-pean Jews. In a further parallel with the Chinese, these Jews were an important element in a discourse which, through the nineteenth century, orientalised European Jews more generally as it began that racialisation.

In an Appendix to the Report of the 1920 Congressional Committee on Immigration, there is a collection of paraphrases from governmental officers who had visited various European countries. These give the impression of a wave of almost sub-humans waiting to roll over the United States. While the Germans who want to immigrate 'are not of the most desirable class,' the real problem lies elsewhere:

> The great mass of aliens passing through Rotterdam at the present time are Russian Jews or Polish Jews of the usual ghetto type. Most of them are more or less directly and frankly getting out of Poland to avoid war conditions. They are filthy, un–American and often dangerous in their habits.[18]

The undesirability of Yiddish-background Jews is classified into four cate-gories: physically deficient, mentally deficient, economically undesirable and socially undesirable. In this last category we are told that 'Eighty-five to ninety percent lack any conception of patriotic or national spirit. And the majority of

this percentage is mentally incapable of acquiring it.'[19] What we can decipher from this intriguing statement is that the naturalisation of a sense of national belonging, assumed in this time on the evidence of this remark to be a natural attribute of a civilised person, was a key quality which qualified a person as a suitable immigrant to the United States. One presumes that it was thought that one's sense of national belonging, and one's patriotism, could fairly easily be morphed from a person's attachment to their country of origin to the United States as a consequence of the commitment inherent in the practice of migration to the United States. Polish Jews were disadvantaged on two grounds, then. They were considered to be 'premodern,' not least because of their synthetic combination of religion and culture, and, second, they were often considered to be 'cosmopolitan' in the negative understanding of the word that suggested that they would not give allegiance to any one nation-state because their primary allegiance was always to the 'Jewish people.'

In the early twentieth century three events occur simultaneously in the United States. First, the entry of over two-and-a-half million Eastern European Jews since the beginning of the pogroms in the Pale in 1881. Second, the upsurge in the United States of the political ideology of Anglo-conformist, assimilationist rhetoric, often called 'Americanisation.' Third, and associated with this, a new assertive American nationalism. Taken together, these three developments precipitated a fourth, increasingly overt exclusionary anti-Semitism. We can take one historical marker here from Leonard Dinnerstein who writes that 'In 1877 a prominent banker was barred as a guest from a resort hotel that had previously accepted his patronage'[20] and who remarks elsewhere that anti-Semitism 'became increasingly troublesome for Jews in the 1920s and accelerated in the 1930s and 1940s.'[21] This anti-Semitism was coupled with the racialisation of the Jews in the United States in much the same way that it was taking place in Europe. For example, Madison Grant, in *The Passing of the Great Race* (1921) claimed there to be three European races, and the Jewish race. Concerned over miscegenation, a typically American anxiety, he wrote that 'the cross between any of the three European races and a Jew is a Jew.'[22] For Grant, the Jewish race was clearly the most inferior race and his identification of mixed-race children as inevitably Jewish echoes the drop-of-blood rule for descendants of black-and-other mixed race liasions.

We have already noted Morse using the neologism 'immigrant' in 1789 after American independence. Higham also tells us that 'Morse explicitly differentiated the "immigrants" from "the original inhabitants," the Dutch and the English "settlers."'[23] Higham goes on to explain that, in all the colonies except New York, the English formed a majority:

> Theirs was the polity, the language, the pattern of work and settlement, and many of the mental habits to which the immigrants would have to adjust. To distinguish immigration from other aspects of

American history we shall have to exclude the founders of a society from the category of immigrant.[24]

Rhetorically speaking, 'settlers' precurse the establishment of the national state. They take on the connotation of being the national group before that group achieves consciousness of itself as a 'nation.' It is the elite who claim descent from 'settler' stock who are then able to designate certain other groups as 'migrants' or, more emotively, as 'immigrants' and, in a move typical of the modern nation-state, require that these 'migrants' 'assimilate' to the culture of the 'settlers,' which is naturalised as the national culture. Even in settler-states, then, and clearly in this example in the United States, there was presumed to be a primordial national group to whom immigrants would have to assimilate.

In Australia, to take another example, there was the same assumption. There, even more than in the United States, there was presumed to be a continuity of English culture – an impossibility, to be sure, given divergences over time and geographical space even discounting any effects of non-English migration. Nevertheless, so strong was the claim that Australian culture was not only distinctively Australian but also English, with the mythic justification that it descended from the pre-Federation 'British' (that is, mythically speaking, primarily English but with a significant admixture of Irish) settlers that, during the 1950s, it was assumed that while other immigrant groups, such as the Italians, would need to assimilate, the English migrants could just merge into the population. Hence, in an important sense, English, and more generally British, migrants were not considered to be immigrants. Here, again, we can see the exclusivist structure of the rhetorical differentiation between 'settler' and 'migrant.' This differentiation continues in a reworked form in the Australian version of multiculturalism where there is, on the one hand, argued to be a core, or 'mainstream,' culture which is now usually described as 'Anglo-Celtic,' signalling its settler claims, and, on the other hand, a plurality of 'ethnic groups,' as they are officially called, or, as they are also sometimes referred to, 'migrant groups.' In Australia this term is even sometimes applied to people born in the country. These groups are also tellingly described as NESBs, that is, people of Non-English Speaking Backgrounds. This term, which originated in educational discourse, has now been appropriated as another form of exclusionary designation.[25]

As the United States began increasingly aggressively to 'Americanise' its immigrants – to make them more like its settlers – it also started to generalise a hierarchical system of institutional acceptability, an exclusivist structure the pattern of which originated in the racialised exclusion of African-Americans. Within this dual organisation, Anglo-conformity did not necessarily mean that a racialised or ethnicised group would be accepted into 'white' Anglo society. In the case of the Jews, and especially the Eastern European, *Yiddishkeit*, Jews, the problem was compounded by their perceived premodern synthesis of

religion and culture which I have already mentioned as one ground for not allowing them to migrate to the United States. This, coupled with Jewish endogamy, was mirrored in Anglo-American exclusionary anti-Semitism, an anti-Semitism which suggested, among other things, that Jews would not commit to the United States and become '100 percent American.' As we shall see, in the United States especially, but in other settler-states as well, one effect of the way 'race' has been constructed as an exclusive category has been that elite exogamy with a particular group has operated as a signifier of the acceptance of that, usually migrant, group. In the United States this has more often than not entailed the identification of that group as 'white.'

Here, then we are returned to the rhetorics, and the politics, which are implied in the discourses of diaspora and migration. Where migration is associated with patriotism and an ability to identify, as an individual, with a national entity diaspora is thought of as connected with a weakening of the undesirable – from a left-wing point of view – nationalism of nation-states. Thus, for example, Arjun Appadurai, without mentioning diaspora *per se*, cites two of the figures most commonly associated with it when he argues that

> Displacement and exile, migration and terror create powerful attach-ments to ideas of homeland that seem more deeply territorial than ever. But it is also possible to detect in many of these transnations (some ethnic, some religious, some philanthropic, some militaristic) the elements of a postnational imaginary. These elements for those who wish to hasten the demise of the nation-state, for all their contradictions, require both nurture and critique.[26]

Here, migration and terror are subordinate terms supplementing the rhetoric of displacement and exile. Interestingly, in western Jewish ideological history, as I have discussed in Chapter 5, the rhetoric of diaspora came to supplant that of exile in modernity; that is to say, exile was thought of as a different experience from that of diaspora. In short, exile, *galut*, was thought of as the exile from the Promised Land, whereas diaspora refers more to the scattering of the people, and thus gives less emphasis to the Land and any notion of return, while privileging the importance of the unity and preservation of the 'Jewish people.' In today's postmodern diaspora rhetoric these two ideas are combined. In this quotation we have the radical edge of diaspora politics, the utopian idea of a progression from the modern nation-state. However, as Appadurai implies, diaspora also has a very conservative element to it.

Unlike migration which, as we have seen, emphasises a commitment as an individual to the new nation-state one enters, the postmodern usage of diaspora emphasises first an ongoing membership of a particular national group and, second, an ongoing connection of some sort with a place of origin, the originating nation-state. Hence, for example, discussion of the South Asian

diaspora conjures up an acknowledgement of cultural (dis)similarity which can also overlap with a political concern with India, or Pakistan, or Bangladesh or any of the other countries in the region, and uses this origin-site as a way to legitimate an assertion of a group's cultural difference in the countries in which these people now live. Amritjit Singh makes this point clearly when he writes that, in the United States

> The label 'South Asian' offers some of the same potential for valuable coalitions and political leverage as the term 'Asian Americans.' 'South Asians' is based on an implicit recognition that new Americans of various national backgrounds in South Asia (India, Bangladesh, Sri Lanka, Nepal, Bhutan and the Maldive Islands) and possibly others of South Asian ancestry from elsewhere in the diaspora (e.g., Fiji, East Africa, Guyana, Surinam, or Trinidad) have a common stake in how they come to terms with significant elements of homeland cultures as they grapple with their new situation in the United States.[27]

Singh goes on to write about how this South Asian grouping can work in the context of American politics and how marginalisation in the United States is 'pushing us toward some kind of homeland activism.'[28] Here we can see how the construction of a group as diasporic enables it to operate as an interest group both within the countries in which the members of the diaspora live and in relation to the country of origin. This notion of an 'origin,' which is key to recent ideological uses of diaspora, has important ramifications in aiding the legitimisation of a group within discussions that privilege a politics of identity.

In some circumstances the conservative cultural and national politics of using diaspora rhetoric are very clear. This is found, for example, in some discussions of those people who used to be known as 'overseas Chinese' but who are now appropriated by certain, nationalistic Chinese intellectuals as members of the Chinese diaspora, a term which slides easily into discussion of 'greater China' which then moves from including Taiwan, Hong Kong and Macau to incorporating Singapore and the Chinese-origin – a hugely complicated term in its own right – communities in other countries. Here, diaspora becomes a way of appropriating those 'Chinese' who, sometimes for many generations, have lived outside of 'China.'[29]

Within the United States and, indeed, other anglophone nation-states including both Great Britain and Australia, the rhetoric of diaspora synthesises with the rhetoric of multiculturalism. Tracking the philosophy of multi-culturalism in the United States back to the feminist and civil rights activism of the 1960s, Marla Brettschneider, in her Introduction to a collection of essays on Jews and multiculturalism in the United States, argues that 'multiculturalism claims that these identity-based groupings do not belong in some apolitical cultural sphere, but are politically relevant in and of themselves.'[30] She goes on to explain that

Multiculturalism does away with the pretence of a separate private sphere to which difference can be relegated by asserting that privatizing difference means privatizing real oppression and thus barring it from the public scrutiny. The feminist movement first asserted that 'the personal is political,' and multiculturalism suggests 'celebrating difference' as a mode of politics itself.[31]

In this description Brettschneider brings out well the basis of multiculturalism's challenge to modern, western democracy which was founded on the idea of individualism and on the separation of a private sphere from a public sphere. For the western European Jews of the European Enlightenment, as we have seen Moses Mendelssohn advocating in Chapter 1, this division had appeared to offer the possibility of acceptance as individuals while retaining a Jewish religio-culture in the private sphere. What the last half of the nineteenth century, and the Holocaust, demonstrated all too well was the idealism in this position – or, more correctly, the historical lack of knowledge that the nation-states of Europe would not live up to their Enlightenment-based, democratic philosophy.

ASSIMILATION AND THE MELTING POT

In Chapter 2 I discussed Zygmunt Bauman's historical identification of the use of the term 'assimilation.' He goes on to note that the majority of the sociological theory of modern assimilation has been written in reference to the Jews. As Bauman writes, this is not accidental, 'as both the assimilatory programme of modern nation-states and the responses to it on the part of the targeted population has been most fully and explicitly developed in the context of Jewish assimilatory problems.'[32] In the United States the anxiety over the failure of 'white' European groups to assimilate began towards the end of the nineteenth century and was compounded by the shift in the 'national' composition of the immigrants towards Southern and Eastern Europeans, and in particular Yiddish-cultural Jews, that we have already noted.

By the 1960s the problematic nature of assimilation as a description of the process of migrant incorporation into American society led to what is still the most sophisticated sociological discussion of the meaning of assimilation. In *Assimilation in American Life*, published in 1964, Milton Gordon distinguished seven 'Types of Assimilation.'[33] His conclusion was that, in the United States, while people tend to assimilate culturally, 'Probably the vast majority of Americans, as revealed in their choices in primary group relations and organizational affiliations, desire ethnic communality, at least in essential outline.'[34] Gordon identified the key determinants of ethnic identity as national origin, religion and race.

261

While on the one hand these variables were possible components in the individual's construction of 'self,' to use Gordon's own symbolic interactionist terminology, they can also be understood, on the other hand, as fault-lines within the national polity or, to change the metaphor, discursive sites of non-assimilation or non-assimilability. Gordon's conclusion, expressed in terms of individual desire, represses the prejudiced behaviour of members of the dominant culture, and its institutionalised social structural forms, in favour of migrant voluntarism. To return to Morse's distinction between immigrants and settlers, race, religion and national origin are the discursive sites which, in the United States over the last hundred years, have been utilised to distinguish settlers from immigrants, no matter how long and over how many generations, the 'immigrants' have been in the United States. These categories have formed the basis of the exclusionary system that I outlined earlier.

In the early years of the century a quite different ideological position had been put forward. October 5, 1908, saw the first production, in Washington, of Israel Zangwill's play, *The Melting Pot*. Now, although Zangwill was not the first person to use this metaphor, or one similar, it was Zangwill's play which established the ideology of the United States as a melting pot in contra-distinction to the assimilatory ideology of Anglo-conformity. As Werner Sollors puts it: 'Zangwill's play was a point of demarcation as it opened the floodgates for melting-pot rhetoric.'[35] The reasons for this are many. For one, the ideology of the melting pot appealed to a national culture that saw itself as the proponent of egalitarianism, and individualist freedom, while, at the same time, the metaphor is vague enough to be appropriable for assimilationist purposes. If we ask, as we should, why the metaphor became so popular in the period after Zangwill's play, the answer is that its very looseness of meaning provides a way of harmonising the interests of migrants and their descendants with those of the Anglo-conformist dominant elite. The early years of the twentieth century were, as we have seen, both a period of massive immigration, in particular of Eastern European Jews who did not want to lose their religio-cultural heritage, and a time of great concern with Americanisation. Zangwill's play is both conservative and utopian. He saw the United States as the quint-essential modern nation and produced a play in which what was advocated was the construction of a unitary American people, united in a new 'race' and a new, distinctively American, culture but a culture to which migrants could contribute elements, even if this was in the sense of these being picked up by people from other backgrounds, not one where they would have to leave behind their own traditions.

The play centres on the relationship between David Quixano and Vera Revendal. David has migrated to New York with his uncle and his uncle's mother. The family is Jewish. They have fled the pogroms in Russia which claimed David's immediate family. Vera, it turns out, also has a Russian back-ground. It is subsequently revealed that Vera's father, the Baron, encouraged the pogrom in which David's family was killed. However, in this New World,

love triumphs for the new generation over the enmities of the Old World. At the end David is looking over the rooftops of New York into the sunset. He makes a rousing speech which begins:

> It is the fires of God round his Crucible. There she lies, the Great Melting Pot — listen! Can't you hear the roaring and the bubbling? There gapes her mouth — the harbour where a thousand mammoth feeders come from the ends of the world to pour in their human freight. Ah, what a stirring and a seething! Celt and Latin, Slav and Teuton, Greek and Syrian — black and yellow.[36]

The first thing to remember here is that Zangwill was an English Jew, not American. Zangwill sees the United States as the product of immigration and he accepts the process of social amalgamation implicit in the ideology of assimilation but rejects the power relation inherent in the nineteenth-century assertion that minority groups should give up their identity and take on the dominant national culture. This, of course had been what had been asked of the Jews in the evolving European nation-states. Zangwill's solution was an intermingling of cultures on an equal basis. As he puts it in his Afterword, published in 1922: 'The process of American amalgamation is not assimilation or simple surrender to the dominant type, as is popularly supposed, but an all-round give-and-take by which the final type may be enriched or impoverished.'[37] Zangwill states that he chose a Jew as one of his main characters because 'The Jewish immigrant is . . . the toughest of all the white elements that have been poured into the American crucible, the race having, by its unique experience of several thousand years of exposure to alien majorities, developed a salamandrine power of survival.'[38] This may have been his conscious reason but the play reads as an assertion of Jewish power — that is, the right to be treated equally, in the Enlightenment sense — in a settler-state, where, from Zangwill's English and outsider perspective, every group should have the right to participate in the production of a new culture and, by virtue of intermarriage, 'a new race.'[39] Here Zangwill is, of course, using the term to identify the establishment of a distinctive national people.

It is important to note that Zangwill's utopian image of the new American 'race' extends to racial intermarriage. In what, for its time in England, was a remarkable position to espouse, and extraordinary in the context of the race-obsessed United States, where the use of 'race' as the key marker of exclusion was most profoundly expressed in the state laws forbidding racial intermarriage, only finally overturned by the Supreme Court in 1967,[40] Zangwill writes:

> No doubt there is an instinctive antipathy which tends to keep the white man free from black blood, though this antipathy having been overcome by a large minority in all the many periods and all the many countries of their contiguity, it is equally certain that there are at work

forces of attraction as well as of repulsion, and that even upon the negro the 'Melting Pot' of America will not fail to act in a measure as it has acted upon the Red Indian, who has found it almost facile to mate with his white neighbours as with his black.[41]

In this way, Zangwill's assimilatory melting pot was more radical than the ideology of pluralism. For Zangwill, everything could be melted together where the pluralists, echoing the Jewish preoccupation with endogamy, emphasised a separation which, with unfortunate consequences, mapped onto the more extreme racial endogamy of 'white' American national practice.

It is worth pausing here for a moment to consider the historical American preoccupation with interracial, especially 'black' and 'white,' sexual relations. Robert Young reminds us that the term 'miscegenation,' to describe inter-racial sexual unions, was invented in 1864.[42] From the outset it had a negative connotation. Young also tells us that

> the debates about theories of race in the nineteenth century, by settling on the possibility or impossibility of hybridity, focussed explicitly on the issue of sexuality and of sexual unions between whites and blacks. Theories of race were thus also covert theories of desire.[43]

In the United States, perhaps more than anywhere else except apartheid South Africa, this preoccupation was transformed into an official policing of the racial, sexual boundaries. Having distinguished membership of the 'black' and 'white,' and other, 'races' in the United States, the descendants of mixed-race liaisons would have – and do – problematised the use of 'race' as an exclusivist national marker, a marker first of all of who was allowed to be a member of the nation and, second, of a person's place in the racialised hierarchy of American civil acceptability. This modern usage of 'race' sits in uneasy conjunction with the premodern, Jewish concern with endogamy.

Zangwill's image of egalitarian assimilation was, however, easily recuperable. Then-President Theodore Roosevelt was so excited by Zangwill's play that he gave Zangwill permission to dedicate it to him. Nevertheless, 'Roosevelt, while viewing America as a nation in which "the representation of many old-world races are being fused together into a new type," maintained at the same time that "the crucible in which all the new types are melted into one was shaped from 1776 to 1789, and our nationality was definitely fused in all its essentials by the men of Washington's day."'[44] We are, then, returned again to the distinction between settlers and immigrants, and to an assertion of a melting pot in which immigrants assimilate to Anglo-conformity.

THE IDEOLOGY OF PLURALISM IN THE UNITED STATES

While the rhetorics of migration and assimilation have historically operated within the ideology which privileged a racially, and culturally, homogeneous nation-state, Jewish migrants, more than most, resisted this, and, indeed, promoted a counter-ideology, pluralism, to legitimate their and others' resistance, and their right to preserve their own religio-cultural practices. As we shall see, the politics of pluralism, especially where the Jews are concerned, have been much more complex than this, though. Sollors' justifiably highly respected account of the debates over how the American national polity should be constituted, *Beyond Ethnicity*,[45] tends not to deal with pluralism as such. This is for two reasons. First, his methodological schema, the binary opposition of consent and descent, leaves little room for the struggle to image an America of groups bound together by consent but distinguished by descent − to put it crudely. But second, and much more important, Sollors' tendency to work primarily with texts, and not their social contexts, leads him to pay too little attention to the power relations involved in the ideologies that he discusses. Thus, for example, Judah Magnes's and Horace Kallen's proposing of pluralism might better be understood as a tactical move by members of a subaltern group. Nor does Sollors discuss how ideologies of assimilationist conformism, including conservative versions of the melting pot, operated in tandem with exclusivist classificatory discourses, most obviously 'race,' to keep certain groups in power while culturally homogenising the nation.

Appadurai has remarked that he believes that pluralism

> is a twentieth-century idea, not really part of the founding principles of the United States. It is a co-optative reaction to the great migrations from Europe of the late nineteenth and early twentieth century, and the fact that it has since become a central aspect of American society, civics, and political science is one of the interesting puzzles of the cultural history of this century.[46]

He is mistaken. The elaboration of the philosophy of pluralism was not a co-optative enterprise at all. Indeed, pluralism was a reaction to the Anglo-conformist Americanisation movement of the early years of this century. At that time, as Higham writes, 'Among many white Protestants, a host of tensions and frustrations came together to produce a broadly exclusionist spirit, which proponents sometimes labeled "100 percent Americanism."'[47] Central to this idea was the formation of a broadly homogeneous national society that was both 'white' and founded in a single range of values, with the implication that these values would be the foundation of a shared American culture.[48]

It should come as no surprise, then, to discover that the parameters for the debate over cultural pluralism in the United States were principally set by

Jewish thinkers. This time was, not coincidentally, also a period when a concern with the formation of an Anglo-conformist homogeneous national culture coincided with an upsurge in anti-Semitism. The most public example of this was the lynching, in Atlanta, Georgia, of Leo Frank in 1913[49] and the rise of the Ku Klux Klan with their anti-Semitic and anti-Black agenda.[50] In the United States, as in nineteenth-century Europe, the rise of modern anti-Semitism was linked with the perception that the Jews, as a group – possibly even a 'race' – within the polity, threatened its national unity.[51]

In *The International Jew*, the anti-Semitic collection of articles first published in *The Dearborn Independent* under the patronage of Henry Ford during the 1920s, there is one article entitled 'Victims, or Persecutors.' Within it there is a section entitled 'Jews Object to "Americanism."' Here we are told that

> To 'Americanize' means, in our ordinary approach, to bring into sympathy with the traditions and institutions of the United States. . . . It would probably give a wrong slant to the fact to say that the Jewish leaders are wholly anti-America, but it is true to say that they are against the 'Americanization' of the Jewish immigrant stream. That is, that the trend of 'Americanism' is so different from the trend of 'Judaism' that the two are in conflict. This does not indicate treason toward American nationalism, perhaps, so much as it indicates loyalty toward Jewish nationalism.[52]

The tone, here, is remarkably moderate compared to many statements in the collection. At the same time, the argument is clear: the Jews are a people and they give their allegiance to the Jewish nation; because of this, they refuse to accept American culture and values – 'traditions and institutions' – and, therefore, it is implied, and stated more explicitly elsewhere, they threaten the integrity of the American nation. Ford's anti-Semitism was the corollary of his Rooseveltian form of melting-pot assimilationist Americanism. I am thinking here, for example, of Ford's Ford Motor Company English School Melting Pot rituals instituted in 1916 in which migrant employees acted out a melting-pot symbolism to become New Americans.[53]

The philosophy of pluralism, then, may best be understood as a minority group's attempt to influence the hegemonic and totalising national ideology, an attempt to legitimate the rights of minority groups. Of much importance was the work of the Rabbi Judah Magnes, for example his sermon criticising Zangwill's play *The Melting Pot*, delivered on October 9, 1909 and subsequently published in an American-Jewish magazine;[54] more significant, however, because it was more widely read, was the work of Horace Kallen published in book form as *Culture and Democracy in the United States* in 1924, but appearing as articles in journals during the previous decade. It was Kallen who popularised the term 'cultural pluralism.' Even Randolph Bourne, who came from a Puritan New England background, and who, in his essay 'Trans-National America,' first

published in *Atlantic Monthly* in 1916, advocated a more syncretic, cosmopolitan pluralism than Kallen's, acknowledged that his inspiration came from Kallen's essays. Moreover, in a public lecture delivered that same year to the Harvard Menorah Society, founded as it happens by Kallen, Bourne remarks that 'the very phrase "transnationalism," I stole from a Jewish college mate of mine.'[55]

In *Post-Ethnic America*, David Hollinger contrasts the pluralist positions of Kallen and Bourne. The latter, he writes

> celebrated the deprovincializing effect of immigrants on the native-born population and hailed a new 'cosmopolitan' America as superior to the more homogenous societies left behind by the immigrants. . . . For Bourne, cosmopolitanism implied strength and resilience rather than lack of deep character. Cosmopolitans engaged a world the complexity of which rendered provincial tastes and skills inadequate and uninspiring.[56]

Hollinger plays up Bourne's emphasis on the immigrants' preservation of their cultural traditions, a preservation which has meant that the United States has, in Bourne's words, 'achieved . . . a cosmopolitan federation of national colonies, of foreign cultures, from which the sting of devastating competition has been removed.'[57] Hollinger's preference is for Bourne's vision of pluralism over Kallen's and in certain ways Bourne's pluralism prefigures the diaspora and multiculturalism rhetoric of the 1990s, especially in its positive understanding of cosmopolitanism as an answer to the problems caused by nationalism. We should remember, here, that Bourne was writing in the United States, looking at a Europe being devastated by war.

Bourne, himself, was critiquing the assimilatory rhetoric of melting pot ideology and the Americanisation rhetoric associated with it. For example, he writes that 'We act as if we wanted Americanization to take place only on our own terms, and not by the consent of the governed.'[58] Sollors notes that 'the cosmopolitan dual citizens Bourne envisioned were described in clear melting-pot language.'[59] The version of the melting pot Bourne is criticising here is much more Roosevelt's Anglo-conformist revision than the representation put forward by Zangwill.

Kallen's preoccupation was with the development of a national ideology that would make acceptable the preservation of group difference within the United States. Hollinger describes Kallen as making a 'conservative mistake . . . [in] wanting to reduce the United States to an administrative canopy under which a variety of old-world clans could perpetuate themselves,'[60] and certainly Kallen's pluralism is not dynamic. His concern with group preservation rather than productive interrelation suggests a particularly Jewish preoccupation. Nevertheless, as Hollinger acknowledges, Bourne also celebrated a non-hybridising pluralism, criticising the 'half-breeds who retain their foreign

names but have lost their foreign savor.'[61] Implicit here is a fantasy of the exotic. It is Bourne's progressive communitarian transnationalism which appeals to Hollinger who, himself, advocates an unsettling and devaluing of the categories of 'race' and 'ethnicity' which, as we have seen, have been so central to the formation of the American nation.

For now, we can note another similarity of Bourne's work with Kallen's. It makes no mention of the 'black' race. At the same time, in 'Toward a Transnational America,' his lecture to the Harvard Menorah Society which I have already mentioned, Bourne says: 'To the Orthodox Jew, I presume the ideas clustering about the founding of Zion will seem only the realization of age-long Jewish hopes. To me they represent an international idealism almost perilously new.'[62] Here, Bourne reworks the modern, negative image of Jewish cosmopolitanism, of which we have already come across a version in Ford's anti-Semitic *The International Jew*, explaining it as the basis for his own view. Thinking in terms of a cultural Zionism – he must be referring to the ideas of Ahad Ha'am – Bourne writes of his own utopian 'co-operative Americanism' which is 'an ideal of a freely mingling society of peoples of very different racial and cultural antecedents, with a common political allegiance and common social ends but with free and distinctive cultural allegiances which may be placed anywhere in the world they like.'[63] Here 'race' sneaks in but, given that earlier Bourne notes that 'The Jews have lost their distinction of being a peculiar people. Dispersion is now the lot of every race,'[64] it must be in connection with the Jews rather than African-Americans. Here, then, the Jews are not-quite-white, in some way racially distinct but acceptable within 'white' society. We should remember that the advantage that the racialised Jews had over other racialised groups in American society is that Jews were not, in the main, thought of in terms of colour. Hence, it was easier for them than for other groups to be incorporated into the 'white' category.

Magnes's and Kallen's pluralism presupposes a political, national public sphere, indeed a civil society, to which all individuals have equal access and in which everybody has equal rights. American multiculturalism, as described by Brettschneider, is founded on a recognition that the public sphere is riven by power and prejudice which operates against groups and against individuals who are marked either 'racially,' or in other ways, as members of particular groups. To put it another way, if 'race' has historically marked the equalitarian divide in American civil society, then pluralism has always implicitly accepted that divide because its presumption of equality between the different groups who make up the civil society makes it blind to that divide.

The sticking point for Kallen's version of pluralism, as Higham points out, 'becomes obvious once we ask what role it assigned to the "Negro."'[65] The short answer is, none. 'Kallen,' Higham explains, 'carefully evaded the problem.'[66] He goes on: 'Although he purported to write about the group life of all of the "American peoples," he drew his examples and arguments exclusively from the experience of European immigrants, particularly Jews.'[67] Only once

does Kallen make clear that he is not discussing 'the influence of the negro. This is at once too considerable and too recondite in its processes for casual mention. It requires separate analysis.'[68] Higham sums up his argument by writing that 'The pluralist thesis from the outset was encapsulated in white ethnocentrism.'[69] Never coming to grips with the circumstances of African-Americans, or indeed other racialised groups at a time when racial difference was taken as a marker of irreconcilable cultural difference, Kallen's version of pluralism harmonised with both the racialist philosophies of separatism and the later one of integration.

For many, if not most, advocates of integration, it was based on the philosophy of value-based assimilation which could, nevertheless, like Kallen's version of pluralism, preserve a distinction between groups. Nathan Glazer who, in *We Are All Multiculturalists Now*, comes over as a nostalgic pluralist and reluctant liberal multiculturalist, writes that 'At one time black leaders wanted exactly what existed for whites: assimilation into American society, culture, economy and polity. That was, after all, the aim of school desegregation.'[70] Ironically, it was the contradiction that integration emphasised assimilation while preserving the dominant, 'white,' preoccupation with racial exclusivity which ultimately highlighted the exclusionary nature of Kallen's cultural pluralism. Indeed, it is the very absence of a consideration of race from Kallen's work which, after the integrationist changes effected by the Civil Rights movement, led to the shift from an ideology of pluralism to the distinctly American version of an originally race-based multiculturalism.

On the other side of the coin, arguments by Kallen and those who followed after him, led to a revision of the understanding of 'whiteness' which presumed a shared normative value system while allowing a variety of cultural diversity. Here we have the basis for a preoccupation with the distinction between acculturation and assimilation. Here, also, we have the understanding which has led to the notion of an acceptable ethnic – for which read cultural – diversity within the 'white,' now reclassified as 'European,' community within the United States.

Glazer notes that, in a multiculturalist, required course at the University of California, Berkeley, 'Europeans were added to the African Americans, Hispanics, Asian Americans, and Native Americans on the list of groups that could serve to fulfill the requirements of the course.'[71] He goes on to write that 'What was lost in that victory was any distinctions among the Europeans, some of whom had earlier been dominant, and some of whom had been subordinate.'[72] Ethnicity in the United States was an aspect of the rhetoric of pluralism but it was 'race' that was first privileged in the ideology of multi-culturalism.

With the recognition that the claimed underlying value-system of cultural pluralism was 'white,' or 'European,' the evolution of a more racially based multiculturalism, ethnic identity, at least at first, got resumed under racial identity. From a Jewish point of view, the irony here was that the very success

of the ideology of cultural pluralism, and the corresponding positioning of Jews
– taken here as an unproblematically homogeneous category, which they are
not – within the pluralist spectrum helped to get them ambivalently accepted
through the 1950s and 1960s as 'white' and thus excluded, in the first instance,
from the 'racial' diversity of multiculturalism.

If pluralism was the philosophy of Jewish group acceptance in the modern
world of democratic individualism, multiculturalism in its American form
might be described as the postmodern consequence of the disillusionment with
that philosophy. In this way multiculturalism breaks with the traditional
political order of the United States which, in the Constitution, espouses the
Enlightenment philosophy of equality while in social life has established a
hierarchy of acceptabilities.

MULTICULTURALISM AND 'RACE'

Multiculturalism affirms a connection with the rhetoric of diaspora. By
asserting the non-'local' origins of the minoritised groups, diaspora rhetoric
provides a cultural *locus* for these groups outside of the political and cultural
national organisation of the United States. It therefore provides a site for
identification and solidarity which exists literally outside of the classificatory
system of American society. In *Post-Ethnic America*, Hollinger describes what he
calls 'Haley's Choice.' How, in the United States, Alex Haley had no choice
when he decided, in his 1976 book *Roots*, to track his father's 'black' history to
Gambia rather than his mother's 'white' history to Ireland because of the way
the United States structures the racialisation of its people.[73] There is another
point to be made though. The extraordinary popularity of Haley's book in the
United States was founded in its unselfconscious syncretising and precursing
of the two ideological positions, diaspora and multiculturalism, which would
become, separately, so important to the intellectual and political left in the
United States a decade or so later.

The diasporic association with multiculturalism is mirrored in the antago-
nism that diaspora rhetoric has to assimilation. Here, for example, is Singh again:

> Possibilities of connection and coalition with other Americans of color
> are lost, for instance, in the vestigial colonial ventriloquism of Dinesh
> D'Souza and the celebratory assimilationism of Bharati Mukherjee. In
> a novel like *Jasmine* and writerly statements such as 'Immigrant
> Writing: Give Us Your Maximalists!' Mukherjee's cheerful, forward-
> looking attitude towards the possibilities of assimilation is achieved
> through a reductive and stereotypical representation of South
> Asian realities, a fantastic view of human psychology and individual
> consciousness, and debatable generalizations about immigrant and
> expatriate writing.[74]

Here, the argument is that assimilation is impossible, that it is a fantasy of the dominant culture. Of course, assimilation was a central tenet of the nineteenth-century European nation-state. Writing about the situation of the Jews in respect of the post-1970s celebration of cultural diversity, Alain Finkielkraut comments on 'a revolutionary cultural shift: anti-Semitic discourse and the discourse of assimilation are no longer opposed – their status for more than two centuries – but have been merged into one.'[75] Where it was previously anti-Semitic to argue that Jews could not, or would not, assimilate, now with the new acceptance of cultural diversity, there is a groundswell of anti-Semitism in some quarters – for example, remarks of Louis Farrakhan in the United States – that sees Jews not as a distinct cultural grouping but as integral extensions of the 'white,' Anglo-conformist social and cultural order. With the new, multicultural emphasis on the public display of cultural diversity, postmodern anti-Semitism now tends to come from subaltern groups and is expressed in terms of Jewish acceptance, and assimilation, into 'white' society, claiming that Jews are now a part of the 'white' elite.

The nation-state form of social organisation was founded on the presumption of a unitary 'race' – this term included as we saw when I discussed Zangwill's play *The Melting Pot*, the notion of a national 'race.' And this unitary race was the foundation of a unitary culture. The catch here, which is elided in assimilation-thinking, was that those desired as the national people were *always already* supposed to have a common culture. Thus, the production of a common culture, the expression of the fantasmatic imagined community in which the nation expressed itself, through such means as a common educational system and national mass media, was presumed to be telling the people what they already knew but of which they had not yet become self-conscious. Those other people who were *not* a part of the national people would not always already have that common knowledge. The point, here, is that, definitionally, assimilation presupposes its own impossibility. This, again, is what the assimilated Jews of Germany, however one defines assimilation here, whether in political, cultural or religious senses found out during the 1930s. Certainly, this is, in practice, because assimilation always takes place on the terms of the dominant (national) culture but it is also because the process of assimilation assumes a person's ambiguous external status to the ideally monocultural, and historically monoracial, national polity. We can illustrate this point by looking again at the United States.

In the United States, Gordon has argued that 'It is quite likely that "Anglo-conformity" in its more moderate forms has been, however explicit its formulation, the most prevalent ideology of assimilation in America throughout the nation's history.'[76] In what we can now recognise as a telling phrase Gordon writes that '"Anglo-conformity" is really a broad "umbrella" term which may be used to cover a variety of viewpoints about assimilation and immigration.'[77] It is within this context that Higham notes that 'To speak of assimilation as a problem in nineteenth-century America is, in an important

sense, to indulge in an anachronism.'[78] He goes on: 'For European peoples it was thought to be the natural, almost inevitable outcome of life in America. For other races assimilation was believed to be largely unattainable and therefore not a source of concern.'[79] One reason for this simple understanding of assimilation was that, as I have already noted, the very ideology of assimilation was itself a novel, nineteenth-century phenomenon. In the United States, the same biological, racial reductionism was operating as was to form later the basis for Australia's White Australia policy in the immediate aftermath of Australian federation in 1901. The assumption being that people of the same 'race' had cultures that were so fundamentally compatible – a compatibility usually expressed in moral terms – that assimilation would easily take place. Here we have a context for the importance of 'race' as the basis for the exclusionary social classificatory system in the United States.

Gordon's book was published in 1964. In it he took the classic liberal, if not pluralist, line and argued that

> The struggle to eliminate racial and religious prejudice and discrimination from American life – a struggle, the unequivocal rightness of which, sociologically and ideologically, this volume takes for granted – goes on against the underlying social reality of ethnic communality tenaciously maintaining itself in an industrial urbanized society. We have described the nature of this ethnic communality as, basically, structural pluralism accompanied by an ever-decreasing degree of cultural pluralism.[80]

Gordon's very typically Jewish attack on racial and religious prejudice is set against the cultural assimilation – deculturation or acculturation depending on your perspective – of migrants' descendants. Of course, this syndrome is by no means uniquely Jewish but, in the American context of the massive Eastern European Jewish migration of the forty years between 1881 and 1923, it is very much the Jewish experience of the 1950s.

When Gordon distinguishes structural pluralism, by which he means a communal distinctiveness founded ultimately on endogamy but including a wide variety of 'social,' institutional, forms, from cultural pluralism he is describing in general terms what he has already outlined as the situation of the descendants of the Eastern European Jews. Here, he writes, 'The acculturation process . . . has drastically modified American Jewish life in the direction of adaptation to American middle-class values, while it has not by any means "dissolved" the group in a structural sense.'[81] There is, then, acculturation without assimilation.

Nine years earlier, in 1955, Will Herberg, another Jewish writer, had argued in a book that reworked a 1944 argument by Ruby Jo Reeves Kennedy, that the United States was really a triple melting pot based on religious difference rather than a single one. For Herberg in *Protestant-Catholic-Jew*, it is the third

generation for whom, 'it seemed obvious that ethnic separateness cannot and should not be perpetuated.'[82] The idea of the importance of the third generation comes from Marcus Hansen's 'The Problem of the Third Generation Immigrant.' Hansen's essay was first published in 1938. In it, Hansen argues that the third-generation children of immigrants recover as history what the second generation seeks to forget of the culture of the first in order to assimilate. Hansen's essay was republished as 'The Third Generation in America' in the Jewish journal *Commentary* in 1952. The significance of this year is that it is at this time that the second generation of descendants of Eastern European Jews was in full adulthood and the third generation was coming to adulthood. In this same year Mark Zborowski and Elizabeth Herzog published their highly nostalgic and romanticised historical ethnography of *shtetl* life in the Pale, *Life Is With People*. Oscar Handlin, who wrote the Introduction for the *Commentary* version of Hansen's article, wants Jews to take Hansen's article as a warning and,

> to turn to the possible ways in which the Jewish group in America is, after all, exceptional and distinctive, and to consider whether, to what degree, and how American Jews, who are as alive to the traditional aspiration to carry forward their unique identity as any group in history, can hope to escape the complete amalgamation which Hansen seems to predict.[83]

In other words, Handlin sensed the problem asserted by Herberg three years later and wanted the Jews to learn from Hansen's work and use it to help preserve their group identity in spite of the Anglo-conformist assimilatory pressures of American society. The publication of *Life Is With People*, implied one solution. It reworked *shtetl* life through a very American celebration of the rural small town, the local, and self-help, and offered a narrative that satisfied the tenets of cultural pluralism while being socially assimilatory, that is, it shared dominant American norms, while acknowledging cultural difference.

For Herberg, what remains by the third generation is religion. He tells a story about the uniqueness of the Yiddish Jews, as compared to, for example, Italian and Polish migrants. Herberg argues that, unlike these other groups, 'Jew' has historically referred to a member of the ethnic group and has also expressed religious affiliation. Consequently, the third generation, in returning to the religion, in addition returns to the culture imbricated with that religion.[84] The tremendous popularity of *Life Is With People* – it has been continuously in print since it was published and, only in 1995, was it reissued with a new introduction by Barbara Kirshenblatt-Gimblet discussing its romantic construction of *shtetl* life as a pre-industrial, pre-Holocaust, in fact premodern, Jewish organic community – can be read as attesting to this 'return' to a utopian past geographically, temporally and emotionally distant.

Herberg's major point about the Jews, however, is that the variety of religio-culturally distinct sub-groups who live in the United States have, by the third generation, amalgamated into a single Jewish-American community. Here, the reference group are the Eastern European migrants and, indeed, in Herberg's narrative, it is this 'strain,' as he puts it, that has become predominant.[85] The Jews, then, have their own melting pot in which minority groups have been assimilated into a gradually Americanised *Yiddishkeit*. Herberg's image of a religious pluralism is able to account for, and eliminate, the cultural diversity within Jewish 'ethnicity' in a way that Kallen never confronted. In the 1990s, as an aspect of generational change among other developments, there has been a renaissance of interest in Yiddish and *Yiddishkeit* among 'generally disenchanted assimilated Jews who are looking for something more appealing, perhaps more "authentic", than Zionism or personal identification with the Holocaust.'[86] Here, if Herberg were describing a version of a cultural pluralist ideal, we have an American multicultural shift to a politics of identity and diaspora. This is coupled with a fragmenting of any unified Jewish-American cultural identity.

Like Kallen, Herberg's religious pluralism, which, of course, leaves Jews as a separate group having only melted Jews together with Jews, is fundamentally 'white.' As Herberg reflects in a note:

> Two major groups stand measurably outside this division of American society into three 'melting pots' – the Negroes and the recent Latin-American immigrants. . . . Ethnic amalgamation within the religious community does not yet include them to any appreciable extent; their primary context of self-identification and social location remains their ethnic or 'racial' group.[87]

Once again 'race' provides the limit for the discussion of the formation of American society, and once again Jews are identified as part of the 'white' social order. This time, in Enlightenment fashion, it is their religion which marks their acceptable difference within American society.

At bottom, aside for a moment from the issue of 'race,' there is an irony which runs through this interested assertion of cultural, religious, and structural pluralism in the context of political and politico-cultural assimilation. This is that the policy of Anglo-conformity, asserted by the dominant Anglo-American core population to the non-Anglo population defined, in this divide, as 'migrants' if they are considered 'white' and therefore acceptably different or otherwise by 'race' – and increasingly since the late 1960s changes in the immigration laws as both migrants and racially distinct – has simultaneously been associated with a systematic exclusionary structure, from clubs, hotels, managerial levels in elite firms, entry to a wide variety of professions, and so forth. Within this context the Jewish move from Magnes to Gordon was to assert their racial inclusion in the primary denominating category of 'white,'

to champion equal rights generally, regardless of 'race,' thus challenging the Anglo-American exclusionary structure, while also championing a form of pluralism, whether that be cultural, religious, or structural. Thus, Gordon can criticise American prejudice and discrimination practised through structural means, while acknowledging the preservation of ethnic groups' identification through often-similar means.

In *We Are All Multiculturalists Now*, Glazer provides a critique of his earlier attack on affirmative action, *Affirmative Discrimination* (1975). He argues that he was misled into thinking of American history as progressively more inclusive and more emphasising of equality. He goes on:

> These days critics of this argument [his attack on affirmative action], would probably note, if they were unkind enough, that my three chief authorities were a child of immigrants, a refugee, and an Israeli, all Jews, who understandably might take this generous view of the course and aims of American history (as I, the child of Jewish immigrants would too).[88]

What does Glazer mean by his remark about critics being unkind in noting that all his major authorities were Jewish: Seymour Martin Lipset, Hans Kohn, Yehoshua Arieli? Perhaps it is the anxiety of the shift from a tactical universalism which disguises the interests of specific groups, and which has been a traditional aspect of the Enlightenment understanding of the role of the public sphere in which power relations were supposed to be absent and all individuals (*sic*) were supposed to have equal possibility of access, to the more recent politics of identity, which have been allied with multiculturalism, and the recognition of the importance of speaking positions. More likely it is the recognition that all three writers are members of the group which has been most successful in its institutional assimilation into Anglo-American society. Glazer's acknowledgement recognises how Jewish acceptance into a broadened Anglo-American society has misled Jewish thinkers into a Whiggish view of Anglo-American society in which any other group will also soon find themselves accepted via a combination of acculturation and Anglo-American accommodation.

Glazer's sense of shock at his discovery of the exclusion of African-Americans from the pluralist America which now includes Jews is palpable. For example, he writes with apparent surprise that 'Multiculturalism is the price America is now paying for its inability or unwillingness to incorporate into its society African Americans, in the same way and to the same degree it has incorporated so many groups.'[89] It is this shock which points us to the failure of the pluralist ideology to take account of the role of 'race' in American society and its use in the Anglo-American, 'white,' classificatory and exclusionary system. Glazer's solution to the problem he now appreciates is explicitly to take on board Hollinger's post-ethnicity argument, writing, 'Let us have

respect for identity in the context of a common culture, but let us avoid the fixing of lines of division on ethnic and racial bases.' And, he adds, 'ethnic and racial affiliation should be as voluntary as religious affiliation.'[90] The incorporation of African-Americans into a post-pluralist, that is multicultural, ideology of diversity requires, it would seem, the disestablishment of that category, 'race,' which previously excluded them while providing a platform for the inclusion of Jews. Such a disestablishment might help the transformation of the modern exclusivist nation-state of the United States into a postmodern inclusivist state but, if it is not allied to a recognition of the damage done to those classified as 'black' then it can once again become a self-serving move by those in powerful positions within the state.

It is, in fact, 'race,' and specifically the 'black' race, which has been the excluded excess in the pluralist ideology in which Jews were deracialised as a people in their own right and reracialised as an ethnic group within the 'white' race. In this context, and to reprise an earlier argument in this chapter, it was the very presence of African-Americans in the United States, creating the problem from the outset of how to establish, in the discourse of the time, a nation with a unified 'race' and, therefore, culture, which distracted concern from the Jews, the group which, especially as Othered into 'the jews', had caused the most problems in Europe in this regard for the nascent nation-states. At the same time, the desire by some American Jews to become a publicly visible and recognisable group within a multicultural United States also offers the possibility of a reracialisation of the Jews as a 'race' in their own right where their earlier deracialisation had been aided by an effacement of public difference. It is in this circumstance, the twin problematics of 'race' and public visibility as 'different,' in which the perception of a visible physical difference is informed by, and informs, the perception of cultural difference, a circumstance the politics of which are now utterly transformed by the new radical politics of multiculturalism, that African-Americans and Jews remain yoked together in the American cultural imaginary.

Pluralism, then, operated within the same Enlightenment logic as assimilation. In turn, we can now recognise how it also accepted, implicitly and albeit critically, the modern settler-state distinction between settlers and migrants, between those who claim a right to decide the national culture and those excluded from it, and often from the political order as well. Migrants were not all racialised, but those who were were deemed unassimilable. The achievement of the Eastern European Jews in the United States was to have themselves more or less deracialised – or rather, inclusively reracialised as 'white' – which enabled them, by way of the promotion of the pluralist ideology, to preserve a degree of religio-cultural difference, at least in the private sphere. The failing of this achievement was not in respect of the Jews, but of those unable to take advantage of pluralism because they were unable to get their racial status transformed. Jews were never properly racialised by colour, the dominant mode of racialisation in the United States, and indeed in the west more generally

– though we should remember that, like the Irish, Eastern European Jews were, at one time, considered to be 'black.'[91] The crucial problem with pluralism in this regard was that it didn't challenge the use of 'race' as a marker of exclusive national difference – indeed it didn't challenge the use of any exclusivist markers.

The politics of multiculturalism, in its American version, has allowed for a highlighting of the ways that 'race' has been imbricated with the power relations that have established the dominant national culture in the United States. With specific reference to African-Americans, the rhetoric of diaspora has been a significant force in legitimating their presence within the American national polity as a distinct cultural, rather than simply racialised, group. It has also served to give African-Americans, and other racialised and excluded groups, a legitimacy that is drawn from outside the United States rather than one dependent on the interests of the dominant, 'white' cultural and political elite. Of course, as I have noted, the uses of diaspora rhetoric are not limited to the ones I have just outlined; however it is these that I wish to emphasise at the end, here. The rhetoric of diaspora has, then, operated in tandem with multiculturalism to disturb, and displace, the Enlightenment categories which the Jewish migrants of the late nineteenth and early twentieth centuries, and their descendants, understandably accepted and within which they worked to legitimate their presence in the United States on the philosophical premises, though not the terms, offered to them. From this point of view, the challenge for Jews will be how to accept the possibilities that multiculturalism offers along with its potential for reinstating 'racial' difference – a possibility aggressively pursued by some multiculturalists themselves. Certainly, multi-culturalism speaks enticingly to Jews of the post-Holocaust, post-assimilationist generation who wish to accept their difference, whether this is an acknow-ledgement of how difference has been imposed upon them, or whether it is a recognition of a Jewish (politics of) identity. Of course, existentially, these are not separable.

NOTES

1 Jacob Drechler, *Black Homelands/Black Diaspora: Crosscurrents of the African Relationship*, Port Washington, N.Y., Kennikat Press, 1975. I have not sighted this obscure publication.

2 Graham Irwin, *Africans Abroad: A Documentary History of the Black Diaspora in Asia, Latin America and the Caribbean during the Age of Slavery*, New York, Columbia University Press, 1977.

3 Edward Jones, *The Black Diaspora: Colonization of Colored People*, Seattle, Wash., Edward L. Jones, 1989. Ronald Segal, *The Black Diaspora*, New York, Farrar, Straus and Giroux, 1995.

4 Stanford Lyman, 'The Chinese Diaspora in America, 1850–1943', republished in *Color, Culture, Civilization: Race and Minority Issues in American Society*, Urbana, University of Illinois Press, 1994.

5 Seymour Martin Lipset (ed.), *American Pluralism and the Jewish Community*, New Brunswick, N.J., Transaction, 1990.

6 Shmuel Eisenstadt, 'The American Jewish Experience and American Pluralism: A Comparative Perspective' in Lipset (ed.), *American Pluralism*, pp. 43–52, *passim*.
7 This piece was written before I had had the opportunity to read Karen Brodkin's *How Jews Became White Folks and What That Says About Race in America*, New Brunswick, N.J., Rutgers University Press, 1998. She places the whitening of the Jews in the context of the racialised organisation of American capitalism and argues that Jews, and other European migrant groups, were able to become white because of the massive expansion in middle-class opportunities. I believe that our two arguments compliment each other well.
8 Marla Brettschneider, *The Narrow Bridge: Jewish Views on Multiculturalism*, New Brunswick, N.J., Rutgers University Press, 1996, pp. 12–13.
9 Alan Dershowitz, *Chutzpah*, Boston, Little, Brown and Co., 1991.
10 James Clifford, 'Diasporas' in James Clifford, *Routes: Travel and Translation in the Late Twentieth Century*, Cambridge, Mass., Harvard University Press, 1997, p. 250.
11 James Clifford, 'Diasporas', p. 246.
12 John Higham, *Send These to Me: Immigrants in Urban America*, Baltimore, The Johns Hopkins Press, rev. ed., 1984, pp. 5–6.
13 Aaron Segal, *An Atlas of International Migration*, London, Hans Zell, 1993, p. 16.
14 John Higham, *Send These to Me*, p. 18.
15 John Higham *Send These to Me*, p. 22.
16 Leonard Dinnerstein, *Uneasy at Home: Antisemitism and the American Jewish Experience*, New York, Columbia University Press, 1987, p. 36.
17 Stanford Lyman, 'The Chinese Diaspora in America, 1850–1943', p. 240.
18 'Congressional Committee on Immigration' extracted in Paul Mendes-Flohr and Jehuda Reinharz (eds.), *The Jew in the Modern World: A Documentary History*, New York, Oxford University Press, 1980, p. 517.
19 'Congressional Committee on Immigration', pp. 511–12.
20 Leonard Dinnerstein, *Uneasy at Home*, p. 34.
21 Leonard Dinnerstein, *Uneasy at Home*, p. 178.
22 Quoted here from Karen Brodkin Sacks, 'How Did Jews Become White Folks?' in Steven Gregory and Roger Sanjek (eds.), *Race*, New Brunswick, N.J., Rutgers University Press, 1994, p. 80.
23 John Higham, *Send These to Me*, p. 6.
24 John Higham, *Send These to Me*, p. 6.
25 For one discussion of this situation see Ien Ang and Jon Stratton, 'Multiculturalism in Crisis: The New Politics of Race and National Identity in Australia', *Topia: Canadian Journal of Cultural Studies*, vol. 1 (2), 1998, pp. 22–41.
26 Arjun Appadurai, 'Patriotism and Its Futures' in *Modernity at Large*, Minneapolis, University of Minnesota Press, 1996, pp. 176–7.
27 Amritjit Singh, 'The Possibilities of a Radical Consciousness: African Americans and the New Immigrants' in Ishmael Reed (ed.), *Multi-Ethnic America: Essays on Cultural Wars and Cultural Peace*, New York, Viking, 1997, p. 221.
28 Amritjit Singh, 'The Possibilities of a Radical Consciousness', p. 221.
29 See, for example, Tu Wei-Ming, *The Living Tree: The Changing Meaning of Being Chinese Today*, Stanford, Stanford University Press, 1994. On this problem see Ien Ang, 'Can One Say No to Chineseness: Pushing the Limits of the Diasporic Paradigm', *Boundary* 2, 1998, pp. 223–42.
30 Marla Brettschneider, 'Introduction: Multiculturalism, Jews and Democracy: Situating the Discussion' in *The Narrow Bridge*, p. 5.
31 Marla Brettschneider, 'Introduction' in *The Narrow Bridge*, p. 6.

32 Zygmunt Bauman, *Modernity and Ambivalence*, Oxford, Polity Press, 1991, pp. 108–9.
33 Milton Gordon, *Assimilation in American Life: The Role of Race, Religion and National Origins*, New York, Oxford University Press, 1964, p. 76.
34 Milton Gordon, *Assimilation in American Life*, p. 263.
35 Werner Sollors, *Beyond Ethnicity: Consent and Descent in American Culture*, New York, Oxford University Press, 1986, p. 97.
36 Israel Zangwill, *The Melting Pot*, New York, Arno Press, 1914, p. 184.
37 Israel Zangwill, 'Afterword' in *The Melting Pot*, p. 203.
38 Israel Zangwill, 'Afterword' in *The Melting Pot*, p. 203.
39 Israel Zangwill, 'Afterword' in *The Melting Pot*, p. 215.
40 For this history see Katya Azoulay, *Black, Jewish and Interracial: It's Not the Color of Your Skin, but the Race of Your Kin*, Durham, N.C., Duke University Press, 1997.
41 Israel Zangwill, 'Afterword' in *The Melting Pot*, pp. 204–5. Stanford Lyman, rather more negatively, writes of Zangwill's 'extraordinary confusion of biosocial ideas as well as increased ambivalence about Negro-white marriages' (*Color, Culture, Civilization*, p. 10).
42 Robert Young, *Colonial Desire: Hybridity in Theory, Culture and Race*, London, Routledge, 1995, p. 9.
43 Robert Young, *Colonial Desire*, p. 9.
44 Milton Gordon, *Assimilation in American Life*, pp. 121–2.
45 Werner Sollors, *Beyond Ethnicity*.
46 Arjun Appadurai, 'Diversity and Disciplinarity as Cultural Artefacts' in Cary Nelson and Dilip Parameshwar Gaonkar (eds.), *Disciplinarity and Dissent in Cultural Studies*, New York, Routledge, 1996, p. 24.
47 John Higham, *Send These to Me*, p. 164.
48 It is interesting to note the European, and indeed Germanic, influence on the American intellectual advocacy of assimilation. Stanford Lyman, in *Color, Culture, Civilization*, says that 'Most of the early American sociologists who came to espouse an assimilationist orientation received their higher education in Wilhelmine Germany' (p. 5).
49 On the Leo Frank case see Leonard Dinnerstein, *The Leo Frank Case*, New York, Columbia University Press, 1968.
50 During the Civil Rights campaign in the late 1960s, the Klan launched a campaign against Mississippi's Jews. This was partly instigated by the role of Jews in the Civil Rights movement and partly traditional anti-Semitism. See Jack Nelson, *Terror in the Night: The Klan's Campaign Against the Jews*, Jackson, University Press of Mississippi, 1996.
51 As I have discussed in Chapter 4.
52 Henry Ford (ed.), *The International Jew: The World's Foremost Problem*; republished Los Angeles, Christian Nationalist Crusade, no date, pp. 38–9. For a discussion of Ford's anti-Semitism see Albert Lee, *Henry Ford and the Jews*, New York, Stein and Day, 1980.
53 One discussion of this ritual can be found in Werner Sollors, *Beyond Ethnicity*, pp. 89–91.
54 It has been republished in Arthur Goren (ed.), *Dissenter in Zion: From the Writings of Judah Magnes*, Cambridge, Mass., Harvard University Press, 1982, under the title 'The Melting Pot', pp. 101–6.
55 Randolph Bourne, 'Toward a Transnational America', republished in Leo Schwartz (ed.), *The Menorah Treasury*, Philadelphia, Jewish Publication Society of America, 1964, p. 852.

56 David Hollinger, *Post-Ethnic America: Beyond Multiculturalism*, New York, Basic Books, 1995, pp. 93–4.
57 Randolph Bourne, 'Transnational America' in Van Wyck Brooks (ed.), *History of a Literary Radical*, New York, B.W. Huebsch, 1920, p. 288.
58 Randolph Bourne, 'Transnational America', p. 268.
59 Werner Sollors, *Beyond Ethnicity*, p. 97.
60 David Hollinger, *Post-Ethnic America*, p. 162.
61 Randolph Bourne, 'Transnational America', p. 279.
62 Randolph Bourne, 'Toward a Transnational America', pp. 851–2.
63 Randolph Bourne, 'Toward a Transnational America', p. 853.
64 Randolph Bourne, 'Toward a Transnational America', p. 850.
65 John Higham, *Send These to Me*, p. 210.
66 John Higham, *Send These to Me*, p. 210.
67 John Higham, *Send These to Me*, p. 210.
68 John Higham, *Send These to Me*, p. 210.
69 John Higham, *Send These to Me*, p. 210.
70 Nathan Glazer, *We Are All Multiculturalists Now*, Cambridge, Mass., Harvard University Press, 1997, p. 51.
71 Nathan Glazer, *We Are All Multiculturalists Now*, pp. 14–15.
72 Nathan Glazer, *We Are All Multiculturalists Now*, p. 15.
73 David Hollinger, *Post-Ethnic America*, pp. 19–20.
74 Amritjit Singh, 'The Possibilities of a Radical Consciousness', pp. 299–300.
75 Alain Finkielkraut, *The Imaginary Jew*, trans. Kevin O'Neill and David Suchoff, Lincoln, University of Nebraska Press, 1994, p. 59.
76 Milton Gordon, *Assimilation in American Life*, p. 89.
77 Milton Gordon, *Assimilation in American Life*, p. 88.
78 John Higham, *Send These to Me*, p. 175.
79 John Higham, *Send These to Me*, p. 175.
80 Milton Gordon, *Assimilation in American Life*, p. 262.
81 Milton Gordon, *Assimilation in American Life*, p. 194. Milton Gordon had been a member of the Chicago School of Sociology led by Robert Park. Barbara Kirshenblatt-Gimblet, in 'Spaces of Diasporas', a commentary on James Clifford's article, 'Diasporas', in *Cultural Anthropology*, vol. 9(3), 1994, pp. 339–44, has noted how the Chicago School's concept of the 'marginal man' who lives between two ethnic groups described at length by Gordon (pp. 56–8) is, in effect 'a psycho-sexual portrait of "the Jew," the prototypical marginal man and model for the sociological concept.' Indeed, Park himself wrote of the Jew as the type of the marginal man. Marginality is, of course, the obverse of the assimilation/acculturation problematic.
82 Will Herberg, *Protestant-Catholic-Jew: An Essay in American Religious Sociology*, Garden City, N.Y., Doubleday, 1955, p. 55.
83 Oscar Handlin, 'Introduction' to M.L. Hansen, 'The Third Generation in America', *Commentary*, vol. 14, 1952, pp. 492–500. Lyman, in *Color, Culture, Civilization*, has an important chapter on Hansen entitled, 'Memory, Forgetfulness: History, Integration: Hansen's Law of "Third Generation Interest" and the Race Question'.
84 Will Herberg, *Protestant-Catholic-Jew*, p. 202.
85 Will Herberg, *Protestant-Catholic-Jew*, p. 203.
86 Noah Isenberg, '"Critical Post-Judaism"; or, Reinventing a Yiddish Sensibility in a Postmodern Age', *Diaspora*, vol. 6 (1), 1997, p. 87.
87 Will Herberg, *Protestant-Catholic-Jew*, p. 56, note 11.
88 Nathan Glazer, *We Are All Multiculturalists Now*, p. 152.

89 Nathan Glazer, *We Are All Multiculturalists Now*, p. 147.
90 Nathan Glazer, *We Are All Multiculturalists Now*, p. 147.
91 On the construction of Irish as 'black' see Anne McClintock, *Imperial Leather*, New York, Routledge, 1995. On the Eastern European Jews as 'black' see Sander Gilman, *The Jew's Body*, New York, Routledge, 1991.

SEINFELD IS A JEWISH SITCOM, ISN'T IT?

The pilot episode of *Seinfeld*, 'The Seinfeld Chronicles,' went to air on July 5, 1989. At this point, the main characters were Jerry, George and the character who became Kramer. 'The Seinfeld Chronicles' was received poorly and NBC only ordered four episodes of the show, which were shown in May and June, 1990. In early 1993 *Seinfeld* started to be broadcast immediately after the high-rating *Cheers* and rapidly became one of the most popular shows on American television, coming in third in the overall Nielsen ratings for the 1993–94 season.[1] By the time the final episode of *Seinfeld* was shown in the first half of 1998, there were, in total, 170 episodes, including a one-hour retrospective of clips. Some idea of the popularity of the series can be gained from knowing that, in 1997, *Business Week* estimated that Jerry Seinfeld was paid $22 million for the new series as an actor, writer and producer. At the same time, the other three main actors negotiated a new pay deal giving them $600,000 each an episode.[2] The extent to which the show has become a part of American cultural life is signalled by Greg Gattuso who notes that 'In addition to the catch phrases ("shrinkage," "slip one past the goalie," "puffy shirt," "Soup Nazi," "Get Out!"), parroted throughout the day by fans, the show was having more lasting effects, inspiring everything from the coffee shop banter in Quentin Tarantino's film *Pulp Fiction* to a knock-off porno film, *Hindfeld*.'[3] A wide range of 'Seinfeld' merchandise has also been marketed.

It is clear that *Seinfeld* struck a chord in American life in particular, but in Western life more generally in the 1990s. Here, I want to think through some of the conditions for its popularity. The underlying narrative issue of *Seinfeld* is, I will argue, intrinsically Yiddish, though ultimately a function of the experience of many other migrant groups and their descendants in the United States. This issue is usually addressed by describing *Seinfeld* as 'a show about nothing.' As *Seinfeld* fans will know, this is the description that George provides of the show that he and Jerry pitch to NBC executives in 'The Pitch and the Ticket' (episode 42):

George: An idea for a show.
Jerry: I still don't know what the idea is.

George: It's about nothing.
Jerry: Right.[4]

But what does this mean? In an interview with the *Hollywood Reporter*, Jerry Seinfeld remarked that 'nothing and everything are the same thing' and went on to explain that the premise of the show involved looking at 'the mini-events of life – the kind of things that comprise most of life for most people . . . I call it micro-comedy.'[5] Distinguishing between etiquette and civility and arguing that civility is a description of the basis of interaction in that phenomenon of modernity, *society*; I will argue that *this* is what *Seinfeld* is about. Not a comedy of manners, as such; it is a comedy about the experience of civility. In this it is typical of the structure of American-Yiddish humour.

However, what complicates matters is how elements of *Yiddishkeit* (Yiddish culture) humour have, themselves, become naturalised as aspects of American cultural life. In this regard I will discuss the *schlemiel* and the *schlimazl* as Yiddish concepts that evolved as aspects of a distinct, subaltern and oppressed culture but which have now become accepted as part of the dominant, Anglo-American culture, and which have been transformed in the process. In short, I will argue that *Seinfeld* is ambivalently Jewish; that it is the most sophisticated example of the surfacing of American-Jewish identity as an ethnic identity in the entertainment sector of the American public sphere in the 1990s, and that it evinces a preoccupation with what has always been the Yiddish dynamic with modernity, the problem of becoming civilised, in the most fundamental sense. However, as an 'American' program rather than a Jewish, or Yiddish, program, *Seinfeld* was able to take advantage of its interrogation of the issue of civility to address topics which would often have been thought of as improper – inappropriate for public discussion – by the dominant Anglo-American culture, and to do this in ways with which very large numbers of Americans, not just the descendants of Yiddish and other migrants from outside of the well-springs of modern, social life, could identify and find humorous.[6]

FROM JEWS TO JEWISHNESS

I want to begin this discussion by thinking about how 'the Jew' and 'Jewish-ness' are represented on *Seinfeld*, and I will centre this on the ambiguous Jewishness of the show's ensemble of characters. There is a fundamental tension between these terms. One way of elaborating this distinction is philosophically. David Theo Goldberg and Michael Krausz comment that

> one can distinguish between membership of a collectivity in virtue, on the one hand, of satisfying some assent-independent criterion like matrilineal descent and, on the other hand, consensual identification

with the collectivity. To *be Jewish* simply by way of descent will differ from assuming a Jewish identity, from *affirming one's Jewishness* as a matter of choice.[7]

Sociologists would describe this in social terms as the difference between ascription and achievement. The two modern discourses onto which these two ways of thinking map most congruently are race and culture. The most succinct expression of this distinction comes in the form of the debate over whether Jews are a race or an ethnic group. The complicating factor here is that, if Jews are considered to be an ethnic group, that is, if the emphasis is on cultural identification – Jewishness by choice – then they must, nevertheless, also be a group within a larger racial grouping.

In the United States Jews went from being considered racially distinct in the period up to the Second World War to being considered members of the white race in the post-Second World War period.[8] However, as is well-known, for Orthodox Jewry, the definition of who is a Jew remains that in *halachic* law which states that a Jew is a person born of a Jewish mother. Conversion is arduous, and only an option for the most determined gentiles. Conversion, though, is to a religion; to Judaism not, we might say, to Jewishness. But, in a further complication of matters, being converted to Judaism makes one a Jew, and, if one is a woman, one's children, those born *after* conversion, will be Jewish also.[9] There are, now, sects of Judaism in which conversion is amazingly easy, and American Reform Judaism accepts the children of male Jews with gentile wives as Jewish, as, indeed, does the Israeli Law of Return. Meanwhile, Orthodox Jews accept neither those who have had 'quickie' conversions nor those with only a Jewish father as Jews.

A part of the confusion here has to do with religion. How can it be that a woman who is converted to Judaism will have Jewish children? There is no solution to this enigma in the modern world which makes a clear distinction between religion, as a special kind of cultural attribute which is, ultimately, considered to be a matter of personal choice, and race, which is an effect of inheritance and, in this way, not a choice at all. To understand this combination we can turn to a non-modern situation. Here is Ilan Halevi describing the complex variety of peasant groupings in the latter part of the nineteenth century in the area now identified as Lebanon, Palestine, Israel, at that time still a part of the Ottoman Empire:

> These communities, whose origins often went back to sectarian splits within a common religion (Shiites, Druzes), were closed groups. Membership of them was not a matter of belief. . . . Each confession constituted a framework for social identification: loyalty to the group, to a mini-nation within the state, or to a tribe, it was no more a matter of choice than is one's country of birth or mother tongue.[10]

284

Here, religion is a crucial aspect of tribal identification. Exceptionally in the modern world the connection between accepting Judaism as one's confession and producing children who are identified by most Jews as Jews, even if they, themselves, then choose another religion, or none at all, is an example of this same non-modern imbrication of religion and community identification. The logic, of course, is that if one is born a Jew one will grow up in, and accept, the Judaic faith. This is because that faith is not just considered to be one's religion but an aspect of a person's entire cultural formation. At the same time, to be able to give birth to Jews when one was not, oneself, born a Jew challenges the conventional, modern biologistic understanding of race.

There is a further problem which concerns the relationship between religion and 'culture,' in its broadest definition. In the modern world religion was withdrawn from everyday cultural life. For Enlightenment thinkers religion was a matter of faith, and choice, not of culture but it, nevertheless, provided the moral and ethical base for life in society. In other words, religion was thought to underpin what we have come to think of as lived culture. As a separate and demarcated area of life religion could be understood as providing the basis for the moral order which made social life possible, while also being viewed as something chosen out of the conviction of belief rather being an attribute of the culture to which one belonged. Hence, modern Christianity could be a religion of conversion. Individuals could convert from one Christian confession to another, and missionaries could convert those living outside of the modern world, in the colonies for example, to Christianity. Judaism, by contrast, has remained a religion deeply embedded in day-to-day culture, in, for example, the regulations of *kashrut*, the dietary laws, which establish among other things what foods are, and are not, *kosher*, that is, allowed to be eaten. For this reason also, Judaism does not seek converts.

John Murray Cuddihy has commented that 'Differentiation is the cutting edge of the modernization process, sundering cruelly what tradition had joined'[11] and one area of life where this is most obvious is in the distinguishing of religion from lived culture. It is, indeed, this distinction, and in a secular context the expression of morality and ethics as identifiable areas of knowledge, which allows for the description of society as being founded on shared moral assumptions. Cuddihy writes about what he calls the Protestant Etiquette, 'those expressive and situational norms ubiquitously if informally institutionalized in the social interaction ritual of our modern Western societies.'[12] It is, then, this reification of religion which has provided the basis for the modern production of societies based on shared moral norms rather than shared cultural practices. Here, we are approaching the understanding of civility as the characteristic modern way of living. Kenneth Boulding has associated civility with civilisation and described how the latter is 'characterised by the elaborate systems of religion, politeness, morals, and manners.'[13] Civility is the typical organising practice for interaction in the modern state. What makes the United

States the most modern of states is that it is founded on a shared moral order rather than a shared culture.[14]

The differentiation of religion from culture, and the progressive secularisation of modern life, has produced the theoretical possibility of being Jewish while not choosing the Judaic religion; the problem often identified as 'the non-observant Jew' or 'the secular Jew.' Cuddihy argues that 'With Jewish secularization-modernization . . . Judaism is psychologized into Jewishness.'[15] He is thinking specifically of Freud here, and of an interpretation of Freud's work as an account of the Ashkenazi-Jewish entry into the civility of modern life. However, the Enlightenment distinction of religion from culture produces a much broader problem, the seemingly cultural category of 'Jewish' and the idea of Jewishness. Elaine Marks has summed up the outlook provided by her secular Yiddish background and American family like this: 'Jews are un-attractive men; we are not Christian; goyim are dumb, blond women; we are Jewish. To be a Jew is not the same thing as being Jewish. Sigmund Freud was Jewish.'[16] Marks had an uncle who, she writes, was 'interminably analyzed.' In this cultural distinction, the Jew is the person who observes the Judaic religion and is, so it would seem, by implication, serious and morally preoccupied. Being Jewish connotes the pleasures of food, humour and the other pleasures of Jewish/Yiddish culture. Thus, Freud became the model for the secular Jew. From this perspective, the modern problem of 'Who is a Jew?' gets reconfigured with the addition of the question 'Who is Jewish?'

If one thinks of the Jews, in the modern way, as a 'race,' much as 'black' or 'white' have been thought of as essentialised categories that identify charac-teristics handed down through biological transference from one generation to the next, then clearly it is possible to be a Jew without the religious affiliation of Judaism. This is what happened as Jews were racialised in Europe and the United States in the latter part of the nineteenth century. The consequence of this racialisation was that the Nazis produced a definition of being a Jew based on heredity which therefore included secular and assimilated Jews. Nevertheless, in the United States, as in many European countries, the definition of a Jew by race was ambivalent, at best. In a subtle piece discussing the formation of the discourse of the Jew in the United States, Daniel Itzkovits has remarked that

> As exacting as early-twentieth-century American accounts of Jewish difference often become, they are most striking, taken as a whole, for their inability to arrive at a solid notion of 'the Jew.' Jewishness kept slipping within and among the categories of race, nation, religion, and culture, and the criteria for affiliation and disaffiliation (notwithstanding the religious law that defines as Jewish those individuals whose mother is Jewish) were very vulnerable to contestation.[17]

The problem is most extreme when it is the category of 'Jewish' which is emphasised. There is a semantic confusion here which complicates matters. 'Jewish' may refer to the qualities pertaining to a Jew. Hence, 'She is Jewish' may mean that the woman is being identified as a Jew, and assumes a particular racial, biologistic reductionism. Having a Jewish mother, or sometimes father, can be understood as a racialised determinant. To state the obvious, this is one reason why both gentiles and Jews find confusing the halachic rule which only identifies the children of Jewish women as Jews. However, 'She is Jewish' may alternatively mean that the woman subscribes to Judaism, in which case she may have converted, and therefore become a Jew, or, and this is the most vexed problem, it may identify a cultural complex which the woman evinces. In common usage the meaning can slide among all three possibilities.

But what can be meant by 'Jewish culture?' Since the end of the Second World War, this problem has become increasingly pressing. One reason for this has been the long-term discursive shift away from a reductionist emphasis on race to a relativistic emphasis on culture, or tradition. This is the shift often summed up in the move to talking about ethnicity.[18] Another reason is the consequence of the modern trend of secularisation. This has produced increasing numbers of non-religious Jews some of whom, nevertheless, observe the rule of endogamy, sometimes for what they claim are entirely practical reasons such as that they get on better with those from Jewish – though not necessarily Judaic – backgrounds. In the United States the continued importance of race has been transmuted into the problem of identity, as exemplified in the American version of the politics of multiculturalism and the new assertion of African-American culture. Typical of this shift in Jewish thought is this argument put forward by David Biale in the context of a debate over the Jewish identity and multiculturalism. He writes:

> I would argue that only a narrow, religious definition of Jewish culture
> – 'Judaism' – restricts the possibilities for contemporary Jewish
> identity. Only once this culture is understood as exactly that, a *secular
> culture*, can all the possibilities, from Orthodoxy to socialism, be taken
> as equally legitimate.[19]

Here we have stated with clarity the argument for thinking of Jews as an ethnic group with a distinctively Jewish culture.

For American Jews the problem was compounded by their becoming ambivalently 'white' after the Second World War.[20] How this happened appears to have been a consequence of at least three developments within the overall context of the movement away from essentialism. First, the Americanisation of the descendants of the Eastern European Jewish migrants who arrived in the period between the 1880s and the 1920s, when this immigration wave was curtailed. By Americanisation here I mean, in particular, the degree to which

these people learnt to be civil. Second, the establishment and acceptance of cultural pluralism for white ethnic groupings which share the moral assumptions of modern civility. Third, and partly as a consequence of the second, the American expansion of the category of white to include other European groups with a 'Judaeo-Christian' moral heritage. Karen Brodkin has discussed in some detail how this happened. She describes the racialised organisation of American capitalism and argues that 'job degradation and racial darkening were linked.'[21] She explains that

> Although changing views on who was white made it easier for Euro-ethnics to become middle class, economic prosperity also played a very powerful role in the whitening process. The economic mobility of Jews and other Euro-ethnics derived ultimately from America's postwar economic prosperity and its enormously expanded need for professional, technical, and managerial labor, as well as on government assistance in providing it.[22]

In being accepted as white, Jews were able to express their Jewishness provided they did so within the bounds of civility. The new possibility of celebrating Jewishness in the sense of a Jewish culture and tradition was an entirely novel circumstance. One of the consequences of being accepted as Jews rather than as Yiddishers has been the problem of defining what a secular Jewish culture might be. Combined with the preponderance of Jews from Yiddish backgrounds in the United States, this has led to a blurring in which Yiddish culture has been generalised into Jewish culture.

At this point we need to note the close conceptual relation between Jews and Italians in the United States. While, as Ivan Kalmar points out, there is a modern European history which equates Jews and Italians as borderline white and borderline European,[23] it was, perhaps most importantly, the two groups' similar lack of civility (and emphasis on the family) and their similar treatment in the United States that has led to a certain conflation of perception about them. Kalmar argues that in the United States it is the images of working class Jews and Italians, what he calls Brooklyn Jews and Brooklyn Italians, that are alike. Their close physical proximity combines with more cultural claims to similarity. For example:

> Both the Jewish and the Italian family have the image of a strongly cohesive if quarrelsome unit, within which the father has trouble living up to the ideal of the upright patriarch, and the mother lives a life of chronic drudgery, mitigated by the love she feels for her family and they for her.[24]

Kalmar notes how, in Woody Allen's film *Broadway Danny Rose*, the Italians 'look and talk just like Jews.'[25] Whatever the reasons, it is certainly the case that

the two groups are supposed to have, and are often portrayed as having, many of the same attributes.

In his article entitled '"Passing" into Multiculturalism' which accompanied the exhibition at the Jewish Museum, New York in 1996, 'Too Jewish? Challenging Traditional Identities,' Norman Kleeblatt has a section called 'Jewish Identity Comes of Age.' Here, he writes that

> The 1980s witnessed the emergence of Jewish themes among a group of mainstream, predominantly secular artists. These themes were primarily celebratory, sometimes nostalgic – familial ancestry and religious heritage, Jewish liturgy, biblical narrative, and the Holocaust as a shared Jewish past.[26]

Kleeblatt goes on to explain that

> The *Too Jewish?* artists recast their Jewish past in the matrix of post-war America, including both positive and negative aspects of growing up as a white Other in what was formerly seen as the munificent melting pot. Few pay attention to earlier Jewish pasts – the shtetls and ghettos of Europe or New York's Lower East Side, places about which previous generations still wax nostalgic.[27]

Too Jewish? marked an important moment in the elaboration of a Jewish-American culture, a culture which is seen as being produced in and through Jewish engagement with American life today. However, the title signals the anxiety that haunts this multiculturalist assertion of Jewish cultural identity. It is an anxiety that goes back to the European emancipation of the Jews and continued through their American whitening, that it is possible to be too Jewish. This has many inflections, from being uncivil and therefore embarrassing in gentile company to making gentiles aware of a Jewish presence which will increase the likelihood of an anti-Semitic reaction. Jews should not stand out too much.

The secular Jewish engagement with American life has to confront the problem of what constitutes secular Jewish culture. In this regard, as I have remarked, there has been an American tendency to generalise *Yiddishkeit* as Jewish culture, and also to utilise the Holocaust as a defining event which can provide a site for all Jews', and not simply Yiddish or Ashkenazi, identification. This also includes secular Jews. The Holocaust was not, in itself, an event of religious significance. It could be argued more generally that one of the effects of thinking of the Holocaust as a genocide is that, along with the migrations to Israel from all parts of the world, these events have forced Jews to think of themselves as an entire group. By this, I mean that whereas before the Second World War, each geographic Jewish grouping had some knowledge of Jews elsewhere, it is only since these two events that Jews have begun to have a sense

of a totality of Jewish presence in the world. I would not want to argue that this new understanding is a consequence of these two events. Rather, genocide and the nation-state are both bound up in the modern discursive shift to thinking of people in terms of distinctive and totalisable groups. This is how both race and national membership were naturalised.

JEWS AND AMERICAN SITCOMS

When *Seinfeld* went to air at the turn of the 1990s, it did so in an America that was emphasising the importance of culture and asserting connections between cultural difference, race and ethnicity. It was also in the context of a new multicultural Jewish visibility that was being made by choice. Nevertheless, the Jewish visibility of the show still had to be negotiated. Brandon Tartikoff, then president of NBC had commented that the show was 'too New York' and 'too Jewish'[28] – this phrase carries the semiotic loading that I have already discussed – and Jerry's neighbour, Kessler in 'The Seinfeld Chronicles' pilot, had his name changed to the less-Jewish-sounding Kramer and was subsequently given the un-Jewish forename of Cosmo. As we will see, there is a fundamental ambivalence about which characters in the show might be Jewish. One of the reasons why this ambivalence has become acceptable is because 'Jewish' here refers primarily to culture; that is to say, the program is made and watched in a cultural context where the essentialist problem of who is or is not a Jew is of less importance to the majority of viewers than the representation of elements of 'Jewish culture.' This may be because of the tendency to think of Jews as an ethnic group within the white race. Where *Seinfeld* pioneered, other sitcoms have followed. *Mad About You*, with the ambivalently Jewish Paul Buchman married to the *shiksa*, Jamie, began in 1992; *The Nanny*, in which Fran Drescher plays Fran Fine, a Jewish nanny, started in 1993; and *Friends*, in which at least two of the main characters, a brother and sister, Ross and Monica, are Jewish (another one is of Italian background) began in 1994. However, as the anonymous author of the article 'Jewish Family Values' notes, 'while certain Jewish values may be present [in *Friends*], the Jewish identities of Ross and Monica are all but invisible.'[29] One way of thinking about this is that in the 1990s there has tended to be an emergence of Jewish culture rather than Jewish characters. *The Nanny* is the exception here. Drescher's character is not presented as only having Jewish moments but as being unremittingly Yiddish-background and upper-working class. I will discuss below why it is that while male characters can present as only partially Jewish, that is to say, can exhibit Jewish cultural aspects, female characters are either not Jewish at all, or, like Drescher's Fran Fine, are shown as unequivocally Jews.

Terry Barr, who has written about the new representation, still thinks in terms of characters and Jews. He puts the development this way: 'Although TV and film have depicted Jewish characters in the past, until recently American

TV has not regularly focused on Jewish characters, and American film has been reluctant to center whole projects on Jewish culture.'[30] Barr goes on to suggest that 'With the abundance of Jews on current network TV shows, the American audience has its best chance to see and understand as never before what being Jewish is like.'[31] On the contrary, I think American audiences, including that increasingly problematic category 'Jews,' are being offered a representation of Jewishness, sometimes, as in the case of Joel Fleischmann in the top-rating early 1990s series *Northern Exposure* about whom Barr writes, embodied in a character identified as a Jew. More often, though, these representations come simply as Jewish moments provided by characters of more or less indeterminate background.

The idea that ethnicity is cultural and can, therefore, be chosen is taken to its humorous limit in the sitcom, *3rd Rock From the Sun*. Here, aliens assume human bodies in order to engage in participant observation of American culture. They set themselves up as a family, taking the name Solomon, we discover, from a removal van. In 'Dick Like Me' (episode 115, first screened in 1996), Tommy finds that in order to fit in at school he needs an ethnicity. In this take-off of multicultural identity politics, the Solomons' neighbour Mrs Dubček, who once had a Jewish husband, helps the family to understand that, given their name, they must be Jewish. That the Solomons are really aliens provides an ironic reworking of the modern idea of the Jew as the stranger who comes to stay.[32] Likewise, that the aliens take their name from a removal van uses humorously the idea of the Jews as being displaced, of being thought of in the modern world as being in diaspora.

Barr quotes Tartikoff in 1983, six years before his remark about *Seinfeld*, which I have already quoted, insisting that 'a show about a specifically Jewish family, à la *The Goldbergs* of 1948–54, "would not work today. It worked when television was new, television sets expensive, and the owners were disproportionately Jewish."'[33] Around the turn of the 1950s there were a number of successful 'ethnic' sitcoms in addition to *The Goldbergs*,[34] including the Norwegian-American *Mama* (1949–56), the Irish-American *Life of Riley* (1949–50) and the Italian-American *Life With Luigi* (1952). George Lipsitz has argued that these shows reconstructed pre-war migrant working-class life, centring it on consumption and, in the process, defusing present-day class consciousness.[35] While this may be correct, the shows also constructed a historical memory of already civilised ethnic migrant groups. Broadcast when all these groups either were already considered to be, or were in the process of being transformed and accepted as white, these shows produced a colourful, deviant but acceptable past for groups who would, in the present generation of the early 1950s, soon only be able to see themselves as upwardly mobile middle-class, white Americans. At the same time, these shows portrayed the cultural diversity of those migrant groups which Anglo-Americans were beginning to acknowledge as contributors to an American society in which the ideology of cultural pluralism was to some extent becoming naturalised.

In the pre-war period, in a country where the primary structural racial definition was between black and white, the problematically racialised status of Jews is well summed up in Michael Rogin's comment that 'by the turn of the twentieth century Jewish entertainers were the major blackface performers.'[36] In film, the tradition had its most popular moment when Al Jolson played a Jew torn between his Yiddish heritage and performing in blackface, that is becoming not quite a white American, in *The Jazz Singer* (1927). At the climactic ending Jolson, whose name in the film is changed from the 'Jewish' Jakie Rabinowitz to the 'white,' Anglo-American Jack Robin, sings 'My Mammy' in blackface. Jolson had performed in vaudeville with his brother as The Hebrew and the Cadet and, David Marc notes, 'there had never been any mistaking the identity of Fanny Brice or Sophie Tucker'[37] both of whom had performed for Yiddish-background Jewish audiences.

Unlike for most people identified as 'black,' who could not pass because of their colouring, for many Jews their possible racial difference was to some extent identified by way of their Yiddish religio-cultural difference. Thus, when George Lipsitz notes that 'Part of the convincing authenticity of *The Goldbergs* came from actors and writers who developed their skills within Yiddish theater and the culture that supported it,'[38] we must remember that this cultural difference continued to mark an ambivalent racial difference even in the early 1950s. Marc notes that

> After the war, the Jew returned to American popular culture cosmology with a vengeance. Milton Berle, Sid Caesar, Groucho Marx, Red Buttons, George Burns, Jack Benny, Phil Silvers and George Jessel were among the Jewish comedians starring in their own prime-time network comedy series in the early fifties.[39]

Becoming ambivalently accepted as white, the Jew became the white Other, the term I have already noted Kleeblatt using, and, coming out of a culture which had evolved as subaltern, American Jews of Yiddish descent were ideally positioned to be comedic commentators on, in particular, white Anglo-conformist American life. When Marc writes that 'the physical and psychological walls barricading New York Jewish ghetto culture began to tilt openward after 1945, and nowhere was this more readily apparent than on television,'[40] the reason was that the relative civilising of the second- and third-generation Yiddish-background Jews had made them more acceptable to white American culture.

By the final year of its production in 1955–56 *The Goldbergs* had been relocated from a New York tenement block to a suburban house on a Long Island subdivision.[41] At the same time, Marc notes: 'As urban identity faded, ethnic identity waned with it.'[42] The key here, though, was the shift in class. Cultural difference and lack of civility were coded urban, migrant and working class, and associated with racial difference. Being accepted as white, which

meant that a group was fully incorporated into American society, entailed becoming civil and middle class, including taking on the dominant ideology. The privatised nuclear family was located at the heart of this civil order.

Through the second half of the 1950s and into the 1960s the most popular sitcoms were shows such as *Father Knows Best* (1954–60) and *Leave It To Beaver* (1957–63). Identifiable Jews, and Yiddish culture, did not exist in these shows where, as Marc puts it:

> The Andersons' Springfield [the mythical suburban town of *Father Knows Best*. The same name is used for the town in *The Simpsons*, the show which helped to establish a working-class, dysfunctional family-based critique of utopian suburbia.] America is so white, so Anglo-Saxon, and so Protestant that even their seemingly Hispanic gardener (Natividad Vacio) goes by the name of Frank Smith![43]

In this binary system, the urban also included the single and the heterodox. The site of non-civility, it was presented as a fragmentary society, represented by its racial diversity, of which the material expression was living in apartments rather than houses. That these apartments were almost always rented, as compared to the owner-occupiers of mortgage-belt tract suburbia, has been another signifier of the lack of solidity and permanence of urban life.

The Cosby Show is a fascinating example of the workings of this binary system. Started in 1984 as the politics of multiculturalism and identity began to take centre stage in the United States, it actually espoused the politics of integration.[44] As is often remarked, the show could just as easily have featured a white family. It makes a play for 'Blacks' to be accepted as white by providing an image of African-Americans that is coded in terms of civility, nuclear family, middle-classness, suburbia and home-ownership.[45] Where the show would have been radical in previous decades, by the 1980s it came over as safe and conservative, reassuring white America that African-Americans could be just like them. However, as we saw in Chapter 9, as the politics of multiculturalism acknowledged, while Jews could be whitened into the ethnic diversity of cultural pluralism, African-Americans would remain black, and excluded from dominant American society by virtue of their racialisation. Nevertheless, the show's increasingly nostalgic presentation of a white, middle-class way of life naturalised as the American way of life, made it the highest rated series on prime time in the 1980s.[46]

While much of the binary system continues to hold good there has been a fundamental transformation in the new white cultural pluralist sitcoms. Also going to air in 1984, *Who's The Boss?* heralded the representation of white ethnic difference by having an upwardly mobile male of Italian descent working as a live-in help for a single Anglo-American career woman. Each has a child. Crucially, the ethnically diverse white characters of shows such as *Seinfeld*, *Mad About You* and *Friends*, mostly Jewish and Italian, are now middle class.

The problem these shows confront is how to represent white ethnic diversity without showing middle-class ethnic families. Were such families to be shown, as working-class ethnic families were shown in the 1940s and 1950s, it would put into question the apparent Anglo-conformist white civil order over which is lain a variety of cultural, identity inflections signifying 'Jewishness' or 'Italianess.' The nuclear family, after all, is thought of as the point of imbrication of civil and cultural codes of behaviour. It is not surprising, then, that familial diversity has been represented by showing Anglo white working-class families rather than non-Anglo ethnic middle-class families. *Married . . . With Children* (1987) was the seminal show here. Along with *The Simpsons*, which started in 1990, these two shows helped to establish the dysfunctional, working-class Anglo family as the basis for the critique of the utopian suburban fantasy presented in 1950s sitcoms. We can now understand the correctness of Tartikoff's statement that a show about a Jewish family wouldn't work today. *The Cosby Show* was popular precisely because it was, to all intents and purposes, simply a middle-class sitcom. The 'blackness' of the family could be ignored because the show did not dwell on cultural difference from the Anglo-American norm.

In the cartoon sitcom *The Simpsons*, the dystopian suburbia is also ethnically and racially diverse. Among the show's characters in the Jewish Krusty the Clown, reproducing once more the idea of the Jew as performer. In 'Like Father, Like Clown' (episode 8FO5) we discover that Krusty's real name is Herschel Krustofsky and that he is estranged from his rabbi father who disowned him when he decided to become a clown. There is, here, an intertextual reference to Jakie Rabinowitz. Where he anglicised his name and went on to perform in blackface, Krusty anglicises his name and puts on clown make-up.[47] However, in 'Like Father, Like Clown,' father and son are finally reconciled with Krusty's father accepting his son's career choice. Echoing Jack Robin in *The Jazz Singer*, Krusty and his father perform together a rendition of the 1954 hit by Eddie Fisher, 'O Mein Papa'/'O My Papa,' a Yiddish-American song. However, while Krusty and his father sing a duet, 'Jack first sings Kol Nidre at the synagogue over his father's dying body and then "My Mammy" to his mother and girlfriend at the Winter Garden Theater.'[48] Eddie Fisher was himself an assimilated Jew. Thus, here, unlike in *The Jazz Singer*, a film that represents an earlier, migrant generation, reconciliation is achieved in the 'melting pot' merging of Yiddish and American cultures.

Given that the wife/mother was presented through the 1950s and 1960s as the site of reproduction of the civil and cultural codes, we have one answer to the question of why there are so few white ethnic female characterisations in present-day American sitcoms. Susan Kray writes that 'Jewish women, like other minority women (except some blacks) do not get through the [gate-keepers onto television].'[49] In the rare cases where Jewish characters do appear, they are usually presented as even more Anglo than their male counterparts. A very good example here is Courtney Cox's character, Monica, as the Jewish

sister to David Schwimmer's much more obviously Jewish character, Ross, on *Friends*.

The virtual absence of a female Jewishness on 1990s American television is matched by the number of male Jewish-identified characters who have relationships with Anglo women. Jerry, on *Seinfeld*, with his parade of Anglo girlfriends, is the classic example here. Paul Buchman on *Mad About You* is another example. Often, this is accounted for from within the Jewish community as a reflection of the very high rate of marrying out by Jewish men in the United States. This is a realist argument. Coupled with this argument is the claim of shiksappeal, that Jewish men find gentile women in some way exotic, fascinating and attractive. There is even a *Seinfeld* episode, 'Serenity Now' (no. 151), which plays with this idea. Elaine, identified here as a gentile, finds herself the source of attraction for both a rabbi and a bar mitzvah boy.

However, there is a more structural answer. Representations of Jewish men with Anglo-American women are reassuringly assimilatory for the dominant culture. When the women are middle class, as they always are, these relation-ships are also reassuring for Americanising Jewish men, as I discussed in the Introduction in connection with *There's Something About Mary*. Jewish-identified women, either having relationships with Anglo-American men, or with Jewish-identified men are more threatening. Aside from the halachic consequences that the children of such a mixed relationship would be identified within the Jewish community as Jewish, there is the cultural assumption that the children, and maybe even the husband, would become more culturally Jewish. In other words, where Jewish men dating and marrying out connotes an increasing social cohesion by reconfirming the Anglo-American cultural dominance, Jewish women whether marrying in or out are more threatening to that hegemony.

Marc describes Roseanne Barsky, star of the sitcom *Roseanne*, as 'a Jewish performer who self-consciously constructed an American, as opposed to a Jewish-American, persona' and, like Jack Benny and George Burns, constructed a '"middle-American" sitcom setting [which] can be seen as part of the performer's reconstruction of self from a culturally marginal Jewish-American personality to an unhyphenated American character.'[50] What Roseanne did, was to transform her relatively unacceptable female Jewishness into an acceptable white, Anglo-American, and indeed Midwest, working classness. Fran Drescher's solution on *The Nanny* has been quite different. Where Roseanne, following the overdetermination of Jewish women on American television, has made herself invisible, Drescher has reacted in the opposite direction. Fran Drescher plays Fran Fine, a third-generation Yiddish-American woman from working-class Queens who gets work as a nanny with a widowed English impre-sario and his children who live in up-market Manhattan.[51] Here we have a scenario not dissimilar to that of *Who's The Boss?* The Fran Fine character is stereotypically Yiddish, exhibiting all the qualities so feared by Elaine Wales, the Jewish Estelle Walovsky, in Laura Z. Hobson's novel *Gentleman's Agreement*

(1946). Wales is anxious that the presence of uncivil, Eastern European Jews will ruin things for those Jews like her who have successfully made themselves invisible. For Wales, the 'objectionable qualities,' as she calls them, are 'loudness, "too much rouge," and troublemaking.'[52] Cuddihy comments about civic culture that 'Intensity, fanaticism, inwardness – too much of *anything*, in fact – is unseemly and bids fair to destroy the fragile solidarity of the surface we call civility.'[53]

Fine is not attempting to make herself invisible. Indeed, she is celebrating her Yiddish identity, which is the basis for much of the show's humour. In her case troublemaking involves her tendency to unthinking overenthusiasm, a trait humorously counterpointed by her boss's English upper-middle-class uptightness. Moreover, the identification of Fine as a Yiddish Jew, and not just as culturally Jewish, is reinforced by the occasional presence of Fine's mother and grandmother. In this way, the Jewish lineage since migration in the early part of the century is made explicit. This matrilineal threat to Anglo-assimilation is mitigated by her lack of a partner. While she constantly talks about looking for a boyfriend, and occasionally goes out on dates with men the audience never properly sees, she remains single. The children she looks after are literally Anglo-Americans. The main relationship tension is with her boss, Mr Sheffield – shades of *Who's The Boss?* again. Because he is English, the disturbance of the American Anglo-assimilation pattern is lessened. So much so that, by the sixth season of the show, she can marry him.

The suppression of ethnic representation, and in this regard both Jewishness and Jews, is most obvious in the story of *The Dick Van Dyke Show* (1961–66). Written by the Jewish Carl Reiner and drawing on his own life, the show was originally called 'Head of the Family.' The pilot that went to air in 1960 had this title and Reiner himself playing Rob Petrie. It was not a success. When the show finally did get made it was with Dick Van Dyke, a gentile Midwesterner and experienced in television and musical comedy in the lead role. As Marc tells it, Rob Petrie was given a Midwestern background very similar to Van Dyke's.[54] Rob works as the senior comedy writer on a television show called *The Allen Brady Show*. One of his co-writers is Buddy, who, it turns out after an episode when he was mistakenly thought to be having an affair while actually studying for his bar mitzvah, is a Jew. The other is a single white woman called Sally. In this way we have a representation of the preferred American cultural order: a WASP family at the top with a more or less invisible, and therefore acceptable, Jew and a single Anglo-American woman, another acceptable deviant, lower in the power hierarchy. Members of other races, such as African-Americans, are excluded. Their presence would threaten the naturalisation of this image of the United States as white, suburban and middle class.

In an intriguing consideration of the Jews on the show, William Swislow has deduced that, in fact, Sally is most likely a Jew, as are the Petries' best friends, the Helpers, and a number of other characters.[55] It would seem that Reiner

accepted the Anglo-Americanisation of the show's central couple, Rob and Laura, but retained many of the other characters as Jews, simply making this almost invisible by decreasing any overtly Yiddish cultural references in their behaviour. Because of this, it is possible to describe *The Dick Van Dyke Show* as an example of Jewish, or perhaps we should say Yiddish, generalisation. It is also an example of the subaltern use of mimicry and invisibility as tactics for enabling access to the public sphere and the expression of group culture. However, marking the multicultural shift, where *Seinfeld* ambivalently presents Jewishness, *The Dick Van Dyke Show* hid it in the context of an era that privileged white middle-class Anglo-conformity.

LENNY BRUCE, WOODY ALLEN AND YIDDISH-AMERICAN HUMOUR

While Jews, and Yiddishness, were repressed from middle-class American sitcom reality in the 1960s and 1970s, stand-up comedians such as Lenny Bruce and Woody Allen, most prominently after he started directing his own films – *Take the Money and Run* (1969) was the first – worked as Jews generalising Yiddish humour, while being somewhat aided by the shift to an emphasis on culture. Kalmar has written about what he calls the 'eji,' an acronym for 'Embarrassed Jewish Individual.'[56] He argues that these people, usually the more or less assimilated Jews of modernity, including those who have made the biggest contribution to modern life, have felt awkward about their Jewish background. He suggests that they want to appear just like everybody else and make contributions to modernity that are 'universal' rather than 'Jewish' while, at the same time, drawing on their Jewish heritage. Typically, those Kalmar calls the Trotskys and the Freuds, the politicians and the intellectuals, tend to minimise their backgrounds while the Woody Allens, the comics, 'are more likely to be loudly eji' and 'make a living off their ejiness.'[57] One reason for this would seem to be that, while Jewish-background politicians and intellectuals seek to universalise themselves so that their contributions do not appear to be 'Jewish' in any way, Jewish-background comics, especially in the United States, have often used their background, and the ambivalent status of being both white and not-white, that is to say the post-war status of being the ambivalently accepted Other, to occupy a position from which they can comment on American life, or modern life more generally. The comedians have emphasised their speaking positions as a way of gaining and legitimating their critical social purchase while the politicians and scientists have erased theirs in order to establish their universalist credentials. Here, then, we can also make a distinction between the sitcom in the 1960s as representational and being preoccupied with naturalising the dominant culture's view of the United States as white and Anglo-conformist, and the stand-up comic, though not of course all comedians, as critical cultural commentators.

297

At the same time, two further processes have been at work. One is the civilising of the Yiddish Jews, and other the Yiddishing of American culture. Ioan Davies, in his discussion of Lenny Bruce, has argued that 'since Hollywood, and the mesmerization of Jews by their own images on the silver screen, the direction of the humor has been to merge their concerns into being acceptable Americans, which means that the ideology of American hyper-realism has taken over from whatever humor Jews may have had before.'[58] Davies distinguishes what he calls the *ethnic* humour of Jackie Mason from Bruce's. The hyperreality argument is not necessary here, though one can make out a good argument for the importance of the mass media as contributors to the attempt by Jews such as Bruce to generalise their Yiddish humour as compared to Mason who has been very much a comedian for Jews.

Where Reiner generalised by subterfuge, Bruce and Allen have generalised by simultaneously teaching the *goys* about the Yiddish outlook on life and reworking that subaltern outlook as an individual experience of modern life. David Biale has argued that

> Bruce saw his role as liberating American culture from the sexual repression of its Puritan heritage. Bruce's comedy was specifically aimed at the intersection between sexual and political hypocrisy in American culture. To 'talk dirty' was to outrage convention, but it was also doing publicly what everyone was already doing privately.[59]

Bruce's critique was, in the first place, of an Anglo–American civility which distinguished what was appropriate in public from what was appropriate in private, a distinction which he saw as being deceitful and self-serving.

Bruce also used the Yiddish lack of civility as a tactic to discuss issues publicly which Anglo-Americans would only normally talk about in private. These included things to do with race, drugs and sex. In actual fact, in a rather less confrontational way, *Seinfeld* does exactly the same thing. One of the best examples is the episode called 'The Contest' (episode 49) which involves George being caught masturbating by his mother and is built around a competition between Jerry, George, Kramer and Elaine to see who can go the longest without masturbating. In another episode, 'The Cigar Store Indian' (episode 71), Jerry has racial slur problems, managing to offend both the Chinese mailman and a Native American friend of Elaine's. A part of the pleasure of *Seinfeld* is being able to watch one's most personal foibles and faux pas being paraded as comedy in public. This is a far cry from the middle-class, nuclear family sitcoms of the 1960s, the didactic purpose of which was to teach people how to be civil even in the privacy of the family home.

Annette Wernblad has suggested a way that Woody Allen's and Lenny Bruce's humour can be differentiated:

> The Allen persona . . . offends and deflates the people he does not like, and his verbal triumphs and revenge are transferred to the

audience in the form of relief. Bruce, in contrast . . . ridicules even the people with whom he sympathizes and identifies, and consequently he offends and deflates himself.[60]

Bruce always positioned himself as the outsider, and in an American individualism where there was no longer a clearly bounded Yiddish community to speak from, and where he did not want to identify with the Jewish community, Bruce's Jewish *shtik* even made fun of its own Jewishness. Perhaps the character of Bruce's that is closest to describing him is his Yiddish Lone Ranger about whom he comments in his act: 'You see, you and J. Edgar Hoover and Lenny Bruce and Jonas Salk thrive upon unrest, violence and disease.'[61] Both the Lone Ranger and Lenny Bruce expect no thanks, the one for solving America's problems, the other for exposing them. Both remain outsiders.

Bruce generalised Jewishness through American culture. In one of his most well-known monologues, he divided American culture up into Jewish and *goyish*. In his words:

> Now I neologize Jewish and *goyish*. Dig: I'm Jewish. Count Basie's Jewish. Ray Charles is Jewish. Eddie Cantor's *goyish*. B'Nai Brith is *goyish*; Haddasah, Jewish. Marine corps – heavy *goyim*, dangerous. Koolaid is *goyish*. All Drake's cakes are *goyish*. Pumpernickel is Jewish . . .[62]

Italians, he goes on to say, are Jewish but Greeks are *goyish*. Broadly speaking this binary system distinguishes that which is, in Bruce's opinion, uncivil, emotionally charged, lacking in respectability, that which has *chutzpah* as compared to superficial style, from all that is civil, merely well-mannered, disciplined. In his autobiography *How to Talk Dirty and Influence People* Bruce added to his distinctions: 'To me, if you live in New York or any other big city, you are Jewish. . . . If you live in Butte, Montana, you're going to be goyish even if you're Jewish . . .'[63] Here the urban/suburban divide that I have already discussed is expressed by Bruce in Jewish/*goyish* terms. From this perspective Rob Petrie and Dick Van Dyke could be nothing but *goyish*, which was, of course, the producers' intention.

Allen's humour attempts to establish a complicity with his audience. While Allen also comments on issues, such as sex and death, which polite American society considers improper, he does so in a way which produces a new temporary subaltern group, as, in fact, does *Seinfeld* which is why, even though it was the most popular show on American television, it is still talked about as a cult program. The source of Allen's humour lies not so much in a critique of civility but in a productive transgression of civility's rules. Allen is the 'real Jew' (the phrase is Dianne Keaton's Annie Hall character's in the eponymous film), who, in the eji fashion described by Kalmar, seeks to generalise his neuroses and anxieties to the gentile population.

Because his humour functions by means of a transgression of civility, when Allen made his first serious film, *Interiors* (1978), it was premised on the politeness of civility. There is a scene in *Annie Hall* where Annie takes Alvy (Woody Allen) to meet her very civil, very *goy* New England family. At the dinner table, that most politely civilised of private sites, Alvy is unable to take part in the social conversation. His contribution is limited to humorous responses which fall on ears unable to comprehend them. *Interiors* is an expansion of this scene without the Yiddish uncivil transgression.

Focusing on sexual behaviour in Allen's films, Biale argues that

> In some of Allen's movies the Jew's sexual ambivalence inflects the gentile women and turns them into mirror images of himself: even gentile Americans become 'Jewish.' The hidden agenda is to identify America with Jewish culture by generalising Jewish sexuality and creating a safe, unthreatening space for the schlemiel as American anti-hero.[64]

Allen's own characters, we can note in passing, are all victims of shiksappeal. For Allen, as for Bruce but with a different inflection, being Jewish is not a cultural mode limited to Jews. We can generalise this insight. Gentile characters can also have Jewish elements, and apparently gentile texts, such as *The Dick Van Dyke Show*, can have Jewish moments.

I am developing the idea of 'Jewish moments' on the model of Alexander Doty's theorisation of 'queer moments.'[65] As aspects of Jewish, but perhaps I mean Yiddish, culture become pervasive in American culture, while also many characters, like those of *Seinfeld* as we shall see, are portrayed only as ambivalently Jews, the idea of Jewish moments becomes an increasingly useful analytical tool. Doty writes that 'unless the text is *about* queers . . . the queer-ness of most mass culture texts is less an essential, waiting-to-be-discovered property than the result of acts of production and reception.'[66] Here, we can substitute Jews and Jewishness for queers and queerness. From this point of view, Jewishness can be understood as a variable textual attribute not neces-sarily tied to characters identified as Jews, and any reader with varying degrees of knowledge of Jewish/Yiddish religion and culture may experience a Jewish moment.

Biale claims that the direction of Allen's films is to generalise Jewish – actually Yiddish – male sexuality as American and, as a consequence, naturalise the *schlemiel* as an American antihero. Now, such a naturalisation, 'creating a safe, unthreatening space,' would transform the *schlemiel* from a construction of a subaltern group, expressing the fears and survival tactics of that group, to membership of the dominant cultural order. In fact, this has been happening to the *schlemiel* but not as a consequence of Allen's films. Rather, these films have been one element in the long-term process of the naturalisation of the *schlemiel* as an aspect of the Yiddishification of American culture. Thus,

in many areas of American life these days, and in many popular cultural texts, one can experience a Jewish moment while identifying a *schlemiel*.

THE *SCHLEMIEL*, THE *SCHLIMAZL* AND AMERICAN CULTURE

The problem with defining a *schlemiel* is a consequence of the transformation the term has undergone in its mainstreaming from subaltern, Yiddish culture to dominant, white Anglo-American culture and thence to becoming a part of general American culture. Ruth Wisse, whose quarter-of-a-century-old book *The Schlemiel as Modern Hero*, remains the authoritative work on the history of the *schlemiel*, argues that he – and the traditional *schlemiel* was always male – evolved out of the medieval European fool. In being taken up by a subaltern group, the fool was gradually transformed from the *idiot savant*: 'Since Jewry's attitudes towards its own frailty were complex and contradictory, the schlemiel was sometimes berated for his foolish weakness, and elsewhere exalted for his hard inner strength.'[67] As Yiddish culture evolved so the *schlemiel* became one of the characteristic figures of the predicament of the community. In Wisse's words: 'At its best, the finished irony [of the *schlemiel*] holds both the contempt of the strong for the weak and the contempt of the weak for the strong, with the latter winning the upper hand.'[68]

Within the Yiddish community the term could simply describe a stupid, if at times funny, loser, but the full complexity only appears when the term is applied to a Jew in interaction with the dominant culture. In this context, the stupid Jew is transformed into a naive innocent, a man imposed upon by the unreasonable and threatening forces of the dominant culture. While he may not be able to win, the *schlemiel* is able to provide insights into the condition of the community. As a character in a joke, the *schlemiel* provides the community with an opportunity to laugh at its own circumstance and at the dominant society that has placed it in this circumstance.

Sander Gilman, in another important and insightful discussion of the *schlemiel*, provides a different genealogy. In doing so, he offers a rather more negative definition of the character. For Gilman: 'Schlemiels are fools who believe themselves to be in control of the world but are shown to the reader/ audience to be in control of nothing, not even themselves.'[69] He argues that the *schlemiel* evolved in the Enlightenment, giving the example of a number of plays including Isaac Euchel's *Reb Hennoch*, or *What Can One Do About It?*, which was written in Yiddish in the mid-1790s. Gilman writes that the *schlemiel* 'is the Jewish enlightener's attempt to use satire to cajole the reader into not being a fool.'[70] A fool, here, is a Jew who continues to follow traditional ways rather than involving himself in the Haskalah (the Jewish version of the Enlightenment). Clearly, Gilman arrives at his rather more negative definition of the *schlemiel* because of the character's polemical and political

usage by those urging Jewish engagement with modern society: you will, they suggest be a fool, and be taken advantage of, if you do not make the commitment. The engagement, it turns out, is fundamentally with civility. Almost two hundred years later, comics such as Lenny Bruce and Woody Allen reverse this use of the *schlemiel*, and, in a more traditional usage, use it as a vehicle to comment on American, and more generally modern, society. Nevertheless, for Bruce and Allen, the *schlemiel* was no longer embedded in a community, and in particular a subaltern Yiddish community. I have already discussed how Bruce was speaking as an individualised Yiddish-American, the Jewish Lone Ranger, and how Allen produced a community of complicity with his audience. In these examples we see the *schlemiel* losing his status as expressing the ambivalences of feeling of a subordinate group.

What happens to the *schlemiel* as the character becomes a part of the dominant American culture? Most typically, the *schlemiel* is returned to being a version of the fool. Coupled with the American ideology of success, the *schlemiel* becomes the naive who succeeds in spite of himself and, in the process, provides moral insights for the audience. As Wisse notes, this character is not a product of Anglo-American culture:

> Natural as his emergence within Jewish culture may have been, the loser-as-winner was not an indigenous American folk-type, and there is much in his make-up that still seems to go against the American grain. Studies of traditional American folk humor portray quite different comic heroes of a decidedly practical bent, resourceful and hard-headed pragmatists who inevitably outwit the fools, be they dimwits or woolly intellectuals.[71]

The high water mark in the Americanisation of the *schlemiel* has been the very popular film *Forrest Gump* (1994). In this film Tom Hanks plays the intellectually sub-normal Gump who becomes a star footballer, is awarded a medal for bravery in the Vietnam War, represents the United States at table tennis, meets two presidents and becomes enormously rich before finally finding love with his childhood sweetheart who is dying of AIDS related cancer. Without his legitimation in a subaltern community, the *schlemiel* becomes most straightforwardly a loser. In *Forrest Gump* the ambivalence of the Yiddish *schlemiel* is reworked in the American cultural context in a tension between what Gump, by all expectations, should be, a loser, and what he becomes, an overwhelming success. This is, if not a Yiddish moment, a Jewish-American moment.

At this point we must return to *Seinfeld*. There has been much discussion about George as a *schlemiel*. The most detailed of these is by Carla Johnson who argues that within the ensemble of characters, George plays the *schlemiel* to Jerry's *schlimazl*.[72] For Wisse, this binary pairing is American. Of all the Yiddish character-types it is these two that have flourished in the American cultural

context. Wisse writes that 'The schlemiel is the active disseminator of bad luck, and the schlimazl its passive victim. Or, more sharply defined, the schlimazl happens upon mischance. . . . The schlemiel's misfortune is his character.'[73]

In an important discussion of the *schlimazl*, Jay Boyer writes:

> Possessing a keener, more rational mind [than the *schlemiel*] the *schlimazl* tries to integrate more information than he should. Try as he might to hold one set of beliefs fixed in his mind, try as he might to maintain one logical superstructure, new information bombards him. He cannot revise quickly enough to keep up with events.[74]

This constant inadequacy to changing circumstances is a very good general description of Jerry's way of living in the world, and a very good way of understanding why he always seems so immobilised, able to comment as a comedian but not able to transform his situation. Outside of the *shtetl* the *schlimazl* has merged with the English music hall and American vaudeville role of the comic's offsider, the butt of the jokes. In short, in gentile humour the *schlimazl* has been transformed into the fall guy.[75]

George's character is descended from Woody Allen's *schlemiel*. As Jason Alexander, who plays George, has admitted: "'If you go back and look at [George's] early episodes, you're seeing a guy do a really blatant Woody Allen imitation.'"[76] However, as the character developed, George became much more self-serving and machinating, and much less self-aware, and yet stymied by his own self-awareness, than Allen's characters. Wild has insightfully noted that 'Sergeant Bilko was a manipulative and self-serving liar decades before George Costanza made a veritable art form of such bad behavior.'[77] Sergeant Bilko, from the sitcom of the same name which ran from 1955–59, starred Phil Silvers, a Yiddish-background comic who, in this show, played a *schlemiel* who, not surprisingly given the era, was never identified as Jewish.[78] In this revision of the *schlemiel*, the inability to take control of one's destiny because of the power and oppression of the dominant group is reworked as lucklessness and alternatively figured in terms of individualist ideology as a character defect. Bilko's schonky money-making schemes always ended in failure suggesting a comparison with George who is always the agent of his own failure whether it be with women or jobs or anything else. In the process, George's failure often impacts on Jerry. We can say, then, that George in particular, but also Jerry, behave as Americanised versions of Yiddish character-types.

SEINFELD AND THE REPRESENTATION OF ETHNICITY

As I have remarked, the representation of some overt Jewishness, if not of Jews, is an aspect of the cultural turn, as epitomised in American multiculturalism,

from the 1980s onwards. To ask whether the main characters on *Seinfeld* are Jews is both foolish and instructive. It is foolish because it appeals to a reductionist and simplistic understanding of who is a Jew, but it is instructive because it enables us to appreciate just how blurred the category has become – that is, the extent to which the show operates in terms of Jewish rather than Jews. When we work back from the characters of the ensemble, that is Jerry, George, Elaine and Kramer, to the people on whom they are based, we find that all of those people are identifying Jews. The same is probably true of the actors who play those characters, though there is no public evidence about Michael Richards, who plays Kramer. The blurring takes place in the characters themselves. Now, to some extent this is obviously an effect of production decisions and is a part of the history that repressed the presence of identifying Jews and overt Jewish culture on the middle-class family sitcoms of the 1950s and 1960s. I have already discussed this in the context of *Father Knows Best* and *The Dick Van Dyke Show*. I have also noted Tartikoff's comment that *Seinfeld* was 'too Jewish' and that Kramer's name was changed from Kessler.

The textual evidence for the show is confusing, indeed contradictory. An article in the *Jewish News of Greater Phoenix*, published on the web, notes the reluctance of the show's publicists to provide the characters' religious identities and goes on to cite an episode in which Kramer

> plans a Jewish singles function with authentic ethnic foods. He wants Jerry and Elaine to attend, and Elaine says, 'Well, I'm not Jewish!' To which Kramer replies, 'Neither am I.'
>
> In the same show, Kramer holds the function at the Knights of Columbus Hall, courtesy of George's dad's membership. Knights of Columbus is a Catholic organization.[79]

An alternative point of view has been put forward by Michael Elkin in an article entitled 'What's with Jerry and the Jews?' at the Jewish Communication Network website. Elkin writes:

> TV's 'Seinfeld' offers multiple signs that the characters are Jewish – the pervasive smell of kasha in Frank and Estelle's [Jerry's parents] apartment, the Costanzas rye-bread rip-off, Jerry's mention of Jerusalem in the 'Yadda Yadda Yadda' episode. Certainly the mohel episode was a tip-off that these neurotic New Yorkers knew their rites from their wrongs.[80]

He goes on to itemise the counter evidence. It should be pointed out that, amid all this ambivalence about the characters being Jews, there is much less ambiguity in the case of Elaine. The show gives a clearer impression that she is a gentile, bearing out the point about the absence of Jewish women on television. The irony being, as I have already noted, that Elaine is played by

Julia Louis-Dreyfus, who is a Jew. To the extent that the audience knows this, and to the extent that she might be recognised as appearing Jewish, a tension is set up. One that comes to the fore in the shiksappeal episode mentioned earlier. The tension is compounded by Elaine's behaviour, especially her neuroticism, which can often be read as stereotypically Jewish.

People do not seem worried by the inconsistencies. Even with the significant amount of overt Jewish references in the show, it can still be read as gentile. Elkin notes that some of his Midwestern colleagues do not think of the characters in terms of being Jews at all; the show's Jewishness is not apparent to them. He quotes one Michigan writer musing: "'I think of them as New Yorkers.'"[81] Here, the binary system I delineated earlier seems to be in operation. The ensemble are thought of as single city folk, any unusual references or incomprehensible behaviour is put down to this: they are New Yorkers. (Some would argue, and I think Lenny Bruce would be one, that New York is Jewish.) Joyce Millman, in 'Cheerio "Seinfeld"' cuts to the chase after noting the ambiguities attending the question of whether or not the characters are Jews. She writes: 'Still, "Seinfeld" was the most successful Jewish-centric sitcom ever seen in prime time.'[82] In multicultural America *Seinfeld* was allowed to be more or less overtly Jewish, while the characters were only ambiguously Jews. Nevertheless, reading it clearly remains a question of identifying Jewish moments.

There is another, more structural way of thinking about the status of the *Seinfeld* characters as Jews. At the core of the show are George, Jerry and Elaine. Jerry is the most clearly Jewish of the three. George is Jerry's best friend from high school days. Given what has been said earlier about the discursive similarities in American thinking between Jews and Italians it should not be a surprise to remember that George's family name is Costanza and he is portrayed as of Italian background when he is not Yiddish. (His background really cannot be identified as Jewish-Italian; and he is certainly of Yiddish background rather than Sephardi, which is the background of the majority of Italian Jews.) Elaine and Jerry used to go out together. Focussing on these three, and their ambiguously Jewish behaviour, the show 'normalises' them. Kramer is, here, the liminal character. He is Jerry's neighbour who has become largely incorporated into the group. His liminal status is regularly reinforced by the way he burst explosively and unexpectedly into Jerry's apartment through the unlocked front door. In modern Western society, as we have seen, the Jew has been thought of as the stranger in the nation-state, the stranger whose fantasy it is that they will be accepted.[83] Kramer, the stranger with the relatively non-Jewish name, certainly as compared to Jerry Seinfeld's name, can be read as the gentile whose stranger status is a part of the inversion of the naturalised gentile nation-state/'stranger' Jew system.

Such a reading is reinforced by the difference in world experience between Jerry and George, and Kramer. As *schlimazl* and *schlemiel* respectively, Jerry and George are luckless, a negative representation of the powerlessness of the

subaltern in Yiddish culture but here normalised as the dominant experience of the world. Kramer, however, is lucky. As Johnson notes: 'The contrast between Kramer, whose uncanny good luck relieves him of fate and control, and the luckless sidekicks creates one of the show's most powerful ironies.'[84] At the same time, reflecting the ambivalence over the Jewish status of the other characters, Kramer's gentile status is offset by his behaviour. Where George, Jerry and Elaine interact with presentations of self which are calm and polite – the content of their interaction is another matter – Kramer behaves like an uncivil Yiddisher. He is loud, brash, indiscreet, has little sense of any division between the private and the public, and tends to cause trouble as a result. These, we should remember, are the qualities that Elaine Wales was anxious about in *Gentleman's Agreement*, and which Cuddihy considers are a threat to the fragile solidarity of civility. Thus, Kramer too is ambivalently Jewish, but structurally opposed to George, Jerry and Elaine.

While being friends with the trio, Kramer is also friendly with Newman. In this system the 'Jews' are known by their given names and the 'gentiles' by their family names. While Kramer is known by his family name there was much fascination by the trio with his given name until it was revealed by his mother. Even when they find out that his name is Cosmo ('The Switch', episode 93), which is certainly not a Jewish name, everybody continues to call him Kramer.

Unlike the ambiguous status of the trio and the more borderline Kramer, Newman is clearly positioned. He is gentile and Anglo-American. He is also, as he likes to say, in a position of power. When he was first introduced, in 'The Suicide' (episode 32), Newman was the son of the owner of the building in which Jerry and Kramer have apartments. Later, it turns out that he is a postal worker and in a joke on his sense of self-importance and power he says, '"When you control the mail you control information."'[85] Newman is manipulative, treacherous and utterly self-interested. Unlike the ensemble, including Kramer, he is also threatening and aggressive. Wayne Knight, who plays Newman, has explained that 'There's a sense of blind aggression out of Newman and it's kind of like you know you can venture to the dark side.'[86] Jerry has described Newman as 'pure evil.'[87] Clearly, Newman is not just a gentile, he takes on many of the threatening traits that Yiddish Jews attributed to the gentiles in the world around them, and also many of the negative qualities. Millman has summed him up as 'a hilarious all-purpose nemesis for Jerry: equal parts empty bluster, sinister greed and snivelling cowardice.'[88] In this structural order, Newman gives subaltern meaning to George and Jerry's *schlemiel* and *schlimazl* while reinforcing the trio's position as Jews through a recognisable Jew/gentile Western relation.

Such a perception is ratcheted up a notch by Newman's Aryan connotations. First, and most obviously, there is his name. 'Newman' suggests the Nazi ideology of remaking the Germans as the Master race, with the further connotation of an intertextual and superficial echo of Nietzsche's idea of the *Übermensch*. Second, there is 'The Soup Nazi' episode (episode no 110). Here,

the main plot involves a temperamental and authoritarian soup chef whom the trio dub the 'soup Nazi'. As Millman notes, Newman 'sucked up to the take-out food despot and proved to be the perfect collaborator.'[89] Third, there is the *Schindler's List* incident. Jerry and his new girlfriend Rachel (opportunely, a likely Jewish name), are spotted by Newman making out at the film. He tells both sets of parents ('The Raincoats' [episode 79]). Jerry's Jewish parents are outraged. Newman, then, also has elements of post-Holocaust Jewish anxiety.

The construction of Newman in this way serves to anchor the show in a Yiddish experience of reality. By realising Anglo-America through a Yiddish prism, but also placing Newman as a marginal, though powerful, character (at least in his own mind) – the first idea of making him the landlord's son suggests strongly the national metaphor in which Jerry, and indeed Kramer, rent rather than own their apartments in a white-American owned block, here connoting national territory in which the renters are (like) modern Jews strangers or guests with limited rights – the show naturalises the trio's way of life as the dominant culture. However, Newman's certainty indicates that the trio are not members of the dominant social group. Their ambiguous status as Jews is reworked diegetically in the show's ambivalent Jewishness, its Jewish moments.

CIVILITY AND *SEINFELD*

As I have already indicated, what is central to *Seinfeld* is not that its characters are, or are not, Jews by any conventional definition, but its content, its Jewishness in the sense of the show's utilisation of the Yiddish problem with understanding and learning that definitionally modern, and bourgeois, way of living, civility. Cuddihy writes that

> The differentiations most foreign to the *shtetl* subculture of *Yiddishkeit* were those of public from private behavior and of manners from morals. Jews were being asked, in effect, to become bourgeois, and to become bourgeois very quickly. The problem of behavior, then, became strategic to the whole problematic of 'assimilation'.[90]

A surprisingly large amount of the time of each episode of *Seinfeld* is taken up by George, Jerry and Elaine discussing not what is proper and improper behaviour, that is to say not etiquette, but what certain forms of behaviour are, what they involve, and how to decipher what other people mean when they act in particular ways or say particular things. Peter Mehlman, a writer-producer on the show, has remarked that 'As urban and sophisticated as Jerry and George seem, they're so in the dark about so many things.'[91] In this way Jerry and George, and to a much lesser extent Elaine, behave like non-modern, indeed Yiddish, immigrants while at the same time appearing to be knowledgeable urbanites.

Etiquette is the conventionalised system in which civility is practised, and which varies from one modern society to another. Gattuso notes that 'Ironically, the zany one tends to be the group's etiquette watchdog. "Without rules there's chaos," Kramer declares at one point.'[92] At this moment, Kramer is the white American bourgeois. He has grown up naturalising the conventions of etiquette. In 'The Face Painter' (episode 103), he tells Jerry that 'Good manners are the glue of society' and goes on: 'If you don't want to be a part of society, Jerry, why don't you get in your car and move to the East Side!?!'[93] The joke, and it is a rather complicated one given the structural inversion I have been describing, is that the East Side is WASP New York. Society, here, then, is the Jewish West Side. Knowledgeable audience members will appreciate that Kramer is suggesting an extraordinary reversal, one which parallels the normalising of Jerry and his friends' uncivil behaviour.

The problematic of civility is most clearly identified in the finale to the entire show. In this one-hour episode NBC decide to make the series called *Jerry* which George suggested should be 'about nothing,' like *Seinfeld*. NBC offer George and Jerry a private plane for a trip to anywhere they would like to go. Taking along Elaine and Kramer, the four head for Paris. However, after a near accident, the plane makes an emergency landing in the white American heartland, at a small town called Latham in Massachusetts. The four are now in suburban, nuclear family land; the land of late 1950s and 1960s sitcoms, where civility is the foundation of society. In town, the four witness a robbery and car-jacking. Rather than aiding the victim they make comments to each other poking fun at him, and Kramer videos the event. The four then find themselves arrested for not helping under a new law, recently introduced in Latham, known as the Good Samaritan Law which, as the four are told by the arresting officer, 'requires you to help or assist anyone in danger so long as it is reasonable to do so.'[94] The Seinfeld four are no longer in a world where their problematically uncivil behaviour is the norm. Rather, they are now a minority group in a society of white bourgeoisie and Anglo-American culture. This, of course, is the way it really is in the United States, at least ideologically.

That the moral obligation to help a person in trouble has had to be legislated suggests that there is a certain breakdown of civility, but, as a narrative ploy, it enables social sanctioning of the four's self-centred behaviour unmodified as it is by any acceptance of a civil moral order which imposes social obligations of aid on its members. As George remarks when they are in the lock-up: 'Why would we want to help somebody? That's what nuns and Red Cross workers are for.' George completely fails to grasp that helping someone could be a social responsibility. He can only think of help as a function of specialised institutions.

If the town is represented as almost entirely white, Anglo-American (here, this does not include Yiddishers) and bourgeois, and the Seinfeld four are now positioned as Yiddishers, albeit selfish and self-centred ones – this, for me, is definitely a Jewish moment – then it is not surprising that the Seinfeld four's lawyer is African-American. Moreover, Jackie Chiles (who first appeared in

'The Maestro' [episode 107]) is also a New Yorker and does not speak in the modulated and measured tones of the civil white bourgeoisie but rants and alliterates in a highly verbal, street rap African-American working class style. Jackie may be a lawyer but he, too, in spite of being able to tell the four what they should wear to evoke the jury's sympathy, is ultimately uncivil. The times we meet him in earlier episodes he is attempting to make dubious liability claims on behalf of members of the four. He also lacks the appropriate etiquette.

There is another point to make about Jackie Chiles. He was practically the only African-American character to appear in *Seinfeld*. As I have argued elsewhere American ideas of race are founded on the 'Black–White' binary. *Seinfeld's* New York remains reassuringly white, even taking into account 'The Cigar Store Indian' episode. One other exception is 'The Diplomats' Club' (episode 102) when George has to find himself an African-American friend and tries to befriend Jerry's flea exterminator. That the show can utilise George's lack of African-American acquaintances for humour actually re-inforces the whiteness/Jewishness of its environments. *Seinfeld's* concern with race is limited to ethnicity and the ambivalent status of Jewishness. Hence, Chiles's presence is a shock and a threatening, deconstructive moment of the same order as the appearance of Mary's step-father in *There's Something About Mary*.

The prosecution, having established its case, and made certain of it by playing Kramer's video, goes on to confirm that this was not an isolated incident by bringing in witnesses who have previously fallen foul of the four's selfish and anti-social behaviour. These include Mabel Choate, from whom Jerry stole a loaf of marble rye in 'The Rye' (episode 115), Marla the Virgin who was deeply shocked at the masturbation competition ('The Content'), the bubble-boy whose anti-viral protective bubble was punctured in an argument with George ('The Bubble Boy' [episode 45]), and Sidra whose breasts Jerry gets Elaine to investigate to check if they are real ('The Implant' [episode 57]). As 'we' the television audience watch this train of witness accounts we are repositioned. Where, first time around, we were complicit with the four as they acted out our own personal fantasies, failings and foibles, now we are positioned with the white bourgeoisie, being asked to appreciate just how improper, transgressive of both etiquette and, finally, civility, the four's behaviour has been. In the end the shocked judge sentences them to one year in jail.

Seinfeld can, itself, be described as a Jewish moment, as well as offering readers Jewish moments, in that it is always already ambivalent about its Jewishness. It has, and yet has not, characters that are Jews – and, at the same time, we are now living in a period when who is a Jew is, itself, problematic and sometimes overridden by the idea of Jewish culture. The program certainly manifests Yiddish cultural aspects, such as the types of the *schlemiel* and *schlimazel*, but in forms that are quite Americanised and, clearly, given the show's immense

popularity, do not seem alien to Americans, and others, unversed in Yiddish culture. Yet, as I have argued, American society has also been, in certain ways, Yiddishised.

The very preoccupation of the show, its humorous disquisition on civility, is fundamentally Yiddish, but the accommodation with civility is, itself, a part of the history of all those who have had European bourgeois culture forced on them, from the working class to those peripherally European, and non-European, who have been colonised. In the United States, this most importantly includes African-Americans. For those who have internalised civility, *Seinfeld* provided an opportunity for them to laugh at the most private, and embarrassing, areas of life. These are areas which, normally, are not portrayed in the public sphere. In *Seinfeld*, the acceptance is made possible by way of four of the most selfish, self-centred, and yet naive, characters that have been envisaged for American television. In this, as I have noted, they follow in the footsteps of that earlier ambivalently Jewish character Sergeant Bilko.

When the moment of Jewish Otherness and commentary is not recognised, the humour of the show is enabled by the excruciating failure of etiquette in characters who either simply do not understand it or, in the main view etiquette at best as something to be disregarded or else utilised as a tactic for personal gain. In other words, the narrative reason for the humorous failure of etiquette, and the showing up of the problematic of civility, can be alternatively identified in terms of Yiddish humour or a comedy of manners. *Seinfeld*, then, is typically modern in the way that it displaces the Jewish circumstance into an apparently universal possibility of modern identification.[95] However, it does this while simultaneously, ambivalently offering itself as, ambiguously, a Jewish program in an era of ethnic identification.

NOTES

1 David Marc, in *Comic Visions: Television Comedy and American Culture*, Malden, Mass., Blackwell, 1997, notes that, in 1994–95 *Seinfeld* was the top-rating sitcom with 20.6 (p. xiv).
2 Most of this information comes from David Wild, *Seinfeld: The Totally Unauthorized Tribute [Not That There's Anything Wrong With That]*, Three Rivers Press, New York, 1988.
3 Greg Gattuso, *Seinfeld Universe: An Unauthorized Fan's-eye View of the Entire Domain*, Secaucus, N.J., Carol, 1996, p. 31.
4 Quoted here from Greg Gattuso, *Seinfeld Universe*, p. 63.
5 Quoted in David Wild, *Seinfeld*, p. 30.
6 In England *Seinfeld* was shown on BBC2 in a late evening slot. It never achieved a comparable popularity to that it attained in the USA. One possible reason for this is that English people are bound together by culture rather than civility. English sitcom humour is very often class-based and concerned with etiquette.
7 David Theo Goldberg and Michael Krausz (eds.), 'Introduction: The Culture of Identity' in *Jewish Identity*, Philadelphia, Temple University Press, 1993, p. 6.

8 On this transformation see Karen Brodkin, *How Jews Became White Folks*, New Brunswick, N.J., Rutgers University Press, 1998.

9 See, for example, chapter 4, 'Who Says I'm Lost?' in Emma Klein, *Lost Jews: The Struggle for Identity Today*, London, Macmillan, 1996.

10 Ilan Halevi, *A History of the Jews: Ancient and Modern*, trans. A.M. Berrett, London, Zed Books, 1988, p. 7.

11 John Murray Cuddihy, *The Ordeal of Civility: Freud, Marx, Lévi-Strauss and the Jewish Struggle with Modernity*, New York, Basic Books, 1974, p. 10.

12 John Murray Cuddihy, *The Ordeal of Civility*, p. 4.

13 Quoted in John Murray Cuddihy, *The Ordeal of Civility*, p. 12. Norbet Elias's work is also relevant here. See *The Civilizing Process*, trans. Edmund Jephcott, New York, Urizen Books, 1978.

14 For a discussion of the differences between the two types of state see Jon Stratton and Ien Ang, 'Multicultural Imagined Communities: Cultural Differences and National Identity in Australia and the USA', *Continuum*, vol. 8(4), 1994, pp. 124–38.

15 John Murray Cuddihy, *The Ordeal of Civility*, p. 5.

16 Elaine Marks, *Marrano as Metaphor: The Jewish Presence in French Writing*, New York, Columbia University Press, 1996, p. 145.

17 Daniel Itzkovits, 'Secret Temples' in Jonathan Boyarin and Daniel Boyarin (eds.), *Jews and Other Differences: The New Jewish Cultural Studies*, Minneapolis, University of Minnesota Press, 1997, p. 180.

18 See, most importantly, Werner Sollors, *Beyond Ethnicity: Consent and Descent in American Culture*, New York, Oxford University Press, 1986.

19 David Biale, 'Jewish Identity in the 1990s', *Tikkun*, vol. 6 (6), 1992, p. 61.

20 See, for example, Karen Brodkin Sacks, 'How Did Jews Become White Folks?' in Steven Gregory and Roger Sanjek (eds.), *Race*, New Brunswick, N.J., Rutgers University Press, 1994.

21 Karen Brodkin, *How Jews Became White*, p 63.

22 Karen Brodkin, *How Jews Became White*, p 37.

23 Ivan Kalmar, *The Trotskys, Freuds and Woody Allens: Portrait of a Culture*, Toronto, Viking, 1993, chapter 8, 'The Brooklyn Jew or the Jewish Italian'.

24 Ivan Kalmar *The Trotskys, Freuds and Woody Allens*, p 182.

25 Ivan Kalmar *The Trotskys, Freuds and Woody Allens*, p 179.

26 Norman Kleeblatt, '"Passing" into Multiculturalism' in Norman Kleeblatt (ed.), *Too Jewish? Challenging Traditional Identities*, New Brunswick, N.J., Rutgers University Press, 1996, p. 6.

27 Norman Kleeblatt, '"Passing" into Multiculturalism', p. 7.

28 David Wild, *Seinfeld*, p. 25.

29 'Jewish Family Values', http://jewishfamily.com/Features/996/tvjews2.htm.

30 Terry Barr, 'Stars, Light, and Finding the Way Home: Jewish Characters in Contemporary Film and Television', *Studies in Popular Culture*, vol. 15 (2), 1993, p. 87.

31 Terry Barr, 'Stars, Light, and Finding the Way Home', p. 87.

32 In Britain the construction of the Jew as the stranger who came to stay is even more obvious in the sitcom *Birds of a Feather* (1989–). In this long-running series two gentile sisters are living together while their husbands do time in gaol. Their neighbour is Dorien Green, a Jewish woman. Much of each episode takes place in the sisters' kitchen where Dorien comes to visit. She literally enacts the role of the stranger who comes to stay, often having to be turfed out by Sharon and Tracey. Dorien's character is composed of many of the stereotypical elements of the 'Jewess.' For example, she is portrayed as self-obsessed if not narcissistic, as

conniving and as sexually insatiable, constantly cuckolding Marcus, her husband – who is portrayed as weak and feminised, a stereotypical view of Jewish men – with younger men.

33 Terry Barr, 'Stars, Light, and Finding the Way Home', p. 94.

34 On *The Goldbergs*, which started out as a radio programme, see Donald Weber, 'The Jewish-American World of Gertrude Berg: *The Goldbergs* on Radio and Television, 1930–1950' in Joyce Antler (ed.), *Talking Back: Images of Jewish Women in American Popular Culture*, Hanover, Brandeis University Press, 1998.

35 George Lipsitz, 'The Meaning of Memory: Family, Class, and Ethnicity in Early Network Television Programs', *Cultural Anthropology*, vol. 1 (4), 1986, pp. 355–87.

36 Michael Rogin, *Blackface, White Noise: Jewish Immigrants in the Hollywood Melting Pot*, Berkeley, University of California Press, 1996, p. 11.

37 David Marc, *Comic Visions*, p. 35.

38 George Lipsitz, 'The Meaning of Memory', p. 373.

39 David Marc, *Comic Visions*, p. 35.

40 David Marc, *Comic Visions*, p. 35.

41 George Lipsitz, 'The Meaning of Memory', p. 372.

42 David Marc, *Comic Visions*, p. 43.

43 David Marc, *Comic Visions*, p. 46.

44 For a detailed discussion of *The Cosby Show* see Sut Jhally and Justin Lewis, *Enlightened Racism: The Cosby Show, Audiences, and the Myth of the American Dream*, Boulder, Westview Press, 1992.

45 Herman Gray, in *Watching Race: Television and the Struggle for 'Blackness'*, Minneapolis, University of Minnesota Press, 1995, has a much more positive opinion about *The Cosby Show*. He argues, among other things, that, 'the show's discursive relationship to television's historical treatment of African Americans and contemporary social and cultural debates (about the black underclass, the black family, and black moral character) helps to explain its insistent recuperation of African American social equality (and competence), especially through the trope of the stable and unified black middle-class family' (p. 80).

46 David Marc, *Comic Visions*, p. 182.

47 The reference is signalled in the narrative when Krusty's father, in dismay, cries: '*Oy vey's mir*! You have brought shame on our family! Oh, if you were a musician or a jazz singer, this I could forgive' (Rabbi Hyman Krustofsy is voiced by Jackie Mason).

48 Michael Rogin, *Blackface, White Noise*, p. 86.

49 Susan Kray, 'Orientalization of an "Almost White" Woman: the Interlocking Effects of Race, Class, Gender, and Ethnicity in American Mass Media', *Critical Studies in Mass Communication*, no. 10, 1993, p. 353.

50 David Marc, *Comic Visions*, pp. 197–8.

51 Joyce Antler provides a rereading of *The Nanny* in 'Epilogue: Jewish Women on Television: Too Jewish or Not Enough?' in Joyce Antler (ed.), *Talking Back*.

52 This précis is from Marjorie Garber, *Symptoms of Culture*, New York, Routledge, 1998, p. 80.

53 John Murray Cuddihy, *The Ordeal of Civility*, pp. 13–14.

54 David Marc, *Comic Visions*, p. 81.

55 William Swislow, 'Interesting Ideas: Gentiles in Paradise' at www.mcs.com/-.

56 Ivan Kalmar, *The Trotskys, Freuds, and Woody Allens*, passim.

57 Ivan Kalmar, *The Trotskys, Freuds, and Woody Allens*, p. 20.

58 Ioan Davies, 'Lenny Bruce: Hyperrealism and the Death of Jewish Tragic Humor', *Social Text*, vol. 22, 1989, p. 113.

59 David Biale, *Eros and the Jews:From Biblical Israel to Contemporary America*, Berkeley, University of California Press, 1997, p. 216.

60 Annette Wernblad, *Brooklyn Is Not Expanding: Woody Allen's Comic Universe*, Rutherford, N.J., Fairleigh Dickinson University Press, 1994, p. 24.
61 John Cohen (ed.), *The Essential Lenny Bruce*, London, Open Gate Books, 1973, p. 31.
62 John Cohen, *The Essential Lenny Bruce*, p. 56.
63 Quoted in David Biale, *Eros and the Jews*, p. 216.
64 David Biale, *Eros and the Jews*, p. 207.
65 Alexander Doty, *Making Things Perfectly Queer: Interpreting Mass Culture*, Minneapolis, University of Minnesota Press, 1993, p. 3.
66 Alexander Doty, *Making Things Perfectly Queer*, p. xi.
67 Ruth Wisse, *The Schlemiel as Modern Hero*, Chicago, University of Chicago Press, 1971, p. 5.
68 Ruth Wisse, *The Schlemiel as Modern Hero*, p. 6.
69 Sander Gilman, *Jewish Self-Hatred: Anti-Semitism and the Hidden Language of the Jews*, Baltimore, The Johns Hopkins University Press, 1986, p. 112.
70 Sander Gilman, *Jewish Self-Hatred*, p. 112.
71 Ruth Wisse, *The Schlemiel as Modern Hero*, p. 74.
72 Carla Johnson, 'Luckless in New York', *Journal of Popular Film and Television*, vol. 22 (3), 1994, pp. 116–24.
73 Ruth Wisse, *The Schlemiel as Modern Hero*, p. 14.
74 Jay Boyer, 'The *Schlemiel*: Black Humor and the *Shtetl* Tradition' in Avner Zvi and Anat Zajdman (eds.), *Semites and Stereotypes: Characteristics of Jewish Humor*, Westport, Conn., Greenwood Press, 1993, p. 6.
75 Jay Boyer, 'The *Schlemiel*', p. 6.
76 Quoted in Greg Gattuso, *Seinfeld Universe*, p. 8.
77 David Wild, *Seinfeld*, p. 17.
78 Phil Silvers' parents migrated from a *shtetl* called Kamenets Podolsk near the Polish border around the turn of the century. Phil Silvers' autobiography is (with Robert Saffron) *The Laugh Is On Me*, Englewood Cliffs, N.J., Prentice Hall, 1973.
79 'To be or not to be . . . Jewish', *Jewish News of Greater Phoenix* at http://www.jew-ishaz.com/jewishnews/970905/tv.sctml.
80 Michael Elkin, 'What's with Jerry and the Jews: Getting Ready to Part Company With His Funniness' at http://www.jcn.
81 Michael Elkin, 'What's with Jerry and the Jews'.
82 Joyce Millman, 'Cheerio "Seinfeld"', *Salon* at http://www.salonmag.com.
83 See, especially, Zygmunt Bauman, *Modernity and Ambivalence*, Cambridge, Polity Press, 1991.
84 Carla Johnson, 'Luckless in New York', p. 119.
85 Quoted here from Greg Gattuso, *Seinfeld Universe*, p. 115. Gattuso asserts that Newman utters this line in 'The Lip Reader' (episode 67).
86 Greg Gattuso, *Seinfeld Universe*, p. 155.
87 Greg Gattuso, *Seinfeld Universe*, p. 18.
88 Joyce Millman, 'Cheerio "Seinfeld"'.
89 Joyce Millman, 'Cheerio "Seinfeld"'.
90 John Murray Cuddihy, *The Ordeal of Civility*, pp. 12–13.
91 Mehlman quoted in Greg Gattuso, *Seinfeld Universe*, p. 5.
92 Greg Gattuso, *Seinfeld Universe*, p. 15.
93 Quoted in Greg Gattuso, *Seinfeld Universe*, p. 15.
94 Good Samaritan laws are quite common in the United States but their purpose is quite different. They aim to protect people, such as doctors, who go to help a person, from being sued.

95 Of course, the more pragmatic reason is network television's attempt to garner the largest possible audience. There are a couple of things to say about this. First, we need to note the impact of cable television and the trend of network, free-to-air, broadcasting to become a residual category in an era of narrow-casting and niche-programming. Second, in the rare instances when ratings are broken down by race, it seems that *Seinfeld*'s audience is predominantly white, including, needless to say, Jewish. To put it another way, it seems that African-Americans do not tend to watch the program.

BIBLIOGRAPHY

Alcalay, Ammiel, *After Jews and Arabs: Remaking Levantine Culture*, Minneapolis, University of Minnesota Press, 1993.

Alderman, Geoffrey, 'British Jewry: Religious Community or Ethnic Minority?' in Jonathan Webber (ed.) *Jewish Identities in the New Europe*, London, Littman Library of Jewish Civilisation, 1994.

Alderman, Geoffrey, 'English Jews or Jews of the English Persuasion? Reflections on the Emancipation of Anglo-Jewry' in Pierre Birnbaum and Ira Katznelson (eds.), *Paths of Emancipation: Jews, States, and Citizenship*, Princeton, N.J., Princeton University Press, 1995.

Allen, Theodore W., *The Invention of the White Race*, vol. 1, London, Verso, 1994.

Alloula, Malek, *The Colonial Harem*, Minneapolis, University of Minnesota Press, 1986.

Althusser, Louis, 'Ideology and Ideological State Apparatuses' in *'Lenin and Philosophy' and Other Essays*, trans. Ben Brewster, London, Monthly Review Press, 1971.

Anderson, Benedict, *Imagined Communities*, London, Verso, rev. ed., 1991.

Anderson, Perry, 'Components of the National Culture' in Alexander Cockburn and Robin Blackburn (eds.), *Student Power*, Harmondsworth, Penguin Books, 1969.

Ang, Ien, 'Can One Say No to Chineseness: Pushing the Limits of the Diasporic Paradigm', *Boundary 2*, 1998, pp. 223–42.

Ang, Ien, and Jon Stratton, 'Asianing Australia: Notes Towards a Transnationalism in Cultural Studies', *Cultural Studies*, vol. 10 (1), 1996, pp. 16–36.

Ang, Ien, and Jon Stratton, 'Multiculturalism in Crisis: The New Politics of Race and National Identity in Australia', *Topia: Canadian Journal of Cultural Studies*, vol. 1 (2), 1998, pp. 22–41.

Ang, Ien, and Jon Stratton, 'The Singapore Way of Multiculturalism: Western Concepts/Asian Values', *New Formations*, no. 31, 1997, pp. 51–66.

Antin, Mary, *The Promised Land*, Boston, Houghton Mifflin, 1955.

Antler, Joyce, 'Epilogue: Jewish Women on Television: Too Jewish or Not Enough?' in Joyce Antler (ed.), *Talking Back: Images of Jewish Women in American Popular Culture*, Hanover, Brandeis University Press, 1998.

Appadurai, Arjun, 'Diversity and Disciplinarity as Cultural Artefacts' in Cary Nelson and Dilip Parameshwar Gaonkar (eds.), *Disciplinarity and Dissent in Cultural Studies*, New York, Routledge, 1996.

Appadurai, Arjun, 'Patriotism and Its Futures' in *Modernity at Large*, Minneapolis, University of Minnesota Press, 1996.

Arnold, Matthew, *Complete Prose Works*, vol. 5: *Culture and Anarchy*, Ann Arbor, University of Michigan Press, 1965.

Avineri, Shlomo, *The Making of Modern Zionism: The Intellectual Origins of the Jewish State*, London, Weidenfeld and Nicolson, 1981.

Azoulay, Katya, *Black, Jewish and Interracial: It's Not the Color of Your Skin, but the Race of Your Kin*, Durham, N.C., Duke University Press, 1997.

Baldick, Chris, *The Social Mission of English Criticism 1848–1932*, Oxford, Clarendon Press, 1983.

Balibar, Etienne, 'The Nation Form: History and Ideology', trans. Chris Turner, in Etienne Balibar and Immanuel Wallerstein, *Race, Nation, Class: Ambiguous Identities*, London, Verso, 1991.

Bammer, Angelika (ed.), *Displacements: Cultural Identities in Question*, Theories of Contemporary Culture, vol. 15, Bloomington, Indiana University Press, 1994.

'Banned Historian Puts PM to the Test', *The Australian*, September 25, 1996, p. 1.

Barkan, Elazar, and Marie Denise Shelton (eds.), *Borders, Exiles, Diasporas: Cultural Sitings*, Stanford, Stanford University Press, 1998.

Barr, Terry, 'Stars, Light, and Finding the Way Home: Jewish Characters in Contemporary Film and Television', *Studies in Popular Culture*, vol. 15 (2), 1993, pp. 87–100.

Bartrop, Paul R., *Australia and the Holocaust, 1933–1945*, Melbourne, Australian Scholarly Publishing, 1994.

Bartrop, Paul R., 'Indifference and Inconvenience: Jewish Refugees and Australia, 1933–1945' in Paul R. Bartrop (ed.), *False Havens: The British Empire and the Holocaust*, Lanham, University Press of America, 1995.

Bauman, Zygmunt, *Modernity and Ambivalence*, Cambridge, Polity Press, 1991.

Bauman, Zygmunt, *Modernity and the Holocaust*, Cambridge, Polity Press, 1989.

Beik, Paul H. (ed.), *The French Revolution*, London, Macmillan, 1971.

Bellamy, Elizabeth, *Affective Genealogies: Psychoanalysis, Postmodernism, and the 'Jewish Question' after Auschwitz*, Lincoln, University of Nebraska Press, 1997.

Bendersky, Joseph W., 'The Disappearance of Blonds: Immigration, Race and the Reemergence of "Thinking White"', *Telos*, no. 104, 1995, pp. 135–57.

Ben-Gurion, David, 'The Imperatives of the Jewish Revolution' in Arthur Hertzberg (ed.), *The Zionist Idea: A Historical Analysis and Reader*, Westport, Conn., Greenwood Press, 1959.

Bennett, David (ed.), *Multicultural States: Rethinking Difference and Identity*, London, New York, Routledge, 1998.

Bering, Dietz, *The Stigma of Names: Antisemitism in German Daily Life, 1812–1933*, Cambridge, Polity Press, 1992.

Berlin, Isaiah, *Four Essays on Liberty*, Oxford, Oxford University Press, 1969.

Berman, Paul (ed.), *Blacks and Jews: Alliances and Arguments*, New York, Delacorte Press, 1994.

Bershtel, Sara, and Allen Graubard, *Saving Remnants: Feeling Jewish in America*, Berkeley, University of California Press, 1993.

Bhabha, Homi, 'Of Mimicry and Man' in Homi Bhabha, *The Location of Culture*, London, Routledge, 1994.

Bhabha, Homi, 'The Other Question' in Homi Bhabha, *The Location of Culture*, London, Routledge, 1994.

Biale, David, *Eros and the Jews: From Biblical Israel to Contemporary America*, Berkeley, University of California Press, 1997.

Biale, David, 'Jewish Identity in the 1990s', *Tikkun*, vol. 6 (6), 1991, pp. 60–2.

Biale, David, Michael Galchinsky and Susannah Herschel (eds.), *Insider/Outsider: American Jews and Multiculturalism*, Berkeley, University of California Press, 1998.

Birnbaum, Pierre, and Ira Katznelson (eds.), *Paths of Emancipation: Jews, States and Citizenship*, Princeton, N.J., Princeton University Press, 1995.

Blakeney, Michael, *Australia and the Jewish Refugees 1933–1948*, Sydney, Croom Helm, 1985.

Bourne, Randolph, 'Toward a Transnational America', republished in Leo Schwartz (ed.), *The Menorah Treasury*, Philadelphia, Jewish Publication Society of America, 1964.

Bourne, Randolph, 'Transnational America' in Van Wyck Brooks (ed.), *History of a Literary Radical*, New York, B.W. Huebsch, 1920.

Boyarin, Daniel, '*Épater l'Embourgeoisement*: Freud, Gender and the (De)Colonized Psyche', *Diacritics*, vol. 24(1), 1994, pp. 17–41.

Boyarin, Daniel, 'Masada or Yavneh? Gender and the Arts of Jewish Resistance' in Jonathan Boyarin and David Boyarin (eds.), *Jews and Other Differences: The New Jewish Cultural Studies*, Minneapolis, University of Minnesota Press, 1997.

Boyarin, Daniel, *Unheroic Conduct: The Rise of Heterosexuality and the Invention of the Jewish Man*, Berkeley, University of California Press, 1997.

Boyarin, Daniel, and Jonathan Boyarin, 'Diaspora: Generation and the Ground of Jewish Identity', *Critical Inquiry*, vol. 19(4), 1993, pp. 693–725.

Boyarin, Daniel, and Jonathan Boyarin, 'Diaspora: Generation and the Ground of Jewish Identity' in Kwame Anthony Appiah and Henry Louis Gates jnr. (eds.), *Identities*, Chicago, University of Chicago Press, 1995.

Boyarin, Jonathan, *Storm from Paradise: The Politics of Jewish Memory*, Minneapolis, University of Minnesota Press, 1992.

Boyarin, Jonathan, *Thinking in Jewish*, Chicago, University of Chicago Press, 1996.

Boyer, Jay, 'The *Schlemiel*: Black Humor and the *Shtetl* Tradition' in Avner Ziv and Anat Zajdman (eds.), *Semites and Stereotypes: Characteristics of Jewish Humor*, Westport, Conn., Greenwood Press, 1993.

Brah, Avtar, *Cartographies of Diaspora: Contesting Identities*, London, Routledge, 1996.

Brawley, Sean, *The White Peril: Foreign Relations and Asian Immigration to Australasia and North America 1919–1978*, Sydney, University of New South Wales Press, 1995.

Brennan, Timothy, *At Home in the World: Cosmopolitanism Now*, Cambridge, Mass., Harvard University Press, 1997.

Brettschneider, Maria (ed.), *The Narrow Bridge: Jewish Views on Multiculturalism*, New Brunswick, N.J., Rutgers University Press, 1996.

Briggs, Asa, 'The Language of "Class" in Early Nineteenth-Century England' in Ron Neale (ed.), *History and Class: Essential Readings in Theory and Interpretation*. Oxford, Basil Blackwell, 1983.

Brodkin, Karen, *How Jews Became White Folks and What That Says About Race in America*, New Brunswick, N.J., Rutgers University Press, 1998.

Brodkin Sacks, Karen, 'How Did Jews Become White Folks?' in Steven Gregory and Roger Sanjek (eds.), *Race*, New Brunswick, N.J., Rutgers University Press, 1994.

Cagidementriu, Alide, 'A Plea for Fictional Histories and Old-Time "Jewesses"' in Werner Sollors (ed.), *The Invention of Ethnicity*, New York, Oxford University Press, 1989.

Caputo, John D., *The Prayers and Tears of Jacques Derrida: Religion without Religion*, Bloomington, Indiana University Press, 1997.

Carter, Paul, *Living In a New Country: History, Travelling and Language*, London, Faber and Faber, 1992.

Castles, Stephen, et al. (eds.), *Mistaken Identity: Multiculturalism and Demise of Nationalism in Australia*, Sydney, Pluto Press, 1988.

Chambers, Ian, *Migrancy, Culture, Identity*, London, Routledge, 1994.

Chen, Kuan-Hsing, 'The Formation of a Diasporic Intellectual: An Interview With Stuart Hall' in Kuan-Hsing Chen and David Morley (eds.), *Stuart Hall: Critical Dialogues in Cultural Studies*, New York, Routledge, 1996.

Cheyette, Bryan, *Constructions of 'the Jew' in English Literature and Society: Racial Representations 1875–1945*, Cambridge, Cambridge University Press, 1993.

Cheyette, Bryan, and Laura Marcus, *Modernity, Culture and 'the Jew'*, Stanford, Stanford University Press, 1998.

Clifford, James, 'Diasporas' in James Clifford, *Routes: Travel and Translation in the Late Twentieth Century*, Cambridge, Mass., Harvard University Press, 1997.

Cohen, John (ed.), *The Essential Lenny Bruce*, London, Open Gate Books, 1973.

Cohen, Philip, 'The Perversions of Inheritance: Studies in the Making of Multi-Racist Britain' in Philip Cohen and Harwant S. Bains (eds.), *Multi-Racist Britain*, London, Macmillan, 1988.

Cohn, Norman, *Warrant for Genocide*, Harmondsworth, Penguin Books, 1970.

Cohn-Sherbok, Dan, *The Jewish Faith*, London, SPCK, 1993.

'Congressional Committee on Immigration', extracted in Paul Mendes-Flohr and Jehuda Reinharz (eds.), *The Jew in the Modern World: A Documentary History*, New York, Oxford University Press, 1980.

Constant, Benjamin, *Political Writings*, B. Fontana (ed.), Cambridge, Cambridge University Press, 1988.

Conzen, Kathleen Neils, et al., 'The Invention of Ethnicity: A Perspective from the USA', *Journal of American Ethnic History*, vol. 12 (1), 1992, pp. 3–41.

Cuddihy, John Murray, *The Ordeal of Civility: Freud, Marx, Lévi-Strauss, and the Jewish Struggle with Modernity*, New York, Basic Books, 1974.

Davies, Ioan, *Cultural Studies and Beyond: Fragments of Empire*, New York, Routledge, 1995.

Davies, Ioan, 'Lenny Bruce: Hyperrealism and the Death of Jewish Tragic Humor', *Social Text*, vol. 22, 1989, pp. 92–114.

Davies, William, *The Territorial Dimension of Judaism*, Minneapolis, Fortress Press, 1991.

Davis, Moshe, *With Eyes Toward Zion*, America and the Holy Land IV, Westport, Conn., Praeger, 1995.

Day, Richard, 'Constructing the Official Canadian: A Geneology of the Mosaic Metaphor in State Policy Discourse', *Topia: Canadian Journal of Cultural Studies*, vol. 1 (2), 1998, pp. 42–66.

Demidenko, Helen, *The Hand That Signed The Paper*, Sydney, Allen and Unwin, 1994.

Derrida, Jacques, *Archive Fever: A Freudian Impression*, trans. Eric Prenowitz, Chicago, University of Chicago Press, 1996.

Derrida, Jacques, 'Circumfession' in Geoffrey Bennington/Jacques Derrida, *Jacques Derrida*, trans. Geoffrey Bennington, Chicago, University of Chicago Press, 1993.

Dershowitz, Alan, *Chutzpah*, Boston, Little, Brown, 1991.

Deshen, Shlomo, and Walter P. Zenner (eds.), *Jews among Muslims: Communities in the Precolonial Middle East*, London, Macmillan, 1996.

Dinnerstein, Leonard, *Anti-Semitism in America*, New York, Oxford University Press, 1994.

Dinnerstein, Leonard, *The Leo Frank Case*, New York, Columbia University Press, 1968.

Dinnerstein, Leonard, *Uneasy at Home: Antisemitism and the American Jewish Experience*, New York, Columbia University Press, 1987.

Diversity Counts: A Handbook on Ethnicity Data, Canberra, AGPS, 1994.

Docker, John, *Postmodernism and Popular Culture: A Cultural History*, Cambridge, Cambridge University Press, 1994.

Dolar, Mladen, '"I Shall Be with You on Your Wedding Night": Lacan and the Uncanny', *October*, no. 58, 1991, pp. 5–23.

Doty, Alexander, *Making Things Perfectly Queer: Interpreting Mass Culture*, Minneapolis, University of Minnesota Press, 1993.

Drechler, Jacob, *Black Homelands/Black Diaspora: Crosscurrents of the African Relationship*, Port Washington, N.Y., Kennikat Press, 1975.

Dubow, Saul, *Illicit Union: Scientific Racism in Modern South Africa*, Cambridge, Cambridge University Press, 1995.

Dyer, Richard, *White*, London, New York, Routledge, 1997.

Eilberg-Schwartz, Howard (ed.), *People of the Body: Jews and Judaism from an Embodied Perspective*, Albany, State University of New York Press, 1992.

Eisen, Arnold, *Galut: Modern Jewish Reflection on Homelessness and Homecoming*, Bloomington, Indiana University Press, 1986.

Eisen, Arnold, *The Chosen People in America: A Study in Jewish Religious Ideology*, Bloomington, Indiana University Press, 1983.

Eisenberg, Azriel (ed.), *The Golden Land: A Literary Portrait of American Jewry, 1654 to the Present*, New York, T. Yoseloff, 1964.

Eisenstadt, Shmuel, 'The American Jewish Experience and American Pluralism: A Comparative Perspective' in Seymour Martin Lipset (ed.), *American Pluralism and the Jewish Community*, New Brunswick, Transaction, 1990.

Elias, Norbet, *The Civilizing Process*, trans. Edmund Jephcott, New York, Urizen Books, 1978.

Eliot, T. S., *Notes Towards the Definition of Culture*, London, Faber and Faber, 1948.

Elkin, Michael, 'What's with Jerry and the Jews: Getting Ready to Part Company With His Funniness' at http://www.jcn.

Encel, Sol, 'Anti-Semitism and Prejudice in Australia', *Without Prejudice*, vol. 1, 1990, pp. 37–47.

Erdman, Harley, *Staging the Jew: The Performance of an American Ethnicity 1860–1920*, New Brunswick, N.J., Rutgers University Press, 1997.

Ettinger, Shmuel, and Israel Bartal, 'The First Aliyah: Ideological Roots and Practical Accomplishments', in Jehuda Reinharz and Anita Shapira (eds.), *Essential Papers on Zionism*, New York, New York University Press, 1995.

Evron, Boas, *Jewish State or Israeli Nation?*, Bloomington, Indiana University Press, 1997.

Fein, Helen, *Genocide: A Sociological Perspective*, London, Sage, 1990.

Finkielkraut, Alain, *The Imaginary Jew*, trans. Kevin O'Neill and David Suchoff, Lincoln, University of Nebraska Press, 1994.

Ford, Henry (ed.), *The International Jew: The World's Foremost Problem;* republished Los Angeles, Christian Nationalist Crusade, no date.

Fortis, Umberto, *The Ghetto in the Lagoon: A Guide to the History and Art of the Venetian Ghetto*, Venice, Storti, 1988.

Foster, Lois, and David Stockley, *Multiculturalism: The Changing Australian Paradigm*, Cleveland, Multilingual Matters, 1984.

Foucault, Michel, *Madness and Civilization: A History of Insanity in the Age of Reason*, New York, Vintage, 1973.

Frankel, Jonathan, and Steven Zipperstein (eds.), *Assimilation and Community: The Jews in Nineteenth Century Europe*, Cambridge, Cambridge University Press, 1992.

Frankenberg, Ruth, *White Women, Race Matters: The Social Construction of Whiteness*, Minneapolis, University of Minnesota Press, 1993.

Freiberg, Freda, 'Lost in Oz? Jews in the Australian Cinema', *Continuum: The Australian Journal of Media and Culture*, vol. 8 (2), 1994, pp. 196–205.

Freud Lowenstein, Andrea, *Loathsome Jews and Engulfing Women: Metaphors of Projection in the Works of Wyndham Lewis, Charles Williams and Graham Greene*, New York, New York University Press, 1993.

Freud, Sigmund, 'Little Hans: Analysis of a Phobia in a Five-Year-Old Child' in James Strachey (ed.), *The Standard Edition of the Complete Psychological Works of Sigmund Freud*, vol. 10, London, The Hogarth Press, 1958.

Freud, Sigmund, *Moses and Monotheism* in James Strachey (ed.), *The Standard Edition of the Complete Psychological Works of Sigmund Freud*, vol. 23, London, The Hogarth Press, 1958.

Freud, Sigmund, *The Interpretation of Dreams*, Harmondsworth, Penguin Books, 1976.

Freud, Sigmund, 'The "Uncanny"' in James Strachey (ed.), *The Standard Edition of the Complete Psychological Works of Sigmund Freud*, vol. 17, London, The Hogarth Press and the Institute of Psychoanalysis, 1962.

Freud, Sigmund, 'The Neuro-Psychoses of Defence' in James Strachey (ed.), *The Standard Edition of the Complete Psychological Works of Sigmund Freud*, vol. 3, London, The Hogarth Press and the Institute of Psychoanalysis, 1962.

Freud, Sigmund, *Totem and Taboo* in James Strachey (ed.), *The Standard Edition of the Complete Psychological Works of Sigmund Freud*, vol. 13, London, The Hogarth Press and the Institute of Psychoanalysis, 1962.

Friedlander, Saul (ed.), *Probing the Limits of Representation: Nazism and the 'Final Solution'*, Cambridge, Mass., Harvard University Press, 1992.

Fryman, Daniel, *If I Were the Kaiser*, extracted in Richard Levy (ed.), *Antisemitism in the Modern World: An Anthology of Texts*, Lexington, Mass., D.C. Heath, 1991.

Gabler, Neal, *An Empire of Their Own: How the Jews Invented Hollywood*, New York, Doubleday, 1989.

Galbally, Frank, *Evaluation of Post-Arrival Programs and Services*, Canberra, AGPS, 1978.

Galbally, Frank, *The Report on the Review of Post-Arrival Programs and Services to Migrants*, Melbourne, The Australian Institute for Multicultural Affairs, 1982.

Galchinsky, Michael, 'Glimpsing *Golus* in the Golden Land: Jews and Multiculturalism in America', *Judaism*, vol. 43 (4), 1994, pp. 360–8.

Gale, Naomi, 'A Case of Double Rejection: The Immigration of Sephardim to Australia', *New Community*, vol. 20 (2), 1994, pp. 269–86.

Garber, Marjorie, *Symptoms of Culture*, New York, Routledge, 1998.

Gattuso, Greg, *Seinfeld Universe: An Unauthorized Fan's-eye View of the Entire Domain*, Secaucus, N.J., Carol, 1996.

Gay, Peter, *A Godless Jew: Freud, Atheism and the Making of Psychoanalysis*, New Haven, Yale University Press, 1987.

Geller, Jay, 'Judenzopf/Chinesenzopf: Of Jews and Queues', *Positions*, vol. 2(3), 1994, pp. 500–37.

Gellner, Ernest, *Nations and Nationalism*, Oxford, Blackwell, 1983.

Gettler, Leon, *An Unpromised Land*, South Fremantle, Fremantle Arts Centre Press, 1993.

Getzler, Israel, *Neither Toleration nor Favour: The Australian Chapter of Jewish Emancipation*, Melbourne, Melbourne University Press, 1970.

Giddens, Anthony, *A Contemporary Critique of Historical Materialism*, vol. 2, Berkeley, University of California Press, 1985.

Gilman, Sander, *Franz Kafka, the Jewish Patient*, New York, Routledge, 1991.

Gilman, Sander, *Jewish Self-Hatred: Anti-Semitism and the Hidden Language of the Jews*, Baltimore, The Johns Hopkins University Press, 1986.

Gilman, Sander, *Jews in Today's German Culture*, Bloomington, Indiana University Press, 1995.

Gilman, Sander, 'The Frontier as a Model for Jewish History', given as a plenary presentation at the 'Jewries at the Frontier' conference, The Isaac and Jessie Kaplan Centre for Jewish Studies, University of Cape Town, South Africa, August, 1996.

Gilman, Sander, *The Jew's Body*, New York, Routledge, 1991.

Gilman, Sander, 'The Jewish Nose' in *The Jew's Body*, New York, Routledge, 1991.

Gilroy, Paul, 'Cultural Studies and Ethnic Absolutism' in Lawrence Grossberg et al. (eds.), *Cultural Studies*, New York, Routledge, 1992.

Gilroy, Paul, *Small Acts: Thoughts on the Politics of Black Cultures*, London, Serpent's Tail, 1993.

Ginsberg, Elaine, *Passing and the Fictions of Identity*, Durham, N.C., Duke University Press, 1996.

Giroux, Henry, *Living Dangerously: Multiculturalism and the Politics of Difference*, New York, P. Lang, 1993.

Glazer, Nathan, *We Are All Multiculturalists Now*, Cambridge, Mass., Harvard University Press, 1997.

Goffman, Erving, *Asylums: Essays on the Social Situation of Mental Patients and Other Inmates*, Garden City, N.Y., Anchor Books, Harmondsworth, Penguin Books, 1968.

Goffman, Erving, *The Presentation of Self in Everyday Life*, London, Allen Lane, 1969.

Goldberg, David Theo, and Michael Krausz (eds.), *Jewish Identity*, Philadelphia, Temple University Press, 1993.

Goldberg, Harvey E. (ed.), *Sephardi and Middle Eastern Jewries: History and Culture in the Modern Era*, Bloomington, Indiana University Press, 1996.

Gordon, Milton, *Assimilation in American Life: The Role of Race, Religion and National Origins*, New York, Oxford University Press, 1964.

Goren, Arthur (ed.), *Dissenter in Zion: From the Writings of Judah Magnes*, Cambridge, Mass., Harvard University Press, 1982.

Gouttman, Rodney, 'A Jew and Coloured Too! Immigration of "Jews of Middle East Origin" to Australia, 1949–58', *Immigrants and Minorities*, vol. 12 (2), 1993, pp. 75–91.

Grant, Linda, *Remind Me Who I Am, Again*, London, Granta Books, 1998.

Gray, Herman, *Watching Race: Television and the Struggle for "Blackness"*, Minneapolis, University of Minnesota Press, 1995.

Grinberg, Leon, and Rebecca Grinberg, *Psychoanalytic Perspectives on Migration and Exile*, New Haven, Yale University Press, 1989.

Grosz, Elizabeth, *Jacques Lacan: A Feminist Introduction*, London, Routledge, 1990.

Gunew, Sneja, *Framing Marginality: Multicultural Literary Studies*, Carlton, Melbourne University Press, 1994.

Haddad, Gérard, 'Judaism in the Life and Work of Jacques Lacan: A Preliminary Study', *Yale French Studies*, no. 85, 1994, pp. 201–16.

Hage, Ghassan, 'Locating Multiculturalism's Other: A Critique of Practical Tolerance', *New Formations*, vol. 24, 1994, pp. 19–34.

Hage, Ghassan, *White Nation: Fantasies of White Supremacy in a Multicultural Society*, Sydney, Pluto Press, 1998.

Halevi, Ilan, *A History of the Jews: Ancient and Modern*, trans. A. M. Berrett, London, Zed Books, 1988.

Hall, Stuart, 'Cultural Studies and Its Theoretical Legacies' in Lawrence Grossberg et al. (eds.), *Cultural Studies*, New York, Routledge, 1992.

Hall, Stuart, 'Minimal Selves' in *Identity: The Real Me*, ICA Documents 6, London, Institute of Contemporary Arts, 1988.

Hall, Stuart, 'New Ethnicities' in Kobena Mercer (ed.), *Black Film, British Cinema*, ICA Documents 7, London, Institute of Contemporary Arts, 1988.

Hall, Stuart, 'Old and New Identities: Old and New Ethnicities' in Anthony D. King (ed.), *Culture, Globalization and the World System: Contemporary Conditions for the Representation of Identity*, Basingstoke, Macmillan Education, 1991.

Hall, Stuart, and Paul du Gay (eds.), *Questions of Cultural Identity*, London, Sage, 1996.

Handleman, Susan, *The Slayers of Moses: The Emergence of Rabbinic Interpretation in Modern Literary Theory*, Albany, State University of New York Press, 1982.

Handlin, Oscar, 'Introduction' to M. L. Hansen, 'The Third Generation in America', *Commentary*, vol. 14, 1952, pp. 492–500.

Haravon, Lea, 'A Child of Survivors Reflects', *The Daily Iowan*, 1997.

Hass, Aaron, *In the Shadow of the Holocaust: The Second Generation*, Cambridge, Cambridge University Press, 1996.

Herberg, Will, *Protestant-Catholic-Jew: An Essay in American Religious Sociology*, Garden City, N.Y., Doubleday, 1995.

Hertzberg, Arthur, 'Is the Jew in Exile?' in *Being Jewish in America: The Modern Experience*, New York, Schocken Books, 1979.

Hertzberg, Arthur, *The Zionist Idea: A Historical Analysis and Reader*, Westport, Conn., Greenwood Press, 1959.

Hertzberg, Arthur, and Aron Hirt-Manheimer, *Jews: The Essence and Character of a People*, Harper, San Francisco, 1998.

Herzl, Theodor, *Old-New Land*, New York, Bloch, 1941.

Herzl, Theodor, *Old-New Land*, trans. Lotte Levensohn, Introduction by Jacques Kornberg, New York, M. Wiener, Herzl Press, 1960.

Herzl, Theodor, *The Jewish State*, New York, Dover, 1988.

Higham, John, *Send These to Me: Immigrants in Urban America*, Baltimore, The Johns Hopkins University Press, rev. ed., 1984.

Hirsch, Marianne, 'Pictures of a Displaced Girlhood' in Angelika Bammer (ed.),

Displacements: Cultural Identities in Question, Bloomington, Indiana University Press, 1994.

Hobsbawm, Eric, and Trevor Ranger (eds.), *The Invention of Tradition*, Cambridge, Cambridge University Press, 1983.

Hoffman, Eva, *Lost in Translation: A Life in a New Language*, New York, Penguin Books, 1990.

Hoffman, Eva, *Shtetl: The Life and Death of a Small Town and the World of Polish Jews*, Boston, Houghton Mifflin, 1997.

Hollinger, David, *Post-Ethnic America: Beyond Multiculturalism*, New York, Basic Books, 1995.

Holmes, Colin, *Anti-Semitism in British Society, 1876–1939*, London, Edward Arnold, 1979.

Irwin, Graham, *Africans Abroad: A Documentary History of the Black Diaspora in Asia, Latin America and the Caribbean during the Age of Slavery*, New York, Columbia University Press, 1977.

Isenberg, Noah, '"Critical Post-Judaism": or, Reinventing a Yiddish Sensibility in a Postmodern Age', *Diaspora*, vol. 6 (1), 1997, pp. 85–96.

Itzkovits, Daniel, 'Secret Temples' in Jonathan Boyarin and Daniel Boyarin (eds.), *Jews and Other Differences: The New Jewish Cultural Studies*, Minneapolis, University of Minnesota Press, 1997.

'Jewish Family Values', http://jewishfamily.com/Features/996/tvjews2.htm.

Jhally, Sut, and Justin Lewis, *Enlightened Racism: The Cosby Show, Audiences, and the Myth of the American Dream*, Boulder, Westview Press, 1992.

Johnson, Carla, 'Luckless in New York', *Journal of Popular Film and Television*, vol. 22 (3), 1994, pp. 116–24.

Jones, Edward, *The Black Diaspora: Colonization of Colored People*, Seattle, Wash., Edward L. Jones, 1989.

Jordens, Ann-Mari, *Redefining Australia*, Sydney, Hale and Iremonger, 1995.

Kabakoff, Jacob, 'The View from the Old World: East European Jewish Perspectives' in Robert Seltzer and Norman Cohen (eds.), *The Americanization of the Jews*, New York, New York University Press, 1995.

Kafka, Franz, *The Trial*, London, Secker and Warburg, 1968.

Kahn, Joel, 'The "Culture" in Multiculturalism: A View From Anthropology', *Meanjin*, vol. 50 (1), 1991, pp. 48–52.

Kalmar, Ivan, *The Trotskys, Freuds and Woody Allens: Portrait of a Culture*, Toronto, Viking, 1993.

Kaplan, Alice, *French Lessons: A Memoir*, Chicago, University of Chicago Press, 1993.

Katz, Jacob, 'The Forerunners of Zionism' in Jehuda Reinharz and Anita Shapira (eds.), *Essential Papers on Zionism*, New York, New York University Press, 1995.

Kessel, Barbara, *Suddenly Jewish: Accounts of Hidden Jewish Heritage*, University Press of New England, forthcoming, 2000.

Kirshenblatt-Gimblett, Barbara, 'Spaces of Diasporas', *Cultural Anthropology*, vol. 9 (3), 1994, pp. 339–44.

Kleeblatt, Norman, '"Passing" into Multiculturalism' in Norman Kleeblatt (ed.), *Too Jewish? Challenging Traditional Identities*, New Brunswick, N.J., Rutgers University Press, 1996.

Kleeblatt, Norman (ed.), *Too Jewish? Challenging Traditional Identities*, New Brunswick, N.J., Rutgers University Press, 1996.

Klein, Emma, *Lost Jews: The Struggle for Identity Today*, London, Macmillan, 1996.

Kluger, Ruth, 'The Theme of Anti-Semitism in the Work of Austrian Jews' in Sander Gilman and Steven Katz (eds.), *Anti-Semitism in Times of Crisis*, New York, New York University Press, 1991.

Knabb, Ken (ed. and trans.), *Situationist International Anthology*, Berkeley, Bureau of Public Secrets, 1981.

Kosofsky Sedgwick, Eve, *Epistemology of the Closet*, New York, Harvester Wheatsheaf, 1990.

Kray, Susan, 'Orientalisation of an "Almost White" Woman: The Interlocking Effects of Race, Class, Gender and Ethnicity in American Mass Media', *Critical Studies in Mass Communication*, vol. 10, 1993, pp. 349–66.

Kumar, Krishan, *Utopia and Anti-Utopia in Modern Times*, Oxford, Blackwell, 1987.

Kureishi, Hanif, *The Black Album*, London, Faber and Faber, 1995.

Laclau, Ernesto, 'Subject of Politics, Politics of the Subject', *Filosofski Vestnik – Acta Philosophica*, vol. 15 (2), 1994.

Laing, R. D., *The Politics of Experience and the Bird of Paradise*, Harmondsworth, Penguin Books, 1967.

Lash, Scott, and Jonathan Friedman (eds.), *Modernity and Identity*, Oxford, Blackwell, 1992.

Lavie, Smadar, 'Blowups in the Borderzones: Third World Israeli Authors' Gropings for Home' in Smadar Lavie and Ted Swedenburg (eds.), *Displacement, Diaspora and Geographies of Identity*, Durham, N.C., Duke University Press, 1996.

Lechte, John, and Gil Bottomley, 'Difference, Postmodernity and Image in Multicultural Australia' in Gordon L. Clark et al. (eds.), *Multiculturalism, Difference and Postmodernism*, Melbourne, Longman Cheshire, 1993.

Lederhandler, Eli, *Jewish Responses to Modernity: New Voices in America and Eastern Europe*, New York, New York University Press, 1994.

Lee, Albert, *Henry Ford and the Jews*, New York, Stein and Day, 1980.

Le Rider, Jacques, *Modernity and the Crisis of Identity: Culture and Society in fin-de-siècle Vienna*, Cambridge, Polity Press, 1993.

Lerner, Michael, and Cornel West, *Jews and Blacks: A Dialogue on Race, Religion and Culture in America*, New York, G. P. Putnam's Sons, 1995.

Levitt, Laura, *Jews and Feminism: The Ambivalent Search for Home*, New York, Routledge, 1997.

Levitt, Laura, and Miriam Peskowitz (eds.), *Judaism Since Gender*, New York, Routledge, 1997.

Lippmann, Walter, 'Australian Jewry – Can It Survive?' *The Bridge*, January, 1973, pp. 6–11.

Lipset, Seymour Martin (ed.), *American Pluralism and the Jewish Community*, New Brunswick, N.J., Transaction, 1990.

Lipsitz, George, 'The Meaning of Memory: Family, Class, and Ethnicity in Early Network Television Programs', *Cultural Anthropology*, vol. 1 (4), 1986, pp. 355–87.

Lockard, Joe, and Melinda Micco (eds.), *Pretending To Be Me: Ethnic Transvestism and Cross-Writing*, forthcoming, University of Illinois Press.

London, H. I., *Non-White Immigration and the 'White Australia' Policy*, Sydney, Sydney University Press, 1970.

Love, Peter, 'The Kingdom of Shylock: A Case Study of Australian Labour Anti-Semitism', *Journal of the Australian Jewish History Association*, vol. 12 (1), 1993, pp. 54–62.

324

Lyman, Stanford, 'The Chinese Diaspora in America, 1850–1943', republished in *Color, Culture, Civilization: Race and Minority Issues in American Society*, Urbana, University of Illinois Press, 1994.

Lyotard, Jean-François, *Heidegger and 'the jews'*, trans. Andreas Michel and Mark S. Roberts, Minneapolis, University of Minnesota Press, 1990.

Lyotard, Jean-François, *The Differend: Phrases in Dispute*, Manchester, Manchester University Press, 1988.

Lyotard, Jean-François, *The Postmodern Explained to Children: Correspondence 1982–1985*, Sydney, Power Publications, 1992.

MacCannell, Juliet Flower, *The Regime of the Brother: After the Patriarchy*, London, Routledge, 1991.

Magnes, Judah, 'The Melting Pot' in Arthur Goren (ed.), *Dissenter in Zion: From the Writings of Judah Magnes*, Cambridge, Mass., Harvard University Press, 1982.

Manne, Robert, *The Culture of Forgetting: Helen Demidenko and the Holocaust*, Melbourne, Text Publishing, 1996.

Marc, David, *Comic Visions: Television Comedy and American Culture*, Malden, Mass., Blackwell, 2nd ed., 1997.

Marin, Louis, 'Frontiers of Utopia: Past and Present', *Critical Inquiry*, no. 19, 1993, pp. 403–7.

Marks, Elaine, *Marrano as Metaphor: The Jewish Presence in French Writing*, New York, Columbia University Press, 1996.

Markus, Andrew, 'Australian Governments and the Concept of Race: An Historical Perspective' in Marie de Lepervanche and Gillian Bottomley (eds.), *The Cultural Construction of Race*, Sydney, Sydney Association for Studies in Society and Culture, 1988.

Marr, Wilhelm, *The Victory of Jewry over Germandom* in Richard Levy (ed.), *Antisemitism in the Modern World: An Anthology of Texts*, Lexington, Mass., D.C. Heath, 1991.

Martin, Jean, *Community and Identity: Refugee Groups in Adelaide*, Canberra, Australian National University Press, 1972.

Massumi, Brian (ed.), *The Politics of Everyday Fear*, Minneapolis, University of Minnesota Press, 1993.

McClintock, Anne, *Imperial Leather: Race, Gender and Sexuality in the Colonial Conquest*, New York, Routledge, 1995.

Medding, Peter Y., *From Assimilation to Group Survival: A Political and Sociological Study of an Australian Jewish Community*, Melbourne, F.W. Cheshire, 1968.

Memmi, Albert, *Portrait of a Jew*, trans. Elisabeth Abbott, London, Eyre and Spottiswoode, 1963.

Mendes-Flohr, Paul, '*Fin-de-Siècle* Orientalism, the *Ostjuden* and the Aesthetics of Jewish Self-Affirmation', in Jonathan Frankel (ed.), *Studies in Contemporary Jewry*, vol. 1, 1984, pp. 96–139.

Mendes-Flohr, Paul, and Jehuda Reinharz (eds.), *The Jew in the Modern World: A Documentary History*, New York, Oxford University Press, 1980.

Mercer, Kobena, *Welcome to the Jungle*, New York, Routledge, 1994.

Michaels, Walter Benn, 'The No-Drop Rule' in Kwame Anthony Appiah and Henry Louis Gates jnr. (eds.), *Identities*, Chicago, University of Chicago Press, 1995.

Millman, Joyce, 'Cheerio "Seinfeld"', *Salon* at http://www.salonmag.com.

Mishra, Vijay, 'The Diasporic Imaginary: Theorizing the Indian Diaspora', *Textual Practice*, vol. 10 (3), 1996, pp. 421–47.

Morris, Brian, *In Favour of Circumcision*, Sydney, UNSW Press, 1999.

Mosse, George, *Toward the Final Solution: A History of European Racism*, New York, H. Fertig, 1978.

Mullin, Harryette, 'Optic White: Blackness and the Production of Whiteness', *Diacritics*, vol. 24 (2–3), 1993, pp. 71–89.

Multiculturalism For All Australians, Canberra, AGPS, 1982.

Nairn, Tom, *The Break-up of Britain: Crisis and Neo-Nationalism*, London, New Left Books, 1977.

Nelson, Jack, *Terror in the Night: The Klan's Campaign Against the Jews*, Jackson, University Press of Mississippi, 1996.

Netanyahu, Benzion, 'Introduction' to Leo Pinsker, *Road to Freedom: Writings and Addresses by Leo Pinsker*, New York, Scopus, 1944.

Nettleford, Rex, *Caribbean Cultural Identity: The Case of Jamaica: An Essay in Cultural Dynamics*, Los Angeles, University of California Press, 1979.

Neusner, Jacob, 'A New Heaven and a New Earth' in Jacob Neusner, *Stranger at Home: "The Holocaust", Zionism and American Judaism*, Chicago, University of Chicago Press, 1981.

Neusner, Jacob, *Israel in America*, Boston, Beacon Press, 1985.

Noah, Mordechai Manuel, 'Proclamation to the Jews (September 15, 1825)' in Paul Mendes–Flohr and Jehuda Reinharz (eds.), *The Jew in the Modern World: A Documentary History*, New York, Oxford University Press, 1980.

O'Regan, Tom, *Australian National Cinema*, London, Routledge, 1996.

Overberg, Henk, 'Introduction' to Theodor Herzl, *The Jewish State*, New York, Dover, 1988.

Oz, Amos, 'The State as Reprisal' in Amos Oz, *Under This Blazing Light: Essays*, Cambridge, New York, Press Syndicate of the University of Cambridge, 1995.

Pagden, Anthony, *The Fall of Natural Man: The American Indian and the Origins of Comparative Ethnology*, Cambridge, Cambridge University Press, 1982.

Palfreeman, A. C., *The Administration of the White Australia Policy*, Melbourne, Melbourne University Press, 1967.

Parker, Andrew, et al. (eds.), *Nationalisms and Sexualities*, New York, Routledge, 1992.

Parsons, Fred, *A Man Called Mo*, Melbourne, Heinemann, 1973.

Pateman, Carole, *The Sexual Contract*, Cambridge, Polity Press, 1988.

Poliakov, Leon, *The Aryan Myth: A History of Racist and Nationalist Ideas in Europe*, trans. Edmund Howard, London, Chatto and Windus Heinemann for Sussex University Press, 1974.

Pollins, Harold, *Economic History of the Jews in England*, Rutherford, Fairleigh Dickinson, 1982.

Prell, Riv-Ellen, 'Why Jewish Princesses don't Sweat' in Howard Eilberg–Schwartz (ed.), *People of the Body: Jews and Judaism from an Embodied Perspective*, Albany, State University of New York Press, 1992.

Price, Charles, *Jewish Settlers in Australia*, Canberra, Australian National University, 1964.

Ragussis, Michael, *Figures of Conversion: 'The Jewish Question' and English National Identity*, Durham, N.C., Duke University Press, 1995.

Rennie, Neil, *Far-Fetched Facts: The Literature of Travel and the Idea of the South Seas*, Oxford, Clarendon Press, 1995.

Reynolds, Henry, *The Law of the Land*, Ringwood, Penguin Books, 1987.

Rice, Emanuel, *Freud and Moses: The Long Journey Home*, Albany, State University of New York Press, 1990.

Ricks, Christopher, *T. S. Eliot and Prejudice*, London, Faber and Faber, 1994.

Ricoeur, Paul, 'Energetics and Hermeneutics in *The Interpretation of Dreams*' in Harold Bloom (ed.), *Sigmund Freud's The Interpretation of Dreams*, New York, Chelsea House Publishers, 1987.

Riemer, Andrew, *The Demidenko Debate*, St Leonard, NSW, Allen and Unwin, 1996.

Robbins, Jill, 'Circumcising Confession: Derrida, Autobiography, Judaism', *Diacritics*, vol. 25(4), 1995, pp. 20–38.

Rogin, Michael, *Blackface, White Noise: Jewish Immigrants in the Hollywood Melting Pot*, Berkeley, University of California Press, 1996.

Rose, Gillian, *Judaism and Modernity: Philosophical Essays*, Oxford, Blackwell, 1993.

Rose, Jacqueline, *States of Fantasy*, Oxford, Clarendon Press, 1996.

Roth, Philip, *Portnoy's Complaint*, Harmondsworth, Penguin Books, 1970.

Rousseau, Jean-Jacques, *The Social Contract*, Harmondsworth, Penguin Books, 1968.

Rubin, Barry, *Assimilation and its Discontents*, New York, Times Books, Random House, 1995.

Rubinstein, Hilary, *Chosen: The Jews in Australia*, Sydney, Allen and Unwin, 1987.

Rubinstein, Hilary, *The Jews in Australia: A Thematic History*, vol. 1: *1788–1945*, Port Melbourne, William Heinemann, 1992.

Rubinstein, William, *Judaism in Australia*, Canberra, AGPS, 1995.

Rubinstein, William, *The Jews in Australia: A Thematic History*, vol. 2: *1945–The Present*, Port Melbourne, Heinemann, 1991.

Russcol, Herbert, and Margalit Banai, *The First Million Sabras: A Portrait of the Native-born Israelis*, New York, Dodd, Mead and Co., 1970.

Rutherford, Jonathan (ed.), *Identity: Community, Culture, Difference*, London, Lawrence Wishart, 1990.

Rutland, Suzanne, *Edge of the Diaspora: Two Centuries of Jewish Settlement in Australia*, Sydney, Collins, 1988.

Safran, William, 'Diasporas in Modern Societies: Myths of Homeland and Return', *Diaspora*, vol. 1 (1), 1991, pp. 83–99.

Said, Edward, *Orientalism: Western Representations of the Orient*, London, Routledge and Kegan Paul, 1978.

Said, Edward, *The Question of Palestine*, New York, Vintage, 1980.

Sampson, Margaret, 'Jewish Anti-Semitism? The Attitudes of the Jewish Community in Britain Toward Refugees from Nazi Germany, *The Jewish Chronicle*, March 1933–September 1938' in John Milfull (ed.), *Why Germany? National Socialist Anti-Semitism and the European Context*, Providence, Berg, 1993.

Santner, Eric, 'Postmodernism's Jewish Question: Slavoj Zizek and the Monotheistic Perverse' in Lynne Cooke and Peter Wollen (eds.), *Visual Display: Culture Beyond Appearances*, Seattle, Bay Press, 1995.

Sartre, Jean-Paul, *Anti-Semite and Jew*, trans. George J. Becker, New York, Schocken Books, 1965.

Scholem, Gershom, *The Messianic Idea in Judaism and Other Essays on Jewish Spirituality*, New York, Schocken Books, 1971.

Scott, Joan W., 'Multiculturalism and the Politics of Identity' in John Rajchman, *The Identity in Question*, New York, Routledge, 1995.

Segal, Aaron, *An Atlas of International Migration*, London, Hans Zell, 1993.

Segal, Ronald, *The Black Diaspora*, New York, Farrar, Straus and Giroux, 1995.

Seidman, Naomi, *A Marriage Made in Heaven: The Sexual Politics of Hebrew and Yiddish*, Berkeley, University of California Press, 1997.

Seidman, Naomi, 'Lawless Attachments, One Night Stands: The Sexual Politics of the Hebrew–Yiddish Language War' in Jonathan Boyarin and Daniel Boyarin (eds.), *Jews and Other Differences: The New Jewish Cultural Studies*, Minneapolis, University of Minnesota Press, 1997.

Shell, Marc, 'Babel in America: The Politics of Language Diversity', *Critical Inquiry*, vol. 20(1), 1993, pp. 103–27.

Sherington, Geoffrey, *Australia's Immigrants 1788–1988*, Sydney, George Allen and Unwin, second ed., 1990.

Shohat, Ella, 'Columbus, Palestine and Arab-Jews: Toward a Relational Approach to Jewish Identity' in Keith Ansell-Pearson, Benita Parry and Judith Squires (eds.), *Cultural Readings of Imperialism: Edward Said and the Gravity of History*, New York, St Martin's Press, 1997.

Shohat, Ella, *Israeli Cinema: East/West and the Politics of Representation*, Austin, University of Texas Press, 1989.

Shokeid, Moshe, *Children of Circumstances: Israeli Emigrants in New York*, Ithaca, Cornell University Press, 1988.

Silvers, Phil (with Robert Saffron), *The Laugh Is On Me*, Englewood Cliffs, N.J., Prentice Hall, 1973.

Simmel, Georg, 'The Stranger' in Donald Levine (ed.), *George Simmel: On Individuality and Social Forms: Selected Writings*, Chicago, University of Chicago Press, 1971.

Singh, Amritjit, 'The Possibilities of a Radical Consciousness: African Americans and the New Immigrants' in Ishmael Reed (ed.), *Multi-Ethnic America: Essays on Cultural Wars and Cultural Peace*, New York, Viking, 1997.

Slobin, Mark, *Tenement Songs: The Popular Music of the Jewish Immigrants*, Urbana, University of Illinois Press, 1982.

Smith, Anthony D., *The Ethnic Origins of Nations*, Oxford, Blackwell, 1986.

Smith, Valerie, 'Reading the Intersections of Race and Gender in Narratives of Passing', *Diacritics*, vol. 24 (2–3), 1993, pp. 43–57.

Sollors, Werner, *Beyond Ethnicity: Consent and Descent in American Culture*, New York, Oxford University Press, 1986.

Sollors, Werner, *The Invention of Ethnicity*, New York, Oxford University Press, 1989.

Solomos, John, *Race and Racism in Britain*, London, Macmillan, 1989.

Spitzer, Leo, *Lives In Between: Assimilation and Marginality in Austria, Brazil, West Africa 1780–1945*, Cambridge, Cambridge University Press, 1989.

Stewart, Susan, *On Longing*, Durham, N.C., Duke University Press, 1993.

Strachey, James, 'Foreword' to Sigmund Freud, 'The "Uncanny"' in James Strachey (ed.), *The Standard Edition of the Complete Psychological Works of Sigmund Freud*, vol. 17, London, The Hogarth Press and the Institute of Psychoanalysis, 1962.

Strachey, James, editorial note in 'The Neuro-Psychoses of Defence' in James Strachey (ed.), *The Standard Edition of the Complete Psychological Works of Sigmund Freud*, vol. 3, London, The Hogarth Press and the Institute of Psychoanalysis, 1962.

Stratton, Jon, 'Multiculturalism and the Whitening Machine' in Ghassan Hage (ed.), *The Future of Australian Multiculturalism*, Sydney, Research Institute for the Humanities and Social Science, Sydney University, 1999.

Stratton, Jon, 'The Beast of the Apocalypse: The Postcolonial Experience of the United States', *New Formations*, no. 21, 1993, pp. 34–63.

Stratton, Jon, *Race Daze: Australia in Identity Crisis*, Sydney, Pluto Press, 1998.

Stratton, Jon, 'The Colour of Jews: Jews, Race and the White Australia Policy, *Journal of Australian Studies*, vol. 50/51, 1996, pp. 51–65.

Stratton, Jon, *The Desirable Body: Cultural Fetishism and the Erotics of Consumption*, Manchester, Manchester University Press, 1996.

Stratton, Jon, and Ien Ang, 'Multicultural Imagined Communities: Cultural Difference and National Identity in Australia and the USA', *Continuum: The Australian Journal of Media and Culture*, vol. 8 (2), 1994, pp. 124–138, reprinted as Stratton, Jon, and Ien Ang, 'Multicultural Imagined Communities: Cultural Difference and National Identity in the USA and Australia' in David Bennett (ed.), *Multicultural States: Rethinking Difference and Identity*, London, Routledge, 1998.

Stratton, Jon, and Ien Ang, 'On the Impossibility of Global Cultural Studies' in Kuan-Hsing Chen and David Morley (eds.), *Stuart Hall: Critical Dialogues in Cultural Studies*, London, Routledge, 1996.

Stratton, Jon, and Ien Ang, 'Speaking (as) Black British: Race, Nation and Cultural Studies in Britain' in Penny van Toorn and David English (eds.), *Speaking Positions: Aboriginality, Gender and Ethnicity in Australian Cultural Studies*, Melbourne, Victoria University of Technology Press, 1995.

Swislow, William, 'Interesting Idea: Gentiles in Paradise' at www.mcs.com/-.

Taft, Ronald, *From Stranger to Citizen: A Survey of Studies of Immigrant Assimilation in Western Australia*, Perth, University of Western Australia Press, 1965.

Ten, Chin Liew, 'Liberalism and Multiculturalism' in Gordon L. Clark et al. (eds.), *Multiculturalism, Difference and Postmodernism*, Melbourne, Longman Cheshire, 1993.

'The Boys Who Never Grew Up', *The Face*, vol. 2 (18), July 1998, pp. 84–92.

'The Demography of Modern Jewish History' in Paul Mendes-Flohr and Jehuda Reinharz (eds.), *The Jew in the Modern World: A Documentary History*, New York, Oxford University Press.

Theophanous, Andrew, *Understanding Multiculturalism and Australian Identity*, Melbourne, Elikia, 1995.

'To be or not to be . . . Jewish', *Jewish News of Greater Phoenix* at http://www.jewishaz.com/jewishnews/970905/tv/sctml.

Tobias, Henry J., *The Jewish Bund in Russia: From Its Origins to 1905*, Stanford, Stanford University Press, 1972.

Tölölyan, Khachig, 'Rethinking *Diaspora(s)*: Stateless Power in the Transnational Moment', *Diaspora: a Journal of Transnational Studies*, vol. 5 (1), 1996, pp. 3–35.

Tölölyan, Khachig, 'The Nation-State and its Others: In Lieu of a Preface', *Diaspora: a Journal of Transnational Studies*, vol. 1 (1), 1991, pp. 3–7.

Tu, Wei-Ming, *The Living Tree: The Changing Meaning of Being Chinese Today*, Stanford, Stanford University Press, 1994.

Vasta, Ellie, 'Dialectics of Domination: Racism and Multiculturalism' in Ellie Vasta and Stephen Castles (eds.), *The Teeth Are Smiling: The Persistence of Racism in Multicultural Australia*, St Leonards, NSW, Allen and Unwin, 1996.

Vella, Walter, *Chaiyo! King Vajiravudh and the Development of Thai Nationalism*, Honolulu, The University of Hawaii Press, 1979.

Vignaud, Henry, 'Columbus: a Spaniard and a Jew', *The American Historical Review*, vol. 18(3), 1912–13, pp. 505–13.

Waller, Louis, 'Legal Curbs on Discrimination and Race Hatred' in *Anti-Semitism and Human Rights*, Melbourne, Australian Institute of Jewish Affairs, 1985.

Wallerstein, Immanuel, *The Modern World-System*, New York, Academic Press, 1974.

Washington, George, 'A Reply to the Hebrew Congregation of Newport' (c. August 17, 1790) in Paul Mendes-Flohr and Judah Reinharz (eds.), *The Jew in the Modern World: A Documentary History*, New York, Oxford University Press, 1980.

Weber, Donald, 'The Jewish-American World of Gertrude Berg: *The Goldbergs* on Radio and Television, 1930–1950' in Joyce Antler (ed.), *Talking Back: Images of Jewish Women in American Popular Culture*, Hanover, Brandeis University Press, 1998.

Weber, Jonathan (ed.), *Jewish Identities in the New Europe*, London, Littman Library of Jewish Civilisation, 1994.

Weber, Samuel, 'The Sideshow, or: Remarks on a Canny Moment', *Modern Language Notes*, vol. 88, 1973, pp. 1102–33.

Weinrich, Max, 'The Reality of Jewishness Versus the Ghetto Myth: The Sociolinguistic Roots of Yiddish' in *To Honour Roman Jakobson*, The Hague, Mouton, 1967.

Wernblad, Annette, *Brooklyn Is Not Expanding: Woody Allen's Comic Universe*, Rutherford, N.J., Fairleigh Dickinson University Press, 1992.

White, Richard, *Inventing Australia*, North Sydney, George Allen and Unwin, 1981.

Wiesenthal, Simon, *Sails of Hope: The Secret Mission of Christopher Columbus*, New York, Christopher Columbus Publications, 1979.

Wild, David, *Seinfeld: The Totally Unauthorized Tribute [Not That There's Anything Wrong With That]*, Three Rivers Press, New York, 1988.

Willard, Myra, *History of the White Australia Policy to 1920*, Melbourne, Melbourne University Press, 1923.

Williams, Raymond, *Culture and Society 1780–1950*, Harmondsworth, Penguin Books, 1963.

Williams, Raymond, *Marxism and Literature*, Oxford, Oxford University Press, 1977.

Wirth, Louis, *The Ghetto*, Chicago, University of Chicago Press, 1928.

Wirth-Nesher, Hana, 'Introduction: Jewish-American Biography', *Prooftexts*, vol. 18 (2), 1998, pp. 113–20.

Wisse, Ruth, *The Schlemiel as Modern Hero*, Chicago, University of Chicago Press, 1971.

Wistrich, Robert, *Socialism and the Jews: The Dilemmas of Assimilation in Germany and Austro-Hungary*, Rutherford, N.J., Fairleigh Dickinson University Press, 1982.

Wohlgelernter, Maurice, *Israel Zangwill: A Study*, New York, Columbia University Press, 1964.

Wood, Nancy, 'The Victim's Resentments' in Bryan Cheyette and Laura Marcus (eds.), *Modernity, Culture and 'the Jew'*, Polity Press, Cambridge, 1998.

Woodward, Sir Llewellyn, *The Age of Reform 1815–1870*, 2nd ed., Oxford, Oxford University Press, 1962.

Yang, William, *Sadness*, St Leonards, Allen and Unwin, 1996.

Yerushalmi, Yosef Hayim, *Freud's Moses: Judaism Terminable and Interminable*, New Haven, Yale University Press, 1993.

Young, Robert, *Colonial Desire: Hybridity in Theory, Culture and Race*, London, Routledge, 1995.

Zangwill, Israel, 'Noah's Ark' in *Ghetto Tragedies*, London, W. Heinemann, 1899.

Zangwill, Israel, *The Melting Pot*, New York, Arno Press, 1914.

Zimmerman, Mosche, *Wilhelm Marr: The Patriarch of Anti-Semitism*, New York, Oxford University Press, 1986.

Zipes, Jack (ed. and trans.), *The Operated Jew: Two Tales of Anti-Semitism*, New York, Routledge, 1991.

Zizek, Slavoj, *For They Know Not What They Do: Enjoyment as a Political Factor*, London, Verso, 1991.

Zizek, Slavoj, *Tarrying with the Negative: Kant, Hegel and the Critique of Ideology*, Durham, N.C., Duke University Press, 1993.

Zizek, Slavoj, *The Sublime Object of Ideology*, London, Verso, 1989.

INDEX

Page numbers in *italic figures* refer to end notes.

Jewish state 172, 173–5, 182; state 157
Herzog, Elizabeth 273
Heyes, T.H. 213, 214
Higham, John 178, 255, 257–8; assimilation 272; exclusionist spirit 265; pluralism 268–9
Hirsch, Baron Maurice de 172, 204
Hirsch, Marianne 97–8, 104
Hirt-Manheimer, Aron 30
Hitler, Adolf 60
Hobbes, Thomas 85
Hobsbawm, Eric 148
Hobson, Laura Z. 295–6
Hoffman, Eva 85–6, 87, 94–8
Hoffmann, E.T.A. 76
Hoggart, Richard 41
Hollinger, David 227–8, 267
Holocaust 28, 57, 67, 289; and assimilation 10–11, 80, 143, 236; and ghetto thinking 98–101; and multiculturalism 241–3, 244, see also Nazis
home: as sanctuary from threat 92–4; and the womb 155, see also family
homeland: and diaspora 150–4; fantasy of 165
homogeneity: and ethnicity 133; strangers 196; threatened by Jews 201
Hornius, Gregorius 38, 199
How to Talk Dirty and Influence People (Bruce) 299
humour 21, 297–301
hysteria 63–4

identity 4, 7–12, 30; and ethnicity 29–30; and Holocaust 241–3; passing and coming out 12–19
Imagined Communities (Anderson) 200
immigrants, and settlers 262, 264
immigration, Australian race policy 201–8
In Duty Bound (Elisha) 242
India 37, 61
Indians (South America) 191
intergenerational transmission 98–9
intermarriage 207, 295
Interpretation of Dreams (Freud) 66, 70
Invention of Tradition (Hobsbawm) 148
invisibility, as tactic 101–6
Irish, as black 37
Irving, David 243
Irwin, Graham 251

Isaacs, Sir Isaac 240
Israel 3, 22–3; as diasporic homeland 137–60; as home 106–11; and the Return 117–18
Itzkovits, Daniel 286

James, Henry 41
Jasmine (Mukherjee) 270
Jazz Singer 292, 294
Jentsch 76, 77
Jerusalem (Mendelssohn) 146
Jesus, crucifixion 124
Jewish, and Yiddish 3–4
Jewish State (Herzl) 143–4, 146
Jewish State or Israeli Nation? (Evron) 183
Johnson, Carla 302, 305–6
Jolson, Al 292
Joseph, Jacques 64
Judaeo-Christian heritage 228
Judaism 201, 284–6; and Jewish culture 8–10, 198–9, see also religion
Judenstaat (Herzl) 168, 172

Kabakoff, Jacob 185
Kafka, Franz 77
Kahn, Joel 232
Kallen, Horace 178, 253, 274; pluralism 265, 266, 267–9
Kalmar, Ivan 104, 288, 297
Kant, Immanuel 67
Kaplan, Alice 89–90, 91–3, 109
Kaplan, Mordechai 179
Katz, Jacob 181
Keaton, Dianne 299
Kipling, Rudyard 200
Kirk, Hyland C. 180
Kirshenblatt-Gimblet, Barbara 273
Kishinev pogrom 86
Kleeblatt, Norman 103, 289, 292
Knight, Wayne 306
Kohler, Kaufman 170–1
Kosofsky, Eve 12–14
Krausz, Michael 283–4
Kray, Susan 246, 294
Kristeva, Julia 72
Kumar, Krishan 165, 168, 177, 181, 185
Kureishi, Hanif 1

Lacan, Jacques 125, 127, 156, 167; castration complex 59; object a 70–2
Laclau, Ernesto 227, 229, 230, 238
Ladino 236
Laing, R.D. 86–8